The Ordering
of the Arts
IN EIGHTEENTH-CENTURY
ENGLAND

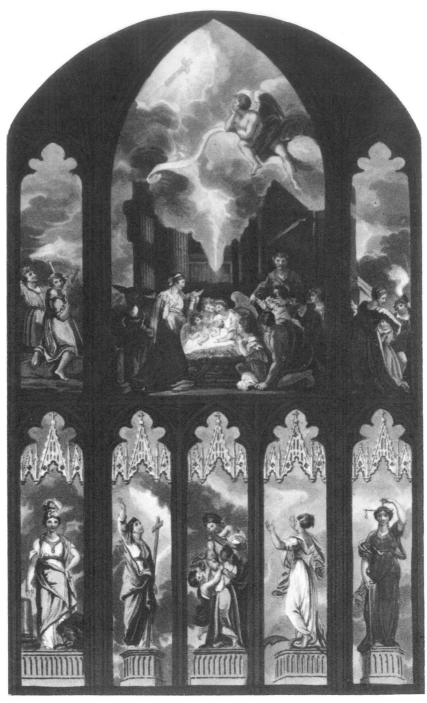

West window, New College Chapel, Oxford. Designed by Sir Joshua
Reynolds (1781). Engraving from Rudolph Ackermann's *History of the
University of Oxford* (1814).

The Ordering of the Arts

IN EIGHTEENTH-CENTURY ENGLAND

BY

Lawrence Lipking

PRINCETON, NEW JERSEY

PRINCETON UNIVERSITY PRESS

1970

For my mother and father

I had seen much, and I had thought much upon what I had seen;
I had something of an habit of investigation, and a disposition to
reduce all that I observed and felt in my own mind, to method
and system; but never having seen what I myself knew, distinctly
placed before me on paper, I knew nothing correctly. To put those
ideas into something like order was, to my inexperience, no easy
task. The composition, the ponere totum *even of a single Dis-*
course, as well as of a single statue, was the most difficult part,
as perhaps it is of every other art, and most requires
the hand of a master.

Sir Joshua Reynolds
DISCOURSE XV

Preface

WHEN studies of the arts have had their day, they often drift into a kind of limbo. Even the best of them, exiled from their original context and from a place in any literary genre, lose some of their authority—Charles Burney's *History of Music*, Sir Joshua Reynolds' *Discourses on Art*, Samuel Johnson's *Lives of the Poets* have all endured periods of reaction and neglect. But the first great English studies of the arts must be recognized for what they are: literary achievements whose breadth and depth put them near the center of their age. Many of them have been allowed to rest in limbo far too long. It is time to end their exile, and do them justice.

This is not a book about works of art, eighteenth-century aesthetics, or the interrelations of the arts. Rather, it is a study of those works which attempted for the first time to describe the whole practice of a single art; to set the history and criticism of an art in order. René Wellek has often deplored, and has done much to remedy, the lack of adequate scholarship on the rise of literary history. I have tried to supply part of this gap with regard to three arts—painting, music, and poetry—in eighteenth-century England. Yet my subject has not remained literary history or the first histories of the arts. In the course of my work, I gradually became convinced that no study of eighteenth-century works on the arts could afford to rest with a single brief period or a single genre. Histories, biographies, encyclopedias, collections of anecdotes, essays, treatises, all shared a common enterprise, a movement that I have come to call "the ordering of the arts." My effort to understand the ramifications of this movement accounts for the size and shape of this book. It considers many kinds of work, three arts, and a period of over a century; but it has been conceived, and must be judged, as a whole.

I began this book in 1958, with the aid of a Cornell University Senior Fellowship, and finished it a decade later, assisted by a

Donald A. Stauffer Preceptorship from Princeton University. In the interim the Princeton University Research Fund and the American Philosophical Society provided grants for summer research. I also wish to thank the staffs of the British Museum and of the Cornell, Princeton, Huntington, Folger, Yale, Berkeley, Bodleian, and John Rylands libraries.

Chapter two of this book was published, in a considerably different form, in the *Journal of Aesthetics and Art Criticism* (Summer, 1965), and chapter three in *Philological Quarterly* (Summer, 1967). In addition, some materials from chapter eleven have found their way into an article in *New Literary History* (Winter, 1970), and a condensed version of chapter seven was read to a conference on Literature and the Arts at Indiana University in the Spring of 1968.

By its nature, a book that spans so large an area must depend upon a community of scholars. The bibliographical sketch at the end of this book notes a few of my greater debts, but I can hardly begin to thank the many friends and colleagues who have stimulated and advised me over the years. A few names must stand for many: Professors David Novarr and Louis Landa, who read my manuscript in its earlier stages; and above all Professors M. H. Abrams and W. R. Keast, who guided my first steps in eighteenth-century studies, and whose work continues to provide a model of humane and searching scholarship. I should also like to mention that two ideal readers have often been in my mind, prompting my conscience to do better: R. S. Crane, who helped set me on this track many years ago; and my wife, the keenest-eyed and most affectionate audience of all.

LAWRENCE LIPKING

Princeton, New Jersey

List of Illustrations

Frontispiece, West window, New College Chapel, Oxford. Designed by Sir Joshua Reynolds (1781). Engraving from Rudolph Ackermann's *History of the University of Oxford* (1814).

Plate 1, William Lock: Frontispiece for Daniel Webb's *Miscellanies* (1802).

Plate 2, Van Dyck: Thomas Howard, Earl of Arundel, and his wife, with Franciscus Junius (*ca.* 1639). Knole. Reproduced by permission of Lord Sackville.

Plate 3, William Blake's copy of *The Works of Sir Joshua Reynolds* (1798), frontispiece and title page. The British Museum.

Plate 4, Reynolds: Admiral Keppel (1779). The Tate Gallery, London.

Plate 5, Reynolds: Commodore Keppel (1753-54). Reproduced by permission of the National Maritime Museum, Greenwich.

Plate 6, Reynolds: Viscount Keppel (1785). St. James's Palace, London. Reproduced by gracious permission of Her Majesty the Queen. Copyright reserved.

Plate 7, Reynolds: Three Ladies Adorning a Term of Hymen (1773). The Tate Gallery, London.

Contents

PART ONE: Themes and Precedents

PART TWO: The Ordering of Painting

CONTENTS

PART THREE: The Ordering of Music

PART FOUR: The Ordering of Poetry

CONTENTS

Abbreviations

DNB *Dictionary of National Biography*

ELH *Journal of English Literary History**

HLQ *Huntington Library Quarterly*

JAAC *Journal of Aesthetics and Art Criticism*

JEGP *Journal of English and Germanic Philology*

JHI *Journal of the History of Ideas*

JWCI *Journal of the Warburg and Courtauld Institutes*

MLN *Modern Language Notes*

MP *Modern Philology*

OED *New English Dictionary*

PMLA *Publications of the Modern Language Association of America*

PQ *Philological Quarterly*

RES *Review of English Studies*

SP *Studies in Philology*

TLS *Times Literary Supplement**

* ELH and TLS have adopted those abbreviations as their official names.

The Ordering
of the Arts
IN EIGHTEENTH-CENTURY
ENGLAND

Introduction

1

BY the middle of the eighteenth century, men interested in the arts had become concerned about a "chasm in English literature." Painting, music, and poetry attracted larger audiences than ever before, but their accomplishments had not been set in order. There was no great native history of any art, no canon of what was best, no model of a standard of taste. For the first time many Englishmen thought it important that their arts should have a history and their tastes should have a guide. They called for authors to satisfy that need. By the end of the century their calls had been answered; the arts had been surveyed by an unprecedented series of major works.

These works took many forms: Walpole's *Anecdotes of Painting in England* (1762-80), Reynolds' *Discourses on Art* (1769-90), Hawkins' and Burney's general histories of music (1776; 1776-89), Warton's *History of English Poetry* (1774-81), Johnson's *Lives of the Poets* (1779-81). They consider different arts and eras, and they differ also in ambition, in structure, and in style. Yet their authors share a common effort: the effort to discuss the entire practice of an art coherently and in detail. Each of them sets out to establish in his own way the standards of taste and knowledge that men draw upon when they wish to speak seriously about paintings and music and poems. And together, by precept and example, they provided a point of departure for English conversation about the arts.

The achievement of those works—how they came about, what they came to be—is the subject of this book. It begins where their authors began, with the predecessors who inspired them to "something of an habit of investigation," and ends where they ended, with the fruits of that habit, their own hesitant but compelling *ponere totum*. But the works that ordered the arts are immense and various, and a book that would do them justice must be many

books in one. It must be partly a history, or a set of histories, of writing about each of the arts; partly a critical analysis of selected works; partly a study of ideas about the arts; and partly a social history of authors and their audiences. Without pretending to be definitive, this book includes something from each of those modes. It draws upon a variety of scholarly methods, of literary kinds, of fields of research; it responds to the size and the hybrid nature of the works it studies. Both in its subject and in its own attitudes, this book is designed to be complicated.

It is complicated, first of all, because it deals with three separate arts. Painting, music, and poetry were not ordered together, nor at the same time. In England the history of poetry was studied long before the history of painting, and painting long before music. Moreover, the arts were rivals as well as sisters. Each had champions who tailored critical theories to flatter their own favorite. Lovers of painting emphasized the ability of art to mirror nature, lovers of music its power to touch human affections, and lovers of poetry its marriage of reason with imagination, picture with song.[1] A book that gives equal weight to each of the arts must be alert to such differences. Three historical movements, each with its own precedents, its own interests, its own kinds of discourse, join in the ordering of the arts.

Secondly, this book is complicated because the works that it examines are many-sided. What category can take the measure of Reynolds' *Discourses*? Reynolds has been studied as an artist, a philosopher of art, and a man of letters; he is all these, but he is something more. Not simply a system of aesthetics, nor a course of

[1] A useful popularization of the immense eighteenth-century literature comparing the arts is offered by the works of Daniel Webb (1719?-1798), especially *An Inquiry into the Beauties of Painting* (1760), *Remarks on the Beauties of Poetry* (1762), and *Observations on the Correspondence between Poetry and Music* (1769). All these works are collected in Webb's *Miscellanies* (London, 1802), whose frontispiece, after a drawing by William Lock, illustrates most of what the author has to say [Plate 1]. The three arts, depicted as sisters, admire a frolicking nude who represents Nature ("nature seems to sport with our understanding, and lays aside her laws to wanton in her own creations"; p. 224). On one side, clear-eyed Painting, dressed in a simple shift, intently studies Nature's form ("of all the arts, Painting is the most natural both in its means and effects"; p. 10); on the other, Music, in classical apparel and with her lyre, turns away, uninterested in imitation, to gaze mysteriously at distant birds in the sky. Between her sisters, Poetry, in robes of the East, both looks and broods, studies and dreams ("poetry is an union of the two powers of musick and picture"; p. 7). Webb, much impressed by this picture, dedicated his volume to the artist.

instruction in painting, nor a series of essays on the history and criticism of art, the *Discourses* mount a retrospective exhibition of great ideas and great writings on art. All discourse about art is their province. Combining an amazing number of literary modes, they cannot be reduced to a single thesis or a single point of view. This book confronts the intricacy of the *Discourses*; it surveys them from many perspectives, and tries to appreciate them as a whole. Similarly, the complexities of Burney's *History of Music,* of Warton's *History of English Poetry,* and of Johnson's *Lives of the Poets* are approached from many sides. I cannot hope to exhaust our means of interpreting such works, but I do hope to enlarge our means of understanding them. When we complicate our views of eighteenth-century studies of the arts we shall begin to see how much they attempt, how much they achieve.

Finally, this book is complicated because of its method. The works that ordered the arts, works themselves so uncertain in method, raise problems of method to an acute degree. They do not offer complete structures of thought so much as a vast indeterminate conversation, and their opinions, often provoked by enemies or borrowed from friends, resist systematic formulation. Works so irregular, so idiosyncratic, challenge the historian of ideas to find a clear way of his own. Shall he look for patterns of history, or for the truth about particular men? Shall he trace the progress of ideas from age to age and work to work, or shall he mark the peculiar integrity of each work in its own time and its own terms?[2] This book takes a middle course. It attempts to balance between the general and the particular: to ground its analysis of ideas in the contexts from which they arose, and to draw a sense of history from comparisons among authors of different eras. I do not discuss eighteenth-century taste, but the meanings of "taste" available to Charles Burney, and his own selection of meanings; I do not survey the growth of aesthetic theory, but the specific changes revealed by translations of *De arte graphica* over a century. So

[2] These alternatives are exemplified by two histories of eighteenth-century aesthetics: Samuel H. Monk's *The Sublime: A Study of Critical Theories in XVIII-Century England* (Ann Arbor, Mich., 1960; first published in 1935), which follows the development of the notion of sublimity from its Longinian origins to its culmination in Kant; and W. J. Hipple's *The Beautiful, The Sublime, & The Picturesque In Eighteenth-Century British Aesthetic Theory* (Carbondale, Ill., 1957), which analyzes the systems of various aestheticians without attempting to link them or to arrange them in a continuous history.

far as possible the generalizations of this book are rooted in the details of an intellectual argument, a historical moment, or a literary career. Like many of the works it considers, it adjusts its method to the task at hand, and prefers an open, pragmatic inquiry to a closed set of ideas.

Even the most open inquiry, however, must define its limits. The ordering of the arts is a process without end; no book can take in more than a part of it. In the following pages I should like to set the terms of my own subject by sketching, first, its history, and second, the way that I propose to treat it.

2

No history of music had ever been written in England; suddenly, in 1776, there were two, the famous rival volumes of Hawkins and Burney. Before the 1770's English poetry had never been surveyed as a whole; in 1781 the complementary works of Warton and Johnson divided the field between them. English writers on painting had always been subservient to the continent; but in 1780, when Walpole finished publishing the first history of English art, the world's leading authority on painting was acknowledged to be his fellow Englishman Reynolds.

What caused this transformation in studies of the arts? No hypothesis can explain, of course, the sudden appearance of so many works and authors. Yet the outline of an answer is relatively clear. Before histories of the arts can be written, two obvious conditions must be satisfied: men must be interested in history, and they must be interested in the arts. In mid-eighteenth-century England both history and the arts attracted interest as never before. The extraordinary historical outpouring that began in the 1750's with Hume and Robertson and Smollet, and culminated in 1776 with Gibbon, established history-writing at once as a high literary form and as a popular entertainment. The vogue of history, the fascination with old manners and styles, saturated contemporary modes of art: the paintings of Benjamin West, the Concerts of Ancient Music (founded in 1776), the poems of Chatterton. At the same time the audience for the arts increased enormously, and so did their status. Such public shows of favor as the founding of the Royal Academy in 1768, the Shakespeare Jubilee of 1769, or the massive Handel Commemoration of 1784 are merely the tokens of

a great surge of popular appreciation and respect for the arts. Unprecedented crowds flocked to exhibitions of painting and to concerts; unprecedented numbers of people began to read and write poetry. The growing interest in history, the growing interest in the arts, inevitably came together. A new kind of author—the historian of the arts—arose to unite the two interests in a single work.

Theoretically, a recipe for joining them had been available to Englishmen at least since 1605. In *The Advancement of Learning*, Francis Bacon had recommended a fresh empirical study of human achievements. "HISTORY is NATURALL, CIVILE, ECCLESIASTICALL & LITERARY, whereof the three first I allow as extant, the fourth I note as deficient. For no man hath propounded to himselfe the generall state of learning to bee described and represented from age to age, as many have done the works of Nature, & the State civile and Ecclesiastical; without which the History of the world seemeth to me, to be as the *Statua* of *Polyphemus* with his eye out, that part being wanting, which doth most shew the spirit, and life of the person."[3] Although Bacon defines literary history as the story of *learning*, not of poetry, his own description of poetry as a kind of learning licensed by the imagination, as well as his esteem for painting and music, encouraged historians to turn to the arts. Many generations of scholars gathered facts of literary history in the name of Bacon; and as late as 1776, when justifying the plan of his *History of Music*, Sir John Hawkins was proud to call himself a Baconian.[4]

Yet Bacon's prescription for a history of learning was premature. A century and a half elapsed before scholars translated their theoretical support for major studies of the arts into the works themselves. The first part of this book considers some of the reasons for the delay: the preference of humanist scholars for classical theory over modern practice, the search for an authority to replace the classics, the ineffectual attempts to found literary history upon the model of the encyclopedia or the philosophical treatise. More broadly, however, the slow progress of histories of the arts may be assigned two causes: the tendency to subordinate

[3] *Advancement of Learning* (London, 1605), Book Two, p. 7ᵛ (I, 2).
[4] See chapter nine, section four below. In the present section I have adopted, for want of a better term, Hawkins' use of "literary history" to refer to a learned history of any of the arts.

the arts to other interests and concerns; and the divided nature of literary history itself. Between them, these two predicaments account for the long interval when the chronicles of painting, music, and poetry were laid aside.

What does it profit a man to study the arts? Even at the moment of advocating literary history, Bacon had hesitated to embrace such studies on their own account. He insists upon a dignified ulterior motive: "The use and end of which worke I do not so much designe for curiositie or satisfaction of those that are the lovers of learning; but chiefly for a more serious, & grave purpose, which is this in fewe wordes, that it will make learned men wise, in the use and administration of learning."[5] Most scholars would have agreed; the end of learning should not be amusement or curiosity but wisdom and usefulness. Here, as so often in the Renaissance, knowledge is required to serve the needs of education. Transposed to the arts, this argument suggests two practical implications: histories of the arts constitute a necessary part of the education of a gentleman (thus the brief surveys of the arts in works like Peacham's *Compleat Gentleman*); histories of the arts teach the artist what he must aspire to become (as in Junius' *Painting of the Ancients*). Learning about the arts, men learn how to use them.

As a guide for historians, however, Bacon's design invites a limited and expedient kind of scholarship. If surveys of the arts are to be used for education, not to satisfy curiosity, then only instructive facts need be chosen. Indeed, lavish learning can be a dangerous thing. A complete gentleman requires as much knowledge of the history of the arts as will refine his taste; beyond that, he must avoid the pedantry of useless information. An artist requires as much knowledge as will improve his talent; beyond that, he must beware of corruption by inferior schools, or by mere eclecticism. Peacham, therefore, taught his gentlemen no more about the arts than was good for them, and Junius taught his artists to shun any school not consecrated by ancient writings. Heirs of the Renaissance, they would not allow their students a promiscuous vulgar fascination with the mere facts of literary history.

Nor had earlier historians of the arts thought that the arts were deserving of attention in their own right. Quintilian, for instance,

[5] *Advancement of Learning,* Book Two, p. 8 (I, 2).

has sometimes been considered the father of literary history, be-
cause of his remarks on poets in Book X of the *Institutio Oratoria*;
yet in context he discusses poetry and painting and music only
insofar as they supply lessons in eloquence. Homer wins special
praise because he is "supreme not merely for poetic, but for ora-
torical power as well," and Seneca is recommended to the student
only in small doses, because in his style (*eloquendo*) he "is for the
most part corrupt and exceedingly dangerous."[6] Such histories of
the arts discourage depth and accuracy of research. Their learning
functions rhetorically, to point a moral, or adorn a tale.

Indeed, prior to the Restoration virtually every "literary his-
torian" had palpable designs upon whatever arts or artists he men-
tioned. We have all encountered the tantalizing fragments of his-
tory passed down by authors like Thomas Wilson, Puttenham,
Sidney, and Daniel—tantalizing, because they seem to suggest that
the author could be genuinely informative (at least about his con-
temporaries) if only he were to set his mind to it. Thus Francis
Meres' brief sentences about "mellifluous & hony-tongued *Shake-
speare*" drop a few grains of knowledge from apparently vast and
precious stores. Yet Meres gives us only those scraps which fit his
"comparative discourse," a schematic parallel between English
artists and those of other times and countries. His whole book is
Wits Treasury, a collection and exhibition of resemblances, and
he obeys no other principle of literary history than witty compari-
son.[7] Such an author (like the combatants in the war of ancients
and moderns) is not a literary historian *manqué* but a literary his-
torian *par aventure*. He bends information of all sorts into the
shape of his own work, and for anything we might recognize as the
proper history of an art he cares not at all.

Gradually, during the seventeenth century, histories of the arts
became more independent. Literary historians began to record
facts that interested them, whether or not such facts offered lessons.
The very word "curiosity," which Bacon had spurned as undue
nicety, "laborious webs of learning," "unprofitable subtility,"
acquired a new meaning: "scientific or artistic interest; the qual-
ity of a curioso or virtuoso; connoisseurship." In the event, naked

[6] *Institutio Oratoria*, X, i, 46; X, i, 129 (Loeb, IV, 29, 73).
[7] *Palladis Tamia. Wits Treasury* (London, 1598). "A comparative discourse of our
English Poets, with the *Greeke, Latine, and Italian Poets*" appears on pp. 279ʳ-
287ʳ; the following pages make similar comparisons of painters and composers.

curiosity could prompt men to study the arts even when they lacked a deeper motive. Furthermore, painting, music, and poetry attracted increasing attention simply because they became easier to identify as objects of learning. The development of the modern system of the fine arts, which reached a climax with D'Alembert's division of knowledge in the "Discours préliminaire" to the *Encyclopédie* (1751), separated the three sister arts (and to some extent sculpture and architecture) from all other human activities, and established them as unique repositories of the "spirit and life" of mankind.[8] Most authorities on the arts had decided, by the mid-eighteenth century, that painting, music, and poetry might properly be considered "sciences" (fields of knowledge), and that like other sciences they required a history. The study of the arts no longer needed to justify itself; the arts had come into their own.

The first great English histories of the arts, therefore, do not claim to be of any use. Curiosity and a love of works of art for their own sake are their only excuse for being. Horace Walpole denied, with some alarm, that his *Anecdotes* could be of any importance, and Charles Burney scandalized the serious Hawkins by calling music "an innocent luxury" and his own *History of Music* "an amusement." Eighteenth-century historians study the arts because that study interests and amuses them; and histories of the arts are vindicated by their power to be interesting and amusing. Purified of extraneous designs and ulterior motives, literary history became free to follow its own internal principles of development.

Perhaps no history of an art, however, can ever be "pure." Even when freed from the purposes of the orators and the educators, literary history continued to serve the purposes of painters, musicians, and poets. The shape of the history of art cannot be a matter of indifference to artists. Moreover, artists arrange the facts of history to benefit their own work. Poets were the first scholars; scholarship itself, we have recently been reminded, "originated as a separate intellectual discipline in the third century before Christ through the efforts of poets to preserve and to use their literary

[8] The origin of such notions of the five "major arts" is traced by P. O. Kristeller, "The Modern System of the Arts," *JHI*, XII (1951), 496-527; XIII (1952), 17-46.

heritage, the 'classics'."[9] Similarly, the efforts of Restoration poets like Dryden to clarify their own relation to the English poetic heritage set the terms of English literary history for a century; and the great poets of the two following eras, Pope and Gray, each left a sketch for a projected history of English poetry—a project carried through by Thomas Warton, then Poet-Laureate. The growth of historical interpretations of the arts is animated by the self-conscious attempts of artists to find fresh sources of inspiration.

This search for a usable past—for what modern critics like to call, rather illegitimately, a "tradition"—sustains the first histories of each of the arts. With few exceptions, early literary historians began as artists and mythographers. The history of painting, that golden legend of a Renaissance culminated by the perfections of Raphael and Michelangelo, is the painter Vasari's most beautiful creation. So powerful did his legend prove, that Jonathan Richardson, Hogarth, Reynolds, and Blake, artists who strove to find historical grounds for the English renaissance they planned, were forced to build their myths of history upon Italian art. Such histories are fables at one remove; they attempt to capture the mysterious aura that surrounds the art of the past, and to project it into the future. "History painting," an imitative genre whose true subject often seems to be the styles of old masters, perfectly represents the ambiguous conversions of myth to history, and history to myth, displayed by eighteenth-century painters.[10] In the same way, poets like Collins, Gray, and the Wartons, who mourn their loss of the myths available to older poets, compensate by making the history of poetry itself their central myth. Looking for forbears, artists both make and find the history of art.

The correspondence between mythmaking and literary history can be treacherous, but it is not fortuitous. Literary history depends upon the search for something immortal. Whether or not they pretend to be artists, historians of the arts cannot avoid the preoccupation with quality, the concentration upon genius, that

[9] Rudolf Pfeiffer, *History of Classical Scholarship from the Beginnings to the End of the Hellenistic Age* (Oxford, 1968), p. 3.

[10] The extent to which neoclassicism itself was a revolutionary conversion of ancient art to modern sentiments has recently been stressed by several art historians: David Irwin, *English Neoclassical Art* (London, 1966); Robert Rosenblum, *Transformations in Late Eighteenth Century Art* (Princeton, 1967); Hugh Honour, *Neo-classicism* (London, 1968).

define the interest of their studies. Poetry, Horace said, "Admits of no degrees, but must be still/ Sublimely good, or despicably ill";[11] in the arts only mastery, or the provenance of mastery, is worth discussing. Thus a historian of the arts, unlike a bibliographer or a philologist, can hardly discharge his task by recording "the facts." The facts of literary history are seldom free from critical implication. They include the judgment, whether explicit or hidden, that some artists (not necessarily the most popular, the most prolific, or the most influential) are better than others, and deserve to be remembered. Without that judgment the arts and the histories of the arts would not exist.

Nevertheless, a literary historian must also respect the discipline of history. He cannot afford to sacrifice his objectivity and his quest for knowledge to a complacent assumption that he already knows which artists have transcended time. Charles Burney, who began as a musician and an arbiter of taste, became a historian in the process of writing his *History of Music,* and discovered that much of the music he had previously condemned offered unfamiliar pleasures. Literary history compels such adjustments. The truth about the past never quite accords with what the critic would like it to be. Taste and information, criticism and history, each asserts its claims; in a divided field, the literary historian must strive to develop both the patience to accumulate facts and the sensibility to judge their importance.[12]

11 "Si paulum summo decessit, vergit ad imum"; *De arte poetica,* l. 378; tr. Roscommon.

12 The tendency of literary historians to generalize without adequate information was stringently policed, in the second half of the eighteenth century, by antiquarians and pamphleteers. The most famous work of this kind, Joseph Ritson's *Observations on the three first Volumes of the History of English Poetry* (1782), was printed in a format suitable for binding into Warton's *History.* In a pamphlet attacking John Brown's *Dissertation on the Rise, Union, and Power, The Progressions, Separations, and Corruptions, of Poetry and Music* (1763), the anonymous author justifies such labors of correction. Since the arts are so uncertain in their operations, "to think by laying down one or a few principles to deduce the progress of them systematically, is parallel to Almanack-makers foretelling the weather. . . . such disquisitions as Dr. Brown's are to be considered, not as important *investigations,* but almost entirely as amusing gratifications of curiosity." It follows, therefore, "That the Doctorial manner, the air of science with which it has been so fashionable of late to advance conjectures, is equally unsuitable to the purpose, and the topics of such dissertations," and "That since information is the principal purpose they can answer, misinterpretation, or even error in matter of fact, is less excusable in them than any other kind of enquiry." *Some Observations on Dr. Brown's Dissertation* (London, 1764), pp. 2-3.

Yet the two strains of literary history are difficult to reconcile. Bacon had wanted "a just story of learning" that would affirm "the spirit and life" of man, a mirror for scholars that would inspire as well as inform. Many later advocates of histories of the arts demanded still more, calling for "a clear idea of the noblest species of beings we are acquainted with." Like Vasari, they valued the spirit common to all great artists more than the details that distinguish one man from another. At the same time other descendants of Bacon, the savants and virtuosi of the late seventeenth century, concluded that the prime virtues of the historian must be accuracy and fullness. Few historians of the arts could answer both demands. In practice, either they supplied facts wholesale without arranging them (like George Vertue and William Oldys), or (like Hildebrand Jacob and Charles Avison) they selected bits of history to illustrate their ideas of taste. Hawkins alone, of eighteenth-century critics, thought that in the modern age a detailed story of learning could reveal the life of man; and men of taste said that he had revealed the living death of a pedant. The union of critic and scholar in the literary historian was not the triumph of an ideal, but a marriage of convenience.

Indeed, the works that ordered the arts in eighteenth-century England are not, properly speaking, literary histories at all. I have called them instead "canons and surveys" to emphasize that they fall into two distinct kinds. One kind, represented by Walpole, Hawkins, and Warton, insists on the primacy of source materials and research. The product of scholars, men of leisure who work without patrons or deadlines, it subordinates criticism to a collection of antiquarian documents, and does not pretend that the field it surveys possesses an underlying unity. The other kind, represented by Reynolds, Burney, and Johnson, displays a strong critical bias. The product of acknowledged professional authorities, it undertakes to enhance the dignity of the several arts by condemning mediocrity and praising excellence; it envisages an imaginary order of merit in which artists of every period compete for a place. Like the arts themselves in the eighteenth century, the two ways of describing the history of art were rivals, partitioned in thought as in a diagram.

LITERARY	HISTORY
canons (value)	surveys (historical particulars)
the definition of the fine arts	the growth of empiricism
professional; critic; intellectual	amateur; scholar; antiquarian
Reynolds, Johnson, Burney	Walpole, Warton, Hawkins

Like the arts themselves, however, the ways of describing art were also interrelated. The major works on painting, music, and poetry break through their partitions of thought. As Reynolds extended his canon of great painters into the full range of history, he produced an informal survey of the art; as Hawkins assembled all documents pertaining to music, his commentary upon them traced a general definition of music; and Johnson wrote Warton that only historical scholarship like his could reform the practice of criticism. The complicated and delicate play between an ideal of art and the minute particulars of experience that both confirm and adulterate that ideal accounts for much of the fascination of eighteenth-century literary history. Theorists like Daniel Webb and John Brown constructed models of history to fit their ideas; antiquarians like Thomas Percy and Thomas Tyrwhitt generated theories to justify their taste for old poetry. Slowly the historical facts and the ambitions of critics were brought together. From the clash and balance between the opposing tendencies of literary history, and from their uncertain reconciliation, the first English histories of the arts were born.

3

Many generations, hundreds of authors, took part in that process. Of necessity this book can discuss no more than a selection of relevant works. It concentrates upon three arts (at the expense of sculpture, architecture, and landscape gardening), upon England (at the expense of equal efforts by the other nations of Europe), and upon the late eighteenth century. Moreover, its résumé of history depends heavily on a few representative works and authors. Part One, for instance, would have offered a different choice of themes and precedents had it been based (as at various times I intended) upon studies of Robert Fludd, John Evelyn,

Roger North, and John Brown. By neglecting such authors and emphasizing others, this book defines its own range of inquiry and its own set of problems.

To begin with, I have chosen to study works of a certain size, a certain ambition. Some ideas about the arts, some notions of history and some ranking of the greatest artists, have existed almost as long as the arts themselves. The phenomenon that I have called "the ordering of the arts" is not a radical departure from such ideas, but a radical extension of them in quantity and depth. Eighteenth-century critics of the arts were not content, like their predecessors, with a few words of praise or censure. They insisted upon detailed analysis, upon a search through history and philosophy for principles of art, and upon enormous stores of information. The works examined by this book are pretentious; they try to investigate and distinguish the whole of an art.

What constitutes the whole of an art, however, is subject to different interpretations at different times. Part One of this book inspects four authors who claim to provide "an entire and certain knowledge" of an art, but who provide very dissimilar kinds of knowledge. For Franciscus Junius, the whole art of painting is embodied in a collation of precepts and stories by ancient writers; for C. A. du Fresnoy, in doctrines exemplified by the best modern painters. For William Oldys, the only sure knowledge of poetry consists of particular facts purged from speculation and error; for James Harris, one knows an art by understanding philosophically its causes and effects. Each of these authors, given his terms, is significant and persuasive. Yet none of them undertakes to heal the divisions in literary history, to write a work at once canon and survey, the theory and practice, of a whole art. However stimulating, their studies of art remain partial.

Jonathan Richardson, Charles Avison, and the early historians of English poetry had fewer preconceptions about what constitutes the whole of an art; indeed, each of them suspected that men as yet knew very little about the arts. In place of the "dark diallect, and jargon" of their predecessors, the painter Richardson and the musician Avison, like Addison in literary criticism, sought to adopt a language suited to common understanding, and a criticism tempered by practical experience of painting, music, and poetry. If they did not themselves transfigure writing about

15

the arts, these reformers demonstrated the errors and evasions of previous work. They demanded better sources of information, better critics and historians; and their successors, the men who wrote the first English canons and surveys, paid tribute to their inspiration.

It is those successors whose works are the heart of this book. Walpole, Reynolds, Hawkins, Burney, Warton, and Johnson each devised his own massive individual solution to the problem of writing about the whole of an art, and each of them deserves the sustained attention we owe a major work. For the first time in English, they test ideas about painting, music, and poetry against specific accounts of artists and works of art. Synthesizing and building upon previous scholarship, they reach for a better and fuller understanding. This book considers each of those major texts in many aspects: its precedents, its place in the author's career, the quality of its erudition and style, its form, the relation of parts to the whole. Some of the works thus considered have never before been examined at length; and never before, of course, have they all been examined together.

What is the justification, however, for bringing together works of different kinds, works that review different arts? Is there an integral relation among them? Perhaps a truthful answer to questions like these must be personal. Works that have been studied over a period of years gradually arrange themselves in the mind, and some of them seem to join in a coherent pattern. That slow convergence of thought, as much as any conscious principle, has influenced my grouping of works. Yet if such a process is at all trustworthy, it should be possible to unravel it, and to bring to light its latent principles of relation.

In one way, the relations among the major works are obvious: they share a time and a milieu. Their authors made part of a single intellectual community bounded at opposite ends by Horace Walpole and Samuel Johnson; every one of them was conversant with the accomplishments of every other. Johnson wrote the dedications for his friend Reynolds' *Discourses* and his friend Burney's *History of Music*, encouraged and parodied the labors of his sometime friend Thomas Warton, and eventually became the subject of his friend and executor Hawkins' second most notorious book. Walpole instigated Hawkins' *History of Music*, aided

Warton's *History of English Poetry,* and thought his own *Anecdotes of Painting* a tributary to Reynolds. Sir Joshua, for his part, trained his mind with lessons from all his peers. Burney, the friend of everyone in general and Reynolds in particular, asked Warton for help. And so on. Whatever their rivalries and animosities, these contemporaries read the same historians, critics, and newspapers, checked their facts in the same biographical dictionaries, were invited to meet the same celebrities, and reckoned with the same audience.

Inevitably, then, the major works on painting, music, and poetry have much in common, a community of interest they acknowledge with frequent analogies among the arts. They draw upon a similar vocabulary, similar critical habits, and similar assumptions about the place of the arts in life. But more important, they face a common problem. Borne upon a rising tide of interest in the arts, each author seeks to impose his own will on the current, to gather a vast miscellany of facts and tastes into an intelligible whole. This problem cuts across the usual boundaries of subject matter and genre. Walpole's *Anecdotes of Painting,* Burney's *History of Music,* Johnson's *Lives of the Poets* resemble each other as a whole far more closely than any of them resembles its forerunners, the early brief outlines of the history of an art. The sheer size of their enterprise causes a difference in kind.

Indeed, the major works do not conform to kinds; they improvise and discover them. Like many novelists and poets of the late eighteenth century, authors on the arts found no established form that could contain all they wanted to say. Walpole, rather than write anything so grand as a History of English Painting or Lives of the Painters, contrived new sorts of *Anecdotes*; Hawkins, scoffing at the unscientific prejudices displayed by previous chroniclers of music, begot his own anomalous system of music history; if Johnson had not cited the advertisements in French miscellanies as the model for his own *Prefaces to the English Poets,* it is doubtful whether anyone else would have noticed the likeness. As each author made his work, his countless decisions and choices of material led him through an individual train of thought to an individual plan, but hardly to a fixed genre. Every one of these works resists firm classification. Part by part they tend to

be medleys, and as a whole they offer a virtual encyclopedia of forms.

Moreover, a sort of hypertrophy forced itself upon authors even against their will. Hawkins, Burney, Warton, and Johnson all intended to write shorter, more schematic books, but found that the pressure of arranging such various materials drove them towards a freer and greater mode of organization. During the making of the works a pattern recurs again and again as if by compulsion. The author's initial optimism fades into a time of hesitation and delay; his first program is discarded; he despairs of coming to an end of his research, or reducing it to form; changing to a discursive and irregular structure, he pushes to a conclusion; the critics complain that the finished work is a tissue of confusions. The task itself seems to have enjoined a new plan, open, flexible, and untidy.

Nor could authors of works on the arts rely upon any general agreement about the bounds or the value of their task. During the mid–eighteenth century, on the continent as well as in Britain, the whole nature of the arts was being subjected to a thorough reinvestigation. A new kind of philosopher, the aesthetician, had begun to debate the theory and the psychological principles of art, and the debate encouraged a new critical relativism that found arguments in favor of Ossian and Rousseau as well as Homer and Racine. Painting, music, and poetry were all embattled fields; some English critics refused to agree that Pope, the greatest poet of the century, could be called a poet. At a time when established opinions about culture and society were being challenged so deeply, historians and critics of the arts could not assume that their own opinions would be welcomed with kindness.

Thus eighteenth-century works on the arts try to satisfy many different audiences, many contrary interests, at once. They woo connoisseurs and antiquarians and common readers; they serve patriotism and taste and scholarship and tradition and romance. The struggle to reconcile such divergent interests affects all the major authors. According to temperament some, like Reynolds, might smooth over differences of opinion; others, like Hawkins, might defy any reader who chose not to agree. But whether the strain of speaking to mixed audiences and defending mixed values

appears on the surface or in underlying tensions, it leaves its trace on every work. The problematical forms of the first histories of the arts tell their own story: they stretched and buckled with the fatigue of responding to too many demands.

Yet the works brought together by this book resemble each other not only in their tensions and cross-purposes but in their efforts to resolve them. Unlike our own literary history, the product of specialists and seminars, eighteenth-century literary history was generated in the minds of a few men. Each work summarizes the reflections of a life devoted to an art (in the case of *Anecdotes of Painting*, not Walpole's life but that of George Vertue, who gathered the materials). Putting his ideas to the test, the author was proving the significance of his own vocation. Reynolds and Burney, showing that the enterprising methods of a painter and musician could also lead to literary success, hoped to demonstrate at last that their arts were intellectual; Warton and Johnson, famous exponents of rival modes of poetry, set out to defend their own poetic heritage. Amid the tangle of conflicting claims, each of them sought answers to questions he had asked for a lifetime: where is artistic greatness to be found? what do men learn about the arts by studying the past?

Questions like these, and circumstantial answers to them, distinguish the common effort described by this book. But they are also personal questions. The men who wrote the first English studies of painting, music, and poetry imposed upon their answers something of their own character. It is important that Horace Walpole, not George Vertue, published the first survey of English painting, and that Samuel Johnson, not William Oldys, put his hand to the *Lives of the Poets*. Such figures bring to a major work the lessons of their whole career; their own style, their own habits of thought color their interpretations of the past. To comprehend eighteenth-century canons and surveys of the arts, we must understand the pursuits of the men who made them.

We must also compare the accomplishments of those men. Each chapter of this book juxtaposes an author against others who shared his problems. Junius on ancient painting is contrasted with Turnbull a century later; Harris's ideas about criticism are opposed to Johnson's; Warton's judgment of poetry is arbitrated by Coleridge. These comparisons, stretching across time, substitute

for a formal history. Part One of this book considers representative authors from four successive generations; Parts Two, Three, and Four trace developments in writing about each art individually. Yet historical circumstances provide only a setting for the major works, not a rationale. If in one respect my subject is the Age of Johnson—Samuel Johnson plays a part in almost every chapter—that is because Johnson's words and Johnson's example seem to embody a standard of comparison that no eighteenth-century critic of the arts can escape.

Finally, however, it is the texts themselves that most need study. They have not, on the whole, received the attention they deserve, and what attention they have received has often been condescending. In weak moments, eighteenth-century historians sometimes spoke of the "dark ages" before the seventeenth century as a time when the taste of intelligent men resembled that of modern children; in our own weak moments, we sometimes turn a similar charge against eighteenth-century historians. The motive, in both cases, is the same: by distinguishing our own tastes from those of children, we hope to prove ourselves adults. But eighteenth-century critics of the arts learned a better conception of maturity, a conception based not upon rejecting the past but upon discovering its continuity with the present. Exploring history, they found their own inheritance—as we do, exploring them. The major texts have left a legacy that can be appreciated only when we recollect that before their time no standards existed by which to measure them.

One hundred years after the *Lives of the Poets*, Matthew Arnold testified how admirably fitted they were "to serve as a *point de repère*, a fixed and thoroughly known centre of departure and return, to the student of English literature."[13] In the twentieth century, the canons of the arts established in the eighteenth still serve as a point of departure. We return to them not only because they are among the great accomplishments of their age, but because with them our own ordering of the arts begins.

13 *The Six Chief Lives from Johnson's "Lives of the Poets"* (London, 1881), p. xii.

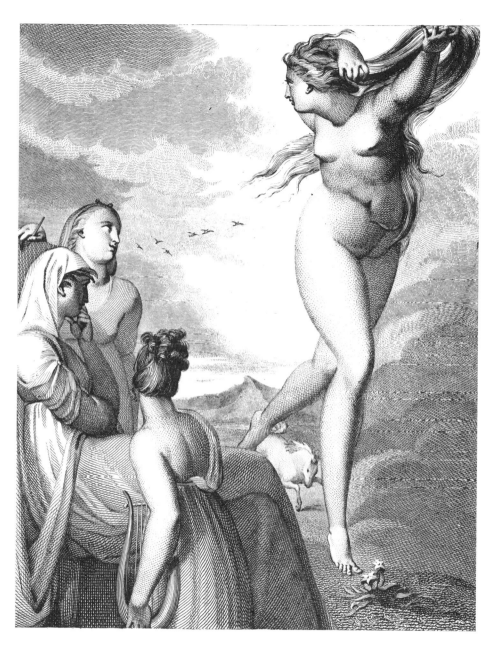

Plate 1, William Lock: Frontispiece for Daniel Webb's *Miscellanies* (1802).

Plate 2, Van Dyck: Thomas Howard, Earl of Arundel, and his wife, with Franciscus Junius (*ca.* 1639). Knole. Reproduced by permission of Lord Sackville.

Part One

THEMES
AND
PRECEDENTS

Franciscus Junius, George Turnbull, and the Passing of Humanistic Order

1

WHEN in 1638 Franciscus Junius the Younger transformed his own *De pictura veterum* into *The Painting of the Ancients*, he brought British study of the arts into the demesne of humanistic scholarship. For the first time in history an English work had attempted to deal comprehensively with the whole art of painting, to order it according to the best principles of research. Junius was superbly qualified for this task; he had every advantage. Born and educated on the continent among a race of scholars,[1] he had been bred to a profound knowledge of the classics and of painting. His friends included Rubens, Van Dyck, and Inigo Jones. In England, he was librarian and curator for Thomas Howard, second Earl of Arundel, the great English collector of ancient statuary.[2] He was intelligent, he wrote well, and he was so industrious that he began his studies daily at 4 a.m. No wonder that more than a hundred years later, when the race of scholars from whom he sprang had vanished from the earth, the name of Junius still conjured up a giant. His work was a monument, a masterpiece. But by then no one believed in its kind of order, and no one read it through.

What had happened to *The Painting of the Ancients*? Evidently it had entered a world where its gifts seemed somehow be-

[1] The standard memoir of Junius (Francis Du Jon, 1589-1677) remains the vita by J. G. Graevius published with *De pictura veterum libri tres* (Rotterdam, 1694). There are useful accounts in the *Allgemeine Deutsche Biographie* and the *DNB*. The autobiography attributed to Junius by the British Museum Catalogue, and published in *Bekenntnisse Merkwürdiger Männer von sich selbst*, ed. J. G. Müller (Winterthur, 1806), is actually by his father, Franciscus Junius the Elder, himself a distinguished humanist.

[2] See M. F. S. Hervey, *The Life Correspondence and Collections of Thomas Howard Earl of Arundel* (Cambridge, 1921), and Francis Springell, *Connoisseur & Diplomat* (London, 1963).

side the point. No scholar had surpassed Junius; his learning remained definitive. Yet readers of the eighteenth century wanted a work constructed on different principles, a work which would teach them a different sort of truth about painting. The conversation about art that Junius had begun had left Junius behind. Slowly his labors receded into a legendary past.

In a sense they had always belonged to legend. Although Junius, as Arundel's resident expert, must have known whatever little was to be known about actual remnants of ancient paintings,[3] that was not a knowledge he cared to preserve. He had never seen an ancient painting in all its colors, and he preferred the pictures and visions made by the mind. Indeed, the very insubstantiality of antique art as it appears to moderns, the obliteration of anything tangible, seems part of its attraction for him. Ancient painting is quite literally a scholar's dream. Since it deals with no material object, only with words and intellect, its secrets belong to the imagination, and Junius is not only the master of his subject but the sorcerer who creates it according to his fancy.

Thus *The Painting of the Ancients* is both more and less than its title implies: more, because it offers a general theory not only of ancient painting but of all painting and kindred arts; less, because it relies entirely on what it calls "Historicall Observations and Examples," not at all on any observation or example of an actual painting. "The first booke toucheth the first beginnings of Picture. The second booke propoundeth diverse meanes tending to the advancement of this Art. The third booke speaketh of the maine grounds of Art, the which being well observed by the old Artificers, made them come neerer to the height of perfection."[4] The structure is philosophical. No records and measurements, no chronology, no evaluations of existent pictures are allowed to intrude upon perfection. Instead, Junius compiles references made to the arts by the most unexceptionable texts of Greek and Latin literature, texts whose classical authority needs no corroboration and brooks no dissent. Such authority is beyond cavil, and so is what the mind makes from it: a single, internally consistent

[3] A census of antique works of art known to Renaissance artists is currently being sponsored by the Institute of Fine Arts of New York University and by the Warburg Institute.

[4] *The Painting of the Ancients* (London, 1638), pp. 1-2. Page references in the text are from this edition.

theory of the ideal to which painters should aspire and of the moral imperatives which can raise men to that ideal.

The search for an ideal of painting is timeless. And *The Painting of the Ancients* is not a historical work. Though Junius cannot help but impress with the weight and passion of his learning, he confirms his imperatives not by any discernible rules of evidence, but by two kinds of sanction: the prestige of classical authors, and the anagogical wisdom contained in ancient stories. An endless stream of anecdotes from Quintilian and Pliny the Elder and Pliny the Younger and Cicero and the Philostrati carries every argument before it. Nor does Junius differentiate history from philosophy, fact from legend. In the lengthy catalogue or index of ancient comments on particular "artificers" which he later assembled for the sumptuous, posthumously published 1694 edition of *De pictura veterum*, he paid equal attention to Phidias and Daedalus, and made no attempt to distinguish between man and myth. Junius does not wish to explore the world of ancient painting; he wishes to demonstrate that its soul still lives.

Thus for Junius the sum of ancient painting equals the sum of lessons about painting to be drawn from classical writers. With a theological conviction that truth lies in the explication of consecrated repositories of wisdom, with an equal conviction that truth must be what truth ought to be, he distills for mortal men the immortality of ancient painters, perfect and unchallengeable because they survive only in literary encomia. No man can touch, nor any man match, the grapes of Zeuxis.[5]

2

Within a few months of the publication of *De pictura veterum*, Peter Paul Rubens wrote a letter to Junius in which the panegyric flickers with delicate intimations of irony.

Expressed with admirable erudition, a most elegant style, and in

[5] When Junius recounts the story of Zeuxis (265), he significantly uses the idealizing version told by Seneca the Rhetorician, in which "*Zeuxis* did put out the grapes, keeping what was better in the picture, and not what was more like." According to Luigi Salerno, "Seventeenth-Century English Literature on Painting," *JWCI*, XIV (1951), 239, "There is in Junius no idolatry of the antique." Although that may be true of Junius' attitude towards any particular master or work, he does reverence the ideal "consummation" to be learned from antiquity as a whole.

correct order, this entire work is carried out with the greatest perfection and care, even to the slightest details. But since those examples of the ancient painters can now be followed only in the imagination, and comprehended by each one of us, more or less, for himself, I wish that some such treatise on the paintings of the Italian masters might be carried out with similar care. For examples or models of their work are publicly exhibited even today; one may point to them with the finger and say, "There they are." Those things which are perceived by the senses produce a sharper and more durable impression, require a closer examination, and afford a richer material for study than those which present themselves to us only in the imagination, like dreams, or so obscured by words that we try in vain to grasp them (as Orpheus the shade of Eurydice), but which often elude us and thwart our hopes.[6]

Mortal painters need real objects to imitate, and connoisseurs need real paintings to look at. That Junius had constructed a worthy ideal, no one doubted; that a classical theory of painting was necessary as a prelude to creation, few would deny; but only scholars believed that the idea of painting could substitute for its reality.

In the course of more than a century *The Painting of the Ancients* was never mentioned without respect. Yet Rubens was not the only reader who would have traded its glory for something more useful. Fréart de Chambray, like Junius, hunted *An Idea of the Perfection of Painting* (1662; trans. J. Evelyn, 1668), but his enthusiasm waned in the face of Junius' principles of art, "being treated of in so *general* Terms, that it were almost impossible, our *Workmen* should derive the Fruit and Instruction which is so necessary for them to practise; I will here explain them in Order, and more at large, and endeavour to render them intelligible, both by *Reasons* and *Examples*."[7] The Abbé Du Bos, in 1719, pointed to the impossibility of forming judgments about painting from knowledge like that disseminated by Junius: "Les Ecri-

[6] *The Letters of Peter Paul Rubens*, tr. R. S. Magurn (Cambridge, Mass., 1955), p. 407. The letter, dated 1 August 1637, was originally published in Flemish in *De pictura veterum*.

[7] *An Idea of the Perfection of Painting* (London, 1668), p. 11. Evelyn, the translator, who was also a member of the Arundel circle, specifically acknowledges his debt to Junius.

vains modernes qui ont traité de la peinture antique, nous rendent plus sçavans sans nous rendre plus capables de juger la question de la supériorité des Peintres de l'antiquité sur les Peintres modernes."[8] G. E. Lessing, in the toils of his *Laokoon* (1766), thought that Winckelmann had been led astray by relying on Junius, "ein sehr verfänglicher Autor; sein ganzes Werk ist ein Cento, und da er immer mit den Worten der Alten reden will, so wendet er nicht selten Stellen aus ihnen auf die Malerei an, die an ihrem Orte von nichts weniger als von der Malerei handeln."[9] Sir Joshua Reynolds plucked classical precepts from his own well-thumbed copy of *The Painting of the Ancients*, and forgot to acknowledge where he had found them.[10] The successors of Junius drew freely upon his learning; but as time passed they could not accept the form of his work nor the philosophy behind it.

3

The form of *The Painting of the Ancients* is not easy to define. Part treatise, part history, part sermon, it piles quotation upon quotation as relentlessly as the *Anatomy of Melancholy*;[11] and like the *Anatomy* it moves beyond the sense of its title into the realm of miscellany and eventually philosophical disquisition. Junius' principle of organization is not so much logical as microcosmic. He begins with the universal prevalence of the arts of imitation: God was the first painter, and "Man, whom many ancient Authors call the little world, is not made after the image of God to resemble the wilde beasts in following of their lusts, but that the memory of his originall should lift up his noble soule to the love of a vertuous desire of glory" (3). Thus painting is inherent in the very constitution of man and in the world about him. From the sense that painting is a microcosm of at least the moral world, *The Painting of the Ancients* derives its three-part order: the birth of painting in man's nature, its proper nurture,

[8] *Réflexions critiques sur la poësie et sur la peinture* (Paris, 1719), I, 353.

[9] *Gesammelte Werke* (Munich, 1959), II, 957.

[10] See G. L. Greenway, *Some Predecessors of Sir Joshua Reynolds in the Criticism of the Fine Arts* (unpublished Ph.D. dissertation, Yale, 1930), chapter I; F. W. Hilles, *The Literary Career of Sir Joshua Reynolds* (Cambridge, 1936), pp. 123-27.

[11] Hilles makes the comparison, *ibid.*, p. 123. On the structure of the *Anatomy*, see Rosalie Colie, *Paradoxia Epidemica* (Princeton, 1966), pp. 430-60. Junius' clerical acquaintance in England included Bishops Andrewes, Laud, and Ussher.

its eventual triumph or apotheosis in the works of the ancients. It is no accident that the book concludes after an extended discussion of grace, the uniting of all individual perfections into one;[12] "never any artificer could attaine the least shadow of this grace, without the mutuall support of Art and Nature" (334). As man ends with a day of judgment, so must painting, and only the graceful will be chosen. The ancients compose an ideal for Junius because the idea of their work, unlike the obliterated works themselves, has been forever saved. In writing about classical art, the scholar traces the accomplished pattern of artistic virtue as he would trace the pattern of a virtuous life.

The formal advantage of taking a microcosmic view of painting is that every piece of information becomes potentially relevant. When painting like the world is seen to be charged with moral significance, no element of painting can or need be excluded from consideration, because the slightest fact may contain the greatest wisdom. *The Painting of the Ancients* evidently originated as a commonplace book, a storehouse of classical quotations, yet even Junius' cataloguing implies a synthesizing imagination as well as scholarship. Moreover, the conviction that the ancients neared the height of perfection allows him to make a work that is definitive and complete, because humanistically idealized, a kind of celestial mathematics: "Indeed God the maker and framer of the Universe hath in all his creatures imprinted plaine and evident footsteps of this most beautifull Harmonie, which all Artificers endeavour to follow" (259). For such certitude, Junius pays a price, the elusiveness and inflexibility complained of by Rubens. What he gains is a dignity and authority which many later writers on painting would have bought at any price.

4

Considered as a treatise, *The Painting of the Ancients* defines that perfection which is the consummation of painting. Yet the lesson it offered contemporary Englishmen was far more immediate. Junius had proclaimed that painting must be acknowledged a

[12] The implications of Vasari's *grazia* have been much discussed, for instance by Anthony Blunt, *Artistic Theory in Italy: 1450-1600* (Oxford, 1940), pp. 93-98. For "grace" in the seventeenth century, see Ernest Tuveson, *The Imagination as a Means of Grace* (Berkeley, 1960). In "A Grace beyond the Reach of Art," *JHI*, V (1944), 143-45, S. H. Monk traces a line of influence from Junius to Pope.

liberal art, that "among so many Arts as doe procure us everlasting glory, this Art is none of the meanest" (5). He was not, of course, the first to say so. The dignity of painting had been a constant theme of Italian artists and theoreticians, and it is insistently, even resentfully, pressed by such English works as Richard Haydocke's version (1598) of Lomazzo and Nicholas Hilliard's *Arte of Limning* (ca. 1600).[13] But in England this argument had fallen upon stony ground. Whatever the theoretical justification for painting, its social place remained menial.

The contrast between theoretical dignity and practical subordination is displayed by the writings of another Arundel dependent, Henry Peacham.[14] The titles of his works alone tell most of the story. *The Art of Drawing . . . and Limning* (1606) was enlarged and ennobled in *Graphice* (1612), issued again the same year as *The Gentleman's Exercise*, and eventually incorporated into *The Compleat Gentleman* (1622). Peacham pleads the cause of painting, and he transmits some bits of Vasari's *Lives*, the hagiography of the art. Yet all his praise cannot dispel the clear implication that arises from the context: the highest aspiration of painting is to while away a few of the gentleman's heavy hours. Though Peacham had been commissioned to provide the shortest way to courtesy, heraldry was the art he described most fully. English painting survived as an art in servitude.

The prestige of Van Dyck altered this situation. At least for a time, one painter could consort with English nobility. And friends of painting and painters caught some of his luster.[15] In one version of Van Dyck's magnificent "Madagascar Portrait" of Thomas Howard and his wife [Plate 2], the figure of Junius hovers in the background with emblems of his trade: scroll and skull and antique bust. Ghostly and discreet in black robes, he is evidently

[13] For the situation of painting among the liberal arts, see Salerno, *JWCI*, XIV, 234-38. Hilliard's defense of the dignity of his art is discussed by John Pope-Hennessy, "Nicholas Hilliard and Mannerist Art Theory," reprinted in *England and the Mediterranean Tradition: Studies in Art, History, and Literature* (London, 1945), pp. 69-80.

[14] Peacham (ca. 1576-ca. 1642) served briefly as tutor to the Howard children, and later wrote *The Compleat Gentleman* at Arundel's request.

[15] On Van Dyck's reception in England, see Ellis Waterhouse, *Painting in Britain 1530 to 1790* (London, 1953), pp. 43-48. Like Rubens, Van Dyck wrote a testimonial letter for *De pictura veterum* (14 August 1636).

there as an afterthought; but there he is. Under the aegis of a discerning patronage, the painter and the scholar join forces.

Indeed, such a collaboration seems part of Junius' intention. He combines the scholar's dream of ancient painting with the artist's invocation of a pristine reality. Again and again we are told that painting comes from the mind, not from the hands and eyes: "as it is a very great matter to carry in our mind the true images both of living and lifelesse creatures, so is it a greater matter to worke out a true and lively similitude of those inward images" (5-6); that the imagination is superior to mere imitation: "how much these Artes are advanced by a well-ordered Imagination; for it is brought to passe by her meanes that the most lively and forward among the Artificers, leaving the barren and fruitlesse labour of an ordinarie Imitation, give their minds to a more couragious boldnesse" (40); that "a good Artist may justly be esteemed a wise man" or even a demiurge: "The greatest part of invention consisteth in the force of our minde; seeing our minde must first of all be moved, our mind must conceive the images of things, our minde must in a manner bee transformed unto the nature of the conceived things" (231). As we gaze upon the image of this ideal artist we see him change before our eyes into a humanist scholar.

In the effort to establish the worthiness of painting and the learning required by painters, Junius may have overstated his case. After all, "the learned painter is a highly theoretical personage who, if he cannot be called an actual figment of the imagination, has never had much more than a partial basis in reality,"[16] and a mere insistence upon the universal perfection achieved by ancient painters has no power to convince a skeptic that perfection exists. Nevertheless, Junius' very extravagance helped to pull English estimates of painting into the Renaissance. Real or unreal, here was a world of learning, here was a bountiful intellectual heritage. An art that has become the subject of scholarly debate has ceased to be beneath serious notice.

Painters required the professional dignity to which Junius exhorted them, and both Rubens and Van Dyck were grateful for his condescension. Yet they might have preferred a work that did

16 R. W. Lee, "*Ut Pictura Poesis*: The Humanistic Theory of Painting," *Art Bulletin*, XXII (1940), 235.

not protest quite so much. Like Sir Philip Sidney's apology for poetry, Junius' apology for painting is a theoretical manifesto in reply to a practical objection, and such arguments tend to be at once too grand and too playful to be altogether convincing. Thus Junius borrows Sidney's aid for a touch of mystification: "*Poesie* and *Picture* . . . are very neere of the selfe same nature. Both doe follow a secret instinct of Nature" (45).[17] The would-be gentleman, having once been told that he must dabble in painting to complete the round of his accomplishments, was now to learn that he needed knowledge of painting to complete his soul. But that sort of claim, like *The Painting of the Ancients* itself, was so lofty that a sensible man could only admire it and ignore it.

Moreover, the apology for painting also reflects a kind of servitude. In the subject matter of scholarly rebuttal, as in other types of warfare, we often come to resemble our enemies. Junius' tributes to art evidently take shape from the nature of the opposition, from his attempt to meet a vast indifference with a transfiguring zeal.

In this respect he anticipates much of the aesthetic discourse of the next century. The development of English writing about the arts was determined largely by theories designed to counter three indictments: poetry is immoral; the skills involved in painting are manual; music is an idle (or sacrilegious) amusement. As a result, critics throughout the seventeenth and eighteenth centuries are likely to argue that poetry is supremely and primarily moral, that painting is the result of intellectual contemplation, and that music is important (or holy) work. Whatever the rights and wrongs of these arguments, critical debate was founded upon them. Only when painting had acquired a place of its own, its own appropriate respectability, could the successors of Junius relax their pretensions and begin to speak as equals to equals, as men to men.

5

The Painting of the Ancients began as a collection of classical sayings. George Turnbull's *Treatise on Ancient Painting* (1740)

[17] Cf. *An Apology for Poetry*, ed. Geoffrey Shepherd (Edinburgh, 1965), pp. 102-103, on the third sort of poets and painters. As an authority on the first sort (*vates*) Sidney cites Franciscus Junius the Elder.

began with fifty engravings of classical paintings. By 1740 critics and historians of art did not choose to follow Junius into his microcosmic spiritual world. Turnbull presents himself as a practical man who will be content only with the evidence of his senses. He had taken immense pains to reproduce ancient paintings in good style: the great collection of Richard Mead furnished archeological treasures, Camillo Paderni was commissioned to execute the drawings and J. Mynde the engravings, and the sizes of the originals and the places where they were found were described in long notes.[18] Nothing was to be left to the imagination. "Some may suspect, that Men of fine Imaginations have carry'd these Arts further in Speculation than they have ever been actually brought to, or than they can really be advanced. . . . And in truth it is hardly possible to set their Power, Extent, and Merit in a better light, than by shewing what they have actually produced."[19] The written word, the thought of antiquity, are not sacred for Turnbull. Unlike Junius, he emphasizes the difference between fact and legend, and he attempts to establish some continuity between the relics of ancient art and the work of the best modern masters. Moreover, his avowed aim is merely and modestly "to prepare young Travellers for seeing Statues, Sculptures, and Pictures to better advantage than they can possibly do if they have not previously turned their Thoughts a little that way."[20] After the impassioned idealism of Junius, Turnbull seems to produce Baedekers for Eldorado.

Yet the apparent practicality, the apparent historicism of *A Treatise on Ancient Painting* are deceptive. Perhaps they are even something of a sham. Turnbull fixes his eye not on engravings but, all too often, on *The Painting of the Ancients*. He appropriates Junius' scholarship, describes the same phantasmal paintings that Junius had described, uses the same quotations to draw the same morals. And his much-vaunted sense of history proves to be shallow. Given no specific image to consider, no fact or date, the reader must be satisfied with ingenious intellectual

[18] Turnbull's *Curious Collection of Ancient Paintings* (London, 1741) prints the same engravings with a slightly expanded commentary. Immediately after finishing this commission Paderni, a specialist in the antique, participated in the excavation of Herculaneum (1738—). By 1741 Turnbull had heard of the discoveries there, though too late to add to his *Collection*.

[19] *A Treatise on Ancient Painting* (London, 1740), p. xxi.

[20] *Ibid.*, p. xv.

parallels between Greek and Italian painters, who are paired off and framed to emphasize their matching qualities of mind.[21] The result is a verbal, not a pictorial, exercise. Turnbull knew and approved of the work which Joseph Spence was then engaged in and which would culminate in 1747 with *Polymetis: or, An Enquiry concerning the Agreement Between the Works of the Roman Poets, And the Remains of the Antient Artists*; and one might maintain against Turnbull's history what has been objected to in Spence's: "that he made no inquiry as to the age of a work; that he did not recognize ancient art as a result of the gradual development of successive types which more or less fully represent successive periods of national culture and thought; that he made no distinction between schools or between types of art."[22] For Turnbull as for Junius the idea of ancient painting, its use as a standard for purposes of instruction, remains far more important than the quest for an authentic and accurate history.

The difference between *A Treatise on Ancient Painting* and *The Painting of the Ancients*, a difference which also illuminates the century that separates them, must be approached in another way. Both works consider similar materials, and both subordinate painting to a theory of education and to moral philosophy. But each author had been prepared by his whole career to conceive of his work in terms individual to a special time and a special audience. Junius, immensely learned, scholar and son of a scholar, was brought up to be the elect guardian of philological treasures. The great object of his career, which included the first edition of *Caedmon*, a Gothic glossary, and the collections for *Etymologicum Anglicanum*, was to restore obscure and forgotten texts to the community of his fellow humanists.[23] He spoke to a very few in a language that few were intended to understand. In compiling *The Painting of the Ancients*, Junius had rescued the

[21] Turnbull's comparisons are discussed and criticized by S. H. Monk, *The Sublime* (Ann Arbor, Mich., 1960), p. 179.

[22] Austin Wright, *Joseph Spence: A Critical Biography* (Chicago, 1950), p. 112.

[23] See E. N. Adams, *Old English Scholarship in England from 1566-1800* (New Haven, 1917), pp. 70-71; D. C. Douglas, *English Scholars 1660-1730* (London, 1951), pp. 64-65. Among later beneficiaries of Junius' industry were Samuel Johnson, who praised his learning but not his judgment in the "Preface to the *Dictionary*" (1755), and Jacob Grimm, who used his manuscripts. It has been suspected that Junius introduced Milton to Old English poetry; see, however, B. J. Timmer, *The Later Genesis* (Oxford, 1948), pp. 60-65.

dignity of painting from the ignorant multitude, and from paint-
ers themselves: "These Arts were in times past studied with much
respect; but now . . . all goe to it without any reason or modestie"
(201).

Turnbull, on the other hand, spent much of his life educating
the public to trust in its own common language and common
sense. One of the first though not most prominent of the Scottish
philosophers,[24] he labored to show that natural philosophy and
the arts, which teach men the operations and appearances of
things, could also teach men the common sense of virtue. His
major work, *The Principles of Moral Philosophy* (1740), pub-
lished the same year as his *Treatise*, tries to persuade readers to
look away from perplexing words and mysteries, and towards the
human nature that everyone can recognize. Similarly, in the
Treatise his historical enquiries are "chiefly intended to prepare
the way for a philosophical Consideration of the fine Arts; . . . it
is shewn, that good Taste of Nature, of Art, and of Life, is the
same; takes its Rise from the same Dispositions and Principles in
our moral Frame and Make; and consequently that the most suc-
cessful way of forming and improving good Taste, must be by
uniting all the Arts in Education agreeably to their natural Union
and Connexion."[25] As a professional teacher, Turnbull wishes to
inculcate the minds of young men not only with the principles
of virtue but with the images and pictures of virtue. He is train-
ing not learned painters but receptive audiences, and therefore
he reads paintings as if they were primers of morality. What are
all the arts, he asks, but means "of impressing on the Mind some
useful Rules and Maxims for our Conduct, founded upon Na-
ture's Laws and Connexions, by such Representations of them
as are most likely, in Consequence of our Frame and Constitu-
tion, to find easiest Access, sink deepest into, and take firmest Hold
of our Hearts?"[26]

The contrast between Junius and Turnbull is exemplified by
their descriptions of the famous painting by Aristides of Thebes,

[24] The influence of Turnbull (1698-1748) on Thomas Reid is discussed by James
McCosh, *The Scottish Philosophy* (New York, 1875), pp. 95-106, and S. A. Grave,
The Scottish Philosophy of Common Sense (Oxford, 1960), pp. 6-7.
[25] *Treatise*, p. xxiii. [26] *Ibid.*, p. 180.

"an expugnation of a great and populous towne."[27] Although Junius' portrait is drawn from Pliny, it has an extraordinary visionary quality that is all its own. By stringing the violent details of the rape of the town into a single Faulknerian sentence that covers most of four pages, by choosing graphic images and headlong prose rhythms, he whips up a sort of hysteria. Only with an effort can we detach ourselves from this hysteria, and understand that it is part of a deliberate program. Junius has set out to stimulate the imagination, even at the risk of overstimulating it: "a perfect and accurate admirer of Art is first to conceive the true Images of things in his minde, and afterwards to applie the conceived Images to the examination of things imitated" (65). Thus lovers of art should be "studying always to enrich their Phantasie with lively impressions of all manner of things" (67). Junius *wants* us to lose control, wants us to be abandoned to all but the imagination. By exercising our fantasies, we enter the world of images that lies behind creation; we join the elect; we appreciate the creative mysteries of a work of art.[28]

Like many of his contemporaries, Turnbull considers the workings of the imagination a threat as well as an aid to learning. Since painting is a language, and the arts "so many Methods of conveying Truths agreeably or strongly into the Mind; or of exciting our Affections by means of Ideas fitted to move them,"[29] only true and perspicuous images must be chosen. Turnbull's summary of Aristides' painting is brief and chaste. Moreover, he carefully prefaces it to emphasize, not the glories of the imagination, but its usefulness: "What cannot Painting teach or express in the most forcible Manner! For see there in another Piece the Constancy, the Serenity, the Fortitude of Heroes."[30] Instead of promiscuously multiplying visions in the unreined fancy, the teacher selects a few details conducive to virtue, and conveys them painlessly into his student's mind. Junius' description encourages us

[27] Junius, *Painting of the Ancients*, p. 69. The subject, popular with artists of the Italian Renaissance, derives ultimately from the story of the storming of Calydon in Book IX of the *Iliad*. Junius' immediate source is Pliny the Elder, *Naturalis Historiae*, XXXV, xxxvi, 98-99. Cf. Quintilian, *Institutio Oratoria*, VIII, iii, 67-70.

[28] The most detailed study of the wedding of classical pictorialism and Christian aesthetic theory, with specific reference to Junius, is Jean Hagstrum's *The Sister Arts* (Chicago, 1958), chapters II-IV.

[29] *Treatise*, p. ix. [30] *Ibid.*, p. 150.

to forget, Turnbull's to remember, our own common human nature.

A philosophy based on human nature, however, was a philosophy of art that eighteenth-century readers were prepared to understand. The microcosmic order of *The Paintings of the Ancients* could be made intelligible to Turnbull's audience only after it had been domesticated into a more immediately accessible form. Thus Junius' slow search ending in an idea of perfection yielded to Turnbull's tidy chronological chapters ending in modern times. Junius, like one of his own ancients, had come to seem a remnant of the mysterious and legendary past. Readers no longer wanted a text that had to be penetrated layer by layer, until one reached a sanctum of ideas too refined for any painting to contain them. They wanted a criticism specific to painting, in a form that proceeded step by step until the last mystery had been dispelled.[31] And they did not want to be involved in the act of creation, nor in the dreams of scholars.

Yet *A Treatise on Ancient Painting* did not supplant *The Painting of the Ancients*. Turnbull aimed his work at the common reader, but the common reader was not at all interested.[32] If the world of the Renaissance humanist had passed, the eighteenth-century historian of art had yet to make a world of his own. The conversation Junius initiated still used the words and the research of Junius. Turnbull added a dollop of fashionable psychology to the microcosm of classical learning, and he began to sketch a modern canon to match the ancient pantheon of artists, but he had not written a proper history of painting, nor had he found a principle of order as fascinating as his master's. Junius remained the leading authority; to exceed his philosophical devotion to the idea of painting was impossible. What had yet to be done was to flesh the philosophy with information, with particular judgments, with unphilosophical truths. The new century awaited its

31 The contrast between the scholarly audience of Junius' time, and the more utilitarian audience that emerged later in the century, is documented by Walter Houghton, Jr., "The English Virtuoso in the Seventeenth Century," *JHI*, III (1942), 51-73, 190-219. The Arundel circle, at whose specific request Junius translated *De pictura veterum*, played a leading part in the change.

32 Hogarth's print of "Beer Street" shows a copy of the *Treatise* being hauled to the wastepaper man.

own ordering of the arts. In 1740 as in 1637, Rubens might have searched England without finding the knowledge he desired. "Hitherto no one has satisfied our appetite, among all those who have treated the material. For it is necessary, as I have said, to speak of individual personalities."[33]

[33] *Letters*, tr. Magurn, p. 408.

CHAPTER TWO

De arte graphica
and the Search for a New Authority

1

CHARLES Alphonse Du Fresnoy's *De arte graphica* was conceived
under the shadow of Horace's *De arte poetica*. From Horace, Du
Fresnoy took a title, a language to write in, an opening line, a
number of texts and ideas, and some compositional procedures;
but he took much more. What *De arte poetica* offered neoclas-
sical readers was first of all its own classical authority, a confi-
dence that precepts which had stood the test of time and of vary-
ing interpretations would remain axiomatic no matter how
tastes might change.[1] What *De arte graphica* claimed was a like
authority with regard to painting. Du Fresnoy did not attempt
to be original or exhaustive, but to be oracular: to state the basic
truths of his art in language so concise, elegant, and memora-
ble that, carved on stone, it could serve by itself to educate a race
of painters. By the twenty years of effort which he spent in pol-
ishing his 549 lines, he hoped to make up for the disadvantage
of not having been born an ancient; and his effort largely suc-
ceeded. The pervasive if variable authority which Horace wielded
over the poets of Europe from 1670-1790, Du Fresnoy wielded
over her painters.

Because the significance of Du Fresnoy, like that of Horace, is so
largely rhetorical, however, consisting in the superior formulation
of commonplaces rather than in any profundity of thought, his
individual propositions are not in themselves nearly so impor-
tant as in what was made of them. In context, Horace's "Ut pic-
tura poesis" attempts to be neither a commandment nor a philo-

[1] *"Horace* will our superfluous Branches prune,/ Give us new Rules, & set our
Harp in Tune" (Waller's preface to Roscommon's translation, Roscommon's *Poems*
[London, 1717], pp. 176-79). Cf. Pope's "Epistle to Jervas" on the function of Du
Fresnoy.

sophical truth; but for multitudes of artists and critics it was both, and their interpretations put "Ut pictura poesis" at the heart of Neoclassicism.[2] We need to know the history of *De arte poetica* far more than we need to know what Horace meant. And the same is true of *De arte graphica*. Translated and/or annotated by such formidable judges as De Piles, Dryden, and Reynolds, it remained like Horace's epistle one of those works which set the terms in which men wrote about the arts. In studying the versions and translations of *De arte graphica* we study the artistic thought of a century.

The eighteenth century was a seedtime of revolutions, and among its less portentous revolutions was the birth of aesthetics: a word and a science. When we consider what Wladyslaw Folkierski calls "l'étrange fortune du *De Arte Graphica* de Du Fresnoy en Angleterre,"[3] it is tempting to see the changes introduced into Du Fresnoy's text as the signs of a vast change in aesthetic doctrine. Yet for the most part the doctrine of painting, or at least the words of that doctrine, stayed the same; the truisms of 1670 were the truisms of 1790. Modern readers of Reynolds' *Discourses* who seize upon some insight as especially contemporary or significant often find to their embarrassment that the insight merely repeats a source. Much of Reynolds' doctrine goes back to Richardson, to Du Fresnoy, to Junius, to Lomazzo, to Pliny.[4] What *had* changed between Du Fresnoy and Reynolds was a matter of context, the kind of system within which doctrine might be embodied. The authors of the eighteenth century looked for new ways to make old ideas convincing.

Most of all they looked for a theory strong enough to seem definitive, and flexible enough to admit modern discoveries. That search had been going on for a long time. The lack of a classical theory of painting had been a constant frustration to Renaissance scholars and artists. Horace had not called his own "Epistle to the

[2] See W. G. Howard, "*Ut Pictura Poesis*," *PMLA*, XXIV (1909), 40-123; R. W. Lee, "*Ut Pictura Poesis*: The Humanistic Theory of Painting," *Art Bulletin*, XXII (1940), 197-269; Bernard Weinberg, *A History of Literary Criticism in the Italian Renaissance* (Chicago, 1961), I, 71-249.

[3] *Revue de littérature comparée*, XXVII (1953), 385-402. Folkierski supplements Lee by considering the doctrine of "ut pictura poesis" in the light of a Crocean aesthetic.

[4] See note 10, chapter one above. Chapter II of G. L. Greenway, *Some Predecessors of Sir Joshua Reynolds* (unpublished Ph.D. dissertation, Yale, 1930), discusses translations of Du Fresnoy.

Pisos" an Art of Poetry,[5] but the needs of critics had made it one, and critics of painting had similar needs. In the absence of a single treatise, theoreticians like Junius were compelled to manufacture their own classics from whatever fragments about ancient painting they could salvage. But such reconstructions, however skillful, were always open to rebuttal, the rude awakening that comes to the scholar's dream. "I wish that some such treatise on the paintings of the Italian masters might be carried out with similar care."

It was exactly to this task that Du Fresnoy addressed himself even as Junius was writing. Born in Paris in 1611,[6] he had come to Rome three years before the appearance of *De pictura veterum*, and under the influence of Italy had begun the work which would culminate with the posthumous publication of *De arte graphica* in 1668. His principles seem formed in reply to Junius.[7] Instead of gathering materials which "present themselves to us only in the imagination, like dreams," Du Fresnoy, himself a painter, attempts to originate a set of rules tested by modern experience. The force of such rules derives from no outside authority, but from their own specific relevance to painting: their ability to describe known facts and to survive repeated application to the processes of making and apprehending works of art.

The strongest argument for the authority of *De arte graphica* was made in the preface to its first edition by Roger de Piles, Du Fresnoy's friend, editor, translator, and deputy. The lovers of painting, according to De Piles, are ignorant; they require an entire and certain knowledge. "I shall satisfy my self with telling you, that this little *Treatise* will furnish you with infallible Rules of judging truly: since they are not onely founded upon right Reason but upon the best *Pieces* of the best *Masters*, which our *Author* hath carefully examin'd during the space of more than thirty years; and on which he has made all the reflections which are necessary to render this *Treatise* worthy of Posterity: which

[5] The title *De arte poetica* was coined by Quintilian.

[6] The fullest treatment of Du Fresnoy's life is Paul Vitry's *De C. A. Dufresnoy pictoris poemate quod "De arte graphica" inscribitur* (Paris, 1901). The main English source of information is the life by Thomas Birch supplied for Wills' translation in 1754 (see note 14 below). See also Louis Gillet, *La Peinture, XVIIe et XVIIIe siècles* (Paris, 1913) pp. 314ff.

[7] See F. P. Chambers, *The History of Taste* (New York, 1932), pp. 89-96.

though little in bulk, yet contains most judicious Remarks; and suffers nothing to escape that is essential to the Subject which it handles."[8]

However academic this claim may seem to be, we must observe that Du Fresnoy's experience, not a metaphysical assertion about the arts in general or painting in particular, is recommended as the source in which a reader may place his confidence. De Piles assures painters that in the future they "may work with pleasure; because they may be in some manner certain that their Productions are good,"[9] but he does not pretend to have discovered a secret formula for them. Any painter using his right reason could have done what Du Fresnoy has done. In recent years critics have increasingly come to see that Boileau's *L'Art poétique* (1674), which has often been regarded as the complement of *De arte graphica*, depends not so much upon a methodical championing of abstract rules as upon a continual application of judgments wrought from experience: "Boileau's dogmatism is not that of a rule-bound pedant but, rather, a faith in his own critical responses. He never hesitated to swell these personal reactions into general propositions, which were or should be, he felt, universally evident."[10] What De Piles claims for Du Fresnoy is the same sort of response, refined and tempered by decades of meditation.

The authority of *De arte graphica*, then, is justified by the wisdom and the practicability that it demonstrates. Yet the poem has another, more subtle, justification. As De Piles insists, "there is not a word in it, which carries not its weight; whereas in all others, there are two considerable faults which lie open to the sight (viz.) That *saying too much, they always say too little.* . . . 'Tis to be used like *Spirits* and *precious Liquors*, the less you drink of it at a time 'tis with the greater pleasure: *read* it often, and but little at once, that you may digest it better."[11] Not experience alone, but experience distilled, confers infallibility; Du Fresnoy, because of his compression, speaks also in his silences. At the same time, however, he throws the burden of understanding him

8 Dryden, tr., *De Arte Graphica. The Art of Painting* (London, 1695), p. lviii.
9 *Ibid.*, p. lix.
10 Jules Brody, *Boileau and Longinus* (Geneva, 1958), p. 78. See also E. B. O. Borgerhoff, *The Freedom of French Classicism* (Princeton, 1950), pp. 200-12.
11 Dryden, tr., *De Arte Graphica*, p. lix.

upon his interpreters. An ellipsis cannot be refuted, but neither can one ever be sure that its final significance has been comprehended. Thus *De arte graphica* has the characteristic strength of aphorism, its immunity from argument or from limitation to one particular set of conditions, as well as the characteristic defect that its relevance to particular circumstances can never be certain.

A French critic has indicated the reasons for the enormous popularity of Du Fresnoy's poem: "On comprend que ce poème, où l'idée se prête assez aisément aux interprétations différentes des commentateurs, ait fait fortune à l'Académie: quoiqu'on n'y trouvât pas cette rigueur de pensée qui ne permet pas d'échapper aux conséquences d'un système, il était d'esprit et de ton doctrinal; il soutenait des principes que tout le monde jugeait excellents parce qu'ils exprimaient les tendances communes."[12] Unlike a system, whose success depends upon the logical interrelationship and coherence of its parts, *De arte graphica* offers doctrine, whose success depends upon how well it can be accommodated to a variety of situations in which we require a guide. In this sense, doctrine need not be accepted whole; it may be arranged, selected, or explicated to suit an audience; its popularity is as unconditional as our willingness to make use of it. Yet the ambiguous elegance which is the source of doctrinal authority grants it no defense against the interpretations of its own disciples. The precepts of a system may be expounded honestly only with reference to the context in which they are placed; doctrinal precepts are made to be revised.

<div align="center">2</div>

Thus, on its first appearance *De arte graphica* was already cloaked and to some extent modified by a tissue of De Piles' introductions, annotations, interpretations, translations, and addenda. De Piles' "observations" alone are almost four times as long as the text he observes. By insisting upon the value of Du Fresnoy's judgments and by reproducing them in the vernacular for the instruction of the widest possible audience, he adds a pretentiousness lacking in the original poem. Reducing Du Fresnoy's Scar-

12 André Fontaine, *Les Doctrines d'art en France; peintres, amateurs, critiques, de Poussin à Diderot* (Paris, 1909), p. 19. See also Philippe Chennevières-Pointel, *Recherches sur la vie et les ouvrages de quelques peintres provinciaux de l'ancienne France* (Paris, 1847), IV, 39.

ron-like Latin verse to French prose, laboriously glossed, De Piles clearly seeks to appeal to the uninstructed many, not to the happy few. Moreover, despite his claim that Du Fresnoy approved the French version, he is not above taking liberties with the original.

Doubtless the most significant instance of De Piles' tampering occurs in line 24: "Tantus inest divis honor Artibus atque potestas"; which becomes "Tant ces Arts divins ont esté honorez, & tant ils ont eu de puissance"; translated in turn by Dryden as "So much these Divine Arts have been always honour'd: and such authority they preserve amongst Mankind."[13] As the painter James Wills was to point out in his translation of 1754, a proper construction of the Latin would be "So great power and honour is in the divine arts," "a commendation of the arts, that enhances their value; for the respect a person receives may be only a proof of the regard of the bestower, but what he deserves is his natural right, and he ought not to be defrauded of it."[14] Wills' indignation at the translation he corrects is not misplaced, for De Piles had appended one of his longest notes, recording many examples of royal patronage to painters. More is at stake here than De Piles' understanding of Latin case endings. He is conscious, to an extent far beyond Du Fresnoy, of the social circumstances of the painter, and his presentation of *De arte graphica* is designed to enhance the prestige, not merely the dignity, of the art. If, as his biographer has said,[15] De Piles' translation led him to his distinguished career as a popularizer of the theory of painting, he began by treating painting as the proper study not merely of professional artists, but of gentlemen.

The tendency of De Piles to adapt Du Fresnoy to his own interests may seem opportunistic, yet we must remember precedents: Du Fresnoy himself, in the prefatory lines of his poem, had borrowed both Horace's "Ut pictura poesis erit" and Simonides' phrase about mute poetry and speaking pictures. When

[13] *L'Art de peinture* (Paris, 1673), p. 6; Dryden, tr. *De Arte Graphica* (1695), p. 4. In a later edition, "L'Art de peindre," in *L'Ecole d'Uranie ou L'Art de la peinture* (Paris, 1753), p. 5, the Latin was compromised still more: "Tel est l'honneur attaché à ces Arts divins, telle est leur puissance!"

[14] *De Arte Graphica; or The Art of Painting* (London, 1754), pp. i-ii.

[15] Léon Mirot, *Roger de Piles, peintre, amateur, critique, Membre de l'Académie de Peinture (1635-1709)* (Paris, 1924), p. 85.

a critic is translating or quoting doctrine as ubiquitous as that of Horace or as flexible as that of Du Fresnoy, we must expect him to suit himself. The pastiche of the beginning of *De arte graphica,* along with its subsequent transformations in other languages, constitutes a little lesson in the art of using another's words as if they were one's own.

3

Ut Pictura Poesis erit; similisque Poesi
Sit Pictura; refert par aemula quaeque sororem,
Alternantque vices et nomina; muta Poesis
Dicitur haec, Pictura loquens solet illa vocari.[16]

De arte graphica opens with classic words: tags from Horace and Simonides, spliced together. What do those tags mean in their new context? We can expect a certain kind of answer, a neoclassic answer. As is well known, Horace's phrase, which in *De arte poetica* serves modestly to remind us that different works please in different ways, not to proclaim a universal principle, was twisted by neoclassic critics into an inviolable law; and Simonides' phrase, a fragment quoted by Plutarch, so that its original context is irrecoverable, went through a similar metamorphosis. Jean Hagstrum has pointed out Du Fresnoy's important role in this change. By punctuating "Ut pictura poesis erit" to include the verb with the first clause, and by adding a second clause which urges painting to resemble poetry, "Dufresnoy brings to a climax the dogmatic intensification of Horace's meaning that had begun during the Italian Renaissance."[17] Henceforth to the time of Lessing, each critic of painting would have to come to terms with the sisterhood of the arts.

The difficulty in following the opening of *De arte graphica,* however, is that the quotations which introduce the poem are not incorporated into its ideas. "Ut pictura poesis erit" is at best an ambiguous text which requires explanation, yet it seems meant to be recognized rather than understood by the reader of Du Fresnoy. Nor does the further information that the arts are sisters,

[16] Unless otherwise specified, the text of *De arte graphica* will be that included in *The Art of Painting of Charles Alphonse Du Fresnoy,* tr. William Mason, notes by Sir Joshua Reynolds (York, 1783).
[17] *The Sister Arts* (Chicago, 1958), p. 175.

that they exchange "offices" and name, and that Simonides has associated them in an aphorism, shed much illumination. From the first four lines we have no way of knowing how literally we are to take the analogy, nor whether it refers to similarities in painting and poetry themselves, in their practitioners, in their subject matter, in their traditions, or simply in the audiences to which they appeal. Indeed, as we read on the source of the identity of the arts seems to become even more confused. "Ambae quippe sacros ad religionis honores/ Sydereos superant ignes, aulamque tonantis/ Ingressae, Divûm aspectu, alloquioque fruuntur."[18] Apparently the arts share a divine subject matter, capable of immortalizing heroic actions; but what has the conversation of the gods to tell us about mere mundane painting? The context in which Du Fresnoy has placed "Ut pictura poesis" may inspire us, yet he has not informed us exactly how or why painting is like poetry.

Nevertheless, the prologue of *De arte graphica* becomes clear as soon as we realize that its object is invocation rather than definition. Du Fresnoy's eulogy of painting has ample precedent in Junius; and his exalted opening closely parallels that of Vida's *Ars poetica* (1527),[19] which had combined a grandiose appeal to the Muses with fulsome praise for Francis, Dauphin of France. While Du Fresnoy denies that his precepts need the aid of the Muses, he is willing to accept the aid of scholars, kings, and poets. Horace and Simonides, Junius and Vida, the identification of painting with poetry, and the glorification of both arts, are all parts of a strategy designed to raise our expectations, to convince us that we have come into the presence of a modern classic; Du Fresnoy proves the worthiness of *De arte graphica* by immediately if vaguely establishing the exaltation of that art whose ideal conception he will explore. The glory of painting in those opening lines is not a matter of its social prestige, but of its ability to attain, through classical and metaphysical sanction, the status of

18 Lines 9-11, p. 2: "For both those Arts, that they might advance the sacred Honours of Religion, have rais'd themselves to Heaven; and, having found a free admission into the Palace of *Jove* himself, have enjoy'd the sight and conversation of the Gods" (Dryden translation, revised by Jervas, 1716, p. 5. After 1695, Dryden's *Art of Painting* was invariably printed with Jervas' revisions).

19 The influence of Vida on Du Fresnoy is analyzed in detail by Howard, *PMLA*, XXIV, 73-83.

pure idea. And it is the idea, not the practice, of painting which the invocation to *De arte graphica* celebrates so ceremoniously.

<div align="center">4</div>

Du Fresnoy's intentions, however, are by no means the same as those of his followers, many of them immersed in a daily struggle to make the art respectable and profitable. Comparison of some versions of Du Fresnoy's opening lines will indicate not only stylistic differences, but the way that other writers use Horace's analogy of the arts in order variously to promote some view of their own about painting or to insinuate painting's aesthetic and social value.

> Ut Pictura Poesis erit; similisque Poesi
> Sit Pictura; refert par aemula quaeque sororem,
> Alternantque vices et nomina; muta Poesis
> Dicitur haec, Pictura loquens solet illa vocari.
>
> DU FRESNOY

> La Peinture & la Poësie sont deux Soeurs qui
> se ressemblent si fort en toutes choses, qu'elles
> se prestent alternativement l'une à l'autre leur
> office & leur nom. On appelle la premiere une
> Poësie muette, et l'autre une Peintre parlante.
>
> DE PILES

> Painting and Poesy are two Sisters, which are so
> like in all things, that they mutually lend to each
> other both their Name and Office. One is call'd a
> dumb Poesy, and the other a speaking Picture.
>
> DRYDEN (1695)

> Painting and Poetry two Sisters are,
> And, like in Features, equal Beauties share;
> Changing both Name, and Office, they agree,
> A Speaking Picture This, Dumb Poem She.
>
> DEFOE (1720)

> As Painting, Poesy, so similar
> To Poesy be Painting; emulous
> Alike, each to her sister doth refer,

<div align="center">*46*</div>

Alternate change the office and the name;
Mute verse is this, that speaking picture call'd.
 WILLS (1754)

True Poetry the Painter's power displays;
True Painting emulates the Poet's lays;
The rival Sisters, fond of equal fame,
Alternate change their office and their name;
Bid silent Poetry the canvass warm,
The tuneful page with speaking Picture charm.
 MASON (1783)

Painting and *Poetry* from heav'n *descend,*
Twin, social sisters, emulous of fame!
Exchanging each her office, name and end,
'*That* a dumb *muse,* and *this* a speaking *frame!*'
 CHURCHEY (1789)[20]

Of all these translations, only that of Wills is literal, especially in preserving the ambiguity of the original. If we object that Wills has not written English, at least part of his trouble is that he holds Du Fresnoy's text in such reverence that he will not corrupt its deliberately indefinite meaning by subjecting it to interpretation. None of the other translators shares such compunctions. Dryden has translated De Piles rather than Du Fresnoy, and the version in couplets usually attributed to Defoe is apparently based on Dryden, probably on the revised edition made by Jervas (1716) under the wing of Pope. Both Mason and Churchey, who worked contemporaneously without knowing of each other's labor, went back to the original Latin for their text, though neither was scrupulously careful to reproduce its exact sense. The three earlier translations, then, as well as that of Jervas, depend upon De Piles' reading of *De arte graphica,* while the latter three represent a fresh look at Du Fresnoy.

5

Even the small sample of lines above will demonstrate how a shift of emphasis can result in a shift of meaning. By skillfully clarify-

[20] For Du Fresnoy, De Piles, Dryden, Wills, and Mason, see notes 13, 14, and 16 above. Defoe (*pseud., D. F.* Gent.), *The Compleat Art of Painting* (London, 1720), p. 1; W. Churchey, "The Art of Painting," *Poems and Imitations of the British Poets* (London, 1789), p. 1.

ing the syntax of the Latin, De Piles not only dissipates the classical echoes which are so important to the original, but insinuates at the first possible moment that the arts are sisters so closely related, "si fort en toutes choses," that we cannot take the analogy to be merely rhetorical, or merely an introductory device. In De Piles' French and Dryden's English we are not confronted with an ambiguous motto so much as with an assertion of the veritable identity of painting and poetry; the sisters have become Siamese twins. Similarly, in De Piles it is the impersonal "on," not Simonides, who calls the arts cognate. Mute poetry, speaking picture are thus offered as *definitions* of the arts, rather than as the celebrated aphorisms supplied by a famous thinker. The syntactical variations which produce these alternative interpretations may be slight (I do not imply that they constitute a deliberate attempt to deceive), yet in combination with the prose and the prosaic style of the French they modify the quality and the dignity of Du Fresnoy's analogy of the arts. Unlike Du Fresnoy, De Piles need not construct a classical idea of painting—that task had been accomplished in the Latin printed on the facing page in the original edition. Unlike Du Fresnoy, he is in a position to profit socially and psychologically from the aggrandizement of painting.

In De Piles' substantial note to the first line of *De arte graphica* he not only pursues and supports the identity of the arts, he suggests that painting, as a universal and graphic language, has in some respects the advantage of poetry. The burden of the note is to complete the process begun in the translation, of making specific what had been general in the analogy between the arts, and making literal what had been metaphorical. Whether painting should be judged superior to poetry or not is not in itself important to the advocate of painting, but that the two arts should be considered literally equivalent is all important, for it verifies the birthright of the less widely accepted sister. Future aestheticians like Lessing might attempt to distinguish among the means and the possibilities of the arts, but after De Piles and his followers[21] theoreticians could no longer easily deny painters their

[21] The works of De Piles, like those of Du Fresnoy, made many appearances in English; e.g., *The Art of Painting and the Lives of the Painters* (London, 1706). Some of the English writers influenced by De Piles, among them William Aglionby, Thomas Page, and Jonathan Richardson, are discussed in chapter five below.

right to be taken seriously as artists. Du Fresnoy had invoked the ancients in order to become as one of them; the French translation of *De arte graphica*, taking the classical authority of painting for granted, already goes a long way towards making the prestige of the graphic artist practically useful in the modern world.

<div align="center">6</div>

When John Dryden, at the instigation of Kneller and others, interrupted his work on the *Aeneid* in order to render *De arte graphica* into English for the first time,[22] it was to De Piles' text and De Piles' ideas about the equivalence of the arts that he turned. "A Parallel betwixt Painting and Poetry," prefaced by Dryden to his translation, is a literal-minded point by point comparison, not an aesthetic inquiry into the common sources of painting and poetry. Indeed, Dryden reveals a deep suspicion of theories about the idea of painting. After quoting liberally from Bellori's *L'Idea del pittore*, obviously to rid himself from any obligation to write theoretically, he comments, "though I cannot much commend the Style, I must needs say there is somewhat in the Matter: *Plato* himself is accustom'd to write loftily, imitating, as the *Critiques* tell us, the manner of *Homer*; but surely that inimitable Poet, had not so much of Smoke in his writing, though not less of Fire. But in short, this is the present *Genius* of *Italy*."[23] Exactly that genius had nourished Du Fresnoy, Bellori's contemporary and corrival. Dryden's pen may have been enlisted into the service of an Italianate idea of painting, but his sympathies are evidently elsewhere; unable to omit generalizations about painting *sub specie aeternitatis*, he removes himself from them doubly, first by confining them to quotations, then by expressing his own reservations. Even the poetic idealism of Du Fresnoy appears only as strained through De Piles' prose.

[22] See *The Critical and Miscellaneous Prose Works of John Dryden*, ed. Malone (London, 1800), I, 251-52; Charles Ward, *The Life of John Dryden* (Chapel Hill, 1961), pp. 272, 367. James Wright's *Country Conversations* (London, 1694), pp. 56-75, had translated Du Fresnoy's "Sentiments" about painters. According to Vitry and several later scholars, Wright also translated *De arte graphica*. After long search I have not been able to find a record of any such work, and I doubt its existence.

[23] Dryden, tr., *De Arte Graphica*, pp. xii-xiii. A defense of Bellori is offered by Kenneth Donahue, " 'The Ingenious Bellori'—A Biographical Study," *Marsyas*, III (1943-1945), 107-138.

Because Dryden was who he was, his translation of *De arte graphica* became, from the time of its first appearance, the standard against which subsequent translators must measure themselves. Pope, in a famous epistle (1715) to Jervas, who was to revise Dryden's version in 1716, lends his own substantial endorsement to the English line of succession.

> Read these instructive leaves, in which conspire
> *Fresnoy*'s close Art, and *Dryden*'s native Fire:
> And reading wish, like theirs, our fate and fame,
> So mix'd our studies, and so join'd our name,
> Like them to shine thro' long succeeding age,
> So just thy skill, so regular my rage.[24]

Jervas took the hint. But later translators, all too conscious of whom they were trying to replace, were anxious to deny the adequacy, let alone the precedence, of Dryden's Fresnoy. Their objections took three forms: Dryden, though a great poet, was ignorant of the art of painting; his version was composed hurriedly and carelessly to get some ready money; no prose can capture the essence of verse precepts.[25]

Each of these objections has some weight. Dryden's comparisons do favor poetry at the expense of painting; he certainly did work quickly; and, as we have seen, prose translation is not appropriate to the rhetorically heightened doctrines of Du Fresnoy. Nevertheless, to attack the translation and the "Parallel" for what they omit doing is somewhat to miss the point. Dryden's mentor in painting was Kneller, and his assignment was ably tailored for the English school, or portrait factory, which Kneller headed. By 1695 Kneller had been knighted, and his pre-eminence generally recognized.[26] Seldom if ever can a painter have been so

[24] "*Epistle* to Mr. *Jervas*, With *Dryden*'s Translation of *Fresnoy*'s *Art* of *Painting*," *Minor Poems*, ed. N. Ault and J. Butt (London, 1954), p. 156, ll. 7-12. Samuel Johnson took over 400 quotations for his *Dictionary* from Dryden's translation. See W. K. Wimsatt, "Samuel Johnson and Dryden's *Du Fresnoy*," *SP*, XLVIII (1951), 26-39.

[25] Wills, *The Art of Painting*, pp. i-iii, 2-6; Mason, *The Art of Painting*, pp. v-viii, xii. For a modern rebuttal of Dryden's parallels, see Lee, *Art Bulletin*, XXII, 259.

[26] "Kneller's supremacy at the beginning of the eighteenth century was unquestioned. He had enormous influence among the painters of the period, and a host of imitators, who, seeing nature only through his eyes, were led astray by him." W. T. Whitley, *Artists and their Friends in England 1700-1799* (London, 1928), I, 4. Kneller's portrait of Dryden dates from about 1693.

highly praised in verse by successive generations of poets. As Horace Walpole wrote, "Can one wonder a man was vain, who had been flattered by Dryden, Addison, Prior, Pope, and Steele?"[27] Moreover, Kneller enjoyed and used his authority; in 1711 he was to found the first English Academy, and long before then he had prided himself on his good favor with princes and with God. But Kneller's art, like the music of Henry Lawes, did not compete against poetry. When Dryden, the year before his translation of Du Fresnoy, addressed a long effusive epistle to Sir Godfrey, he knew very well what sort of talent he was praising.

> Some other Hand perhaps may reach a Face;
> But none like thee, a finish'd Figure place:
> None of this Age; for that's enough for thee,
> The first of these Inferiour Times to be:
> Not to contend with Heroes Memory. . . .
> Mean time, while just Incouragement you want,
> You only Paint to Live, not Live to Paint.
> Else shou'd we see, your Noble Pencil trace
> Our Unities of Action, Time, and Place.[28]

Kneller was not the painter to inspire a vision of the art that would be fit to compare with the dignity of epic or tragic poetry; and Dryden was not the poet to pretend to an ideal of painting which he neither saw nor felt. The humble secondary role which painting plays in the "Parallel," where it is repeatedly used to reinforce criticism which could conveniently refer to poetry alone, is a direct reflection of Kneller's own limited ambitions. James Wills was probably correct when he wrote, in 1754, "If instead of mere Face-painters, or such who professed History-painting, yet seem to have thought expression, or telling a story, justly no part of their duty, Mr. *Dryden* had conversed with *Raphael, Corregio*, the *Carraches* or their scholars, *Poussin, Le Seur*, or *Carlo Marat*, he would have had other conceptions of the art, or if he had had also a proper intelligence of the author, that lay

[27] *Anecdotes of Painting in England* (London, 1782), III, 213. Reynolds and Johnson both comment adversely on Kneller's vanity. See also Whitley, *Artists and their Friends*, I, 19-22.

[28] "To Sir *Godfrey Kneller*," *The Poems of John Dryden*, ed. James Kinsley (Oxford, 1958), II, 861, 862, lines 115-19, 164-7.

before him,"[29] but he was wrong in attributing Dryden's reservations about an idealized view of painting to a lack of sophistication. Insofar as Dryden had salvaged Du Fresnoy for an English audience, and had modified and expanded his precepts according to the best respected opinion of his day, he was demonstrating an intimacy with the affairs of painting that could not have been bettered by any initiate of the art. Like De Piles', his reconstitution of *De arte graphica* reconciles modern practice with classical authority. In a country dominated by a painter who aspired only to fashionable portraiture and literary esteem, Dryden bestows upon the art no more and no less than the highly craved weight of his personal condescension.

That condescension, however, is what Wills suspects most; it seems a sort of literary glibness applied to an art which only those who are themselves craftsmen can appreciate. Part of his feeling may be merely the professional's distrust of the amateur, yet as a practicing painter Wills might justifiably resent the domination of his art by literary men. "As every body pretends to Poetry, so she flatters every body; all are happy in her good graces; she is very loquacious and will be heard; but Painting has no tongue; she is a recluse lady, busied in labour, toiling always, coy and reserved."[30] These words sound very much like some of Dryden's own: "Painting . . . is a dumb Lady, whose charmes are onely to the eye";[31] but Dryden's way of paying court to the lady is consistently to tell her that her eyes seem to speak; painting aspires to become a kind of poetry. Thus, his highest praise for Kneller's pictures is that Nature "Lives there, and wants but words to speak her thought./ At least thy Pictures look a Voice; and we/ Imagine sounds, deceiv'd to that degree,/ We think 'tis somewhat more than just to see."[32] To a painter like Wills, this patronage of painting as a somewhat crippled literary fashion must have been infuriating. Yet Wills might have been less angry if he had been able to substitute, for the powerful names of Dryden and Pope, a more essential and effective authority of his own. Dryden might have had no cachet to legislate in matters of painting, but

29 Wills, *The Art of Painting*, p. 4n. 30 *Ibid.*, p. 5.
31 "Dryden's Dedication for *The Music of The Prophetesse*, 1691," R. G. Ham, *PMLA*, L (1935), 1070. See also Kinsley's notes to Dryden's *Poems*, IV, 2029.
32 "*Kneller*," lines 10-13. Cf. Dryden's ode on Anne Killigrew.

at least he was a celebrated critic. A painter like Wills could have no such easy way of justifying his opinions.

7

Indeed, after Dryden the whole problem of what constitutes authority in discourse about painting would never again be quite so simple. Du Fresnoy, as we have seen, was engaged in the largely theoretical task of constructing the equivalent of a classical doctrine for painting. De Piles and Dryden, though more immediately practical in their aims, could at any rate lay claim to the doctrine of Du Fresnoy as a legitimate extension of classical literary criticism.[33] The English successors of Dryden, however, have only the most specious interest in Du Fresnoy's theoretical classicism. Whether their ambitions are professional, like those of Jervas, Richardson, Wills, and Reynolds, or patriotic in the desire to found a specifically British school, or narrowly didactic, as with Defoe, they can hardly be seen as Horatian, genuinely concerned with reconstituting the doctrine that a hypothetical or composite ancient might have formulated. The elegant and equivocal aphorisms at the heart of Du Fresnoy's achievement are robbed of their doctrinal significance in the century that succeeds him. In the new dispensation each critic must prove his own authority by any means at hand.

The Compleat Art of Painting, by "D. F., Gent.,"[34] for instance, is an amusing example of how the spirit of Du Fresnoy can be compromised by lack of respect for his expression. Its authority, from the "Beauties" of its second line to the bromides which it sprinkles throughout, is that of the do-it-yourself manual, uninspected, unsophisticated, untroubled, and mixed with a good leaven of religious piety. The doggerel couplets hacked out by Defoe are clearly intended as mnemonic aids, not for pleasure, and the tone of the translation indicates that the audience it expects, unlike Du Fresnoy's or Dryden's, is young and impressionable. No opportunity for moral reinforcement is allowed to escape. Du Fresnoy's l. 468, "Nulla dies abeat, quin linea ducta

[33] The translations of De Piles, Dryden, Wills, and Mason were accompanied at their first appearances by the Latin text.

[34] The attribution to Defoe has never been challenged; apparently **Defoe** himself thought highly of the work. See J. R. Moore, *Daniel Defoe: Citizen of the Modern World* (Chicago, 1958), pp. 229-230.

supersit" (Dryden: "Let no day pass over you without a line"), becomes "Let no Day pass you without something done;/ For *Life* is *short, Art difficult* and *long,"*[35] whose italics are by no means mine.

With regard to the technique of translating and the technique of painting, such willingness to preach can be fatal. It is easier to find a moral tag than to be exact, and Defoe is evasive wherever technical precision is required. For instance, one of Du Fresnoy's more dubious tenets is that a strict adherence to perspective may be visually incorrect: "corpora falso/ Sub visu in multis referens, mendosa labascit," which Dryden renders "frequently falling into Errors, and making us behold things under a false Aspect." Defoe reduces it to "representing Bodies in false View/ In many Things, 'tis faulty and untrue,"[36] where the student may well wonder whether he is being instructed ethically or technically, and, if technically, to what obscure purpose. What *The Compleat Art* has to offer in place of authority or precision is only a desperate earnestness. To identify aesthetic with moral imperatives is as dangerous morally as aesthetically, unless the imperatives are as bland as "Whatever helps the *Art*, with *Care persue*;/ And what's *repugnant*, equally eschew."[37] Defoe's work may have been useful to young men in search of a short way to self-improvement, but its materials are as perishable as its abruptly terminated conclusion: "Thus I, contemplating the uncertain Date/ Of *Human Things*, and their *precarious Fate*,/ Have ventur'd these few *Maxims* to entrust/ To th' Immortal Muses to prevent from Dust."[38] The immortal muses could not have been very grateful for the favor.

8

The question remains: how can a translator or an adapter of Du Fresnoy retain his authority without pledging himself to the reverence for antiquity which is its basis? The interesting solution attempted by Wills in 1754 is to accept the text of *De*

[35] Dryden, tr., *De Arte Graphica*, p. 64; Defoe, *Compleat Art*, p. 46. Du Fresnoy's line 496 is "Vitaque tam longae brevior non sufficit arti."
[36] De Fresnoy, lines 119-20 (pp. 14-15); Dryden, *De Arte Graphica*, p. 19; Defoe, *Compleat Art*, p. 13.
[37] *Ibid.*, p. 43.
[38] *Ibid.*, p. 53. The equivalent is Du Fresnoy, lines 542-4.

arte graphica itself as the source of doctrinal authority, and ferociously to defend that text against corruption or emendation. Wills had reason to be sensitive to neglect. Himself an unsuccessful professional painter, who only a few months after his translation gave up his career to take orders,[39] he was very much on the outside of that circle of fashionable artists praised by literary men which had included Kneller and Jervas and was already beginning to include Reynolds. Without the sanction of society, Wills took refuge in the pride of his art—"If I acquit myself as a painter, I shall be satisfied"[40]—and in whatever mantle he might inherit from Du Fresnoy. It is significant that Wills' translation of *De arte graphica* includes, in lieu of the supplementary materials furnished by De Piles, Dryden, Graham, and Jervas, a life of Du Fresnoy especially supplied by Wills' friend, the antiquary Thomas Birch. It is equally significant that when in 1769-73 a mysterious antagonist, very probably the Rev. Wills, attacked Reynolds in the pages of the *Middlesex Journal* and the *Morning Chronicle*, he used the pseudonym "Fresnoy." The ordinary justification for tampering with the Latin text had been that an indigenous British school needed rules adapted peculiarly for itself. Wills, who "even in his despair speaks of himself as one possessing powers 'that would be esteemed anywhere but in England,' "[41] skeptical about the possibilities of British art at a time when everyone talked of a Royal Academy but none had been established,[42] puristically insists upon adherence to the only rules widely acknowledged by painters, and so identifies his own interests with those of Du Fresnoy.

Thus Wills, of all the translators of *De arte graphica*, most nearly reproduces its exact sense, even at the cost of its elegance. He corrects the errors introduced by De Piles, Dryden, and Jervas, approximates the original versification and lineation, points to the inadequacy of literal parallels of poetry and painting, and rebukes the literary domination of his art: "the endless puerilities we meet with in the best modern writers, when Painting

[39] For biographical information on Wills, see Whitley, *Artists and their Friends*, II, 272-79.

[40] Wills, *De Arte Graphica*, p. iii.

[41] Whitley, *Artists and their Friends*, II, 273. Whitley presents plausible circumstantial evidence for identifying "Fresnoy" with Wills.

[42] The Royal Academy was realized only in 1768. "Fresnoy" was then its most vociferous critic.

is the subject, are very painful."[43] As an act of rectification and discipline Wills' translation succeeds. Unfortunately, it has few other virtues. Perhaps Mason, in 1783, was being unduly harsh when he wrote that Wills had "produced a version which (if it was ever read through by any person except myself) is now totally forgotten";[44] but he was probably uncomfortably close to the truth. Without grace of style or a glamorous name to recommend it, Wills' version could not have captured many readers in the teeth of its famous competitors. What Wills can offer as his authority is only the literal word of Du Fresnoy; and that narrowly conceived word could not be enough to force the acquiescence of unprofessional students. If the essence of the prestige of *De arte graphica* is its doctrinal resiliency, its power of accommodation to disparate points of view, its flexibility cannot produce absolute standards with which to rebuke heretics. Du Fresnoy's artful nets might be well contrived to catch the winds of change, but they make only the shoddiest of bulwarks.

There is another reason, moreover, why the power of "Fresnoy" could not long be appropriated by Wills. In 1754 Englishmen would have been ready to acknowledge the inferiority of their writers on painting (with the single exception of Jonathan Richardson the elder) as well as the ignorance of their painters. Within thirty years, largely as the result of Reynolds' *Discourses,* the situation had changed completely. No longer were English painters assumed to be provincial, or French writers to be authoritative. "It was felt that England had demonstrated her ability to use the classical idiom and had established her ambitious claim to be as civilised as France,"[45] and mere patriotic pride insured that as the British Academy rivalled its French counterpart, so must British critics of art declare their independence from continental formulas. The reputation of *De arte graphica* remained great, but Wills' insistence on the inviolability of its every word could only seem a reminder of provinciality that Englishmen were eager

43 Wills, *De Arte Graphica,* p. 3n.
44 Mason, *The Art of Painting,* p. xiii. For a comparison and defense of Wills' translation against Mason's, see an anonymous letter in *The Gentleman's Magazine,* LIII (Feb., 1783), 118.
45 John Steegman, *The Rule of Taste From George I to George IV* (London, 1936), p. 133. For the continuation of French influence, see S. H. Monk, *The Sublime* (Ann Arbor, Mich., 1960), chapter IX.

to forget. What the English audience required was the "Muse of *Fresnoy* in a modern vest";[46] dress available from the workshop of William Mason.

<center>9</center>

From first to last, Mason's unquestioned intention was not so much to translate *De arte graphica* as to adapt and improve it for British use. Taking a dim view of Du Fresnoy's versification— "As to the poetical powers of my Author, I do not suppose that these alone would ever have given him a place in the numerous libraries which he now holds"—Mason considers himself justified in polishing the style; bearing reservations about the timeliness of the ideas—"many of the precepts it contains have been so frequently repeated by later writers, that they have lost the air of novelty, and will, consequently, now be held common"[47]— he does not scruple to bring them up to date. According to Mason himself, he would never have revised or published his translation had not Reynolds proposed to annotate it,[48] and the priority of British views about art over Du Fresnoy's views is never concealed. Indeed, what Mason's *The Art of Painting* offers is as much akin to the popular eighteenth-century genre of "imitation" as to straightforward translation. Like Johnson transmuting Juvenal's Rome into contemporary London, the poet aims at a psychological and imaginative, not a linguistic and historical, equivalence. For instance, Du Fresnoy had concluded with praise for France's campaigns against Spain; Mason, in 1781, has other sentiments: "But mark the Proteus-policy of state:/ Now, while his courtly numbers I translate,/ The foes are friends, in social league they dare/ On Britain to 'let slip the Dogs of War.'/ Vain efforts all. . . ."[49] Far from revering the text of his original, the Englishman will not always countenance it.

Stylistically, Mason's "improvements" had an excellent press. According to Horace Walpole, "This is the best translation I ever

[46] Mason's "Epistle to Sir Joshua Reynolds," *The Art of Painting*, p. viii.

[47] Mason, *The Art of Painting*, pp. x and ix.

[48] For the genesis and reception of Mason's translation, see *Horace Walpole's Correspondence with William Mason*, ed. W. S. Lewis, G. Cronin, Jr., and C. H. Bennett (New Haven, 1955), I and II *passim*; and J. W. Draper, *William Mason: A Study in Eighteenth-Century Culture* (New York, 1924), especially pp. 308-13.

[49] Mason, *The Art of Painting*, p. 64. Some of the reviewers thought that Mason had gone too far.

<center></center>

saw. . . . there is the precise sense of every sentence, and yet they are not translated. They are like the same pair of legs, before being taught to dance and afterwards." Dr. Johnson, after reading "not a great part," wrote to Reynolds, "I find him better than exact, he has his authours distinctness and clearness, without his dryness and sterility." The *Critical* and *Monthly Reviews* agreed that Mason had "suffused over the naked and unornamented images of the original the most exquisite grace—and to the truth and precision of Fresnoy, has joined the warmth and colouring of Corregio." William Hayley also thought the changes all to the good: "With pride, by envy undebas'd,/ My English spirit views/ How far your elegance of taste/ Improves a Gallic Muse./ I thought that Muse but meanly drest/ When her stiff gown was Latin;/ But you have turn'd her grogram vest/ Into fine folds of sattin."[50]

The slickness of texture which this praise suggests is borne out by Mason's performance; unhappily, so is the floridness. It is worth noting that of the five English translations quoted above of the opening sentence of *De arte graphica*, Mason's is considerably the longest. For the poem as a whole, Du Fresnoy needed 549 lines; Mason, 798. Moreover, rhetorical inflation is responsible for significant modifications throughout the text. "True Poetry the Painter's power displays" gratuitously grafts onto "Ut Pictura Poesis erit" three riders: the idea that certain kinds of poetry, presumably those with frequent and effective reference to visual phenomena, are "true" or "genuine" (l. 8) in a way that other kinds of poetry are not; the assumption that the source of such "truth" lies in the painterly abilities of the poet; and the implication that the analogy between the arts affords a method of testing the "truth" of artistic performances. Whether or not Mason would have subscribed to these tenets philosophically presented,[51] his expansive rhetoric commits him to notions undreamt of by Horace and unspecified by Du Fresnoy.

[50] Walpole *Correspondence*, II, 103, 106; *The Letters of Samuel Johnson*, ed. R. W. Chapman (Oxford, 1952), III, 9; *Monthly Review*, LXVIII (June, 1783), 472; Hayley, "To Mr. Mason," *Poems and Plays* (London, 1788), p. 191. Other encomia are listed by Draper, *William Mason*, pp. 312-13.

[51] For Richard Hurd's "A Letter to Mr. Mason, On the Marks of Imitation," with reference to Horace, a philosophical analysis some 76 pages long, see *Q. Horatii Flacci Epistola ad Augustum: With an English Commentary and Notes* (Cambridge, 1757), II.

To some extent, Mason's embroidery of his original may reflect no more than changing tastes in verse illustrated by a poet who misses no opportunity "to display/ The bright effulgence of the noontide ray" and "the full-orb'd Ruler of the skies" where he found only the light of day ("lumen . . . diei"). Though twentieth-century readers may itch to remind the author in his own words that "Vain is the flow'ry verse, when reasoning sage,/ And sober precept fill the studied page," eighteenth-century readers were delighted at the profusion of colors ("Refulgent Nature's variegated dyes")[52] and expected no less. Nevertheless, serious objection may be made to Mason's *Art*, not so much because his decorations are inorganic as because cumulatively they produce an organic effect that contradicts the Latin text. To eighteenth-century ears Du Fresnoy's lines were harshly dry, yet De Piles had correctly emphasized from the first that the price of doctrinal authority is compression; the classicism of *De arte graphica* depends upon the density of its aphorisms, not their occasional felicities. Mason's well-watered little flowers do not grow in the ground which nurtures a doctrinal habit of mind. For distinction, he substitutes luxury; for timelessness, leisure; for ambiguous elegance, elegant variation. *The Art of Painting*, unlike its predecessor, demands admiration, but disarms too careful an investigation. Its reader is not expected to make the English text an object of study, let alone of veneration. His response to its instructions about painting will be determined partly by the pleasure he feels, but much more by the context in which the translation appears, beautified by a noted poet, annotated by the most renowned of painters, dedicated to dressing up old commonplaces in fresh English garb. The virtues of *The Art of Painting*, that is to say, are not primarily those of doctrine, related to lapidary, disconnected, and adaptable phrases. They are rather those of system, related to a whole made up of many parts. Whatever its particular merits, Mason's ornamental style subtly transforms the doctrine of Du Fresnoy into the more expansive rhythms of systematic discourse. To be sure, Mason has no distinctive system of judgments about painting to put forward; but that want is remedied by the contribution of Sir Joshua Reynolds.

[52] Mason, *The Art of Painting*, pp. 41, 4, 30; Du Fresnoy, lines 365, 26-27, 267.

Mason's prefatory epistle to Reynolds handsomely accords him pride of place over Du Fresnoy as well as himself.

> Know, when to thee I consecrate the line,
> 'Tis but to thank thy Genius for the ray
> Which pours on *Fresnoy's* rules a fuller day:
> Those candid strictures, those reflexions new,
> Refin'd by Taste, yet still as Nature true,
> Which, blended here with his instructive strains,
> Shall bid thy Art inherit new domains;
> Give her in Albion as in Greece to rule,
> And guide (what thou hast form'd) a British School.[53]

To Reynolds the task has been given of sophisticating and domesticating the well-worn foreign ideas of *De arte graphica*. No annotator has ever been put into a position where his superiority to the text he comments upon has been more clearly marked. As President of the Royal Academy, leading painter of his day, and world-famous aesthetician, Reynolds could speak with an authority that has seldom been equalled, certainly not by the obscure Frenchman who had furnished the Latin precepts. Moreover, Reynolds himself had been so successful in inculcating the principle that the decisive abilities of a painter are mental —"were there no other evidence of Sir Joshua Reynolds's abilities than what might be collected from the annotations . . . , they alone would be sufficient to establish his reputation as a painter"[54]—that his artistic prestige enhanced his ideas. In his own person he harbored much of the stature that Du Fresnoy had hoped to import from the ancients.

As it happens, at the time when Reynolds was writing his notes he had reason to be particularly concerned with questions about what constitutes authority in the arts and in their commentators. In late 1781 and early 1782, while he fulfilled his promise to Mason, he was approaching the height of his literary career. Ten Discourses had already been published, the collected volume of the first seven had recently been translated both into Italian

53 Mason, *The Art of Painting*, p. vii.
54 *Monthly Review*, LXVIII (June, 1783), 476.

and German, and he had received flattering recognition from prominent men of letters.[55] The Eleventh Discourse, delivered December 10, 1782, between the completion and publication of *The Art of Painting*, is one of a series of works of this period which confront the sources of artistic greatness in an effort to adjudicate the varying claims of study against genius, particular against general nature, rules against free perception. Reynolds was taking his role of arbiter very seriously, just as his close friends Burney and Johnson were contemporaneously attempting to fix the standards of English taste in music and poetry. The responsibility of Anglicizing the most celebrated treatise on painting, no matter how casually undertaken, could not be lightly satisfied.

The usual comment about Reynolds' revision of Du Fresnoy (and of De Piles, from whom Reynolds borrows freely though tacitly) has been that he restates the theory of the original in an immediately useful form. Thus Henry Fuseli pays tribute to his former master: "From Du Fresnoy himself, we learn not what is essential, what accidental, what superinduced, in style; from his text none ever rose practically wiser than he sat down to study it: if he be useful, he owes his usefulness to the penetration of his English commentator; the notes of Reynolds, treasures of practical observation, place him among those whom we may read with profit."[56] Similarly another critic, citing Reynolds' emphasis on *seeing* rather than *knowing* nature, remarks that the difference between Du Fresnoy and his annotator "is the difference between reasoning and contemplation, between knowledge and observation."[57] Whether or not we accept these somewhat oversimplified distinctions, there can be no doubt that Reynolds' writing here is more specific than in the *Discourses*. During the summer of 1781 he had journeyed to Flanders and Holland, and the frequent ref-

[55] See F. W. Hilles, *The Literary Career of Sir Joshua Reynolds* (Cambridge, 1936), chapters IV and V. In George Colman's version of "The Art of Poetry" (1783), he translates "Ut pictura poesis" as "Poems and Pictures are adjudg'd alike," and his note to this line points to the usefulness of Reynolds' *Discourses* in refining the taste of poets. *Prose on Several Occasions; accompanied with some pieces in verse* (London, 1787), III, 24.

[56] Introduction to "The Lectures of Henry Fuseli," in *Lectures on Painting, by the Royal Academicians Barry, Opie, and Fuseli*, ed. R. N. Wornum (London, 1848), p. 344. Fuseli's introduction was first published in 1820.

[57] Christopher Hussey, *The Picturesque: Studies in a Point of View* (London, 1927), p. 52.

erences he makes to the painters of those countries, who were always associated in Reynolds' mind with minute or "mechanical" observations and techniques, not with the grand style,[58] demonstrate his concern with specific mechanical problems of painting (for instance, he transcribes De Piles' measurements of the human body). As an annotator, moreover, Reynolds of course must illustrate the precepts in the text with examples.

Yet the student who took Fuseli at his word and turned to the notes of *The Art of Painting* for detailed practical instruction would be disappointed. Reynolds does not purchase his particulars at the cost of philosophical elevation. The constant dialectical alternation between general and particular which scholars have recently asserted to be the methodological basis of the *Discourses*[59] is altogether apparent in the less disciplined structure of the notes; Reynolds shifts back and forth from principles to specific instances without worrying about seeming inconsistencies. In Note 43, for example, speaking of styles of coloring, he says: "To all these different manners, there are some general rules that must never be neglected"; in his final note, 46, he concludes: "In all minute, detailed, and practical excellence, *general* precepts must be either deficient or unnecessary: For the rule is not known, nor is it indeed to any purpose a rule, if it be necessary to inculcate it on every occasion."[60] As anyone used to Reynolds' methods of composition will realize, such contradictions are more apparent than real. The first statement introduces a practical piece of learning, the second concludes a philosophical discussion of the precedence of nature before rules. Each, in its place, makes sense; each, plucked out of context, might be used to embarrass its author. Unlike Du Fresnoy and Bellori, Reynolds pays no service to the unity of painting as *idea*. "Critics seem to consider man as too uniformly wise, and in their rules make no account for the playful part of the mind."[61] For him the art is not to be subsumed under a single definition, since like all the expressions of mind it partakes of all possible human interests, and its many parts require individual solutions, perhaps solutions inconsistent with one another, to individual problems.

[58] Reynolds had made this distinction as early as October 1759, in *Idler* No. 79.
[59] See below, chapter VII, section 3. [60] *The Art of Painting*, pp. 103, 119.
[61] *Portraits by Sir Joshua Reynolds*, ed. F. W. Hilles (London, 1952), p. 119.

That the rules which satisfy a dialectical system are not the same as those of doctrine, Reynolds well understood. "Rules are to be considered likewise as fences placed only where trespass is expected; and are particularly enforced in proportion as peculiar faults or defects are prevalent at the time, or age, in which they are delivered; for what may be proper strongly to recommend or enforce in one age, may not with equal propriety be so much laboured in another, when it may be the fashion for Artists to run into the contrary extreme."[62] As a teacher, Reynolds accepted the obligation "to form a *mind*, adapted and adequate to all times and all occasions";[63] it was no part of that obligation to arrive at the ultimate formulation of immutable truths, or to deliver opinions whose force would be without reference to circumstances. Philosophically, he could not believe in principles of art which resided anywhere except in the human mind, that complicated and flexible repository of multiple truths always subject to revision. Practically, he knew his writings to be involved in contradictions inseparable from their utility. "I found in the course of this research, many precepts and rules established in our art, which did not seem to me altogether reconcileable with each other, yet each seemed in itself to have the same claim of being supported by truth and nature; and this claim, irreconcileable as they may be thought, they do in reality alike possess."[64] We have here come very far from the "entire and certain knowledge," the "infallible rules of judging truly," which De Piles had promised the readers of his Du Fresnoy. By the time Reynolds took leave of the Academy, he believed that he had "succeeded in establishing the rules and principles of our art on a more firm and lasting foundation than that on which they had formerly been placed,"[65] yet even from such a pinnacle he could offer no guarantee that those rules and principles would not soon be superseded by better ones, or ones better suited to the needs of another age. Detached from the extravagances they were intended to counteract, Reynolds' partial truths lost part of their meaning. Only a knowledge of the whole, of circumstances and precedents and conditions, could make his system of rules intelligible.

[62] *The Art of Painting*, pp. 117-18.
[63] *Discourses on Art*, ed. R. R. Wark (San Marino, Cal., 1959), p. 204.
[64] *Ibid.*, p. 268. [65] *Ibid.*, p. 269.

De arte graphica had drawn its authority from two sources: antiquity, and its own excellence. The nature of the authority possessed by the Mason-Reynolds *Art of Painting* is more complex. Scholars used to say that the difference between works like *De arte graphica* and *The Art of Painting* is that in the middle of the eighteenth century "respect for authority gave way to confidence in the results of the processes of logic."[66] Yet if Mason's translation and Reynolds' notes had been far more florid and casual than they are, the version they produced would still have been greeted enthusiastically, not because of the processes of logic but because of the processes of intellectual and social history. *The Art of Painting* was born into a context of British artistic ambitions that insured its triumph.

Not all works enjoyed such advantages. Before the combined powers of his rivals, W. Churchey could only bow respectfully and withdraw. In the Preface to his translation of *De arte graphica*, composed at the same time as Mason's though not published until 1789, Churchey is lavish with apologies: he would not have undertaken the task had he known of his competitors, he has used a different verse form, his poem was written in nine days and not revised, he "would wish to have this Translation of the Poem, considered rather as a poetical, than a scientific attempt, to please the lovers of Poetry more than the Student."[67] Surely this little "Art of Painting" does not require so many excuses. It is no worse than most of the translations of Du Fresnoy, and one might argue that its compactness, its graceful versification, and such details as the preservation of a sense of quotation in the fourth line place it among the best. Indeed, its insignificance stems from no fault of its own, but from its timing. Churchey's agreeable poetry cannot stand against the full weight of "science"; a mere translator cannot hold the field against world-famous authorities. And by the 1780's in England the authority of a Reynolds, a Burney, a Johnson could be gained only by striving for completeness and particularity, by piling fact on fact and generalization on gen-

[66] Howard, *PMLA*, XXIV, p. 43. The supposed change from authority to reason has recently been reassessed by Robert Voitle, "The Reason of the English Enlightenment," *Studies on Voltaire and the Eighteenth Century*, XXVII (1963), 1735-74. Theological debate on the question is analyzed by G. R. Cragg, *Reason and Authority in the Eighteenth Century* (Cambridge, 1964).

[67] "The Art of Painting," p. x.

eralization, by summoning up and embodying in one's own work the whole range of an art.

Thus the serene attempt of *De arte graphica* to realize the essence of painting in a handful of verses was absorbed by the restless systematizing activity of Englishmen who sought a more inclusive kind of aesthetic truth. Du Fresnoy's rules became part of a whole, always subject to addition and emendation; Horace's verses ceased to be the font of artistic thought, and were used to adorn a system. Even the authority disposed and jealously guarded by Reynolds proved to be so much his own property, the tribute paid to his whole career, that it could not be transferred. *The Art of Painting* summarizes the most informed opinion of its day in the most significant context, and it does not invite correction. It takes to itself the authority it denies to any set of rules. No longer the distillation of wisdom about painting, *De arte graphica* assumed its small place in the new classicism that modern writers had made from their own past and present. Its authority and its transformations had come at last to an end.

William Oldys and the
Age of Diligence

1

THE most significant fact about William Oldys, according to a general consensus, is that he did not write the first History of English Poetry nor the first Lives of the Poets. It is a very negative fact; one feels like apologizing for it. We do not know for certain that Oldys *intended* to write that History or those Lives, and we *do* know that during most of his life he was poor, obscure, hard-working, and unencouraged.[1] Why should we wonder about his failure? or violate his decent obscurity? Why should anyone spend a moment speculating about a work that never existed?

Yet the persistence of regret about Oldys' career is itself a fact. It has a long history, beginning while Oldys was alive, continuing into our own century. In the words of Professor Nichol Smith, "The more we know of his work . . . the more we regret that a man of such knowledge should not have preserved it in a form that would have compelled our recognition."[2] The ultimate tribute of this sort, a little epic of unfulfillment, is the essay on Oldys with which Isaac D'Israeli closed the last volume of his *Curiosities of Literature*. The sympathetic D'Israeli takes leave of his own life work with a hail and farewell. "Oldys affords one more example how life is often closed amidst discoveries and acquisitions. The literary antiquary, when he has attempted to embody his multiplied inquiries, and to finish his scattered designs,

[1] The fullest life of Oldys (1696-1761) is James Yeowell's memoir, *A Literary Antiquary* (London, 1862), reprinted from *Notes and Queries* of that year. The *DNB* contains a thorough summary of facts by Thompson Cooper. All Oldys' published works were commissioned by the booksellers, his only source of income except for periods when he was librarian to the Earl of Oxford (1738-1741) and Norroy King-at-Arms (after 1755). He spent 1751-1753 in Fleet prison for debt.

[2] "Warton's History of English Poetry," *Proceedings of the British Academy*, XV (1929), 82.

has found that the LABOR ABSQUE LABORE, 'the labour devoid of labour,' as the inscription on the library of Florence finely describes the researches of literature, has dissolved his days in the voluptuousness of his curiosity; and that too often, like the hunter in the heat of the chase, while he disdained the prey which lay before him, he was still stretching onwards to catch the fugitive!"[3] Though Oldys' ability to have fathered English literary history is purely conjectural, it can capture the imagination.

What accounts for these conjectures? First of all, a vast curiosity, a vast industry:[4] in the field of biography and its offspring literary biography, Oldys' (often anonymous) signature is everywhere. "The Life of Sir Walter Ralegh" (1736), a work that made Oldys' reputation if not his fame, "set a new standard as the most thoroughly documented and careful piece of biographical research that had so far been achieved."[5] His most ambitious task, the general editorship of and particular contributions to the first edition of *Biographia Britannica* (1747-66), is an initial great landmark in that trail of systematic lives which would lead eventually to the *Dictionary of National Biography*.[6] Oldys' twenty-two articles, "which may rank with some of the most perfect specimens of biography in the English language,"[7] include pioneering lives of Caxton, Drayton, Etherege, Farquhar, Sir John Fastolff, Thomas Fuller, Fulke Greville, and Richard Hakluyt. By themselves they would establish their author as an enquirer whose depth of research was not surpassed by any contemporary.

In view of the scope and importance of these achievements, we may well ask whether Oldys did not employ his one and only lifetime very satisfactorily as a biographer.[8] "Literary biography"

[3] "Life and Habits of a Literary Antiquary—Oldys and his Manuscripts," *Curiosities of Literature* (London, 1834), VI, 391.

[4] Gibbon, Sir S. E. Brydges, and Thomas Park all professed themselves unable to improve upon Oldys' investigation of source materials. His methods are described by Francis Grose, *The Olio* (London, 1796), pp. 136-39.

[5] Donald Stauffer, *The Art of Biography in Eighteenth Century England* (Princeton, 1941), I, 254.

[6] *Ibid.*, I, 249-52. [7] Yeowell, *Literary Antiquary*, p. xxix.

[8] The question is put most strongly by Bolton Corney, "Facts relative to William Oldys, Esq., Norroy King at Arms. Comprising an Attempt to Vindicate him from the Vindication published by I. D'Israeli, Esq., D.C.L. and F.S.A.," *Curiosities of Literature Illustrated* (London, 1837).

was not recognized as a separate genre in the eighteenth century;[9] literary history, according to Dr. Johnson, was put upon a sound basis only with the publication of Warton's *Observations on the Faerie Queene of Spenser* in 1754.[10] Is it reasonable to wonder why Oldys, laboring mightily in a field he knew, did not embark into the unknown?

If the regrets about Oldys depended primarily upon his published work, we could cease to wonder here. The situation, however, is far more complicated; something more subtle is at work. Studying the development of English literary history and literary biography in the eighteenth century, sooner or later we come to sense a presence not quite tangible and not quite in focus: the extraordinary ubiquity of Oldys' researches. His manuscript annotations and notes, his compilations and prefaces, his abstracts and digests and catalogues, the remnants of his verbal and epistolary communications, constitute a legacy far greater than his biographies. Whatever the fire of Oldys' talent, the prevalence of his smoke is intriguing; we cannot search for the origins of literary history without stumbling across its lingering traces.

Consider, for instance, *The Polite Correspondence: Or, Rational Amusement* (1741), which contains one of the first projects for a history of English poetry.[11] The man primarily responsible for this collection of letters was evidently Dr. John Campbell, a prolific miscellaneous writer who was the friend and informant of Johnson and later Thomas Warton.[12] In his preface, Campbell attributes all the virtues of his historical plan to the conversation of Oldys, "a Person with whom it is impossible to spend an Evening without being wiser for it." When *The Rational Amusement* went through another edition in 1754, Campbell, who had contributed copiously to *Biographia Britannica* in the meantime, was encouraged to hope for more: "If [Oldys], who is

[9] The phrase itself did not become current until the nineteenth century. On the development of the genre, see Richard Altick, *Lives and Letters: A History of Literary Biography in England and America* (New York, 1965).

[10] *Boswell's Life of Johnson*, ed. G. B. Hill and L. F. Powell (Oxford, 1934), I, 270.

[11] See Alan Dugald McKillop, "A Critic of 1741 on Early Poetry," *SP*, XXX (1933), 504-21; D. N. Smith, *Proceedings of the British Academy*, XV, 84-85; René Wellek, *The Rise of English Literary History* (Chapel Hill, 1941), p. 162.

[12] *Boswell's Life of Johnson*, I, 418; John Wooll, *Biographical Memoirs of the Late Revd. Joseph Warton, D.D.* (London, 1805), pp. 241-42, 263-64.

of all men living the most capable, would pursue and perfect this plan, he would do equal justice to the living and to the dead."[13] Had Oldys supplied Campbell with fragments from a literary history in progress? Did Campbell have reason to believe that Oldys was ready to complete the project? We are left with hints and conjectures.

Still more characteristic of Oldys' peculiar shadowy presence are the travels of his two generously annotated copies of Langbaine's *An Account of the English Dramatick Poets*.[14] The first of these, which became the property of Theophilus Cibber, furnished some of the factual material in the Cibber-Shiels *Lives of the Poets* (1753), a collection whose anticipation of or complementarity with Johnson's *Lives* has recently come in for scholarly attention.[15] The second Langbaine, annotated after 1727, was later mined by Birch, Percy, Nichols, Steevens, Malone, and Isaac Reed.[16] Well into the nineteenth century, one could agree with the bibliophile T. F. Dibdin that "Oldys' *interleaved Langbaine* . . . is re-echoed in almost every recent work connected with the belles-lettres of our country. Oldys himself was unrivalled in this method of illustration."[17]

2

The extent of Oldys' residual contributions to literary history can be measured by the variety of his certain or possible connections with Warton and Johnson. In addition to his reference biographies of poets, Oldys had assisted on many of the anthologies or commonplace-books of poetry which Warton employs.[18] Warton owned Oldys' own annotated copy of *England's Parnassus*, and he also singles out for praise ("comprehensive and exact")[19] Thomas Hayward's *The British Muse* (1738), which Oldys had helped

[13] The plan referred to is that of *The British Librarian* (see below).

[14] Corney, *Curiosities of Literature Illustrated*, pp. 168-71; Yeowell, *Literary Antiquary*, pp. xlii-xliv.

[15] See chapter thirteen, section four, below.

[16] Yeowell, *Literary Antiquary*, p. xliii. The Shakespeare Society once planned to publish Peter Cunningham's selections from Oldys' notes. See Harrison R. Steeves, *Learned Societies and English Literary Scholarship in Great Britain and the United States* (New York, 1913), pp. 145-46.

[17] *Bibliomania* (London, 1842), p. 499n.

[18] Yeowell, *Literary Antiquary*, pp. xli-xlii. Warton himself contributed a "Life of Sir Thomas Pope" to the *Biographia Britannica*.

[19] *History of English Poetry*, III (London, 1781), 281.

to compile, and for which Oldys had provided a long "Preface, Containing an Historical and Critical Review of all the Collections of this Kind that were ever published."[20] Another service performed by Oldys for the future literary historian consists of extensive cataloguing and abstracting of rare books. *The British Librarian* (1738), "a Compendious Review or Abstract of our most Scarce, Useful, and Valuable Books in all Sciences, as well in Manuscript as in Print,"[21] supplies reliable information about works that were hard to find. As sometime librarian and secretary to the second Earl of Oxford, Oldys naturally became one of the collaborators in the disposal of the Harleian Library, and with Johnson helped superintend both the *Catalogus Bibliothecae Harleianae* (1743-44) and *The Harleian Miscellany* (1744-46).[22] A more tangled knot of indebtedness is tied to the friends from whom Warton was constantly requesting and receiving materials. Some of them, like Campbell, had benefitted personally from Oldys' fund of knowledge; others, like Percy, had access to such manuscript stores as Oldys' Langbaines and *Worthies of England* and account of the London libraries.[23] The precise nature and degree of these minuscule accumulated repositories of fact cannot be estimated, but clearly Oldys was one of those who had broken the ground which Warton was to cultivate.

The connections between Oldys and Johnson are still more nebulous and profound. The two men were fellow laborers for years in Osborne's hack-shop, but Johnson did not reminisce much about their old acquaintance. Temperamentally they were opposites. According to Hawkins, Johnson "was never a sedulous inquirer after facts or anecdotes, nor very accurate in fixing dates: Oldys was the man of all others the best qualified for such an employment; Johnson's talent was disquisition; a genius like his, disdained so servile a labour."[24] *Rambler* 177, "A Club of Antiquaries" (Nov. 26, 1751), describes some "virtuosos," Hirsutus

[20] According to Oldys, Campbell was hired by the publishers "to cross it and cramp it, and play the devil with it." See the *Diary of William Oldys, Esq.*, which accompanies Yeowell's *Literary Antiquary*, pp. 20-21.

[21] From the title page. The work was originally published as a periodical in 1737.

[22] James Clifford, *Young Sam Johnson* (New York, 1955), pp. 267-71.

[23] Yeowell, *Literary Antiquary*, pp. xlv-xlvi; "London Libraries" is reprinted, pp. 58-109.

[24] Sir John Hawkins, *The Life of Samuel Johnson, LL.D.* (London, 1787), p. 533. Hawkins had himself been aided by Oldys' researches (see Oldys' *Diary*, in Yeowell, *Literary Antiquary*, pp. 15-16).

and Chartophylax, who come uncomfortably near what we know of Oldys; and its conclusion represents Johnson's balanced judgment of antiquarians: "Leisure and curiosity might soon make great advances in useful knowledge, were they not diverted by minute emulation and laborious trifles. . . . [Yet] whatever busies the mind without corrupting it, has at least this use, that it rescues the day from idleness, and he that is never idle will not often be vitious."[25] The combination of superiority and envy with which Johnson regarded men whose bustle kept the imagination at bay might be epitomized by the first line of Oldys' famous verses, "Busy, curious, thirsty Fly";[26] Johnson himself rescued one day from idleness by translating the verses into Latin.[27] In his later years Johnson did not like to think about the work that makes scholarship possible, and he probably did not like to think about Oldys.

Nevertheless, *The Lives of the Poets* borrow many of Oldys' materials. Besides Cibber's *Lives*, the *Biographia Britannica* (renewed but not completed by Andrew Kippis after 1778 with the aid of Oldys' manuscript notes), the Harleian collaborations, and whatever indirect benefit derived from conversations or from the use of Oldys' annotations by other writers, we must take into account Mrs. Cooper's *The Muses' Library* (1737). This "Series of English Poetry," an anthology with biographical and critical comments, has been regarded as one of the precedents for the form of Johnson's *Lives*; and Oldys, a friend of Mrs. Cooper, was instrumental in its preparation.[28] In all probability Johnson relied on Oldys more than he would have liked to know.

One more thin chain of circumstances will indicate the span of time during which Oldys' researches provide connecting links in the rise of literary scholarship. Through the Earl of Oxford, Oldys had become acquainted with Pope. According to Malone, "[Oldys] was the person who suggested to Mr. Pope the singular course which he pursued in his edition of Shakespeare"

25 *Works* (Oxford, 1825), III, 333.
26 First published in *The Scarborough Miscellany* in 1732; Yeowell, *Literary Antiquary*, pp. xii-xiii.
27 Samuel Johnson, *Poems*, ed. E. L. McAdam, Jr., with George Milne (New Haven, 1964), p. 282.
28 Oldys' *Diary*, p. 1. See below, chapter thirteen, section three.

(1725),[29] that is, drastic revision of the text to achieve clarity at any cost. Among the projects which Oldys left incomplete at his death (1761) was a life of Shakespeare, for which his collections had been extensive,[30] and which may have furnished bits of information for Johnson's edition (1765). Most of this manuscript collection eventually came into the hands of Malone, as he chased down materials for his own great edition of Shakespeare (1790). Boswell, who praised Oldys as "a man of eager curiosity and indefatigable diligence, who first exerted that spirit of inquiry into the literature of the old English writers, by which the works of our great dramatick poet have of late been so signally illustrated,"[31] was most likely thinking of the "additional anecdotes" used by both Malone and Steevens.[32] Thus Oldys left traces in three generations of Shakespeare studies.

The variety of Oldys' provision of materials for literary history, then, is suggestive of the resources he might have brought to bear upon a major work. Other fragments of evidence indicate that he may have been contemplating such a work.[33] The fact remains that he did not write it. Whether his critical powers would have proved equal to the task is at least dubious; the correspondent in the *Gentleman's Magazine* who charges that "He was an excellent picker-up of facts and materials; but had [little power] of arranging them, or connecting them by intermediate ideas"[34] overstates his case, but he reflects an opinion shared by others. In any case, Oldys' ability or opportunity to have executed a major work is a dead issue, if it was ever alive. For Oldys, the question was not why he was not writing a major work, but what such a work might and could be. The real interest of his career must be sought in the nature of literary studies in his time, and in the principles he relied upon to shape a contribution of his own.

[29] "Choice Notes by William Oldys," Yeowell, *Literary Antiquary*, p. 45n; from a note in Malone's *Shakespeare*.

[30] D'Israeli, *Curiosities of Literature*, p. 386; Corney, *Curiosities of Literature Illustrated*, p. 180.

[31] *Boswell's Life of Johnson*, I, 175.

[32] D'Israeli says that Boswell once showed him a copy of Fuller's *Worthies*, with a transcript of Oldys' notes, which had belonged to Steevens and later to Malone.

[33] See for instance Oldys' note on William Browne's plan for a history of English poets, Yeowell, *Literary Antiquary*, p. 39.

[34] *The Gentleman's Magazine*, LIV (1784), 260.

When the first volume of Warton's *History of English Poetry* was published in 1774, it "introduced and established, at least in England, the whole conception and possibility of literary history";[35] but it had come late. For more than a generation men of letters had been advocating a formal, substantial history of English poetry, and the project had been enthusiastically taken up, and then gradually forgotten, by a succession of authors, most famously by Pope and Gray.[36] It is not surprising that such a work should have been contemplated, or that it should not have been accomplished. An Augustan age would have liked an account of the precedents that had led to its own mastery; and patriotic Englishmen would have welcomed a guide to the literature of their country.

At the same time, so ambitious a history is easier to contemplate than to write. The erudition and the dedication required must have staggered everyone who faced the task, as Warton was staggered. Prior to the growth of antiquarian research the sheer difficulty of assembling materials might itself have been prohibitive. Warton had the advantage of a historical moment when much of his preparation had been done for him, he was prosperous and had time to work, he lived at Oxford with access to more than one great library, and the friends who offered him encouragement included many of the foremost contemporary antiquarians; even so, his *History* was long delayed and never finished.[37] The desire for definitive English literary history long preceded anyone's ability to put it into intelligible form, let alone to write it. Similarly, a public willingness to have Samuel Johnson legislate for it in matters of literary biography was far more easily come by than Johnson's willingness to legislate.

Partly thanks to Oldys' labors, as well as to their own, Warton and Johnson had available a wealth of information that Oldys could not have matched two or three decades earlier. Yet the growth of sources of information, however important, cannot have been decisive in making large works of literary history and

[35] Wellek, *Rise of English Literary History*, pp. 199-200.
[36] *Ibid.*, pp. 162-65; D. N. Smith, *Proceedings of the British Academy*, XV, 82-88.
[37] See chapter twelve below.

biography possible. To the extent that quantities of facts were superabundant, they were also a burden: at times both Warton and Johnson despaired of coming to terms with the plethora of materials, and the conscientious Warton very nearly failed to start what he eventually failed to complete. Given the acceptance of the task of writing an ambitious literary history or biography, the crucial moment is not when one has gathered every last piece of information, but when one has decided that the amount of information at hand will suffice to begin according to a particular plan. The decisive condition for the development of English literary history, that is to say, was not antiquarian research, but the accommodation of that research to a form, a way of ordering.

As early as the introduction to *The British Librarian* (1738), Oldys had specified the problem of contemporary literary scholarship:

> The vast Number of Books which the Pen and Press have produced, has made all Lovers of Literature desirous of knowing, by some compendious Methods, what has been written in the several Sciences to which they have appropriated their Studies: And this Desire grows more importunate, as the Difficulty encreases of satisfying it; the Works of the Learned multiplying so much beyond the Accounts which are given of them. . . . how many *would be* Authors, as excellent as ever appear'd, had they but such Plans or Models laid before them, as might induce them to marshal their Thoughts into a regular Order; or did they but know where to meet with Concurrence of Opinion, with Arguments, Authorities or Examples, to corroborate and ripen their teeming Conceptions?[38]

The solution proposed by Oldys, a critical abstract of all useful publications, could hardly suffice to bring the chaos of scholarship into order. Only history and biography on an ambitious scale could begin to provide anything like a concurrence of opinion. Fledgling scholars awaited ladders to bear them to the shoulders of their giant forefathers.

If Oldys understood the need for a more orderly study of literature, however, he could not have known any clear precedent

[38] P. i. Cf. Sir Joshua Reynolds, *Discourses on Art*, ed. R. R. Wark (San Marino, Cal., 1959), Discourse I, p. 15.

for answering that need. The precedents directly available to him may be illustrated by two works, one biographical, one historical, which first appeared in 1740. *Biographia Classica: The Lives and Characters of all the Classic Authors. . . . With an Historical and Critical Account of Them and Their Writings* (London, 1740), which devotes its first volume to the Greek and Roman poets, is a simplified survey of information and popular opinion, obviously intended for the young student. In place of criticism, it offers a review of reputations—"*Hesiod* has the Current of learned and judicious Criticism in his favour";[39] in place of history, it supplies a chronological arrangement and frequent comparisons. No originality or revision of attitudes is attempted. *Biographia Classica* is a useful book, at least as a propaedeutic,[40] but its method is so cursory, its judgments so superficial, that it defines no principles upon which one might seriously construct a history or large-scaled criticism of literature.

Bibliothèque françoise, ou histoire de la littérature françoise, by the Abbé (Claude Pierre) Goujet (Vol. I, Paris, 1740),[41] on the other hand, ambitiously and patriotically strives to trace French language and literature from their historical beginnings and at the same time to arrive at a critical judgment about the principal works in each genre, as well as to purvey knowledge of history and the arts and sciences.[42] Yet such aims, even in a monument of eighteen volumes, prove too vast in scope for the author to avoid glib summary and second-hand criticism. The work tends to resolve into a catalogue of writers and books, interspersed with comments on the rhetorical capabilities of the French language. Because it proposes a detailed canon of the best French literature, *Bibliothèque françoise* sets the stage for literary history and biography; because its criticism is narrowly applied, the naming rather than the describing of books and their excellences,[43] it fails to

39 P. 39.

40 Besides its three English editions, it was translated into German (Halle, 1767-1768).

41 Eventually completed in eighteen volumes (Paris, 1740-1756).

42 The plan, an extension of that of Charles Sorel, *La Bibliothèque françoise* (Paris, 1664), includes long sections on language, rhetoric, oratory, poetics, philosophy, and translations. Its main source is Jean-Pierre Niceron, *Mémoires pour servir à l'histoire des hommes illustres dans la république des lettres* (Paris, 1729-1745), 43 vols. Goujet himself helped to edit the last four (posthumous) volumes after 1740.

43 See the Discours préliminaire, especially p. viii.

satisfy the expectations of its grandiose title. If *Biographia Classica* is essentially a dictionary, the *Bibliothèque* is primarily a catalogue with essays and evaluations pasted into it. Neither offers a viable method to the would-be literary historian or biographer.

In one respect, however, both the *Biographia* and the *Bibliothèque* are the products of a tradition which at one time seemed to promise Oldys the design he required. Each of them draws heavily upon the encyclopaedias of Moréri and Bayle for principles as well as for information.[44] In the 1730's and '40's there was reason to believe that such a conjunction would rule the future of systematic literary studies.

4

The publication of Louis Moréri's *Le Grand dictionnaire historique* at Lyons in 1674 set into motion a chain of editions, revisions, translations, and corrections[45] that testified to a vast public thirst for the learning it had to offer. As its subtitle implies *(Le Mélange curieux de l'histoire sacrée et profane)*, Moréri's work originated in a swollen commonplace book, a miscellaneous lore alphabetically arranged, each entry concluded by a citation of reference materials.[46] The effect of gathering so great a store of knowledge into one place was profound. Jeremy Collier, the translator and editor of the most influential English version of Moréri, claimed that "As for the Usefulness of this *Work*, 'tis a *Collection* of almost *Universal Knowledge,* and may be call'd rather a *Library* than a *Book*: It not only runs through the greatest part of Learning, and affords a vast variety of Matter; but also acquaints the *Reader* with most of the considerable *Authors* that have written upon any Subject, and which is more, their Writings are often distinguish'd and mark'd in their Intrinsick, and Value."[47] Although Moréri offers only scant opinions about literature, his effort at putting a weight of scholarship into immedi-

[44] Goujet published a supplement to Louis Moréri's *Le Grand dictionnaire historique* in Paris, 1759; *Biographia Classica* lifts passages directly from Bayle's *Dictionnaire historique et critique.*

[45] Richard Christie, *Selected Essays and Papers* (London, 1902), pp. 11-16, discusses this chain reaction.

[46] For precedents, see DeWitt Starnes and Ernest Talbert, *Classical Myth and Legend in Renaissance Dictionaries* (Chapel Hill, 1955), p. 9.

[47] *The Great Historical, Geographical, Genealogical and Poetical Dictionary* (London, 1701), preface, p. iv.

ately useful form seemed to portend a world of universal knowledge with whose aid, like that of the universal languages which contemporaries were formulating,[48] all men could communicate on all scholarly matters of importance.

The answer to Moréri was, of course, Pierre Bayle; and the answer to Moréri's catholic hope for universally disseminated knowledge[49] was Bayle's rigorous and pessimistic insistence on the necessity of skeptical criticism.[50] Bayle's *Dictionnaire historique et critique* (1697) originated as a review of Moréri's errors, and its subsequent burgeoning of scope does not quite disguise the skeleton of the earlier encyclopaedia. The great difference, Bayle's great innovation, is the shift of interest from the text to the notes, from the commonplace book to critical analysis: "I have divided my composition into two parts: one is purely historical, and gives a succinct account of matters of fact: the other is a large commentary, a miscellany of proofs and discussions, wherein I have inserted a censure of many faults, and even sometimes a train of philosophical reflections."[51] For some time Bayle had been searching for a form adequate to display the range of his analytical powers.[52] The *Nouvelles de la république des lettres* (1684-87), a periodical review of world literature, had established his influence; the *Dictionnaire*, by giving him free reign over the entire history of scholarship and of error, exactly suited his talents. "Bayle's productions were usually inspired by some occurrence which aroused his critical sense—a fact which shows Bayle to have been essentially a pragmatic critic rather than a metaphysical philosopher";[53] and the design of a critical encyclopaedia supplied him with all the nonsense he wanted to refute.

The British Librarian, first published periodically in 1737, was Oldys' *Nouvelles de la république des lettres*; "The Life of

[48] E.g. Dalgarno and Leibniz. Although Moréri was trained by the Jesuits, he provides a thorough review of the works of Antoine Arnauld, the guiding spirit of Port-Royal grammar.

[49] The *Dictionnaire* is dedicated to the Catholic church.

[50] Two influential discussions of this shift are those of Paul Hazard, *La Crise de la Conscience Européenne* (Paris, 1935), I, 131-54, and Ernst Cassirer, *The Philosophy of the Enlightenment* (Princeton, 1951). Revaluations appear in *Pierre Bayle, le philosophe de Rotterdam*, ed. Paul Dibon (Amsterdam, 1959).

[51] *The Dictionary Historical and Critical of Mr. Peter Bayle*, tr. P. Desmaizeaux, I (London, 1734), preface.

[52] The standard life is Elisabeth Labrousse, *Pierre Bayle* (The Hague, 1963-1964).

[53] Léo P. Courtines, *Bayle's Relations with England and the English* (New York, 1938), p. 5.

Ralegh" (1736) was his first major attempt at a critical analysis of all available source materials; and the *Biographia Britannica* (1747-66)[54] was to have been his grand reconciliation of Moréri's plan with Bayle's method. English interest in Bayle had reached fever pitch with the publication in 1734 of the first volumes of two competing versions of the *Dictionnaire*. Oldys himself contributed[55] to the more ambitious of these, *A General Dictionary, Historical and Critical* (1734-41), a ten-volume "Supplement to Bayle" directed by Thomas Birch.[56] Here at last were principles of composition that a scholar could respect. "The *General dictionary* was the first attempt in England to apply the inductive method to biography";[57] men of letters felt the excitement of a form which elevated their own researches and textual study above the prescriptions of authority.

Oldys was caught up in this excitement. According to the preface to the first volume of *Biographia Britannica*, Bayle's revision of Moréri had "shewed how, instead of a *Library* for the *Ignorant*, it might be made the *Treasure* of the *Learned*."[58] The manner of Bayle's perpetual commentary, in this optimistic view, "enables us to see the most material points in our History, in all the several lights in which they have been placed by different authors, accompanied frequently with observations and remarks, that serve to explain and illustrate them, so as to clear up truth more effectually, than it was possible to do by any other method."[59] Sanguine about their perpetual access to the truth, the contributors to the *Biographia Britannica* thought to expedite "a more complete *Body* of *Personal History*, than, as yet, the world has seen, or so much as expected."[60] Here was the major work for which Oldys' career had been a preparation.

[54] See Yeowell, *Literary Antiquary*, pp. xxix-xxxii. Oldys' co-editor was Joseph Towers.

[55] *Ibid.*, pp. xix-xx. According to Chalmers, Oldys had previously worked with Desmaizeaux, Bayle's friend, who was the translator of the rival edition.

[56] See James M. Osborn, "Thomas Birch and the *General Dictionary* (1734-41)," *MP*, XXXVI (1938), 25-46. When Oldys was imprisoned in the Fleet for debt (1751), he wrote to Birch for aid.

[57] Osborn, *MP*, XXXVI, p. 25.

[58] *Biographia Britannica*, I (London, 1747), xvi.

[59] *Ibid.*, p. xiii. [60] *Ibid.*, p. xvi.

5

Yet the performance of *Biographia Britannica* was not so assured, its form so coherent, as its editors had hoped. The later volumes, to which Oldys ceased to contribute because of the indisposition which led eventually to his death,[61] are notably more rushed than the earlier, and the series as a whole lacks the definitive energetic momentum without which a reference work must forfeit the best of its ambitions. A few of Oldys' lives, for instance those on Sir John Fastolff, Caxton, and Richard Hakluyt, are particularly thorough and well managed, but that level is not maintained; and only twelve years after the completion of the first edition another, more substantial, was undertaken under the direction of Andrew Kippis, this time to cease publication with the letter F.[62] Thus the *Biographia Britannica* is best known as a magnificent and praiseworthy ruin. Moreover, such merits as it possesses are not literary, nor in the field of literary biography for which Oldys' researches had best qualified him. In spite of all that had been learned from Bayle, in spite of an impressive wielding of scholarly tools, Oldys had not broken through the obstructions in the path of the historian or biographer of English literature.

An examination of "The Life of Sir Walter Ralegh,"[63] Oldys' most distinguished single piece of authorship, will reveal how far from literary biography he was carried by the method he adopted. The virtues of the work are most apparent in its footnotes. Oldys has read literally everything obtainable, and his use of sources is rigorous and analytic; where no final adjudication of a point of fact is possible, he states the problem clearly and provides all the information on which a decision might be based. Nor did his scholarly enterprise cease even after publication: the British Museum copy of "The Life of Ralegh" includes a seven-page longhand "Review" by Oldys with manifold additions and corrections. As an inquiry into the truth of what had been said about the

[61] Oldys wrote nine lives for I (1747), three for II (1748), six for III (1750), three for IV (1757), and one for V (1760). Thus all but the life of May treat authors whose names begin with letters preceding "I" in the alphabet.

[62] See Stauffer, *Art of Biography*, I, 249-50.

[63] Originally commissioned by the London booksellers to prefix a new edition of Ralegh's *History of the World* (1736).

events of Ralegh's career, Oldys' work could hardly have been improved in its time. Gibbon, for one, thought better of competing with it.[64]

As a biography of Ralegh, however, and still more as a literary biography, "The Life of Sir Walter Ralegh" tends to be submerged in its footnotes. The text mingles a straightforward chronicle of events with moralistic praise of Ralegh's fortitude; the notes contain not only bibliography but most of the arguments, as well as critical interpretations quoted from other authorities. Bayle's system of perpetual commentary, whatever its virtues, retards the presentation of a unified and consistent view of character. Oldys responds to and rejects opinions, he does not initiate them. Indeed, the elaborate critical apparatus of "The Life of Ralegh" works against any attempt to convey a sense of character or the qualities of a literary work. Bayle himself had been notoriously indifferent to art,[65] and his effort was consistently directed toward establishing the truth even at the expense of fine fabling; the imagination, and the artistic chimeras it breeds, were necessarily objects of Bayle's suspicion. In an encyclopaedia the search for literal truth serves splendidly as the sole criterion of every article. Literary biography, however, requires other criteria. Neither literary criticism nor biography can survive without the exercise of sympathetic imagination and interpretation, and the establishment of proper documentation must be the beginning, not the end, of the biographer's task. When Oldys adopted perpetual commentary as his method, he ensured a sound scholarly procedure, but he forfeited the flexibility and concentration of interest which give life to biographical writing.

If Bayle's principles prove insufficient to allow for the art and craftsmanship of literary biography, they are still less pertinent to estimating an author's literary achievement. The section of "The Life of Ralegh" which surveys Ralegh's writing draws no significant connection between his life and his authorship other than "That *Ralegh*, in his greener years, did attain to such a taste of letters as all his succeeding avocations could never remove;

[64] *Gibbon's Journal*, ed. D. M. Low (London, 1929), p. 102.

[65] "It is clear that with Bayle literature is hardly a matter of art and that he is not a man of artistic discernment." Horatio Smith, *The Literary Criticism of Pierre Bayle* (Albany, 1912), p. 113.

and which proved not only an ornament to those his earlier and happier days, but a relief in his age and afflictions. . . ."[66] The writings, that is to say, are a "flowry garden" as opposed to "the high road . . . of publick action," and Oldys sees no need to investigate Ralegh's literary works either for themselves or for what light they might throw upon the man. Literary criticism is confined to a few quotations showing the general esteem in which Ralegh's works are held; no attempt is made to revise or to confirm Ralegh's reputation as poet or historian.

The test case for the relevancy of Oldys' methods to literary biography, however, must be those lives in the *Biographia Britannica* where he deals with authors whose careers, unlike that of Ralegh, have no interest outside of literature. The lives of Drayton and Farquhar, for instance, straightforwardly recount the course of their works and publications. Nevertheless, one cannot claim that these sketches are important early illustrations of literary biography. The text of the "Drayton,"[67] to take one example from many, does little but ascertain a few particular facts of the poet's life; and though the notes, much more substantial, supply a great deal of information, and quote at length from the judgments of the best authorities, they neither indulge in independent criticism nor seek to provide a pattern for life or work. The sum of thought is contained in the opening tag: "a renowned Poet." In the major work of his career, Oldys was putting his learning to use, yet he had not discovered the ordering principles which he himself thought necessary for the dissemination of learning.

An analysis of Oldys' career must remain, then, with the more or less tautological conclusion that he did not write literary biography or literary history because, whether or not he had the will, he had not found the way to write them. Yet ways were found, the several ways of the Wartons and Johnson, which can be seen more clearly against the background of Oldys' rudimentary and encyclopaedic ideas of order. Within a generation the modes of literary scholarship had passed the stages of becoming, and come into being.

[66] I (London, 1736), clxxiii.
[67] *Biographia Britannica*, III. The editorship of Drayton's *Works* (1748) has been attributed to Oldys (Yeowell, *Literary Antiquary*, pp. xxviii-xxix).

Samuel Johnson began his career in the same sub-literary jungle where Oldys spent his life, and during the course of his career he worked a revolution. From a professional point of view, the reason that Oldys failed and Johnson succeeded in writing *The Lives of the Poets* is that the booksellers at last agreed to commission it. By 1777 Johnson had earned prestige, money, leisure; the booksellers had come to him. He had come free of Oldys' round of curiosity and drudgery.

He had also come free of Oldys' scholarly method. Yet he had started from the same place. Like Oldys, Johnson thought that application, a critical attention to facts, was the quality most needed by the literary biographer. He began with Bayle. As he told Boswell, "Bayle's *Dictionary* is a very useful work for those to consult who love the biographical part of literature, which is what I love most."[68] *The Lives of the Poets* employs a version of Bayle's perpetual commentary in which a review of previous commentaries furnishes a train of thought from sentence to sentence—we must remember that the first of the *Lives* opens, not with a statement about Cowley, but with a critique of Sprat's "Life of Cowley." Formally it is perpetual commentary, not moral or critical philosophy, that governs the structure of Johnson's literary biography.

Nevertheless, the surface of a Johnsonian Life hardly resembles that of a Life by Bayle or Oldys. Too much has been suppressed. Where Johnson differs from his predecessors, and differs increasingly in the later *Lives*, is in his reluctance to elevate the commentary into the text, or even to find a place for it in footnotes. There is no perpetual acknowledgment. Johnsonian commentary is not well documented, not consistent in its method, not always specific about the objects of its criticism. Indeed, one must often be alert to recognize that it is there at all.[69]

Faced with such cavalier treatment of sources, such indifference to tracing and citing the facts, scholars have felt ready enough to grumble at *The Lives of the Poets*. Oldys had selflessly devoted his life to sharing information with others; John-

[68] *Boswell's Life of Johnson*, I, 452.
[69] Examples of Johnson's concealed commentary are discussed in chapter thirteen below.

son sometimes conceals his own indebtedness. Bayle had set out to accept no fact merely on the basis of authority; Johnson seems to claim authority for his own pronouncements.

Yet only such ruthlessness could have achieved *The Lives of the Poets*. Oldys' Lives offer a history of scholarship, but Johnson's *Lives* never cease to focus their wisdom upon the poet and his poetry. It is a part of his authority that Johnson presents the reader with assertions, not with arguments; with conclusions, not with debates; with a tradition, not with the uncertain facts and fragments that compose it. By offering only the last stage of the scholarly train of thought, Johnson can be ungenerous and unfair. In his *Lives* as well as his life, he will not always allow his adversary to speak. What he gains, however, is well worth it: a single-minded, unified vision. English literary biography moved beyond Oldys when Johnson became free to judge poets in his own person, and on his own terms.

Thomas Warton's *History of English Poetry*, for all the learning it contains, similarly grew from a denial as well as an affirmation of scholarly procedures. As Warton pursued a pattern of literary history through a jumble of documents, he came to see that he would never know enough to write a book that was both coherent and scrupulously accurate. True antiquarians agreed: Warton did *not* know enough. Joseph Ritson, whose curiosity and industry matched Oldys', would have traded all Warton's *History* for a fresh supply of Oldys' hard unvarnished facts.[70] Warton could become the first historian of English poetry only by compromising with scholarship, compromising with history.

Such compromises are built deep into the structure of the *History of English Poetry*. Rather than organize his materials into a finished narrative, Warton merely offers them in a state of processing. The *History* incorporates all the modes on which Oldys had labored—anthology, abstract, catalogue, bibliography, criticism, biography—,[71] saturates them in a new sense of history, and presents them under one handsome cover. Considered as a

[70] See Bertrand H. Bronson, *Joseph Ritson: Scholar-at-Arms* (Berkeley, 1938), chapter V. The conflict between antiquary and historian is emphasized by Robert D. Thornton, "The Influence of the Enlightenment upon Eighteenth-Century British Antiquaries, 1750-1800," *Studies on Voltaire and the Eighteenth Century*, XXVII (1963), 1601ff.

[71] Wellek, *Rise of English Literary History*, p. 174; chapter twelve below.

form, the first English literary history did not come into being so much through an effort of synthesis or unification as through acceding at last to call its heterogeneous mixture of forms a *History of English Poetry*.

Warton was not alone in coming to terms with the limitations of his scholarship. He defined his age as one "in which the curiosity of the antiquarian is connected with taste and genius, and his researches tend to display the progress of human manners,"[72] and many of his contemporaries agreed to mine their research for taste and manners and social amusement. If the scholars of Oldys' generation,[73] men like Hearne and Vertue and Stukeley and Birch, had still shared Moréri's hope that their learning might be gathered into a single world of knowledge, Warton's generation knew better. Walpole and Joseph Warton and Burney were men of taste before they were scholars. The price which the first English histories of the arts had to pay in order to exist was the death of the antiquarian's dream of perfection and completion.

The payment was made by years of labor and neglect. Oldys and his contemporaries were the last survivors of a race of selfless men of letters, the descendants of the humanist scholars, who had given their lives to collection and classification. In "An Address" interrupted by his death on January 16, 1794, Edward Gibbon pronounced their belated and melancholy obituary. "The age of Herculean diligence, which could devour and digest whole libraries, is passed away; and I sat down in hopeless despondency, till I should be able to find a person endowed with proper qualifications, and ready to employ several years of his life in assiduous labour, without any splendid prospect of emolument or fame."[74] Johnson and Warton, the inheritors of the antiquarian age, had talents that dwarfed those of their predecessors, but selflessness and contempt for fame were not among them. In the Age of Johnson literary historians ceased to be anonymous; the name of Johnson, the name of Warton meant more to readers than the names of many of the poets they discussed.

[72] *History of English Poetry* (London, 1774), I, 209.

[73] See David C. Douglas, *English Scholars 1660-1730* (London, 1951); Stuart Piggott, *William Stukeley* (Oxford, 1950). Nichols' *Anecdotes* and *Illustrations* both inherit and record the work of the literary antiquaries.

[74] *The Miscellaneous Works of Edward Gibbon, Esq.*, ed. Lord Sheffield (London, 1837), p. 839.

Thus the first *History of English Poetry* and the first *Lives of the Poets*, self-conscious founders of a new order, used the fruits of Oldys' disinterested curiosity only while repudiating his refusal to set limits to curiosity. They had learned the significance of his failure. Yet the example of Oldys was not so easily dispelled. When Johnson retained the shadow of perpetual commentary, when Warton preferred to confuse his history rather than to rationalize it, they were paying guilty tribute to the scholarly generation from which they had been emancipated. Philosophic history, that eighteenth-century ideal so discriminatingly expressed in the *Encyclopédie* by the doctrine that the country of facts is inexhaustible but the country of reason has no place for useless information,[75] never came to dominate the study of English poetry. Pope and Gray descried a mirage of philosophic literary history, but at closer range the histories resolved into facts innumerable as the sands of a desert. Johnson's *Lives* contain the husks of many antiquarian lives, and Warton's *History* is an antiquarian history at its core. The English histories of the arts never resolved the mixture of antiquarian curiosity and critical ambition on which they were predicated. They were born not in a moment of fulfillment and completion, but in a moment when men contemplated the radical imperfection of the unphilosophical and incomplete work-in-progress they had wrought, and decided that they could let it be.

[75] A paraphrase of remarks in the Discours préliminaire (1751). The passage is discussed by Arnaldo Momigliano, "Ancient History and the Antiquarian," *JWCI*, XIII (1950), 308.

James Harris, Samuel Johnson, and the Idea of True Criticism

1

THE life of James Harris was devoted to forms. The nephew of Shaftesbury, the friend of Fielding and Handel and Reynolds and Gibbon and George Grenville and Queen Charlotte, he represents perfectly the placid and benevolent image of that idealized eighteenth century we once thought of as the Age of Reason. A profound scholar, a dispassionate philosopher, a kind parent, a faithful and cheerful companion, Harris passed a life "exemplary and uniform."[1] If there was a fault beneath this perfect surface, it was only the dark side of his virtue: a certain lack of heat, a certain equable dimness. Once Mrs. Thrale asked Harris's daughter for his opinion of a singer; "oh my Papa says the Girl makes it a Rule to say he likes every thing & every body, we never mind him."[2] In public life such pliancy kept him aloof from the exertions of ambition. When he lost his post as Lord of the Treasury, we are told by Horace Walpole, he had "no other blemish on his character than of having thought too much as a scholar, and too little as a senator."[3] In any case, Harris's most cherished appointment was that with which his services were rewarded: Secretary and Comptroller to the Queen. Serenely observing forms, he closed the circle of an impeccable career.

The great work of Harris's life turned, however, upon another kind of form; his true mistress was Philosophy. From the time of

[1] The phrase comes from the brief memoir which Harris's son, the first Earl of Malmesbury, prefixed to his edition of *The Works of James Harris, Esq.* (London, 1801), I, xxvi. This memoir remains the standard source on Harris's life. Austin Dobson's "Mr. Harris of Salisbury," *The National Review*, LXXI (1918), 202-216, is largely paraphrased from it.

[2] *Thraliana*, ed. K. C. Balderston (Oxford, 1942), p. 107.

[3] *Memoirs of the Reign of King George the Third*, ed. G. F. R. Barker (London, 1894), I, 178.

his youth he applied himself unremittingly to the search for "philosophical arrangements," the universal causes and properties of the order of the world. The guides to whom he gave his allegiance in this search were Plato, Aristotle, and the peripatetic school. As Lord Monboddo wrote: "I believe that there have been many, since the restoration of letters, that understood Greek as well, some few perhaps better, than Mr *Harris*: But this praise I may give to my friend, without suspicion of partiality, that he has applied his knowledge in that language more to the study of the Greek philosophy, than any man that has lived since that period."[4] The result of these years of study was a series of works which aimed at restoring, against the followers of Locke and their "baneful and destructive system of modern philosophy,"[5] a system of universal forms derived from the ancients.

Harris's system is embodied in four books: *Three Treatises* (1744) on Art, on Music, Painting, and Poetry, and on Happiness; *Hermes, or A Philosophical Inquiry concerning Universal Grammar* (1751); *Philosophical Arrangements* (1775), a summary of peripatetic doctrine; and *Philological Inquiries* (1780). Although the subjects of these works may seem to be miscellaneous, they were intended to exhibit a complete order. Shaftesbury was the immediate source of Harris's philosophical position,[6] but in respect of form he had been found wanting. According to a modern scholar, "The one glaring example of inconsistency in Shaftesbury is his recurrent stress on the necessity of classical unity in a work as spasmodic as the *Characteristics*. . . . Every reader knows that it is not based upon any model and that it does not consti-

[4] James Burnet (Lord Monboddo), *Of the Origin and Progress of Language* (Edinburgh, 1774), I, 52-53n. When Harris's son was envoy to Moscow in 1779, Catherine the Great tried to interest him in supporting a war for Greek independence, and told him "she spoke this language to me as she knew my father was an admirer of the Greeks." *Diaries and Correspondence of James Harris, First Earl of Malmesbury*, ed. by his grandson, the third Earl (London, 1844), I, 238.

[5] Harris's *Works*, I, xxv.

[6] The *Three Treatises* were dedicated to the fourth Earl of Shaftesbury, son of the philosopher. In "Lines addressed to James Harris," William Collins alluded to the philosophical line of succession: "And Thou the Gentlest Patron born to grace/ And add new Brightness ev'n to Ashley's race/ Intent like Him in Plato's polished style/ To fix fair Science in our careless Isle." *Drafts & Fragments of Verse*, ed. J. S. Cunningham (Oxford, 1956), pp. 19-20. Dr. Johnson, on the other hand, is reported to have said that Harris foolishly became "an Infidel, because Lord Shaftesbury wrote the Characteristicks." *Thraliana*, p. 35.

tute an integrated whole."[7] Harris set out to remedy this defect by making coherent organization the type of his own clarity of mind.

Thus at the end of his career Harris could boast of having exemplified the precepts of Aristotle. "The Author, in *his own* Works, as far as his Genius would assist, has endeavoured to give them a just TOTALITY. He has endeavoured that each of them should exhibit a real *Beginning, Middle,* and *End,* and these *properly adapted* to the places, which they possess, and *incapable of Transposition,* without Detriment or Confusion."[8] The emphasis on method which this claim suggests is reinforced by constant scholastic definitions of how each part of each treatise is related to the whole; we are repeatedly told where we have been and where we are going. Even the *Three Treatises,* the first and third of which are composed in dialogue form closely modeled on that of Plato, are asserted to display a schematic Aristotelian unity of beginning, middle, and end. "The first treats of Art in its most comprehensive Idea, when considered as a Genus to many subordinate Species. The second considers three of these subordinate Species, whose Beauty and Elegance are well known to all. The last treats of that Art, which respects the Conduct of Human Life, and which may justly be valued, as of all Arts the most important, if it can truly lead us to the End proposed."[9] Similarly Harris's three philosophical works describe an orderly progression from the arts that manifest human nature to the language that reveals the workings of the mind in a tangible form to the arrangements of ideas within which nature and the mind are subsumed. Harris takes pains to keep his structure intelligible and logical on every level, in the whole as in the part.

As a result of this emphasis on methodology, Harris's works were best known to his contemporaries as a modern epitome of argumentation. Monboddo called the Dialogue concerning Art "the best specimen of the dividing, or diaeretic manner, as the ancients called it, that is to be found in any modern book with which I am acquainted";[10] Bishop Lowth applauded the great

[7] A. O. Aldridge, "Lord Shaftesbury's Literary Theories," *PQ,* XXIV (1945), 49.
[8] *Philological Inquiries, Works,* II, 357. Volume and page numerals in the text refer to the 1801 edition.
[9] From the "Advertisement to the Reader," *Works,* I.
[10] Quoted in Harris's *Works,* I, xiii-xiv.

"accuteness of investigation, perspicuity of explication, and elegance of method" of *Hermes*, "the most beautiful and perfect example of analysis, that has been exhibited since the days of *Aristotle*";[11] Gibbon thought that "The most elegant commentary on the categories or predicaments of Aristotle may be found in the philosophical arguments of Mr. James Harris,"[12] a reference to the *Philosophical Arrangements*; even Mrs. Thrale, who was no admirer of Harris, praised the Dialogue concerning Happiness on the grounds that "one should learn Logic if it was but to defend oneself from the Logicians."[13] Far more attention was bestowed upon the method and the manner of Harris's arguments than upon what he had to say.

2

To some extent this concentration upon form rather than content is unfortunate, because some of Harris's hypotheses have an interest that is only beginning to be acknowledged.[14] In particular Book III of *Hermes*, and especially its fourth chapter, "Concerning general or universal Ideas," contains the most cogent eighteenth-century English reply to Locke's denial that innate ideas form the basis of language. Only within the last few years have linguists and philosophers begun to see the importance of the

[11] Robert Lowth, *A Short Introduction to English Grammar* (London, 1762), preface.

[12] Quoted by J. Mitford in his edition of *The Correspondence of Horace Walpole, Earl of Oxford, and the Rev. William Mason* (London, 1851), p. 422.

[13] *Thraliana*, p. 784.

[14] In his introduction to *Aristotle's "Poetics" and English Literature: A Collection of Critical Essays* (Chicago, 1965), p. xxii, Elder Olson writes "Influential as his work was in his own day, Harris has had far less than his due from the generality of latter-day critics. There is however probably more sound and original thought manifested in [the second treatise] than in the combined works of most of Harris' detractors." The fullest recent study of Harris's thought is "Harris and the Dialectic of Books," a chapter in Robert Marsh's *Four Dialectical Theories of Poetry* (Chicago, 1965). According to Marsh, "Harris is himself concerned to apprehend, organize, and present to the world the comprehensive and universal forms of human art, the manifestations of the highest powers of mind. His is a 'dialectic of books,' then, in the noble sense that it strives to demonstrate the providential circulation both of the one universal truth and of the active human mind's pervasive, unquenchable power to conquer recalcitrant matter and thus reveal its apprehension of ultimate reality and its harmony with the mind of God." A "dialectic of books" is thus very much like what I have called an "idea of true criticism." Marsh makes no attempt to account for the disparity between Harris's high critical ambitions and modest success.

issues raised by Harris.[15] Horne Tooke's brilliant and erratic attack in the "Letter to Mr. Dunning" and *The Diversions of Purley*—"Hermes, you know, put out the eyes of Argus: and I suspect that he has likewise blinded philosophy"[16]—demolishes many of Harris's particular efforts at definition without answering his central premise, that the principles upon which languages are based correspond to an innate faculty of the human mind. By challenging the mannerisms of *Hermes*, Tooke effectually obscures its meaning. Coleridge was right when he said that Tooke's "success in attacking Harris consists . . . in utterly misrepresenting all they [sic] have said by applying to one subject what was meant of another. He gives the accidental history of words, . . . while the other grammarians treated of the essential and logical connection of ideas, which of necessity reflects itself in words."[17] Yet in the long run the refusal to consider what Harris says, the concern merely with his peculiarities of style,[18] was probably inevitable, and perhaps not so irrelevant as it may seem.

The reason why Harris's arguments were bound to be misrepresented has partly to do with the difficulty, a difficulty most of us share, in seeing the intellectual issues of Harris's times in their own terms, rather than as stages in a shift from neoclassicism to pre-romanticism, or from prescriptive rule-making to empirical psychological investigations. Modern critics all agree that Harris exemplifies a tendency; *which* tendency, is not so clear. One critic pictures him as the harbinger of a new subjective conception of art with affinities to Platonism;[19] another, as a straightforward neoclassicist, the slave of Aristotelianism, whose *Philological Inquiries* "is notable chiefly for the lateness of the

15 In *Cartesian Linguistics* (New York, 1966), Noam Chomsky claims *Hermes* as a precursor of modern transformational grammar. For the historical place of Harris's view of language, see Otto Funke, *Englische Sprachphilosophie im späteren 18. Jahrhundert* (Berne, 1934), pp. 8-18, and René Wellek, *The Rise of English Literary History* (Chapel Hill, 1941), pp. 85-86.

16 *The Diversions of Purley*, ed. Richard Taylor (London, 1829), I, 14-15. For Tooke's attack on Harris and Monboddo, see Hans Aarsleff, *The Study of Language in England, 1780-1860* (Princeton, 1967).

17 *Coleridge's Miscellaneous Criticism*, ed. T. M. Raysor (London, 1936), pp. 389-90.

18 See Dugald Stewart, *Works*, ed. Sir William Hamilton (Edinburgh, 1855), VI, 43; VII, 294 *et passim*.

19 Louis Bredvold, "The Tendency toward Platonism in Neo-Classical Esthetics," *ELH*, I (1934), 107.

date at which it sponsors rules in the old-fashioned way."[20] The linguists have put him in both camps at once: "Harris ververeinigt . . . die Tendenz des 18. Jahrhunderts zur Universal-Grammatik mit der Tendenz zu einer an die empirische Mannigfaltigkeit der Sprachen sich anlehnenden, individualisirenden Auffassung."[21] If we take one step backwards, we shall arrive again at Saintsbury's dubiously enlightening observation that "no one shows that curious eighteenth-century confusion of mind . . . better than Harris."[22] On the rack of opposing tendencies, Harris's individual theories are stretched into thin air.

The use of Harris as a representative of warring aesthetic factions or parties is reminiscent of the history of eighteenth-century English politics as it used to be written in the days before Namier; and the connection with politics is perfectly appropriate. The authority of the ancients dispenses a kind of power, and power invites contention. Indeed, the principals in the campaign of ideas were quite ready to identify their linguistic policies with their political stands. Tooke launched his missile against *Hermes* from prison, and he ascribes the "universal approbation" with which the book had been received to a tyranny of the learned, "because, as Judges shelter their knavery by *precedents,* so do scholars their ignorance by *authority.*"[23] The king and the queen consoled Harris for the attack, and he professed himself "happy in the abuse, as it brought him into the best company he could wish to be in."[24] It is no wonder that we have been led to think of Harris in terms of partisanship and schools, as a small warrior in the battles of thought.

There is a better reason, however, for concentrating upon Harris's method and style of argument at the expense of the arguments themselves. We have seen the care he took to maintain an intelligible structure; whether or not "Perspicuity, simplicity and correctness are Harris's idols,"[25] they are never far from

[20] Gordon McKenzie, *Critical Responsiveness: A Study of the Psychological Current in Later Eighteenth-Century Criticism* (Berkeley, 1949), p. 56.

[21] From a review by H. J. Pos, *English Studies,* XI (1929), 224.

[22] *A History of English Criticism* (Edinburgh, 1930), p. 209.

[23] *The Diversions of Purley,* I, 121n.

[24] From a letter of Mrs. Harris to her son, in *A Series of Letters of the First Earl of Malmesbury His Family and Friends from 1745 to 1820,* ed. by his grandson (London, 1870), I, 389.

[25] A. Bosker, *Literary Criticism in the Age of Johnson* (The Hague, 1930), p. 133.

his sight. At its worst, the laborious effort to clarify every slightest component of a logical sequence can be stultifying, a sort of Chinese water torture: "why have CONCATENATION and ACCUMULATION such a Force?—From these most simple and obvious Truths, that *many* things *similar*, when *added together,* will be more in *Quantity,* than *any one* of them *taken singly;*—consequently, that *the more* things are thus added, *the greater* will be their Effect" (II, 311). (A long note on this passage cites support from Quintilian and Aristotle.) The justification for such scrupulosity is a theory of causation: "EFFECTS indeed strike us, *when we are not thinking about the* CAUSE; yet may we be assured, if we reflect, that A CAUSE THERE IS, and that too a CAUSE INTELLIGENT, and RATIONAL" (II, 306). By asking ourselves on every occasion the cause of every effect,[26] and by demanding a complete and rational answer with no short cuts or obscurities, Harris promises, "we shall be enabled to do by *Rule,* what others do by *Hazard*" (II, 10).

When Harris claims so much for his method, he has already passed beyond methodology; he expects metaphysical effects from formal causes. His influence, in fact, lay most of all in his insistence that, with proper machinery, any effect could be traced to its cause. Coleridge, following Moses Mendelssohn's *Morgenstunden* in debating the issues raised by *Hermes,*[27] concluded that all questions that were not irrational must be answerable. The conclusion is explicit in Harris's works; still more, implicit in their structure. Thus the emphasis upon the form and style of Harris's arguments, even when it results in doing his ideas an injustice, is hardly irrelevant to his main philosophical concerns.

Most of Harris's readers, moreover, were not philosophers, and were better equipped to analyze his mannerisms than his significance for the history of ideas. As an aesthetician, he offered them principles of a just taste; as a linguist, he fixed standards for propriety of expression; as a philologist, he represented "the Idea of true Criticism."[28] It was not unreasonable of them to hold

26 Dr. Burney called the *Philosophical Arrangements* "the Pourquoi de Pourquoi." *Thraliana,* pp. 35, 107-108.

27 See A. D. Snyder, "Coleridge's Reading of Mendelssohn's 'Morgenstunden' and 'Jerusalem,'" *JEGP,* XXVIII (1929), 505-509.

28 *The Letters of David Garrick,* ed. D. M. Little and G. M. Kahrl (Cambridge, Mass., 1963), II, 632.

Harris himself accountable for good taste, proper expression, and true criticism. For many of his generation, he was the major philosopher of the arts, and when they set themselves to think or write seriously about painting,[29] music, or poetry his reliance upon systematic and formal discourse furnished the best guide they knew. Harris was reputed to be perhaps the most learned English writer who had studied the nature of the arts—with one important exception.

3

Samuel Johnson's fondness for philosophic words never extended to metaphysical language. *Idler* No. 36 (23 December, 1758) evinces a literary horror of the "bugbear style" in terms very similar to those he was later to employ against metaphysical poets and poets of Sensibility. "To quit the beaten track only because it is known, and take a new path, however crooked or rough, because the strait was found out before"[30] aroused all Johnson's distrust of licentious speculation. The main example of "these dreadful sounds" is John Petvin's *Letters concerning Mind* (1750), a work which Petvin, at his death, had left in shorthand, and which had subsequently been "corrected" (apparently, edited and revised) by his friend Harris.[31] Letter VI, which had aimed at demonstrating that *"there is an eternal invariable Mind,"* receives most of Johnson's fire: "The author begins by declaring, that 'the sorts of things are things that now are, have been, and shall be, and the things that strictly Are.' In this position, except the last clause, in which he uses something of the scholastick language, there is nothing but what every man has heard and imagines himself to know. . . . All this, my dear reader, is very strange; but though it be strange, it is not new." Against the bugbears of abstract propositions, if the pupil "has but the courage to stay till the conclusion, he will find that, when speculation has done its worst, two and two still make four."[32] Without paying

[29] Reynolds' last Discourse is especially indebted to Harris. *Discourses on Art*, ed. R. R. Wark (San Marino, Cal., 1959), p. 277. Cf. Harris's *Works*, II, 285-86.

[30] *The Idler*, ed. W. J. Bate, J. M. Bullitt, and L. F. Powell (New Haven, 1963), p. 112.

[31] See the preface to *Letters concerning Mind* (London, 1750), pp. iii-iv; and W. P. Courtney and D. N. Smith, *A Bibliography of Samuel Johnson* (Oxford, 1915), p. 81.

[32] *The Idler*, p. 114. In his notes to the copy of *Letters concerning Mind* now

attention to the content of the argument, Johnson kicks at it as roughly and decisively as if it were a stone in his path.

The motivation of this attack, as of Johnson's other attacks upon Harris, doubtless owes something to personal differences— one could hardly have worse claims on Johnson's moral, literary, and political esteem than blood-kinship with Shaftesbury and the friendship of Fielding and Grenville![33]—but the attack itself is no more superficial than Johnson's assault upon Berkeley's sensationalism.[34] When Johnson ridiculed the style of *Letters concerning Mind*, he was challenging its fundamental assumption: that the mind has a rational structure which can be logically analyzed into discrete faculties. By mocking the manner of argument, he directly appealed to the superiority of intuition as a judge of how the mind reaches conclusions. Just as Johnson followed Harris's abstract treatise on language with a concrete and empirical English dictionary,[35] and Harris's abstract treatise on happiness with the concrete searches of the Prince of the Happy Valley, he rebuffed the theory of mind by invoking what the mind knows without theories.

Twenty years later, in conversation with Boswell, Johnson increased the violence of his objections. "JOHNSON. 'Harris is a sound sullen scholar; he does not like interlopers. Harris, however, is a prig, and a bad prig. I looked into his book, and thought he did not understand his own system.' BOSWELL. 'He says plain things in a formal and abstract way, to be sure: but his method is good: for to have clear notions upon any subject, we must have recourse to analytick arrangement.' JOHNSON. 'Sir, it is what every body does, whether they will or no. But sometimes things may be made darker by definition. I see a *cow*, I define her, *Ani-*

at the Huntington Library, Coleridge defends Petvin by adding one to Johnson's addition. He argues that Locke only refutes nonsensical positions, by attributing to his opponents "$2 + 2 = 5$, cross-readings!"

[33] The association of *Idler* 36 with Shaftesbury, Harris, and other people and tendencies deplored by Johnson is specifically made by Sir John Hawkins in *The Life of Samuel Johnson, LL.D.* (London, 1787), pp. 254-57.

[34] See H. F. Hallett, "Dr. Johnson's Refutation of Bishop Berkeley," *Mind*, LVI (1947), 132-147.

[35] Johnson's *Dictionary* and Harris's *Hermes* are specifically contrasted by R. S. Crane in *The Idea of the Humanities* (Chicago, 1967), I, 112-115. Crane's whole set of lectures on the modes of philosophical criticism is pertinent to my argument. For Johnson's understanding of intuition, see Robert Voitle, *Samuel Johnson the Moralist* (Cambridge, Mass., 1961), especially pp. 13-20.

mal quadrupes ruminans cornutum. But a goat ruminates, and a cow may have no horns. *Cow* is plainer.' "[36] The force of this brilliantly commonplace critique lies in Johnson's view of the way that the mind intuitively breaks the objects of its thought into arrangements: "it is what every body does, whether they will or no." To claim, as Harris does, that our deductive powers are capable of rendering the universe intelligible, is to ignore on the one hand the radical imperfection of human reason before the immensity and mystery of nature, and on the other hand the perfectly good sense we inductively make of the world so long as the ambitions of reason are held in check.[37] By formal and abstract methods we can only hope to define laboriously those truths which children know better than philosophers. "*Cow* is plainer."

Thus Johnson's dissatisfaction with Harris goes far beyond Boswell's puzzled suggestion that "Johnson thought his *manner* as a writer affected, while at the same time the *matter* did not compensate for that fault."[38] To Johnson, who habitually thought of style as the servant of meaning, Harris's belief that proper understanding could only be approached through a certain formal method or procedural style was a fatal confusion of master with servant, of truth with its expression. "Language is only the instrument of science" for Johnson, not the hermetic type of universal mind, and a man who strove to make a peculiar linguistic structure substitute for the wisdom of experience could only be a *prig*, "a pert, conceited, saucy, pragmatical, little fellow."[39] The subordination of matter to manner, of intuitive sense to "dreadful sounds," is the philosophical equivalent to the egoistic poetry of Sensibility.

A conversation which occurred only two days after Johnson had called Harris a prig displays the differences between the two men with comical felicity. It began with Harris in a pontifical mood. "HARRIS. 'I think Heroick poetry is best in blank verse; yet it appears that rhyme is essential to English poetry, from

[36] *Boswell's Life of Johnson,* ed. G. B. Hill and L. F. Powell (Oxford, 1934), III, 245. In the *Dictionary* Johnson's definition of "cow" had been less philosophical; it begins with "the female of the bull."

[37] Cf. J. H. Hagstrum, "The Nature of Dr. Johnson's Rationalism," *ELH,* XVII (1950), 191-205.

[38] *Boswell's Life of Johnson,* III, 245n.

[39] This is of course the definition in Johnson's *Dictionary* (London, 1755). The previous quotation comes from the preface to the *Dictionary,* p. ii.

our deficiency in metrical quantities. In my opinion, the chief excellence of our language is numerous prose.' JOHNSON. 'Sir William Temple was the first writer who gave cadence to English prose. Before his time they were careless of arrangement, and did not mind whether a sentence ended with an important word or an insignificant word, or with what part of speech it was concluded.' "[40] As W. K. Wimsatt has acutely noted, Johnson effectively turns the discussion from the manner of prose style to its weighting of matter. "Harris doubtless intended the word 'numerous' to refer to some quality of words as 'music,' as merely sound. But Johnson made plain by his answer that the word 'cadence' when applied to prose style meant practically and concretely for him a certain management of sense through sound. . . . In short, cadence means putting emphasis at the end."[41]

A bit later the conversation moved to the prose of Clarendon, and once again Johnson refused to separate form from content. " 'He is objected to for his parentheses, his involved clauses, and his want of harmony. But he is supported by his matter. It is, indeed, owing to a plethora of matter that his style is so faulty. Every *substance*, (smiling to Mr. Harris,) has so many *accidents*. —To be distinct, we must talk *analytically*. If we analyse language, we must speak of it grammatically; if we analyse argument, we must speak of it logically.' "[42] Johnson's smile, obviously an acknowledgment of his scholastic terminology, seems a little poisonous when we recall that not long before, in other company, "of James Harris Dedication to his Hermes he said that tho' but 14 Lines long, there were 6 Grammatical faults in it."[43] The force of the argument does not depend, however, upon a private joke. Johnson is proposing that prose style be judged in terms of the dependency of style upon thought. Rather than accept a particular verbal or logical procedure as desirable in every circumstance, he insists that the substance of each discourse must control its expression. For Harris's reliance upon methodology, Johnson would substitute a recognition that the internal pressure generated by a body of thoughts and facts will create an individual form in its own peculiar image.[44]

[40] *Boswell's Life of Johnson*, III, 257-58. Cf. *Rambler* 122.
[41] *The Prose Style of Samuel Johnson* (New Haven, 1941), pp. 155-56.
[42] *Boswell's Life of Johnson*, III, 258. [43] *Thraliana*, p. 208.
[44] See J. H. Hagstrum, *Samuel Johnson's Literary Criticism* (Minneapolis, 1952),

The corollary of this idea, illustrated consistently by Johnson's criticism, is that when we analyze literature we must be literary. And philosophical argument is not literary. Johnson's notorious refusal to build systems, or to define an explicit theory of literature, marks his determination not to confine works of art within one limiting framework.[45] The metaphysics of literary criticism might safely be left to the systematizers, the formalists, the prigs —the Harrises.

Nevertheless, the issue was never so simple for Johnson. It has always been understood that his distrust for philosophical abstraction was imposed by an act of will; he was quite capable of thinking like a philosopher, even of talking (with a smile) like one, and he viewed his own propensity for speculation with a religious fear. "The Idea of true Criticism," for Johnson as well as for his contemporaries, exerted a chimerical fascination. To establish literary criticism upon sound historical and philosophical principles was, after all, the great work of his career. Johnson never systematized those principles. We know from Hawkins that he once contemplated a "History of Criticism as it relates to judging of authors,"[46] but he seems to have gone no further. To one work of his time which attempted to put literary criticism upon a systematic basis, however, Johnson paid a very rare compliment: he read it to the end.[47] That work was Harris's *Philological Inquiries.*

4

Philological Inquiries promises much; that is why it is so frustrating. Its promise is defined by the rise of literary studies. Eighteenth-century England had witnessed the birth of aesthetics, the formulation of a philosophy of art rigorous and exact beyond precedent, at the same time as it had been enriched by the first

chapter VI. This view of prose style parallels Harris's view of the internal form of languages. Cf. Wellek, *Rise of English Literary History*, p. 86.

[45] W. J. Bate, *The Achievement of Samuel Johnson* (New York, 1955), chapter V; W. R. Keast, "The Theoretical Foundations of Johnson's Criticism," in *Critics and Criticism: Ancient and Modern*, ed. R. S. Crane (Chicago, 1952), pp. 389-407.

[46] Hawkins' *Life of Johnson*, p. 81.

[47] "He owned he had hardly ever read a book through. The posthumous volumes of Mr. Harris of Salisbury (which treated of subjects that were congenial with his own professional studies) had attractions that engaged him to the end." From the biographical sketch by Thomas Tyers, *Johnsonian Miscellanies*, ed. G. B. Hill (Oxford, 1897), II, 344.

substantial histories of poetry and biographies of poets.[48] The conventional explanation of this double movement has been that developments in philosophy triggered a new practical interest in history, including the history of the arts: the new empirical psychology demanded an empirical criticism based upon historical fact. Yet such histories as Warton's and Burney's are related to philosophy only at a great distance. Indeed, it is far more easy to *assume* that Hume's *History of England* applies and practices his philosophical ideas than to *demonstrate* it.[49] In the eighteenth century, for the first time, English literary studies became compartmentalized. The rise of literary history, the rise of aesthetic philosophy, were accompanied by their increasing separation. The attempt forcibly to join them once more, to construct a new criticism based equally upon history and philosophy, accounts for the odd conjunctions of fact and theory in the literary speculations of writers like John Brown and Sir William Jones.[50] Philosophers interested in literature, literary men interested in philosophy, awaited a synthesis. The burden passed to Harris.

The historian of English literary criticism must approach *Philological Inquiries*, therefore, with quickening interest. He is likely to come away from it with a different attitude. For Saintsbury, searching for a philosopher's stone to transform base Rules criticism into good lively opinions, "Harris is positively irritating." The third part of *Philological Inquiries* ("The Taste and Literature of the Middle Age") "raises the expectation almost to agony-point. Here is what we have been waiting for so long: here is the great gap going to be filled. At last a critic not merely takes a philosophic-historic view of criticism, but actually proposes to supplement it with an inquiry into those regions of literature on which his predecessors have turned an obstinately blind eye. As is the exaltation of the promise, so is the aggravation of the disap-

[48] The genres of eighteenth-century literary studies are defined by R. S. Crane, "English Neoclassical Criticism: An Outline Sketch," reprinted in *Critics and Criticism*, pp. 372-388.

[49] Standard introductions to the relations of eighteenth-century philosophy and historiography are J. B. Black, *The Art of History* (New York, 1926), and R. G. Collingwood, *The Idea of History* (London, 1946).

[50] For example, John Brown, *History of the Rise and Progress of Poetry through it's Several Species* (Newcastle, 1764); Sir William Jones, "Two Essays" added to his *Poems* (Oxford, 1772). Cf. Gibbon's *Essai sur l'étude de la littérature* (1761).

pointment."[51] Very genially and politely, Harris had turned his back on his chance for historical importance.

To some extent the frustrations of reading *Philological Inquiries* can be explained by a study of its genesis. Harris had originally published a sketch *Upon the Rise and Progress of Criticism* in 1752.[52] Late in his life he reworked this pamphlet, and added to it "An Illustration of Critical Doctrines and Principles, as they appear in distinguished Authors, as well Ancient as Modern" and also the section on medieval literature. Over the years his philosophical ambitions had softened; according to his son, "this publication appears to have been meant, not only as a retrospective view of those studies which exercised his mind in the full vigour of his life, but likewise as a monument of his affection towards many of his intimate friends."[53] At times philosophy takes a holiday, while gentlemanly praise showers upon Shaftesbury, Reynolds, the Wartons, Fielding, or Garrick. In thus passing from philosophy to philology, Harris claims a privilege of age: "You may compare me, if you please, to some weary Traveller, who, having long wandered over craggy heights, descends at length to the Plains below, and hopes, *at his Journey's End*, to find a smooth and easy Road" (II, 275). Criticism must be disarmed by this modest retirement.

Yet the miscellaneousness and the relaxation which characterize *Philological Inquiries* will not account for the hopes it raises and disappoints in readers like Saintsbury. Harris was gathering together a sheaf of leaves from his notebooks; but he was also attempting a full-scale anatomy of criticism. The same emphasis upon method, the same confidence about tracing every effect to its cause which had informed Harris's philosophical works, were here to be applied to the natural chaos of literature. In the truly philosophic mind, the pleasures of letters might yield their secrets and be transformed into a system.

The desire of Harris to have his literary studies both ways, to be miscellaneous and logical at once, is most evident in the way he uses the word "philology." In the eighteenth century, the primary

[51] Saintsbury, *History of English Criticism*, pp. 207-208.
[52] See Wellek, *Rise of English Literary History*, pp. 157-58.
[53] *Works*, I, xix.

sense of the word was "polite learning";[54] almost any literary study might come under its rubric. As Harris says, "PHILOLOGY should hence appear to be of a most *comprehensive* character, and to include not only all Accounts both of *Criticism* and *Critics*, but of every thing connected with *Letters*, be it *Speculative* or *Historical*" (II, 276). By calling his work *Philological Inquiries*, he is making room for any ornament of learning he may care to display. Yet at the same time Harris insists that philology is a kind of science, the literary equivalent of natural philosophy. "When wise and thinking men, the subtle investigators of principles and causes, observed the wonderful effect of these works upon the human mind, they were prompted to inquire *whence this should proceed*" (II, 279). The reliance upon his theory of causation, upon the potential of every question for being rewarded with a clear answer, reaches a climax at the end of the second part of *Philological Inquiries* with Harris's defense of rules, "our whole Theory having been little more than RULES DEVELOPED" (II, 401).[55] Between the belletristic and the scientific definitions of "philology," Harris moves back and forth at his convenience.

Thus, while *Philological Inquiries* does not accept the responsibilities of a stringent philosophical discourse, it does proclaim that a philosophical certainty about works of literature is possible. If we seek for principles, we are encouraged to believe that we shall find them. The first chapter of Part the Second neatly coordinates historical fact and logical doctrine: "*That the Epic Writers came first*, and that *nothing excellent in Literary* Performances happens merely from *Chance*—the *Causes*, or *Reasons* of such Excellence, illustrated by Examples" (II, 305). To a literary eye, these causes and reasons may look bleak; reduced to three or four propositions, an epic shivers in its nakedness. Yet Harris holds aloft the promise of a truer criticism, a precise philology in which all doubts are resolved, all works classified.

It is unfortunate that Harris's own attempt at historical criticism, the long survey of medieval literature that concludes the *Philological Inquiries*, should be quite so slipshod. Far too

[54] According to the *OED*. The complete definition in Johnson's *Dictionary* is "Criticism; grammatical learning."

[55] This is the passage most responsible for the view of Harris as a "rules critic." But the sense of "rules" remains conditional. Cf. the discussion of Reynolds' rules in chapter three above; Reynolds had been influenced by Harris.

much of it consists of pseudo-historical anecdote. Of Sulla, for instance, we learn that "His Face (which perhaps indicated his Manners) was of a purple red, intermixed with white. This circumstance could not escape *the witty Athenians*: they discribed him in a verse, and ridiculously said, 'SYLLA'S *face is a Mulberry, sprinkled with meal.*' THE Devastations and Carnage, which he caused soon after, gave them too much reason to repent their *Sarcasm*" (II, 434-35). Of the English poetic tradition we hear nothing before Chaucer, and after him only "From *Chaucer*, thro' *Rowley*, we pass to Lords *Surry* and *Dorset*; from them to *Spencer, Shakspeare*, and *Johnson*: after whom came *Milton, Waller, Dryden, Pope*, and a succession of Geniuses, down to the present time" (II, 542). The meandering trickle of Harris's information cannot keep his theories afloat.

Yet even that part of *Philological Inquiries* which is factually correct and philosophically relevant seems eccentric rather than convincing. The philosophical machinery labors, and brings forth, as "the model of A PERFECT FABLE, under *all* the Characters here described" (II, 366), Lillo's *The Fatal Curiosity*. Principles announced with great fanfare are illustrated by trivial examples. After a long discussion concerning the proper relation of the whole to its parts in a "*legitimate* Composition," Harris subjoins some mild pastoral verses ("No more thy brilliant eyes, with looks of love,/ Shall in my bosom gentle pity move"), and with "paternal Solicitude" asks "indulgence to a juvenile Genius, that never meant a private Essay for public Inspection" (II, 356). It is endearing of Harris to be as fond of his own child as of his beloved Aristotle, but the two do not mix well together. Another odd mixture occurs when, on the grounds of inconsistency, the "Manners" (characterization) of Hamlet are unfavorably compared with the "Manners" in Lillo (II, 374-76). Something in the critic's sense of proportion has gone awry.

The obvious source of trouble is Harris's own first principle: the theory of causation. By reiterating that every literary effect has a rational and intelligent cause, that "Nothing would perhaps more contribute to give us a *Taste truly critical*, than on every occasion *to investigate* this Cause" (II, 306), Harris substitutes the procedures of his philosophy for literary discourse. The pertinent answer to such procedures is Johnson's famous distinction,

101

in the "Preface to Shakespeare," between kinds of proof: "To works, however, of which the excellence is not absolute and definite, but gradual and comparative; to works not raised upon principles demonstrative and scientifick, but appealing wholly to observation and experience, no other test can be applied than length of duration and continuance of esteem."[56] *Philological Inquiries* pursues a kind of certitude, an absolute, verifiable, programmatic method of judgment, that never seems quite relevant to any particular literary work.

5

The fault is not merely Harris's lack of critical power nor the weaknesses in his philosophical position. A far more subtle and sophisticated theory of causation, in the adept hands of David Hume, did not promote literary criticism or literary history of a quality equal to his other distinctions.[57] Like the chapters on the arts in Hume's *History of England, Philological Inquiries* seems to expose a rift between the author's philosophical pretensions and the literary culture upon which he can draw. Harris takes pains with his critical method, and he loves literature, but he cannot bring the two into equilibrium. There is something incurably *amateurish* about his criticism. Delighted to find a place for Lillo or for Miss Louisa Harris within the predicaments of Aristotle, he assigns causes to effects with sanguine simplicity. And we search in vain for those small insights, that particular trenchancy in close analysis of a passage, which can make a more partial and nervous criticism come alive.

Harris's problem in reconciling philosophy with literary studies reflects that of most of his contemporaries. When we compare Longinus with the Longinians of the eighteenth century,[58] for instance, we soon become aware that *Peri Hupsous* rides easily upon the swell of a great sea, a generous and specific familiarity with an immense literary heritage, while the English sublimators have far more to teach us about aesthetics than about poems. Longinus can regard all literature as his province without los-

[56] Samuel Johnson's *Works* (Oxford, 1825), V, 104.
[57] See Ralph Cohen, *The Critical Theory of David Hume* (unpublished Ph.D. dissertation, Columbia, 1952).
[58] See Samuel H. Monk, *The Sublime: A Study of Critical Theories in XVIII-Century England* (Ann Arbor, Mich., 1960), chapter I.

ing hold of particulars. By contrast, the English work of the eighteenth century which is most dedicated to the idea that all literature comprises a single whole, the *Essay on the Genius and Writings of Pope* (1756-1782) by Harris's friend Joseph Warton, wastes much of its energy on the thankless and small-minded task of showing that Pope's poems are "not of the most *poetic* species of *poetry*."[59] The leap from categories and principles to particular judgments proved to be beyond the range of the generality of English aestheticians.[60] The most rigorous philosophers remained amateurs of letters, and the literary men whose scope was greatest, Johnson and Goldsmith and Gray and Thomas Warton, resisted the urge to systematize their knowledge into a theory.

Thus "the Idea of true Criticism" remained a chimera. What Harris's friend Reynolds accomplished for painting, what his friend Burney tried to accomplish for music, Harris himself did not accomplish. He did not envision literature as a great continuing conversation to which all works contribute (what Reynolds called the *ponere totum*), nor did he found a scientific theory of criticism that his successors could use. Moreover (to the irritation of Saintsbury) he seems to have had little sense of his own inadequacy. When Harris chose to think of philology as a smooth and easy road, he denied his own attempt to take literary studies seriously.

Indeed, *Philological Inquiries* signals the divorce between philosophy and literature, not their wedding. The readers who looked to Harris for a method that would illuminate the beauties of poetry were rewarded with no other beauty than that of method itself. If Johnson turned from his work on the *Lives of the Poets* to *Philological Inquiries* hoping to find a more precise formulation of what criticism might be, he must have returned to the *Lives of the Poets* with a refreshed awareness that, in spite of all definitions, his own work was where criticism was to be found. No idea of criticism could substitute for its living example.

The lesson of Harris's failure, and the virtue of Johnson's refusal to systematize his thought, was difficult to accept. Not every-

[59] See below, chapter twelve, section three.
[60] I am setting aside here the contributions of such Scottish critics as Lord Kames and Hugh Blair.

one, of course, *did* accept it. In spite of his immeasurably greater powers, Coleridge knew himself to be lineally descended from Harris, equally convinced that he could "reduce criticism to a system, by the deduction of the Causes from Principles involved in our faculties."[61] Coleridge's own investigations, the fragments of the treatise he was always planning and which he may or may not have gotten around to writing, affirm once more that in accounting for the effects of poems A CAUSE THERE IS. To be sure, the literary intelligence behind his synthesis occupies a different plane from Harris's. If the disparity between aesthetic pretensions and critical judgment in *Philological Inquiries* is comic, in Coleridge's life work it approaches the tragic. Yet its philosophical origins are the same. Deep in the shadow of his own obscure sublime, Coleridge insists that all his critical illuminations are finally intelligible.

In thus pursuing the idea of true criticism and the forms of Harris, however, Coleridge was not repeating the main line of the English eighteenth century. The German aestheticians who read Harris and whom Coleridge read in turn were more enthralled by the metaphysics of literary criticism than even Harris himself had been. For Harris's English contemporaries, it was the method of his discourse that remained fascinating, not its substance. When Johnson penetrated the speculative side of philosophical language and found that two and two still made four, he was displaying the skepticism toward abstract thought that most English readers felt in their hearts. Much as he despised the seditious delinquency of Tooke, he responded to the liveliness and particularity of his criticism; *that*, not universal forms, was "literature."[62]

Moreover, *Philological Inquiries* itself acquiesces in the separation of criticism from aesthetics. Its forms dissolve in a wash of good temper and a patter of anecdotes; it breathes the spirit of a philosopher whose ultimate rule is to say he likes everything and everybody. In his last work, from whatever cause, Harris abandons causes for effects, ends for beginnings. Humbly and cheerfully he lays aside the burden of his philosophy, and follows

[61] Letter to Lord Byron, 15 October 1815, *Collected Letters of Samuel Taylor Coleridge*, ed. E. L. Griggs, IV (Oxford, 1959), 980.
[62] See *Boswell's Life of Johnson*, III, 354.

the footsteps of the historians. Johnson had won his argument. The pages of *Philological Inquiries* review and reminisce about Harris's eighteenth century from a distance just this side of death; they write farewell to his friends and to his life work. And they also take leave, for one generation and for one nation at least, of the idea of true criticism.

Part Two

THE ORDERING OF
PAINTING

The Uncomplicated Richardson

1

PAINTING was the profession of Jonathan Richardson; writing about painting was his reason for living. As his friend Pope was a man of letters, Richardson was a man of art, and he would not rest content until all men of sense worshipped art as he did. "I am never like to be of any Consequence to the World unless in the way I am in as a Painter, and one endeavouring to Raise, and Cultivate the Love of the Art by shewing its true Uses, and Beauties. This I have apply'd my self to as the great Business of my Life."[1] In a series of works which included *The Theory of Painting* (1715), *Essay on the Art of Criticism* and *The Science of a Connoisseur* (1719),[2] and *An Account of Some of the Statues, Bas-reliefs, Drawings and Pictures in Italy* (1722), Richardson had put down "All I have been capable of doing," and so had staked the prestige of painting and his own reputation. Single-handed, with ambitions that had no precedent, he had set out to change the way that Englishmen thought about the arts.

The works of Richardson were not sent into a void. Since Junius, a considerable English literature on painting had come into being.[3] Yet Richardson had reason to believe that his art

[1] *An Account of Some of the Statues, Bas-reliefs, Drawings and Pictures in Italy, &c. with Remarks* (London, 1722), preface. This work, like *Explanatory Notes and Remarks on Milton's Paradise Lost* (London, 1734), was written by Richardson in collaboration with his son; hence, "let Me be Understood as the Complicated Richardson" (*Notes*, p. cxli), a remark parodied by Hogarth in a well-known print. The materials gathered by Vertue for a life of Richardson (1665-1745) are conveniently published in the *Volumes of the Walpole Society*, especially XXII (Vertue Note Books III, Oxford, 1934). G. W. Snelgrove's *The Work and Theories of Jonathan Richardson* (unpublished Ph.D. dissertation, London, 1936) is more useful for its biographical collections than for its study of theory.

[2] These three were reprinted in the 1773 edition of Richardson's *Works*, revised by his son, and again in 1792. Page numerals in the text refer to the 1773 *Works*.

[3] Henry and Margaret Ogden have provided "A Bibliography of Seventeenth-Century Writings on the Pictorial Arts in English," *Art Bulletin*, XXIX (1947), 196-201; and their *English Taste in Landscape in the Seventeenth Century* (Ann

needed better defenders. The problem was not so much that his predecessors had done nothing as that they had tried to do everything at once. The audiences for books about painting clearly divide into two kinds—those who wish to correct their ideas about art, and those who want to learn how to paint—and the authors similarly may be divided into literary men, like Junius or Dryden, and artists, like Edward Norgate and Alexander Browne.[4] Nevertheless, in practice the art treatises of the seventeenth century tend to mix philosophical analysis of painting even into their simple manuals of technical instruction. This encroachment of the intellectual upon the artist reaches a sort of culmination with Shaftesbury, who hired painters as "hands" to execute his ideas.[5] Far more confusion, however, attends those handbooks which rarefy and sublime their discussion of technique until all practical usefulness evaporates in speculation.

Sir William Sanderson's *Graphice. The Use of the Pen and Pensil. or, The most excellent art of Painting* (1658), for instance, is a fascinating melange. According to its preface, this little book was founded upon a collection of technical details discovered in wide readings, and upon lessons given by painters in conversation. Sanderson's professed aim is only "to reduce that discourse into a *Method*, legible to all."[6] Yet his performance seems designed to frustrate any search for method. A grandiose apology for painting (sight, the greatest of the senses, is equivalent to heaven, the master of the elements)[7] is succeeded by a philosophical *paragone*, a discussion of the superiority of originals to copies, a critical appreciation of some painters, and advice about where and how to hang paintings. The only apparent principle of organization is described by Flatman's dedicatory verse: "Thus (like the *soul oth' world*) our *subtle Art*,/ Insinuates it self through

Arbor, Mich., 1955) discusses many of the authors. A useful summary is that of Luigi Salerno, "Seventeenth-Century English Literature on Painting," *JWCI*, XIV (1951), 234-58.

[4] For Norgate, see the edition of his *Miniatura or The Art of Limning*, ed. Martin Hardie (Oxford, 1919); for Browne, see Frederick Hard, "Richard Haydocke and Alexander Browne: Two Half-forgotten Writers on the Art of Painting," *PMLA*, LV (1940), 727-41.

[5] See Edgar Wind, "Shaftesbury as a Patron of Art," *JWCI*, II (1938), 185-88.

[6] *Graphice* (London, 1658), preface.

[7] On Sanderson's aesthetic, see E. L. Tuveson, *The Imagination as a Means of Grace* (Berkeley, 1960), pp. 102-106.

every part." *Graphice* trails at last to an end in dozens of blank pages. Sanderson tells us in a note that he had intended to conclude with a group of prints, the visible proof of all his arguments, but that they had been stolen en route by pirates.

The result of all this misfortune is that *Graphice* develops its own lopsided charm. To put the matter nicely: "This treatise is very important for its spontaneity, which is the outcome of the curious arrangement of the material."[8] But like many kinds of expressive effect, this charm arises from a difficulty in keeping proportions. In spite of Sanderson's statement that his book is based on personal observations, most of it comes directly from one source or another: Junius, Lomazzo, Peacham, Wotton, Norgate, etc.; and the splicing of passages is often crude.[9] What looks like a rich confusion of mind frequently turns out to be a petty confusion of sources. *Graphice* has neither the simplicity which comes from direct experience of painting nor the harmony which comes from working in an established tradition. It is at once inflated and little, dependent and adrift.

Not all seventeenth-century English writings on painting are as charmingly problematical as *Graphice*, but neither do they avoid Sanderson's disproportions. We need not seek far for an explanation. The author who tried to account for the qualities of a particular painting with a terminology borrowed from Lomazzo or Junius always stood in danger of having his technical knowledge buried by idealism. Moreover, as the century passed writers more and more faced a split between the traditions of writing about art and the new tendency among virtuosi to demand scientific precision from aesthetic discourse.[10] On a few occasions, notably in the work of Evelyn,[11] this demand was satisfied fruitfully, but for the most part it merely created new discords incapable of resolution. Thus a writer and painter like Alexander Browne might pretend to divorce himself wholly from the old mysteries—"Weary Philosophy expires in strife/ Whil'st you ex-

[8] Salerno, *JWCI*, XIV, 244.

[9] A good example is the contradiction of Lomazzo and Bacon, noted by Salerno (p. 244n.). Ogden and Ogden (*English Taste in Landscape*, pp. 65-68) comment on other borrowings.

[10] See Walter Houghton, Jr., "The English Virtuoso in the Seventeenth Century," *JHI*, III (1942), especially p. 205.

[11] Particularly *Sculptura* (1662), edited with an introduction by C. F. Bell (London, 1906).

pose plain truth unto the Life"—yet quietly plagiarize from a work already seventy years old.[12] The most popular book of the time, William Salmon's *Polygraphice* (1672), is a similar assemblage of largely outmoded texts. English writers tacitly acknowledged how little they could contribute to the conversation about art.

Furthermore, they knew themselves to be inferior to the writers of the continent. That inferiority is the theme of one of the most elegant English treatises for connoisseurs, William Aglionby's *Painting Illustrated in Three Diallogues* (1685). Aglionby is frankly a snob, and he directs his snobbery against English painting and English ideas about art: "of all the *Civilized Nations* in *Europe,* we are the only that want *Curiosity* for *Artists.*"[13] The participants in the dialogues are a traveller and his friend, and the traveller alone has any knowledge of art, because he has left the shores of England and gone to places where painting is understood and appreciated. Aglionby travels too: he takes his ideas from Du Fresnoy and eleven lives from Vasari. English subservience to French critics enforced a defensive attitude. Significantly, the first important compilation of lives of British painters, "An Essay towards an English-School" by Bainbrigg Buckeridge, appeared as an appendix to a translation of De Piles' *The Art of Painting, and the Lives of the Painters* (1706).[14] The English writers of the seventeenth century add only footnotes and rephrasings to doctrines they import from abroad.

We can hardly blame Richardson's predecessors for their lack of originality. They served an art which, except for one moment in the Arundel circle, had seldom received much distinction in England, and they were not esteemed nor well paid. They claimed a dignity for painting which their own audiences denied. And they lacked a theory to persuade any reader not already in-

[12] The quotation occurs in the dedicatory poem (by J. H.) to Browne's *Ars Pictoria* (London, 1669). For Browne's borrowings from Richard Haydocke's translation (1598) of Lomazzo's *Trattato* (1584), see Hard, *PMLA,* LV. According to C. H. Collins Baker, "The Sources of Blake's Pictorial Expression," *HLQ,* IV (1941), 359-67, Blake used Browne in turn.

[13] Preface. Tancred Borenius, "An early English Writer on Art," *Burlington Magazine,* XXXIX (1921), 188-95, offers a brief résumé of *Painting Illustrated,* though he overestimates the extent to which Aglionby is "a literary pioneer."

[14] The "Essay" is actually a small biographical dictionary of painters who had lived in England, largely based upon the biographical sketches contributed by Richard Graham to Dryden's version of Du Fresnoy (1695).

clined in their favor. When Richardson began to think about his art, his first thought was to discard any help from his countrymen.

2

Richardson began with a conviction, that painting need only be explained to become esteemed; with an advantage, his own professional knowledge; and with a method, to rely so far as possible not upon authority or precedents but upon the presentation of clear and distinct ideas. The conviction had been shared by others, the advantage could have been matched by others, but the method was new. The extent to which Richardson borrows the ideas of French critics like De Piles[15] should not prevent us from seeing him the way that he saw himself, as an objective thinker consistently applying the test of logic to all departments of the art of painting. The science of a connoisseur, not merely the tastes and information of a connoisseur, is his field of study, and "It is as necessary to a connoisseur as to a philosopher or divine, to be a nice logician; the same faculties are employed, and in the same manner, the difference is only in the subject" (237). For the first time in English Richardson was prepared to debate the issues of painting without recourse to Apelles or Lomazzo, the ancients or the muses, with only experience and reason as his judges.[16]

The analytical method, and to some extent the use to which that method should be put, Richardson derived from Locke and his literary followers.[17] *The Science of a Connoisseur*, which argues from the principle that "Painting is another sort of writing" (250), attempts to fix the imitative language of painting upon the same philosophical postulates that Locke had applied to language proper. Richardson's description of the genesis of his work carries the parallel further: "This indeed is properly a Discourse on the Conduct of the Understanding, apply'd to Paint-

[15] Influences upon Richardson are discussed by Samuel H. Monk, *The Sublime: A Study of Critical Theories in XVIII-Century England* (Ann Arbor, Mich., 1960), pp. 174-78. In "Some Remarks on French Eighteenth-Century Writings on the Arts," *JAAC*, XXV (1966), 187-95, R. G. Saisselin ascribes a significance to the work of De Piles in France which is similar to my view of Richardson's significance in England.

[16] "I advance nothing upon the foot of authority," he says, in introducing some comments on Apelles (*Works*, pp. 173-74).

[17] See Snelgrove, *Work and Theories of Jonathan Richardson*, p. 286.

ing; and led me Naturally, and Unavoidably into a way of Thinking such as would have been necessary in a Philosophical Discourse upon the Conduct of the Understanding at Large; nor is there any Other way of treating the Subject as it ought to be treated; at least I know of none."[18] Richardson may have exaggerated the need for his philosophical analysis of connoisseurship, but he had brought the study of painting squarely into line with the most advanced thought of his day.

The first and most important result of Richardson's method is an insistent reliance upon making distinctions, upon reducing the art of painting to a set of distinguishable parts. "Whatever we look upon therefore should be considered distinctly and particularly, and not only seen in general to be fine or not, but nicely defined, wherein it is one or the other. Most of our writers have been very superficial in this respect" (182). For Richardson nothing is more desirable or more frequently invoked than "clear and distinct ideas." Indeed, the justification of painting itself rests on the intelligibility and separability of its parts. "Language is very imperfect . . . whereas the painter can convey his ideas of these things clearly, and without ambiguity; and what he says every one understands in the sense he intends it" (2). Just as clarity and discrimination are the core of Richardson's method of analyzing painting, so they are what he searches for in the art and in particular works of art.

In the light of this approach, when he criticized paintings Richardson was inevitably drawn to formulae like De Piles' famous "steel-yard."[19] Since paintings may be analyzed into parts, and since each part, separately considered, must be distinguishable as of greater or lesser excellence, a scale assigning numerical values to the painter's performance in each function of his art would be a precise method of evaluation, as well as a paradigm of the clear and distinct ideas present in a well-conducted mind. Like a programmed computer, a trained viewer could methodically exhaust the value of a painting by breaking it into small manageable segments. An illustration of the system is pro-

[18] *An Account* . . . , pp. v-vi.

[19] See John Steegman, "The 'Balance des Peintres' of Roger de Piles," *Art Quarterly*, XVII (1954), 255-61. Shaftesbury, who also insisted that the fine arts were a branch of speculative philosophy, had already adopted some of De Piles' ideas by 1712.

vided in detail by Richardson's own estimate of a Van Dyck portrait, summarized "Composition 10/ Colouring 17/ Handling 17/ Drawing 10/ Invention 18/ Expression 18/ Grace and Greatness 18// Advantage 18 Pleasure 16" (190). On a scale of 18, the painting is declared to have attained a statistically significant sublimity.

One need not be hypersensitive to be disquieted by the choplogic machinery employed by such criticism. Yet our disquiet must not prevent us from noticing how specific and how considered Richardson's criticism can be. Against the background of his English predecessors Richardson appears a luminary of good sense and rigorous statement; logic-chopping has its reasons of which unreason knows nothing. The steel-yard provided a method by which a viewer could examine a painting with prolonged, relevant attention, focussed upon a succession of particularities rather than a single quirk of expectation.[20] No superior critical eye or critical vocabulary was available. As Horace Walpole was to say, Richardson's works "are full of matter, good sense, and instruction: and the very quaintness of some expressions, and their laboured novelty, show the difficulty the author had to convey mere visible ideas through the medium of language."[21] Richardson's language, even at its most mechanical, could account for more of the facts of art than any previous English criticism.

The insistence upon clear and distinct ideas, and upon a precise language to distinguish and foster them, had implications for future criticism. The most obvious of these was to raise hopes that criticism might attain scientific exactness, and free itself from the vagaries of taste and authoritative prescriptions. Richardson's connoisseur is a sort of intellectual athlete dedicated to the full pursuit of lucidity. "A man that thinks boldly, freely, and thoroughly; that stands upon his own legs, and sees with his own eyes, has a firmness and serenity of mind which he that is dependent upon others has not, or cannot reasonably have" (344). A reader of Richardson would have been encouraged to believe that painting might be reduced to demonstrable psychological principles, and that anyone willing to use his eyes and mind might be trained to a perfection of connoisseurship. The word

[20] The development of such processes is one theme of Ralph Cohen's *The Art of Discrimination* (London, 1964).
[21] *Anecdotes of Painting* (London, 1786), IV, 34.

"connoissance," suggested by Richardson's friend Matthew Prior,[22] describes a field of knowledge which wanted only scientific study to justify its scientific name. Yet the analytical attack upon the problems of painting raised problems in turn. When the confusions in the theory of painting had been dispelled, could its fascinations remain?

3

Richardson wrote in defense of an art that was, he believed, misunderstood, unappreciated, unjustly undervalued. Undoubtedly he was right; but undoubtedly the art he championed was accepted by most of his contemporaries as the paradigm of all arts. An impressive array of modern scholars[23] has demonstrated the dependency of eighteenth-century poets, and to some extent musicians, upon pictorialism, and upon conceptions of art derived analogously from the process by which pictures are made in the mind. Because painting, of all the arts, most clearly illustrates the doctrine that the arts are imitative, and because psychological analysis of the imagination took its pattern, after Hobbes, from the sense of sight, painting was invoked again and again in the early years of the eighteenth century as the model and test for all works of art.[24] *Ut pictura poesis*, whatever it had once meant, exhorted poets to think of themselves as the wielders of a phantom brush; and poets like Pope, constantly in Richardson's company,[25] were prepared to criticize poems as so many pictures, and to defend their own practice with paintings wielded like a shield of Achilles.

The consequences of using painting as a paradigm of the arts were not, however, entirely fortunate for painting itself. The tradition of literary pictorialism cut both ways; painters borrowed in turn from poets who strove to write like painters. At no time have artists been so subservient to literature for subject mat-

[22] The anecdote is related by Richardson (*Science of a Connoisseur*, p. 282).

[23] The scholarship up to 1958 is well summarized by Jean Hagstrum in his own contribution to it, *The Sister Arts* (Chicago, 1958).

[24] Richardson's own version of "Pictoribus atque Poetis" is described in *Science of a Connoisseur*, p. 253ff.

[25] *The Correspondence of Alexander Pope*, ed. George Sherburn (Oxford, 1956), contains 39 letters to the Richardsons. For Pope's efforts as a painter, see Norman Ault, *New Light on Pope* (London, 1949). W. K. Wimsatt, *The Portraits of Alexander Pope* (New Haven, 1965), relates Richardson's portraiture to his theory.

ter as at the moment when the subject matter of paintings became of acute literary concern. Moreover, whatever we may think of the vogue of history painting, its attempts at dignity did not convince viewers and aestheticians of its profundity. A paradigm, by its nature reductive and simplified, does not necessarily command the respect bestowed on richer models. During most of the time when painting was acknowledged to be the pattern of the arts, its advocates fought for its prestige as something more than grammar or illustration.[26] Richardson's earnest attempts to demonstrate the theoretical intelligibility of his art were not conclusive even in an age which cultivated intelligibility. The comparatively mysterious mimetic processes by which poets and musicians created their works suggested that they called upon a more encompassing genius, and partook of that sublimity whose dwelling place is not calculus but wonder.

Thus clarity alone could not sustain the defense of painting. At moments when a mechanical application of logical distinctions threatens to cheapen his art, Richardson predictably has recourse to a category, grace and greatness, beyond all the categories, to a vision of an ideal nature superior to the real, and to an artist, Raphael, who embodies the perfect nobility of which painting is capable.[27] To invoke these supports costs him something. "Grace" as such, the *je ne sais quoi*, is employed by Richardson with notable restraint; he will not readily admit that graces lie beyond the reach of art; he is much more interested in the definable graces. Nevertheless, there are times when he must sacrifice the rigors of definition, must sacrifice even the clear and distinct ideas which contribute so much to his pride, for the sake of a metaphysical justification of painting. The passages in which he assumes the mantle of "the complicated Richardson" offer a complex insight into the problems he must overcome.

[26] An exception should be made for the Abbé Du Bos, whose *Réflexions critiques sur la poésie et la peinture* (1719), published the same year as Richardson's *Science of a Connoisseur*, maintains that the affects of painting are deeper than those of poetry because the former arise immediately from a direct, indefinable physical sensation. In "'The Reach of Art' in Augustan Poetic Theory," *Studies in Criticism and Aesthetics, 1660-1800*, ed. Howard Anderson and J. S. Shea (Minneapolis, 1967), pp. 193-212, W. H. Halewood argues that the analogy with painting helped poetry to resist a narrow restriction to mimesis.

[27] Cf. Monk on Richardson's "sublime," *The Sublime*, pp. 174-78, and Walter J. Hipple, Jr., *The Beautiful, The Sublime, & The Picturesque in Eighteenth-Century British Aesthetic Theory* (Carbondale, Ill., 1957), pp. 344-45.

"Perhaps Albert Durer drew as correctly, according to the idea he had of things, as Raphael; and the German eye saw (in one sense) as well as the Italian; but these two masters conceived differently, nature had not the same appearance to both, and that because one of them had not his eyes formed to see the beauties that are really there; the perception of which lets us into another world, more beautiful than is seen by untaught eyes: And which is still improveable by a mind stored with great and lovely ideas, and capable of imagining something beyond what is seen. Such a one every designer ought to have" (80).

Upon a casual reading, this passage may seem merely to assert a neoclassical dogma, that generality and beauty are preferable to particularity and literal truth. To rest here, however, is to miss the main point of Richardson's comparison, which is intended to illustrate the maxim "No man sees what things are, that knows not what they ought to be" (79). The key word of the passage is "see," and what is being instilled is a lesson in perception, not in Platonic ideas.[28] Like modern psychologists, Richardson is arguing that we perceive according to the formulae made by our expectations,[29] and that by storing our minds with certain kinds of images we can quite literally revise our visions. "Knowing" or "conceiving" are not separable from "seeing," nor the mind from the eye, and therefore every painter may be trained to see according to intellectually respectable visual traditions. To this extent Richardson's comparison of painters displays a competent awareness of the psychology of perception.

We can hardly allow Richardson his point, however, without noticing how much he has insinuated by playing upon various senses of "see." If Dürer's eye indeed saw in any sense as well as Raphael's, presumably he was able to notice and represent a great many of the details of the visual field, and his formulae of expectation ("the idea he had of things") cannot have been inadequate for stimulating his perceptions. On the other hand, "to see the beauties that are really there" must require a different quality of formulae, a mental set conditioned to one type of vi-

[28] This point may be reinforced by placing Richardson's comments against the similar but more idealistic comparison of Dürer and Michelangelo in Sir Henry Wotton's *Elements of Architecture* (London, 1624), p. 95.

[29] In *Art and Illusion* (New York, 1961), p. 12, E. H. Gombrich puts Richardson's argument in a similar context.

sion; evidently some visions are better than others. The argument Richardson is here presenting in favor of idealized designs is certainly commonplace and respectable, but his method of argumentation is less than candid. By putting so great a burden upon "see," by speaking of beauties that "are really there" rather than beauties that "may readily be imagined," by refusing at once to admit the distinction between seeing and imagining which he allows later in the passage, he is attempting to transform a psychological principle into a mystery.

Richardson wants painting to be understood; but he wants it to be admired as well. Where the two responses might clash, the prose itself becomes elusive. "Grace and greatness," used sometimes to name an effect reminiscent of Aristotelian pity and terror upon an audience, sometimes to denote the quality of a painting or painterly techniques, sometimes to compliment the spirit of an artist, are terms which, like Reynolds' "nature,"[30] serve to join with a word stages of an argument which strict definition and logical sequence could not join. Since Richardson does not often depart very far from the craft of painting—the function of the imagination is not to imitate the Ideal but to help a painter in constructing balanced designs—he does not often swim in the theoretical shallows of his predecessors. Yet where his two loves, painting and reason, collide, he will at least muddy the waters. After Richardson had clarified his art as much as he could, he had still to ask for something more. With all the means at his disposal he described painting as it might become.

4

The most famous passage in Richardson's works occurs near the end of that section of *The Theory of Painting* in which he has enlarged upon grace and greatness. "And now I cannot forbear wishing that some younger painter than myself, and one who has had greater and more early advantages would exert himself, and practise the magnanimity I have been recommending, in this single instance of attempting and hoping only to equal the greatest masters of whatsoever age or nation" (123). It is this call to greatness, and the similar passages of exhortation and prophecy that surround it, which are supposed to have inspired the career

[30] See chapter seven, section five, below.

of Richardson's foremost successor. "The true Genius is a mind of large general powers, accidentally determined to some particular direction. Sir Joshua Reynolds, the great Painter of the present age, had the first fondness for his art excited by the perusal of Richardson's treatise."[31] A teacher who had devoted his life to encouraging the study of art could not have wished for a happier issue; few prophets have had their calls answered so concretely.

The lucky event of Richardson's exhortation was not, however, so accidental as Johnson liked to think. Richardson had correctly estimated that painting would soon become a more important part of English life, he had produced by far the most lucid work in English upon the art, and he had himself demonstrated that only ambitious effort and education could begin to provide an adequate understanding of the art. *The Science of a Connoisseur*, that presumptuous title, implies like "connoissance" that painting is founded upon serious principles, but it also implies that painting is an area of knowledge. Richardson was proposing not only techniques for knowing about the art, but the more fundamental belief that something was to be known.

The extent to which Richardson did in fact change attitudes towards painting may be illustrated by an anecdote from Northcote. "Once Johnson being at dinner at Sir Joshua's in company with many painters, in the course of conversation Richardson's Treatise on Painting happened to be mentioned, 'Ah!' said Johnson, 'I remember when I was at college, I by chance found that book on my stairs: I took it up with me to my chamber, and read it through, and truly I did not think it possible to say so much upon the art.' Sir Joshua . . . desired of one of the company to be informed what Johnson had said; and it being repeated to him so loud that Johnson heard it, the Doctor seemed hurt, and added, 'but I did not wish, Sir, that Sir Joshua should have been told what I then said.' "[32]

When Johnson commented on Richardson's work that "truly I did not think it possible to say so much upon the art," he was registering his rather complacently low opinion of painting, yet he was acknowledging that some little was indeed to be said.

[31] Johnson's *Lives of the English Poets*, ed. G. B. Hill (Oxford, 1905), I, 2.
[32] James Northcote, *The Life of Sir Joshua Reynolds* (London, 1819), I, 236.

Moreover, Johnson's hurt when his remark was repeated to Reynolds implies some guilt at his own facetiousness. Reynolds, more than anyone else, had shown that painting could be written about with dignity and at length, and an art which can be treated with such a degree of seriousness has already established itself in the company of the liberal arts. Richardson's life work was addressed against patronizing attitudes exactly like those of Johnson, and the results of his work were at least to make the slighters uncomfortable.

In 1722, reviewing his writings on painting, Richardson was able to show a satisfaction that not many authors can have felt about their appointed tasks: "I know not any particular Branch of it that I have not Consider'd, and as Fully as it Ought to be." The sequence of his books from 1715 constitutes a complete systematic survey of the art. Beginning with *The Theory of Painting*, "what I conceiv'd to be the Principles of the Art," he had moved on to the *Essay on the Art of Criticism* and *The Science of a Connoisseur*, which demonstrate the theory both in particular instances and in relation to "the Conduct of the Judgment," and had concluded with *An Account* of Italian art intended "to Apply the foregoing Rules by Remarking Upon a Collection of Pictures, and Statues; and 'tis the Collection of the whole World."[33] The whole world of painting, in theory, in conduct, in history, in expectations of the future, Richardson had sought to present; and he was not the only one who thought that his attempt had succeeded. As late as 1792, the Strawberry-Hill Press reprinted an edition of *The Works* of Richardson, dedicated to Reynolds, "The Whole intended as a Supplement to the Anecdotes of Painters and Engravers,"[34] which was offered as a summary of the art. Richardson had found English writing about painting in a chaos, and he had made it into a well-appointed household.

The system of painting that Richardson formulated had its oversimplifications and overcomplications, but it was a whole. Perhaps that was to be the most important of his legacies to Reynolds. For the generation after Du Fresnoy, the justification

[33] *An Account* . . . , pp. v-vii.
[34] The format of the 1773 *Works*, supervised by Jonathan Richardson, Jr., also corresponds with that of Walpole's *Anecdotes* (completed 1770).

of painting in terms of classical theory was not quite convincing; but the generation of English painters after Richardson had in him a champion who had carried out his general recommendations in precise detail. The young Reynolds must have found in Richardson a source for that sense of noble emulation, that tremulous reverence before the magnificent possibilities of art, which inspired his own career.[35] Yet the older Reynolds should have been still more grateful for the evidence that painting had an amplitude and coherence which required a lifetime to explore. Sir Joshua's lifelong search for an ever more comprehensive view of his art, for the *ponere totum* he labored to construct, was exactly the result that Richardson's work as a whole had striven to produce.

Such great expectations may be hazardous. Reynolds' "aims were set so high that it was likely that he would be continually dissatisfied with his achievement and committed to a ceaseless struggle for improvement."[36] Richardson's sense of a high calling had been happily accompanied by a disposition to think well of his own work. When he compared his accomplishment, and his reputation both social and intellectual, to those of his predecessors, he had reason to be pleased. For Reynolds, the stakes had been raised, and also the pressures. He sought to master a far greater world. Nevertheless, the example of Richardson had demonstrated that the art of painting both demanded and rewarded nothing less than absolute dedication from its servants. Richardson had offered a life to his art, and on that condition alone his work had been granted a life in return.

5

Richardson had begun a long English conversation about painting, as he very well knew. What he could not know was the extent to which his own work would eventually become irrelevant to that conversation. The defenses of painting could survive everything but popular acceptance, and when Richardson's ideas had come to sound like commonplaces, his passionate espousal of

[35] As Northcote points out (*Life of Reynolds*, I, 8), Reynolds learned to worship Raphael at a time when all Reynolds' knowledge of the paintings was derived from Richardson's verbal descriptions.

[36] Derek Hudson, *Sir Joshua Reynolds: A Personal Study* (London, 1958), p. 11.

the art he loved might seem so much and too much protesting. Hardly anyone would have disagreed with his two most frequent assertions—that painting should be understood in terms of clear and distinct ideas, and that knowledge of the history of the art is essential to form a painter or a connoisseur—but the application of those assertions changed as philosophy and history themselves changed. The development of eighteenth-century English writing about painting may be seen in the ways that Richardson's prophecies were not answered, his work not fulfilled.

When Richardson premised that the criticism of painting was inseparable from "A Philosophical Discourse upon the Conduct of the Understanding at Large,"[37] he was nicely anticipating the aesthetic concern which criticism would assume as its main task. Since previous English and continental critics had justified their judgments, and even their technical information, with philosophical arguments, Richardson had performed a service by bringing philosophical discussion into the open, and by bringing it up to date. In such discourse, however, he was an amateur, and his principles were too limited to be definitive. The reliance upon constant logical distinctions, an admirable innovation in English criticism, could not master the aesthetic problems raised by empirical psychology; the processes of the mind, as they are discussed for instance in Hogarth's *Analysis of Beauty* (1753) or Burke's *Philosophical Enquiry into the Origin of our Ideas of the Sublime and Beautiful* (1757), have visual and emotional complications far beyond Richardson's comparatively simple appeal to reason.[38]

Thus the structure of Richardson's works, while intelligible and calculated to a revolutionary degree, does not admit of the depth or sophistication of argument which we have a right to expect from philosophical discussion. "The Conduct of the Understanding" refers to a recommended procedure for parcelling out reactions to paintings, not to the mental habits of a connoisseur as they have been developed and refined. *The Theory of Painting* divides the art into seven parts (the Sublime was added in 1725) and discusses each separately; *The Essay on the Art of*

[37] *An Account* . . . , p. vi.
[38] Monk, *The Sublime*, and Hipple *The Beautiful, The Sublime, & The Picturesque*, offer respectively the best introduction to and the closest analysis of the developments in aesthetic theory.

Criticism and *The Science of a Connoisseur* each consists of numerous general and particular observations of a page or two without a unifying argument; *An Account of . . . Pictures in Italy,* though a useful guide-book,[39] is at best a piecemeal "Collection of the Whole World." Even the Richardsons' later *Explanatory Notes and Remarks on Milton's Paradise Lost* significantly is organized line by line, note by note, rather than according to a single interpretative essay. This structural limitation has the advantage of making Richardson's works more useful in detail than works more philosophically unified could hope to be: "these Arts have Contributed to the Greatest Happiness of My Life, and I wish with all my Soul I may be Instrumental in making Them Greatly Serviceable to Ingenious Minds."[40] Yet some ingenious minds would desire a more profound instrument of analysis. When Richardson had once succeeded in persuading readers that painting was a dignified art, could be discussed rationally, could be studied profitably at length, his success had freed writers to go a direction different from his own.

The assumptions that Richardson made about how he would be followed are painfully evident in his call for someone "to give us the history of mankind with respect to the place they hold among rational beings; that is, a history of arts and sciences" (284). Although Richardson is asking for a successor, for a historian who can supplement his own theory, he thinks he knows exactly what that as yet unwritten history will prove to be. He knows, for instance, its significance: "Such a history well written, would give a clear idea of the noblest species of beings we are acquainted with, in that particular wherein their pre-eminence consists. And (by the way) I will take leave to observe, that we should find them to have arrived at a vast extent of knowledge and capacity . . ." (285). He knows its general pattern, as we learn in a series of sentences in the form of "In such a history it would be found that . . ." or "In such a history it would follow that . . ." (286). He even knows its details: "such an historian will go on to shew how the flame which blazed so gloriously in Raphael . . . decayed by little and little; till it was blown up

[39] The great J. J. Winckelmann, in the preface to his *History of Ancient Art,* tr. G. H. Lodge (Boston, 1872), I, 153, called Richardson's guide to ancient art "the best we have."
[40] *Notes on Milton,* p. clxxviii.

again in the school of the Caracci in Bologna" (288-89). No wonder that Richardson's historian, already told what he must think and what he must do, never appeared. Richardson believed that he had solved historical questions which had in fact hardly begun to be formulated. Future historians would ask different questions, and answer them differently.[41]

Just as Richardson's criticism depends upon constant definitions and evaluations of separable parts, so his history would aim at clear and distinct ideas. Its purpose would be a better definition of mankind; its means would be not the accumulation of facts but extended comparisons between epochs and between men. Implicit in Richardson's program is the typical corollary of the idea of progress, that history, of whatever subject, follows a single, continuous line, which rises and falls, progresses and retrogresses, and can ultimately be charted in terms of neat balances, contrasts, cycles. The history he promulgates is a history for the connoisseur, requiring most of all an expert and judicious eye which can assign any moment of painting to a place on a scale and display a fine historical taste. Thus Richardson shows much less respect for the discipline of history than for the art of painting; history is of interest for him only because it can instill proper tastes. It was reserved for another generation of historians to decide that the patterns and the lessons of history could be described only after a thorough examination of historical facts. Richardson fathered no school of history.[42]

In perspective, however, Richardson has far more in common with Walpole and Reynolds than with Junius or Sanderson. He did not determine the exact course of future English writing about painting; but he forever changed the course of the writing

[41] W. Folkierski, *Entre le classicisme et le romantisme: étude sur l'esthétique et les esthéticiens du XVIII⁰ siècle* (Cracow, 1925), includes pioneering work on the relation of Richardson to later writers on the arts. We still lack a definitive study of changes in historiography during the eighteenth century, though important contributions toward such a study have been made by R. G. Collingwood, R. S. Crane, and A. D. Momigliano.

[42] Although Henry Bell's *Historical Essay on the Original of Painting* (London, 1728) is indebted to Richardson, its true affinities are with seventeenth-century authors like Junius and Wotton; in spite of the pretentious title page of its reissue—*The Perfect Painter: or, a Compleat History of . . . Painting* (1730)—it ends with Giotto. Matthew Pilkington, *The Gentleman's and Connoisseur's Dictionary of Painters* (London, 1770), like Walpole, shares neither Richardson's homage to painters nor his interest in historical progress.

he had found before him. Critics and historians of art could no longer rely on the authority of the classics, the muses, or the French. They turned to the study of history and of the mind. After Richardson the scope of writers on painting widened, their defensiveness eased, and their confusion changed to steady confidence. He had communicated the sincerity of his passion for painting and his belief in reason, and had made the two one. Painting and sculpture "are not necessary to our Being; Brutes, and Savage Men subsist without them: But to our Happiness as Rational Creatures they are Absolutely so."[43] Into the wilderness of aesthetics Richardson had made a clear and distinct way; and those travellers who came after began their journey on his uncomplicated road.

[43] *An Account* . . . , p. 97.

CHAPTER SIX

Horace Walpole's
Anecdotes
and the Sources of English History of Art

1. VERTUE AND WALPOLE

RICHARDSON had called for a historian of painting whose clear sight and distinct knowledge would provide a new unity of purpose for English art. His call was answered by a complicated and divided partnership made up of two great originals: a tireless collector named Vertue and a tireless man of letters named Walpole.

George Vertue (1684-1756),[1] a distinguished professional engraver, an antiquary, and a close friend of Oldys,[2] spent his life like Oldys in heroic preparations for a major work he never began. Between 1713 and 1756 Vertue compiled thirty-nine manuscript notebooks packed minutely with bits of information intended for "his proposed work the (Musaeum pictoris Anglicanum) History of the Art of Painting and Sculpture in England from. 1500 to. 1700. or thereabouts, which work may be a large foundation designd for a more compleat work hereafter, when, as it is to be hop'd that true public Encouragement here will bring forth Natives proffessors of Art in as high perfection as any Nation or part of the Universe."[3] The Age of Diligence took its

[1] The primary source of information about Vertue, his own "Autobiography," has been published in *The Eighteenth Volume of the Walpole Society* (Oxford, 1929-30), pp. 1-21. Walpole ended *Anecdotes of Painting in England* with "The Life of Mr. George Vertue," drawn from Vertue's notes. John Nichols' *Literary Anecdotes of the Eighteenth Century* (London, 1812-15), II, 246-54, adds many details, and the account in the *DNB* is useful.

[2] See the selection from Oldys' diary included in Yeowell's *A Literary Antiquary* (London, 1862), p. 10 *et passim*.

[3] Vertue's "Autobiography," *Walpole Society* XVIII (1929-1930), 6.

usual toll: Vertue never brought his labors to an end. At his death he left only his notes, undigested and unindexed and thoroughly unpublishable, gathered into no better form than strings of miscellaneous facts and anecdotes.

What happened next is one of the fortunate chances of art history: Horace Walpole, who had been acquainted with Vertue, purchased the manuscripts from his widow, and decided to arrange and polish them into a book. For this work Walpole was supremely fit. He was experienced at cataloguing art, he had recently compiled a *Catalogue of the Royal and Noble Authors of England* (1758), which had given him practice at writing a discursive "treatise of *curiosity*," and his own notebooks at this time[4] show him in active pursuit of old pictures throughout England. Temperamentally Walpole was perhaps "by no means adapted in his own person to have acquired the original information, owing to a certain degree of fastidiousness in his manners,"[5] but a lifetime of diversions had adapted him to transmute the raw material of research into a sophisticated and informed amusement.[6] No one could have been better suited to mediate between an antiquarian and the literary public.

What Walpole produced, however, was not Musaeum pictoris Anglicanum but *Anecdotes of Painting in England,* not the history to which Vertue had devoted his career so much as another "treatise of *curiosity*." Indeed, Walpole was capable of rating Vertue's labors cheap; as he wrote to Lady Hervey, in the dedication to the *Anecdotes,* "If his industry has amassed anything that can amuse one or two of your idle hours, . . . I shall think his life was well employed."[7] A master of the art of graceful self-deprecation, Walpole constantly advised his correspondents that

[4] Extracted in *Walpole Society* XVI (1927-1928), 9-80.

[5] Edward Edwards, *Anecdotes of painters who have resided or been born in England, with critical remarks on their productions* (London, 1808), preface, p. iii. Edwards, who had been engaged by Walpole to continue the *Anecdotes* (though they later quarreled), gives an account of the progress of English art history up to his own time.

[6] Walpole's desire to inform and to entertain is emphasized by Wilmarth Sheldon Lewis, *Horace Walpole* (New York, 1960).

[7] Dedication. The first two volumes of the *Anecdotes of Painting in England* were completed in 1760, and published two years later by the Strawberry Hill Press. The third volume, with the *Catalogue of Engravers,* appeared in 1764; the fourth, though printed in 1771, was not issued until 1780. Page numbers in the text refer to the edition of London, 1786.

his Vasarihood was of little account, that Vertue had discovered little of value. "My history of artists proceeds very leisurely; I find the subject dry and uninteresting, and the materials scarce worth ranging—yet I think I shall execute my purpose, at least as far as it relates to painters: it is a work I can scribble at any time, and on which I shall bestow little pains—Things that are so soon forgotten should not take one up too much."[8] Richardson's exhortations, Vertue's ambitions, dribbled away to a part-time display of brilliant piecework.

The explanation of why Walpole rejected any pretensions to historical study is simple enough. He was making "a work, the chief business of which must be to celebrate the arts of a country which has produced so few good artists. This objection is so striking, that instead of calling it *The Lives of English Painters,* I have simply given it the title of *Anecdotes of Painting in England.* As far as it answers that term, perhaps it will be found curious" (I, ii-iii). Rather than risk a foolish claim to systematic treatment, he insisted upon the limitations of his task. When in May of 1761 William Hogarth, who had himself toyed with a history of painting, badgered Walpole about his intentions, he was quickly put right. "H[ogarth]. I wish you would let me correct it—besides, I am writing something of the same kind myself, I should be sorry we should clash. W[alpole]. I believe it is not much known what my work is; very few persons have seen it. H. Why, it is a critical history of painting, is not it? W. No, it is an antiquarian history of it in England; I bought Mr Vertue's MSS, and I believe the work will not give much offence. . . . H. Oh! if it is an antiquarian work, we shall not clash. Mine is a critical work."[9] Walpole would not be drawn into argument either with the living Hogarth or with the dead legions of theoreticians and historians of painting.

The distance between its two compilers defines the character of *Anecdotes of Painting in England.* Walpole prefers to regard himself as editor rather than author. He adopts an appreciative and patronizing tone toward much of the material he presents, a tone

[8] *The Yale Edition of Horace Walpole's Correspondence,* ed. W. S. Lewis, XVI (New Haven, 1951), 40. This edition will subsequently be referred to as *Correspondence.*

[9] *Correspondence,* IX, 366. For Hogarth's manuscript, see Michael Kitson, "Hogarth's 'Apology for Painters,'" *Walpole Society* XLI (1968), 46-111.

which effectively dissociates him from "the labours of another person" (I, i). For instance, after ridiculing the search for national origins of art, he continues "as Mr. Vertue's partiality flowed from love of his country, and as this is designed for a work of curiosity, not of speculation and reasoning, I shall faithfully lay before the reader such materials as that laborious antiquary had amassed for deducing the History of English Painting from a very early period" (I, 2-3). The result of such an introduction is to make Walpole seem a sort of surrogate for the reader, the reviewer of a book that is and is not his own. The *Anecdotes* is not a straightforward antiquarian history so much as a perpetual disinterested commentary upon that history; it calls delicate attention to its own strengths and weaknesses. Vertue's industry and Walpole's graceful manner constitute the never quite disharmonious poles of a soft never-ceasing internal argument.

2. THE NOTEBOOKS AND THE ANECDOTES

Fortunately, we can evaluate the extent of Walpole's contribution very precisely. The publication of Vertue's Notebooks by the Walpole Society[10] has made it convenient to measure the raw materials against the work to which they were refined. Such study reveals immediately that Walpole was far more than an editor. Vertue is prodigal of facts; indeed, he finds room for so many more facts than the *Anecdotes* that his notebooks furnish a significant addition to art history. But the essential decisions about form, about style, about the combination of facts into a sequence or narrative, all belong to Walpole.[11]

Two sample biographies will illustrate the manner in which the *Anecdotes* were constructed. The subject of the first, the distinguished miniaturist Samuel Cooper (1609-1672), had flourished at a time too long past for Vertue to find out much about him. The greater part of the information about Cooper in Vertue's manuscripts consists of a literal transcription of the facts and

[10] In its volumes nos. XVIII, XX, XXII, XXIV, XXVI, XXIX, XXX (1929-1952). The Walpole Society was founded partly for this purpose. See Lionel Cust, "George Vertue's Note-Books and Manuscripts Relating to the History of Art in England: Introduction, and Proposal of a Scheme for their Publication," *Walpole Society* III (1913-1914), 121-128, and the introduction to volume XVIII.
[11] Cust, *Walpole Society* III, 125-127, contrasts the methods of Vertue and Walpole with reference to John Greenhill.

opinions in Richard Graham's additions to *The Art of Painting*, supplemented by some remarks from Buckeridge's "Essay towards an English-School."[12] To this material Vertue was able to add two anecdotes supplied by Lawrence Cross and Thomas Murray, older artists of his acquaintance. In addition, he scatters through his notes dozens of particulars about the subjects, sales, and current ownership of Cooper's work, as well as bits of biography— e.g., "Geldorp painter says Mr. Cooper (who knew him) livd till after the restoration."[13] Vertue nowhere attempts to sort out his particulars; and he never comes near venturing a critical opinion of his own.

When we turn to the pages on Cooper in the third volume of the *Anecdotes*, we are at once confronted with historical and critical evaluation. "SAMUEL COOPER Owed great part of his merit to the works of Vandyck, and yet may be called an original genius, as he was the first who gave the strength and freedom of oil to miniature. Oliver's works are touched and retouched with such careful fidelity that you cannot help perceiving they are nature in the abstract; Cooper's are so bold that they seem perfect nature only of a less standard. Magnify the former, they are still diminutively conceived: if a glass could expand Cooper's pictures to the size of Vandyck's, they would appear to have been painted for that proportion" (III, 110-111). Taking his start from some commonplaces on Cooper's relation to Van Dyck— Graham: Cooper "derived the most considerable Advantages, from the *Observations* which he made on the *Works* of *Van Dyck*"; Buckeridge: "he was commonly stiled the Vandyck in little"[14]—, Walpole adroitly presents us with a finished estimate of Cooper in a few sentences which seem to be based on personal inspection. Everything is contrived to keep us aware of the author's fresh response. When Walpole returns to a comparison of Cooper with Van Dyck, he contrasts two specific portraits at length in vivacious style. When he goes on to repeat the usual comment that Cooper excelled in drawing heads but tended to

[12] Vertue does not acknowledge these sources in his notes. Graham, in Du Fresnoy's *The Art of Painting* (London, 1716), pp. 375-76; Buckeridge, in De Piles' *The Art of Painting*, 3rd ed. (London, ca. 1750), pp. 364-65; Vertue, in *Walpole Society* XX (1931-1932), 129-130.

[13] *Walpole Society* XVIII (1929-1930), 106.

[14] Graham, in Du Fresnoy, *Art of Painting*, p. 375; Buckeridge, in De Piles' *Art of Painting*, p. 364.

leave bodies unfinished, he interjects "It looks as if he was sensible how small a way his talent extended" (III, 112). Cooper's want of grace (his women "are seldom very handsome") leads to a digression on the need "to make truth engaging." Even the tiny truths of biographical fact which conclude Walpole's memoir are made engaging by lively presentation and by frequent use of the first person singular. We never forget the presence of our charming and opinionated cicerone. In the *Anecdotes*, Vertue's neutral sprinklings of fact about Cooper are firmly put in their place.

Charles Jervas (1675[?]-1739) was a contemporary of Vertue, and here the manuscript reports are neither impersonal nor neutral. Vertue's notes follow the leaps of his mind: we are told that Jervas "learnt. or rather dwel'd with Kneller, one year," or that "Mr Jervase his Majestys painter has had no success in painting their Majesties pictures & from thence he lost much the favour & Interest at Court. nor that picture of the King on horseback the face which he was to do. was thought like. Mr Wooton did the Horse./ But Mr. Jervais had the good fortune to marry a Gentlewoman with 15 or 20 thousand pounds."[15] Vertue lets his animus shine through. Nor does he hesitate to criticize Jervas' work: "there is something wanting in the truth of the lines the just or good imitation of nature his works rather appear to me like. fan painting fine silks. fair flesh white & red. of beautifull colours but no blood in them or natural heat or warmness. much a manerist."[16] For destructive economy and vitality, no future historian of art could improve on Vertue's notes.[17]

What Walpole chose to write about Jervas was not, however, an expansion of Vertue's attack so much as an elegant little essay on the ephemeral nature of the vogue in painting. To this general purpose he was willing to sacrifice particular information and criticism. Indeed, he was willing to sacrifice Vertue. The memoir in the *Anecdotes* begins "No painter of so much eminence as Jervas, is taken so little notice of by Vertue in his memorandums, who neither specifies the family, birth, or death of this artist. The latter happened at his house in Cleveland-court, in 1739. One would think Vertue foresaw how little curi-

15 *Walpole Society* XXII (1933-1934), 15, 59.
16 *Ibid.*, p. 17.
17 Cf. Ellis Waterhouse, *Painting in Britain 1530 to 1790* (London, 1953), pp. 101-2.

osity posterity would feel to know more of a man who has be-
queathed to them such wretched daubings" (IV, 23). As we have
seen, Walpole need not have speculated about Vertue's opinion
regarding Jervas' claims on posterity. Vertue knew very well
about whom he was writing. Moreover, a little more care would
have revealed to Walpole that the information he prints about
Jervas' death might be found in Vertue's notes.[18] For the sake of
his *mot*, Walpole is capable of making free with his sources.

Yet if we wish to understand Walpole's aim in composing his
notice of Jervas, we must have reference to something other than
the facts and analysis relevant to a history of painting. Jervas'
reputation was a matter then, and is now, of literature, not of
painting, dependent upon his eminent choice of friends and
patrons, not upon his work.[19] In Vertue's time, in Walpole's, in
ours, one had rather be acquainted with Jervas than admire
him. Walpole assesses the scale of interest quite nicely: "what
will recommend the name of Jervas to inquisitive posterity was
his intimacy with Pope, whom he instructed to draw and paint,
whom therefore these anecdotes are proud to boast of and enrol
among our artists, and who has enshrined the feeble talents of
the painter in 'the lucid amber of his glowing lines' " (IV, 24-25).
Unlike Vertue, Walpole is in search of whatever will amuse
and inform, and Jervas the painter is of far less moment to him
than Jervas the episode in social history. Jervas painted feebly,
but Jervas had won entrée. It is this phenomenon, not the de-
tails of art, which the *Anecdotes* observe.

Taken on its own terms, Walpole's essay on Jervas succeeds
admirably, thanks to the letter-writer's elegance, propriety, and
malice of phrase. For instance, Vertue's blunt statement about
Jervas' marriage is neatly turned to account when Walpole, after
quoting the *Tatler*'s praise of the painter, adds "To this incense
a widow worth 20,000£. added the solid, and made him her hus-
band" (IV, 28). A fine touch is displayed in the observation that
fashionable and expensive portraits "that proudly take possession
of the drawing-room, give way in the next generation to those of
the new-married couple, descending into the parlour, where they

[18] *Walpole Society* XXII (1933-1934), 96.
[19] See W. T. Whitley, *Artists and their Friends in England 1700-1799* (London,
1928), I, 40-45. For the relations of Jervas and Pope, see Norman Ault, *New Light
on Pope* (London, 1949), pp. 68-69.

are slightly mentioned as *my father's and mother's pictures"* (IV, 29). No footnote is provided, but one should be: Sir Robert Walpole had been one of Jervas' most faithful patrons.

The interest of the memoir of Jervas, however, is the product not so much of individual felicities as of Walpole's genuine discrimination in the aesthetic marketplace. The moral lesson of Jervas' downfall—"his own vanity thought no encomium disproportionate to his merit" (IV, 24)—seems to weigh far less than the fall in his prices. Walpole arranges his notes to enforce two conclusions: Jervas' portraits no longer receive attention; other portraitists will suffer the same fate. Neither conclusion has much to do with the criticism of painting, but then neither does much of the *Anecdotes.* "It will easily be conceived by those who know any thing of the state of painting in this country of late years, that this work pretends to no more than specifying the professors of most vogue" (IV, 28-29). Walpole is content to be the servant, not the rival, of King Vogue. The life of Jervas, however insignificant for the critic, is a perfect illustration of how a reputation is made and how it dies; and there the *Anecdotes* rest.

3. ROYAL CATALOGUES

One day in October, 1760, while Walpole was tranquilly writing his Anecdotes in dishabille, he heard the bell at the gate ring— called out "Not at home"—Harry came running up—la!—embarrassing and delightful—the Prince of Wales at the door— no more Anecdotes that day.[20] The compliment was returned many times over in literature; the *Anecdotes of Painting* pay frequent unexpected visits to royalty. Fresh from cataloguing the Royal and Noble Authors, Walpole knows the value of names that can shed luster on his subject. At every turn the stories of painters meet with noble connections.

Moreover, the very structure of the *Anecdotes* is fitted to royalty: its four volumes are divided according to the reigns of British kings. The king sets the style for his age. Although the basic form of the *Anecdotes* is a series of brief biographies and catalogues of painters, Walpole introduces each chapter with a summary of artistic success during the reign, and often that summary consists merely of a description of the monarch himself, his

[20] A paraphrase of a letter to Montagu, *Correspondence,* IX, 304.

character, his taste, his dispensations. The author breaks this repetitive sequence for some essays on architecture and other fine arts, but he makes no attempt to find a unifying principle drawn from the nature of painting. Chronology and monarchy furnish all the links.

Such close attention to patronage and to the personalities of kings has an important effect: the history of art seems reduced to a sort of fever chart of royal taste. In his own person Henry VIII summons up the art of his realm. "The accession of this sumptuous prince brought along with it the establishment of the arts. He was opulent, grand and liberal—how many invitations to artists! . . . Though Henry had no genius to strike out the improvements of latter ages, he had parts enough to choose the best of what the then world exhibited to his option" (I, 89). Even when Walpole avoids diminishing the arts to a function of the king's personality, he relinquishes any historical momentum. The fluctuations of patronage from reign to reign, not changing ideas and techniques of painting, chart all the history of the *Anecdotes*. We learn that Charles I brought real taste to England, that the Puritans (too ugly to be picturesque)[21] destroyed it, and that Charles II revived and corrupted it. In the pages of the *Anecdotes* prince succeeds prince, painter succeeds painter, festooned in flourishes of gossip, without any sense of continuity.

Walpole's concern for reputation, his interest in the likes of Jervas, eventually marks his separation from his partner. Vertue had amassed the information for a shrine of honor to those men who live by and for their art; Walpole selects choice morsels for the delectation of readers who would have accepted the company of most artists only while sitting for a portrait. The *Anecdotes* patronize painters far more than they celebrate them. Junius might as well never have written; he is tucked into a sentence at the end of a section on his patron Lord Arundel. Even Walpole's praise has the taste of condescension. We are told that Rubens "is perhaps the single artist who attracts the suffrages of every rank. One may justly call him the *popular painter*; he wanted that majesty and grace which confine the works of the greatest masters to the fewest admirers" (II, 135). In such pas-

[21] Macaulay attacks such aestheticism in his famous analysis of Walpole, *Works* (London, 1875), VI, 11.

sages the connoisseur takes pride of place over the work he deigns to consider.[22]

The *Anecdotes* are not Vertue's would-be history, nor are they sympathetic to the aspirations of painters. Nevertheless, their emphasis upon patronage serves a purpose no less valuable for its inherent snobbery. If Walpole thought that English painting required a catalogue more than a historian or champion, perhaps he was right. "My view in publishing the *Anecdotes* was to assist gentlemen in discovering the hands of pictures they possess, and I am sufficiently rewarded when that purpose is answered."[23] As a guide for collectors, as a summary and commonplace book of critical opinion, the *Anecdotes* have a worth far out of proportion to the triviality of some of their pages. Walpole writes about patrons and for patrons, and he never fails to tell his readers where they are to look for paintings and what the best people think about them. And it is this desire to initiate readers into the ranks of the *cognoscenti* that justifies the method and the style of the *Anecdotes*.

From the standpoint of the patron, the history of painting is one aspect of the history of wealth.[24] Walpole's observations, which at once sum up and influence the current value of items on painting's stock market, seem calculated for the purchaser. Unlike Johnson, he does not assume the responsibilities that fall upon the curator of a tradition. Each painter is assigned a rating or label, but without lengthy consideration either of the individuality of his work or of its relation to the progress of art. Significantly, Walpole's general estimates of each artist tend to be confined to the opening paragraphs; he rarely concludes with a summary or with a retrospective assessment. The *Anecdotes* do not strive to establish or to articulate a canon of what is best in English art. However assured, their opinions are always offhand.

The critical weakness of the *Anecdotes* nevertheless signals a complementary strength. As soon as one sets aside Vertue's ambi-

[22] "Few men were more capable of appraising the splendid powers of Gainsborough and Reynolds; but he preferred to publish fulsome nonsense about Lady Lucan's water-colours and Mrs. Damer's terra-cotta dog." R. W. Ketton-Cremer, *Horace Walpole: A Biography* (London, 1940), p. 316.

[23] Letter to Cole, *Correspondence*, I, 25.

[24] G. R. Reitlinger, *The Economics of Taste*, 2 vols. (London, 1961, 1963), begins with the time of Walpole; see especially II, 75-81. See also John Pye, *Patronage of British Art, An Historical Sketch* (London, 1845).

tions and begins to examine his notes and Walpole's revisions for what they are, it becomes evident that the *Anecdotes* profit from being not so much history, nor even biography or gossip, as an annotated catalogue. In digesting the vast pile of notes he had acquired, Walpole's first task was to compile an index, and structurally he never looked far beyond that task. The richest part of the *Anecdotes,* a part which frequently consumes more than half of a biographical memoir, is the descriptive cataloguing of the painter's work. To the limit of his and Vertue's knowledge, Walpole tells us where each "most capital picture" in England is to be found and what it represents. Good biographical order may be violated by such extensive lists, but not without compensations. In the artistically uncharted world of eighteenth-century England, Walpole's cataloguing must have been invaluable. Not only did it guide the prospective traveller, it also stocked, no matter how unselectively, an imaginary museum where one might review the accumulated images of English art. Like Richardson's *Account of Pictures in Italy* and Reynolds' *Journey to Flanders,* the *Anecdotes* embody the experience which gives a shape to theory. Walpole's refusal to synthesize gave his contemporaries the cream of Vertue's industry unviolated by any idea. There was no better museum in England.[25]

4. WALPOLE'S FREEDOM

Thus the solid achievement of the *Anecdotes* is in part a product of the casualness with which Walpole approached criticism. Of all forms, the annotated catalogue best served to remove him from the onerous obligations of systematic thought at the same time as it afforded him an opportunity for the smooth and nimble chatter he had polished to an art. Walpole was free to say what he liked without concession to a narrow principle of organization.

Indeed, the defining characteristic of Walpole's chosen role in the making of the *Anecdotes* is freedom. He begins by separating himself from "the labours of another person," he proclaims his low esteem for English art, he implies throughout that his at-

[25] For a history and bibliography of museums and collections, especially in England and Scotland, see David Murray, *Museums: Their History and their Use,* 3 volumes (Glasgow, 1904). Thomas Martyn, *The English Connoisseur* (London, 1766), described works of art in noble houses.

tention to artists is an act of condescension, and he accepts no restriction on form or subject matter.[26] When we have once been exposed to the full weight of these disclaimers, perhaps we are entitled to wonder whether Walpole was effecting a separation from Vertue, from authorial responsibility, or from the part of his own nature that thought the *Anecdotes* worth doing. As a historian of art and as a literary man, Walpole's position was ambiguous, and his responses were more complicated than most critics have acknowledged. If, as W. S. Lewis wisely suggests, "the connecting word that illuminates Walpole's life" is *fame*, "the condition of being much read and talked about,"[27] there was always a price of exposure to be paid for fame; and Walpole was not a spendthrift when it came to exposing himself to critics. The *Anecdotes* employ an elaborate machinery for balancing ambitions for fame against a tender and fastidious superiority.

Walpole's elusiveness as a critic and historian of art must have been congenital—the annotated catalogue was the form in which he repeatedly chose to work—but he had acquired discretion over the years. The *Aedes Walpolianae* (1747), a description of Sir Robert Walpole's pictures at Houghton Hall, is introduced by a notorious history of painting which presumes to judge and dismiss most of the masters. The influence of De Piles and Richardson, though not acknowledged, is evident in Walpole's insistence on clarity and in his incessant discrimination of faults from virtues. Yet here the measurements of the steel-yard are stretched into absurdity. "In short, in my opinion, all the qualities of a perfect painter never met but in Raphael, Guido, and Annibal Caracci."[28] The *Aedes*, like the *Catalogue of the Royal and Noble Authors of England*, exposes the superficiality of Walpole's criticism too thoroughly for comfort.[29]

The *Anecdotes*, whether because of Vertue's ballast or Walpole's own control, provoked critics less. The limitation on sub-

[26] Supplements to the *Anecdotes of Painting* include chapters on "Statuaries, Carvers, Architects, and Medallists," an essay on modern gardening, and a full *Catalogue of Engravers*. See also the miscellaneous materials edited and published by F. W. Hilles and P. B. Daghlian in *Anecdotes of Painting in England (1760-1795): Volume the Fifth* (New Haven, 1937).

[27] *Horace Walpole*, p. 187.

[28] Walpole's *Works* (London, 1798), II, 236.

[29] The reception of the *Royal and Noble Authors*, which was harshly treated by the *Critical Review*, the *Gentleman's Magazine*, and a number of pamphlets, probably helps to account for the critical caution of the *Anecdotes*.

ject matter removed Walpole from the temptation to lecture his readers about the only three perfect painters in the history of the world, and the sort of art he was considering was well suited to his critical abilities. "His tastes had shifted from the lavish and spectacular to the small, detailed, and exquisite."[30] Among the miniature achievements of English artists, Walpole could stride like a giant. Moreover, he could indulge his antiquarian preference for minutiae. Vertue "did not deal even in hypothesis, scarce in conjecture. . . . being so little a slave to his own imagination, he was cautious of trusting to that of others" (I, v-vi), and Walpole follows him in severe suspicion of "fables, researches, conjectures, hypotheses, disputes, blunders and dissertations, that library of human impertinence" (I, 179). In the tiny world of fact that remained, however, he could find room for anecdotes.

The word "anecdotes" itself signifies some of the divisions in Walpole's view of his work. Its primary sense in the eighteenth century was "Something yet unpublished; secret history" (Johnson's *Dictionary*). Thus it might refer either to collections of facts like Vertue's notebooks, or to works like Walpole's own *Memoirs* which could not be made public because of "speaking with too much freedom . . . of persons in authority."[31] By the time that Walpole wrote the *Anecdotes*, however, our own sense of the word as the narrative of an interesting event, or simply as gossip, had already been imported from France. When Boswell, in 1789, mentioned that his *Life of Johnson* would include many *anecdotes*, he apologized for the word—"(which word, by the way, Johnson always condemned, as used in the sense that the French, and we from them, use it, as signifying particulars)"[32]—but he used it anyway. Walpole had fewer prejudices about French usage. He was writing unpublished details of history, and also amusing stories, and he did not care to discriminate between the two kinds of "anecdote" too precisely. In word as well as attitude he could safeguard his own license. And he chose to be free from limitations, even the limitations of a word, a form, a genre.

Walpole's struggle for freedom is more than a game. In appearing before the public, he risks not only his reputation, but his

[30] Ketton-Cremer, *Horace Walpole*, p. 206.
[31] Chambers' *Cyclopedia*, quoted by the *OED*.
[32] *Letters of James Boswell* (London, 1857), p. 311.

sense of himself. His own study of noble authors had revealed
how often the author and the gentleman must be at odds. The
biographers of Walpole have frequently stressed that the central
problem of his career was to reconcile literary pretensions with
social position. "D'un côté, Horace, chercheur et littérateur, assez
fier de ses talents et de son labeur; de l'autre, Horace, homme du
monde, qui dénigre l'auteur et se moque de ses prétentions.
Quel conflit pour un épicurien!"[33] To some extent such dilemmas
may be of our own making. As a historian of art Walpole did not
lead "la vie d'un dilettante" unless we understand "dilettante"
in its eighteenth-century sense (what we would call an "amateur,"
a dedicated enthusiast who does not earn a living). At any rate,
Walpole was too serious a dilettante to join the Society of Dil-
ettanti.[34] Yet he could not admit how much of his self-esteem
depended on popular and scholarly approval.

Nevertheless, Walpole's divided commitment to his anecdotes
of art must be analyzed as more than a personal problem. His
fastidiousness and affectations may have turned him away from
the Musaeum pictoris Anglicanum, but he had accomplished
more than any English historian of art of his generation. If he
lacked the dedication of a Junius, a Du Fresnoy, a Richardson,
a Vertue, the reason must be sought in the kind of truth about
painting that his own age preferred. The *Anecdotes* inherited and
created a new set of expectations.

5. Antiquarianism and the School of Walpole

Antiquity, how poor thy Use!
A single *Venus* to produce?
Friend *Eckardt*, antient Story quit,
Nor mind whatever *Pliny* writ;
Let *Felibien* and *Fresnoy* declaim,
Who talk of *Raphael*'s matchless Fame,
Of *Titian*'s Tints, *Corregio*'s Grace,
And *Carlo*'s each *Madonna* Face,
As if no Beauties now were made,
But Nature had forgot her Trade.[35]

33 Paul Yvon, *La Vie d'un dilettante: Horace Walpole* (Caen, 1924), p. 421.
34 See the letter to Mann, 14 April 1743, *Correspondence*, XVIII, 211.
35 *The Beauties. An Epistle to Mr. Eckardt, the Painter* (London, 1746), pp. 3-4.
Walpole claimed the poem for his *Fugitive Pieces* (1758).

In 1762, the year when the first two volumes of the *Anecdotes of Painting* appeared, Walpole was not a lonely scholar. He was surrounded by men who thought they were reforming British antiquarian research. In that year Bishop Hurd published his *Letters on Chivalry and Romance,* and succeeded in persuading Thomas Warton that he was destined to be the historian of English poetry. Percy was assembling his *Reliques.* The poems of Ossian, now supplemented by *Fingal,* were stimulating research and refutation. The Society of Dilettanti achieved its finest hour with the publication of Volume I of *The Antiquities of Athens,* "measured and delineated" by James Stuart and Nicholas Revett. Anquetil du Perron brought to England news of Zoroaster.[36] The usual controversies raged around Warburton and Lowth. Richard Gough and Edward Gibbon published their first works.[37] And most important of all, the English countryside swarmed with inquisitive parsons whose love of antiquities was often their most sincere profession.

The center of this antiquarian movement, at least its literary center, hovers about the friends and correspondents of that very reluctant antiquary Walpole. Gray and Montagu and Cole and Mason and Zouch, and at a further remove Percy, Hurd, and the Wartons, spent most of their time poring over historical rarities. Often they were antiquarians in spite of themselves—Gray and Thomas Warton would wince when the word was applied to them too familiarly—but they were the most prominent such group in England. Seven years later, when a youth named Thomas Chatterton "discovered" a Curious Manuscript, "The Ryse of Peyncteynge yn Englãde, wroten bie T. Rowleie," he would naturally send it to Walpole for use in the *Anecdotes.*[38]

As a group, the antiquarian School of Walpole may be distinguished by the extreme diffidence with which its members regarded their own researches. The energy exhibited in exchanges of information is matched only by the habitual note of apology that introduces each exchange. The reason for such diffidence may

[36] See *The Annual Register,* V (1762), 103-129.

[37] Gough, *The History of Carausius* (London, 1762); Gibbon, *Essai sur l'étude de la littérature* (Paris, 1762). Both men later became associated with Walpole, who worked out the plan for Gough's *Sepulchral Monuments in Great Britain* (1786).

[38] The Chatterton-Walpole affair is thoroughly documented by E. H. W. Meyerstein, *A Life of Thomas Chatterton* (London, 1930).

be sought in individual psychologies: Walpole's snobbery, Gray's fastidious shyness, Mason's shallow sentimentalism, Warton's precocious romanticism, or the clergy's collective guilt about its neglect of pastoral duties. Yet the apologetics are too widespread to be personal in origin. What was at stake was evidently more fundamental, the relation of antiquarian research to literature, to history, and to society.

By 1762 the English public was more curious about antiquities than ever before; but a great age of scholarship had come to an end. The line of scholars from Dugdale to Hearne, "the age of Herculean diligence which could devour and digest whole libraries,"[39] had given way to a more literary, occasional, and casual sort of industry. Walpole and his circle did not pretend to be the successors of the scholarly giants. Self-sacrificing antiquarians like Vertue and Oldys, remnants of an earlier generation, won little honor from their countrymen, and Walpole "and his like were chiefly concerned to dress up the products of antiquarian research in attractive garb, and to parade the result as a new toy. Even as he studied the past, he jested at those who made it a serious business. 'We antiquarians,' he murmured, 'who hold everything worth preserving merely because it has been preserved!' "[40] The integrity of scholarship, its intrinsic power to reward a lifetime of zealous effort, had ceased to be acknowledged.

In one respect this willingness to exploit scholarship proved to be a major creative stimulus in the mid-eighteenth century. It is no accident that so many of Walpole's antiquarian friends achieved their greatest recognition as poets. Gray and Thomas Warton may have seen their lives in terms of the struggle between scholar and poet that raged within them,[41] but an exceptionally large proportion of their poems is the direct product of antiquarian learning. Indeed, much of the poetry of the 1750's and '60's is interesting primarily for its attempt to salvage remnants of the past. It would not be inaccurate to say that the antiquarianism of Walpole's time survives as a subdivision or dependency of poetry; a

39 This quotation from Gibbon, and the change in antiquarian research it laments, are discussed in chapter three, section six above.

40 David C. Douglas, *English Scholars 1660-1730* (London, 1951), p. 275.

41 See for instance William Powell Jones, *Thomas Gray, Scholar* (Cambridge, Mass., 1937); and chapter twelve below.

less sympathetic reader might maintain that poetry of the mid-century is a footnote to antiquarianism.

The transformation of historical research into material for literary treatment goes beyond poetry. The *Anecdotes of Painting* were themselves regarded as specimens of literature, and the effort they represent to make facts entertaining owes more to literary than scholarly tradition. Walpole's avid culling of anecdotes often looks like a flight from boredom, a restless chase after small amusements. William Warburton thought Walpole not an antiquarian but a *wag*. Offended at what he construed as a slighting reference to himself in the *Anecdotes*, Warburton demanded an apology, and explained to Garrick that "I knew Mr W. to be a wag, and such are never better pleased than when they have an opportunity of laughing at an antiquarian."[42] Walpole had laughed at his own antiquarian interests once too often. By treating Vertue's raw materials as the stuff of literary diversion, he had severed himself from the community of scholars.

Nevertheless the antiquarianism of the School of Walpole may have served an important purpose. Properly speaking Walpole and his friends are the successors not of seventeenth-century scholars but of seventeenth-century virtuosi.[43] Their motives, like those of the virtuosi, are essentially utilitarian; they seek to satisfy curiosity, and to win social and professional reputation. Again and again they subordinate theory to the pleasure of continually replenished factual oddities. By eighteenth-century standards such a concern with particular rather than general discoveries of scholarship was bound to seem eccentric. Philosophic history on the model of the French tended to deny the importance of minutiae,[44] and philosophy itself insisted upon the singular value of general ideas. At a time when philosophers, historians, and literary critics pursued the origins of human arts and human life into the structure of the mind, antiquarians like Walpole threw their trivia against the current.

[42] Walpole's *Correspondence*, XIII, 40n. Walpole must have been irritated by the argument, since he devotes a long peevish paragraph to it in the "Short Notes" of his life.

[43] For this distinction see Walter Houghton, Jr., "The English Virtuoso in the Seventeenth Century," *JHI*, III (1942), 57-58.

[44] The nationalistic response of English antiquarians to French philosophers is analyzed by Bernard Schilling, *Conservative England and the Case against Voltaire* (New York, 1950) especially chapter IV.

Walpole himself was quite aware of what he was resisting. A part of his inveterate hostility to Johnson, for instance, was his reaction to just those "philosophic words," that "abstraction, simplification, and systematization of the world seen by the mechanical science . . . turned inward to the analysis of the soul,"[45] which we have recently been taught to notice. Because of its malicious intention, we may overlook the insight of Walpole's charge that "Dr. Johnson, like the chymists of Laputa, endeavours to carry back what has been digested, to its pristine and crude principles."[46] Yet the charge has some justice. Johnson's criticism aims always at the more pristine, the more nearly universal truth. Characteristically his immense historical erudition was accompanied by a professed disregard for any history that lacked moral or philosophical significance. Johnson's great restless mechanism of analysis breaks down facts until they yield generalizations. He has little esteem for collections and still less for collectors: "to have rambled in search of shells and flowers, had but ill suited with the capacity of Newton."[47]

In contrast, "the antiquary was a connoisseur and enthusiast; his world was static, his ideal was the collection. Whether he was a dilettante or a professor, he lived to classify."[48] Against systematic philosophy, history, and criticism, Walpole and his friends shored up unremitting and ungeneralized collections, deliberately designed to evade significance.

If such collectors could not always escape feelings of self-directed irony, they also directed their irony outward. The danger of Britain's great age of abstract thought, as contemporaries suspected, was inattention to those facts which depart from or contradict theory. "Historical investigation withered in an atmosphere of abstract Cartesianism which neglected development, and by insisting upon the uniformity of human thought, discouraged the study of the distinguishing growth of diverse nations."[49] The antiquarians, primed in the diversity of nations, of counties,

[45] W. K. Wimsatt, *Philosophic Words* (New Haven, 1948), p. 104.
[46] "General Criticism on Dr. Johnson's Writings," Walpole's *Works*, IV, 362.
[47] *Rambler* 83, Johnson's *Works* (Oxford, 1825), II, 392.
[48] Arnaldo Momigliano, "Ancient History and the Antiquarian," *JWCI*, XIII (1950), 311.
[49] Douglas, *English Scholars*, p. 274.

of villages, could not be taken in by notions of uniformity. Whatever their individual interests, they exerted a pressure for factual catholicity and scrupulosity which, according to some historiographers, first reformed and finally became incorporated into historical method.[50] To deflate abstractions was the antiquarian's special and endless joy. Walpole introduced *Historic Doubts on the Life and Reign of King Richard the Third* (1768), and to his great annoyance his own Society of Antiquaries devoted its first two volumes of papers to doubts of his doubts.[51] The antiquarian movement, working a vein of triviality which even its own members sometimes thought perverse, helped to protect the world of things from the would-be philosophic historian.

For Walpole and his friends, however, the issue was not clearcut. They resisted the logic of the philosophers, but to serious antiquarians like Warburton and Ritson they seemed mere wags. If with Walpole "a safe rule to go on is that his facts are first class, and his generalisations worthless,"[52] we must not conclude that he shared our preference. Perhaps style means more to him than literal truth. He never wrote a work more carefully and accurately than the *Memoirs*, but the life of the *Memoirs* is notoriously informed by styptic, history-making prejudices. Walpole enjoys playing many parts. The *Anecdotes* confront us with a historian, a biographer, a critic, an editor, an antiquarian, a diarist, a moralist, a patron, and an entertainer. The School of Walpole supplied useful enemies of abstract thought, but Walpole was no one's dependable ally.

Despite Walpole's important contributions to antiquarianism, then, his devotion to facts is always at the mercy of his fascination with style. The value of the *Anecdotes* depends on their mass of information; the interest of the *Anecdotes* depends on their variety of manners. Walpole mixes a unique blend of high fashion and history. Nowhere is this blend more characteristic or more peculiar than in his discussion of Gothic style.

[50] Both Momigliano and Douglas discuss the historiographical tradition in their closing pages.

[51] See Ketton-Cremer, *Horace Walpole*, pp. 231-32.

[52] Romney Sedgwick, quoted by Bonamy Dobrée, "Horace Walpole," in *Restoration and Eighteenth-Century Literature*, ed. Carroll Camden (Chicago, 1963), p. 186.

6. GOTHIC AND WALPOLE

The most famous section of *Anecdotes of Painting in England* does not concern painting. In Volume I, chapter V, "State of Architecture to the end of the Reign of *Henry VIII*," Walpole wrote a few pages about Gothic architecture which for a long time gained him recognition as "the central figure in every account of eighteenth-century medievalism."[53] We had better be dubious about that recognition. Abundant evidence suggests that Walpole was not an innovator in fostering a taste for Gothic, that his knowledge of it was irregular, and that at best he "brought to a focus artistic and antiquarian interests that he found already current."[54] Even in his own circle Walpole did not lead: Gray, whose knowledge was far more profound, "condescended to correct, what he never could have descended to write" (I, 195n.); and the notes to the 1762 edition of Thomas Warton's *Observations on the Faery Queen* trace the development of Gothic with more learning and judgment than the *Anecdotes* can muster. Walpole was no expert. Only an age of more than Gothic ignorance could have looked to him for mastery of Gothic style.

There remain two reasons why Walpole's remarks on Gothic deserve our interest. The first, of course, is that they were representative and influential. "He brought it into fashion. He was already a well-known *connoisseur,* an acknowledged arbiter of taste and a man of rank and influence; when he adopted Gothic, talked and wrote about Gothic, built a small but spectacular Gothic house and crammed it with exquisite and precious things, it soon ceased to be regarded as a rather paltry middle-class craze."[55] The second is more personal. Whether or not Walpole contributed much to the study of Gothic, through it he revealed a great deal of his life. Walpole was only the first of many to see his country house as the physical manifestation of a psychological state: "I am all plantation, and sprout away like any chaste nymph in the *Metamorphosis*."[56] Eighteenth-century Gothic, as architec-

[53] Kenneth Clark, *The Gothic Revival* (London, 1950), p. 53.

[54] B. Sprague Allen, *Tides in English Taste, 1619-1800* (Cambridge, Mass., 1937), II, 80-81.

[55] Ketton-Cremer, *Horace Walpole*, pp. 152-53.

[56] To Montagu, *Correspondence*, IX, 79. Cf. Lewis, *Horace Walpole*, p. 101: "When we talk about Strawberry Hill we are talking about Horace Walpole himself."

ture and as conception, was created in the image of eighteenth-century men.

If we wish to understand the importance of "their" Gothic to Walpole and his contemporaries, however, we must first be clear about what the word meant to them; perhaps clearer than they were themselves. The general outline of how "Gothic" lost its pejorative connotations is familiar. In Walpole's words, "the term *Gothic Architecture*, inflicted as a reproach on our ancient buildings in general by our ancestors who revived the Grecian taste, is now considered but as a species of modern elegance" (I, 181). Professor Frankl's monumental gathering of literary sources and interpretations, though it scants the eighteenth century in England, conveniently traces the word through its Renaissance nadir to its spire of revival.[57] Yet the many different contexts in which "Gothic" occurs must recommend caution in interpreting what it means at any given moment. Without a preliminary distinction between historical Gothic and stylistic Gothic, we can have no hope of following their evolving uses.

The "dark ages" were dark indeed to English historians in the eighteenth century, and few of them before Gibbon so much as attempted to separate the Goths from other peoples of the fifth to fifteenth centuries. In the arts, this lack of historical discrimination may be epitomized by a phrase from Batty Langley, whose effort to reconstruct the principles of Gothic architecture helped to spur the revival: "Every ancient Building which is not in the Grecian Mode is called a Gothic Building" (1742).[58] Insofar as men cannot appreciate what they cannot distinguish, the necessary prolegomenon to an eighteenth-century Gothic revival was a greater historical and archaeological clarity. Thomas Gray could have provided it. His knowledge and his sense of the evolution of styles are displayed in his Commonplace Book, in the notes he supplied to Walpole, and in the historical discussion he contrib-

[57] *The Gothic* (Princeton, 1960). Among a host of other studies, one must cite at least A. O. Lovejoy, "The First Gothic Revival and the Return to Nature," *MLN*, XXVII (1932), 414-446; E. S. de Beer, "Gothic: Origin and Diffusion of the Term; The Idea of Style in Architecture," *JWCI*, XI (1948), 146-62; Samuel Kliger, *The Goths in England* (Cambridge, Mass., 1952).

[58] Quoted in the *OED* from Langley's *Ancient Architecture*, Dissertation I. Warburton, who thought he had *exhausted* the subject of Gothic architecture in a note in his edition of Pope, distinguished "Saxon" style (debased Greek) from "Norman" (a Saracen Gothic).

uted to James Bentham's important *History of Ely* (1771).[59] Walpole himself was less well equipped. The *Anecdotes* make one central distinction between "the Saxon style," characterized by the round arch, and Gothic, which introduced the pointed arch; they hardly go further. Walpole was conscious that "Gothic" might be used as a term of objective chronological description, but he did not use it that way himself. His own special interests lay elsewhere, in criticism and taste.

Thus Walpole, like most Englishmen between 1680 and 1780, meant by "Gothic" a style or taste opposite to the "Classic." "All that has nothing of the Ancient gust is call'd a barbarous or Gothique manner" (1695). This kind of Gothic has little to do with history. Like "barbarous," with which Augustan writers invariably associated it, or like our own "primitive," it refers to a state of mind and to the forms which such a state of mind is supposed to produce. Shaftesbury, who repeatedly sets "Gothic" against that other favorite word of all purposes, "taste," is thinking not of a historical period so much as an eternal calamity, a decay of the soul: "Barbarity and Gothicism were already enter'd into Arts, ere the Savages had made any Impression on the Empire." When Walpole wrote Bentley that "The hospitality of the house was truly Gothic; for they made our postilion drunk," when he wrote Gray that "*Mr* is one of the Gothicisms I abominate,"[60] he was not repudiating the past, only the vulgar present. Such phrases are almost innocent of historical implication. If we are irritated at the glibness with which eighteenth-century critics dismiss Gothicism, we must recollect that such criticism is not necessarily directed towards "our" Gothic, a Gothic we locate in a time and place, but merely towards any sort of bad taste or bad manners.

What is more, even as a stylistic, anti-classic term "Gothic" may be used in different ways. When Pope compares Shakespeare's plays to Gothic architecture, for example, he is trying to understand the laws of asymmetrical form, and to account for a success brought off in spite of classical rules; when Shaftesbury compares a work of art to its Gothic ancestors, he intends no more than to condemn its utter lawlessness. This range of uses for

[59] See Jones, *Thomas Gray*, pp. 112-115.
[60] *Correspondence*, XIV, 65. To Bentley, in *Letters*, ed. Mrs. Paget Toynbee (Oxford, 1903), III, 120.

Gothic exactly parallels and opposes the range of "classic," which can denote a historical period, a particular style (symmetrical, cleanly articulated in design, harmonious and massive, simple, undecorated, un-Gothic, etc.), or any work of lasting value.[61] Gothic revivalists like Walpole exploited such confusions. They took care to divorce Gothic as a term of description from Gothic as a term of condemnation, while at the same time they enjoyed the iconoclastic feeling of daring that accompanied their praise of a word so weighted with derogatory connotations. "Their" Gothic would borrow the vocabulary invented to ridicule non-classic art, and would use it to subvert Classicism itself. All the wrong people would be puzzled.

Walpole's understanding and sympathy for Gothic were limited, however. "Gothic" signified different styles when applied to different arts, and the approval which it came to receive as architecture and later as literature could not be exported to Gothic styles of painting or music, or even of gardening. "I perceive you have no idea what Gothic is," Walpole wrote to Horace Mann, "you have lived too long amidst true taste, to understand venerable barbarism. You say, 'you suppose my garden is to be Gothic too.' That can't be; Gothic is merely architecture."[62] In another mood, he would have admitted poetry into the fold; but he never demonstrated any sympathy for medieval painting or music. When applied to those arts, Gothic designated outmoded and outrageous tastes which no connoisseur would willingly endure.

Because of the habitual neoclassic urge to associate the arts, to discuss the qualities of one art in the terms of another, the restriction on approving "Gothic" outside of architecture could be embarrassing. If anti-classic Gothicisms were ruinous to painting, their equivalents in poetry were hard to justify. Thus Dryden's schematic parallel, honed on the War between Ancients and Moderns, causes him discomfort: "The Gothic manner, and the

[61] For a brief history of the word, see René Wellek, "The Term and Concept of 'Classicism' in Literary History," *Aspects of the Eighteenth Century*, ed. Earl Wasserman (Baltimore, 1965), pp. 105-128.

[62] *Correspondence*, XX, 372. Cf. Walpole "On Modern Gardening": "The noble simplicity of the Augustan age was driven out by false taste. The gigantic, the puerile, the quaint, and at last the barbarous and the monkish, had each their successive admirers" (*Anecdotes*, IV, 306).

barbarous ornaments, which are to be avoided in a picture, are just the same with those in an ill-ordered play. For example, our English tragi-comedy must be confessed to be wholly Gothic, notwithstanding the success which it has found upon our theatre. . . . Neither can I defend my *Spanish Friar*, as fond as otherwise I am of it, from this imputation."[63] The doctrine of *ut pictura poesis* could hardly cope with so nebulous and complicated a conception as the Gothic in literature.

Nevertheless, literature is undoubtedly the center of the eighteenth-century Gothic revival. When Sir Kenneth Clark argues that "Gothic architecture crept in through a literary analogy,"[64] he is taking liberties with chronology, yet he may be excused for emphasizing the prevalence of poetry in English notions of Gothic. Not many discussions of Gothic architecture in the eighteenth century remained free of associations derived from Spenser. Indeed, Professor Pevsner explains the Englishness of English Gothicism largely "as an expression of the narrative as against the purely aesthetic interest."[65] Before the English novelists began to ransack Gothic architecture in search of stories, the poets, the antiquarians, and even the architects had been there. From that train of literary reminiscence, and from the pleasing confusion of historical and critical connotations, Walpole took his sense of Gothic style.

7. "LORD GOD! JESUS! WHAT A HOUSE!"

If read carelessly or out of context, the best-known sentence of the *Anecdotes* may sound like the trumpet of a Romantic prophecy. "One must have taste to be sensible of the beauties of Grecian architecture; one only wants passions to feel Gothic" (I, 183). With one thrust, apparently, Walpole puts an Age of Reason to the sword, and makes way for the claims of the emotions. Even his later disclaimer—"I certainly do not mean by this little contrast to make any comparison between the rational beauties of regular architecture, and the unrestrained licentiousness of that

[63] "A Parallel of Poetry and Painting," in *Essays of John Dryden*, ed. W. P. Ker (Oxford, 1926), II, 146-47.

[64] *The Gothic Revival*, p. 42. Such statements have been extensively criticized by B. Sprague Allen, *Tides in English Taste*.

[65] Nikolaus Pevsner, *The Englishness of English Art* (London, 1956), p. 56.

which is called Gothic" (I, 184-5)—cannot dispel our sense of something new.

Before we expatiate upon the significance of Walpole's evocation of the passions, however, we had better linger on the passage that precedes it. "It is difficult for the noblest Grecian temple to convey half so many impressions to the mind, as a cathedral does of the best Gothic taste. . . . [The priests] exhausted their knowledge of the passions in composing edifices whose pomp, mechanism, vaults, tombs, painted windows, gloom and perspectives infused such sensations of romantic devotion; and they were happy in finding artists capable of executing such machinery" (I, 182). One might choose to dwell upon the literary approach to architecture, suggested by the words "composing" and "romantic"; one cannot help but notice the language of sensation that considers architecture to be primarily a psychological mechanism for conveying impressions. Perhaps the most obtrusive feature of what Walpole says, however, is its celebration of paraphernalia, the ingenious multiplicity of machinery. The men who first used the pointed arch, according to the *Anecdotes,* were "so lucky as to strike out a thousand graces and effects, which rendered their buildings magnificent, yet genteel, vast, yet light, venerable and picturesque" (I, 182). More than any particular quality of feeling, Walpole's sense of Gothic seems to require number and variety in its effects. The Gothic of the *Anecdotes* is the Gothic of proliferation, of unrestrained licentiousness, of a thousand graces and ten thousand impressions.

The same impulse toward multiplication of effect, as a browse through Walpole's *Description of Strawberry Hill* will certify,[66] assembled the Gothic among which he lived. Strawberry Hill itself was a little house that proliferated to keep up with its collections. The exteriors were never its main charm; visitors were overwhelmed by an intimate barrage of objects, a sort of museum of relics and re-creations that intrigued and bewildered the eye. Within this exquisite clutter, no strait-laced rule of taste had breathing space. "Lord God! Jesus! what a house!"[67] Walpole

[66] *A Description of the Villa of Mr. Horace Walpole . . . , with an Inventory of the Furniture, Pictures, Curiosities, &c.* (Strawberry Hill, 1784).

[67] Etheldreda, Lady Townshend, reported by Walpole; Ketton-Cremer, *Horace Walpole,* p. 150. Lady Townshend was startled by the diminutive size of the house.

himself knew that some of his curiosities were trumpery, but he knew also that no one could be cool to such variety.

It is this suffocation of thought by a love of elaboration, and not any remarkable intensity of emotion, which provides a context for the claim that "one only wants passions to feel Gothic." Walpole finds no contradiction in an art whose parts are all machinery and whose effect is all feeling. For him the Gothic moment begins when the effort to distinguish and to adjudicate has been drowned beneath a sea of impressions; he would have seen quite well the point of Hawthorne's description of a statue so overgrown with moss and lichens "that its classic beauty was in some sort gothicized."[68] Moreover, his historical grasp of Gothic was vitiated by a similar tendency to define Gothic architecture in terms of its licentiousness. According to the *Anecdotes*, "When men inquire, 'Who invented Gothic buildings?' they might as well ask, 'Who invented bad Latin?' The former was a corruption of the Roman architecture, as the latter was of the Roman language" (I, 181n.). In Walpole's archaeology, the road of excess leads to the Gothic cathedral.

The deliberation with which Walpole and his contemporaries cultivate a spirit of abandonment through excess has provoked many critics to question their sincerity. By luxuriating in a welter of sensations, Walpole seems bent upon restoring appreciation for Gothic buildings only at the cost of denying that religious unity of thought and feeling which today seems at the center of medieval accomplishment. He rescues the design of blackletter by sacrificing the Word.[69] The detachment, the often ironic self-consciousness in terms of which Professor Pevsner characterizes Walpole's Gothicism,[70] is the very obverse of that "passionate single-mindedness" we attribute to the builders.

Without worrying questions of sincerity, we can at least perceive that the context of "Gothic" which Walpole inherited made his line of defense plausible, perhaps inevitable. Almost everyone for a century had seen and described the same characteristics of Gothic art that Walpole sees and describes: the same elaborate

[68] *English Note-Books*; quoted by the *OED*.

[69] In eighteenth-century printers' usage, "Gothic" type was equivalent to blackletter.

[70] *Englishness of English Art*, pp. 70-71.

ornamentation, the same violation of "chastity" of design, the same ingenuity and variety, the same spectacular effects rising from the same imaginative lack of restraint. By and large Walpole acquiesces to this tradition of description. What he changes is the focus; he moves from the object to the beholder. Charles Avison's scathing appraisal, ten years earlier, of "the numerous and trifling ornaments in the *Gothic architecture,* productive of no other pleasure, than that of wondering at the patience and minuteness of the artist,"[71] anticipates Walpole's verdict in every way except the sense of "wonder." The line of defense was ready-made. By diverting attention from the ornaments to the effects, from the causes of bewilderment to the state of being bewildered, Walpole could neatly reverse the argument. Instead of being compelled to analyze a style, he had only to follow the lead of his adversaries and promulgate his own reactions. Gothic lay in his own heart, and none had the advantage of him there.

The obvious concomitant of such a position is to promote self-consciousness and discourage study. Abandoned in the hearts of English Gothicizers, we meet a wilderness of sensations. The embarrassments of at once accepting and reversing the tenets of eighteenth-century Gothic compose the substance of Bishop Hurd's *Letters on Chivalry and Romance.* As the literary historians tell us, Hurd defends medieval institutions and literature with a new boldness, and passionately argues that Gothic must be studied in its historical context.[72] Yet his own practice blurs all historical distinctions except the one inherited from tradition, the dichotomy of Gothic and classic. From the first sentence of the first letter—"The ages, we call barbarous, present us with many a subject of curious speculation"—we find awkwardly ingenious apologetics preaching the vitality of the "barbarous" and the fascination of the "curious." Hurd's appreciation for faery, the incredible, the marvellous, admiration and delirium, may be genuine, but it willfully interferes with any objective search for the historical Gothic. The motto of the *Letters* might be those lines from "a wise antient" with which Hurd rebukes modern critics at the end of Letter Ten: "they, who deceive, are

71 *An Essay on Musical Expression* (London, 1753), p. 47.

72 Hoyt Trowbridge reviews and criticizes such claims for Hurd's significance in "Bishop Hurd: A Reinterpretation," *PMLA*, LVIII (1943), 450-65.

honester than they who do not deceive; and they, who are deceived, wiser than they who are not deceived."[73] Those who invite deception have no need of history.

In similarly internalizing the criteria for Gothic, Walpole pushed the opposition of "classic" and "Gothic" into absurdity. No enemy of medieval style could have taken more liberties with it. As a matter of principle, he insisted upon propriety of materials in Palladian architecture, while in the early years at Strawberry Hill "he seems to have been instinctively opposed to anything made of its right material."[74] If "classic" meant ancient, pure, and lasting, by contrast "Gothic" taste must strive for the novel, artificial, and ephemeral. We all know that the influence perpetrated and disseminated by *The Castle of Otranto* lay not in any exploration of the historical middle ages so much as in the exploitation of an armory of mysterious and horrifying contraptions: dungeons, secret passages, creaking doors and clanging weapons, the shadows cast by stained glass, "pomp, mechanism, vaults, tombs, painted windows, gloom." Most of this apparatus was derived by Walpole from the play of his uncensored imagination upon the physical appearance of Strawberry Hill,[75] itself admittedly not so much imitation Gothic as imaginary Gothic. The peculiar *Gothicism* of his novel, Walpole argued, consists of a suspended, dreamlike entertainment of every kind of prodigy. It duplicates the process of making Gothic rather than literally representing its manifestations: "one only wants passions to feel Gothic." Shorn of any content outside of verbal and psychological associations, the spirit of Gothic took revenge upon its critics. Universal darkness at last became popular.

As an episode in the history of taste, and as the harbinger of a less playful Romanticism, Walpole's contribution to the Gothic revival was not insignificant. Moreover, as the years passed he became more scholarly, more interested in distinguishing the historical realities of Gothic from its camp followers; the plan supplied for Gough's *Sepulchral Monuments in Great Britain* is an

[73] *Letters on Chivalry and Romance*, ed. E. J. Morley (London, 1911), p. 144.

[74] Clark, *Gothic Revival*, p. 85. Cf. Walpole's letter to Bentley, in *Letters* (Oxford, 1903), III, 108-121.

[75] Oswald Doughty describes the circumstances of composition in his edition of *The Castle of Otranto* (London, 1929).

ambitious beginning at accurate and informed restoration.[76] Nevertheless, the *Anecdotes* arrive at no useful definition of Gothic, and no critical principles with which to judge it. By shifting emphasis from the work to the sensations of the audience, Walpole justified his preference without opening the subject for fuller discussion. He elided a century of argument into a timely refuge of antiquarian romance. Once again he had slipped away from a critical commitment. To systematize, to redefine, to reason about Gothic architecture or English art were not Walpole's attainments. To have noticed them at all, and through his notice to have lent them glamor, was his peculiar and great accomplishment.

8. WALPOLE, VASARI, AND BIOGRAPHY

In spite of himself, however, Walpole had been enlisted as the leading biographer of English painters. As the *Anecdotes of Painting in England* accumulated, willy-nilly they developed a biographical method of their own, determined by their authors' views of human character and of art. Nor was Walpole unwilling to pose as the English Vasari. He knew that Vertue had hoped to challenge comparison with *Le Vite de' Più Eccellenti Pittori, Scultori e Architetti*, and he liked to refer gracefully to his own "Vasarihood." English lives of painters had begun, quite literally, as a slender supplement to Vasari; the *Anecdotes* would complete that supplement.

To pit *Le Vite* against the *Anecdotes* is of course to overmatch the English work. Vasari, in spite of his lack of sympathy for Gothic style, had laid the foundation for an art-historical approach to Gothic remains;[77] Walpole, in spite of his sympathy for Gothic, had muddled its history. Among the moderns, Vasari was preserving an age which he believed had achieved perfection; Walpole was recording fragments of the past in the hope that future painters would learn to do better. Vasari was an artist writing for artists; Walpole an antiquarian writing for collectors. As a

[76] Walpole's letter to Cole of 11 August 1769, which outlined the plan, was sent to Gough, who reprinted it in *Sepulchral Monuments*.

[77] See Erwin Panofsky, "The First Page of Giorgio Vasari's 'Libro,'" *Meaning in the Visual Arts* (New York, 1955), pp. 169-235.

critic and theoretician Vasari influenced Walpole, but Walpole shied from theory and scattered his criticism in small dabs. Moreover, Walpole omitted just those sections for which Vasari was most noted: the introductory discussions of style, and the commentary on technique. Surely Walpole's Vasarihood did not run very deep.

In calling his work *Anecdotes* rather than *Lives*, Walpole himself had shunned the comparison. Yet the difference between the words will not account for the differences of method unless we preserve each word's older sense: "anecdotes" as secret histories, and "lives" as in "Lives of the Saints," the pattern rather than the literal facts of biography. Vasari is interested above all not in the life of individual painters, not even in their glorification, so much as in the history of style and the glorification of painting itself.[78] The greatest painters, "mortal gods" as Vasari delights in calling them, ascend into a celestial purity of style where biographical facts or personality cease to matter. "Although Vasari has called his history of art the *Lives of the Painters*, and although in it the education of the artist, to whom the book is in part addressed, assumes the importance of that of the prince, the fame for which the artist works involves a kind of sacrifice of individuality."[79] Vasari demands one thing of his painters—that they devote their lives to the service of art—and he arranges his biographies emblematically to consecrate that service.

The strength of Vasari's method consists in its ability to subsume a wide range of material in a unified pattern. Biographical anecdotes, *ekphrasis*, aesthetics, and technique all are relevant to a consideration of the artist's unique contribution to his art. The problem of the *Anecdotes* is that it possesses no equivalent principle of biographical organization. Walpole is no more anecdotal than Vasari, but he seems so, because he fails to put facts or stories to any service higher than their inherent capacity to inform or amuse. Just as the criticism of the *Anecdotes* is intended for collectors and the history of the *Anecdotes* focuses on patronage,

[78] E.g., Vasari on Raphael: "O art of painting, thou couldst then esteem thyself most blessed, in possessing a craftsman who, both with his genius and his virtues, exalted thee higher than Heaven!" *Lives of the Most Eminent Painters, Sculptors and Architects*, tr. G. Du C. De Vere (London, 1912-1914), IV, 249.

[79] Svetlana L. Alpers, "*Ekphrasis* and Aesthetic Attitudes in Vasari's *Lives*," *JWCI*, XXIII (1960), 212.

the biography of the *Anecdotes* is broken into a piecemeal gathering of antiquarian tidbits. To be sure, Walpole is adept at capturing a personality; his acute and cunning sketches of character succeed just where Vasari is weak, in the preservation of individuality. Yet that success depends upon a deliberate refusal to make personality the servant or the emblem of an artistic whole.

Because Walpole's memoir of William Hogarth is more consistently carried through than most of the *Anecdotes,* it helps to reveal what he expects from biography. Here for once we find a critical estimate: Hogarth was a "great and original genius . . . considering him rather as a writer of comedy with a pencil, than as a painter" (IV, 146-7); for "as a painter, he had but slender merit" (IV, 160). Beneath the wit with which Walpole pushes home the analogy and paradox of Hogarth as an author—"It was reserved to Hogarth to write a scene of furniture" (IV, 159)—one can perceive a controlling judgment. Walpole attributes Hogarth's successes and failures alike to his powers as a visionary, his inventive capacity to people the air with imaginative detail: "the genius that had entered so feelingly into the calamities and crimes of familiar life, deserted him in a walk that called for dignity and grace" (IV, 164). Anecdotes about Hogarth's ambition and self-esteem contribute to a vivid (if malicious) study of a great comic author aspiring to excellences not his own.

If one takes exception to such an estimate, it should not be because Walpole is wrong to see Hogarth's personality in his art. Modern critics agree that "All these elements in his character are apparent in his work."[80] Nor should Walpole's inability to perceive Hogarth's (now acknowledged) resources as a painter prejudice us against his biographical method. The *Anecdotes* make a handsome *attempt*, at any rate, to be objective. What compromises that attempt, however, is the way in which all the facts and the criticism are aimed at isolating a personality, or more precisely some quirks of personality. Walpole's praise for Hogarth's comic genius can be generous and detailed, but it teaches us nothing about painting. Almost every remark about a specific work could equally refer to a poem: "If he had an

[80] Waterhouse, *Painting in Britain*, p. 118.

emblematic thought, he expressed it with wit, rather than by a symbol. Such is that of the whore setting fire to the world in the Rake's Progress" (IV, 156). The principle of biography in the *Anecdotes* is that of a cicerone who wishes to whet curiosity and satisfy it, not to explore a problem of art or character. The success of such biography can only be measured by its power to divert an audience always in peril of boredom.

A similar diversion of interest away from art and problems of artistic form may be observed in Walpole's *ekphrasis*,[81] or rhetorical descriptions of paintings. We have already spoken of the importance of the *Anecdotes* as an imaginary museum, and Walpole does his best to stock such a museum with verbal descriptions. Vasari had placed a major emphasis on *ekphrasis*, and Walpole took some pride in his own ability to paint with words. What immediately strikes us, however, is his tendency to find anecdotal interest in the represented object, rather than in the painter's conception or representation of a subject. The *Anecdotes* gossip about those who sit for portraits; the portraitist is sufficiently praised when told that he has caught a likeness. A familiar example of this habit of finding the picturesque in life rather than art is Walpole's comment on Watteau. Having always been puzzled by the unnatural trees in Watteau's landscapes, Walpole discovered the truth when he visited Paris. "There I saw the originals of those tufts of plumes and fans, and trimmed-up groves, that nod to one another like the scenes of an opera" (IV, 74). When Walpole looks at a painting, he sees scenery, drama, or literature.

Because Walpole's eye for the picturesque is famously keen,[82] the *Anecdotes* abound with charm and insight, particularly when they survey an artist like Hogarth whose work rewards literary associations and alertness to detail. What we cannot expect from such quickness of eye is exactly what Richardson had thought to be the purpose of a history of painting: "a clear idea of the noblest species of beings we are acquainted with, in that particular

[81] In his own discussion of *ekphrasis* (*The Sister Arts*, p. 18n.) Jean Hagstrum introduces a distinction between "speaking pictures," which he would call "ecphrastic," and "iconic" literary descriptions.

[82] The varied reactions of Gray and Walpole to the landscape of their Grand Tour in 1739-1741 have often been cited as containing the origins of the eighteenth-century "picturesque moment."

wherein their pre-eminence consists."[83] It is personality, not the sort of dedication that consumes and transmutes personality, which Walpole seeks out both in men and in works of art. The biography practiced by the *Anecdotes* is based upon no clear ideas, upon no general formulation of the relationship between artists and their works, upon no conviction about the nobility of art.

Unlike Vasari, Walpole does not elevate our ideas of painting. Yet he gives us something in exchange, something that might be called (depending on whether or not we like it) either the Commonsense Tradition or the Philistine Ideal. Refusing to claim a great deal for art, he is animated by the same genial and modest spirit that would lead Charles Burney to define music as "an innocent luxury, unnecessary, indeed, to our existence, but a great improvement and gratification of the sense of hearing."[84] That Walpole respects painting and is interested in painters, the *Anecdotes* themselves attest. For the rest, he is content to make obvious criticisms and to take short views. He enjoys walking among Watteau's trees, or pulling the beards of unpicturesque Puritans, or showing the family portraits to visitors. He patronizes painters in the good as well as the bad sense. And if we want more, we are at liberty to look elsewhere.

9. WALPOLE, BECKFORD, AND NEW DIRECTIONS

Where else, however, shall we look? In eighteenth-century England there was no model of art history or biography, no accepted principle of what a biographer should do. If the necessary preliminary to art history is an interest in schools of painting, if the necessary preliminary to full-scale biographies of artists is an interest in the creative process, then Walpole's contemporaries had hardly begun to lay the groundwork for either. A few painter-heroes, notably Michelangelo and Raphael, had been adopted by the English, but the nature of their heroism had yet to be determined. Indeed, the pretensions of artists, the importance of their lives, often seemed a bit comic to Walpole and his readers. The biographer of painters would do well not to be too serious about his work.

Perhaps the full weight of such attitudes can best be appreciated

[83] *Works*, p. 285.
[84] *A General History of Music*, ed. Frank Mercer (New York, 1957), p. 21.

by adding a new member to a familiar series: Walpole, Strawberry Hill, *The Castle of Otranto, Anecdotes of Painting in England*; Beckford, Fonthill, *The History of the Caliph Vathek, Biographical Memoirs of Extraordinary Painters*. Comparisons of Walpole with Beckford have always seemed inevitable.[85] Fonthill, in spite of the notorious speed with which its tower crumbled, was strong precisely where Strawberry Hill was weak, in the creation of a powerful imaginative order behind the gestures of imagination; the ruin which it became was no sham. Similarly *Vathek* tests the faults of *Otranto*. Beckford's visionary excesses uncover the restraint at the heart of Walpole's own would-be excess.

The *Biographical Memoirs of Extraordinary Painters*, a little volume of satires composed before Beckford was twenty,[86] and published in 1780, the same year as the long-withheld fourth volume of the *Anecdotes*, defames "anecdotes" in both senses of the word: the collection of minute facts, and the telling of tall stories. Actually, Beckford took aim at nearer targets than Walpole. The cicerone he had in mind was his own housekeeper as she chattered to visitors about the pictures at Fonthill; the antiquarian work he parodies is Jean Baptiste Descamps' *La Vie des peintres flamands, allemands et hollandois* (Paris, 1753-1763). Yet the *Memoirs* eventually bring into question not only Walpole's methods, but the validity of artistic biography itself.

In form Beckford's early work is not revolutionary. The *Biographical Memoirs* describe the strange careers of six imaginary painters whose faults seem neatly arranged to balance each other. Thus Og of Basan, who searches for an ultimate wilderness, is succeeded by his tame and cautious rival Sucrewasser; the anatomist Blunderbussiana literally strips life to the raw, and Watersouchy never touches it. The position behind the satire seems to approximate a neoclassic ideal of the mean between extremes. Beckford's own tastes in painting were middle-of-the-road,[87] and he sig-

<hr />

[85] See for instance H. A. N. Brockman, *The Caliph of Fonthill* (London, 1956), p. 199, and Pevsner's introduction to it, p. xii.

[86] Fifty-five years later, Beckford told Cyrus Redding that the book was written at seventeen, but evidence suggests that some lives date from 1777 (when he was sixteen), and others from 1779-1780 (when he was nineteen). See "Lewis Melville" (L. S. Benjamin), *The Life and Letters of William Beckford of Fonthill* (London, 1910), pp. 67-75; and Robert Gemmett, "The Composition of William Beckford's *Biographical Memoirs of Extraordinary Painters*," PQ, XLVII (1968), 139-141.

[87] See the list of his acquisitions in Brockman, *Caliph of Fonthill*, p. 173.

nificantly avoids burlesquing any Italian or French painter. His butts are Northern painters, the fanatics and miniaturists who lose themselves in the particular.

A similar prejudice against the particular is directed against biographers like Descamps or Walpole, men who consider any trivia worth noting, and who share the pettiness of Northern painters without sharing their concern for accuracy. The anecdote of Aldrovandus Magnus' painting of the burning bush, for instance, tells us all we need know about anecdotes: "the young Princess Ferdinanda Joanna Maria being brought by the Duchess, for a little recreation, to see him work, cried out, 'La! Mamma, I won't touch that bramble bush, for fear it should burn my fingers!' This circumstance, which I am well aware some readers will deem trifling, gained our painter great reputation amongst all the courtiers, and not a little applause to her Serene Highness, for her astonishing discernment and sagacity."[88] This sugary piece of apocrypha discredits the teller (or his self-conscious *persona*) far more than the courtiers. What sort of biographer could consider such childishness worth recording? Perhaps a biographer like Walpole. The anecdote of the precocious infanta recalls some of Walpole's most characteristic practices: his flattering digressions into royalty and patronage,[89] his refusal to censor any bit of gossip, his literal-minded concentration on the represented object.

The effect of the *Biographical Memoirs*, then, is to ridicule the interests of contemporary antiquarian art history. Beyond that, Beckford seems bent on destroying the very idea of writing biographical anecdotes of artists, which can only substitute fictions and romance for the paintings themselves. Thus far he is a proper orthodox neoclassicist. Yet his burlesque suffers from strange lapses in tone. A critic in the *Monthly Review*, for one, was not at all sure he understood such "vexatious obscurity," such a "mingled mess of true and fictitious history": "Not content with studying this performance carefully, we have consulted both professors and virtuosos concerning it; but still remain in the dark with

[88] *Biographical Memoirs of Extraordinary Painters* (London, 1834), p. 14.
[89] Beckford (however snobbish himself) despised Walpole's snobbery when the two men met ("Melville," *Life and Letters of William Beckford*, p. 299).

respect to the Author's real drift."[90] Beckford's wit was appreciated, but it seemed to uphold no clear and distinct ideas.

The life of Og exemplifies what went wrong. Og, an amazing and insufferable genius, pursues a Faustian quest for a landscape adequate to his powers, and he ends like Faust; his story illustrates "the dangers and extravagances to which genius is exposed."[91] Yet at moments the satirist seems to be replaced by the author of *Vathek*, whose finesse does not prevent him from relishing, with an ambiguously mixed fascination and laughter, the supernatural bravado of his puppet. As Og wends south to Sicily in fulfillment of his quest, Beckford becomes more and more long-winded, and his humor becomes more and more difficult to separate from horror. When at last Og's disciple, having traced him to a volcano, "fancied he beheld strange shapes descending and ascending the steeps of the fiery gulph. . . . believed he heard the screams of desolation and the cries of torment issuing from the abyss,"[92] we are forced to conclude that the author, having begun by condemning romantic embroidery, has finished by admiring it. Faustian himself, Beckford more than half believes in the wild genius he has invented.

Thus the *Biographical Memoirs,* whose satire purports to defend art and the lives of artists from the dabblings of biographers, finally surrender to biographical fantasy. Beckford could not control his own point of view. If the reasons for this include his febrile and volcanic imagination, they also include the mixed state of biography in his time. Raconteurs like Walpole had shown little concern for the relation between works of art and the psychology of artists; the *Anecdotes* provide information about all the objects of creation save the creative process itself. Hence creative process, denied and ignored, became a mystery associated with that "insistence of horror," that supernatural refuge of poetry,[93] which produced such destroyers and creators as Gray's Bard and Walpole's Manfred and Beckford's Og. The biographies of artists could not forever evade such mysteries. When Beckford uncontrollably swerves his attention from biographical anec-

[90] *Monthly Review,* LXIII (1780), 469. [91] *Biographical Memoirs,* p. 87.

[92] *Ibid.,* p. 85. Cf. *Vathek,* tr. Samuel Henley, in *Shorter Novels of the Eighteenth Century,* ed. Philip Henderson (London, 1930), p. 209.

[93] Patricia Spacks, *The Insistence of Horror: Aspects of the Supernatural in Eighteenth-Century Poetry* (Cambridge, Mass., 1962).

dotes towards the dangerous creative spirit behind the art, he is being "Romantic" in more senses than one. The *Biographical Memoirs* anticipate the effort to explore the life of the creator in hope of finding the source of his work.

Walpole makes no such effort. The *Anecdotes* do not seek out connections between painters and their works, and they display no standard of biographical relevance. For an idea of painting readers were advised to go to Reynolds' *Discourses* (advertised as a complement to the *Anecdotes*),[94] and for an idea of the creative process they would have to wait for another generation of painters. Walpole is no syncretizer or synthesizer, no disciple of Richardson, no harbinger of Romantic thought. He writes to amuse, not to win followers, and he has no method to promulgate.

Nevertheless, part of the future also belonged to the *Anecdotes*. Walpole's interest in the affairs of painting proved more durable than any amount of speculation. In the absence of an English Vasari, it was his Vasarihood which shaped the history of English art, and it is to him we return to understand the common run of eighteenth-century connoissance. Reynolds might affirm the theoretical dignity of painting, but Walpole's communicable affection for the business of the antiquarian and collector charmed scholars to humbler pleasures. The Walpole Society is not idly named. We respect the heirs of Junius, we esteem and honor Reynolds, but our practice of scholarship does not follow their directions. In our own time historians of English art must still look to Vertue and Walpole to find their own sources.

[94] Walpole's criticism of art has recently been discussed in relation to Reynolds by F. W. Hilles, "Horace Walpole and the Knight of the Brush," *Horace Walpole: Writer, Politician, and Connoisseur*, ed. W. H. Smith (New Haven, 1967), pp. 141-66.

The Art of Reynolds'
Discourses

1. BLAKE AND THE BOOK

BY the time Sir Joshua Reynolds died in 1792, most of his pictures had begun to fade; but his literary degradation had yet to come. Great writers gather all past history to themselves, and the more we perceive the greatness of William Blake, the more likely we are to perceive Reynolds' *Discourses* through the screen of Blake's famous marginalia. Indeed, those embattled and overscribbled pages often seem to preserve the ultimate romantic repudiation of the neoclassical world: its aesthetics, its style, its psychology, even its politics.[1] Blake himself approved this vision of a war between giants. "It is not in Terms that Reynolds & I disagree Two Contrary Opinions can never by any Language be made alike."[2] Compromise and reconciliation were not Blake's weapons. With mental force he had confronted Reynolds' eighteenth century, a century abandoned by the muses, and he had put its feeble shades to flight.

One fact about the "Annotations to *The Works of Sir Joshua Reynolds*," however, is so obvious that we are prone to overlook it: first of all and above all, they are an attack on a book. The attack begins on the title page, where the official portrait of Reynolds is forced to gaze across at the taunts of his enemy [Plate 3] —"This Man was Hired to Depress Art This is the opin-

[1] Among the many studies of Blake's attack on Reynolds, there is a useful introduction by Herbert Wright, "William Blake and Sir Joshua Reynolds: A Contrast in Theories of Art," *The Nineteenth Century*, CI (1927), 417-31 (and see the reply by D. H. Banner, 620); a clear summary by Frederic Will, "Blake's Quarrel with Reynolds," *JAAC*, XV (1957), 340-49; an elegant interpretation by Edgar Wind, "Blake and Reynolds," *The Listener*, LVIII (1957), 879-80.

[2] "Annotations to *The Works of Sir Joshua Reynolds*," in *The Poetry and Prose of William Blake*, ed. David Erdman with commentary by Harold Bloom (New York, 1965), p. 648. This edition will hereafter be cited as *Blake*.

ion of Will Blake my Proofs of this Opinion are given in the following Notes"—and by the back of the page the attack has risen to white heat: "Having spent the Vigour of my Youth & Genius under the Opression of Sr Joshua & his Gang of Cunning Hired Knaves Without Employment & as much as could possibly be Without Bread, The Reader must Expect to Read in all my Remarks on these Books Nothing but Indignation & Resentment."[3] Blake does not *reason* with Reynolds. "What has Reasoning to do with the Art of Painting?"[4] Rather, he sets out to deface and defame the *Discourses*; to throw blots on Reynolds' scutcheon.

No one has ever been more conscious than Blake of the total impression given by a book, the complex composite art which blends its physical appearance and inner meaning in a single vision.[5] In their original form, the *Works* of the president of the Royal Academy supply one such image; annotated and defaced, they supply quite another. Blake "revisions" the definitive Reynolds and makes it his own. Just as he surrounds his literal copy of the *Laocoon* group with a hallucinatory barrage of mottoes and revelations that convert Laocoon into Blake's own myth of Jehovah,[6] so he rings Reynolds' proper and considered sentiments with a swirl of little satiric poems and rallies and aphorisms and challenges. "Fool—A Mock—Slang—Villainy—A Lie—O Shame False—Folly!—Damned Fool—Nonsense—I certainly do Thank God that I am not like Reynolds." Blake attacks the page, the eye, the spirit. With magic and art he exorcises the demon of Sir Joshua, and possesses his book.

The book that Blake claimed for his own, however, was not a symbol only for him. It was, indeed, *the* book on painting: Malone's Reynolds, as authoritative in its way as Malone's Shakespeare.[7] *The Works of Sir Joshua Reynolds, Knt.*, sumptu-

[3] *Blake*, p. 625. The dating of the marginalia remains problematical. For various reasons ca. 1808 seems most plausible, but Blake's reference to himself as still poor at sixty-three (p. 631) indicates that at least a part was written as late as 1820.

[4] *Blake*, p. 636.

[5] See Northrop Frye, "Poetry and Design in William Blake," *JAAC*, X (1951), 35-42; Jean Hagstrum, *William Blake: Poet and Painter* (Chicago, 1964).

[6] יה *& his two Sons Satan & Adam; Blake*, pp. 270-72 and plate 3.

[7] The first edition of Reynolds' collected *Works*, prefaced by Edmond Malone's "Account of the Life and Writings of the Author," was published in London in two handsome quarto volumes in 1797. Blake annotated the first volume (including Malone's Account and the first eight Discourses) of the three-volume second edition published in octavo in 1798. His copy is now in the British Museum, along with

ously edited and introduced, were intended to "comprise the whole science and practice of painting,"[8] and for most readers they had succeeded. Even Reynolds' natural enemies paid homage to his authority. Thus Henry Fuseli, the only man who did not make Blake almost spew, introduced his own lectures at the Royal Academy by sending his students back to The Book. "Of English critics, whose writings preceded the present century, whether we consider solidity of theory or practical usefulness, the last is undoubtedly the first. To compare Reynolds with his predecessors would equally disgrace our judgment and impeach our gratitude. His volumes can never be consulted without profit, and should never be quitted by the student's hand, but to embody by exercise the precepts he gives and the means he points out."[9] The generation of artists who followed Reynolds had to cope with a problem that no previous English generation had faced —the heritage and burden of a tradition, of Reynolds himself.

For Blake and many of his contemporaries, that heritage represented a vast weight upon the spirit.[10] Not only did Reynolds stand for authority, he had anticipated most of the recourses against authority; "when me they fly, I am the wings." The *Discourses* had found room for opinions that an original and creative mind might prefer to discover for itself. Here Blake could encounter some of his own favorite principles of art—the centrality of mind in the work of the artist, the supremacy of Raphael and Michelangelo, the reliance of the great style upon firm outlines, the equation of art and truth—insidiously combined with doctrines he believed to be so pernicious that only a devil could have conceived them. So smooth a mixture of contraries seemed to violate not only Blake's ideas about painting, but the sources of his creativity.

The mixture of contraries was not accidental. Reynolds had

unmarked copies of the second and third volumes. Malone's great edition of Shakespeare had been published in 1790.

[8] Malone's "Account," in Reynolds' *Works* (1797), I, xliii.

[9] *Lectures on Painting, delivered at the Royal Academy* (London, 1820), introduction. Fuseli here recants the earlier harsh view of the *Discourses,* in his revision of Pilkington's *Dictionary of Painters* (London, 1805), that being written "before he had profoundly considered the subject, they are frequently vague and unintelligible, and sometimes contradictory" (p. 446).

[10] See L. M. Trawick, III, "Hazlitt, Reynolds, and the Ideal," *Studies in Romanticism,* IV (1965), 240-47.

meant to disarm his critics by incorporating their attacks into his work; even Blake's *graffiti* might have found place in a new variorum. By the time of the last Discourse Reynolds thought he had succeeded in putting the whole art into order: "though in what has been done, no new discovery is pretended, I may still flatter myself, that from the discoveries which others have made by their own intuitive good sense and native rectitude of judgment, I have succeeded in establishing the rules and principles of our Art on a more firm and lasting foundation than that on which they had formerly been placed."[11] In a characteristic British way, the Establishment that Reynolds had formed ruled by being reasonable. It dealt with dissenters by inviting them to tea and reviewing their works with mild favor, not by stimulating them with opposition. The *Discourses* dispose of inimical views of art by polishing them to a new and unobjectionable luster.

Such acceptance can be very disquieting. To a passionate believer, the absence of resistance may seem the ultimate insult, and in his last years Reynolds met with recurrent hostility of a kind that seemed beyond a rational motive or object.[12] James Barry offers an instructive example. A complicated and irascible personality who bore patrons even less well than fools, Barry began his career as the protégé of Burke and Reynolds, and became the foremost disciple of their encouragement of history painting in the grand style. Having listened carefully to his mentors, he knew that portraits occupied an inferior rank, and that only an unceasing quest for grandeur could properly dignify the mental adventures of a young painter. The result of this teaching was predictably ironic: Barry applied Reynolds' principles far more uncompromisingly than Reynolds ever had, turned his ideals savagely against him, and mocked his work. Eventually Reynolds' disciple became the only man whom Reynolds ever confessed he hated.[13]

[11] Sir Joshua Reynolds, *Discourses on Art*, ed. R. R. Wark (San Marino, Cal., 1959), p. 269. Page numerals in the text will refer to this edition.

[12] The various controversies are best followed in *Life and Times of Sir Joshua Reynolds: with Notices of some of his Cotemporaries*, commenced by C. R. Leslie, concluded by Tom Taylor (London, 1865), 2 vols. Joseph Farington's *Diary*, ed. James Grieg (London, 1922-1928), 8 vols., provides other contemporary accounts.

[13] James Northcote, *Memoirs of Sir Joshua Reynolds* (Philadelphia, 1817), p. 253.

Despite his quarrels with Reynolds, however, Barry never came free of his domination. Moreover, Reynolds himself seems to have modified his work as an oblique reply to Barry's criticism. The late heroic portraits and the later Discourses are calculated to achieve a new grandeur, and Barry, at any rate, believed that he had impelled Sir Joshua, in his old age, toward "pursuit of the extraordinary and grand of the art."[14] The result was a fresh reconciliation. In a lengthy tribute to Reynolds read to the Academy a year after his death, Barry made his peace: he used the style of his old mentor to enroll Sir Joshua himself among those great predecessors gathered from all ages to train the minds of painters. The spirit of Reynolds might have been speaking. "Go home from the academy, light your lamps, and exercise yourselves in the creative part of your art, with Homer, with Livy, and all the great characters, ancient and modern, for your companions and counsellors."[15] Perhaps Barry's own lectures, like his uneasy genius as a painter, would have achieved more distinction had they not been so intellectually bound to the authority he resented.[16]

That Reynolds had succeeded in creating a tradition, a Book that was quoted even by its enemies, must be regarded as the most remarkable of all his remarkable achievements. At the end of his career his position as the official representative of the artistic establishment may have appeared constricting, but at the beginning of his career a painter who had made such a claim would have been merely impertinent. The Discourses had convinced readers that painting was worthy of systematic discussion.

Such recognition had been a long time coming. When Reynolds furnished his first epistle to The Idler in 1759, he took care to sound casual: "For my own part, I profess myself an idler, and love to give my judgment, such as it is, from my immediate perceptions, without much fatigue of thinking"; and he went on to apologize for his specialized topic: "I do not know whether you will think painting a general subject. By inserting this letter, perhaps you will incur the censure a man would deserve, whose

14 *The Works of James Barry, Esq.: Historical Painter* (London, 1809), I, 556.
15 *Ibid.*, p. 555.
16 For Barry's career, see R. R. Wark, *James Barry* (unpublished Ph.D. dissertation, Harvard, 1952), and David Irwin, *English Neoclassical Art* (London, 1966), pp. 38-43.

business being to entertain a whole room, should turn his back to the company, and talk to a particular person."[17] Yet by the 1780's he could fill a lecture hall on his own terms with a company of the most intellectually distinguished men in England.[18] Between the time of his first diffident gestures, and the age when his dead hand seemed able to threaten the greatest of talents, Reynolds had persuaded the world that there was a main line of thought about painting, and that he was its spokesman.

2. A Literate Profession

The authority of the *Discourses*, then, was the triumph of Reynolds' career; or rather, of his two careers, his career as the most successful painter whom England had produced, and his equally gratifying literary career. He had hoped and planned for that triumph from the beginning. Indeed, throughout his life his aspirations were extraordinarily consistent. As Boswell records in his notes towards a biography of Reynolds, "When he read Richardson's *Principles of Painting*, he was struck with admiration of the art—thought it beyond all others—thought Raphael beyond Pope and all eminent persons—'and indeed' (said he smiling, 20 December 1791) 'I have indulged that notion all along.' "[19] The words of Richardson, his call for a young painter capable of "attempting and hoping only to equal the greatest masters of whatsoever age or nation,"[20] echo through the decisive moments of Reynolds' career, from the moment when, at sixteen, he told his father that "he would rather be an Apothecary than an *ordinary* Painter, but if he could be bound to an eminent master, he should choose the latter"[21] to the moment when, at sixty-seven, he passed Richardson's legacy on to his students: "I Have endeavoured to stimulate the ambition of Artists to tread in this great path of glory, and, as well as I can, have pointed out the track which leads to it" (280-81). He had not swerved from his attempt to go beyond the ordinary.

[17] *Idler* No. 76, 29 September 1759, in the Yale Edition of the *Works of Samuel Johnson*, II (New Haven, 1963), 236; 238-39.
[18] See Leslie and Taylor, *Life and Times*, I, 318.
[19] *Portraits by Sir Joshua Reynolds*, ed. F. W. Hilles (London, 1952), p. 21.
[20] Richardson's *Works* (1773), p. 123.
[21] Samuel Reynolds to Mr. Cutcliffe, March 17, 1740; William Cotton, *Sir Joshua Reynolds, and his Works* (London, 1856), p. 45.

Reynolds cared deeply about success, however much he managed to hide it. A man does not become first president of the Royal Academy of Arts by accident. The intensity of his drive toward success, his unceasing manipulation of his career, account for some of the hostility of his contemporaries, and have continued to disturb his critics. Professor Waterhouse, for instance, finds something obsessional about Reynolds' determination to impose his authority on public taste,[22] and the biographers of Reynolds are coming to see that "beneath the surface he was tense and intense, restless and sensitive."[23] Yet our own discomfort about the means by which a professional man builds a career should not blind us to the significance of Reynolds' success. Eighteenth-century men of letters did not share the modern tendency to regard a desire for worldly success as a dirty little secret, incompatible with art. Indeed, Samuel Johnson shows more interest in a poet's habits of work, or attentions to his art and public, than in any other aspect of literary biography. With a professional's shrewd grasp of ethics, he knew that Reynolds' success was honorable, because achieved by hard work that served the cause of painting as well as his own.[24] Reynolds' art cannot be separated from the efforts that won recognition for his whole profession.

Nor can Reynolds' career as a painter easily be separated from his literary career. When Burke memorialized his dead friend in the famous "eulogium of *Apelles* pronounced by *Pericles*," he found it natural to stress his consistency. "He was the first Englishman, who added the praise of the elegant arts to the other glories of his country. . . . His paintings illustrate his lessons, and his lessons seem to be derived from his paintings."[25] Reynolds had earned that sort of praise. He never tired of repeating that literature and painting were alike accommodated "to all the natural propensities and inclinations of the mind" (234), and that all his work was primarily intellectual. Moreover, his literary success had proved that the mental discipline he had acquired as a painter

[22] E. K. Waterhouse, *Three Decades of British Art 1740-1770* (Philadelphia, 1965), p. 71 ff.

[23] Derek Hudson, *Sir Joshua Reynolds: A Personal Study* (London, 1958), p. 237.

[24] Johnson wrote the Dedication to the King for the 1778 edition of the first seven Discourses. *Boswell's Life of Johnson*, ed. G. B. Hill and L. F. Powell (Oxford, 1934), IV, 320, records his admiration for the *Discourses*.

[25] Reynolds' *Works*, I, lxix.

could be transferred to the preparation of his lectures.[26] The *Discourses* themselves demonstrate their favorite proposition, that a painter is a kind of philosopher.

A similar logic, the attempt to establish the intellectual dignity of art through example, explains why Reynolds should have worked so hard at his literary career long after he was wealthy and famous as a painter. In spite of Richardson's efforts, most eighteenth-century Englishmen still thought of painting as a narrow imitative skill. Though Samuel Johnson showed respect for the art when Reynolds was present, he probably spoke more from the heart when he said "I had rather see the portrait of a dog that I know, than all the allegorical paintings they can shew me in the world."[27] Amiable condescending attitudes like these were what Reynolds felt himself born to correct.

No one has ever been more sensitive to the problems of a painter in a literary culture than Roger Fry, whose elegant annotations to the *Discourses* return again and again to the theme that painting expresses the ideal. Shortly before Fry's death, he wrote "Looking back on my own work, my highest ambition would be to be able to claim that I have striven to carry on [Reynolds'] work in his spirit by bringing it into line with the artistic situation of our own day."[28] In the light of this inheritance, it may be appropriate to illustrate Reynolds' difficulties with an anecdote from Fry's career. According to Bernard Shaw, he once lunched with Fry and Sir Edward Elgar, and Shaw and Elgar, the music critic and the composer, monopolized the conversation. Amid all the talk of music Fry could find nothing to say. At last there was a pause, and he managed to slip in an innocent remark after the style of Reynolds: "After all, there is only one art: all the arts are the same." At this Elgar fell into "an appalling rage. 'Music,' he spluttered, 'is written on the skies for you to note down. And you compare that to a DAMNED imitation.' "[29] Fry made no reply. The only answer would have been to hand Sir

[26] This transference is a main theme of F. W. Hilles' *The Literary Career of Sir Joshua Reynolds* (Cambridge, 1936), a work to which I am much indebted.

[27] *Johnsonian Miscellanies* (Oxford, 1897), II, 15.

[28] Quoted by Virginia Woolf, in *Roger Fry: A Biography* (London, 1940), p. 125.

[29] The story is told in a letter from Shaw to Virginia Woolf, printed most recently by Leonard Woolf, *Beginning Again* (London, 1964), p. 126.

Edward a copy of Sir Joshua's *Discourses*; they had been fashioned to meet just such a predicament.

Indeed, so far was Reynolds from admitting Elgar's line of attack that he was reluctant to allow the very word *imitation*, in the sense understood by the enemies of painting, into his vocabulary.[30] The subject of Discourse VI, he writes, "will be *Imitation*, as far as a painter is concerned in it. By imitation I do not mean imitation in its largest sense, but simply the following of other masters, and the advantage to be drawn from the study of their works" (94). A painter, he suggests in this context, is not concerned to imitate mere particular nature; he will not dip his hands into the flux and oils of everyday reality, like any mechanic.[31] Rather, a painter's kind of imitation refers only to a self-contained world of art, to paintings that mirror other paintings. Such imitation ignores whatever in the art may be mechanical or illiberal. In Discourse VI Reynolds is quite uncompromising on this point, and the reason why is clear from the context: he has just reminded his students that one of the main purposes of the *Discourses* was "to intercept and suppress those prejudices which particularly prevail when the mechanism of painting is come to its perfection; and which, when they do prevail, are certain utterly to destroy the higher and more valuable parts of this literate and liberal profession" (93).

A literate and liberal profession—that was the career which Reynolds had chosen. It must be liberal (as opposed to servile or mechanical)[32] because the painter must be free to pick his own subjects; it must be literate (as opposed to unlearned or artless) because the painter must be well "read," familiar with previous accomplishments in his art.[33] Like the ideal poet envisioned by

[30] Reynolds' understanding of imitation has lately been discussed by R. Wittkower, "Imitation, Eclecticism, and Genius," *Aspects of the Eighteenth Century*, ed. E. R. Wasserman (Baltimore, 1965), pp. 143-161; and H. D. Goldstein, "*Ut Poesis Pictura*: Reynolds on Imitation and Imagination," *Eighteenth-Century Studies*, I (1968), 213-235.

[31] Cf. Discourse XIII, especially pp. 232-233.

[32] *OED*. Johnson's first definition of "liberal" is "Not mean; not low in birth; not low in mind."

[33] Such literacy did not necessarily require knowledge of literature. Northcote, following Reynolds, argued that "literary" painters like Poussin were merely pedantic, since dependent on poetry for their subjects and sentiments. "On the Independence of Painting and Poetry," No. IX (May 9, 1807) in Prince Hoare's collection *The Artist* (London, 1810), Vol. I.

Imlac, Reynolds' ideal painter acquires a liberal education in the course of mastering his profession. "Like a sovereign judge and arbiter of art, he is possessed of that presiding power which separates and attracts every excellence from every school; selects both from what is great, and what is little; brings home knowledge from the East and from the West; making the universe tributary towards furnishing his mind and enriching his works with originality, and variety of inventions" (110). This passage might have convinced Rasselas that no human being can ever be a painter; but from Edmund Burke it won the highest praise: "This is, indeed, excellent, nobody can mend it, no man could say it better."[34]

Burke's praise must have been important to Reynolds, because Burke as much as any other critic supplies a test of Reynolds' theory of imitation and his literate profession.[35] *A Philosophical Enquiry into the Origin of Our Ideas of the Sublime and Beautiful* (1757) had argued that painting, unlike poetry, achieves its effects largely through the lower kind of imitation, literal description. "In reality, poetry and rhetoric do not succeed in exact description so well as painting does; their business is to affect rather by sympathy than imitation, to display rather the effect of things on the mind of the speaker, or of others, than to present a clear idea of the things themselves."[36] This line of argument, with its suggestion that painting appeals to the eye rather than the mind, made Reynolds uncomfortable. In Discourse VIII (1778), his own comparison of poetry and painting insists that both arts work upon the passions and affections of the mind, and differ only in means. "A complete essay or enquiry into the connection between the rules of Art, and the eternal and immutable dispositions of our passions, would be indeed going at once to the foundation of criticism" (162). Later Reynolds added a footnote: "This was inadvertently said. I did not recollect the admirable treatise *On the Sublime and Beautiful*." A painter who

[34] James Northcote, *The Life of Sir Joshua Reynolds* (London, 1818), II, 316.

[35] On Burke and Reynolds, see D. C. Bryant, *Edmund Burke and his Literary Friends* (St. Louis, 1939), chapter III.

[36] *Philosophical Enquiry*, ed. J. T. Boulton (London, 1958), p. 172. Burke, who pronounced himself insensitive to paintings, agreed that they affected through sympathy (p. 44), but to a lesser degree than poetry (pp. 174-75).

thought his own art as noble as any other might sometimes find it convenient to forget Burke.[37]

Eventually, however, Burke came round to Reynolds' view of painting as a literate and liberal profession, an art working rather by sympathy than by exact description. Near the end of his magnificent valedictory *Letter to a Noble Lord* (1795), it was to a painting he turned for an image of those sympathies which hold together a civilized society. "It was but the other day, that on putting in order some things which had been brought here on my taking leave of London for ever, I looked over a number of fine portraits, most of them of persons now dead, but whose society, in my better days, made this a proud and happy place. Amongst these was the picture of Lord Keppel. It was painted by an artist worthy of the subject, the excellent friend of that excellent man from their earliest youth, and a common friend of us both, with whom we lived for many years without a moment of coldness, of peevishness, of jealousy, or of jar, to the day of our final separation."[38]

By summoning an idealized vision of Lord Keppel to administer the *coup de grâce* to Keppel's brash nephew, the Duke of Bedford (the antagonist of the *Letter*), Burke borrows not only Reynolds' picture but a chain of associations. Augustus Viscount Keppel had figured beyond any other man in Reynolds' career.[39] It was he who whisked the 25-year old Joshua off to the Mediterranean and his Italian Renaissance in May 1749; and it was the great portrait of Commodore Keppel in 1753-1754 that made Reynolds famous. Its tempestuous heroism, modelled on the Apollo Belvedere,[40] set a pattern not only for English art but for the idealized character portrayed by Burke. "Lord Keppel was something high. It was a wild stock of pride, on which the tenderest of all hearts had grafted the milder virtues."[41] The portrait Burke owned, one of five commissioned from Sir Joshua to

[37] Late in Burke's life, however, Reynolds solicited him to bring out an improved edition of the *Philosophical Enquiry*. James Prior, *Life of Burke* (London, 1826), I, 58.

[38] *The Works of the Right Honourable Edmund Burke* (London, 1803), VIII, 63-64.

[39] For Keppel, see Thomas Keppel, *The Life of Augustus Viscount Keppel* (London, 1842), 2 vols.

[40] Reynolds also drew upon the Italians and probably Allan Ramsay. E. K. Waterhouse, *Painting in Britain: 1530-1790* (London, 1962), pp. 156-57.

[41] Burke, *Works*, VIII, 66.

celebrate Admiral Keppel's acquittal at court-martial in 1778, deliberately reaffirms that character [Plate 4]. Reynolds chooses a style and background that invoke his earlier portrait,[42] and the features of his friend are aged in a heroism obviously intended as a reminiscence of a long pictorial and emotional association. Such a portrait must have affected Burke "rather by sympathy than imitation." It aroused memories of friendship, of a heroic style, and of a virtue triumphantly vindicated against the accusations of little men. Moreover, it proved its own civility by literate reference to an honored past. With the mastery of a cultivated art, *Letter to a Noble Lord* makes use of all the implications of Reynolds' portrait. Burke, who had so often aided Reynolds, ended his own career by drawing upon the support of his two dead friends. In thus using the powers of literary art to imitate the powers of painting, he had paid tribute at the last to a literate and liberal profession.

3. THE PRACTICE OF IMITATION

What Reynolds desired most for his art, however, was not literary praise, but an acknowledgment of its own heritage and resources. The theory of "imitation," in its confined sense of "the following of other masters," was central to Reynolds' idea of painting, because it supplied the art both with a science, its own individual field of knowledge, and with a practice. By commanding a large repertory of attitudes, poses, and effects derived from older paintings, the painter demonstrated his independence from everything but his art. He was literate; he was liberal (since even when executing a commissioned portrait, he could select his own artistic precedents); he followed ancient and noble guides.

Ever since Horace Walpole, art historians have been showing us that "imitation" is the main feature of Reynolds' style. Professor Wind in particular has demonstrated again and again how Reynolds constructs a portrait by splicing together styles and figures from the past.[43] The student of these portraits soon

[42] Plate 5. For the circumstances, see Leslie and Taylor, *Life and Times*, II, 229-39; and John Steegman, *Sir Joshua Reynolds* (London, 1933), pp. 95-97. A later portrait of Keppel by Reynolds [Plate 6] directly imitates the portrait of 1753-4, with the storms of the sea and of youth now calmed.

[43] The basic work is "Humanitätsidee und heroisiertes Porträt in der englischen Kultur des 18. Jahrhunderts," *Vorträge der Bibliothek Warburg* (1930-1931), 156-229.

becomes accustomed to the little recurrent shock with which he perceives that here Reynolds has borrowed an attitude, there an expression or a gesture, from Poussin or Van Dyck or Michelangelo. Sir Joshua builds a picture as a magpie builds a nest. The word for this artistic borrowing is a matter of taste. What Reynolds called "imitation," Walpole called "wit" or "quotation," Nathaniel Hone called "conjuring," and Blake called "thievery." But by any name, it is the life of Reynolds' literate art; the art of the *Discourses* as well as the art of his paintings. Whether employed trivially, as in his early parody of *The School of Athens*, or with the complexity and energy of *The Family of the Duke of Marlborough* (1777), imitation lends Reynolds his method and his ideas.[44] He practices his own advice: "A mind enriched by an assemblage of all the treasures of ancient and modern art, will be more elevated and fruitful in resources in proportion to the number of ideas which have been carefully collected and thoroughly digested. There can be no doubt but that he who has the most materials has the greatest means of invention" (99).

How did Reynolds' mind work in practice? E. H. Gombrich's full and elegant study of *Three Ladies adorning a Term of Hymen* [Plate 7] furnishes an instructive example.[45] After receiving his commission for a portrait group of the three sisters Montgomery, Reynolds ransacked his notebooks for appropriate expressive attitudes. The variation on the Graces that he finally arranged quotes directly from at least five sources: an "ignoto" in his Italian sketchbook,[46] Rubens' *Three Graces*, Poussin's *Sacrifice to Hymen* and *Bacchanal*, and his own *Lady Keppel*. From pieces of these he blended together a single composition. In addition, he took account of his sitters. The Montgomerys were noted amateur actresses, and they pose with the playful exaggeration of living statues in a masque. Moreover, the eldest Miss Montgomery, who became Mrs. Gardiner during the execution

[44] On the caricature of *The School of Athens*, see Edgar Wind's discussion in the *Harvard Library Bulletin*, III (1949), 294-97. R. E. Moore has reviewed "Reynolds and the Art of Characterization" in the Monk festschrift, *Studies in Criticism and Aesthetics, 1660-1800* (Minneapolis, 1967), pp. 332-57.

[45] "Reynolds's Theory and Practice of Imitation," *Burlington Magazine*, LXXX (1942), 40-45.

[46] Reynolds recommends this use of the porto-folio in Discourse XII, p. 214.

of the group (which had been commissioned in her honor by her fiancé), is shown passing the term of Hymen, thus dancing out of her state of grace and into the more statuesque bliss of wedlock. The lively dancers and their ancient dance comment upon each other. "The two worlds of portraiture and of history, of realism and imagination are held in a perfect, if precarious, balance."[47]

Like the *Three Ladies* itself, the pleasure we derive from such a work of art is of a very mixed kind. Part stems from Reynolds' genuine inventiveness in combining all his sources into a lively whole, thus adding a new member to a long series; part depends on the very overtness with which Reynolds displays his debts, the gimcrack charm of assembling such unlikely companions. Just as we choose, we may admire the willing graces, or the Gothic pile. Either way we shall admire not only something pictorial, but Reynolds' play of mind across his canvas.

This play of mind has always been the most controversial aspect of Reynolds' method. As Gombrich points out, homage to the past cannot retrieve the past; in some ways it subverts the past, by making anachronism into an art. The painter who props his flagging invention with splints from the old masters forces us to appreciate his own self-consciousness and artificiality. What is more, he betrays a Lockean distrust of the imagination. "The mind is but a barren soil" (99), Sir Joshua told his audience, stinging Blake to reply that "The Mind that could have produced this Sentence must have been a Pitiful a Pitiable Imbecillity."[48] By so frankly assembling his paintings from a process of thought, rather than depending on the eye, the hand, or the vision, Reynolds made the painter into a kind of connoisseur. He rarely finished his own paintings. That could be left for his studio, his apprentices. The *idea* of a painting, its general effect, was all he had to supervise; he was paid for his play of mind.

Such an emphasis upon the intellectual rather than executive qualities of his art must have seemed to Reynolds the redressing of an old wrong, the wrong inflicted by critics who underesti-

[47] Gombrich, *Burlington Magazine*, LXXX, 45.

[48] *Blake*, p. 646. In Discourse XIII Reynolds himself takes the other side of the argument, and celebrates the imagination. Cf. Dr. Bernard's epistle to Reynolds in 1770: "Thou say'st not only skill is gain'd,/ But genius too may be attain'd,/ By studious imitation" (Northcote's *Memoirs*, p. 110).

mated the mental force required by painters. He challenged comparison with other arts. "Without doubt influenced by the works of James Harris, Reynolds was deliberately experimenting to translate into the language of painting the movement, metaphors, allusions and emotional surprises of poetry."[49] Yet such translations sometimes hardly seemed to leave room for the rights and acts of painting itself. Thus Hazlitt protested that Reynolds shared the fault of Rembrandt: "he enveloped objects in the same brilliant haze of a previous mental conception"; and Northcote's worshipful defense did not attempt to justify Reynolds as a *painter*: " 'Yes,' he said; 'but though Sir Joshua borrowed a great deal, he drew largely from himself: or rather, it was a strong and peculiar feeling of nature working in him and forcing its way out in spite of all impediments, and that made whatever he touched his own. In spite of his deficiency in drawing, and his want of academic rules and a proper education, you see this breaking out like a devil in all his works. It is this that has stamped him.' "[50] Northcote, Reynolds' best pupil, came to think that force of mind was all his master had to offer, and not everyone agreed that that was enough.

As an aesthetic principle, Reynolds' theory of imitation may be defended or attacked. To view it only as a matter of aesthetics, however, is to miss its direct relation to his work and his career. First of all, it must be said that emphasis upon mind was not a choice for Reynolds so much as a necessity. Technically, as Northcote implies and Sir Joshua admitted, he was far from a master. He never drew well, his quirky experiments with pigments and glazes caused his pictures to fade rapidly, and his professional schooling and teaching were indifferent. He knew that he had to compensate for weaknesses. "I began late. Facility of invention was therefore to be given up. I considered it impossible to arrive at it, but not impossible to be correct, though with more labour. I had the grace not to despise the riches I could not attain, and sometimes administered to myself some comfort in observing how

[49] Charles Mitchell, "Three Phases of Reynolds's Method," *Burlington Magazine*, LXXX (1942), 36.

[50] *Conversations of James Northcote, Esq., R. A.*, in William Hazlitt's *Collected Works* (London, 1903), VI, 344-45. The theme was a favorite with Northcote; cf. *Conversations of James Northcote R. A. with James Ward on Art and Artists*, ed. Ernest Fletcher (London, 1901), p. 73.

often this facility *ended* in common place."[51] With mind, and with nothing else, Reynolds could lift his career above the ordinary.

Secondly, of course, Reynolds made mind pay; he found a market for it. By 1782 his prices had reached unprecedented heights: fifty guineas for a head, a hundred as far as the knees, and two hundred for a whole length.[52] Excellence of technique, the painter's mystery, all too often ended in the commonplace. But that devil breaking out in Reynolds—his charm, his spirit, his play of mind—was something that the public learned it wanted.

Most important of all, however, the practice of imitation lent Reynolds a working method he used again and again in his literary career. Far more than the paintings, the *Discourses* take remarkable pains to incorporate and assimilate the thoughts of every predecessor. Reynolds borrowed his knowledge of ancient painting from Junius, annotated Du Fresnoy and Dryden, transmitted the principles of Richardson, imbibed philosophy from Harris, polished his style under the direction of Burke and Johnson, and set out to please Horace Walpole.[53] He fortified himself by building upon received opinion; he wrote according to program. On the title page of *The Theory of Painting*, Richardson had placed Michelangelo's comment about Raphael: "that he did not possess his art from nature, but by long study."[54] Near the conclusion of his own farewell Discourse, Reynolds returns to that comment in a spirit of imitation, and applies it in turn to Michelangelo. We are certainly entitled to carry the chain one link further, and reapply the comment to Sir Joshua. Long study was his art; long study was his program for success.

Just how programmatic Reynolds' literary art tended to be has been carefully documented by F. W. Hilles.[55] Studying the manuscripts of the *Discourses*, we find a palimpsest of stages of development. Reynolds built his elegant prose out of minute accretions and combinations of notes, gradually revised into generality.

[51] Printed by William Cotton, *Sir Joshua Reynolds, and his Works. Gleanings from his Diary, Unpublished Manuscripts, and other Sources* (London, 1856), p. 214.

[52] E. K. Waterhouse, *Reynolds* (London, 1941), p. 14. Cf. *Letters of Sir Joshua Reynolds*, ed. F. W. Hilles (Cambridge, 1929), p. 56.

[53] See G. L. Greenway, *Some Predecessors of Sir Joshua Reynolds in the Criticism of the Fine Arts* (unpublished Ph.D. dissertation, Yale, 1930), and chapters V-VII of F. W. Hilles' *The Literary Career of Sir Joshua Reynolds*.

[54] "Che Raffaelle non ebbe quest' arte da natura, ma per lungo studio"; *Discourses*, p. 281.

[55] *Literary Career*, chapter VIII and appendices.

The process began with his reading which, while not especially wide, was thoroughly mined for well-expressed sentiments, suitable to be transferred to his commonplace books or folders under such rubrics as "Analogy," "Self," "Michael Angelo," or "The Advantage of Early Habits." These folders, like his portfolios and sketchbooks, supplied him with the means of invention. Once he had decided upon the topic for a Discourse, Reynolds would go through another course of reading, and then assemble his notes in loose arrangement on a page, and compose sentences to connect them. After successive tightenings, additions, and revisions, after many sleepless nights, an order would emerge. Then he would submit (or read) the manuscript to a friend, preferably Johnson[56] or Burke, for criticism. After further revisions, the corrected text was copied by an amanuensis, and read at the Academy. Before publication there would be more criticism, and more rewriting. The last stage was completed when Reynolds revised a set of several Discourses for an integral edition.

Thus many hands living and dead join in the composition of the *Discourses*. Reading through the manuscripts, one almost comes to believe in something impossible: that a masterpiece can be written by a committee. The familiar calumny that the *Discourses* were composed by Reynolds' friends has been too decisively refuted to bear repetition,[57] yet it contains the seed of a truth. Blake's remark is pertinent: "The Contradictions in Reynolds's Discourses are Strong Presumptions that they are the Work of Several Hands But this is no Proof that Reynolds did not Write them The Man Either Painter or Philosopher who Learns or Acquires all he Knows from Others. Must be full of Contradictions."[58] The practice of imitation gave Reynolds a program for synthesizing a literary heritage, but it also involved him in all the ambiguities and uncertainties of the predecessors he sought to surpass.[59]

[56] In "Sir Joshua's Prose," *The Age of Johnson* (New Haven, 1949), p. 58, Hilles amusingly points out that in Discourse XII Reynolds borrowed a sentence from Johnson's *Life of Cowley*: "His known wealth was so great that he might have borrowed without loss of credit."

[57] The relevant evidence is gathered by G. L. Greenway, *Alterations in the Discourses of Sir Joshua Reynolds* (New York, 1936).

[58] *Blake*, p. 628.

[59] Reynolds' management of such problems is the subject of Michael Macklem's "Reynolds and the Ambiguities of Neo-Classical Criticism" *PQ*, XXXI (1952), 393-98.

4. The Unity of the *Discourses*

Nevertheless, the description of Reynolds' process of composition omits an essential quality: somewhere along the line, the many fragments and scraps from his workbench coalesce. In spite of all the influences and all the imitations, the *Discourses* project a sense of harmony that has been recognized by each succeeding generation. The full weight of such an achievement can be appreciated only by noting how many diverse purposes and modes of thought are orchestrated in that harmony. Reynolds intended the *Discourses* to instruct students; to represent the aims and aspirations of the Royal Academy; to establish a canon, a critical survey of the history of art; to demonstrate that his profession was noble; and to ascertain the basis of painting in psychology and philosophy. The formal counterpart to this diversity is a medley of genres. Some of the *Discourses* (III and XI, for instance) are essays in philosophy; some of them (V and XIV, for instance) deal largely with practical criticism; and with a little ingenuity we might point to a sermon (IX), a lesson in technique (X), a guide to travel (XIII). If Reynolds, as Burke said, "is always the same man; the same philosophical, the same artist-like critick,"[60] he expresses himself in many different guises.

How can such variety be brought to unity? in what way do the *Discourses* form a single whole? Such questions have been the major focus of recent critical debate, and they were also questions that preoccupied Reynolds. "The composition, the *ponere totum* even of a single Discourse, as well as of a single statue, was the most difficult part, as perhaps it is of every other art, and most requires the hand of a master" (268). One answer, the answer preferred by the nineteenth century and adopted even by Northcote when he had grown old in a Romantic age, would be simply *genius*. Reynolds knew that answer well, and at times he entertained it. He knew the harmonizing power of genius, "that energy," according to Johnson, "which collects, combines, amplifies, and animates";[61] and he admired the genius of a painter like Salvator Rosa, whose works, "though void of all grace, elegance, and simplicity" (85), were yet imbued with "a peculiar cast of

[60] Letter to Malone, May 4, 1797; Leslie and Taylor, *Life and Times*, II, 637n.
[61] *Life of Pope, Lives*, ed. G. B. Hill (Oxford, 1905), III, 222.

nature" that made everything of a piece.[62] Yet Reynolds, as his enemies have often charged, was never quite comfortable with genius. He perceived it to be the insidious bait for a heresy: that some painters could afford to disdain hard work. No part of the Ironical Discourse with which Reynolds defied the coming age is more ironical than his praise for this heresy. "We know that if you are born with a genius, labour is unnecessary; if you have it not, labour is in vain; genius is all in all. It was wittily said by a bright genius, who observed another to labour in the composition of a discourse which he was to deliver in public, that such a painstaker was fitter to make a pulpit than to preach in it."[63] As the irony suggests, even Reynolds' humor tends to be labored. He did not claim to unify his works through the force of genius.

The most convincing modern answer to the question of what unifies the *Discourses* has taken another key term: not genius, but dialectic. According to this view, Reynolds' arguments fit into an elaborate hierarchical system that assigns each idea to its proper level or stage in a dialectical context.[64] Thus the apparent contradictions of the *Discourses* may actually constitute the poles that sustain it. In the words of Elder Olson, "The problem with which Reynolds is concerned is the education of the painter; . . . Reynolds differentiates the phases through which the artist must pass in the development of his faculties, and discovers them to pose different problems requiring different methods of solution."[65] Since each painter passes through three stages—technical apprenticeship, a disciplined study of the art as a whole, and final mastery—any seeming alteration in Reynolds' thought must be tested against the particular requirements of the student at a given moment.

The description of the *Discourses* in terms of an ordering dia-

[62] On the vogue of Rosa, see Elizabeth Manwaring, *Italian Landscape in Eighteenth Century England* (New York, 1925), chapter III. W. O. Clough, "Reason and Genius—An Eighteenth Century Dilemma," *PQ*, XXIII (1944), 33-54, argues that Reynolds was gradually won over to genius.

[63] *Portraits by Sir Joshua Reynolds* (London, 1952), p. 132. The "bright genius" was probably James Barry.

[64] The philosophical justification for this approach is given in a long footnote by Richard McKeon to "The Philosophic Bases of Art and Criticism," originally published in *MP*, XLI (1944), and reprinted in *Critics and Criticism*, ed. R. S. Crane (Chicago, 1952), pp. 525-26n.

[65] Introduction to *"Longinus" On the Sublime and Reynolds Discourses on Art* (Chicago, 1945), p. xiv.

lectic has one exceptionally persuasive advocate: Reynolds himself. No one else, after all, could be so conscious of the contradictions inherent in his sources and materials.

To clear away those difficulties, and reconcile those contrary opinions, it became necessary to distinguish the greater truth, as it may be called, from the lesser truth; the larger and more liberal idea of nature from the more narrow and confined; that which addresses itself to the imagination, from that which is solely addressed to the eye. In consequence of this discrimination, the different branches of our art, to which those different truths were referred, were perceived to make so wide a separation, and put on so new an appearance, that they seemed scarcely to have proceeded from the same general stock. The different rules and regulations, which presided over each department of art, followed of course: every mode of excellence, from the grand style of the Roman and Florentine schools down to the lowest rank of still life, had its due weight and value; fitted some class or other; and nothing was thrown away. By this disposition of our art into classes, that perplexity and confusion, which I apprehend every Artist has at some time experienced from the variety of styles, and the variety of excellence with which he is surrounded, is, I should hope, in some measure removed, and the Student better enabled to judge for himself, what peculiarly belongs to his own particular pursuit. (268-9)

There is no better guide than this to a reading of the *Discourses*. Separating painting into branches and classes, each possessed of its own rules and given "its due weight and value," Reynolds presents his art as a complete eighteenth-century world, disposed along its great chain of being by an economical god of painting who throws nothing away. He teaches us to become aware of sequences and levels of argument, and to refer each rule to the problem it was designed to correct. Moreover, Reynolds' summary of method throws light upon the notion, popular with historians of ideas, that the *Discourses* gradually shift their sympathies from classic to romantic.[66] Though plausible, such a shift remains un-

[66] Influential statements of this view include those by S. H. Monk, *The Sublime* (New York, 1935), pp. 186-190; C. B. Tinker, *Painter and Poet* (Cambridge, Mass.,

proven. As Reynolds prepared to take leave of the Academy, he addressed himself increasingly to the higher reaches of art, the higher context epitomized by the mere reverent mention of the name Michael Angelo. Nevertheless, his recommendation of a greater mode of excellence did not dismiss the lesser modes. The Ironical Discourse confirms that Reynolds ended as he had begun, a spokesman for the academy and for an aesthetic universe with every element in its designated place.

Without upsetting this tidy structure, however, one must ask whether it constitutes a philosophical position, an account of Reynolds' practice, or only a system of classification. A hierarchy may serve to order an otherwise unintelligible multitude of facts, but (as Johnson knew) it seldom helps in their interpretation; its one lesson is, whatever is, is right. Confronted with rules and opinions that he could not make agree, Reynolds could smoothly deposit them in different classes where no conflict need openly appear. The great chain of art fixed the *Discourses* in Olympian detachment from partial and revolutionary enthusiasms; and so long as the existence of the hierarchy was conceded, no argument or painting was beyond its pale. Yet a system so expansive that it can include anything inevitably comes to look empty, a form without content.[67]

The advantages and problems that result from a strictly dialectical reading of the *Discourses* are well exemplified by Walter J. Hipple, Jr., who argues that "all the problems of genius, of taste, and of art . . . are given their form in Reynolds' aesthetics by the dialectical method and the psychological orientation of the system." The terms of this system have meaning only within a context which they themselves compose. Thus, "the primary and ubiquitous principle of Reynolds' aesthetic system is the contrariety of universal and particular," defined through their opposition, and similarly "the paradox that genius is the product of art is the chief purport of the discourses,"[68] since within the dia-

1938); W. J. Bate, *From Classic to Romantic* (Cambridge, Mass., 1946). The case has been well made by Fernando Ferrara, "Presagi del romanticismo in Sir Joshua Reynolds," *English Miscellany*, IX (1958), 101-126.

[67] My argument here presupposes, A. O. Lovejoy's *The Great Chain of Being* (Cambridge, Mass., 1936), especially the opening pages of chapter X.

[68] *The Beautiful, The Sublime, & The Picturesque In Eighteenth-Century British Aesthetic Theory* (Carbondale, Ill., 1957), pp. 146; 136; 145. The chapter

lectic now one, now the other, seems to take on the functions of its contrary. The virtue of Hipple's tenacious reading is that it presents the *Discourses* as a perfectly self-enclosed and flexible unity, irrefutable because all its statements are internally coherent, and hence one of the permanent alternatives in aesthetics. Unfortunately, however, the dialectic achieves its logical consistency at the cost of sacrificing most of Reynolds' complications. The *Discourses* are not only a work of philosophy, and to understand them we need to go beyond their oppositions of a few terms and explore the many contexts that Reynolds entered, the many strategies that he employed. Predictably, a narrow defense of the *form* of an aesthetic argument leads to the sort of embarrassment in which critics protect an author from his own violations of form, from his own enthusiasms. "If this indeterminacy of terms is a prerequisite for a Platonic system that is not to be dogmatic, it is apparent that Reynolds erred in attempting to tie down so literally the meaning of 'beauty' in the *Idler* papers."[69] Hipple is right: doubtless Reynolds did err; but then Reynolds, especially in 1759, was not nearly so loyal to his own system as his critic would be.

If we follow the dialecticians in arguing that "the problem with which Reynolds is concerned is the education of the painter" at three successive stages of his career, then the nature of Reynolds' audience becomes a crucial question. Reynolds himself was perturbed by the question, especially in the early *Discourses*: "It is not easy to speak with propriety to so many Students of different ages and different degrees of advancement. The mind requires nourishment adapted to its growth; and what may have promoted our earlier efforts, might retard us in our nearer approaches to perfection" (41). The convenient and symmetrical response to this problem would have been a progressive elevation in the level of the *Discourses*, as the president addressed himself to more and more advanced students. Some dialecticians argue that Reynolds did respond that way. Yet obviously such a progression would have been hopelessly at odds with the real nature of the audience. Over a period of twenty-one years even the most delib-

is slightly condensed from Hipple's "General and Particular in the *Discourses* of Sir Joshua Reynolds: A Study in Method," *JAAC*, XI (1953), 231-47.
[69] Hipple, *The Beautiful, The Sublime, & The Picturesque*, p. 141.

erate and popular teacher cannot expect to keep the same students. Sir Joshua was not training a single group throughout its successive phases of improvement; he was struggling to find some common ground upon which to meet a miscellaneous body in which all levels of learning were represented at the same time.

Furthermore, of the three stages in the painter's education only the second, journeywork, could be eligible for much attention. The first stage, apprenticeship, "confined to the rudiments" of technique, could hardly rise to general interest; and mastery, "The third and last period emancipates the Student from subjection to any authority, but what he shall himself judge to be supported by reason . . . ; exercising a sort of sovereignty over those rules which have hitherto restrained him" (26-27). Insofar as the education of the painter is indeed the purpose of the *Discourses*, Reynolds could hardly choose but concentrate upon students in the second stage, those who had acquired a modicum of technique without having attained "the same rank with those masters whom [they] before obeyed as teachers" (27). Almost all of his lessons were in effect directed to journeymen, or to beginners and professors who could adjust themselves to the middle level.

Yet the audience of the *Discourses* was anything but static, nor did Reynolds tailor his dialectic for a handful of students. In spite of his role as mentor to the young, the president of the Academy envisioned a much grander company.[70] It is probable, in fact, that at many of the later *Discourses* students were outnumbered by visitors. During Sir Joshua's farewell address to an audience of two or three hundred, two terrifying cracks threatened to demolish the exhibition room where he was speaking;[71] if the beams had indeed given way, a good part of intellectual England would have gone under, including Burke, Burney, and Boswell. Yet according to Burney, "There were fewer people of fashion & dilettanti there than usual, though a croud of young Artists & mixtures." Reynolds had never spoken very clearly, and the students, who naturally sat further back than the invited guests, "seemed unable to hear & diverted themselves with con-

[70] The prominence of the audience to whom Reynolds sent copies of the *Discourses* is demonstrated by Hilles, *Literary Career*, pp. 144-45.

[71] See W. T. Whitley, *Artists and their Friends in England 1700-1799* (London, 1928), II, 134-35.

versation & peripatetic discourses more audible than that of poor Sr. Jos."[72] If the president had designed his remarks primarily to reach students in the last stages of cultivation, he had sadly miscalculated. His common sense must have told him that his fit audience consisted of the celebrities in the front rows.

Indeed, everything we know about Reynolds indicates how much he valued the opportunity of addressing a world less confined than the workshop. The extent to which acceptance by literary people dominated his life has been amply documented,[73] and he sought the admiration of writers far more zealously than that of painters. As a teacher of his craft, despite all his emphasis on education, he failed. Northcote told Hazlitt that Reynolds' genius "made him a very bad master. He knew nothing of rules which are alone to be taught; and he could not communicate his instinctive feeling of beauty or character to others."[74] Students might be the immediate audience, the *occasion*, of the *Discourses*, but Sir Joshua took satisfaction from reaching a wider, more catholic circle. Thus the last Discourse, which reviews the *Discourses* as a whole, assumes an audience interested in Reynolds' justification and interpretation of his career; as he departs, in a hubbub of controversy,[75] he takes leave of a tribunal of his peers. Moreover, he sights beyond them to the printed text, and to the philosophers and connoisseurs and general readers who may one day sit in judgment.

A consideration of Reynolds' audience, then, suggests that his lectures hardly needed to follow a regularized didactic program or format. Yet that is not to deny the *Discourses* their own kind of unity. In the hands of an artist, interested in the practices to which his theories lead, aesthetics is seldom "pure" philosophy. When Reynolds borrows a moment to adjust the history of art or his own reputation, the lapse in dialectic does not forfeit his intellectual interest. He remains the best and most flexible of all English philosophers of art. Nevertheless, the unity of the *Discourses* consists of something more than a philosophical

[72] Letter to Fanny, Dec. 13, 1790, published by Hilles, *Literary Career*, p. 182.
[73] Hilles, *Literary Career*, chapter VI. [74] Hazlitt's *Works*, VI, 345.
[75] Earlier that year, Reynolds had temporarily resigned his presidency. Joseph Farington, in his *Diaries* and in *Memoirs of the Life of Sir Joshua Reynolds* (London, 1819), describes the contemporary reaction; Hilles prints Sir Joshua's own *Apologia* as Appendix III to the *Literary Career*.

paradigm; it is hard won, the result of many conflicting aims and slow decisions. We do justice to Reynolds' complications only when we affirm that as well as a philosopher of art he is, in more senses than one, an artist.

5. THE UNITY OF ART

Reynolds liked to think that the *Discourses* were a straightforward, even simple presentation of "a plain and *honest method*" (269). He was wrong, of course; the *Discourses* are not simple. They incorporate so many disparate aims, so many kinds of literary artistry, that no analysis can hope to exhaust them. The best that a critic can do is to choose an example of Reynolds' complicated art, and observe how it functions.

A useful epitome of the *Discourses*, a summary of many of the problems and consequences of his art, is a long sentence in a short discourse—the noble period that concludes Discourse No. IX, October 16, 1780. The moment of its composition represents the very peak of Reynolds' career. Never again, perhaps, would his success be so undisputed and so visible. The ninth Discourse was read to dedicate the opening of the Royal Academy at its new home in Somerset House. Reynolds was justifiably proud. The new building was not only a sign of royal and public approbation, but a triumph of taste[76] (he had yet to quarrel with the architect, Sir William Chambers, and the lecture hall had yet to yawn open beneath his feet). The King and Queen themselves had come for a tour, and allowed Sir Joshua to paint their royal portraits (he was never again to have such a favor). For the same occasion he painted Theory, sitting on a cloud on the ceiling of the library, in his best allegorical style.[77] The figure imitated Raphael's "Mars" in the Chigi chapel of Sta. Maria del Popolo; the manner imitated Titian's "Wisdom" in the Library of St. Mark's; the left arm was bent to support the head in the traditional gesture of Contemplation; and the right hand held a scroll with the fine ambiguous message "Theory is the knowledge of what is truly nature" (when Blake engraved this work as *The*

[76] "If the architecture of London could be compared to a symphony, Somerset House would rank with St. Paul's Cathedral, the Bank of England, and the British Museum as part of the grand double bass." A. T. Edwards, *Sir William Chambers* (London, 1924), p. 7.
[77] See Charles Mitchell, *Burlington Magazine*, LXXX, 37.

Graphic Muse for Prince Hoare in 1806, he clarified the lines, modified Titian's manner into Michelangelo's, and omitted the inscription).[78] For the moment, at least, Sir Joshua reigned supreme, and he was eager to bend all his powers of art in service of the principles that had rewarded him so well.

The Art which we profess has beauty for its object; this it is our business to discover and to express; but the beauty of which we are in quest is general and intellectual; it is an idea that subsists only in the mind; the sight never beheld it, nor has the hand expressed it: it is an idea residing in the breast of the artist, which he is always labouring to impart, and which he dies at last without imparting; but which he is yet so far able to communicate, as to raise the thoughts, and extend the views of the spectator; and which, by a succession of art, may be so far diffused, that its effects may extend themselves imperceptibly into publick benefits, and be among the means of bestowing on whole nations refinement of taste: which, if it does not lead directly to purity of manners, obviates at least their greatest depravation, by disentangling the mind from appetite, and conducting the thoughts through successive stages of excellence, till that contemplation of universal rectitude and harmony which began by Taste, may, as it is exalted and refined, conclude in Virtue. (171)

Within this single sentence, this literally breathtaking sentence, we can locate evidence for most of the views that have been adopted toward Reynolds. The historian of art will perceive its derivations; by collating Longinus, Lomazzo, Junius, Bellori, Du Fresnoy, Richardson, and Algarotti, we could reassemble its thoughts and phrases almost verbatim.[79] The historian of ideas cannot but notice that Reynolds transfers the importance of the idea of beauty from the work or artist to the audience, and ends by emphasizing the effect of beauty on the mind of the beholder.[80] The philosopher may linger over the idealism itself,

[78] K. A. McDowall, "*Theory*, or *The Graphic Muse* Engraved by Blake after Reynolds," *Burlington Magazine*, XI (1907), 113-115. The engraving was made for Hoare's *Inquiry into the Requisite Cultivation and Present State of the Arts of Design in England.*

[79] Such a chain is traced by R. W. Lee, "*Ut Pictura Poesis*: The Humanistic Theory of Painting," *Art Bulletin*, XXII (1940), 197-269.

[80] M. H. Abrams, *The Mirror and the Lamp* (New York, 1953), pp. 45-46.

and compare it to the ideas of Plato, or the psychology of Locke.[81] A harsher critic might pick some quarrels: surely Reynolds has taken liberties in his use of "beauty." Can the beauty which is the object of art, the beauty which is an idea in the mind of the artist, and the beauty which is diffused into public benefits, be one and the same? Through subtle variations on the word, Sir Joshua has led us step by step to a dubious conclusion: that the incommunicable aspiration of the artist can somehow be transformed into the rectitude of whole nations.[82] To this charge, the dialectician will reply that Reynolds himself has spoken of "conducting the thoughts through successive stages of excellence"; the word and thought of beauty have been raised to higher and higher levels of dialectical context not to deceive us, but to demonstrate their variety of application through the whole range of the system. Beginning with one sort of beauty, Reynolds says, we may hope to climb to another.

Something may be said for each of these views, and none is clearly falsifiable. Yet each of them disregards the making of the sentence, and the force of Reynolds' art. In the way of an artist Sir Joshua has constructed a significant form. He gives his argument a shape and a compelling emotion that weigh equally with its meaning. The sheer suspension of the sentence, its fine-spun balancing of clause on clause, its fascinating length and luxuriant rhythms, its constant rise and fall, suspend us in a journey toward the ideal. Reynolds has tried to express with language an almost inexpressible quest. The repeated definitions of the idea of beauty, the relentless syntactical striving for an adequate statement, convey better than any logic the urgent aspiration of the artist as he searches for something "he is always labouring to impart" and will die without imparting; the stately progress of the period, falling at last to rest in Virtue, parallels the effort of the president himself, conducting the thoughts to excellence until his very last breath. From such everlasting labor is born the reward of labor: a building; Somerset House; the unity of art. The varieties of

[81] The argument for Reynolds' Platonism by Louis Bredvold, "The Tendency toward Platonism in Neo-Classical Esthetics," *ELH*, I (1934), 91-119, has been redirected toward Locke by Hoyt Trowbridge, "Platonism and Sir Joshua Reynolds," *English Studies*, XXI (1939), 1-7.

[82] Joseph Burke, *Hogarth and Reynolds: A Contrast in English Art Theory* (Oxford, 1943), argues that Reynolds' theory of art is characterized by contradictions.

thought and purpose and emotion join in a single balanced form. The sentence ends, and we find that it is one.

The art of such a sentence draws upon the many arts that advanced Reynolds' career: his hard work, his imitation of predecessors, his care for his audience and occasion, his play of mind. Emotionally, however, it is unified by something else, a steady undertone of pathos. Inevitably the artist-hero will die in his endeavor to raise the minds of his countrymen; he will die without imparting the idea in his breast. All artists suffer the same fate, since they never reach pure mind, pure beauty, pure virtue. The temple of art is too far above them, and their efforts to climb to it are always heroically pathetic.[83] That note of pathos seldom quits the dying falls of Reynolds' rhetoric; it supplies the unifying emotion of all his later work. Eventually the pathetic glory of service he associated with his own career became an effect he could not do without in any idea of art.

This devotion to art, this readiness to sacrifice any immediate satisfactions to an ideal of service, is one more way of accounting for the unity of the *Discourses*. Like Richardson, Sir Joshua might have claimed "This I have apply'd my self to as the great Business of my Life." Many readers who have misunderstood Reynolds' dialectic have found that his exhortations to the painter to forsake all for art can linger in the memory when all else has faded. From this point of view his final surrender of his career to the spirit of Michelangelo, the spirit of whatever is best in painting, seems not a new beginning but a preordained end.

Indeed, for most contemporary Englishmen Reynolds *was* the art of painting. His success extended beyond his own circle and into society at large. Northcote chooses his words with care when he writes that "he procured for Professors of the Arts a consequence, dignity, and reception, which they never before possessed in this country."[84] He raised the whole art with himself, "at once to make and prove it a matter fit to occupy cultivated and serious minds."[85] In this respect Reynolds' ontogeny recapitulated the phylogeny of painting. As he delighted to remind his students, the academy itself, the building of Somerset House, sym-

[83] Roger Fry constantly returns to this effect in the notes to his edition of the *Discourses* (London, 1905).
[84] *Memoirs*, p. 320. [85] Leslie and Taylor, *Life and Times*, I, 318.

bolized a long and noble tradition born again. The unity of Reynolds' art assimilated and manipulated the history of painting. Thus the view of history put forward by the *Discourses* forms an essential part of the way they are made as well as the ideas they represent.

6. REYNOLDS AND HISTORY

In an age that valued history-writing as much as the later eighteenth century did, no lover of painting could be satisfied until his art too had acquired a history. Richardson, we have seen, thought that painting urgently needed a writer who would complement its theory with an account of the practice of its greatest masters. His own career as a writer anticipates the course later taken by eighteenth-century criticism in general, and authors like Hume and Harris in particular, of retiring from the toils of philosophy into the more relaxed search for historical fact. Yet the men who wrote the history of English painting were to be chroniclers and compilers, like Vertue and Walpole and Pilkington;[86] they did not follow Richardson's line. Thus the *Anecdotes of Painting in England* represents an abandoning, not a practical embodiment, of theory. It was left to Reynolds, Richardson's most attentive reader, to answer the call for a historian in terms that his mentor would have recognized. Reynolds alone combined Richardson's love for the philosophy and grandeur of painting with an informed knowledge of what painters had already achieved.

To describe the *Discourses* as history, however, goes against the grain of most modern criticism. Until recently, scholars took it for granted that Reynolds "remained completely under the spell of Neoplatonic ideas," which "must always imply an unhistorical approach."[87] To some extent this belief has changed. We now perceive that Reynolds' "Neoplatonism" was an ambiguous and eclectic system, not an idealistic dogma.[88] Moreover, anyone

[86] Matthew Pilkington, *The Gentleman's and Connoisseur's Dictionary of Painters* (London, 1770), digests the lives of painters from standard sources. His most useful contributions to art history are two catalogues he appends on disciples and imitators of famous masters.

[87] René Wellek, *The Rise of English Literary History* (Chapel Hill, 1941), p. 52.

[88] Compare E. N. S. Thompson, "The *Discourses* of Sir Joshua Reynolds," *PMLA*, XXXII (1917), 339-66, with R. R. Wark's fine introduction to the Huntington Library *Discourses* (San Marino, Cal., 1959).

who has read the *Discourses* knows that, whatever Reynolds' ideas, they did not prevent him from filling his work with a wealth of historical examples.

Nevertheless, Reynolds' understanding of history and the work of a historian remains in question. His sense of tradition did not compel him to judge the art of the past in its own terms. Like T. S. Eliot, he was constructing and managing, not acquiescing in, a tradition;[89] he was drawing historical prototypes into a continuous present for contemporary use. He ransacked time for aids to invention. "With us, History is made to bend and conform to this great idea of Art" (244). Thus "history painting," for Reynolds, signified a genre, a lofty and idealized style, rather than a genuine effort to recover the various styles or realities of the past.[90] "Agesilaus was low, lame, and of a mean appearance: none of these defects ought to appear in a piece of which he is the hero. In conformity to custom, I call this part of the art History Painting; it ought to be called Poetical, as in reality it is" (60). Reynolds did not, like Walpole, regard history as his plaything, but neither did he acknowledge that the past might have an integrity or an intention that differed from his own.

Although Reynolds lacks one part of a historical sense—recognition of the pastness of the past—his recognition of its presence is keen and sophisticated. His paintings as well as his writings reveal an indifferent historian but a brilliant critic of history. Moreover, the complexity of his philosophical method provides important safeguards against oversimplification. The constant dialectical alternations in the *Discourses* continually bring fresh perspectives to bear upon each style. If the Venetians serve in one place as a merely ornamental foil to the grand style, in another they display the power of invention; if one context emphasizes Dutch vulgarity and meanness, another sets off Dutch accuracy. Within a hierarchy of schools, of genres, of styles, and of ideas, all art finds a place and a use. "In every school, whether Venetian, French, or Dutch, [the student] will find, either ingenious

[89] "If we can postulate a modern tradition, we must add that it is a paradoxically untraditional tradition." Ellmann and Feidelson, preface to *The Modern Tradition* (New York, 1965), p. vi. Note the word "postulate."

[90] For the reaction against Reynolds' anachronism, see Edgar Wind, "The Revolution of History Painting," *JWCI*, II (1938), 116-127; and Charles Mitchell, "Benjamin West's 'Death of General Wolfe' and the Popular History Piece," *JWCI*, VII (1944), 20-33.

compositions, extraordinary effects, some peculiar expressions, or some mechanical excellence, well worthy of his attention, and, in some measure, of his imitation" (108). If such rummaging through the past is not exactly historical, at least it insures a perpetual renewal of interest in the history of art, especially of art hitherto neglected.

The immediate historical concern of the *Discourses*, however, is to establish a canon of painting, an immortal roll of honor. Reynolds has a sort of Telemachus complex: he searches history for fathers. Thus Masaccio "appears to be the first who discovered the path that leads to every excellence to which the Art afterwards arrived, and may therefore be justly considered as one of the Great Fathers of modern Art" (218); Michelangelo is the "exalted Founder and Father of modern Art" (272); and, in a Junius-like mixture of father and holy ghost, "All the inventions and thoughts of the Antients, whether conveyed to us in statues, bas-reliefs, intaglios, cameos, or coins, are to be sought after and carefully studied: the genius that hovers over these venerable reliques, may be called the father of modern art" (106).[91] Reynolds shapes a paternity of his own. Rather than follow Vasari in dating the restoration of painting from Cimabue and Giotto, he begins his own canon with Masaccio, and some of his other choices seem eclectic: as "a model for Stile in Painting, . . . LODOVICO CARRACHE (I mean in his best works) appears to me to approach the nearest to perfection" (32).[92] Yet there is nothing casual or self-indulgent about such choices. Sir Joshua takes his role as president seriously; he stands before the gates of history like a guard. When in Discourse XIV he undertakes to place Gainsborough in his historical position, the initiation has all the formal dignity of an official ceremony. The *Discourses* preserve an inspiring pantheon of the elders of art.

Unfortunately, a wrong fact can inspire a student just as much as a right one. The use of the past for stimulation and instruction does not demand accuracy of research. It is not in the least surprising that the works of art most influential upon eighteenth-

[91] Unlike Junius, however, Reynolds draws upon relics, rather than upon literary ideas, for his sense of ancient art.

[92] On this preference see Denis Mahon, "Eclecticism and the Carracci: Further Reflections on the Validity of a Label," *JWCI*, XVI (1953), 303-341.

century England, the Raphael cartoons, should have been discovered by later, more careful historians to have come only in part from the hand of Raphael.[93] To an age so prolific of forgeries and anachronisms, such an error was no more than justice. If Reynolds is not content, like Junius, to instruct by means of paintings that are wholly figments of the imagination, neither does he restrict his own imagination to things that are visible and verifiable.

Indeed, the opposing claims of literal historical truth and of exemplary didactic models are never reconciled in the *Discourses*. Reynolds looks to the past, but he remains an artist, and "It is allowed on all hands, that facts, and events, however they may bind the Historian, have no dominion over the Poet or the Painter" (244). The words are almost exactly those of Junius, and the impatience with "the natural imperfection of things" also belongs to Junius. What belongs to Reynolds is an understanding that the struggle between history and art cannot simply be resolved in favor of art. A painter works with his mind, and the ability to analyze facts, as well as to transcend them, displays the powers of a rational being. Thus Reynolds constantly suggests that even the most ideal types of art—even the grand style, even genius itself—are conditioned by their historical context: "the truth is, that the *degree* of excellence which proclaims *Genius* is different, in different times and places; and what shews it to be so is, that mankind have often changed their opinion upon this matter" (96). Even the most significant of all contemporary critical problems, proof of the reality of a standard of taste, is perceived by Reynolds to require historical analysis, a search through history for ideals that time has not diminished.

In this historical search, Reynolds' peculiar virtue lies in the variety of styles he is capable of appreciating. He practices the eclecticism he recommends. "Damn the man, how various he is!" Gainsborough exclaimed, and the extraordinary range of Reynolds' sympathies, as well as his willingness to borrow, is underlined by Northcote. "Like the bee that extracts sweets from the most noxious flowers, so his active observation could see every thing pregnant with a means of improvement, from the wooden

[93] John Pope-Hennessy, *The Raphael Cartoons* (London, 1950), however, attributes to Raphael a large share in the handling of the scenes.

print on a common ballad, to the highest graces of Parmegiano. Perhaps there is no painter that ever went before him, from whom he has not derived some advantage, and appropriated certain excellencies with judicious selection and consummate taste."[94] If some touch of condescension here offends our historical sensibilities—twentieth-century noses do not find the air of the middle ages so "noxious"—we must still admire Reynolds' alertness and catholicity.

"The habit of contemplating and brooding over the ideas of great geniusses, till you find yourself warmed by the contact, is the true method of forming an Artist-like mind" (219); and one of the pleasures of reading Reynolds is to see him warm his imagination at some hitherto unnoticed flame of art. *A Journey to Flanders and Holland,* for instance, depicts a growing love affair with Rubens. It is not that Sir Joshua ceases to judge: he deliberately balances his praise with a long list of faults. It is rather that he begins to have a sense of Rubens as a contemporary and rival, and to admire him with the frank competitive eye of a fellow craftsman: "there is such an airiness and facility in the landscapes of Rubens, that a Painter would as soon wish to be the author of them, as those of Claude, or any other artist whatever."[95] Reynolds cannot study a picture for long without grasping something he can use. As he looks at Breughel's *Slaughter of the Innocents,* his prejudice yields to historical insight. "This painter was totally ignorant of all the mechanical art of making a picture; but there is here a great quantity of thinking, a representation of variety of distress, enough for twenty modern pictures. In this respect he is like Donne, as distinguished from the modern versifiers."[96] The more weighty periods of the *Discourses* reveal the same readiness in the president to go to school, the same mild shock of recognition.

A similar flexibility of mind supplies the *Discourses* with their copious frame of reference. We are so used to reading Reynolds for his philosophy that we may easily forget how many painters

[94] *Memoirs,* p. 310.

[95] *A Journey to Flanders and Holland* (1781), in Reynolds' *Complete Works* (London, 1797), II, 121.

[96] *Ibid.,* II, 112. Cf. Johnson's comments on the "very extensive and various knowledge" of Donne in the recently published "Life of Cowley," *Lives of the English Poets,* ed. G. B. Hill (Oxford, 1905), I, 22.

This Man was Hired to Depress Art

This is the Opinion of Will Blake my Proofs of this Opinion are given in the following Notes

THE

WORKS
OF

SIR JOSHUA REYNOLDS, KNIGHT;

LATE PRESIDENT OF THE ROYAL ACADEMY:

CONTAINING

HIS DISCOURSES, IDLERS,

A JOURNEY TO FLANDERS AND HOLLAND,

AND HIS COMMENTARY ON DU FRESNOY'S ART OF PAINTING;

PRINTED FROM HIS REVISED COPIES,

(WITH HIS LAST CORRECTIONS AND ADDITIONS,)

IN THREE VOLUMES.

TO WHICH IS PREFIXED

AN ACCOUNT OF THE LIFE AND WRITINGS OF THE AUTHOR,

BY EDMOND MALONE, ESQ.

ONE OF HIS EXECUTORS.

THE SECOND EDITION CORRECTED.

QUASI NON EA PRÆSTEM ALIIS, QUÆ MIHI IPSI DESUNT. CICERO.

VOLUME THE FIRST.

LONDON:

PRINTED FOR T. CADELL, JUN. AND W. DAVIES, IN THE STRAND.

1798.

Degrade first the Arts if you'd Mankind Degrade,
Hire Idiots to Paint with cold light & hot shade:
Give high Price for the worst, leave the best in Disgrace,
And with Labouring of Ignorance fill every place.

SIR JOSHUA REYNOLDS.

Tum demum sana mentis oculis acute cernere
incipit ubi corporis oculus incipit hebescere. Seneca.

Sir Joshua Reynolds Pinxit. Caroline Watson Engraver to her Majesty sculpsit.

According to Act of Parliament. March 1794 by T. Cadell Strand.

Plate 3, William Blake's copy of *The Works of Sir Joshua Reynolds* (1798), frontispiece and title page. British Museum.

Plates 4-6, Reynolds: Three portraits of Augustus Viscount Keppel.

Plate 4, Admiral Keppel (1779). The Tate Gallery, London.

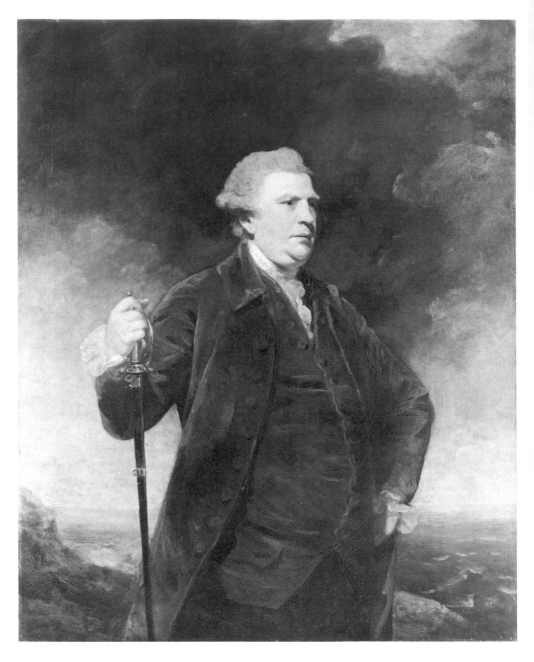

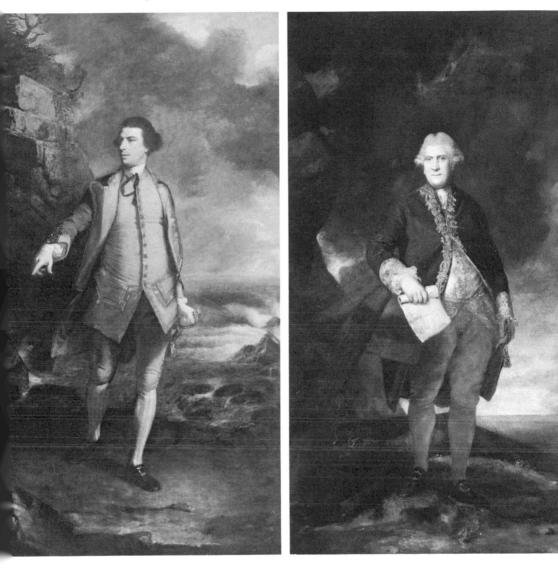

Plate 5, Commodore Keppel (1753-54). National Maritime Museum, Greenwich.

Plate 6, Viscount Keppel (1785). St. James's Palace, London. Reproduced by gracious permission of Her Majesty the Queen. Copyright reserved.

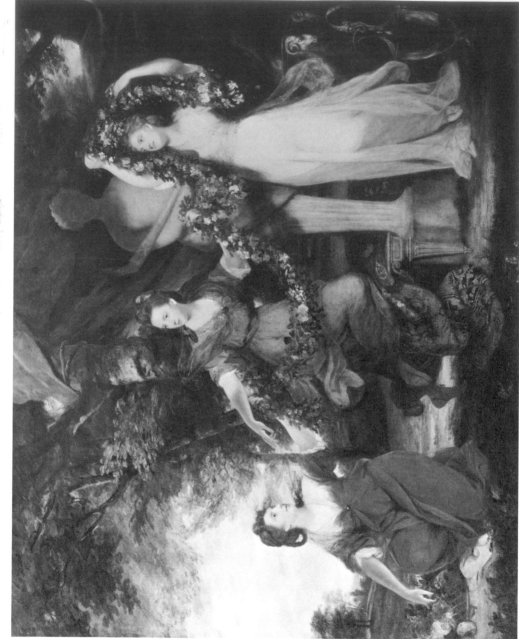

Plate 7, Reynolds:
Three Ladies
Adorning a Term
of Hymen (1773).
The Tate Gallery,
London.

he puts to account. Although he rarely lists the members of schools (as in Discourse VI), he consciously draws from all quarters in his pursuit of instructive examples. We might expect to find Raphael, Titian, and Poussin, we shall not be taken aback by Reni or Vanbrugh or the Carracci, yet we cannot help but be impressed when Vouet and Steen and Franco and La Fage also spill out of Sir Joshua's cornucopia. Despite his significant omissions, especially of Spanish painting,[97] Reynolds' history has a breadth that would have been impossible a generation earlier.

The search for precedents gave Reynolds ideas, and it gave him comfort as well. After the theoretical effort to prove that painting was philosophically respectable, he pleasantly reflected that painting as a liberal art had been certified by history. Like his friend Harris, he could indulge his old age by taking a many-travelled road. Turning to Michelangelo, invoking his spirit, allowing the richness of his name to roll across the tongue again and again, Reynolds bought a security beyond theory. "If the high esteem and veneration in which Michael Angelo has been held by all nations and in all ages, should be put to the account of prejudice, it must still be granted that those prejudices could not have been entertained without a cause" (281). Paintings could be found somewhere outside the mind. The words with which Rubens had chided Junius served Reynolds when all the talk was done: one could point to paintings with the finger and say, "There they are."

7. REYNOLDS AS A CRITIC

In his view of history, then, Reynolds tries to reconcile the practice of art with its theory. Yet what exactly does he see when he looks at a picture? The answer, with Reynolds even more than with most critics, seems to depend on what he is looking for. As we have noted, he uses many perspectives. When Veronese and Tintoretto are set against the grandeur of the Roman, Florentine, and Bolognese schools, they illustrate a historical disaster: "These are the persons who may be said to have exhausted all the powers of florid eloquence, to debauch the young and inexperienced. . . . By them, and their imitators, a style merely ornamental has been

[97] Though Reynolds drew upon Velázquez in his paintings, he does not mention him in the *Discourses*.

disseminated throughout all Europe" (67). When the same painters are used to show that "perfection in an inferior style may be reasonably preferred to mediocrity in the highest walks of art" (130), we learn to esteem them. Similarly, Raphael and Michelangelo are the counters of an incessant dialectical game: Raphael *or* Michelangelo? As Reynolds devotes prolonged attention to a painting, it seems to fluctuate like one of those optical illusions in which interlocked geometrical figures, as one stares at them, alternately emerge from and retreat into the background.

The paradigm of this technique is Discourse XIV, the memorial of Gainsborough,[98] and Reynolds' only extended piece of evaluative criticism. He takes for his subject no particular painting, but the general quality of Gainsborough's art, and characteristically that quality is defined as a series of balanced excellencies and defects. The central term of the discussion is Englishness, which determines Gainsborough's place in history in two ways: his independence from influences, and his importance as an example for the future. "If ever this nation should produce genius sufficient to acquire to us the honourable distinction of an English School, the name of Gainsborough will be transmitted to posterity, in the history of the Art, among the very first of that rising name" (248). Reynolds compares English artists with contemporary Romans,[99] who grow in a more favorable soil, but who suffer because they routinely mimic a style now fallen into decay. In contrast, Gainsborough's defects of background are compensated by the freshness of his opportunity.

Similar contrasts structure the whole discussion of Gainsborough's art. His natural genius for observing and capturing the peculiar look of whatever he paints is played against his lack of academic training; his ability to unify his works is played against his failure to idealize them. "If Gainsborough did not look at nature with a poet's eye, it must be acknowledged that he saw her with the eye of a painter; and gave a faithful, if not a poetical, representation of what he had before him" (253). The genres

[98] The two painters had been reconciled six months earlier, just before Gainsborough's death. For their personal relations, see W. T. Whitley, *Thomas Gainsborough* (London, 1915).

[99] Especially Pompeo Batoni and Anton Raphael Mengs. There had already been bad feeling between Reynolds and Mengs, and it was to continue. See Northcote's *Life*, II, 317-20.

in which he excelled are evaluated by comparison with the greatness above them and the pettiness below. "As Gainsborough never attempted the heroick style, so neither did he destroy the character and uniformity of his own style, by the idle affectation of introducing mythological learning in any of his pictures" (255). A final peroration adds the sum of excellencies and deficiencies, and Gainsborough is himself absorbed into history as one more example available for comparison.

Reynolds' critical estimate is nothing if not judicious; but the precise nature of his judgment remains elusive. Modern scholars have been of two minds about the critique of Gainsborough. Some think it reveals a "classicistic restriction" relaxed by Reynolds' generosity to an old rival and "his ability to recognize genius even when it departed from the established rules of greatness";[100] others think that Reynolds is essentially patronizing Gainsborough, explaining away the total effect of his work through a series of mental gymnastics.[101] This difference of emphasis cannot be resolved, because the criticism balances between opposite possibilities and interpretations. Just as Reynolds points out that Gainsborough's "undetermined manner" forces the beholder to create the picture in his own imagination,[102] so Reynolds' dialectical manner leaves final judgment to the imagination of the reader.

Whether criticism of any quality can be based on such principles is arguable. The *Discourses* display "the persistent inorganic view of art in the eighteenth century";[103] like Richardson on Van Dyck, or Johnson on Shakespeare, or Burney on Handel, Reynolds tabulates art according to a balance sheet of plusses and minusses. "Every artist has some favourite part on which he fixes his attention, and which he pursues with such eagerness, that it absorbs every other consideration; and he often falls into the opposite error of that which he would avoid, which is always ready to receive him. Now Gainsborough having truly a painter's eye for colouring, cultivated those effects of the art which proceed

[100] Jakob Rosenberg, *On Quality in Art* (Princeton, 1967), p. 66.

[101] Emilie Buchwald, "Gainsborough's 'Prospect, Animated Prospect,'" *Studies in Criticism and Aesthetics, 1660-1800* (Minneapolis, 1967), pp. 359-61.

[102] P. 259. The point is emphasized by Gombrich, *Art and Illusion* (New York, 1960), pp. 199-200.

[103] Monk, *The Sublime*, p. 186.

from colours; and sometimes appears to be indifferent to or neglect other excellencies" (259–60). Even Raphael, Reynolds says, is defective in finishing his pictures. Such criticism analyzes painting into distinguishable parts, whose relative importance can only be determined by the immediate focus of the critic. In analyzing and in making paintings, Reynolds often looks like a watchmaker,[104] mechanically stripping and reassembling the cogs and balances of his trade.

A famous instance of Reynolds' mechanical approach to art is the image of the pendulum in *Idler* No. 82. Every species, he argues, has "a fixed or determinate form towards which nature is continually inclining, like various lines terminating in the center; or it may be compared to pendulums vibrating in different directions over one central point."[105] This metaphor, with its implication that beauty can be discovered through statistical calculations, has been seized upon by many readers as proof of Reynolds' inorganicism. Yet such a verdict is subject to two vital qualifications. First, the central metaphor of *Idler* 82, far from describing the laws of mechanics, is the relation of works of art to the work of nature, and artistic beauty to the beauty of animal and vegetable species. Reynolds embeds his pendulum amid horses and birds and blades of grass. Furthermore, he often envisioned a painting as a living growth. "Another practice Gainsborough had, which is worth mentioning as it is certainly worthy of imitation; I mean his manner of forming all the parts of his picture together; the whole going on at the same time, in the same manner as nature creates her works" (251). Watchmakers do not speak this way.

Second, Reynolds' pendulums, and the search for a central form of beauty that they represent, stay in motion. He never views a work of art as essentially fixed and static, and his own critical method is forever "vibrating in different directions." Each painting he analyzes swings between opposing tendencies, and establishes equilibrium only through being perceived as itself a tiny dialectical system in which the balance of opposites substitutes for any definition of a whole. If, as R. S. Crane says, neoclassical

[104] H. E. Gerber, "Reynolds' Pendulum Figure and the Watchmaker," *PQ*, XXXVIII (1959), 66-83.
[105] *Idler* 82, in Yale Edition of Johnson's *Works*, II, 255.

critics had invariably found artistic excellence "to consist, like moral excellence, in a mean between two extremes or, what amounts to the same thing, in a just mixture . . . of opposite qualities,"[106] then Reynolds had gone a step further: he had made the process of adjustment, the mixture itself, the end of his quest for excellence. The movement of the critical pendulum, not the central point through which it passes, provides the method of the *Discourses*, and their criticism lives in the tension, not the resting place, between extremes.

Reynolds' own practice as a painter confirms his emphasis upon process, upon tension. In spite of his division of the art into a hierarchy of classes and genres, he constantly violates decorum by mixing styles within a single painting. Taking liberties is his stock in trade. Thus *Master Crewe as Henry VIII* (1776) is well described as "an easy and superior play on several levels, none taken too seriously, a play with Holbein, the King, the boy, and also the grand portrait and those advocating it, including Reynolds himself."[107] Reynolds seems not to have suffered "that perplexity and confusion, which I apprehend every Artist has at some time experienced from the variety of styles" (268-9) so much as to have seen, with remarkable clarity, the opportunities offered by a *composite* style.[108] The habit of thinking in terms of hierarchies lent him a subtle command over the technique of pitting one rank or class against another. In their hybrids and class-consciousness, Reynolds' paintings experiment with a great chain of becoming.

This ability to move comfortably between historical and critical extremes accounts for much of the fascination of the *Discourses*, and also for their power to annoy artists like Blake. A work of art that plays on several levels, none taken too seriously, depends on standards of taste; it is no longer *unique*. Conversely, the modern notion that every good painting has an organic structure which criticism cannot fragment without killing, or the modern notion that the responsible critic ought to judge a work of art only according to the laws of its own being, its self-

[106] "English Neoclassical Criticism: An Outline Sketch," *Critics and Criticism*, p. 380.

[107] Nikolaus Pevsner, *The Englishness of English Art* (London, 1956), p. 56.

[108] See Discourse IV, especially p. 72. According to Blake "There is No Such Thing as A Composite Style" (*Blake*, p. 641).

fulfillment, would have seemed to Reynolds a denial of the reality of a standard of taste, and thus a repudiation of those general principles he had pursued through a lifetime. Reynolds knew that some paintings have a mystery which resists partition and analysis, and that some minds are "too high to be controled by cold criticism" (276), but he also knew that careful study could extract some principles and lessons from even the highest flight of art. No painting was immune from the balance sheet and the learning processes of his critical method. However he might change his opinions, he would not abandon the method itself.

8. The Steps of a Master

Reynolds was right to prize his methods: the practice of imitation, the strategy of dialectic, the art of controlled tension. They gave him the means of making the *Discourses*, and they gave a new order to painting and a new authority to the literature of painting. Yet in one respect the critics of the next generation were also right:[109] Reynolds' methods largely determine the habits and the quality of his thought. The subtle encroachment of a mode of procedure upon the ideas it presents is the final lesson that the *Discourses* have to teach us.

Once again an example drawn from Reynolds' practice of his art may help to make things clear. As a teacher Sir Joshua strongly recommended distinct, precise outlines. Like all contemporary theoreticians, he associated clear outlines with an emphasis on form, as opposed to the indeterminate expressive charm of coloring. Few colorists could draw correctly, and Reynolds, who owned a great collection of drawings, admired the mastery of imagination revealed by a single unmodified stroke. The painter, he says, "is to exhibit distinctly, and with precision, the general forms of things. A firm and determined outline is one of the characteristics of the great style in painting; and let me add, that he who possesses the knowledge of the exact form which every part of nature ought to have, will be fond of expressing that knowledge with correctness and precision in all his works" (52).[110] Blake, who

109 The attack was focused by Hazlitt in a series of articles in *The Champion* in 1814 and 1815. Hazlitt's *Works*, XI, 208-230.

110 In a letter to James Beattie, Reynolds says that Hogarth's passion for "the line of beauty" has led him against nature: "His pictures therefore want that line

believed in clear visions, and as an engraver was committed to clear outlines, rejoiced at this corroboration of his views: "A Noble Sentence Here is a Sentence Which overthrows all his Book."[111]

In practice, however, Reynolds himself did not draw correctly. He never mastered the art of a draughtsman, he painted directly upon the canvas, and according to Northcote "There was nothing he hated so much as a distinct outline."[112] Characteristically, Reynolds transformed this technical weakness into a stylistic asset. The variations in his outlines, the wavering and tremulous softness he adapted from the Venetians, were put to account as one of his principal beauties. In thus sacrificing a hypothetical grandeur for the sake of a real and various charm, he had done what he had to do. "A man is not weak, though he may not be able to wield the club of Hercules; nor does a man always practise that which he esteems the best; but does that which he can best do" (52). Yet he did pay a price for the success of his methods as a painter. His habitual revisions, his constant tampering and refining and correction of any original impulse, gradually eroded the purer line and grander beauty that he himself most admired.

A similar pressure of methodology upon style is manifested by the *Discourses*. Reynolds' painstaking revisions eventually contrived that flexibility and smoothness of expression which have been so often praised. If this "style which admits of no eccentricities, no mannerisms," hardly even any "distinctive quality,"[113] has polished away its own vividness of outline, its luster and elegance have not faded. Yet the effect of Reynolds' method goes far deeper than style. To begin with, it partly accounts for the peculiarly English quality of "detachment" that critics have found at the center of Reynolds' art.[114] The long process by which the *Discourses* were accumulated, distilled, and resublimated from the writings and thoughts of other men tended to

of firmness and stability which is produced by straight lines" (March 31, 1782; *Letters*, p. 92). Beattie repeated this phrase in his *Dissertation on Imagination*.

111 *Blake*, p. 638.

112 Hazlitt's *Works*, VI, 345. Derek Hudson, however, suggests that Reynolds' drawings have been somewhat underestimated (*Sir Joshua Reynolds*, p. 42).

113 Hilles, "Sir Joshua's Prose," p. 58.

114 Pevsner, *Englishness of English Art*, chapter III.

detach the president of the Royal Academy from personal responsibility for any one idea. There is security in numbers, as Boswell knew when he associated himself with Reynolds in the dedication to the *Life of Johnson,* remarking that Johnson had called Sir Joshua "the most invulnerable man he knew; whom, if he should quarrel with him, he should find the most difficulty how to abuse."[115] Reynolds avoided quarrels by joining everyone to him. It must have seemed to him that no reasonable man could argue with so objective an authority; in a curious way, his claim to have established the rules and principles of painting on a firm and lasting foundation cannot even be called immodest. His method insured his detachment.

The deepest effect of Reynolds' methods upon the *Discourses,* however, stems from a lesson he had been taught by the whole course of his life. According to his own account, painting came hard to Sir Joshua, and writing came harder still. During the length of a career successful beyond precedent, he thought that he had found an answer: no doors were closed to deliberate industry, a proper and careful method was the one path to genius open to mortal men. It might be true that "the minds of men are so very differently constituted, that it is impossible to find one method which shall be suitable to all" (209),[116] but in practice he had long ago chosen his own way. The sense that he had overcome difficulties was precious to Reynolds. It was happiness for him; perhaps his one kind of happiness.

Fanny d'Arblay's *Memoirs* record an impassioned outburst by Sir Joshua on the nature of happiness, words that Roger Lonsdale has recently used to conclude his fine life of Reynolds' friend Charles Burney.

It is not the man who looks around him from the top of a high mountain at a beautiful prospect on the first moment of opening his eyes, who has the true enjoyment of that noble sight: it is he who ascends the mountain from a miry meadow, or a ploughed field, or a barren waste; and who works his way up

[115] *Boswell's Life of Johnson,* I, 2.

[116] The context of this passage in Discourse XII is Reynolds' refusal to plan a method of study for artists abroad, which accounts also for his still more extreme statement, "Whatever advantages method may have in dispatch of business (and there it certainly has many,) I have but little confidence of its efficacy in acquiring excellence in any Art whatever" (209).

to it step by step; . . . —it is he, my lords, who enjoys the beauties that suddenly blaze upon him. They cause an expansion of ideas in harmony with the expansion of the view. He glories in its glory; and his mind opens to conscious exaltation; such as the man who was born and bred upon that commanding height . . . can never know; can have no idea of;—at least, not till he come near some precipice, in a boisterous wind, that hurls him from the top to the bottom, and gives him some taste of what he had possessed, by its loss; and some pleasure in its recovery, by the pain and difficulty of scrambling back to it.[117]

Satisfaction and pathos are exquisitely balanced in this artistic retrospect. Gradually Reynolds came to identify the painstaking labor of compiling and finishing his works with the ideals toward which they aimed. Happiness and pain, beauty and labor, were bound together. The slow road up the mountain and the glory of its prospect became one.

A manuscript page headed "Industry," which contains notes for the *Discourses*, exemplifies this process. "The state of things is such that every thing is bought by labour, even our intellectual pleasures the most refin'd, cannot be acquired without labour. the mind must be disciplined to a tast of the Arts

I consider painting as an Intellectual pleasure have placed sweat and labour before the Gates of honour."[118] Professor Hilles suggests that "I" should precede "have" in the final sentence. A more logical insertion would be "The Gods";[119] presumably the gods, not the painter, should have jurisdiction over the Gates of honor. But perhaps Professor Hilles is right. It would be very like Reynolds to think of his sweat as an offering to honor. He was accustomed to pay a tribute of hard work for the glory he won, and he was inclined to measure works by the toil they exacted. The logical consequence of the manuscript "Industry" is the sentiment into which it was condensed to begin Discourse

[117] Madame d'Arblay, *Memoirs of Doctor Burney* (London, 1832), II, 281-82. The characteristic art of this passage, which Fanny found in a note in her father's possession, suggests that Reynolds may have had a hand in composing the written version of his speech.

[118] Hilles, *Literary Career*, p. 219.

[119] Cf. the use of "the Gods" in the variation quoted below from Discourse XV, p. 281.

IV: "The value and rank of every art is in proportion to the mental labour employed in it, or the mental pleasure produced by it" (57). Sir Joshua respected the labor that had secured his rise; at times it filled his whole horizon.

The love of method, however, supplies no final order to the *Discourses*. Reynolds recommended devotion to art and insisted that an artist must reason philosophically, yet he never promised that devotion would be rewarded or that philosophy could explain painting. Only the aspiration could remain constant. The unifying emotion of the *Discourses*, we have noted, is the pathos that accompanies the unending search for "perfection, which is dimly seen, at a great though not hopeless distance, and which we must always follow because we never can attain" (170). Unlike his friend Harris, who believed that all meaningful questions are answerable, Reynolds believed only in the necessity of questions. The end of a life's dedication was the knowledge that something more remained to be done; the end of philosophical justification of painting was the admission that no theory could account for greatness. At best, "the pursuit rewards itself" (170). The mountain that Reynolds ascends in his quest for glory always turns into Pisgah. The French Academicians of a century before had raised painting to the status of an idea with a confidence born of theory, but the new Academy had no such confidence. The aspiration towards harmony would have to supply the place of harmony itself.

At the end of his last Discourse, a moment when he formally took stock and took leave of his career, Reynolds drew the relation between method and aspiration once again. He ended, of course, with a symbol of divinity, the name of Michael Angelo. Yet he introduced his final praise of Michelangelo with still another variation upon "Industry": "It is an ancient saying, that labour is the price which the Gods have set upon every thing valuable" (281). To Michelangelo's strength and sublimity, students are now encouraged to add his "indefatigable diligence." Even to the last, Reynolds will not relinquish the method he has learned so well.

Nevertheless he does relinquish a great deal. The subject matter of Discourse XV is a review of the *Discourses*, and the price Reynolds pays for reviewing his own career is a consciousness of his own inadequacy. He has not been the great master for whom

Richardson had called, and for the moment he is unsatisfied with his success. Considering the decorum of neoclassical art, Reynolds' intrusion of his own feelings and his own accomplishments into his peroration seems a breach of proper academic reserve. The first-person singular pronoun deposes the editorial plural. "I have taken another course, one more suited to my abilities, and to the taste of the times in which I live. Yet however unequal I feel myself to that attempt, were I now to begin the world again, I would tread in the steps of that great master: to kiss the hem of his garment, to catch the slightest of his perfections, would be glory and distinction enough for an ambitious man" (282).

Much has been surrendered in this moment. Reynolds becomes a common man again; like Prospero saying farewell to his magic, he drowns his book and forgoes his arts. Moreover, he also writes a period to some of his favorite methods. By deliberately espousing Michelangelo, rather than balancing his virtues against those of Raphael as so often before, he rejects the ambiguities of dialectic. By deliberately exposing his own emotions, rather than observing the decorum of the president of an Academy, he abandons the magisterial authority built with such labor over so many years. Nor does he surrender only his literary art. In his final public address, he concedes the charges made by younger artists like Barry, repudiates his unheroic past, and wishes for another life in which to become a greater painter.

Yet even at this moment Reynolds is recapitulating the lessons he had taught the English public,[120] reminding them of the artist's method, and of his aspirations. Surrendering to Michelangelo's genius, he redefines that genius in terms of labor, as a capacity for infinite pains. Conceding his own shortcomings, he evokes once more the bittersweet pathos of striving for an unattainable glory. To overcome the limits of his imagination, he reaches out with his mind to touch the mind of a greater predecessor. Even when Reynolds took leave of all discourse and gave the ordering of English art over to his successors and the name of *Michael Angelo*, he was following "the true method of forming an Artist-like mind" (219), the practice of imitation, and the quest for an ideal; once more he was following the steps of a master.

[120] As Wark notes, Reynolds prepares for his farewell with references drawn from Harris, Junius, and Richardson.

Part Three

THE ORDERING OF
MUSIC

Charles Avison and the Founding of English Criticism of Music

1

THE first English work that attempted to order the art of music for a general public announced itself modestly. It was not entitled *Universal Harmony,* nor *Treatise of Musick, Speculative, Practical, and Historical,* nor *A General, Critical, and Philological History of Music,* nor, certainly, *Gradus ad Parnassum,* nor even *The Musicall Grammarian.*[1] Charles Avison, its author, was a professional musician, and with businesslike restraint he chose to call his book *An Essay on Musical Expression.*[2]

Avison did not set out to describe a universal harmony that would awe his audience into silence. He wished instead to begin a conversation about the terrestrial music that could be heard by men. As he wrote in defense of his *Essay,* "It had nothing to do with the theoretic Principles, and the mere Mechanism of the Science. It's Aim was widely different. Intended, indeed, as a critical, but yet as a liberal, Examen of this pleasing Art; according to Rules, not drawn from the formal Schools of systematical Professors, but from the School of Nature and Good Sense."[3] The execution of this simple plan, however, could hardly be simple. Avison's fresh look at "this pleasing Art" was clouded by centuries of speculation. In 1752 the backgrounds of writing about music were too rich, and too confused, for mere good sense to clarify them.

Like Avison himself, we can hope to patch together no more

[1] Authored, respectively, by Marin Mersenne (1636), Alexander Malcolm (1721), Charles de Blainville (1767), J. J. Fux (1725), and Roger North (ca. 1728).

[2] London, 1752. Page numerals in the text refer to the enlarged second edition (London, 1753). There are useful accounts of Avison (1709-1770) in the *DNB* and in *Grove's Dictionary of Music and Musicians.*

[3] *A Reply to the Author of Remarks on the Essay on Musical Expression* (London, 1753), p. 4. See note 37 below.

than a superficial outline of the history of discourse about music. That outline must begin with the distinction between speculation and practice, which may be exemplified respectively by two masterpieces of the sixteenth century, Gioseffe Zarlino's *Istituzioni armoniche* (1558) and Thomas Morley's *A Plain and Easy Introduction to Practical Music* (1597).[4] Far more than painting, music was torn between theorists and performers. As a member of the quadrivium it was studied in the form of mathematics, and the mathematical perfection of harmonic theory encouraged other speculations about the ethical and theological virtues of musical sounds.[5] Junius' claim that God was the first painter was a persuasive metaphor, but everyone knew without need for persuasion that God was the first composer. The status of music as an idea could not be questioned.

At the turn of the sixteenth century, a new cosmology and physics shook that idea; "the quadrivium exploded from its inner stresses and expanding constituents and the two disciplines, musical art and musical science, began to acquire their separate modern identities."[6] Slowly the idea of music lost its power. The great works of the seventeenth century, most notably those of Michael Praetorius, Marin Mersenne, and Athanasius Kircher, may be seen as heroic but doomed attempts to assimilate the new lessons of science into the old mythological and hermetic lore we associate with Orphic lyres and Pythagorean spheres.[7] Yet such compromises, like Sanderson's *Graphice* in painting, could not hold a modern audience. More and more writers chose to describe the effects of music rather than its doctrine. By the end of the cen-

[4] John Hollander's useful distinction of speculative and practical music, in chapter II of *The Untuning of the Sky: Ideas of Music in English Poetry 1500-1700* (Princeton, 1961), begins with these two authors. The contrast is not absolute. Morley, in spite of his suspicion of speculation, draws upon musical cosmology; Zarlino, in spite of his commitment to speculation, gives practical instruction in musical composition.

[5] See N. C. Carpenter, *Music in the Medieval and Renaissance Universities* (Norman, Okla., 1958), and Leo Spitzer, "Classical and Christian Ideas of World Harmony," *Traditio*, II (1944), 409-64; III (1945), 307-64.

[6] Claude Palisca, "Scientific Empiricism in Musical Thought," *Seventeenth Century Science and the Arts*, ed. H. H. Rhys (Princeton, 1961), p. 93.

[7] Praetorius, *Syntagma Musicum* (Leipzig, 1615); Kircher, *Musurgia universalis* (Rome, 1650). On humanistic views of music, see D. P. Walker, "Musical Humanism in the Sixteenth and Early Seventeenth Centuries," *The Music Review*, II (1941), 1-13, 111-121, 220-227, 288-308; III (1942), 55-71; and G. L. Finney, *Musical Backgrounds for English Literature: 1580-1650* (New Brunswick, N.J., 1962).

tury the notion of the *affektenlehre*, with its psychological and rhetorical emphasis upon music's ability to call up passions in listeners, had begun to replace cosmology and mathematics as a model of the powers of harmony.[8]

In England music criticism and music history rather lagged behind continental efforts in the sixteenth and seventeenth centuries. Although English poetry of the century before Dryden displays a wealth and beauty of musical allusion that have never been surpassed,[9] England produced no great encyclopedist of music,[10] no rival of Mersenne nor equivalent of Junius. Perhaps the most important humanist treatise on music was written, in fact, by Junius' nephew, Isaac Vossius. Published at Oxford in 1673, *De Poematum cantu et viribus Rhythmi* is reminiscent of *De pictura veterum* in its reliance upon classical literary authority, and in its contempt for the moderns. Unfortunately, Vossius does not resemble Junius in depth of learning nor in the ability to make his authority persuasive. His contemporaries patronized him. Desmaizeaux reports "that he was intimately acquainted with the genius and customs of antiquity, but an utter stranger to the manners of his own times," and Charles II is supposed to have struck off one of his *mots*: "there is nothing which he refuses to believe, except the Bible."[11] Hawkins spoke for many when he called Vossius' book "an unintelligible rhapsody," "a very futile and unsatisfactory disquisition."[12] The quarrel between "ancients" and moderns that Vossius had fueled continued to rage in English discussions of music,[13] but no native encyclopedist came forward to set terms for the argument.

Nevertheless, the heritage of English music criticism was extensive in five directions: literary, theological, scientific, prac-

[8] This process is the subject of D. T. Mace, *English Musical Thought in the Seventeenth Century: A Study of an Art in Decline* (unpublished Ph.D. dissertation, Columbia, 1952). See also Brewster Rogerson, "The Art of Painting the Passions," *JHI*, XIV (1953), 68-94.

[9] See Hollander, *The Untuning of the Sky*.

[10] An exception might be made for the musical portions of Robert Fludd's important collection of hermetic doctrine, *Utriusque cosmi historia*, Book I (Oppenheim, 1617-18).

[11] Reported by Sir John Hawkins in *A General History of the Science and Practice of Music* (New York, 1963), II, 661n.

[12] *Ibid.*, p. 661.

[13] See H. M. Schueller, "The Quarrel of the Ancients and the Moderns," *Music & Letters*, XLI (1960), 313-330.

tical, and philosophical. Most of the English poets had paid trib-
ute to music, and some of them, for instance Wyatt, Herbert, and
Milton, were themselves devoted to and expert in the art.[14] In
theology, dozens of pamphlets explored the question of whether
music was proper in church.[15] Scientifically, the Royal Society
contributed at least two theoreticians, John Wallis and Thomas
Salmon, whose intellectual ties to Pythagoreanism did not prevent
them from developing new studies of musical phenomena.[16] Ex-
amples of practical criticism could be multiplied; for instance,
Henry Peacham, a friend of Dowland, devotes some pleasant
pages of *The Compleat Gentleman* (1622) to praise of indi-
vidual composers.[17] Above all, music provided a challenge for
aestheticians who sought to discover a single principle, whether
imitation or expression, underlying and unifying all the arts.[18]
Although the doctrine of *ut musica poesis,* like that of *ut pictura
poesis,* was largely derived from French sources, English philos-
ophers adapted it to their own interests, "casting off the highly-
wrought schematism which was so attractive to the French."[19]

To a writer like Avison, attempting to explain music in terms
that everyone could understand, this profusion of kinds of dis-
course about music must have seemed more like a chaos than a
tradition. The time when an author could hope to synthesize
every aspect of music in a single universalizing treatise was gone
forever, but disputation rather than clarity had succeeded it. In
1752 almost every tenet of musical taste was the subject of a con-

14 Bruce Pattison's *Music and Poetry of the English Renaissance* (London, 1948)
is an unpretentious introduction to these relations, which are analyzed more
deeply in the cited works by John Hollander and Gretchen Finney.

15 See Percy Scholes, *The Puritans and Music* (London, 1934).

16 The special study of Wallis was sympathetic vibration; of Salmon, clef reform.
In *Science and Imagination* (Ithaca, 1956), pp. 120-123, Marjorie Nicolson suggests
that Swift had these two scientists in mind when he created his musical Laputans.

17 *The Compleat Gentleman* (Oxford, 1906; a reprint of the 1634 edition), pp.
96-104. Cf. chapter one, section four above.

18 The most influential works are those of the Abbé Du Bos (1719), translated
by Thomas Nugent as *Critical Reflections on Poetry, Painting and Music* (Lon-
don, 1748), and Charles Batteux, *Les Beaux Arts réduit à un même principe* (Paris,
1747). An early English example is Hildebrand Jacob's "Of the *Sister Arts*; an
Essay" (1734), in his *Works* (London, 1735), pp. 379-419. Some of the many other
English parallels of the arts are specifically related to Avison by H. M. Schueller,
"Correspondences between Music and the Sister Arts, According to 18th Century
Aesthetic Theory," *JAAC,* XI (1953), 334-59.

19 Brewster Rogerson, *Ut Musica Poesis: The Parallel of Music and Poetry in
Eighteenth Century Criticism* (unpublished Ph.D. dissertation, Princeton, 1945),
p. 113.

troversy. While music theory, in the hands of such masters as Fux and Rameau, aspired to a new exactitude and perfection— "Fux dealt with the fundamental principles of harmony and counterpoint, which always existed, which are still valid and will be valid as long as the system of the world remains unchanged and the rules according to which it exists"[20]—music criticism could not even agree about what music might be considered classic. There was no Homer, no Raphael, of music. Critics argued the case of the ancients against the moderns, but differed about whether the ancients were the Greeks or the Renaissance polyphonists.[21] In France, the "Querelle des Bouffons" gave most criticism the quality of a manifesto.[22] No consensus existed on even the most fundamental questions: whether instrumental music without the support of words and voices could be said to be music at all, whether literal imitation of natural sounds was a beauty or a blemish, whether large scale musical forms contradicted the emotional nature of music, whether music itself was basically a speculative or a practical art.

Because of this extreme confusion of critical principles, music required a historian far more urgently than did painting or poetry. Jonathan Richardson might preach that a history of painting would clarify the art, but he thought that he knew already what the results of such a history would be. From Dryden on, English critics of poetry were not starved for historical precedents. When Johnson asked "If Pope be not a poet, where is poetry to be found?" he was right in assuming that an answer would be superfluous, particularly after his own *Lives of the Poets*. For a critic of music at the time of Avison, no such question could be purely rhetorical. Where is music to be found? was something that writers on music kept asking. Many tried to answer it. The works

[20] Leopold Mizler (a pupil of J. S. Bach), quoted by Egon Wellesz, *Fux* (London, 1965), p. 10.

[21] See Schueller, *Music & Letters*, XLI. The Academy of Antient Music, founded by Dr. Pepusch in 1725/26, carried its researches no earlier than Palestrina, according to Hawkins' *Account of the Institution and Progress of the Academy of Ancient Music* (London, 1770), pp. 18-19.

[22] Louisette Reichenburg, *Contribution à l'histoire de la "querelle des Bouffons"* (Philadelphia, 1937). Two of the central documents in the quarrel, F. W. von Grimm's *Le petit prophète* and Rousseau's *Lettre sur la musique française*, both published in the year of Avison's revised *Essay*, 1753, are printed by Oliver Strunk, *Source Readings in Music History* (New York, 1950).

of Printz, Bontempi, Brossard, Malcolm, and Mattheson[23] are
evidence of the need, as well as efforts to restore at least a partial
harmony to the world of music. Yet none of them, in 1752, pos-
sessed an authority that was easy to use. Music had lost its rela-
tion with the divine, and it had not yet found writers who could
make good sense of it as something human.

2

Against this background *An Essay on Musical Expression* takes
its place with zeal and trepidation. When Avison tried to state
the fundamentals of his art in the clearest language he could
find, he was struggling against a vocabulary suited for mystery
and controversy but hardly for the simplest plain description.
The situation had been well summarized in 1728 by Avison's
only near English predecessor, that bustling and attractive per-
sonality Roger North: "no art is more enveloped in dark diallect,
and jargon, than Musick is, all which *impedimenta* I would have
removed, that the access to the art and practise may be more
recomendable and inviting." But North had addressed him-
self "onely to freinds and familiars,"[24] whereas Avison was after
a wide audience; he frankly hoped, in fact, to become the father
of English music criticism. It would have pleased him immensely
to read that "British music criticism of the eighteenth century falls
into two parts, with Avison's *Essay* as the mark of a new tendency
to give music the kind of *separate* attention which painting and
poetry had long received."[25] Before he could inaugurate the new
conversation, however, he had to come to terms with the old
jargon.

Indeed, the process of smoothing over the complex differ-
ences among his predecessors weighs far more heavily with Avi-

[23] The most thorough review of these histories remains that of Hawkins' *History
of Music*. K. H. Darenberg, *Studien zur englischen Musikaesthetik des 18.
Jahrhunderts* (Hamburg, 1960), provides a useful survey of English criticism of
music. See also E. R. Jacobi, *Die Entwicklung der Musiktheorie in England nach
der Zeit von Jean-Philippe Rameau* (Strasbourg, 1957).

[24] *Roger North on Music*, ed. John Wilson (London, 1959), pp. v, xxvii. North's
Memoirs of Musick, written in 1728, are actually a delightful brief history of mu-
sic; they were used by Burney in his own *History*, but not published until 1846, by
E. F. Rimbault. Another part of the same manuscript was later published as *The
Musicall Grammarian*, ed. Hilda Andrews (London, 1925).

[25] H. M. Schueller, "The Use and Decorum of Music as Described in British
Literature, 1700 to 1780," *JHI*, XIII (1952), 74.

son than any originality of his own. He labors to reconcile warring factions. A recent study of Avison's significance for aesthetics includes among his influences Polybius, Montesquieu, Bayle, Tosi, and perhaps Hume;[26] certainly more names could be added to the list. The *Essay* borrows from the most varied sources, and hesitates to choose among them. Nor will Avison choose between views of music even when they contradict each other. "In a sense, Avison was making a compromise between the scientific ('geometric') notion of Rameau that melody 'comes' from harmony—as though it were *deduced* from harmony—and that of Rousseau that melody is 'free' and expressive. It is almost as if Rameau's *Génération Harmonique* (1737) and Rousseau's articles in the *Encyclopédie* crossed with the doctrine of the affections in Avison."[27] This compromise is not a matter of chance. Avison wanted to present the public with a unified method for appreciating music; he was not interested in airing the internecine quarrels of musicians.[28] If he could not smother debate, he could adopt parts of each side.

Thus the *Essay* incorporates, in a small space, morsels from each of the styles of music criticism that had preceded it. The advocates of the ancients are given a long passage from Polybius about the soothing of the Arcadians (7-15); the advocates of the moderns are told that music is advancing to a new perfection (72). The theologians are supported in their desires for a more decorous church music: "We seem, at present, almost to have forgot, that Devotion is the original and proper End of it" (88); yet music, as Montesquieu said, is guiltless: "of all sensible Pleasures there is none that less corrupts the Soul" (18). A full section "On the Analogies between *Music and Painting*" draws the correspondences between the arts; other pages insist that music requires understanding on its own terms. The *Essay* offers definitions, like a *Dictionary*; a specimen review of a musical composition, for the guidance of periodicals; extended historical observations, as an encouragement to future historians; and constant excursions into philosophy. In view of this variety of genres, it is not surpris-

[26] H. M. Schueller, "'Imitation' and 'Expression' in British Music Criticism," *Musical Quarterly*, XXXIV (1948), 550n., 561.

[27] *Ibid.*, p. 559n.

[28] In his *Reply* to Hayes, Avison pledges to refrain from the malevolence that musicians so often show to each other.

ing that Avison, like Reynolds, should have been suspected of not being sole author of his book. He himself conceded that he had been given aid by learned friends. He included a Letter, "concerning the Music of the Ancients," by John Jortin; and Dr. John Brown, the well-known estimator of modern corruptions, was also rumored to be a correspondent.[29] So many styles, so many purposes and cross-purposes, seemed to argue for multiple authorship; and whatever the truth of the charge, it was certainly true that Avison wished to be many authors in one.

What the *Essay* attempts to be, however, is not an anthology of music criticism so much as a distillation of it. Avison rehearses most of the traditional ways of writing about music, but he betrays no very intense interest in the questions that had agitated the writers of the previous century. His own ambitions are evidently professional and social; he wants to have a way of training and impressing audiences, and he will select any precedent that enables him to sound authoritative. The various genres of music writing are means to this end, and so are his aesthetic principles. It is the *adaptability* of Avison's style, not its variety, that characterizes *An Essay on Musical Expression*. And nowhere is this resourcefulness more on display than in his use of the word "expression" itself.

3

Expression is the word on which the *Essay* is built, and the word by which Avison is known. In substituting expression for imitation as the principle underlying musical effects, the *Essay* helped to alter the terms of a major debate.[30] That debate went through many phases; it was most aggressively argued in France, and had its most lasting repercussions in Germany.[31] In England it fol-

[29] Like Avison, Brown was active in the musical life of Newcastle; in 1761 he became vicar of St. Nicholas, Newcastle, where Avison had long been organist. The *Essay* quotes with approval (p. 41) Brown's sentiments on the decline of simplicity in *Essays on the Characteristics* (London, 1751), and Jortin's letter on ancient music anticipates some arguments of Brown's *Dissertation on the Rise, Union, and Power, the Progressions, Separations, and Corruptions, of Poetry and Music* (London, 1763). Other members of Avison's *"junto"* may have included Harris and Dr. Pepusch.

[30] See Schueller, *Musical Quarterly*, XXXIV. According to A. R. Oliver, *The Encyclopedists as Critics of Music* (New York, 1947), p. 138, Avison is a representative of encyclopedist opinion in England, but in fact his treatment of expression precedes that of the *Encyclopédie*.

[31] M. H. Abrams, *The Mirror and the Lamp* (New York, 1953), chapter IV.

lowed conservative lines set by philosophers who tried to define Aristotelian mimesis in some way that could apply to music.[32] The second of Harris's *Three Treatises* (1744), "A Discourse on Music, Painting, and Poetry," put the question into a clear form by pointing out that music had weak powers of imitation at best,[33] and therefore must derive its efficacy from another source: its power of raising "Affections." During a generation of argument, aestheticians like James Beattie and Daniel Webb tried to reconcile this position with Aristotle. At last the issue was effectively resolved by Thomas Twining, Charles Burney's collaborator, in the dissertation "On the different Senses of the Word, Imitative, as applied to Music by the Antients, and by the Moderns" he prefixed to his translation of *Aristotle's Treatise on Poetry* (1789). Twining distinguished the kinds and effects of imitation, and concluded that when the ancients "speak of Music as imitation, they appear to have solely, or chiefly, in view, its power over the *affections*. By *imitation*, they mean, in short, what *we* commonly distinguish from imitation, and oppose to it, under the general term of *expression*."[34]

The desire to supplant "imitation" with "expression" arose partly, as Twining realized, from too narrow and literal-minded an understanding of mimesis, but it also reflected a genuine shift in aesthetic theory. As writers on music increasingly stressed its ability to evoke specific passions (*affektenlehre*) or fluctuating emotions (*empfindsamkeit*) in an audience, they required a term that would emphasize the range of sensations. "By the main line of English theorists, therefore, music was defined in terms of its effects, as a tonal medium for evoking or specifying feeling in the listener."[35] *An Essay on Musical Expression* lent currency to the notion that the place to look for the meaning of music could only be in men's responses to it.

There can be no doubt that Avison knew his place in this development. In the first version of the *Essay*, he went out of

[32] See J. W. Draper, "Aristotelian Mimesis in Eighteenth Century England," *PMLA*, XXXVI (1921), 372-400.

[33] In *Gluck and the Opera* (London, 1895), p. 260, Ernest Newman argues that "Harris perpetrates the common fallacy of his epoch" by judging music with a criterion drawn from poetry.

[34] "Dissertation II," *Aristotle's Treatise on Poetry* (London, 1789), p. 46. A footnote refers to Beattie and Avison.

[35] Abrams, *The Mirror and the Lamp*, p. 92.

his way to praise Harris for the argument by which that "judicious Writer, with that Precision and Accuracy which distinguishes his Writings" (60), had shown the limitations of "imitation" as applied to music. After William Hayes (curiously enough, also a friend of Harris)[36] had attacked the *Essay*—"without *Imitation* there cannot possibly be any such Thing as true *musical Expression*"[37]—Avison returned to Harris's theory for a defense, and reaffirmed that he was merely converting the distinctions of his "learned Friends" into practice. The *Essay* consciously attempts to describe music with the terms of the new aesthetics.

In the light of such a deliberate emphasis upon expression, we might expect Avison to define the word precisely and prominently. If we do, however, we shall be disappointed. What he means by "expression" is not easy to discover. The *Essay* is divided into three parts, which relate musical expression respectively to the listener, the composer, and the performer, and each part seems to describe something different. With respect to the listener, expression derives from the association of ideas, and refers to the internal sense through which the emotions raised by musical sounds are brought forcibly home: when to "the natural Effect of *Melody* or *Harmony* on the Imagination . . . is added the Force of *Musical Expression*, the Effect is greatly increased; for then they assume the Power of exciting all the most agreeable Passions of the Soul" (3). With respect to the composer, expression depends upon the ability to rouse such emotions: it is "such an happy Mixture of Air and Harmony, as will affect us most strongly with the Passions or Affections which the Poet intends to raise" (69). With respect to the performer, expression is a matter of execution: "it is to do a *Composition* Justice, by playing it in a *Taste* and *Stile* so exactly corresponding with the Intention of the Composer, as to preserve and illustrate *all* the Beauties of his Work" (108). All that these kinds of expression have in com-

[36] See the Hayes-Harris correspondence printed by Betty Mathews, "Handel—More Unpublished Letters," *Music & Letters*, XLII (1961), 127-131. As a founder of the St. Cecilia Festival at Salisbury, Harris was a patron of most of the leading musicians of his day; according to Richard Eastcott, *Sketches of the Origin, Progress and Effects of Music* (Bath, 1793), p. 78, he was an excellent musician, and was looked up to at Salisbury as "the father of harmony."

[37] *Remarks on Mr. Avison's Essay on Musical Expression* (London, 1753), p. 69. Many contemporaries thought that Hayes, newly appointed Professor of Music at Oxford, had the better of the argument.

mon is a connection with feeling, and a mastery over the means by which feeling is rendered.

Indeed, Avison systematically discourages any attempt to understand "expression" other than according to its successful effects. "The Power of Music is . . . parallel to the Power of Eloquence: if it works at all, it must work in a secret and unsuspected Manner" (70). A musical composition is expressive if it works; and if we inquire *why* it works, we may prevent it from working at all. Thus to call a piece "expressive" is to praise it, not by any means to describe it. Definitions must take the form either of particular examples of expressive effects (Avison's proposed edition of the Psalms of Marcello was intended to display a complete range of such examples)[38] or of outright tautology: "*Musical Expression* in the *Composer*, is succeeding in the Attempt to express some particular Passion," so long as "the Word *Passion* is here taken in the most extensive Sense, as it may be applied to every Species of Excellence in musical Compositions" (107). That is, expression is success in expressing something successfully. No wonder that Avison is perfectly ready to abandon the whole enterprise of definition. "AFTER all that has been, or can be said, the Energy and Grace of *Musical Expression* is of too delicate a Nature to be fixed by Words: it is a Matter of Taste, rather than of Reasoning, and is, therefore, much better understood by Example than by Precept" (81). A chorus of *Black-ey'd Susan* can teach us more than the complete Works of Harris about this kind of expression.[39] Avison deliberately refrains from any commitment to a formal definition, or to words themselves.

This strategy of aesthetic non-commitment pervades the *Essay*. Another example may prove illuminating. One of the most problematical issues for eighteenth-century writers on music was the notion of *subject* (sometimes identified with *air*): if music were

[38] The specimens are grouped under three heads: The Grand (subdivided into Sublime, Joyous, Learned), The Beautiful (Cheerful, Serene, Pastoral), The Pathetic (Devout, Plaintive, Sorrowful). The edition of Marcello's Psalms, adapted to English words, was eventually edited by John Garth in eight volumes with an introduction by Avison (London, 1757). Both Hayes and Hawkins, who may have been offended by Benedetto Marcello's vitriolic literary productions, thought the "levity" of his style unsuitable for the Psalms.

[39] Avison praises *Black-ey'd Susan* as a specimen of proper composition (*Essay*, p. 85).

not an imitative art, how could one speak of its subjects?[40] An obvious solution would be to restrict the word to its technical meaning (i.e., "A melody which, by virtue of its characteristic design, prominent position, or special treatment becomes a basic element in the structure of a composition").[41] This solution was adopted by Rousseau, who called subject "the principal part of the design";[42] and the implications of such a restriction were spelled out by Adam Smith in his dictum that "The subject of a composition of instrumental Music is a part of that composition: the subject of a poem or picture is no part of either."[43] Other authors, conscious of the indivisibility of melody and harmony, and perplexed by the apparent independence of musical structures from anything like a unifying idea or moral, saw "subject" as the essence, or the central mystery, of music. Roger North, who was not a man to be satisfied with "dark diallect, and jargon," asked the question "What is Ayre?" again and again, and answered it according to his many lights.[44]

Thus Avison, when he proposed to define the "subject" with new clarity, had a choice of technical or philosophical contexts. Here is his response: "THE Term *Subject*, (or *Fugue* or *Air*) is, in a musical Sense, what the Word Subject likewise implies in Writing. The Term *Air*, in some Cases, includes the Manner of handling or carrying on the Subject" (iii). Such a definition is not so much confusing as temporizing. Avison wants to use the word in several ways, and he will not limit himself to a single context or a single interpretation. In his "Remarks on the Psalms of Marcello," for instance, where he wishes to defend the composer from the charge of levity—changing his subject too often—the argu-

[40] An influential later discussion of this problem is chapter VII of Eduard Hanslick's *Vom Musikalisch-Schönen* (Leipzig, 1854).

[41] *The Harvard Dictionary of Music.* James Grassineau, *A Musical Dictionary* (London, 1740), a version of Brossard's *Dictionnaire de musique* (Paris, 1703), offers no definition of *subject* or *expression*, and the definition of *imitation* is strictly technical ("a particular way of composition, wherein each part is made to imitate the other").

[42] Rousseau's *Dictionary of Music*, tr. William Waring (London, 1779; originally published 1768).

[43] "Of the Nature of that Imitation which takes Place in What are called the Imitative Arts," *Essays on Philosophical Subjects* (Edinburgh, 1795), p. 173. Smith's lectures were delivered 1751-1764. See Rogerson, *Ut Musica Poesis*, pp. 111-112.

[44] *Roger North on Music*, chapter IV.

ment depends on shifting from one sense of "subject" to another. "As the Subjects of the Psalms are various and desultory, . . . the Composer was to express these Changes in his Music." Therefore, Avison argues, in the music "the Subjects are remarkably various, and some of them carried into extreme Modulations."[45] Here the analogy between literary and musical subjects suggests that a variety in a poem's story or sentiments justifies the composer's freedom of technique. Avison blends the imitative and expressive theories of music, not with a theory but with a word. For the moment, of course, he risks talking nonsense; but in the long run the ambiguities he has prepared allow him a free exercise of taste.

The aesthetic significance of *An Essay on Musical Expression,* then, is much less profound than it may appear to be at first sight. Avison has no coherent theory of expression to expound. Roger North had apologized because "It seems odd to give descriptions and caracters to a thing so litle understood as musicall Ayre is—a meer *je ne scay quoy,*"[46] but the *Essay* takes advantage of every *je ne sais quoi,* every rich and relevant ambiguity it can find. "Expression" itself is such an ambiguity, a receptacle for notions of good taste and grace and effectiveness and felicity, and that is why it serves as the center of Avison's aesthetic.

A similar opportunism lies behind all the theory of the *Essay.* Comparisons with other arts, especially painting, poetry, and architecture, offer critical opportunities without requiring a theoretical or systematic precision. Avison's extensive introductory series of analogies between music and painting, "an Art much more obvious in its Principles, and therefore more generally known" (20), is not a contribution to aesthetics but an exploitation of whatever resemblances glorify music. The *subject* of a composition, for instance, must be compared to the noble figures of history painting rather than to portraiture;[47] in the same way, poetry lends the sanction of Homer, Shakespeare, and Waller. *An Essay on Musical Expression* snatches tastes beyond the reach of definition. In thus untuning and evading the traditional argu-

[45] Marcello's *Psalms,* I, xvi-xvii. Cf. the use of *principal* for "theme" or "design," *Essay,* pp. 24-25, 76.

[46] *Roger North on Music,* p. 68.

[47] Cf. Dryden's concentration on history painting, and his equivocation over "subject," in the "Parallel of Poetry and Painting" (1695).

ments about music, it effectively separates music criticism from the philosophy of music. Perhaps that was the price that English music criticism had to pay in order to exist at all.

4

According to Burney, "musical criticism has been so little cultivated in our country, that its first elements are hardly known. In justice to the late Mr. Avison, it must be owned, that he was the first, and almost the only writer, who attempted it. But his judgment was warped by many prejudices. He exalted Rameau and Geminiani at the expense of Handel, and was a declared foe to modern German symphonies."[48] The charge of prejudice, so similar to many made against Burney himself, helps to confirm that Avison is a true precursor of later criticism, already embroiled in the rivalry and alarums that were to enliven the 70's and 80's. Hayes had levelled the same charges; he had even implied that Avison's low opinion of imitation was a subterfuge intended to disparage Handel, the master of imitation.[49] About tastes, of course, there is always dispute, and by emphasizing the primacy of taste Avison had put his own on trial. After the *Essay* no refuge could be found in theory or generality. If Avison acknowledged no rule but the school of nature and good sense, then everyone was competent to judge him.

Music criticism, like musical expression, was not easy to fix by words. Avison had combined or annulled the traditions of music writing without finding an authoritative substitute. He did not develop a theory of expression with which to defend his preferences; Hayes suspected that "expression" was no more than a mask for prejudice. Some better principle of taste, or at least some better structure for presenting and arguing tastes,[50] had to be found.

The real originality of *An Essay on Musical Expression*, in fact, stems from its varied attempts to discover new methods of organizing, new methods of justifying, its opinions. One side of this effort is the variety of genres we have already noted. Another is an experimental classification of composers according to their combinations of melody, harmony, and expression. "When these

[48] *A General History of Music,* ed. Frank Mercer (New York, 1957), II, 7.
[49] *Remarks,* pp. 58ff. [50] See chapter ten, section four below.

three are united in their full Excellence, the Composition is then perfect: if any of these are wanting or imperfect, the Composition is proportionably defective" (29). Thus each composer can be rated on a scale that shows whether he neglects melody for harmony, like such "Ancients" as Palestrina, or harmony for melody, like Pergolesi, or everything at once, like Vivaldi.[51] As well as an "objective" means for judging musical compositions, this scheme furnishes a view of history in terms of the progressive union and separation of musical elements.[52] History itself can be criticized retrospectively by the new steel-yard. As a critical instrument, however, the tri-partite classification has only a limited usefulness; it depends too heavily on its third term, Avison's favorite indefinable "expression," which is not so much a category as a wild card used to trump any opinion with which he disagrees.

By far the most frequent of Avison's critical methods, however, is the argument from analogy. Once he had forgone those technical terms that had enveloped music in dark dialect, he had no alternative but to borrow terms from the common language of the other arts. Like Reynolds after him, Avison was involved in a paradox: in order to criticize music clearly and specifically in its own right, he had to speak in terms that everyone could follow, those that describe the response to music as it affects the mind, and such terms had already been appropriated by the poets, the painters, and the philosophers. The language of nature and good sense, as Avison knew it, was a jargon too, and a jargon that could not pretend to have precise application to music. Moreover, as a principle of organization the argument from analogy forced criticism to be couched in elegant general phrases. The *Essay* saves music from the hands of the musicians only to deliver it into the hands of the prose stylists.

Consider, for instance, the fine set piece with which Avison defends his judgment of Handel. "Mr HANDEL is in Music, what

[51] As an enemy of musical imitation, Avison also condemns the "mimickry" of Vivaldi's *Seasons* (*Essay*, p. 109). In his "Letter to the Author," John Jortin managed a kind of defense: "as to *Vivaldi*, give me leave to say, that with all his caprices and puerilities, he has a mixture of good things, and could do well when he had a mind to it" ("Letter," p. 18).

[52] This approach strongly resembles that of Dr. John Brown (see note 29 above), and probably reflects his personal influence.

his own DRYDEN was in Poetry; nervous, exalted, and harmonious; but voluminous, and, consequently, not always correct. Their Abilities equal to every Thing; their Execution frequently inferior. Born with Genius capable of *soaring the boldest Flights*; they have sometimes, to suit the vitiated Taste of the Age they lived in, *descended to the lowest*. Yet, as both their Excellencies are infinitely more numerous than their Deficiencies, so both their Characters will devolve to latest Posterity, not as Models of Perfection, yet glorious Examples of those amazing Powers that actuate the human Soul."[53] The technique of this passage is probably borrowed from Dryden himself. Like Johnson, who made use of Dryden's and Pope's comparisons of Virgil and Homer in writing his own comparison of Dryden and Pope,[54] Avison pays tribute to the poet in his own coin: his dialectical juggling of qualities, his racy, dramatic language, his final generous impulse. Yet Avison's dialectic is far more shaky. Dryden's contrasts serve to draw distinctions which isolate each poet in a precise individuality. Avison works with analogies, not distinctions; he compares the *characters* of Dryden and Handel, not their art. To reconcile the musician with the poet, he is driven to a shifty, generalized vocabulary: the fine-sounding word "harmonious," for example, connotes so much because it denotes so little. The analogies rob the criticism of specific reference to music, and leave it vague and unsupported.

On the other hand, Avison benefits in three important ways from his use of analogy. He writes a criticism that can be understood by a reader who knows nothing about music; in associating Handel with Dryden, he associates music with poetry and hence with all the powers of "the human Soul"; and he has every opportunity to be stylish. Freed from technical language and from philosophy, Avison is the first English writer on music who has pretensions to elegance.

Nevertheless, all Avison's experiments with critical classifica-

[53] *Reply*, pp. 50-51.
[54] See chapter thirteen, section eight and note 120 below. The appropriate passages are, Dryden, "Preface to the Fables," *Essays of John Dryden*, ed. W. P. Ker (Oxford, 1926), II, 251-54; Johnson, "Life of Pope," *Lives of the Poets*, ed. G. B. Hill (Oxford, 1905), III, 220-223. A closer analogue to Avison is the comparison of Dryden and Pope in Cibber's *Lives*, which may also have been composed or influenced by Johnson, and which was published in the same year as Avison's *Reply*, 1753.

tion, all his search for principles of taste, are compromised by superficiality. His models were not good enough; he did not know enough. *An Essay on Musical Expression* had evaded the burden of a tradition that it could not use, but it had not established new precedents, better ways of thought. No one was more aware of this inadequacy than Avison himself. He felt alone, and he asked for support: for an academy, for periodical reviewers, and above all for historians. One man could not improve musical taste, but it would surely improve, "were there any History of the Lives and Works of the best Composers; together with an Account of their several *Schools,* and the *characteristic Taste,* and *Manner* of each:—A Subject, though yet untouched, of such extensive Use, that we may reasonably hope it will be the Employment of some future Writer. . . . THUS, and thus alone, can we hope to reach any tolerable Degree of Excellence in the nobler Kinds of musical Composition. The Works of the greatest Masters are the only Schools where we may *see,* and from whence we may *draw,* Perfection" (98-100).

The need for such a history is demonstrated by Avison's own weak historical sense. He recognizes only three historical eras, ancient, Gothic, and modern, and his sole criterion for describing an age is the simple opposition of barbarity and elegance. As models of the greatest masters he selects, in vocal music, Benedetto Marcello, in instrumental, his own teacher, Geminiani.[55] Hayes accused Avison and his teacher of forming a critical *junto;* but even his rebuke displays the imprecision of a historical vocabulary based on analogy: "GEMINIANI may be the *Titian* in Music, but HANDEL is undoubtedly the RUBENS."[56] An art whose criticism is so impoverished in historical models urgently requires new sources of knowledge.

Like Richardson, Avison called for a general history of his art, hoping that ideas about music could be given a new basis in fact. Unlike Richardson, he was rewarded with a direct reply. In 1752 both Hawkins and Burney had begun to collect materials

[55] Of Avison's own compositions, the best-known is undoubtedly the march printed by Robert Browning to conclude his rhapsody to Avison in *Parleyings with Certain People of Importance in their Day.* A charming Italianate concerto for strings first published in 1751 has recently been recorded by the English Chamber Orchestra for English Decca. See also P. M. Young, *A History of British Music* (London, 1967), pp. 334-335.

[56] *Remarks,* p. 128.

pertaining to the history of music, though not yet with a specific project in mind. Divergently, like the *Titanic* and its iceberg, they were already heading for a distant rendezvous. *An Essay on Musical Expression* had helped to banish the world of music where *Universal Harmony* was possible. In the wake of Avison the conversation about music shifted from metaphysics to taste, and the historians, the antiquarians, and the critics replaced those authors for whom the idea of music was more important than any musical composition could ever be.

Yet the *Essay* did not enter the new world to which it had pointed. It remained an experiment; narrow in taste, vague in vocabulary, sciolistic in history. Avison did not found a school. Nevertheless, he had demonstrated that writers on music could aim for a new audience, the public at large, and he had provided a model, however faint, of taste in action. For a brief historical moment between philosophies, the question What is music? would defer to another question: Where is music to be found? And in this question, if in this alone, Avison's *Essay* had prepared English writers on music for their greatest effort in history.

The Science and Practice
of Sir John Hawkins'
History of Music

1. HAWKINS AND BURNEY

THE rivalry between Hawkins' and Burney's histories of music began long before their publication, and it has not yet ended. The two works have come down to us fatally wedded by a chain of coincidence: their almost simultaneous appearance in 1776, their complementarity, the fascinating gossip that surrounds them both, their eccentric and problematical greatness.[1] Even at this distance, Hawkins and Burney can hardly be seen except in terms of each other.[2] The two histories that form the basis of English musicology were born in competition, and they have grown old together in competition.

In some ways this rivalry is fortunate. Although both authors were plagued by fear and malice, they were also stimulated to heroic efforts to excel. Moreover, the competition contributed to their fame. As early as 1773, Dr. Johnson had foreseen this advantage with a practical bookman's wisdom: BOSWELL. "Both Sir John Hawkins's and Dr. Burney's *History of Music* had then been advertised. I asked if this was not unlucky: would not they hurt one another: JOHNSON. 'No, sir. They will do good to one another. Some will buy the one, some the other, and compare them;

[1] Indispensable information about the circumstances of the rivalry is provided by Roger Lonsdale, *Dr. Charles Burney: A Literary Biography* (Oxford, 1965), and by Percy Scholes' two biographies, *The Great Dr. Burney*, 2 vols. (London, 1948), and *The Life and Activities of Sir John Hawkins* (London, 1953).

[2] Most of the discussions of the histories continue to center on their oppositions; see, for instance, W. D. Allen, *Philosophies of Music History* (New York, 1962), pp. 76-81. Robert Stevenson, " 'The rivals'—Hawkins, Burney, and Boswell," *Musical Quarterly*, XXXVI (1950), 67-82, supplies a useful introduction.

and so a talk is made about a thing, and the books are sold.' "[3] In the short run this prophecy turned out to be wrong: Burney's ruthless tactics succeeded in driving Hawkins out of the market. In the long run, however, Johnson was right. Critics compare the histories, new editions come out, talk is made about a thing. Both Hawkins' *History* and Burney's are more vivid for the ever-renewed argument between them.

On the most superficial and popular level, the memoirist's world of gossip and personality, the anecdotes still go on. The stuffy, "unclubable,"[4] self-righteous, forensic, pietistic Sir John provides a noble foil for the graceful, clever, facile, companion-able, fashionable father of Fanny. The contrast goes deeper, how-ever. To a remarkable extent the rivals defend positions as nicely opposed and discriminated as any musicologist could wish. Haw-kins, a musical amateur with an antiquarian bias, insists that music is a "science" based on universal principles; Burney, a profes-sional musician disposed to polite letters, claims that music is an art which, like the other arts, pretends to no higher purpose than amusement. For Hawkins, the great age of music is the six-teenth and seventeenth centuries; for Burney, his own age is golden. Hawkins tries to write a peculiarly English history, us-ing materials gathered at home; Burney tries to bring England into the continental mainstream, using the collections he gath-ered as the most famous musical traveller of his time.[5] Hawkins declares war on "taste"; Burney is taste itself. Two philosophies of music, two historical eras, cross and engage in them.

Nevertheless, in spite of the inevitability of these contrasts, Hawkins and Burney have something in common: the effort to construct the first English history of music. They share the same problems of organization, the same burden of finding a sys-tem to master a vast and incoherent body of information. And the result is that all their differences of theory and personality, all their rivalry and disputation and partisanship, cannot prevent the two histories from resembling each other.

[3] *Boswell's Journal of a Tour to the Hebrides with Samuel Johnson, LL.D.*, ed. F. A. Pottle and C. H. Bennett (New York, 1961), p. 50.

[4] Dr. Johnson's famous coinage for Hawkins is reported by Fanny d'Arblay, *Diaries and Letters of Madame d'Arblay*, ed. Austin Dobson (London, 1904-1905), I, 59. Cf. Burney to Malone, Bodleian MS. Malone 38, f.159.

[5] *Dr. Burney's Musical Tours in Europe*, ed. P. A. Scholes, 2 vols. (London, 1959).

There is an extraordinary kind of evidence for this pressure towards resemblance. When Burney first learned that Hawkins was competing with him, he was consoled by the belief that their approaches were utterly irreconcilable.[6] Any reader with taste would know that Hawkins' support for old music was ludicrous; and Hawkins' well-known pedantry would keep him from writing a history with the clarity and grace to appeal to a modern audience: "If Sr John had ever had any Taste, the reading such a pack of old rubbish as he seems to delight in wd have spoilt it."[7] The histories would be diametrical opposites. As time went on, however, Burney was distressed to find that his own history was inexorably drifting onto Hawkins' barren ground. He had no choice but to read much of the same "rubbish," and to pass judgment on the same quibbles. Moreover, Burney's taste itself was changing. As he delved more and more into "ancient" music, and made the attempt to understand it, it came to seem less barbarous; perhaps Josquin and Palestrina and Tallis were not after all so very inferior to Hasse and Jommelli.[8] The act of writing a history of music forced Burney into a new respect for the past.

Burney's problem became still more acute after the publication of the five volumes of Hawkins' *History* in November, 1776. Only one volume of Burney's *History* had yet appeared, and from now on his work would have to submit to detailed comparison. The situation was infernally embarrassing. While refraining from mentioning Hawkins' name, Burney constantly referred to or took issue with his materials and interpretations; and as so often happens in cold wars and marriages, he came to resemble his other self, that alien object always in the mind. The bulk of Hawkins' *History* also loomed large. Burney's own *History*, its completion

[6] Lonsdale, *Dr. Charles Burney*, pp. 189-91.

[7] Burney to Twining, 28 April 1773, British Museum Add. MS. 39929 ff.54-56. A version of this letter appears as an appendix to Scholes' *Hawkins*, pp. 238-39.

[8] Compare Burney's defense of Jommelli and his contemporaries in a letter to Ebeling, Nov. 1771—"There are Times for shewing learning and contrivance; but I think the best of all contrivances in Music, is to please people of discernment and taste, without trouble" (Scholes' *Burney*, I, 202)—with his admission in the *General History of Music* (1789) that the demand to please audiences without trouble may have harmed Jommelli's music—"It is the *excess* of learning and facility that is truly reprehensible by good taste and sound judgment; and *difficult* and *easy* are relative terms, which they only can define" (Burney, *A General History of Music*, ed. Frank Mercer [New York, 1957], II, 931).

delayed until 1789, gradually swelled to meet the challenge,[9] and instead of the two volumes he had originally intended he eventually produced four. The fashionable *History of Music* had become, like its rival, a monument of scholarship, not easily read through, not scanting of praise for old music, not clearly organized. It was, in fact, a work of the same kind as Hawkins'. In later years Burney himself acknowledged the fact; "his anxiety to ensure that the new generation of musicologists respected the earlier labours which had made their own work possible almost forced him into a kind of truce with Hawkins, whose name he often linked with his own, when pointing out what an easy task musical history had become since the publication of the two giant *Histories*."[10] Against his will Burney had adopted the rival he despised.

Thus the competition between the two historians of music, while emphasizing their individuality and opposition, also teaches us how much they share. We all know how resistant a piece of writing can be to complete control. Somehow the work does not take the direction we had envisaged; new thoughts, new structures demand their own way. The histories of music, in spite of the intellectual powers of their makers, were largely composed by forces beyond their control. In the absence of precedents, a history of music was required to be at once scholarly and critical, objective and principled, conservative and modern. Hawkins and Burney could not accomplish quite so much. They drifted with their materials, they solved small problems at the cost of forsaking larger ones, and they did not provide the definitive sense of order and of history they had promised. The evidence of the changes imposed upon Burney's plan is impressive; "it" and Hawkins wrote a great deal of his *History*.

To insist upon the uncontrollability of the histories of music, however, is not to diminish them. The rivalry of Hawkins and Burney with each other is intriguing, but their rivalry with everything previously written about music is far more ambitious and praiseworthy. The struggle of each historian to make sense of the whole art he studied, a struggle that took more than two decades, is what defines his stature. The principles and methods according to which Hawkins made his history were not the prod-

9 Lonsdale, *Dr. Charles Burney*, p. 219.
10 *Ibid.*, p. 222.

uct of his controversy with Burney, and they can be understood, if at all, only by considering them in the context of history, and in the context of the *History of Music* itself. It is time to declare a truce. The histories of music, and the men who made them, are interesting enough in their own right.

2. HAWKINS HIMSELF

The difficulty in dealing justice to Hawkins' *History of Music* has always been Sir John himself.[11] If the work had been published anonymously and without a competitor, its magnificence would have been acknowledged at once; but Hawkins was anything but anonymous. His personality presides over every page. And on the whole that personality has been an embarrassment to everyone who has sought to argue for the merits of the lifework. Percy Scholes' recent biography, a sort of supplement to his own life of Burney, might well have been called *Trying to Like Sir John Hawkins*; its justifications are as damaging as any attack. "What he really lacked, perhaps, was a sense of humanity (of being a unit in the suffering human family) and a sense of humour. . . . There was at least *something* good about a man whose list of familiar acquaintances was as long as his daughter shows it to have been."[12] One is reminded of Dr. Johnson's celebrated "defense" of his "friend": "as to Sir John, why really I believe him to be an honest man at the bottom: but to be sure he is penurious, and he is mean, and it must be owned he has a degree of brutality, and a tendency to savageness, that cannot easily be defended."[13] Even Hawkins' advocates find it hard to warm to him.

Thus the career of Hawkins hangs upon a paradox.[14] On the one hand, he devoted his life to formidable projects, and he completed them honorably; on the other hand, all his accomplish-

[11] Another difficulty is his daughter, Laetitia Matilda Hawkins, whose three volumes of *Anecdotes, Biographical Sketches and Memoirs* and *Memoirs, Anecdotes, Facts, and Opinions* (London, 1822; 1824) provide rather a chaotic biographical account. Like Fanny Burney, Miss Hawkins won some fame as a novelist; like Fanny, she memorialized her father at so late a time in life that her memory (and her intentions) cannot always be trusted.

[12] Scholes' *Hawkins*, p. xiii.

[13] *Diaries and Letters of Madame d'Arblay* (note 4 above), I, 58.

[14] The paradox is emphasized by Bertrand Bronson in his review of Scholes' *Hawkins*, *MLN*, LXIX (1954), 521-24. Cf. Edward Boyle, "Johnson and Sir John Hawkins," *The National Review*, LXXXVII (1926), 77-89.

ments brought him pain and personal abuse. There is a remarkable parallel between the receptions of Hawkins' *History of Music* and his *Life of Johnson* (1787).[15] Each book was damned by a conspiracy of clever enemies before it was published, and each was superseded immediately by a more glamorous but less scrupulous rival. Even the details of the two affairs (for instance, the harassment engineered by George Steevens)[16] induce a sense of *deja vu*. Hawkins seems to have had a gift for being betrayed.

The fair response to such persecution is undoubtedly that offered recently by Bertram Davis: "the real object of the critics' abuse was not so much Hawkins' book as Hawkins himself."[17] That is true for the *History of Music* as for the *Life of Johnson*. Yet it is not the whole truth. In each case the critics found much to abuse in the book itself: ponderous style, overly circumstantial though not strictly accurate batches of information, uncharitable opinions, digressive organization, reactionary prejudice against modern works. These targets may be variously excusable, but they are not imaginary. And each of them is a literary trait connected with a trait of character. The problem faced by Hawkins' defenders is that his personality, with all its rough edges and lack of ease, does bear upon his work, and that its intrusions present his adversaries with a not-irrelevant butt for their scorn.

An example of Sir John's genius for getting himself into trouble is provided by a note in his best received work, his edition (1760) of *The Compleat Angler*. Most of this comment confers inoffensive praise upon English understanding of music at the time of Milton. In an expansive mood, however, Hawkins cannot resist adding something: "And, now I am upon this Subject, I will tell the reader a secret; which is, that Music was in its greatest perfection in *Europe* from about the middle of the sixteenth to the beginning of the seventeenth Century; when, with a variety of treble-instruments, a vicious taste was introduced, and harmony received its mortal wound."[18] Whatever one thinks of the value of this opinion, it is surely gratuitous and imprudent;

[15] See Stevenson, *Musical Quarterly*, XXXVI. The reception of Hawkins' *Life* is the main subject of B. H. Davis, *Johnson before Boswell: A Study of Sir John Hawkins' Life of Samuel Johnson* (New Haven, 1960).

[16] Cf. Scholes' *Hawkins*, pp. 131-34; Davis, *Johnson before Boswell*, pp. 4-10.

[17] *Ibid.*, p. vi.

[18] Izaak Walton, *The Complete Angler*, ed. Hawkins (London, 1760), p. 238n.

and in one practical respect it proved disastrous, because Burney, upon reading it, concluded that his own history would be very much needed.[19] Hawkins generously supplied his critics with ammunition. He could not prevent a characteristic acerbic tone, a characteristic lack of proportion, from compromising his objectivity.

Insofar as such intrusions merely reflect a quirk of personality, they are better left to the social historian. We require a study of Hawkins' *History* far more than gossip about his lack of manners. Nevertheless, the presence of Sir John's forceful voice where he would have been better advised to retire and be silent has something to teach us about his work. He was not at ease about what he was doing. His self-consciousness, his harshness of tone, reveal his uncertainty; his authoritarian manner continually betrays a lack of felt authority. No devious psychologizing is necessary to establish this trait. It is transparently on show in his works, in their notorious combination of dogmatic pronouncements with proliferating and digressive anecdotes, and it was immediately apparent to his contemporaries. Hawkins' personality became an issue because he forced it upon his readers, as if to intimidate them when they noticed contradictions or disorganization. For this reason, he tends to assert himself most glaringly at the end of a long digression, for instance the note on music in *The Compleat Angler* or the attack on Fielding's morality in the *Life of Johnson*,[20] when the necessity arises of justifying his excursion. Our awareness of Hawkins himself is a dependable sign of a lack of harmony in his work.

There was good cause for Sir John to feel a certain insecurity. His enemies were not, of course, imaginary; and both in society and in literature he was attempting to combine two worlds. The genesis of the *History of Music* illustrates this attempt. In 1759 Hawkins, through his wife, came into a fortune that enabled him to retire, at the age of forty, from his practice as an attorney. He then "found himself in a situation that left his employments, his studies, and his amusements in a great measure to his own choice."[21] The following year he moved to Twickenham, where

19 Lonsdale, *Dr. Charles Burney*, p. 190.
20 *The Life of Samuel Johnson, LL.D.* (London, 1787), pp. 214-15.
21 Sir John Hawkins, *A General History of the Science and Practice of Music*

he made the acquaintance of Horace Walpole. Walpole, then in the process of dashing off the *Anecdotes of Painting*, suggested to Hawkins that he also should fill his time with a project: a history of music.[22] Hawkins had probably already thought of such a project; at any rate, he accepted the idea, and also the help that Walpole could provide through his very extensive antiquarian connections.[23] His new leisure had found a sixteen-year occupation.

Hawkins, however, faced problems with which Walpole did not have to cope. Above all, Hawkins had no Vertue. Although an enthusiastic amateur of music, a member of the Academy of Ancient Music and the Madrigal Society, and a friend of musicians, he lacked professional knowledge, and he could not buy it in such a tidy package as had been available to Walpole.[24] Moreover, his position was awkward. Until recently he had moved in circles where antiquarianism was a hard business rather than the indolent prerogative of gentlemen, and where research was meant to bring in a profit. He had once been the acquaintance of William Oldys;[25] now he was better suited to be his patron. Indeed, Hawkins has been accused of concealing his obligations to Oldys, who certainly supplied him with a life of Cotton for the edition of Walton, and perhaps also gave him collections for a history of music, as well as passing along the manuscripts of Dr. Pepusch.[26] In any case, Hawkins could not be so "fastidious" as Walpole. He had to do his own research, and he did not

(New York, 1963), "Author's Dedication and Preface," I, xix. Page numbers in the text will refer to this edition, which is a reprint of the edition published by J. Alfred Novello in 1853.

[22] Scholes' *Hawkins*, pp. 114, 115n. Immediately upon Hawkins' arrival at Twickenham, he was presented with the first two volumes of the *Anecdotes*.

[23] See for instance the letter to Mann, 2 January 1761, Walpole's *Correspondence*, XXI (New Haven, 1960), 466-67.

[24] His musical advisors included John Stanley, William Boyce, and John Stafford Smith; for the last, see Elizabeth Cole, "Stafford Smith's Burney," *Music & Letters*, XL (1959), 35-38. His main cache of materials was the collection left by the learned Dr. Pepusch.

[25] Both had been contributors to *The Universal Spectator*. See James Yeowell's memoir of Oldys, *A Literary Antiquary* (London, 1862).

[26] See Oldys' *Diary*, pp. 15-16, published by Yeowell in *A Literary Antiquary*. Scholes' defense of Hawkins (*Hawkins*, pp. 119-121) cannot be quite accurate; he seems to forget that Pepusch died in 1752, before Sir John began his researches. Oldys himself had once contemplated writing a history of music in England.

pretend to elegant indolence.[27] Socially and intellectually, he would have liked to think himself above the battle, but practically he was as exposed as any Grub-Street hack. The difficulties of this position were repeatedly exploited by Hawkins' enemies, who preyed upon his dignity, secure in the knowledge that his pride and self-importance would not suffer him to reply in kind.[28] After he had been knighted in 1772, upon his own earnest solicitation,[29] he became still more vulnerable to satire. It is no wonder if poor persecuted Sir John developed symptoms of a persecution complex.

As a historian of music, Hawkins was similarly caught between two worlds. Walpole had presumably encouraged him to write an antiquarian history like the *Anecdotes,* and such a history was undoubtedly the kind most proper for a gentleman. Yet Hawkins, however far he had come from *The Universal Spectator,* was a serious man. He had no trace of that self-directed irony which is the leading characteristic of the antiquarian school of Walpole, he respected his own scholarship, and he remained convinced that music was as dominated by moral principles as he himself was. His history must be philosophical as well as antiquarian, Johnsonian as well as Walpolesque. Thus Walpole's favor to the history that emerged was bestowed with equal measures of amusement and condescension.

They are old books to all intents and purposes, very old books; and what is new, is like old books too, that is, full of minute facts that delight antiquaries—nay, if there had never been such things as parts and taste, this work would please everybody. . . . My friend Sir John is a matter-of-fact man, and does now and then stoop very low in quest of game. Then he is so exceedingly religious and grave as to abhor mirth, except it is printed

27 According to Miss Hawkins (*Anecdotes,* p. 314), Hawkins suggested the publication of Percy's *Reliques of Ancient English Poetry* (1765), and gave Percy antiquarian aid (three of his letters to Percy are published by John Nichols, *Illustrations of the Literary History of the Eighteenth Century* [London, 1817-58], VIII, 242-47). The forthcoming *History of Music* was puffed in the third edition of the *Reliques* (London, 1775), III, xxxix, though Percy later became offended at Hawkins.

28 He did, however, publish a fierce poem in response to Steevens' attack on the *History* in the *St. James's Chronicle;* the poem is reprinted in Scholes' *Hawkins,* p. 133.

29 Scholes' *Hawkins,* p. 111.

in the old black letter, and then he calls the most vulgar ballad pleasant and full of humour. He thinks nothing can be sublime but an anthem, and Handel's choruses heaven upon earth. However he writes with great moderation, temper and good sense, and the book is a very valuable one.[30]

Hawkins' work could please the most cultivated antiquarian, but only because it was a ready-made artifact, a modern relic to tease the imagination. He had not won a place for himself among his contemporaries.

To the lack of coherence which struck all observers of music history, therefore, Hawkins brought a special lack of harmony of his own. His high aspirations to transform the art he loved were out of date before they were realized, and his very seriousness had to bend "his Austerity" toward the collection of trivia. He was not at home nor at ease in the field he wished to define. He felt vulnerable, and he did not like to be criticized. His authority had yet to be proven. He was surrounded by enemies. He was not brilliant. The circumstances were not ideal for the birth of a major work.

3. THE INTENTIONS OF HAWKINS' *History*

The focal point for all of Hawkins' problems with the *History of Music* has usually been found in its structure. Indeed, many critics would deny that the work has a structure at all. Percy Scholes, who thought himself a defender of the *History*, considers it a "quarry" rather than a finished piece. "The lack of any constructive sense in Hawkins's literary mind is indeed phenomenal, and the effect is sometimes positively crazy. There are moments when we feel almost impelled to cry, '*Was this writer perfectly sane?*' "[31] The devastating review with which William Bewley, under the direction of Burney, destroyed the contemporary reputation of Hawkins' *History* similarly denies that it shows any order or balance, whether literary or psychic. "We have seldom met with a performance so pregnant with confusion as

[30] To Lady Ossory, 3 December 1776, Walpole's *Correspondence*, XXXII (New Haven, 1965), 333.

[31] Scholes' *Hawkins*, p. 192. This comment is directed at the *Life of Johnson*, but Scholes directs similar remarks at the *History*, including the quickly disproven prophecy that "It will perhaps never be reprinted again" (p. 130).

the present: and yet the Author has not bestowed upon it even a simple table of contents; nor has the bewildered Reader any clue to lead him to any particular part of this extensive wilderness. . . . it is not easy, in general, to find a reason why a particular book or chapter begins, or ends, where it does, rather than any where else; neither is there a title prefixed to any one of them, notwithstanding the various and heterogeneous matter contained in many of them."[32] Bewley's charges are prejudiced, but not incorrect. The reader of Hawkins' *History* is confronted with five volumes, twenty books, one hundred and ninety-seven chapters, a brief index, a preface, introduction, and conclusion, and little sign of what has brought them all together. If literary structure be defined as that principle which conducts a work from its beginning through its middle to its end, or as that arrangement of parts which induces a reader to scan a work in a certain sequence or order rather than at random, then the *History of Music* seems to have none. Not even "the history of music" furnishes an organizing principle, because Hawkins deals with many matters that are unrelated to music, nor does he observe strict chronology.

Before we abandon Hawkins to his critics, however, we should pay a little attention to what he thought he was doing. About his *intentions*, at any rate, he was not incoherent.

> The end proposed in this undertaking is the investigation of the principles, and a deduction of the progress of a science, which, though intimately connected with civil life, has scarce ever been so well understood by the generality, as to be thought a fit subject, not to say of criticism, but of sober discussion: instead of exercising the powers of reason, it has in general engaged only that faculty of the mind, which, for want of a better word to express it by, we call Taste; and which alone, and without some principle to direct and controul it, must ever be deemed a capricious arbiter. Another end of this work is the settling music upon somewhat like a footing of equality with those, which, for other reasons than that, like music, they contribute to the delight of mankind, are termed the sister arts;

[32] *The Monthly Review*, LVII (August, 1777), 151. For the circumstances of the review, see Lonsdale, *Dr. Charles Burney*, pp. 209-19.

to reprobate the vulgar notion that its ultimate end is merely to excite mirth; and, above all, to demonstrate that its principles are founded in certain general and universal laws, into which all that we discover in the material world, of harmony, symmetry, proportion, and order, seems to be resolvable. (xix)

The main aims of the *History*, then, are two: to establish music as a fit subject for reasonable discussion, and to demonstrate its importance and universality. Hawkins would like to banish taste in favor of reason and law, and to make criticism "sober." Insofar as both his aims depend upon the elucidation of principles, rather than upon merely exciting or certifying "mirth," they may be seen as one. In its devotion to principle, to "general and universal laws," the *History of Music* has a unity of purpose.

From the standpoint of Avison and the long conversation about music that he had attempted to reformulate, Hawkins' proposal looks like a distinct retrogression. Once again the idea of music is given precedence over any inspection of the music that we hear; once again philosophical and moral debate is substituted for practical criticism. Like Junius and the humanist scholars of music,[33] Hawkins argues for an ideal art, an art not only based upon universal laws but so extensive in its operations and its dignity that it constitutes the ordering principle of the material world itself. The implications of this point of view are ominous. As always when music is identified with the laws of harmony, symmetry, proportion, and order, we can expect the study of music to be utterly lacking in order, since all particulars are indiscriminately resolvable into the same few general propositions. When facts have only an emblematic value, they need not be sorted or compared. Universal harmony tends to be equivalent to structural chaos.[34]

In spite of Hawkins' brave sounding proposal, however, he is not the prisoner of universals that he professes to be. The au-

[33] The *History* provides very extensive summaries of the humanist treatises; it remains the best reference work on Renaissance studies of music. Though Hawkins ridicules the pretensions of such "enthusiasts" as Kepler, Fludd, or Isaac Vossius, he has high praise for such men of "universal learning" (p. 627) as G. J. Vossius, Junius' brother-in-law.

[34] In his long review (pp. 600-616) of Mersenne's *Harmonie Universelle*, Hawkins himself comments on the digressiveness of its method, and the difficulty of using it for reference.

thority of a Zarlino or a Mersenne clearly attracts him, but he does not claim a similar authority. Unlike Junius, he refuses to equate the laws of the universe with the practice of (or hearsay about) the ancients. Indeed, he sees the history of music as a progress from "the hideous and astonishing sounds" of barbarians to the modern "scientific practice of music."[35] The general principles into which Hawkins would resolve all he knows about music are not only to be deduced from writings and from mathematical demonstration, but induced from the facts at his command. Hawkins loves facts, and he respects them. His old-fashioned desire to capture music and the world that music epitomizes in the precepts of a single definitive text is compromised by his equal instinct towards unending accumulation.

The terms of this compromise are stated by the full title of Hawkins' book: *A General History of the Science and Practice of Music.* On the one hand, he earnestly requires music to take its place as a science, that is, "a branch of study which is concerned either with a connected body of demonstrated truths or with observed facts systematically classified and more or less colligated by being brought under general laws, and which includes trustworthy methods for the discovery of new truth within its own domain."[36] He wants it to be a field of knowledge and speculation available only to the learned, not to every vulgar person who happens to have ears. "Of what importance then can it be to enquire into a practice that has not its foundation in science or system, or to know what are the sounds that most delight a Hottentot, a wild American, or even a more refined Chinese?" (xix). On the other hand, he must reluctantly admit that music is an art, and thus subject to the practice of musicians: "in various instances the lives of the professors of arts are in some sort a history of the arts themselves" (xix). This admission is crucial. If music as a science can be reduced to a set number of principles, as a practice its only principle is diversity, its only bounds the record of all those who have taken an interest in it. Even

[35] Preface, p. xix. Hawkins refers here to Shaftesbury's *Characteristicks*, but he probably intends to hit at the opinions of John Brown (the *estimator* of Shaftesbury), whose *Dissertation . . . on Poetry and Music* (1763) argued that modern refinements had corrupted the original passionate simplicity of music known to the ancients and to savages.

[36] OED, Science, 4. Watt's *Logic* (1725) is the earliest citation for this sense.

mistakes are a part of that record. Hawkins was indeed committing himself to a *general* history.

Moreover, whether he knew it or not he was surrendering the possibility of keeping his work in proportion. The principles of science are few, the facts of practice are inexhaustible. When philosophic and antiquarian history meet, as in *Philological Inquiries*, the philosophy will always be in danger of being buried under weight of numbers. This process of drift is already obvious when Hawkins describes *how* he will prove the worth of music.

> The method pursued for these purposes will be found to consist in an explanation of fundamental doctrines, and a narration of important events and historical facts, in a chronological series, with such occasional remarks and evidences, as might serve to illustrate the one and authenticate the other. With these are intermixed a variety of musical compositions, tending as well to exemplify that diversity of style which is common both to music and speech or written language, as to manifest the gradual improvements in the art of combining musical sounds. The materials which have furnished this intelligence must necessarily be supposed to be very miscellaneous in their nature, and abundant in quantity. (xix)

By the end of this statement of method the fine pretension to doctrine has begun to take on a note of apology. Hawkins consistently proclaims his intention to reform the confusions and caprices of music writing, but he is powerless to control his own digressions. Inadvertently, his attack on taste yields to an appeal to the tastes of readers, "who cannot be supposed to be unanimous in their opinions about" his incidental anecdotes.[37] At a very early stage of methodology the *History of Music* abandons the attempt to decide what materials it will include or exclude.

Thus the problems of organization emphasized by Hawkins' critics are to some extent built into the *History* by his mixed intentions. It would have been simpler for him to write a simpler work, but he would not enforce an artificial distinction between science and practice when music itself combined them, and

[37] It is worth noting that Hawkins' literary reputation before 1776 rested on his edition of *The Compleat Angler*, where his digressions had been favorably received by the critics and public.

he had a perhaps blind confidence that a sound exposition of the one would somehow exemplify the other. Hawkins will not accept a part of the world of music for the whole. The courage of an amateur, and disgust at centuries of partial and obtuse writers, urge him to settle every question. The intention at least is generous, and demands a generous response. Hawkins has the right to ask for indulgence: "perhaps the best excuse the author can make for the defects and errors that may be found to have escaped him, must be drawn from the novelty of his subject, the variety of his matter, and the necessity he was under of marking out himself the road which he was to travel" (xix).

Given its praiseworthy ambitions and its double purpose, however, the *History of Music* remains a structural puzzle. Its aims and its means seem to be at odds. Why should Hawkins have thought that, merely by explaining doctrines and narrating events, he could free music from its bonds to taste and establish it as a science? To Hawkins' credit, he supplies no dogma, no artificial design, which might reduce music history to a set of principles; yet he seems to believe that such principles will arise of themselves. Somehow the method of his *History*, the disorganization so palpable that it became a laughing-stock, to him appeared the fruit of reason. How did he arrive at such an idea? Why did he think he had achieved his aims?

4. The Advancement of Musical Learning

Part of the answer must lie in the very process of writing the *History of Music*. The prospect of cleansing music from the encrusted jargon of centuries was clear and attractive, but the way to do it was not so clear. In many respects what happened to Hawkins resembles the "profound change of plan and method"[38] which was obtruding itself on Thomas Warton just at this time while he worked at his *History of English Poetry*. As materials grew and spread, the notion that they could be encompassed by any historical formula began to seem absurd. The one man incapable of seeing the history of an art as the logical working out of a scheme of development was the historian himself; he had come to know too much. For Hawkins as for Warton, the day-to-day fascination

[38] René Wellek, *The Rise of English Literary History* (Chapel Hill, 1941), p. 173. See chapter twelve below.

of disentangling documents and resurrecting forgotten works gradually replaced an overriding view. Even Burney, who tended to be distressed rather than fascinated by the obscurity of his materials, succumbed to the slow grinding erosion of his own process of work.[39]

The pressures of this erosion suited Hawkins temperamentally, and he was not distressed. Moreover, he had a theoretical reason for believing that the accumulation and comparison of documents would serve his purpose. Hawkins did not fear that the universal laws of music might be lost under the avalanche of paper, because he regarded his task as essentially *literary*: "such a detail is necessary to reduce the science to a certainty, and to furnish a ground for criticism; and may be considered as a branch of literary history" (xxiii). The originator of this attitude is Bacon, one of Hawkins' heroes, and the definition of literary history is also drawn from Bacon: "a just story of learning, containing the antiquities and originals, of knowledges and their sects, their inventions, their traditions, their diverse administrations and managings, their flourishings, their oppositions, decays, depressions, oblivions, removes, with the causes and occasions of them, and all other events concerning learning, throughout the ages of the world, I may truly affirm to be wanting."[40] If the history of music is seen in terms of the advancement of learning, then all the materials of learning become appropriate to its composition.

By modelling his history upon the paradigm of Bacon, Hawkins was accepting many corollaries: it would be primarily inductive rather than deductive; it would contain, and hopefully correct, a history of error; it would acknowledge no limitation on the kind or amount of musical learning to be surveyed, and would not sacrifice information for the sake of arrangement; and it would concentrate on documentation, the written record, rather than on unrecorded speculations or modern tastes. The first of these is the source of the rest. Hawkins believes faithfully in the powers of induction. He assumes that the history of music will yield all its secrets to patient study, and that the principles of music will form themselves into a coherent pattern. Just as a

[39] See Lonsdale, *Dr. Charles Burney*, especially p. 265.

[40] *History*, p. xxiii. Hawkins is here quoting the *Advancement of Learning*, Book Two, I, 2.

science may take its shape from the collection and correction of data into more precise and elegant laws, so music awaits only a more scientific investigator to define its essence.[41] That is the role which Hawkins modestly claims to fill.

To base music history upon an analogy with scientific method may be arguable (we shall argue with it in a later section),[42] but it represents a worthy ambition. Yet Hawkins had adopted a method which he could not control. The logical drawback of using induction as the measure of music history is that it provides no distinction between speculative and practical music, or among the literature of music, the theory of music, and musical compositions. Hawkins is aware that such a distinction is desirable: "In tracing the progress of music, it will be observed, that it naturally divides itself into the two branches of speculation and practice, and that each of these requires a distinct and separate consideration. . . . The two branches of the science have certainly no connection with each other" (xxxi).[43] But the *History of Music* observes the distinction only in theory. In Hawkins' work speculation and practice are judged by the same standards, as two dialects of the same language, two aspects of the same historical process. As subjects of literary discourse, their claims are not logically distinct, and they receive a similar weight of analysis. Hawkins' *History*, like Bayle's *Dictionary* or Oldys' biographies, is limited only by the total number of documents upon which it exercises a perpetual commentary.[44] Nothing disputable is alien to it.

Thus the overwhelming impression left by the *History of Music* is that of a massive critique not so much of musical compositions as of every form of writing which remotely bears upon music. Bewley complains that Hawkins intermixes history, biography, and review without combining them,[45] but the charge

[41] Hawkins especially praises the "Bacon-faced generation" of the seventeenth century, musical scientists like Wallis and Salmon. For the influence of Bacon on the Royal Society, see R. F. Jones, *Ancients and Moderns* (St. Louis, 1961), chapter IX.

[42] Section seven below.

[43] According to a note, the only musicians distinguished both in theory and practice are Zarlino, Tartini, and Rameau.

[44] Hawkins' earliest literary connections were with the writers who adapted the technique of perpetual commentary to English biography: i.e., Oldys, Thomas Birch, John Campbell (see chapter three above).

[45] *Monthly Review*, LVII (August, 1777), 150.

is false: all the *History* is a review. Hawkins comments upon every system of music, every composer of music, every attitude towards music that he can find. The Preliminary Discourse, for instance, opens with an evaluation of how well music has been understood by some prominent philosophers and poets (Temple, Dryden, and Addison betray their ignorance, Milton and Bacon are adepts), and only then moves on to survey previous histories of music and the evidence that music has progressed. The order of discussion is proper. Discourse about music, not music itself, is the real subject of the *History of Music*, and Hawkins must first review the present state of discourse.

From this perspective it becomes apparent that the confusions of Hawkins' *History* spring from a kind of consistency. Far from abandoning a principle of organization, Hawkins invokes one at every turn. He leads us through the complete literature about music; if he seldom supplies more than a summary analysis of each document, he never gives us less. It is this scrupulosity which defines the structure of his work. The unit of structure, each individual debate and all the documents that pertain to it, may be too small for us to retain a sense of the composition of the *History* as a whole; yet piece by piece, part by part, Hawkins remains true to his principles. They are undoubtedly shortsighted. The application of a single analytical technique to materials of the most disparate sort will not of itself provide structural unity. Nevertheless, the structural particularization of the *History of Music* testifies to an integrity and regularity of method that do not falter. If the virtues of this method seem essentially negative and plodding, they remain constant. Hawkins departs from previous writers on music in considering no document beneath consideration and no doctrine beyond analysis.[46] He will not sacrifice comprehensiveness for a momentary clarity, or for a greater appearance of unity. The breakdown of order which results from this stubborn insistence cannot be separated from the momentum and the patience that made a *History of Music* where none had been before.

[46] The closest parallel to Hawkins is Martin Gerbert, *De Cantu et Musica sacra*, 2 vols. (St. Blasien, 1774), which appeared, however, only after Hawkins' fifth volume was already in the press (*History*, p. xxv). See Elisabeth Hegar, *Die Anfänge der neueren Musikgeschichtsschreibung um 1770 bei Gerbert, Burney und Hawkins* (Strassburg, 1932).

5. The Truth about De Muris

As a specimen of Hawkins' method, Book VI, Chapter XLIX provides a standard; its style is typical, its judgments largely agree with those of Burney, and its opinions are not provocative. The subject of the chapter is Jean de Muris (fl. 1330)[47] and his role in the invention of mensurable music. That rare reader who is working his way consecutively through the *History of Music* may well feel stirrings of memory. De Muris has in fact been discussed three times already—in the Preliminary Discourse, Chapter XXXIII, and Chapter XXXIX—and a very attentive reader may have noticed that the discussions contradict each other: different authorities have been adduced to affirm or deny that De Muris was a true inventor. Indeed, the difference of authority gives rise to the chapter. "THE aera of the invention of mensurable music is so precisely determined by the account herein before given of Franco, that it is needless to oppose the evidence of his being the author of it to the ill-grounded testimony of those writers who give the honor of this great and last improvement to De Muris: nevertheless the regard due to historical truth requires that an account should be given of him and his writings, and the order of chronology determines this as the proper place for it" (217). Hawkins is determined to omit nothing which has been dignified by eliciting earlier debate, and to settle every controversy in music history. In his previous references to De Muris, he had enlisted him rather superficially in different contexts, first the general argument about the Greek system of musical notation, next the particular moment when modern notation came into being. This time Hawkins has obviously gone more deeply into the business of resolving "the De Muris question" once and for all.

Chapter XLIX proceeds to trace the career of De Muris by citing each source of information with a comment on its reliability, and by listing the names of manuscripts attributed to him. Here Hawkins' scholarly caution stands him in good stead. One work

[47] On De Muris and his works see Heinrich Besseler, *Archiv für Musikwissenschaft*, VII (1925), 181ff.; VIII (1926), 207ff. Strunk, *Source Readings in Music History* (New York, 1950), pp. 172-79, prints excerpts from De Muris' *Ars novae musicae* (1319). In the first edition of Hawkins' *History*, the chapter on De Muris is Volume II, Book II, chapter II.

often credited to De Muris is the *Speculum Musicae*, actually a severe attack upon him. Burney accepts the attribution, and uses the work as source material.[48] Hawkins, who had not personally seen the *Speculum*, merely notes that Mersenne had mentioned it (218). (To even the score, Burney, by reinvestigating Hawkins' documents, was able to demonstrate his mistakes in alleging De Muris to be English.)[49] At length Hawkins denies that De Muris' manuscripts contain the improvements ascribed to them by previous authors, and draws a scholarly moral.

> That these mistaken opinions respecting De Muris and his improvements in music should ever have obtained, is no other way to be accounted for than by the ignorance of the times, and that inevitable obscurity which was dispelled by the revival of literature and the invention of printing. But the greatest of all wonders is, that they should have been adopted by men of the first degree of eminence for learning, and propagated through a succession of ages. The truth is, that in historical matters the authority of the first relator is in general too implicitly acquiesced in; and it is but of late years that authors have learned to be particular as to dates and times, and to cite authorities in support of the facts related by them. (218)

Here as elsewhere Hawkins' first concern is to preserve and purify the tradition. If the subject of the discussion sometimes appears to have vanished under piles of disputation, that only builds a firmer ground for sober authority.

The remainder of the chapter, considerably longer than the remarks about De Muris himself, answers the question "to what mistaken representation is it owing that the honour of this important improvement in music is ascribed to one who had no title to it, and that not by one, but many writers?" (219). Hawkins exposes the source of the error by quoting at length from its propagator, Don Nicola Vicentino—"it seems hardly yet determined whether his ingenuity or his absurdity be the greater" (219)—and from Kircher, who passed it on. Morley is then ad-

[48] *A General History of Music*, ed. Frank Mercer (New York 1935), I, 546. In a note on p. 529 Mercer compounds the blunder by stating that "Probably the only authentic work by de Muris is the *Speculum musice* [sic]."

[49] *Ibid.*, I, 549-51. Both Hawkins and Burney drew their bibliographical information from Thomas Tanner, *Bibliotheca Britannico-Hibernica* (London, 1748).

duced as a member of the Franco party, and a long and not absolutely relevant quotation from him is offered as evidence of a correct account; "and lest the truth of it should be doubted, recourse has been had to those testimonies on which it is founded" (221), which are duly named and described. Chapter XLIX concludes with a reassertion that "Franco, and not De Muris, is intitled to the merit of having invented the more essential characters, by which the measures of time are adjusted" (222). The reputation has been judged, tradition has been set in order. Perhaps one thing should be added: Hawkins was right.

From such chapters, nearly two hundred of them, the bulk of the *History of Music* is made. It would take a reader of infinite patience, oblivious to all the repetitions, the heavy-handed pursuit of minutiae, the supererogatory documentation, the ponderous adjustment of every slightest reputation, not to be oppressed by the tedium of much of the performance. Moreover, one can hardly avoid remarking the evidence these pages provide of Hawkins' legal background. The prose style draws upon the weighty jargon of courts and contracts, and the tone can only be described as magisterial.[50] But most of all, law furnishes a pattern for Hawkins' view of history. In terms of jurisprudence much becomes clear: the desire to preserve all documents regardless of their immediate relevance; the reliance upon ceaseless recital and revaluation of precedents; the urge to end every dispute by delivering a final verdict. The *History of Music* never allows us to forget how closely contemporary Hawkins was to Blackstone.[51]

The effects of such circumstantiality and such contentiousness are necessarily erratic. Hawkins did not set out to satisfy taste. The principle of structure that he applies, his constant rational effort to purify the discussions and the traditions of music, cannot by itself supply that suspense or perpetually refreshed interest which is the mark of more artfully composed historical structures, like Gibbon's or even Burney's. In exchange for the sort of history which develops and intensifies from chapter to chapter, however, he does offer a history without a touch of elegant falsi-

[50] From 1765 to 1781, Hawkins served as chairman of the Middlesex Quarter Sessions, and twice published pamphlets on its proceedings.

[51] Hawkins, 1719-1789; Blackstone, 1723-1780. The *Commentaries on the Laws of England* were first published 1765-1768.

fication. Scholars have reason to be grateful. Since Hawkins refuses to omit any stage of an argument or any document associated with it, subsequent research is given every opportunity to discover any point at which he may have been led astray. The virtues of this method remain unchallengeable: "fashions change in music, and facts abide. Much of Burney is now just a monument to bad taste; the patient, multifarious instinct of Hawkins for facts has given longer life and more permanent value to his *History*."[52] It is a comfort to know that we can depend upon Hawkins.

So long as the *History* is concerned with problems that yield to careful documentation, therefore, it justifies its own legalism, its own prolixity. But other sorts of problems pose a sharper challenge. If Hawkins is to establish music upon a new footing, he must provide some basis for historical and critical understanding. The method that isolates the truth about De Muris must also cope with the reputations of Gesualdo and Purcell. Here, in the movements of criticism, Hawkins' objectivity itself must go on trial.

6. HAWKINS AS A CRITIC

Hawkins does not believe in criticism; that is his handicap as a critic. Repelled by the disciples of taste—by Avison, Rousseau, and Burney—he often speaks as if music criticism has been no more than the airing of arbitrary opinions. He insists upon something better: either firm principles, or else a consensus of judgment. Again and again the *History of Music* laments the absence in music criticism of that generally accepted, widely disseminated accord which makes literary criticism possible. Until such accord shall provide a basis for tastes in music, Hawkins declares a plague upon all the houses of criticism.

The adamant refusal to judge like a critic marks most of the critical judgments of the *History*. Consider, for instance, Hawkins' arbitration of the fiercest musical controversy of the century.[53] The competition between the parties of Handel and Bononcini, he says, can be imputed only "to ignorance, and an utter inabil-

[52] W. W. Roberts, "The Trial of Midas the Second," *Music & Letters*, XIV (1933), 312.
[53] For materials relating to the Handel-Bononcini rivalry, consult O. E. Deutsch, *Handel: A Documentary Biography* (London, 1955).

ity to form any judgment or well grounded opinion about the matter" (863). Attempts to choose between the rivals through a preference based on over-refined judgment or the affectation of a musical taste have only shown the infatuation and childishness of opera connoisseurs.

> But where was the reason for competition? Is it not with music as in poetry and painting, where the different degrees of merit are not estimated by an approximation to any one particular style or manner as a standard, and where different styles are allowed to possess peculiar powers of delighting? . . . Milton and Spenser were not contemporaries; but had they been so, could the admirers of one have had any reason for denying praise to the other? In this view of the controversy, the conduct of the parties who severally espoused Handel and Bononcini can be resolved only into egregious folly and invincible prejudice; and that mutual animosity, which men, when they are least in the right, are most disposed to entertain. (863)

The wisdom of this position, coming from an author who was himself to suffer so much from rivalry and fashionable prejudice, is prophetic as well as ironic. Yet it demonstrates the shakiness of the ground upon which Hawkins stands. Most of us today think ourselves disinterested about the Handel-Bononcini controversy, but we also think that we know which party had the better case.[54] In the arts there are few facts unburdened with critical implications. When Hawkins argues that "THE merits of Bononcini as a musician were very great," and that comparisons with Handel are idle, his own fairness and objectivity appear in a flattering light, but his critical judgment seems less than brilliant. Bononcini, after all, resembles neither Milton nor Spenser. Is Hawkins displaying a praiseworthy historical relativism, or has his war on taste merely led him to abrogate the use of ears?[55]

The problem goes deeper. Hawkins is striving to overcome the lack of accepted standards for music criticism, but that very lack of standards prevents a selection of texts and precepts upon

[54] Bononcini's current reputation as a melodist of great talent owes something to the interest in him kept alive because of his rivalry with Handel. On the charge of plagiarism levelled at Bononcini, Hawkins judges him severely as a man, but not as a composer.

[55] Cf. Burney's *History*, II, 747-49.

which to construct a more solid critical tradition. What principles can be used to develop principles? In the absence of a secure answer to this question, Hawkins puts forth only an exaggerated and sometimes absurd reverence for the written word; a reverence which at times reveals a composer's essence, but more often merely his laundry bill. Such is his praise of Lassus. "The memory of Orlando de Lasso is greatly honoured by the notice which Thuanus has taken of him, for, excepting Zarlino, he is the only person of his profession whom that historian has condescended to mention" (349). One must be versed in Hawkins to realize that no irony is intended here. The *memory* of Lassus is the prime concern of the *History*, and even minute indications of reputation must be thrown onto the scales. No hint of a tradition is too humble to be substituted for personal tastes.

At its extreme, Hawkins' pursuit of authorities seems like a critical principle which would rate composers according to how many lines scholars have written about them. Hawkins loves the work of history; he cherishes his own labor in dredging up sources as much as the living reality to which sources refer. Such tirelessly undiscriminating compilation of recondite opinions convinced his enemies that he could see nothing for himself. "Black-Lettered Chains his cold Ideas bind/ Nor let Conviction beam upon his Mind."[56] At least eight satires against Hawkins were circulated during his lifetime,[57] and his blind dependence upon precedent recurs as their constant theme.

The extent of Hawkins' reluctance to deliver his own critical opinions on music is extraordinary. He was by nature an opinionated man, not given to holding his peace. We have seen his imprudent attack on modern music in *The Compleat Angler,* and the so-called "dark uncharitable cast"[58] of the *Life of Johnson* includes angry digressions, most notably the assault upon mod-

[56] From Burney's satire of Hawkins, "The Trial of Midas the Second," in the John Rylands Library. The poem was never published, though parts of it are printed by Scholes (*Hawkins* pp. 140-48) and W. W. Roberts, *Music & Letters,* XIV.

[57] The best known of these are "Peter Pindar" (John Wolcot), *Bozzy and Piozzi; or the British Biographers: A Town Eclogue* (1786), a contest in which Hawkins is the judge; and *Probationary Odes for the Laureatship* (1785), whose scurrilous Preliminary Discourse purports to be the work of Sir John (the attribution has deceived C. A. Miller, *Sir John Hawkins* [Washington, D.C., 1951]).

[58] *Boswell's Life of Johnson,* ed. G. B. Hill and L. F. Powell (Oxford, 1934), I, 28.

ern novelists. Nor does the *History of Music* manifest a reserved or prudent author. We are told, for instance, that at the close of the sixteenth century, poetry "was arrived to great perfection, when it received some little check from the attempts of a few fantastic writers to improve it by certain rules, teaching men to become poets, or makers, as they affected to call them, rules that left scarce any room for the exercise of those faculties with which it is, though perhaps a little hyperbolically, said a poet is born; much of this affected cant about poets and makers is observable in the writings of Roger Ascham" (520), and some in *The Defense of Poesie,* Jonson's *Discoveries,* and *The Arte of English Poetry.* These are not discreet words.[59] Hawkins is inclined to say whatever he thinks, even about subjects where his competency is dubious.

The absence of personal music criticism from the *History of Music,* then, can only be viewed as the result of an effort of will. Hawkins restrains himself with a kind of suppressed violence; he goes to great lengths, and to buried authorities, to refrain from direct comment. When he wishes to praise Purcell, for instance, the defense is framed with elephantine delicacy: "And yet there are those who think that, in respect of instrumental composition, the difference between Purcell and Corelli is less than it may seem. Of the Golden Sonata the reputation is not yet extinct; there are some now living who can scarce speak of it without rapture: and Dr. Tudway of Cambridge . . . has not scrupled to say of it that it equals if not exceeds any of Corelli's sonatas. Which sentiment, whether it be just or not, the reader may determine by the help of the score here inserted" (755). There is something valiant about such self-effacement. Hawkins strives mightily, against his own nature and against the criticism of his day, to keep music unspoiled by any taste.

In spite of all this disengagement, however, a critical position

[59] A still more gratuitous indiscretion was committed by Hawkins in his attack on Swift and Gay. "The effects of the Beggar's Opera on the minds of the people have fulfilled the prognostications of many that it would prove injurious to society. Rapine and violence have been gradually increasing ever since its first representation: the rights of property, and the obligation of the laws that guard it, are disputed upon principle" (875). William Mason, highly offended, wrote Horace Walpole that Hawkins, though ordinarily "at worst a harmless simpleton," had here "shown himself petulant and impertinent"; Mason to Walpole, 10 March 1782, Walpole's *Correspondence,* XXIX (New Haven, 1955), 194.

does gradually emerge from the *History of Music*. It is in part the inevitable result of a "scientific" or documentary approach. By insisting upon each composer's place in a single developing tradition of music, Hawkins tends to view the composer as himself a kind of scholar who selects the precedents he will follow from his historical background.[60] At this level, as in Reynolds' dialectic, labor and study are the mark of talent. "In the course of his studies Palestrina discovered the error of the German and other musicians, who had in a great measure corrupted the practice of music by the introduction of intricate proportions, and set about framing a style for the church, grave, decent, and plain, and which, as it admitted of none of those unnatural commixtures of dissimilar times, which were become the disgrace of music, left ample scope for invention" (421-2). This is the criticism of a historian, who values an artist for his good historical judgment, and the criticism of a man of principle, who likes artists to compose on the basis of sound principles. Learned critics prefer learned musicians. We can hardly expect Hawkins to lose his chance of instilling some useful doctrine even in his criticism.

Yet Hawkins' criticism is not merely didactic. For all his conservatism, his scholarship, his effort at reason and control, Sir John feels the passions of an enthusiast. Nor is he ashamed of them. His astonishing argument against the *Lives of the Poets*, in his *Life of Johnson*, proclaims the inadequacy of didactic criticism. "It is, nevertheless, to be questioned, whether Johnson possessed all the qualities of a critic, one of which seems to be a truly poetic faculty. . . . he was a scrupulous estimator of beauties and blemishes, and possessed a spirit of criticism, which, by long exercise, may be said to have become mechanical." In the preface to Shakespeare,

60 In the "Memoirs of Dr. William Boyce" which Hawkins prefaced to the second edition of Boyce's *Cathedral Music* (London, 1788), he placed the composer second only to Handel on account of Boyce's union "of the various excellencies of former church musicians": the erudition of Tallis and Byrd, the harmony of Gibbons, the melody of Purcell and Weldon (I, xi). Like Dr. Pepusch, the source of Hawkins' collections, Boyce represented true musical learning; without them, "the character of a learned musician had probably, by this time, been unknown among us" (I, vii). Cf. the tradition of "the learned painter" recommended by Junius. For Hawkins, the tradition of the learned musician is essentially literary and scholarly, not practical; he shows little interest in the practice of "imitation" in which musicians like painters use themes from their predecessors. On such practices see F. B. Zimmerman, "Musical Borrowings in the English Baroque," *Musical Quarterly*, LII (1966), 483-95.

"by a kind of arithmetical process, subtracting from his excellencies his failings, he has endeavoured to sink him in the opinion of his numerous admirers, and to persuade us, against reason and our own feelings, that the former are annihilated by the latter."[61]

As a description of Johnson's preface this is obtuse, but it throws strong light on Hawkins' own criticism. His own poetic faculty always stands ready to declare itself. The passage that is perhaps Hawkins' most famous, his account of Handel's performance on the organ, aspires towards the condition of a poetry beyond criticism: "who shall describe its effects on his enraptured auditory? Silence, the truest applause, succeeded the instant that he addressed himself to the instrument, and that so profound, that it checked respiration, and seemed to controul the functions of nature, while the magic of his touch kept the attention of his hearers awake only to those enchanting sounds to which it gave utterance" (912). Here the heaviness of diction, the slight pomposity and languor of Hawkins' prose, only accentuate the burden of his rapture. No sophistication is allowed to mar the full weight of the moment's spell. Once again Hawkins has appealed to something more profound than taste.

Thus the *History of Music* substitutes for the rule of taste two principal alternatives: historical pedantry and emotional assertion. There is not much middle ground. Hawkins provides us with no set pieces, no lengthy critical analyses; we must take his judgments or leave them. He will not refine our taste, nor intricately differentiate the strengths of a composition from its weaknesses. Indeed, the most complete musical experience that he can recommend approaches stasis, a calm of mind where criticism becomes irrelevant. "The passions of grief and joy, and every affection of the human mind, are equally subservient to [music's] call; but rational admirers of the science experience its effects in that tranquillity and complacency which it is calculated to superinduce, and in numberless sensations too delicate for expression" (919).[62] Scholarship and rapture are controlled in a static and permanent appreciation that has no need of words. Hawkins' criticism points

[61] *The Life of Samuel Johnson, LL.D.* (London, 1787), pp. 534, 536.

[62] Cf. note, p. xlii, where "the wisest men in all ages," from Luther to Milton, affirm the superiority of solemn music.

to the history of music and to the pleasures of musical experience, and then withdraws.

It remains to be seen whether such a diffident critical principle can point out the standards of judgment which Hawkins thinks are needed. That he thought his criticism at all sufficient to produce standards seems to indicate an unjustified confidence. The confidence becomes more intelligible, however, when put in the context of Hawkins' belief that music is a science, a field of knowledge. So long as the history of music is perceived as a gradual clarification of universal principles, and the experience of music is classified as part of a universal rhetoric of psychology, criticism need only acknowledge an established truth; it certifies rather than creates the judgments passed by time and by the nature of the universe. The humility of Hawkins' criticism is possible because he does not expect much from criticism. The *History of Music* is written as if its mere rational sorting of precedents will provide a secure standard of taste. Evidently Hawkins expected to be paid in full for keeping rein on his opinions. What criticism could not unify, perhaps scientific method could take as its own province.

7. HAWKINS AND SCIENCE

The meaning of the word "science" was changing in the late eighteenth century, and so was the image of the sciences. As "natural philosophy" gradually appropriated "science" entirely for its own use, so men came increasingly to see that scientific methods, cutting with an edge of objectivity, might possess a certainty and authority to which mere accumulative scholarship could no longer pretend.[63] Science began to take on its modern prestige as the most dependable of all fields of knowledge—the one mode of thought which could influence lives directly for better or worse, the one form of learning which could decipher the mysteries of the universe.

[63] The focal point of this development is of course the *Encyclopédie* (1751-1772). In his Preliminary Discourse, d'Alembert praised Rameau as an *artiste-philosophe* who had brought laws to the art of music, and had thus established it as a science; see A. R. Oliver, *The Encyclopedists as Critics of Music* (New York, 1947), and James Doolittle, "A Would-Be *Philosophe*: Jean Philippe Rameau," *PMLA*, LXXIV (1959), 233-48. Jeremy Bentham, who tried to bring scientific method to the study of English law, was also an amateur of music who knew Hawkins well (ca. 1767), and liked to quarrel with him (*Johnsonian Miscellanies*, II, 80).

To speak of science as a whole, however, is to speak imprecisely. We have become more and more conscious that the history of scientific influence upon thought corresponds to a series of models or metaphors which suggest different insights about what the universe may be and how it works.[64] At any one time a single science may tend to be the paradigm for all. Mathematics, physics, botany, chemistry, geology, biology, each carries with it a train of possible implications about the nature of the world. The "natural philosophies" of Newton, Linnaeus, Diderot, and Darwin are not philosophically compatible, and they stimulate different sorts of ideas. If Hawkins believed that the principles of science could illuminate music, he had still to choose a scientific model.

What models were available to him? Not long before, the answer would have been clear. It is a commonplace that eighteenth-century thought was dominated by those sciences capable of precise mathematical demonstration. "Although the phrase 'natural philosophy' in its general sense meant all the knowledge of nature which was based upon demonstrable fact, in common usage it seems to have been often employed to suggest simply Newtonian physics and astronomy."[65] Since Whitehead we have certainly heard enough about the mechanical and abstract conception of science in its Age of Reason. By the 1770's, however, the paradigmatic force of mechanics and mathematics had been somewhat weakened. Quite aside from the attack upon mechanics by such renegades as Lord Monboddo, who "insisted that God works only through general laws; but these are not merely the physicists' laws of matter of mass and motion,"[66] a respected scientist like Joseph Priestley could declare his indifference to abstractions and theories derived from mathematics. And this indifference to theory is significant. When Charles Burney persuaded a reluctant William Bewley to review first his own *History of Music* and then Hawkins', he was luring him away from the review of a book in which Bewley's interest was far greater: Priestley's *Experiments on Air* (1775).[67] Bewley's exasperation with Hawkins' pretensions to sci-

[64] See for instance Alexandre Koyré, *From the Closed World to the Infinite Universe* (Baltimore, 1957); Stephen Toulmin and June Goodfield, *The Discovery of Time* (New York, 1965), chapter IV.

[65] C. C. Gillispie, *Genesis and Geology* (Cambridge, Mass., 1951), p. 17.

[66] E. L. Tuveson, *Millennium and Utopia* (Berkeley, 1949), p. 184.

[67] Lonsdale, *Dr. Charles Burney*, p. 177. Bewley had long been a correspondent of Priestley, whose great work contains three of his letters.

ence may stem partly from his espousal of a very different kind of science. Hawkins longed for a scientific model that would transmit a purity completely foreign to practical experimenters like Priestley and Bewley.[68]

Indeed, Hawkins' paradigm was quite out of date. Not only did he see music as a science constantly improving its theory according to "the natural course and order of things, which is ever towards perfection, as is seen in other sciences, physics and mathematics, for instance" (xxx), but he tended to hail modern physics as a confirmation of an older metaphysics. In his quest for a certainty beyond taste, he liked to think that science would confer an absolute illumination. "God said, *Let Newton be!* and All was *Light.*"[69] Thus Hawkins searches history for a closed circle of truth.

> Among many tenets of the Pythagoreans, one was that there is a general and universal concent or harmony in the parts of the universe, and that the principles of music pervade the whole material world; for which reason they say that the whole world is enarmonic. . . . At a time when philosophy had derived very little assistance from experiment, such general conclusions as these, and that the universe was founded on harmonic principles, had little to recommend them but the bare probability that they might be well grounded; but how great must have been the astonishment of a Pythagorean or a Platonist, could he have been a witness to those improvements which a more cultivated philosophy has produced! . . . For Sir Isaac Newton happily discovered, that the breadths of the seven primary colours in the sun's image, produced by the refraction of his rays through a prism, are proportional to the seven differences of the lengths of the eight musical strings.[70]

This passage seems almost a parody of Augustan complacency about science. Hawkins wants Newton's *Opticks* to serve as a confirmation that the whole material world makes a kind of music,

[68] Hawkins also detested Priestley's politics; see the letter in Scholes' *Hawkins*, p. 244.

[69] Pope's "Epitaph on Newton," *Poems* (New Haven, 1963), p. 808.

[70] Pp. 65-66. The reference is to the *Opticks*, Book I, part II, prop. iii, prob. i, exper. vii (*History*, p. 788). Cf. Burney's *History*, I, 345. On the aesthetic and metaphysical implications of the *Opticks*, see M. H. Nicolson, *Newton Demands the Muse* (Princeton, 1946), chapters V and VI.

and so he grandly equates Newton's mathematical study of proportions with the Pythagorean doctrine of numbers. Newton is being asked to carry the heavens on his shoulders. Hawkins demands not merely a theory of proportions, but a principle of universal harmony, with all the overtones and relations of harmony. The optimism with which he offers Newton's discovery, without further commentary, as a proof of such "concent," might well astonish a Pythagorean, a Platonist, or Newton himself.[71] Like many men of his generation, Hawkins derives a comfort from physics that does not require prolonged reflection. That Newton had found cosmic principles, order, harmony, was the great point. It would be irrelevant to ask whether celestial mechanics differed in any essential respect from the belief that every aspect of human life obeys coherent laws of order. Newton had tuned the sky, and for Hawkins all tunes were music.

The major advantage for a historian of music in taking Newtonian physics as his scientific paradigm was that it seemed to put previous discussion of music into an intelligible form. To conceive of music as another division of mathematics or mechanics or astronomy did not necessitate any leap of the mind at all. Boethius and Franchinus and Kircher turned out to have been part of a single story, a story with a happy ending in the secure foundations of modern science. Hawkins had taken hold of a simple formula for weighing all past speculative achievements: "the system itself as it is founded in nature, will admit of no variation; consonance and dissonance are the subjects of immutable laws, which when investigated become a rule for all succeeding improvements. . . . In the sciences the accumulated discoveries of one age are a foundation for improvement in the next" (917-8). The *History of Music* records a steady theoretical progress towards a certain goal.

The disadvantage of modelling the history of music upon the advances of Newtonian physics, however, was how little the metaphor explained in any detail. A mathematical paradigm might account for the music of the spheres, and for the sense of ecstasy that accompanies a perception of ultimate harmony, but it had little to do with the pleasures of listening to an old ballad. More-

[71] The extent to which Newton was, in Hawkins' sense, a Newtonian continues to be debated by historians of science. See C. C. Gillispie, *The Edge of Objectivity* (Princeton, 1960), especially pp. 152-53.

over, it somewhat smacked of what Hawkins' most respected friend liked to call *cant*.[72] In 1776 most Englishmen held a patriotic allegiance to Newton, but they did not often carry their admiration to the point of reading him, and they certainly did not welcome his ideas into their entertainments.[73] Hawkins' theoretical devotion to an idea of music based on mathematical harmony seemed more than a little old-fashioned, or at best the kind of truth whose consistent application leads to dogmatism and perplexity. A more flexible model was needed to fit the variety of musical experience and music history.

Indeed, Hawkins himself was uncomfortably aware that the practice of music followed other laws than Newton's. He could not choose but recognize that few musicians had much use for physics. It was his firm conviction that the advances in musical science had been accompanied by a recent decline or corruption in musical taste; a history of music was compelled to find the causes of this decline. Some other principle must be at work. Most of Hawkins' contemporaries would have known where to look for it. What Newton had done for the physical world, Locke had done for the psychological, and the application of clear and distinct psychological analysis to music criticism had already been popularized by Avison.[74] Burney, for instance, assumed as a matter of course that music was to be understood primarily in terms of the operations of the mind, and he accepted Locke as the mind's great explorer.

[72] Like Samuel Johnson, with whom he was often compared in the late eighteenth century, Newton was notoriously insensitive to music: "Newton, hearing Handel play on the harpsichord, could find nothing worthy to remark but the elasticity of his fingers." *Johnsonian Miscellanies*, II, 103.

[73] Burney's relation to Newton is instructive. Himself an enthusiastic amateur astronomer, he greatly admired Sir Isaac, especially after 1774, when he moved into a home that had once belonged to him. In the *History of Music* he often quotes Newton's *Chronology of Ancient Kingdoms* (1728) with rueful deference; and many of his last years were spent composing "*Astronomy, an historical & didactic Poem, in XII Books*" (Lonsdale, *Dr. Charles Burney*, chapter IX), now lost, of which a book was devoted to Newton. Four lines have been preserved by Professor Scholes: "Great Newton's comprehensive soul/ Saw system after system rowl./ Could read the rules, explain the Cause/ Which kept them firm to given Laws" (*Great Dr. Burney*, II, 157). Despite all these tributes, however, Burney never once connects Newton's laws to a system or idea of music.

[74] See H. M. Schueller, "The Pleasures of Music: Speculation in British Music Criticism, 1750-1800," *JAAC*, VIII (1950), 155-71. E. L. Tuveson, *The Imagination as a Means of Grace: Locke and the Aesthetics of Romanticism* (Berkeley, 1960), points to the role of Locke in the movement away from, as well as towards, clear and distinct ideas.

Hawkins did not find Locke's authority so easy to accept. Morally and theologically he distrusted too keen an interest in psychology, and the association of ideas was a doctrine that menaced his search for a theory of music beyond individual tastes. Men must not be taught to pay extravagant attention to their own sensations, whether in religion, in politics,[75] or in music. "We have seen the time when music of a kind the least intelligible has been the most approved. . . . The prevalence of a corrupt taste in music seems to be but the necesary result of that state of civil policy which enables, and that disposition which urges men to assume the character of judges of what they do not understand" (919). Hawkins has nothing but contempt for a psychology of music that will not distinguish learning and correctness from ignorance. He is relatively uninterested in how men *respond* to music. The question is rather how well they *understand* it. The model for a theory of music in relation to its audience, therefore, cannot be psychology, certainly not Lockean psychology. It must rather resemble the processes by which we are persuaded and instructed. According to Hawkins, music, like poetry, "is a separate and distinct language" (xxvii).[76]

Thus the *History of Music* complements its paradigm of music as a Newtonian meta-physics with a paradigm drawn from the "science" of rhetoric. As the forms of language are more intelligible than the workings of psychology, so the student of music can analyze a composition very precisely according to its ability to speak coherently. Like an orator, the composer must develop a repertory of skills. "The art of invention is made one of the heads among the precepts of rhetoric, to which music in this and sundry places bears a near resemblance; the end of persuasion, or affecting the passions, being common to both. This faculty con-

[75] Dorothy George has unsympathetically reviewed Hawkins' social views (which she compares to those of Blifil and Thwackum) in "Sir John Hawkins as a Justice of the Peace," *The National Review*, LXXXVIII (1926), 433-441.

[76] The notion was of course not original with Hawkins. Among contemporary analogues, we may cite the words (1772) of Sir William Jones, who defines "*true musick to be no more than poetry, delivered in a succession of harmonious sounds, so disposed as to please the ear*" (*Works* [London, 1799] IV, 555-6); and J. G. Sulzer, as translated by the *Annual Register* in 1774 (Part II, p. 166): "Whilst listening to a musical performance, try to forget that you are hearing sounds of an inanimate instrument, produced only by great and habitual dexterity of lips or fingers. Fancy to yourself, that you hear a man speaking some unknown language, and observe whether his sounds express some sentiments." Deryck Cooke, *The Language of Music* (London, 1959), has recently attempted to restore the parallel.

sists in the enumeration of common places, which are revolved over in the mind, and requires both an ample store of knowledge in the subject upon which it is exercised, and a power of applying that knowledge as occasion may require" (xxx-xxxi). So long as both the composer and his audience recognize their obligations to knowledge, the language of music will remain clear and eloquent. It is the illiteracy of modern times, Hawkins claims, which has produced the "vanity and emptiness" of modern music.

To view music as a language, and the art of the composer as essentially rhetorical, suited Hawkins well. It avoided the squabbles about taste that he hated, and it held out the promise of standards that might still exist when the fashions of his age had long been consigned to oblivion. Unfortunately, like the idea that music is a scientific formulation of the laws of universal harmony, the rhetorical premise was a view that men found increasingly difficult to believe.[77] The doctrine of the *affektenlehre* had long since ceased to guide composers, and the new psychology had called the compartmentalization of passions, or their one-to-one equation with specific musical modes, into doubt. Rhetoric itself was coming into some disrepute as it acquired its modern connotation of mere ornament or artifice.[78] If music depended on its intelligibility, then it was susceptible to the charge made by philosophers like Harris, that its limited capacity for conveying specific ideas or emotions defined its inferiority to the other arts.

Hawkins might reply indignantly to all these challenges to his approach, yet in effect he knew their force. The length and obscurity of the *History of Music* testify to its lack of confidence in clear scientific principles. Hawkins protests the decline of rhetorical and mathematical doctrines of universal harmony, but his own discursive method exemplifies disharmony. Respect for science provides the thread of his arguments, not their structure.

The science of the *History of Music*, then, remains a program, an aspiration, rather than an achievement. Hawkins did not discover in Newton the critical certainty for which he had restrained his own opinions. The *History of Music* requests something from science that science is not prepared to give: a substitute for hu-

[77] See H. M. Schueller, "Correspondences between Music and the Sister Arts, According to 18th Century Aesthetic Theory," *JAAC*, XI (1953), 334-59.
[78] See W. S. Howell, "The Plough and the Flail: The Ordeal of Eighteenth-Century Logic," *HLQ*, XXVIII (1964), 63-78.

man responses in the face of the effects and obscurities of art. Hawkins seeks to prove that science is superior to taste, and proves only that the acceptance of scientific authority in matters of aesthetics is itself an exercise in taste. The criticism of music had not been given laws. As a noble experiment in scientific method, Hawkins' *History* is too honest to hide the frank inconclusiveness of its results.

8. THE PARADOX OF THE FUTURE

Hawkins had tried to recover the metaphysical grandeur of music by faithfully recording the particulars of its historical development, and he had not succeeded. Taste was not to be conquered so easily. Professional musicians could work without believing that they were displaying the principles of universal order, and antiquarians were unwilling to take their own fact-mongering too seriously. On its own ambitious terms, the *History of Music* is a failure. Hawkins was powerless to show that all previous writing on music illustrated a single theme or progression, and he did not convince his contemporaries that music was primarily a science, let alone the foundation of all other sciences. In attempting to conserve and restore the lessons of his predecessors, he had instead demonstrated that the musical standards of the future would have to find a new kind of authority. A mere reverence for the past, and for the written word, could only enshrine epitaphs for a dead idea of art. Yet somehow, during the course of the next century, it became clear that Hawkins was more than the last of a line of musical metaphysicians and pedants. He proved, in fact, to have been a founder of modern musicology;[79] perhaps the most important of all its English founders.

How are we to resolve this paradox? Several explanations are

[79] On the foundations of musicology see W. D. Allen, *Philosophies of Music History*, and Elisabeth Hegar, *Gerbert, Burney und Hawkins*. The importance of Forkel is demonstrated by Wolf Franck, "Musicology and its Founder, Johann Nicolaus Forkel (1749-1818)," *Musical Quarterly*, XXXV (1949), 588-601; and Vincent Duckles, "Johann Nicolaus Forkel: the Beginning of Music Historiography," *Eighteenth-Century Studies*, I (1968), 277-90. Both these scholars tend to overstress the exclusively German basis of musicology (perhaps my preceding discussion has not stressed it enough). In this they take a cue from Forkel himself, whose *Allgemeine Geschichte der Musik* (first vol. Leipzig, 1788) both reviles and plagiarizes the English historians (see Lonsdale, *Dr. Charles Burney*, pp. 339-40, and Burney's *History*, II, 961). Hawkins' emphasis on documentation and musical rhetoric was improved and systematized by Forkel (Duckles, pp. 286-90).

possible. The first would emphasize simply that Hawkins provides more, and more dependable, information than any previous historian of music. "Facts abide." Our own musicology, after all, prospers because we have so many sources of knowledge, not because we are so wise or so sure about theory. The sheer multitude of Hawkins' facts, his antiquarian amplitude, ensured reprintings in the nineteenth century.[80] The *History of Music* appealed mightily to the Victorian taste for rich stuffing.

> No amount of care has been deemed too much; and the reader feels grateful for being spared the trouble of seeking, while he luxuriously profits by the result. He sits in his arm-chair, comfortably ruminating the stores of knowledge which have been culled for him from various wide-spread sources, by patient, worthy Sir John. . . . Anything entertaining, that can by possibility be linked on to the subject of music, is easily and chattily introduced; as though the author and his reader were indulging in a cheerful gossip by the way. We have, in quaint succession, such things as that romantic love-passage of Guiffredo Rudello, the troubadour poet; or that wondrous account of the Moorish Admirable Crichton, Alpharabius,—which is like a page out of the 'Arabian Nights;' or that naïve detail of bluff King Harry's fancy for my Lord Cardinal's minstrels. . . .[81]

We should not be too quick to scorn these somewhat otiose and chintzy pleasures. They were the daily fare by which Horace Walpole lived, and Walpole studies furnish abundant proof that an intense cultivation of trivia may survive when much relevant regularity and infallible good taste have gone under. If the *History of Music* achieves greatness only as a bedside book, that too is a characteristic and not ignoble form of eighteenth-century greatness.

A more serious case can be made for Hawkins, however. Again nineteenth-century opinion may direct our own. It was Hawkins, rather than Burney, who spoke to German musicologists from

[80] One class of writers with whom Hawkins has never been out of favor is compilers of musical biographies, from Thomas Busby (*A General History of Music*, 1819) and F. J. Fétis (*Biographie universelle des musiciens*, 1835-1844) in the nineteenth century to Percy Scholes and Charles Cudworth in our own.

[81] "Life of Sir John Hawkins," prefixed to the 1853 edition of the *History* (in the 1963 edition, p. xiii). The edition was prepared by J. Alfred Novello, with the assistance of Mrs. Cowden Clarke.

Forkel to Ambros,[82] and whose insights seemed to be of a piece with Romantic notions of what music was and could be. To some extent this may have been a historical accident. Hawkins' worship of music, his passionate insistence that it was not an entertainment so much as the building stuff of the universe, reflected a doctrine so old that it had begun to sound new. The German critics who tended "to use music as the apex and norm of the pure and nonrepresentative expression of spirit and feeling"[83] were comfortable in the presence of obscure raptures glorifying a sacred art. They were much less happy with rationalists who left the soul out. At least the *History of Music* matched their level of feeling. "Hawkins probably was one of the few writers after 1750 to insist that religious music lead the soul to God because the 'proper' effects of music were in his day becoming classified or systematized into a theory of musical decorum."[84] Because Hawkins had not acquiesced in the fashions of his day, because he had uncompromisingly spoken for the high seriousness and moral stature of the art he loved, posterity honored him as a prophet spurned by his own country.[85] On the whole the honor was deserved. Hawkins had performed a service in keeping alive the view that the laws of music are spiritual, and he had hardly received his due.

Furthermore, the *History of Music* had helped to keep alive a great deal of unpopular music. Given the later development of musicology, Hawkins' desire to preserve the memory even of music whose value he did not understand was bound to seem prescient. His love for the Tudors, his sympathy for the early Renaissance have by now achieved an overwhelming vindication. In this respect his influence went far beyond his own *History*. Burney provides almost as much historical material, but without the example of Hawkins to spur and threaten him he would certainly have written a much more narrowly fashionable work. At a time when little but contemporary music ever won a hearing, Hawkins looked forward to an age more generous in its liking for the old.[86]

[82] Developments in musicology through the time of Ambros (*Geschichte der Musik*, 1862-1878) are surveyed by P. O. Naegele, *August Wilhelm Ambros: His Historical and Critical Thought* (unpublished Ph.D. dissertation, Princeton, 1954).

[83] M. H. Abrams, *The Mirror and the Lamp* (New York, 1953), p. 94.

[84] H. M. Schueller, "The Use and Decorum of Music as Described in British Literature, 1700 to 1780," *JHI*, XIII (1952), 87.

[85] See the Novello "Life," p. xviii.

[86] In *A History of British Music* (London, 1967), pp. 379-82, Percy Young em-

"How far remote that period may be when music of this kind shall become the object of the public choice, no one can pretend to tell" (xlii). If the public has not joined Hawkins in his choice of treasures, the scholars know his worth. The *History of Music,* espousing no fashion, has not gone out of fashion.

There is yet another reason why Hawkins has a right to be considered a father of modern musicology. Strangely enough, it results from his much-maligned peculiarities of organization. When Hawkins abandoned the effort to compress his *History* into a tidy and lucid arrangement of parts, he opened the way for many different kinds of material and for many perspectives. Formally, he was willing to include anecdotes, brief biographies, dictionary articles, poems, descriptions of instruments, arguments about theory, hundreds of musical illustrations, and various matter which even he thought of as digressive. This inclusiveness had a fortunate sequel. As standards of relevance changed, it became apparent that much of Hawkins' miscellaneous information could be put to uses of which he had hardly been aware. For instance, his pictures of antique instruments[87] are offered principally as curiosities, or else as prototypes of modern versions. Hawkins did not clearly foresee that students of music would one day take an interest in reconstructing exact replicas of old instruments, yet his detailed descriptions aided such reconstructions. What was for Hawkins essentially an antiquarian preservation of dead lore proved to be a beginning in the task of making past styles and ideas live again. The ambition of every scholar, that his research may restore what should never have been lost, and that his fascination with forgotten things may be ahead of his era in the cycle of history, was realized by Hawkins' work.

Thus the *History of Music* has been well repaid for its devotion to the past. Hawkins' deficient sense of history allows none of the historical snobbery which dismisses previous opinions as beneath argument. Precisely because every document possesses equal value for him, he records and argues with them all as if the written word occupied an eternal present. When Hawkins' enemies

phasizes the importance of Stafford Smith, Hawkins' associate, in furthering the revival of *Musica Antiqua.*

[87] E.g., *History,* pp. 328-332. The Novello edition, which printed the portraits of composers as a separate volume, required over 200 woodcuts of instruments.

charge that he lives in a world of books where Pope Sylvester II and King George III, Franciscus Salinas and Alexander Malcolm, seem to be contemporaries, they are stating a truth that redounds to his credit. A critic more certain of his own historical position would not have felt such a need to enter into old debates, to refute or to revive ideas about music that would otherwise have perished in silence. The *History of Music* pays all its predecessors the courtesy of a summary, some quotation, and a vigorous response. Hawkins' lack of historical perspective led him to consider everything in any way related to music as potentially relevant to his subject. He was capable of censuring or misunderstanding documents, but not of omitting them.

If Hawkins fathered confusions as well as music history, then his confusions match those we see around us. His uncertainty about standards provides a surer eclecticism than Burney's eclectic taste, and he enters a universal disharmony where every kind of music may be amalgamated to the musicologist's ambition of a complete library in which no scrap or sound is ever lost. To be sure, he enters it with some reluctance. Right to the end he insists that music intended merely to gratify the public cannot satisfy a learned critic. The memoir of William Boyce which Hawkins prefixed to the second edition of Boyce's *Cathedral Music* in 1788 (a year before his death) continues to damn the music of the present (J. C. Bach) in the name of the past (Handel).[88] Yet such criticism counts for less than the example of his *History;* in music as well as in history-writing, the critic who is open to all the past cannot help but open the way to all the present.

The refusal to cater to any audience, however, draws Hawkins into a very private place in history. No one had ever been quite so far above the battle—certainly not Hawkins' mentor Dr. Pepusch, who for all his learning had not scrupled to lend his musical talents to that *Beggar's Opera* whose vulgarity Sir John so much deplored.[89] Hawkins' interpretation of history, for all

[88] Although Hawkins deliberately refrained from noticing contemporary music in the *History*, his jaundiced view of the present in *The Compleat Angler* (1760), *An Account of . . . the Academy of Ancient Music* (1770), and the Preface to *Cathedral Music* (1788) demonstrates how consistently he was dissatisfied with the music of his time.

[89] Hawkins' own harsh account of the *Beggar's Opera* (*History*, pp. 874-75) tactfully refrains from mentioning Pepusch's name.

his emphasis on traditional values, often seems eccentric and isolated, the product of a tradition with only one inventor and one adherent. Unlike Reynolds, he did not sum up the critical thought of his day nor did he, like Johnson, set its tone. He is rather a hero of Abdiel's stubborn stamp, a man for no seasons, unclubable even in musical society at large.

Nevertheless, Hawkins' resolute determination not to be a man of his time testifies to the strength of his *History*. An amateur among professionals, an antiquarian among musicians, an enemy of taste in an age of taste, he worked against fashion and superficiality and himself; he drew no easy conclusions. Under the banner of Reason, he had waged the battle of the Romantics, and had helped to make a bridge between the Elizabethan age he loved and the coming age he feared.[90] Hawkins' *History of Music* survives as a work of timeless literary history, almost as exasperating and almost as valuable as when it first appeared. It has survived its faults and its critics, and the joke has turned out to be on Peter Pindar, who praised Hawkins more truly than he knew:

> Whose volume, though it here and there offends,
> Boasts *German* merit—makes by *bulk* amends.
> High plac'd the venerable QUARTO sits,
> Superior frowning o'er octavo wits . . .
> Whilst undefil'd by literary rage,
> He bears a *spotless* leaf from age to age.[91]

[90] The revival of Elizabethan song in which Hawkins participated was instrumental in bringing the Elizabethan lyric to the attention of the Romantic poets. See E. R. Wasserman, *Elizabethan Poetry in the Eighteenth Century* (Urbana, Ill., 1947), pp. 168-69.

[91] "Bozzy and Piozzi: or, the British Biographers. A Town Eclogue," John Wolcot (pseud. "Pindar"), *Works* (London, 1794), I, 332.

Charles Burney's
History of Music
and a Whole Audience

*Praise when you can; play the best productions of gifted
men; and let alone the spots in the sun which are invisible to
common eyes and you will not find it impossible to please
a whole audience.*[1]

1. A MAN FOR ALL THE WORLD TO LOVE

At those times when the Age of Johnson appears to the mind in
the shape of a perpetual dinner party, warm and alive with bright
talk and genial spirits, ringed by familiar faces which move from
anecdote to anecdote as in the circle of a dance, Dr. Charles Bur-
ney is always one of the guests. Few men have ever had more of a
knack for keeping good company. Wherever he went, he pleased,
and he went everywhere. Reading Burney's account of his musical
tours in France, Italy, Germany, and the Low Countries, one is
astonished at how quickly he won entrée into any society that
might be useful to him. With Padre Martini, the most learned
historian of music in Europe, he established a close friendship
within the course of a few hours; Rousseau, Diderot, Metastasio,
and C. P. E. Bach were conquered at the same rate.[2] At home in

[1] Burney to William Crotch, 17 February 1805. Printed by Frank Mercer in an
appendix to his edition of *A General History of Music: From the Earliest Ages to
the Present Period (1789)* (New York, 1957), II, 1036. Page citations in the text
will refer to this edition, which is a republication of the London edition of 1935.
The dates of the original four-volume publication of Burney's *History* are Vol. I,
January, 1776; Vol. II, 1782; Vols. III and IV, 1789. Vol. 1 was revised for the
integral edition of 1789; it is this edition that Mercer reprints.

[2] *Dr. Burney's Musical Tours in Europe*, ed. P. A. Scholes (London, 1959), I,
145-47, 313-17; II, 101-4, 219-220. The *Tours* of France and Italy were first pub-
lished in 1771; those of Germany, the Netherlands, and the United Provinces, in
1773.

England the best people competed in singing his praises. Johnson himself paid tribute: "Dr. Burney is a man for all the world to love: it is but natural to love him."[3] Such charm, and such mobility, would alone have won him a place in history.

That place, however, would not have been enough for Burney. Nor would he have been content with recognition as the expert on music who had replaced Hawkins in the Club. Like Reynolds', his sights were aimed higher. As Roger Lonsdale's literary biography has recently demonstrated, Burney's "chief ambition and achievement was to be accepted as a 'man of letters' rather than as a 'mere musician'."[4] His amazing energy was directed at "regulating and correcting the public taste in music, as sir Joshua Reynolds has done in a sister art,"[5] but beyond that at proving that a man who understood music could count himself one among scholars, philosophers, and the intellectual aristocracy. Burney was willing to work for such an honor. He sacrificed time and comfort as well as much of the society where his success was so assured. In return, it seems only fair that we should acknowledge the Great Doctor Burney[6] as he would have liked: not only as one of the guests in the Johnsonian circle, but as a host, a major figure in his own right.

Yet that acknowledgement is not easy to give. The problem is not only that the fascinations of Burney's life and acquaintance and relations are of interest to more readers than is his work. It is rather that the work itself seems to ask for a kind of social approval. Its most obvious virtues are grace, charm, energy, and good humor. It delights us with a liveliness of personality, and coaxes us into friendship. Fanny d'Arblay can be believed when she claims that "the History of Music not only awakened respect and admiration for its composition; it excited, also, an animated desire, in almost the whole body of its readers, to make acquaint-

[3] *Diary and Letters of Madame d'Arblay*, ed. Austin Dobson (London, 1904-1905), I, 203. The friendship is traced by Roger Lonsdale, "Johnson and Dr. Burney," *Johnson, Boswell and their Circle* (Oxford, 1965), pp. 21-40.

[4] *Dr. Charles Burney: A Literary Biography* (Oxford, 1965), p. viii.

[5] *Critical Review*, LV (1783), 118. The resemblance between Reynolds' career and Burney's, most recently drawn again by Lonsdale, is best witnessed by Burney's own "Elegy on the death of Sir Joshua Reynolds, 1792," written on the flyleaf of the British Museum copy of the Mason-Reynolds *Art of Painting* (York, 1783).

[6] On Burney's doctorate, see P. A. Scholes, *The Great Dr. Burney: His Life—His Travels—His Works—His Family—and His Friends* (London, 1948), I, 140-46; and Lonsdale, *Dr. Charles Burney*, pp. 77-79.

ance with its author."[7] How pleasant to meet Dr. Burney! And how difficult to take his work quite seriously.

Indeed, Burney's very popularity, his ability to make himself agreeable to any audience, has come to be regarded with a great deal of suspicion. Hawkins' unpleasantness, after all, is directly related to a rudely expressed honesty and conviction. Burney seldom expresses himself rudely. It is but natural to beware the man whom everybody loves. Thus much of the commentary on Burney betrays a thinly-disguised animus. Hazlitt set the tone adroitly: "The founder of [the Burney family] was himself an historian and a musician, but more of a courtier and man of the world than either. . . . There is nothing like putting the best face upon things, and leaving others to find out the difference. He who could call three musicians 'personages,' would himself play a personage through life, and succeed in his leading object."[8] In various forms this insinuation that Burney lacked substance has been repeated often, from Johnson's condescending remark of 1772 that "Dr. Burney was a very pretty kind of man" to the blunt statement of a modern critic that "Beneath Charles Burney's many virtues, beneath his wide culture and prodigious industry, lay one chief failing: he was fashionable,"[9] to Virginia Woolf's more artistic portrait. "It is, perhaps, his diffuseness that makes him a trifle nebulous. He seems to be for ever writing and then rewriting, and requiring his daughters to write for him, endless books and articles, while over him, unchecked, unfiled, unread perhaps, pour down notes, letters, invitations to dinner which he cannot destroy and means some day to annotate and collect, until he seems to melt away at last in a cloud of words."[10]

The tendency to suspect that Burney's grace and activity conceal an essential hollowness, if not something more ominous, cannot be brushed aside. In one respect, at least, it touches on the truth.

[7] *Memoirs of Dr. Burney* (London, 1832), II, 71.

[8] "On the Aristocracy of Letters," in *Table-Talk* (1822); Hazlitt's *Works* (London, 1903), VI, 209. According to Hazlitt, Reynolds remarked that "No one had a greater respect than he had for his profession, but that he should never think of applying to it epithets that were appropriated merely to external rank and distinction."

[9] Samuel Johnson, *Boswell for the Defence, 1769-1774*, ed. W. K. Wimsatt and F. A. Pottle (New York, 1959), p. 49; W. W. Roberts, "The Trial of Midas the Second," *Music & Letters*, XIV (1933), 305.

[10] "Dr. Burney's Evening Party," *Collected Essays* (London, 1967), III, 134.

When Burney's professional ambitions were at stake he could behave nervously and ruthlessly, and he was not above an intrigue. His treatment of Hawkins, perhaps the darkest page in his career,[11] hints of a desire to excel, and a readiness to use his friends, that stamp his character with a most unamiable selfishness. Evidently much of his charm was manufactured by the will. A comparison of Burney with his close friend Thomas Twining reveals at once the difference between a good nature born of a restless effort always to please and one that flows from a reservoir of inner harmony.[12] The equable surface of Burney's life and work covers pride and fear and turmoil.

So much is true. We gain nothing by pretending that life with the Burneys rattled by with the glibness of an endless anecdote.[13] Dr. Burney was a hard-working, often tense, professional careerist. Nor is this truth necessarily discreditable. The man who manages to convey a sense of ease and cheerfulness even when bowed down by self-imposed labors, and who reaps the fruit of those labors, the man who is (in William James' memorable phrase) twice-born, surely deserves as much sympathy as the man who spends a lifetime like Twining in husbanding his strength. The revelation of Burney's careerism hardly diminishes his accomplishment.

Nevertheless, Burney's work, like his life, continues to bear a somewhat dubious reputation. Perhaps its main handicap is the peculiarly English mistrust of professionalism. Both Hazlitt and Mrs. Woolf obviously find Burney's immersion in his trade a little too self-interested, a little profitable and excessive, and they are given their cue by someone very close to him. As Fanny d'Arblay "edited" and readjusted her father's memoirs, she took pains to omit anything that might smack of business or social inferiority.[14] We learn from her that Burney had severe claims upon his leisure, but not very much about what was occupying

[11] See Lonsdale, *Dr. Charles Burney*, chapter V.

[12] Twining's cheerful character is best revealed by *Recreations and Studies of A Country Clergyman of the Eighteenth Century*, ed. Richard Twining (London, 1882). He is also a secondary hero of Lonsdale's biography of Burney, and much of his unpublished correspondence with Burney is quoted there.

[13] The tensions of the Burney household have been thoroughly documented by Joyce Hemlow, *The History of Fanny Burney* (Oxford, 1958).

[14] The attack on the dependability of Madame d'Arblay's editing was launched by J. W. Croker, *Quarterly Review*, XLIX (1833), 97-125; renewed by Miriam Benkovitz, "Dr. Burney's Memoirs," *RES*, X (1959), 257-68; and has been amply reinforced by Lonsdale.

him. To eyes less blinkered than a daughter's, and equally snobbish, the Doctor seemed rather to overdo his calling. Mrs. Thrale, who thought him a "male coquet"[15] for being so sparing of his company, deplored his professional concerns: "there is no Perfection to be found in Character: Burney is narrow enough about his own Art: envious of Hawkins, jealous of Piozzi; till I listened a little after Musick, I thought he had not a fault but Obsequiousness: *that* however is a *Vice de Profession*."[16] Hawkins boasted of his own *History*, perhaps with a silent invidious comparison, that "The motives to the undertaking were genuine, and the prosecution of it has been as animated as the love of the art, and a total blindness to lucrative views, could render it."[17] Burney, after all, needed music for his living; his love for the art was not disinterested. The tone of condescension which this need provoked even in his friends is nicely matched by a modern commentator: "Like all true 'professionals,' he was a born entertainer to mankind, with a *flair* for talent whose service it quickly became his to command: a genial showman who pulled the strings that Society might meet Genius in the 'freedom' of Bohemia."[18] In this passage the quotation marks, the capitals, and the italics would serve by themselves to declare that the style had become "a bit thick"; Burney was trying too hard.

He did try hard. With competing demands of twelve hours of teaching a day, travels, research, and writing, his *History of Music* required almost superhuman energy: "I have no Time to be happy."[19] Yet the effect of such labor was not a sense of effort. Burney had smoothed his style and knowledge into a surface so perfectly accomplished that amateurs might think it bland. Mrs. Woolf can seize upon no gross features suitable for a gallery of English eccentrics, and Hazlitt cannot penetrate to any singular or intense flash of gusto. Burney's professionalism, like that of Reynolds, shows itself most in its concealment of underlying tensions or individual uncertainties. It aims, if not at a neoclassic universal, at least at a central and standard reflection of its age. To an extent unequalled by anyone else, Burney was conversant

[15] *Diary and Letters of Madame d'Arblay*, I, 203.
[16] *Thraliana*, ed. K. C. Balderston (Oxford, 1951), I, 458.
[17] *History of Music* (New York, 1963), preface, xix.
[18] R. B. Johnson, *Fanny Burney and the Burneys* (London, 1926), p. 306.
[19] Burney to Twining, 30 August 1773, British Museum Add. MS. 39929, ff.59-64.

both with the best musical opinion of his time and with the needs and ignorance of the general public. He had earned the privileges of the insider, the cunning-man. From the professional point of view Hawkins might be controversial, but Burney represented the sort of expertise that settles controversies. Managing reviews and opinions, he served as his own jury.

This power, won by charm as well as dedication, is at the heart of our reluctance to acknowledge Burney as a major figure. He had sacrificed his time, his tranquillity, all the rough edges that go into the structure of a character that is individual and unique, for the sake of intellectual acceptance, and he had succeeded. For most readers, then and now, Burney's *History of Music* is a complete guide to eighteenth-century English musical taste. It defines every standard, and attracts every resentment. To call this merely a matter of Burney's being the slave of fashion is to underestimate his own centrality, his shaping of the musical world he ruled. Yet not everyone respects the man who has refined his taste into the taste of a world. Perhaps, as the condition of his power, Burney had sacrificed too much.

Unless we are very lazy, however, we shall not think that he melted away in a cloud of words. The *History of Music* weighs more than our personal reactions to its author. If Burney seems too busy in his chase after acceptance, too thoroughly the voice of his age, he nevertheless produced a work of music history whose value for its own time has never been surpassed by any single English musicologist. Even his representativeness contributes to this value. In Burney's work such eighteenth-century developments as the growth of an idea of progress, the predominance of "taste," the application of mechanical analogies to musical structures, even the conception of music as a fine art, are focused for us through the lens of a clear and elegant mind. The *History of Music* enters a wilderness of music criticism and leaves it a garden. That accomplishment could seem easy only after the work had been done. From the other side, from Burney's great ambitions and anguish of labor, grace and charm were not enough. What was required was the hand of a master.

2. THE SEARCH FOR ORDER

When Burney, in May, 1770, wrote to the Rev. William Mason[20] in search of advice about ancient music, he was in a state of depression. He had already been gathering materials for twenty years, and was planning European travels to gather still more, but he had not yet hit upon principles of order for his *History*. Nor was he sure that such principles could be found. Without Avison's willingness to oversimplify, or Hawkins' patient devotion to documents, he longed to discover a way of his own.

> Several Friends, who, through partiality, perhaps overated my abilities, have been desirous that I should write a *History of Music*: & it is an undertaking upon which I have already spent much meditation, & for which I have been some time collecting materials. The prospect widens as I advance. 'Tis a chaos to which God knows whether I shall have life, leisure, or abilities to give order. I find it connected with Religion, Philosophy, History, Poetry, Painting, Sculpture, public exhibitions & private life. It is, like gold, to be found, though in but small portions, even in lead ore, & in the coal mine; which are equivalent to heavy Authors, & the rust & rubbish of antiquity. . . . I have got together and consulted an incredible number of Books & Tracts on [ancient music] with more disappointment & disgust than satisfaction, for they are, in general, such faithful copies of each other, that by reading two or three, you have the substance of as many hundred.[21] It is far more easy to compile a dull Book of bits & scraps from these writers, than to get any one to read it after it is done.[22]

The modesty with which the letter opens may be disingenuous, but the sense of travail with which it continues is certainly genuine. Like most of his musical contemporaries, Burney was oppressed by the confusions, the utter impracticality, the rust and

[20] Like his friend Gray, Mason had assembled an extensive antiquarian collection of music; see J. W. Draper, *William Mason: A Study in Eighteenth-Century Culture* (New York, 1924), chapter XIII. Mason's "Critical and Historical Essay on Cathedral Music" (*The Works of William Mason* [London, 1811], III, 285-327), first published in 1782, takes issue with the *History*'s lack of interest in psalmody, a weakness Burney was quick to acknowledge.

[21] Burney was to repeat this passage in the introduction to the *Tours*, I, xxvii, as well as in the preface to the *History*, I, 17.

[22] Printed by Scholes, *Great Dr. Burney*, I, 148-50.

rubbish of previous writing on music. He felt himself to be abandoned in a dark waste where the light of good sensible modern criticism could hardly enter. Worst of all, he would have to begin his history with a discussion of ancient music, an obscure but embattled subject fit more for the nephews of Junius than for a musician who preferred the testimony of his own ears to any number of testimonials for the Greeks, and who much preferred Orpheus to Aristotle.[23] "It is indeed, with great and almost hopeless diffidence, that I enter upon this part of my work; as I can hardly animate myself with the expectation of succeeding in enquiries which have foiled the most learned men of the two or three last centuries" (I, 15). The overture to the *History of Music* begins on a note of dejection.

In 1770 and afterwards, Burney had two characteristic reactions to his depressing situation. The first was to seek help. He looked to Mason, to Thomas Gray, to Padre Martini, later and most importantly to William Bewley and Thomas Twining, for literate and professional opinions in regions where he was not at home; an expert himself, he consulted the experts. The second reaction, however, was still more typical: he set out upon a trip where he could learn the *present* state of music. Burney undertook his *Tours* with two intentions, to gather better, more authentic materials about ancient music, and to hear for himself the best of the new,[24] but the former was a duty, the latter a pleasure and consolation. Through the whole of the *History* he sustained his interest in scholarship by looking forward to the modern improvements that would justify music history itself. Ancient boasts and obscurities would be tested against modern clarity, and be found wanting. From the vantage point of a professional in touch with everything that was going on, the idea of progress seemed to furnish a principle adequate to measure the past.

Unfortunately for Burney's peace of mind, expertise in the present state of music did not grant the kind of order that a history could use. There were too many facts to be absorbed, too many arguments to be disputed. Even the most knowledgeable

[23] Twining strongly criticized Burney's predilection for myths, and the 1789 edition of Burney's first volume excises much of its mythological contents. For Burney's low opinion of Isaac Vossius, see *History*, I, 269.

[24] See the letter to Garrick from Naples, 17 October 1770, *The Private Correspondence of David Garrick* (London, 1831-1832), I, 403.

of musicians had very little advantage when he tried to apply his connoissance to *Selah* or the *Phorminx*.[25] We have already glanced at the changes which overtook Burney's *History* and his taste in competition with Hawkins'. The enormous chaos of music history was far too well entrenched to yield at the first ordering touch of progressive dogma. When Burney had finished rebuking the Greeks or the Goths for their ignorant barbarity, he first began to settle down to the long hard work of reconstructing the actual barbarous nature of their music. He could not afford the luxury of dismissing facts before they were known. It is easy to browse through Burney's *History*, to note a few key opinions, and to conclude that all is fashion; but anyone who has read through the work understands that Burney made himself into a historian. Painfully, pursued by twinges of conscience and Twining, lapsing into despair and feverishly rallying, he gave up the hope that mere good sense and modernity could descry an intelligible order in the history of music.[26]

Moreover, he gradually accepted his obligation to pay attention to *all* music. At first he had planned to begin the *History* only with the birth of "modern" music at the time of Guido (ca. 1022). Later, he determined to throw the music of the Greeks and Romans "into a *Preliminary Dissertation*, in order that the narrative might not be interrupted by discussions concerning dark and disputable points, which will be generally uninteresting even to musical readers" (I, 14). Privately he expected to treat the ancients rather casually, as he wrote Twining: "my Say will be much more to laugh at what others have written, perhaps, than to offer anything of my own concerning them."[27] Yet eventually the "Dissertation" proliferated into a full long volume, padded with its own contributions (or those of Twining)[28] to pedantry and scholarship. Burney's contempt for antiquarianism, his alertness to whatever was modish, his fear of boring his readers, were not sufficient to supply him with a principle of omission.

Thus the *History of Music*, however reluctantly and ironically it pays its debts to recondite historical research, pays them in full.

[25] *History*, I, 204, 405.
[26] Burney himself describes the process in the preface to the *History*, I, 13-20.
[27] Lonsdale, *Dr. Charles Burney*, p. 145.
[28] Lonsdale, chapter IV, demonstrates that Twining's scholarly assistance to Burney's first volume was so great as to amount to collaboration.

Burney apologizes for old music, but he also honors it. Nor is Orpheus neglected. "If I have selected with too much sedulity and minuteness whatever ancient and modern writers furnish relative to Orpheus, it has been occasioned by an involuntary zeal for the fame of this musical and poetical patriarch; which, warm at first, grew more and more heated in the course of enquiry; and, stimulated by the respect and veneration which I found paid to him by antiquity, I became a kind of convert to this mystagogue, and eagerly aspired at initiation into his mysteries—in order to reveal them to my readers" (I, 267-8).

The anti-climax with which this clever sentence ends implies a great deal. Burney play-acts the role of a "convert to this mystagogue" without quite committing himself to it. Like his readers, he accepts the Orphic mysteries only upon sufferance, in a spirit of playfulness which builds into a show of scholarly zeal and then breaks into detachment. The story of Orpheus has many attractions for Burney—it heralds the dignity of music, and the fame that great musicians deserve—but the space devoted to it in the *History of Music* most likely reflects a momentum generated by the course of enquiry itself, and sustained by the probability that readers will be interested. Once Burney had embarked on the task of the *History*, all his self-consciousness and anxiety not to look absurd could not keep Orpheus out. The only course was to act the scholar, and to make the role amusing.

The most obvious result of Burney's hesitant and conditional assumption of the scholar's mantle is the *History*'s manipulation of *tone*. Few monuments of research can have relied to such an extent upon establishing an intimacy with the reader, and inquiring from time to time whether he is still entertained. As Walpole conducts a dialogue with Vertue, so Burney converses with his scholarly alter ego, and strives to compensate for the tedium of facts by offering the pleasures of style and friendship. Sometimes he openly trades amusement for attention, by following a technical discourse with a bit of poetry or mythology. Indeed, Twining thought that Burney too often pandered to his audience, or at least underestimated it. One could not write a history for a public devoid of curiosity. "Do your utmost, therefore, the most you can reasonably expect of such readers, is that they will *read* the last

half of the *last* volume, & look over the gays in both."[29] By indulg-
ing the sweet tooth of indolent young ladies, Burney might revolt
a taste more mature. So pleasing an author, Twining insisted,
should not have to strain to please.

On this point, however, Burney was not easy to move. If we
wish, we can attribute his little airs and graces, his artful pleas-
antry, to a compulsion to be popular. Nevertheless, there was a
good theoretical reason for the *History of Music* to court and woo
its readers.

> My subject has been so often deformed by unskilful writers,
> that many readers, even among those who love and under-
> stand music, are afraid of it. My wish, therefore, is not to
> be approached with awe and reverence for my depth and erudi-
> tion, but to bring on a familiar acquaintance with them, by
> talking in common language of what has hitherto worn the face
> of gloom and mystery, and been too much 'sicklied o'er with
> the pale cast of thought;' and though the mixing biographical
> anecdotes, in order to engage attention, may by some be con-
> demned, as below the dignity of science, yet I would rather be
> pronounced trivial than tiresome; for Music being, at best, but
> an amusement, its history merits not, in reading, the labour of
> intense application, which should be reserved for more grave
> and important concerns.[30]

As a leader of taste, Burney does not pretend to write a *science*
and *practice*. He would rather found *A General History of Music*
upon common language, and the desire of his audience to be
amused. So long as music is understood to be primarily an enter-
tainment, the historian's business must be to suit his tone to pleas-
ure, and encourage readers to share it.

After a time, moreover, the appeal to taste seemed to provide
Burney with the ordering principle he sought. If he could not
demonstrate the relevance of progress to every bit of information
in music history, if he had to purvey ancient arguments and hear-
say music, he could at least exemplify the superiority and ele-

[29] *Ibid.*, p. 165.

[30] *History*, I, 19. Burney's modest claim for music here somewhat contradicts the
larger claim made by Johnson in the Dedication he had supplied for the *History*
(I, 9-10). See section three below.

gance of his own times. Above all, readers must not be left out. The *History of Music* gathers its audience into its anecdotes and good humor as into a society where all can participate in the formation of a general, enlightened, and improved taste. To make his subject "palatable"[31] was a point of pride for Burney, and a way through the chaos of his predecessors. What scholarship had severed, taste alone could knit.

3. BURNEY AND THE COMMUNITY OF TASTE

The reliance of Burney's *History of Music* upon taste and upon contemporary society is notorious; if people know only one thing about the *History*, that is what they know. Thus our own recent scholarly history of music, Donald Jay Grout's, makes classic use of Burney to introduce Classical style. "In 1776 Dr. Charles Burney published at London the first volume of his *General History of Music*, which contains the following definition: 'Music is an innocent luxury, unnecessary, indeed, to our existence, but a great improvement and gratification of the sense of hearing.' Less than a hundred years earlier Andreas Werckmeister had called music 'a gift of God, to be used only in His honor.' The contrast between these two statements illustrates the revolution in thought that had taken place during the eighteenth century, affecting every department of life."[32] Such a contrast isolates Burney's limitation to a class and a time. The point is reinforced sharply at the beginning of a recent *Social History of Music*: "This definition could only have been drawn up in a society which had come to a tacit agreement that 'the arts' are to be regarded as an ornament to life, and are to a large extent the acquired property of suitably enlightened *cognoscenti.* . . . The social functions of music, in fact, are numerous and varied, and the main difficulty about Dr. Burney's definition is that it would seem to place a disproportionate value on what for want of a better name we must call 'art music.' "[33] By setting music among the luxuries, Burney

[31] "The ingredients which I have now to prepare for the reader, are in general such as I can hardly hope to render palatable to those who have more taste than curiosity" (I, 457).

[32] *A History of Western Music* (New York, 1960), p. 411. Grout is quoting not from the 1776 volume, which presented its definitions in question and answer form, but from the revised edition of 1789.

[33] E. D. Mackerness, *A Social History of English Music* (London, 1964), pp. 2-3.

seems to deny it either metaphysical importance or a place in the daily life of the great mass of men.

Since Burney's definition of music figures so prominently in critical commentary upon his *History*, it deserves to be considered in context. And in context something immediately becomes clear: Burney intended to shock his readers. The questions and answers about music with which he prefaced his "Dissertation on the Music of the Ancients" in 1776 are introduced by a statement that can be appreciated only when seen through the bleary eyes of a very weary historian: "Ancient writers upon science usually began with definitions" (I, 21). Burney is not an ancient writer, he is dealing with an art rather than a science, and his definitions will be of a new kind. *"What is* MUSIC? An innocent luxury."* So much for ancient writers upon science, and so much for modern writers like Hawkins! The modesty of Burney's claim, stemming from an already famous expert on music, challenges pretensions past and future. Compare, for instance, Peacham's claims for music. "Since it is a principall meanes of glorifying our mercifull Creator, it heighthens our devotion, it gives delight and ease to our travailes, it expelleth sadnesse and heavinesse of Spirit, preserveth people in concord and amity, allayeth fiercenesse, and anger; and lastly, is the best Phisicke for many melancholly diseases."[34] After such a reverent doxology, to whisper that music is "a gratification of the sense of hearing" sounds a grateful antiphon.

The contrast between Burney and his predecessors,[35] then, looms so large because he himself deliberately and self-consciously contrived it. He was as aware as we are that his definition illustrated a revolution in thought, and he intended everyone to face the change. Moreover, he knew that his modest claims for music imply a great compliment. When such labors as his own *History of Music* could be presented to the public without any particular metaphysical justification, the art of music had demonstrated its popularity. Burney subtly flatters both his audience and his art

[34] *The Compleat Gentleman* (Oxford, 1906; a reprint of the 1634 edition), p. 104.
[35] Exceptions should be made for two writers whom Burney admired, Avison and Roger North. North's *Memoirs of Musick*, which Burney knew in manuscript, frequently stress that music is an entertainment, one of the "composed delights, formed for the regaling of mankind," like fireworks and comedy; *Roger North on Music*, ed. John Wilson (London, 1959), p. 12.

by assuming that the "innocent luxury" will receive attention without demanding it. He will not disgust sensible readers by perplexing them with incantations and blackletter. In the *History of Music* the untracked oceans of universalized musical chaos are to be succeeded by a clear refreshing draught of easy good sense.

We all know how much Burney was giving up. With hardly a qualm, he was ready to sacrifice Hawkins' dream of proving that music is founded in general laws like those which harmonize the world. Henceforth the enlightened musical public would not need to worry about the tuning of the sky. The idea of music was diminished. Even if we lack a sentimental regard for the universalizing vision of such giants as Mersenne, it is difficult not to salute the passing of Hawkins' dream with a sigh like that of a great string breaking. When Burney treats music as an art, rather than a science or a way of life, he writes an end to an era.[36]

Whatever our regrets, however, we must appreciate that from Burney's point of view his *History* is generously opening a new way through uncharted darkness. He knows the implications of his definition, and his "Essay on Musical Criticism" begins by stressing them. "As Music may be defined the art of pleasing by the succession and combination of agreeable sounds, every hearer has a right to give way to his feelings, and be pleased or dissatisfied without knowledge, experience, or the fiat of critics" (II, 7). Again and again Burney insists that dogma, narrow expectations, or principles of any kind merely cripple the variety of possible responses to music. Ancient writers had argued more or less well, but nothing can come of dispute except more dispute. Burney welcomes every taste into his musical cosmos. And he hates dispute.[37] "There are at present certainly too many critics, and too few candid hearers in France as well as elsewhere. I have seen

[36] A new idea and a new era were already beginning, however, in the work of J. N. Forkel, whose *Allgemeine Geschichte der Musik* (Leipzig, 1788; 1801) accuses Burney of cheapening music, and who founds a new theory of music history on the art of J. S. Bach: "It is certain that if the art is to remain an art and not to be degraded into a mere idle amusement, more use must be made of classical works than has been done for some time past"; *Life of John Sebastian Bach* (London, 1820), preface. The German edition of Forkel's biography of Bach was published in 1802; the English translation has been attributed to A. F. C. Kollmann.

[37] Cf. Avison's *Reply to the Author of Remarks on the Essay on Musical Expression* (London, 1753), in which he complains that musicians spend more time arguing with each other than pleasing the public.

French and German *soi-disant connoisseurs* listen to the most exquisite musical performance with the same *sans-froid* as an anatomist attends a dissection. It is all analysis, calculation, and parallel; they are to be wise, not pleased. Happy the people, however imperfect their Music, if it gives them pleasure! But when it is an eternal object of dispute; when each man, like Nebuchadnezzar, sets up his own peculiar *idol,* which every individual is to fall down and worship, or be thrown into the fiery furnace of his hatred and contempt, the blessing is converted into a curse" (II, 982). In Burney's music criticism pleasure comes before doctrine, and every man is entitled to his own kind of pleasure.

The *History of Music* does not merely pay lip service to catholicity of taste. It exhibits a quite unprecedented variety of tastes in action. The common view of Burney as a narrow and prejudiced captive of his own time is ironic, a legacy we inherit partly from his own practice of criticism. As the first critic to take particular notice of compositions selected from the whole world of music, Burney inevitably exposes his own failures as well as triumphs of apprehension; yet only his willingness to listen to and attempt to understand everything allows us to decide that not everything is within his grasp. No previous musicologist had begun to cover such a range.[38] Hawkins, after all, reserves judgment about the quality of most of the music he reviews, and he refuses to discuss more than a pittance of contemporary music. Burney tries to inform himself about every style, to praise when he can and find reasons when he cannot.

Far from being chained to a single rule, he was, in fact, the first and perhaps the greatest of modern musical internationalists. His travels to foreign countries manifest a striking new curiosity about different approaches to music, and he tried to stay free of preconceptions; he carried very little baggage. At a time when nationalism still determined most attitudes—even Rousseau, the main intellectual supporter of musical simplicity, embraced Italian music only at the cost of concluding "that the French have no music and cannot have any"[39]—Burney rapidly crossed national bound-

[38] Padre Martini never brought the *Storia della musica* up to modern times; Forkel was to reach as far as the sixteenth century.

[39] *Lettre sur la musique française* (1753), in Oliver Strunk, *Source Readings in Music History* (New York, 1950), p. 654.

aries. In this respect he was a harbinger of the immediate future. "The international aspirations of the eighteenth century appear perhaps as clearly in no other art as in music. The style born out of the travail and struggle of change, the style of the Viennese classics, has become the most international style of music; it has conquered audiences the world over. Lully, in his operas, addressed the French court; Bach, in his church music, the German Protestants. But Haydn, in the instrumental music of his later years, Mozart, in his operas, Beethoven, in his symphonies, address mankind."[40] In the humbler sphere of music criticism Burney shared those aspirations and that audience.

Indeed, Burney shows a remarkable ability to adapt his criticism to new music and new tastes. A major delight of following his career through its eighty-eight years of excursions lies in watching him master a succession of challenges. In literature he bridges a century of activity. "The young man who disturbed James Thomson's indolence, who became the intimate friend of Christopher Smart, Samuel Johnson, and Mrs. Thrale, lived to extend a public welcome to the *Lyrical Ballads*."[41] In music his enthusiasms measure the shift from Italy to Germany, from baroque to classical. Taught by Arne, weaned on Handel, captivated by the Neapolitan school, he rose to each new occasion. "HAYDN! the admirable and matchless HAYDN! from whose productions I have received more pleasure late in my life, when tired of most other Music, than I ever received in the most ignorant and rapturous part of my youth" (II, 958).[42] Or, in 1805, "The inexhaustible Mozart, whose compositions I did not like at first; they seemed too capricious and as if he were trying experiments, till he began to compose vocal music, of which he [*sic*] knew nothing till after his decease; but which, both in his serious and comic operas, seems to me, and innumerable others, the most delightful dramatic music that has ever been composed."[43] Or, in a diary entry

[40] E. E. Lowinsky, "Taste, Style, and Ideology in Eighteenth-Century Music," *Aspects of the Eighteenth Century*, ed. E. R. Wasserman (Baltimore, 1965), p. 205.
[41] Lonsdale, *Dr. Charles Burney*, p. 482.
[42] See R. S. M. Hughes, "Dr. Burney's Championship of Haydn," *Musical Quarterly*, XXVII (1941), 90-96; and Scholes, *The Great Dr. Burney*, chapter XLIX.
[43] Letter to William Crotch, 17 Feb. 1805, in Appendix I to the *History of Music*, II, 1035. Crotch himself had been a child prodigy whom Burney compared favorably to Mozart in his "Account of an Infant Musician," *Philosophical Transactions of the Royal Society*, LXIX (1779), 183-206; see Michael Raeburn, "Dr. Burney,

as early as 1803, Beethoven, whose instrumental works "are such as incline me to rank him amongst the first musical authors of the present century."[44] A critic whose instincts are so fine may be forgiven a liking for Sacchini and Schobert.

There is a less glamorous side, however, to Burney's internationalism. Himself pleased by much, he inclined towards music which could please many. As the *History of Music* strives to incorporate and satisfy every audience, it inevitably hearkens to common denominators, music intelligible to every taste and every nation. Burney's writings are popular in two senses: they appeal to, and they are based upon, common opinion. And Burney believes that music should also be popular. In the *History* he reprints without comment (and without acknowledgement) some remarks by Carl Friedrich Abel.[45] "If Sebastian Bach and his admirable son Emanuel, instead of being musical-directors in commercial cities, had been fortunately employed to compose for the stage and public of great capitals, such as Naples, Paris, or London, and for performers of the first class, they would doubtless have simplified their style more to the level of their judges; the one would have sacrificed all unmeaning art and contrivance, and the other been less fantastical and *recherché,* and both, by writing in a style more popular, and generally intelligible and pleasing, would have extended their fame, and been indisputably the greatest musicians of the present century" (II, 955). This judgment contains a grain of truth—certainly J. S. Bach's genius would have been recognized more rapidly if he had sought to win an international following—yet it raises grave questions about Burney's principles. Must a critic and historian merely acquiesce in the public verdict? Does he not also have an obligation to form and to lead taste? And is taste itself, however broadly conceived, a sufficient standard from which to judge?

Mozart and Crotch," *The Musical Times,* XCVII (1956), 519-20. The improvement in Burney's opinion of Mozart is traced by C. B. Oldman, "Dr. Burney and Mozart," *Mozart-Jahrbuch 1962/63,* pp. 75-81.

[44] *Memoirs of Dr. Burney* (London, 1832), III, 334. Burney's views of composers were revised and brought up to date for his articles in Rees's *Cyclopaedia,* written between 1801 and 1805 (Lonsdale, *Dr. Charles Burney,* chapter X).

[45] Burney acknowledged Abel as the author in his article on Bach for Rees's *Cyclopaedia.* Abel, who with J. C. Bach was one of the two dominating figures in the musical life of contemporary London, had studied with J. S. Bach.

Questions about the responsibilities of the critic are directly posed by the passage that follows Abel's remarks in the *History*. Here Burney quotes some reflections supplied by "Emanuel Bach, in his life, written at my request, by himself. . . . When the critics, says he, are disposed to judge impartially, which seldom happens, they are frequently too severe on works that come under their lash, from not knowing the circumstances that gave them birth, or remembering the author's original intention. But how seldom are critics found to possess feeling, science, probity, and courage? qualities without which no one should set up for a sovereign judge. It is a melancholy truth, that musical criticism, which ought to be useful to the art, is in Germany a trade, commonly carried on by dry, malignant, and stupid writers" (II, 955).

This passage has a strange and interesting background. When Burney thought of malignant German critics, he had cause to remember an attack on himself in the previous year. The affair had been prompted by some words in Burney's "Character of HANDEL, as a Composer" (1785). While arguing that "all the judicious and unprejudiced Musicians of every country" would allow Handel to have been the greatest of all composers, Burney asserted "that in his full, masterly, and excellent *organ-fugues*, upon the most natural and pleasing subjects, he has surpassed Frescobaldi, and even Sebastian Bach, and others of his countrymen, the most renowned for abilities in this difficult and elaborate species of composition."[46] In 1788, an anonymous letter in the *Allgemeine deutsche Bibliothek* threw scorn upon this comparison. "Knowledge of art, and particularly taste, we may concede to Dr. Burney; but is he also impartial? Did he know all the works of the two famous men whom he wished to compare? On pages 400 and 401 [sic] there is nothing to be seen but partiality, and of any close acquaintance with the principal works of J. S. Bach for the organ we find in Dr. Burney's writings no trace. . . . no, for him Handel was the greatest organist, and why should he bother about the lesser ones? Hence his unjust and distorted comparisons."[47]

[46] Printed (p. 41) with the Life of Handel that accompanies Burney's *An Account of the Musical Performances in Westminster-Abbey, and the Pantheon, May 26th, 27th, 29th; and June the 3rd, and 5th, 1784. In Commemoration of Handel* (London, 1785).

[47] Reprinted and translated in *The Bach Reader*, ed. H. T. David and Arthur

The objects of this attack—failure to be impartial, ignorance of the composer, a premature readiness to set up for a judge— strongly resemble those of C. P. E. Bach's reflections in the *History*, and for a very good reason. Scholars now suspect that the author of the anonymous letter against Burney was Emanuel Bach himself.[48] Evidently Bach supplied the unknowing Burney with sentiments intended to condemn him from his own mouth. Such treachery would not have been incompatible with the character of Bach, who often amused himself at his friends' expense.[49] The same anonymous diatribe reproaches Burney (whose *Tours* in Germany pay lingering and flattering attention to C. P. E. Bach) for not having sought out musicians who could have informed him about J. S. Bach's greatness on the organ.[50] Certainly such friendship could not contribute much to the *History*. Yet the example of Bach's malice, as well as his critical principles, calls into doubt the very life of the *History*, its belief in a community of taste.

Had Burney replied to this attack, he could have chosen several lines of defense. The most comfortable of these for him would undoubtedly have been the Johnsonian argument that, given

Mendel (New York, 1966), p. 282. The author chooses to overlook Burney's praise for Bach, *Tours*, II, 156.

[48] Dragan Plamenac, "New Light on the Last Years of Carl Philipp Emanuel Bach," *Musical Quarterly*, XXXV (1949), 565-87. The principal evidence is a similar letter written by Bach in 1786 to J. J. Eschenburg, the German translator of Burney's *Account*.

[49] C. P. E. Bach was notorious for borrowing money from his pupils without repayment, for his piecemeal sales of his father's works, and for assorted intrigues; see Karl Geiringer, *The Bach Family* (New York, 1954), pp. 336-52. His friendship with J. N. Forkel, whose *Allgemeine Geschichte der Musik* he reviewed favorably in 1788, and who in turn praised the author of the anonymous attack on Burney, might have motivated Bach's double-dealing.

[50] *Bach Reader*, p. 282. Since only C. P. E. Bach himself could have known for certain that he had not discussed his father's organ-playing with Burney, the anonymous author's failure to mention the meeting with C. P. E. Bach described by Burney in the *Tours* (II, 211-220) seems additional confirmation that only Bach could have written the attack. In the *Tours* Burney comments that Scarlatti and Emanuel Bach "Both were sons of great and popular composers, regarded as standards of perfection by all their contemporaries, except their own children" (II, 220). Samuel Wesley, in a letter of 1809, accused Emanuel Bach himself of having been responsible for Burney's underestimation of J. S. Bach: "I am very much inclined to think that this Son, like many others, made but little scruple of robbing his Father; and that he was not concerned for his Honour seems plain enough by the vile and most diabolical Copy that he gave Dr. Burney as a Present, and from which the latter was wise enough to judge of and Damn his Works (as he thought), but the Phoenix must always revive" (Scholes, *Great Dr. Burney*, II, 215).

enough time, the taste of the public will develop an authority more reliable than any other.[51] In the one part of his discussion of the Bachs which is not borrowed from Reichardt, Abel, or Emanuel Bach himself, he employs just this argument. "Em. Bach used to be censured for his extraneous modulation, crudities, and difficulties; but, like the hard words of Dr. Johnson, to which the public by degrees became reconciled, every German composer takes the same liberties now as Bach, and every English writer uses Johnson's language with impunity" (II, 955). Time was certainly on Burney's side. Eventually, in fact, it worked on him so well that in the last years of his life he developed a taste for J. S. Bach.[52] By extending its survey of taste through time as well as space, the *History of Music* could hope to arrive at judgments that would outlast even its own local prejudice.

This justification appealed to Burney. It had the merit of following what has been called the central movement of taste in eighteenth-century France. "The arts were historical in nature, there were no universally valid rules; but taste might nevertheless create order out of historical chaos by being able to distinguish between what in a work of art was specifically historical and what was universal—its potential of pleasing men of various places and times."[53] Yet Burney, as he found his own taste becoming immersed in historical chaos as well as ordering it, knew that the triumph of taste over the ravages of time was precarious, and that history might merely confirm prejudice. Even "the opinion of professors of the greatest integrity is not equally infallible concerning every species of musical merit" (II, 8), and the public could be trusted still less. For taste to distinguish between the historical and the universal in a work of art, it required some other basis than a consensus of pleasure.

The problem of defending his tastes with a Johnsonian argument could have been discovered by Burney very close at hand: in the Dedication to the Queen (1776) of the *History of Music,* and in the Dedication to the King (1784) of *An Account of the*

[51] One of Johnson's earliest statements of this principle, *Rambler* 92 (1751), specifically attributes it to Boileau. The idea of course is a commonplace, perhaps most famously expressed in the eighteenth century by Hume's essay "Of the Standard of Taste" (1757).

[52] Scholes, *Great Dr. Burney*, II, 210-223.

[53] R. G. Saisselin, *Taste in Eighteenth Century France* (Syracuse, 1965), p. 133.

. . . *Commemoration of Handel,* both of which had been written for Burney by Samuel Johnson.[54] Although Johnson, who agreed that "All animated nature loves music—except myself!",[55] deferred to Burney's opinions about music, he could not keep his own mixed feelings from creeping in. Since he privately believed that "no man of talent, or whose mind was capable of better things, ever would or could devote his time and attention to so idle and frivolous a pursuit,"[56] his dedications are prone to protect music from his own accusations. "THE science of musical sounds, though it may have been depreciated, as appealing only to the ear, and affording nothing more than a momentary and fugitive delight, may be with justice considered as the art that unites corporal with intellectual pleasure, by a species of enjoyment which gratifies sense, without weakening reason" (I, 9). Burney could hardly object to such praise for his "science," but an attentive reader might have seen that the praise would have been more appropriate to Hawkins' *History;* Burney himself felt no need to apologize for the momentary and fugitive delights of music.

Johnson's suspicion of such delights,[57] and of mere musical taste, asserts itself still more strongly in the dedication of Burney's *Account* to George III. Here he perfectly catches the note of Hawkins. That musical "pleasure may be truly elegant, science and nature must assist each other; a quick sensibility of Melody and Harmony, is not always originally bestowed, and those who are born with this susceptibility of modulated sounds, are often ignorant of its principles, and must therefore be in a great degree delighted by chance; but when Your Majesty is pleased to be present at Musical performances, the artists may congratulate themselves upon the attention of a judge in whom all requisites

[54] A. T. Hazen, *Samuel Johnson's Prefaces & Dedications* (New Haven, 1937), pp. 23-33.

[55] *Memoirs of Doctor Burney,* II, 78.

[56] *Johnsonian Miscellanies,* ed. G. B. Hill (Oxford, 1897), II, 404. When a young lady (Miss Johnson, a niece of Reynolds) whispered "I wonder what Dr. Johnson thinks of King David," however, Johnson overheard and promised, "that, on one subject at least, you shall never hear me talk nonsense again." Cf. K. C. Balderston, "Dr. Johnson and Burney's *History of Music,*" *PMLA,* XLIX (1934), 966-68.

[57] Since Johnson, as Hawkins reports (*The Life of Samuel Johnson, LL.D.* [London, 1787], p. 318), was insensible to the delights of music, he tended to defend it on moral grounds: "Of music Dr. Johnson used to say that it was the only sensual pleasure without vice"; *Johnsonian Miscellanies,* II, 301.

concur, who hears them not merely with instinctive emotion, but with rational approbation, and whose praise of HANDEL is not the effusion of credulity, but the emanation of Science."[58]

Although Burney professed himself grateful for these embellishments to his work,[59] he could not easily have written them himself. The king, unfortunately, believed in the excellence of the Royal Ear; his narrow taste had been a great trouble to Burney,[60] and to compliment his Science would have come hard. Furthermore, Johnson's argument tended to undermine the critical principles of the *History*. Johnson praised music as a rational science, and the king, like many other philistines, admired his own taste, but neither Burney's reason nor his taste could subscribe to judgments like theirs. It was not enough for a critic to know what most men thought about music, or to speak idly of taste. One must speak of *good* taste; and to do that, one must know the meaning of taste, and what it involved beyond personal prejudice.

4. BURNEY AND THE DEFINITION OF TASTE

Throughout his career Burney, like Rousseau before him, worried the problem of taste. In the *Tours* he had attempted a technical explanation: "*Taste*, the adding, diminishing, or changing a melody, or passage, with judgment and propriety, and in such a manner as to *improve* it; if this were rendered an invariable rule in what is commonly called *gracing*, the passages, in compositions of the first class, would seldom be changed."[61] Although this definition has reference only to the performer, rather than to the composer or the audience, it is less specialized than may first appear. To understand why, we must appreciate the critical importance of *gracing* in eighteenth-century theories of musical interpretation. For a contemporary performer, the ability to embellish compositions was not merely a pleasant addition to his talents, but an integral part of them. Without knowledge of graces and ornaments one could not perform at all. In France, according to Rousseau, "most of the young students in music used there-

[58] *An Account of the Musical Performances*, dedication, p. v. This passage was written at Burney's request specifically to gratify the king; see the letter of 28 August 1784, Johnson's *Letters*, ed. R. W. Chapman (Oxford, 1952), III, 209-10.

[59] Johnson's *Letters*, III, 215-16 (4 September 1784).

[60] See Lonsdale, *Dr. Charles Burney*, p. 302ff.

[61] *Tours*, I, xxxiv.

fore to have two masters, one in music and one for taste, called *Maitre de Gout-de-chant*,"[62] who taught the embellishing *agrémens*.

The classical statement about the proper nature of embellishments is the long section in C. P. E. Bach's *Versuch über die wahre Art das Clavier zu spielen* (1753-1762), a work much admired by Burney. Here Bach instructs his readers that a knowledge of embellishment requires and implies knowledge of history as well as critical acumen.

> It may well be that some, predisposed to only one taste, will not be satisfied with my choice of ornaments. However, it is my belief that in music no one can offer reasonable criticism who has not listened to all styles and cannot select the best from each. I agree with a certain great man's opinion that, although one taste may be better than another, each contains something good and none is so perfect that it will not endure additions. It is through such additions and refinements that we have progressed this far and will advance even further, but, certainly, not through addiction and restriction to only one style. Everything good must be put to use regardless of its origins.
>
> Embellishments and their execution form a large part of good taste.[63]

From this point of view, a correct use of ornamentation cannot be separated from the historical judgment which grasps both the nature of different kinds of music and their interrelations. The performing problems which we refer to usually as "interpretative" and which Avison more ambiguously termed "expressive" are subsumed by Bach and Burney under a subheading of "taste" known as "embellishment." The additions and refinements applied by a musician display his taste in history. Indeed, Burney's definition of taste centers around *improving* compositions. It begins not with the melody or passage, but with the changes worked upon them. Purity of taste, or playing a passage strictly as written, is itself a function of gracing; one kind of particularly tasteful gracing consists of omitting all graces. The performer and his

[62] Quoted by Burney for his article in Rees's *Cyclopaedia* on "TASTE, in *Music*."
[63] *Essay on the True Art of Playing Keyboard Instruments*, tr. W. J. Mitchell (New York, 1949), p. 85. The "certain great man" is J. S. Bach.

audience, rather than the composer and his work of art, exercise the decisive control over music according to the rights bestowed by taste.

There is something paradoxical, of course, about defining taste in terms of changes and improvements, and then insisting that good taste demands that one let good music alone. Burney could not stay satisfied with his definition. By the time of his contributions to Rees's *Cyclopaedia* in 1801-1805 he was ready to contradict himself explicitly: "TASTE, in *Music,* is often confounded with *graces,* or change of passages; but a movement composed in good taste, is often injured by what are called graces. We rather suppose taste to depend on feeling and expression, than in flourishes, or, as the Italians call them, *riffioramenti*; in sorrow, pathos; in joy, brilliancy and fire."[64] Extending the definition beyond technique toward feeling and expression, Burney rebukes his earlier pre-occupation with embellishments. Yet he still does not offer a principle according to which we might distinguish proper ornamentation from mere flourishes, good taste from bad. Bach's descriptions of tasteful gracing had at least attempted to find an objective basis for taste, in historical progress and in the varieties of style, but Burney seems to slip back into the personal.

The truth is that Burney's *History of Music,* like many works of the eighteenth century, uses "taste" to support its judgment in two ways. The first is as an equivalent of the *je ne sais quoi,* a criterion to be invoked when all others fail. "Taste, says Rousseau, is of all Nature's gifts the most easily felt, and the most difficult to explain; it would not be what it is, if it could be defined: for it judges of objects beyond the reach of judgment, and serves, in a manner, as a magnifying glass to reason."[65] In this sense taste can be seized upon only by intuition, and the critic proves himself merely by stating his preferences without submitting to the futility of looking for reasons. An attempt to support such preferences would violate the essential delicacy and mystery of artistic excellence. "There are some melodies more agreeable than others,

[64] "TASTE, in *Music,*" Rees's *Cyclopaedia.*
[65] *Ibid.* Burney draws upon Rousseau's *Dictionnaire de musique* (1768). Cf. Rousseau on "Genius": "Seek not, young artist, what meaning is expressed by genius. If you are inspired with it, you must fell [*sic*] it in yourself. Are you destitute of it, you will never be acquainted with it" (*Dictionary of Music,* tr. William Waring [London, 1779], p. 182).

though equally well phrased and modulated; there are combina-
tions in harmony of great effect; and others that excite no at-
tention, all equally regular as to composition; there is in the
texture of the parts, an exquisite art of arranging and setting off
one passage by another, which depends on something more
subtle than the laws of contrast."[66] The invocation of so inde-
scribable a quality serves merely to avoid argument. *De gustibus,*
so defined, indeed *non disputandum est.*

Burney's second use of "taste," however, seeks to found it on
something slightly less subjective: the relation between the mind
that judges and the works that are judged. This sense of taste was
defined, for instance, by Dugald Stewart: "in the constitution of
man, there is an inexplicable adaptation of the mind to the ob-
jects with which his faculties are conversant, in consequence of
which, these objects are fitted to produce agreeable or disagree-
able emotions."[67] Though associational principles like these de-
pend upon a cousin of *je ne sais quoi,* "an inexplicable adapta-
tion of the mind," they also imply an identity of stimulus and
response: taste must take cognizance of real objects. Besides the
taste formed by local and accidental associations, many aestheti-
cians agreed, there is a taste founded upon the universal properties
of the mind, the qualities which inhere in works of art, and the
process by which the two establish an equilibrium.[68] In this sense,
taste describes the operation of imaginative sympathy during
which the mind assimilates and "tastes" new objects of apprehen-
sion without violating their own separate integrity. If we were to
go one step further, and direct our attention to the power that
draws subject and object together rather than to the process of
assimilation,[69] we should of course be talking about the next de-
velopment of associational theory: the Romantic imagination.

Without going so far, Burney does attribute to taste the radical

[66] "TASTE, in *Music,*" Rees's *Cyclopaedia.*

[67] *Elements of the Philosophy of the Human Mind,* ii, v; quoted with approval
in the main section of Rees's article on "TASTE."

[68] The standard eighteenth-century analysis of taste according to principles of
faculty psychology is Alexander Gerard's *An Essay on Taste* (1759), whose third
edition (1780) has recently been reproduced in facsimile with an introduction by
W. J. Hipple, Jr. (Gainesville, Fla., 1963).

[69] The crucial figure in this development is Archibald Alison, *Essays on the
Nature and Principles of Taste* (Edinburgh, 1790). See Martin Kallich, "The
Meaning of Archibald Alison's *Essays on Taste,*" *PQ,* XXVII (1948), 314-24.

sympathy which makes music and discourse about music possible. "It is taste which enables a vocal composer to seize and express the ideas of the poet; it is taste which guides the performer to the true expression of the composer's ideas; it is taste which furnishes both with whatever can embellish and enrich the subject; and it is taste which enables the hearer to feel all these perfections."[70] Very nearly transformed into a new principle of universal harmony, this kind of taste offers the critic a standard of judgment that refers to something other than himself alone.

The tastes on show in the *History of Music* may be philosophically justified, then, insofar as they aim at bringing music into vital relation with the imagination. But Burney is devoted to art, not philosophy. His own view of the Romantic imagination and his own interests are splendidly exposed by his review, in June 1799, of a disturbing little volume entitled *Lyrical Ballads*,[71] and in particular a poem about Tintern Abbey. "The reflections of no common mind; poetical, beautiful, and philosophical: but somewhat tinctured with gloomy, narrow, and unsociable ideas of seclusion from the commerce of the world: as if men were born to live in woods and wilds, unconnected with each other! Is it not to education and the culture of the mind that we owe the raptures which the author so well describes . . . ?"[72] Burney's wide range of critical sympathy is genuine, and it extends even to Wordsworth, but it assumes a social and cultural foundation. His first sympathy, and his greatest sensitivity, concern the connections among human beings. Taste, like the imagination, is a civilizing and assimilating force, yet no one man can be tasteful except through his relations with others; the savage, as Burney says in his review, does not "listen in maturer age 'to the still sad music of humanity.' "[73] And the music of humanity is the subject of the *History of Music*.

[70] "TASTE, in *Music*," Rees's *Cyclopaedia*.

[71] See B. C. Nangle, "Charles Burney, Critic," *The Age of Johnson*, ed. F. W. Hilles (New Haven, 1949), p. 108. The circumstances of Burney's reviewing have been clarified by Roger Lonsdale, "Dr. Burney and the *Monthly Review*," *RES*, XIV (1963), 346-58; XV (1964), 27-37.

[72] *The Monthly Review*, XXIX (June, 1799), 210.

[73] *Ibid.* Cf. Burney's "Account of an Infant Musician": "there is a wild kind of music among savages, . . . yet these rude effusions can afford no pleasure to a cultivated ear." Burney encourages Wordsworth to turn to more tasteful themes: "So much genius and originality are discovered in this publication, that we wish to see another from the same hand, written on more elevated subjects and in a more cheerful disposition."

When we speak of Burney as the apostle of taste, therefore, we are speaking of something less systematic than philosophy yet more profound than fashion. The *History of Music* exhibits failures as well as triumphs of historical imagination, but no ordering principle is more fundamental to it than the extension of taste, and the sympathy that informs taste, into the widest possible variety of music. "Whoever writes or speaks to the public must not indulge favouritism."[74] In this precept Burney could hope he had found a support to carry him through the shoals of bad taste on which other historians had foundered. Yet no principle of taste, however impersonal, could yoke different styles and eras of music, or the mind with its musical objects, in abstract terms. The philosophical justification of taste could be presented only through the force of example. In place of the ideal musical community once posited by historians, Burney sought to put a real community bound by mutual sympathy. No previous historian had perceived, or believed in, such a community. The theory of taste awaited its application. Only Burney himself, by convincing his readers that their interests were the same as his, could provide his own first example.

5. BURNEY, HAWKINS, AND CRITICAL TRADITION

With one reader, however, Burney was not in sympathy; and the example of his own taste was forced to take direction from Hawkins'. We have already noticed the changes which the presence of the one *History* induced in the other. Burney was all too conscious of the difficulties of his position. "In pursuing the history of English Minstrels I am frequently obliged to recount circumstances which have lately been rendered familiar to many of my readers; but these circumstances are such as seem so naturally to belong to my work, that those who peruse it would have cause to complain should they be put to the trouble of seeking them elsewhere. There are certain events which every writer *must* relate, however they may have lost the charms of novelty by frequent repetition" (I, 650). The existence of Hawkins' *History* placed a terrible strain upon Burney's good nature, a challenge which his reputation for good humor barely survived. Burney's pleasantries and intimacies often seem to be accompanied by a restrained grinding of teeth.

[74] Letter to Crotch, appendix to the *History*, II, 1035.

Yet Hawkins' science and practice also offered an opportunity. Once demolished by the reviews, he functioned as an irresistible buff; his pedantic opinions, happily sunk by their own ponderous expression, conveniently summarized just those outworn standards which Burney's own triumphant progress was intended to supplant. Burney's response to this temptation nicely mingles tact and malice. He hardly so much as mentions the rival *History*, and quotes only a few phrases from it,[75] but he borrows so much material from Hawkins that he has been accused of plagiarism,[76] and he argues with his ideas incessantly. Repeatedly the very terms and context of Burney's criticism are set by his predecessor; he shapes new bottles to hold the same old wine. The last three volumes of the later *History* are best opened using the earlier *History* as a key.

Here, for example, is Hawkins on Gesualdo: "The distinguishing excellences of the compositions of this admirable author are, fine contrivance, original harmony, and the sweetest modulation conceivable."[77] Here is Burney:

With respect to the *excellencies* which have been so liberally bestowed on this author . . . , they are all disputable, and such as, by a careful examination of his works, he seemed by no means entitled to. They have lately been said to consist in 'fine *contrivance, original harmony*, and the *sweetest modulation conceivable*.' As to *contrivance*, it must be owned that much has been attempted by this Prince; but he is so far from being happy in this particular, that his points of imitation are generally unmanageable, and brought in so indiscriminately on concords and discords, and on accented and unaccented parts of a bar, that, when performed, there is more confusion in the general effect than in the Music of any other composer of madrigals with whose works I am acquainted. His *original harmony*, after

[75] One of Burney's few violations of silence is his harsh comment (I, 784-5 and n.) on Hawkins' charge that music has been corrupted; even here, however, he refers to Hawkins' note in *The Compleat Angler*, not to his *History of Music*, and he does not mention Hawkins by name. Burney's running argument with Hawkins' taste in music is best displayed by the copious querulous notes in his copy of Hawkins' *History*, now owned by the British Museum.

[76] Christopher Welch, *Six Lectures on the Recorder* (London, 1911), pp. 115-116. Welch implies that he has received private information from Hawkins' family supporting the accusation.

[77] Hawkins' *History of Music* (New York, 1963), p. 441.

scoring a great part of his madrigals, particularly those that have been the most celebrated, is difficult to discover; for had there been any warrantable combinations of sounds that Palestrina, Luca Marenzio, and many of his predecessors, had not used before him, in figuring the bases, they would have appeared. And as to his *modulation,* it is so far from being the *sweetest conceivable,* that, to me, it seems forced, affected, and disgusting. (II, 180)

This is not Burney's finest hour. For once his scorn of Hawkins, ordinarily insinuated rather discreetly, erupts into open violence, and the overflow scalds Gesualdo as well. Modern audiences, who have been led by the homage of such champions as Aldous Huxley[78] and Stravinsky into the belief that the strange harmonies of Gesualdo are fully justified by their expressive effects, can only consider Burney's attack superficial. The critic who lives by taste may die by taste.

In fairness to Burney, however, we must temper our condemnation by understanding how he arrived at his judgment. In the first place, it is significant that Hawkins as well as Burney refers to Gesualdo as an *author.* Neither historian can have possessed much more than a paper knowledge of the highly original *sounds* of the madrigals, and even the best reader of scores would have struggled in vain to perceive how they worked in performance.[79] In the second place, Burney, however much we disagree with his conclusions, appreciates more keenly than Hawkins what Gesualdo was attempting. "Through the whole book he seems to be *trying confusions.* . . . It is not every one who ventures to violate established rules, that has knowledge and genius sufficient to find either a series or combination of sounds which has escaped all other Composers, and which, by the pleasure it affords the ear, is above the reach of censure" (II, 180n.). Opinions as wrong-headed as this, like Johnson's on the metaphysical poets,[80] are infuriating pre-

[78] "Gesualdo: Variations on a Musical Theme," *On Art and Artists* (New York, 1960), pp. 286-302. Burney suggests that Gesualdo's reputation largely derives from men of letters (II, 178-9); Huxley, like many of the critics Burney reviews, especially recommends Gesualdo for his union of poetry with music.

[79] A glaring example of paper warfare is the argument, debated without evidence by both Hawkins and Burney, over the hypothetical influence on Gesualdo of Scottish folk songs.

[80] "Cowley," *Lives of the Poets,* ed. G. B. Hill (Oxford, 1905), I, 18-22.

cisely because they are only a hair's breadth from being right. A shift in perspective, the merest touch of approval, would turn the argument inside out, and exchange "ignorance and affectation" for "knowledge and genius." In the third place, Burney's motives for the attack probably resemble those of Gesualdo's modern defenders far more than do Hawkins'. Rather than acquiesce in a traditional verdict, Burney insists upon a fresh evaluation without regard to any authority other than the works themselves. His examination is careful, specific, and original, and the rigor of his conclusion aims not so much at Gesualdo as at "the character he bore among the learned, who so frequently get their musical information from tradition, that whether they praise or censure, it is usually *sans connoissance de cause*" (II, 179). The *History of Music* tries to free music from all that has been said about it.

The object of criticism, then, is not Gesualdo's modulation but Hawkins' prejudice. Burney employs a suppressed perpetual commentary to set the record straight, and to encourage his audience to trust its own direct experience. In this respect his criticism may remind us once again of Samuel Johnson. Indeed, Burney seems to have encouraged this reminder: a modulation "forced, affected, and disgusting" may deliberately recall a form "easy, vulgar, and therefore disgusting."[81] A similar Johnsonian echo probably accounts for a tone of didactic brutality we do not often meet in Burney. "I have bestowed more remarks on this Prince of Musicians, and more time in the examination of his works than they perhaps now deserve, in order to furnish my readers with what seems, to my comprehension, a truer idea of their worth than that which partiality and ignorance have hitherto given" (II, 181). This call for close, fresh inspection has a famous precedent: "Such is the power of reputation justly acquired that its blaze drives away the eye from nice examination. Surely no man could have fancied that he read *Lycidas* with pleasure had he not known its author."[82] To refute the authorities Burney summons the best authority he knows.

The authority of Johnson throws light upon much of Burney's criticism. If the instinctive cry of the *History of Music* is "praise when you can," its critical model instructs that "he who praises

[81] *Lives of the Poets*, I, 163. [82] *Ibid.*, I, 165.

everybody praises nobody."[83] Johnson influenced Burney to take his responsibilities to tradition seriously. The critic must argue for victory, and for the public weal. Just as the dangerous prevalence of pastoral helps to explain Johnson's disparagement of "Lycidas," so the authoritarian strain in Hawkins, as well as his worship of *literature*, helps to explain Burney's diatribe against Gesualdo. From Burney's *Musical Tours*, Johnson learned a relaxed and personal mode of writing that resulted in his own tour of the Hebrides;[84] from Johnson's criticism, Burney learned to be severe and independent.

Nevertheless, severity does not characterize the *History of Music*. Burney displays a more typical and attractive side of the argument with tradition in his long section on Henry Purcell. Here he felt less need to recriminate; Hawkins' plentiful and rather pedestrian comments represented an aid to scholarship, not a threat to taste. Once Burney had disposed of the "insipid" composers who preceded Purcell, he could welcome the music of his countryman with joy. Moreover, he could do his part to set taste in order.

I therefore feel a particular pleasure in being arrived at that period of my labours which allows me to speak of HENRY PURCELL, who is as much the pride of an Englishman in Music, as Shakespeare in productions for the stage, Milton in epic poetry, Lock in metaphysics, or Sir Isaac Newton in philosophy and mathematics.

Unluckily for Purcell! he built his fame with such perishable materials, that his worth and works are daily diminishing, while the reputation of our poets and philosophers is increasing by the constant study and use of their productions. And so much is our great musician's celebrity already consigned to tradition, that it will soon be as difficult to find his songs, or, at least to *hear* them, as those of his predecessors Orpheus and Amphion, with which Cerberus was lulled to sleep, or the city of Thebes constructed.

So changeable is taste in Music, and so transient the favour of any particular style, that its history is like that of a ploughed field: such a year it produced wheat, such a year barley, peas,

<hr>

83 *Johnsonian Miscellanies*, II, 327.
84 *Ibid.*, II, 303; cf. *Memoirs of Doctor Burney*, II, 78-79.

or clover; and such a year lay fallow. But none of its produc-
tions remain, except, perhaps a small part of last year's crop,
and the corn or weeds that now cover its surface. Purcell, how-
ever, was such an excellent cultivator of his farm in Parnassus,
that its crops will be long remembered, even after time has
devoured them. (II, 380)

For a modern reader, beleaguered by classical music that comes
at him in the street, the airplane, and the dentist's office, the meta-
phor of music as a ploughed field has lost its force. As record cata-
logues expand, many husks and even chaff of past music come to
life again. But Burney, when he lamented the probable demise of
Purcell's fame, was not being unduly pessimistic. The perform-
ance of music in the eighteenth century, unlike our own, did not
constitute a sort of museum where professionals display a standard
repertoire of classics, with one tiny room set aside for a glimpse
of the contemporary. Public concerts, arranged by an impresario,
offered only the very latest styles in music; and even private con-
certs, arranged by and for cognoscenti, rarely drew much further
upon the past than a familiar madrigal or a favorite song like
"Mad Bess."[85] At one typical evening reported by Fanny
d'Arblay, the entertainment included works by Schobert, Burney
himself, Echard, Sacchini, Rauzzini, and Müthel.[86] When a com-
poser died his music customarily died with him; an unusually de-
termined effort saved Handel's oratorios, but not his operas.[87]
Burney had reason to fear that the works of Purcell would be
soon forgotten.

It is that fear, and the accompanying urge to vivify tradition,
which justifies the generous catalogue of compositions that makes
up the bulk of Burney's section on Purcell. Virtually every work
of the composer is listed, with brief comments, according to genre.
If we come to this catalogue from Hawkins, we are bound to be
struck by two differences. First, Burney discusses Purcell's work

[85] Thomas Busby, *Concert Room and Orchestra Anecdotes*, 3 vols. (London,
1825); the *Reminiscences of Michael Kelly*, 2 vols. (London, 1826); and C. F. Pohl,
Mozart und Haydn in London (Vienna, 1867) retail useful information about
English concert life in the late eighteenth century.

[86] *Memoirs of Doctor Burney*, II, 14-17.

[87] Burney's *Account* describes the success of a commemoration based princi-
pally on the oratorios; his *History* attempts to redress the balance by omitting the
oratorios in favor of Handel's Italian operas.

far more thoroughly and systematically. Unlike Hawkins, who devotes a chapter to Purcell's life and another, rather sketchy, to his compositions,[88] Burney keeps a detailed description of the music very much to the fore. He leaves no doubt that Purcell must be esteemed as a musician rather than a personage, he is sparing of anecdotes, and he wastes little time upon scholarly controversies or authorities. Second, Burney passes judgment upon everything. Rarely does even a brief paragraph go by without some critical notation. In the short list of Purcell's music for the theater, for instance, we can find "*Indian Queen*. The first movement of this overture is equal to any of Handel's. There are likewise two or three trumpet tunes, well calculated for the instrument, and a rondeau at the end, which would now seem new, if played in a concert by a good band"; or "*The Double Dealer,* 1694. Overture and ten tunes. No. 6 and 9 pretty and curious" (II, 389). Attempting to preserve Purcell's works against the charge of tastelessness, Burney salts them with plentiful opinions.

Whatever we think of the quality of this criticism, it reflects a deliberate strategy. By attending not only to the music but to the play of his own consciousness around it, Burney hopes to give his audience a sense of the excitement that Purcell still has power to convey. One tasteful eighteenth-century hearer, at least, has not stopped responding to the *Indian Queen*. The terms of such criticism, aimed more at vitality and enthusiasm than at cold analysis, tend to be drawn from a vocabulary—"agreeable," "elegant," "sweet"—adapted to taste at large rather than suited specifically to music.[89] Burney wishes to persuade the public, not merely the musical connoisseur, that anyone can and should be excited by the best of Purcell. He stands for the reader; his own quick, feeling responses cast him as entrepreneur and intermediary for the taste of a whole audience.

Thus Burney's detailed review of Purcell's *Te Deum* quite unashamedly strives to whip up an appetite for a work then regarded "as an antique curiosity, even in the country" (II, 388). Readers are both browbeaten and coaxed. "In the verse, 'for the Lord is gracious,' Purcell has displayed his uncommon powers of expression, particularly at 'his mercy is everlasting,' which seems to me

[88] Hawkins, *History of Music,* pp. 743-59.
[89] Cf. Avison on Handel, chapter eight, section four above.

exquisite composition. The *Gloria Patri, alla Palestrina*, but more animated, perhaps, than any movement that Palestrina was ever allowed to compose, is full of such science and contrivance, as musicians can alone properly estimate; but the general effect of the whole is so glorious and sublime, as must charm into rapture the most ignorant, as well as the most learned hearer" (II, 388). If precise description is what one requires from criticism, such a passage will seem too easy, and perhaps also vulgar if not disgusting; but the reader who asks of criticism only that it relish works and point to their beauties will not find Burney stingy in bestowing his affections. The *History of Music* exhibits its tastes at every opportunity, and shines with the kind of egotism that makes it impossible to remain indifferent. Purcell has never had a more animated, or a busier, advocate.

There is one fault, however, from which criticism like Burney's is rarely quite free: condescension. Burney patronizes his readers by telling them explicitly what music is good for them and what they, though ignorant, ought to like. Moreover, he patronizes composers. By identifying his own tastes with those of the widest conceivable international audience, and by applying his standards without embarrassment or hesitation, he assumes a privileged position; his tastes are more sophisticated than any particular musician, restricted to a given moment and place in history, could ever match. We have seen him apologize for the narrowness of J. S. Bach, and he similarly excuses Purcell. "If Purcell, by travelling, or by *living longer* at home, had heard the great instrumental performers, as well as great singers, that arrived in this country after his decease, and had had such to compose for, his productions would have been more regular, elegant, and graceful. . . . But Purcell, like his successor, Arne, and others who have composed for the playhouse, had always an inferior band to the Italian opera composers, as well as inferior singers, and an inferior audience, to write for" (II, 403).[90] From this sort of apology no one seems to emerge superior except Burney himself.

The ultimate expression of such an attitude, and presumably its cause, is Burney's view of history. Again and again he seems to perch upon a vantage point from which all the music of the past

[90] Burney may here be expressing some of his own frustration at his experiences in the playhouse, both as Arne's apprentice (1744-1748) and afterwards as composer.

is discerned stretched out below in various stages of aspiration. Securely ensconced in his own high time in history, Burney can consign whole ages to the depths of oblivion. Even his praise ordinarily contains a hint of condescension; he can think of no better favor to a work than to pronounce it worthy of a modern connoisseur. "If ever it could with truth be said of a composer, that he had *devancé son siècle,* Purcell is entitled to that praise; as there are movements in many of his works which a century has not injured" (II, 392). The purpose of studying history often seems to be mere confirmation of present wisdom, or at best a sort of recruiting of past composers into the ranks of contemporaries. "The superior genius of Purcell can be fairly estimated only by those who make themselves acquainted with the state of Music previous to the time in which he flourished; compared with which, his productions for the Church, if not more learned, will be found infinitely more varied and expressive; and his secular compositions appear to have descended from another more happy region, with which neither his predecessors nor cotemporaries had any communication" (II, 385).[91]

The crux of the passage is that "happy region." Does Burney mean something like "genius" or "inspiration," or does he mean "an age musically enlightened like our own"? One had better not answer such a question too quickly. Burney respects genius, but he also feels himself to be in full communication with the happy region of modern times. And the genius of Purcell, his superiority to his contemporaries, seems precisely equivalent to the superiority achieved by Burney, his age, and his audience.

If we like, we can sum up this view of history, as well as our discomfort with it, by declaring that Burney subscribes unequivocally to the idea of progress. As such summaries go, this is not inaccurate. Yet it does not tell us very much. In the eighteenth century, as Bury[92] and others have demonstrated, to have a sense of history and to have an idea of progress tended to be one and the same.[93] Johnson and Hawkins, those historical conservatives,

[91] Burney had learned of Purcell's powerful effect on contemporaries from his own father, who remembered the composer very well (*History,* II, 383).

[92] J. B. Bury, *The Idea of Progress: An Inquiry into its Growth and Origin* (New York, 1932).

[93] The classic statement of progressive history is Condorcet's *Outlines of a Historical View of the Progress of the Human Mind* (1795).

cherished their own ideas of progress just as surely as Horace Walpole and Burney clung to theirs. We need to be more precise.

6. BURNEY'S IDEA OF PROGRESS

Of all the aesthetic doctrines popularized in the century that witnessed the birth of aesthetics, none has been answered with more violent rebuttal in our own century than the notion that the arts progress.[94] The reason for the violence is obvious: the idea of artistic progress is still very much alive. Indeed, to many critics, especially to those interested in preserving a humanist tradition, it seems like the ultimate heresy. If we accept artistic progress we must also accept artistic obsolescence; and the arts themselves, instead of serving as a permanent record of human values which are not susceptible to change or improvement, are reduced to demonstrating the impermanence of any truth that cannot be proven in mathematical terms. Upon the doctrine that the arts progress, apostles of historicism have raised consequences that look like a nightmare dreamed by Irving Babbitt: a relentless succession of artistic styles justified as "improvements" by a cult of the new and the extreme;[95] a fascination with technique, especially the "experimental" and mechanical techniques suggested by an analogy with scientific progress; a subordination of the arts to some historical or cultural conception of progress, as in communism or advertising. The idea of progress in the arts has much to answer for.

It is impossible not to feel sympathy for those humanists who deplore aesthetic progressivism, and who connect it with a decline in the quality of the arts if not in civilization. By contrast, people who believe themselves to be in possession of the truth towards which all history has been tending, or at least on the side of history, often seem to be narrow, fashionable, dogmatic, and even dangerous. In ridding the world of such chronocentrism, music history appears to be a good place to start. Considerations like these

[94] A typical anti-progressive polemic is Wyndham Lewis's *The Demon of Progress in the Arts* (London, 1954); a typical progressive polemic is André Hodeir's *Since Debussy: A View of Contemporary Music*, tr. Noel Busch (New York, 1961). Perhaps a sufficient aura of contemporaneity and controversy may be summoned in this context merely by mentioning the name of H. M. McLuhan.

[95] On the relation of modern ideas of progress to painting, see Harold Rosenberg, *The Tradition of the New* (New York, 1959).

evidently lie behind the preface which W. D. Allen recently added to his influential *Philosophies of Music History*. "The task before us is more difficult than ever; not only are Western music and civilization threatened, but all life on this planet is involved. In this atomic age all of us need to push aside our parochial barriers."[96]

Moreover (to shrink our horizons radically), just such a parochialism seems to be exemplified by the theme of progress that runs through Burney's *History of Music*. Confronted by Burney's facile use of "barbarous" and "Gothic" to condemn most earlier music, Professor Allen quite naturally concludes that he "voiced the dogma of eighteenth-century taste,"[97] that his sense of history runs in narrow channels. "As for Burney, he was trained to regard the harmony instruction founded by Rameau in the shadow of French absolutism as an infallible guide to the evaluation of the music of the past. And as a critic who loved 'grace and elegance, symmetry, order and naturalness,' he was thoroughly representative of eighteenth-century taste."[98] Here as elsewhere, Burney seems a perfect instance of the smugness and the blindness to which an idea of progress in the arts may lead.

No reader of the *History of Music* will fail to see some justice in this charge. Yet we must note that what Burney remarks about the usefulness of Rameau's system for evaluating music is not so dogmatic.

> M. de la Borde says, that "Music since the revival of arts was abandoned to the ear, caprice, and conjecture of composers, and was equally in want of unerring rules in theory and practice—Rameau appeared, and chaos was no more. He was at once Descartes and Newton, having been of as much use to Music as both those great men to philosophy." But were Corelli, Geminiani, Handel, Bach, the Scarlattis, Leo, Caldara, Durante, Jomelli, Perez, &c. such incorrect harmonists as to merit annihilation because they never heard of Rameau or his system? Indeed, it may be further asked, what good Music has been composed, even in France, in consequence of Rameau giving a new name to the base of a common chord, or chord of the seventh? (II, 969)

96 *Philosophies of Music History* (New York, 1962), p. ix.
97 *Ibid.*, p. 79. 98 *Ibid.*, p. 81.

Whatever patriotic prejudice may have inspired these questions,[99] whatever temporal provinciality may be revealed in the list of harmonists, Burney can hardly be accused of having mistaken the possession of a system for the ability to compose good music. He knows that no idea of progress, however enlightened, can nullify the musical achievements that have gone before.

Indeed, the *History of Music* seems built upon a paradox. Better than any other work of its time, it presents both the view that the moderns own "an infallible guide to the evaluation of the music of the past," and the view that no one man or period or style or system has a monopoly on musical taste and virtue. On the one hand, "So various are musical styles, that it requires not only extensive knowledge, and long experience, but a liberal, enlarged, and candid mind, to discriminate and allow to each its due praise: *Nullius addictus jurare in verba magistri*. A critic should have none of the contractions and narrow partialities of such as can see but a small angle of the art" (II, 8). On the other hand, many ages have no other interest than to set off the superiority of the modern: "Many specimens of melody and harmony are given, not as models of perfection, but reliques of barbarism, and indisputable vouchers that mankind was delighted with bad Music, before good had been heard; and I have spoken of some musicians whose fame is now so much faded, that it is perhaps the last time they will ever be mentioned" (II, 1025).

This paradox does not depend upon seeming contradictions which could be resolved by a better formulation; it is intrinsic, not merely verbal. Burney's comments on Elizabethan music, for instance, exquisitely balance admiration and repugnance, historical perspective and fashionable condescension. From one sentence to the next we cannot be sure whether Burney will be examining works in the terms of their age or whether he will be rebuking their "barbarity." His discussion of vocal music is cavalier. He reproaches the solo songs of Dowland for want of melody and design, and for offensive harmonies (II, 117); and then a few pages later entirely forgets that the Elizabethans wrote solo songs.

[99] As a supporter of Rousseau, whose ballad opera *Le Devin du Village* he had adapted for the English stage as *The Cunning Man* (1766), Burney also had cause to oppose the followers of Rameau. M. de la Borde had been a scornful critic of Rousseau's *Lettre sur la musique française*, which Burney translated and greatly admired.

Worse yet, he accuses them of having no art of singing, since their songs of many parts "are founded upon *democratic* principles, which admit of no sovereignty"[100] and therefore no refinement. What he grants with one hand he takes away with another. "It does not, however, appear just and fair to slight old compositions, though a totally different style at present prevails. *History* does not imply *constant perfection*: the vices, follies, and even caprice of Princes, as well as of mankind in general, constitute as necessary a part of their annals as their virtues" (II, 124). Are we being asked, by way of "justice" to the Elizabethans, to bear with their vices and follies? From the continuation we might conclude otherwise, in spite of the intrusion of that dangerous word "Gothic." "The fugues and canons of the sixteenth century, like the Gothic buildings in which they were sung, have a gravity and grandeur peculiarly suited to the purpose of their construction" (II, 124). This shows a willingness to enter a historical past;[101] yet a further defense of fugues offers the kind of explanation that merely snubs the past: "Indeed, while there was little melody, less rhythm, and a timid modulation, Music could not support itself without fugue" (II, 124). Burney preaches the necessity for historical relativism, but he constantly betrays the most blatant confidence in the superiority of the present.

Indeed, nothing describes the experience of reading the *History of Music* so well as the alternation, at times even the coincidence, of dogma with flexibility, of the absolute and the relative. At one moment Burney impresses with the generosity and enthusiasm of his response; at the next, with the hardness and superciliousness of his limitations. We stroll through a flowered gateway, and come up against a wall of ice. The greatest of English historians of music seems also the most faithful to the prejudices of his own age.

How are we to explain this paradox? At least three kinds of answer are, I think, plausible. The first would indicate simply

[100] II, 123. During the period just before Burney saw this notorious sentence through the press in 1787, much of his life revolved around the king (see Lonsdale, *Dr. Charles Burney*, chapter VII). In music as in politics George III preferred "sovereignty"; i.e., a clear melody without competing parts.

[101] Avison had used the same comparison of fugues and Gothic buildings in order to declare the utter superiority of modern music and modern architecture; *Essay on Musical Expression* (London, 1753), pp. 46-47.

that ideas of progress were too deeply ingrained in contemporary thought for any historian to be immune. Burney's self-conscious efforts to abstain from the quarrel between ancients and moderns could not withstand the pressure upon him to choose. "Though the quarrel of the ancients and the moderns subsumes an underlying quarrel about whether there has been progress in the arts or not, music critics in eighteenth-century England made no references specifically to the idea of progress. When they used the word 'progress,' as Dr. John Brown did and as Charles Avison did, the meaning was similar to that of 'history' or 'chronology.' But progress as fact was everywhere either implied or questioned. The very supercilious attitude of the age towards all past ages was built upon a feeling of superiority, real or feigned, upon a feeling that culture had gone forward."[102] The split in the *History of Music* between historical relativism and a belief in progress reflects a cultural conditioning. Even Hawkins, who had chosen the other side of the ancient-modern quarrel, did not deny that music had progressed as a *science*, though its practice had been temporarily corrupted. "Ebenso wie bei Burney steht Hawkins' Geschichte unter einem einheitlichen Gesichtspunkt, dem des unendlichen Fortschritts. Er hat auch wie Burney ein Bewusstsein historischer Entwicklung."[103] In exhibiting the conflict of the idea of progress with his own more generous critical instincts, Burney was being a man of his time.

A second kind of answer to the paradox would reassert that the development of an idea of progress and the growth of a sense of history are not opposite but complementary. In spite of the shallow dialectical arguments it encouraged, the quarrel between ancients and moderns prepared the way for a more serious historiography.[104] The perception of historical differences, the fundamental recognition that other ages have a life or spirit that is not our own, seems a necessary preliminary to the study of historical change. Burney's work provides an especially fine example

[102] H. M. Schueller, "The Quarrel of the Ancients and the Moderns," *Music & Letters*, XLI (1960) 324-25.

[103] Elisabeth Hegar, *Die Anfänge der neueren Musikgeschichtsschreibung um 1770 bei Gerbert, Burney und Hawkins* (Strassburg, 1932), p. 59.

[104] This process is a major theme of Peter Gay's *The Enlightenment: An Interpretation* (New York, 1967), and the role of historiography in achieving a neoclassical synthesis is stressed by J. W. Johnson, *The Formation of English Neo-Classical Thought* (Princeton, 1967), chapter II.

of the movement from progressivism to history. He came to the *History of Music* expecting to trace "a regular right line" leading to the triumph of the modern; he came away from it half persuaded that no such line could be found, and that the most we can ask is to be free of rules and prescriptions. To his first thought that a *complete theory* of music might be built upon the system of Rameau, he added a significant note: "Many opinions concerning melody, taste, and even harmony, which were current forty or fifty years ago, would now only excite contempt and laughter. IMAGINATION, which had been manacled by narrow rules, formed on Gothic productions, at length broke loose and liberated, flutters and flies about from flower to flower, sipping like the bee its native food wherever it can be found" (II, 969n.). Our paradox is here—it is impossible to tell whether Burney is proclaiming the superiority of modern theory, or the irrelevance of any theory at all to good music. Yet the notion of progress itself has been loosened and liberated from theory, and begun to dwell on the imagination, and the uneven motions of history.

The *History of Music*, then, recapitulates the process by which historical thought came into being. From an idea of progress, one need take only a step to form an idea of development, an idea of evolution. Authors like Vossius and Hawkins, for whom music exists antichronously in an eternal present, avoid the fallacies of progress only at the cost of failing to perceive change. Again and again Burney discovers the reality of the past. Something jars upon his well-tuned ears; he rebukes it, points out its faults, examines it, worries it, and sometimes, if all goes well, decides at last that it obeys principles of its own.[105] The irritation that we sense in such cases is the same irritability that is a characteristic of life, a readiness to react even in advance of understanding. The idea of progress, by provoking such irritation in Burney, also helped alert him to history. Whether or not his sense of history recognized the evolution as well as the progress of musical styles through time—*Entwicklung* as well as *Fortschritt*—he was capable of distinguishing and appreciating an unprecedented variety of music.

A third kind of answer would go still further in defense of Burney, and test the validity of our own discomfort with progress.

[105] See, for instance, his remarks on Josquin, I, 735-53.

When modern critics deny that the arts progress at all, or that the very conception is meaningful in terms of aesthetics, they often contradict their own instinctive judgment. Consider, for instance, the problems raised by Donald Grout's moderate and reasonable criticism of progressive historians:

> it is easy to fall into the error of viewing the late seventeenth-century composers merely as the forerunners of Bach and Handel, and the mid-eighteenth century composers merely as the forerunners of Gluck, Haydn, and Mozart. . . . The fallacy of this "mere forerunner" conception is undoubtedly due to a confused notion that progress occurs when old things are superseded by new; we are prone to imagine that in the same way that the automobile superseded the horse and buggy, the symphonies of Mozart superseded those of Stamitz. To deny this is not to deny that Mozart was a greater composer than Stamitz, but only to assert that the idea of progress is not necessarily relevant in comparing the two.[106]

The choice of example here is admirably fair, because it makes Grout's case so hard. If Mozart's symphonies are not to be viewed as a progress over those of Johann Stamitz, nor Stamitz viewed as a forerunner of Mozart, we had better dismiss the idea of progress in the arts entirely. Yet it is not clear just why progress should be irrelevant in comparing the two. Perhaps Mozart did not drive Stamitz out of circulation in precisely "the same way" as the automobile drove the buggy off the roads, but the analogy makes as much sense as analogies usually do. Mozart took over Stamitz' technique, his chance for popularity, and his place in the history books. (Grout himself, incidentally, speaks of Stamitz' revisions of the symphony as "premonitions of later forms.")[107] Unless we recapture an innocence of any history at all, the idea of progress seems to account very well for what happened.

The argument hinges upon the terms in which art is considered. If we think of music as a revelation of the spirit of the composer, or as the embodiment of a universal form, the idea of progress seems absurd. As soon as we examine the technical side of music, however, the sense in which music is the art of combining sounds

[106] *A History of Western Music* (New York, 1960), p. 416.
[107] *Ibid.*, p. 424.

to affect an audience, progress becomes plausible. The work of
E. H. Gombrich, especially his masterful *Art and Illusion*, suggests
that the progress (not merely the change) of means of representa-
tion in painting may be a useful model of the history of art. Some
of us may sympathize with the perverse and anti-progressive view
that might prefer a young girl's copy of a Constable landscape to
the sophisticated original[108]—the taste for primitivism is of
course another reputable inheritance from eighteenth-century
critics[109]—but no one who has studied the development of tech-
niques of representation will deny that in some sense Constable
"improved" the art of painting. Without perceiving such con-
tributions to progress, we cannot do justice to progressive artists.

Similarly, Burney's comments on the symphonies of Stamitz are,
for all their espousal of the idea of progress and the "mere fore-
runner fallacy," essentially sympathetic and just.

> Though these symphonies seemed at first to be little more than
> an improvement of the opera overtures of Jomelli, yet, by the
> fire and genius of Stamitz, they were exalted into a new species
> of composition, at which there was an outcry, as usual, against
> innovation, by those who wish to keep Music stationary. The
> late Mr. Avison attributed the corruption and decay of Music
> to the torrent of modern symphonies with which we were over-
> whelmed from foreign countries. But though I can readily sub-
> scribe to many of the opinions of that ingenious writer, we differ
> so widely on this subject, that it has long seemed to me as if the
> variety, taste, spirit, and new effects produced by contrast and
> the use of *crescendo* and *diminuendo* in these symphonies, had
> been of more service to instrumental Music in a few years, than
> all the dull and servile imitations of Corelli, Geminiani, and
> Handel, had been in half a century. (II, 945)[110]

These remarks are opinionated, fashionable, contentious, and
supercilious. It is clear that no modern historian would so egre-
giously impose his idea of progress upon history. Is it so clear,

[108] *Art and Illusion* (New York, 1961), pp. 292ff.

[109] Lois Whitney, *Primitivism and the Idea of Progress in English Popular
Literature of the Eighteenth Century* (Baltimore, 1934).

[110] Cf. *Tours*, II, 34-36, 134, where Burney compares Stamitz with Shakespeare.
On Stamitz, see Peter Gradenwitz, *Johann Stamitz* (Prague, 1936).

however, that Burney was not right? Or that anyone has made a better case for Stamitz?

The idea of progress, in short, accounts for Burney's perceptions about history as well as his mistakes, his best criticism as well as his worst. The *History of Music* is based upon an interpretation of history so narrow and categorical that it provides radical insights as well as gratuitous blunders. We learn from Burney sometimes by participating in the strengths of his special point of view, sometimes by being provoked and infuriated into rebuttal. In any case, our own troubled reactions should warn us that we put Burney's idea of progress on trial partly because we do not quite trust our own ideas of history.

Nevertheless, the historical uncertainties of the *History of Music* are not figments of our imagination. Burney knew that his knowledge was limited and that his authority could be questioned; he was grateful that not all his audience could be so informed and demanding as his friend Twining.[111] Moreover, he was all too aware that some of his insecurity showed. In its mingling of historical dogma with historical relativism, the *History of Music* gives evidence of having evaded its author's full control. Like its historical point of view, its structure and its criticism achieve at best a perilous balance. The idea of progress did not provide Burney with a rounded and coherent view of history; it was merely the best that he had. To compose his *History* at all, he was forced to settle for half-truths, for tastes not organically related to each other, for an organization that often threatened to fall into pieces. The paradoxical mixtures so characteristic of Burney are only one sign of the strain of writing a *History* which resisted all his attempts to unify it.

7. THE ORGANIZATION OF THE *History*

Of all the strangenesses in the proportions of the *History of Music*, none seems quite so strange as the length of Chapter VI, Book IV, "Origin of the Italian Opera in England, and its Progress there during the present Century." This chapter, over 300 pages, occupies nearly one-half of Burney's vital last volume, or more than one-eighth of the *History* as a whole It is almost one hundred

111 See Lonsdale, *Dr. Charles Burney*, chapter IV, section iv.

times as long as Chapter IX, "Opera Composers employed at Rome, and Tracts published in Italy on the Theory and Practice of Music, during the present Century," although "Rome is regarded as the post of honour for musicians" (II, 937). By any discernible rule of relevance, Chapter VI is absurdly outsize.

As it happens, Burney's violation of proportion here can be fully explained by an urgent personal necessity. "When he came to write his chapter on the rise and progress of Italian opera in England during the eighteenth century, his gratitude for the King's generosity in permitting him to use the Handel Manuscripts in the Royal Collection obliged him to deal with that composer's theatrical works at enormous length. Earlier threats about the uncensored criticism of Handel which would appear in the *History* were now forgotten and his lengthy and detailed discussion of the operas was obviously written primarily for the delectation of the King; for once Burney hardly cared about his general readers."[112] For the sake of royal approval, Burney was willing to allow the appearance of a flaw in construction. We do not need to resort to theory in order to understand this particular unsightly bulge in the *History of Music*.

Yet the form of Chapter VI, if not its motivation, remains disturbing. Given that Burney felt impelled to devote inordinate space to Italian opera in England, he might at least have tried to justify its inclusion by taking a unified view of it, or by relating it to the rest of his *History*. His closest approach to such a view comes only at the end of the chapter: "as the OPERA includes every species of Music, vocal and instrumental, its annals, if faithfully and amply recorded, seem nearly to comprise the whole history of the art. . . . Indeed, the opera is not only the union of every excellence in the art of Music, but in every other art" (II, 903-4). But this argument is specious. It depends on the words "annals" and "amply," and they do not at all mean "history" and "significantly." Burney cannot seriously believe that a detailed and circumstantial description of many operatic productions will comprise a history of music. Nor does he pretend to discern such a history, or any such union of the arts. Chapter VI is frankly a chronicle, a diary of successive London opera seasons. Burney did not scruple to break his *History* into pieces.

[112] *Ibid.*, p. 337.

This piecemeal approach is strikingly exemplified by Burney's lengthy and particular descriptions of the Italian operas of Handel. Without any general discussion, he moves through the score of each opera more or less in the spirit of a genial periodical reviewer.[113] He records the production history of *Sosarmes*, for instance, and then reviews its parts in turn. The separate movements of the overture, and each recitative, air, and ensemble receive flattering notice. Burney finds something good to say about everything: "The next air, for Bertolli: *Si, minaccia*, is as good as generally comes to the share of a subaltern singer of bounded abilities, and has, moreover, the merit of facility and a sprightly accompaniment" (II, 773). The conclusion furnishes the only hint of a comprehensive estimate. "Though Sosarmes contains fewer great airs in an elaborate style of composition than several of Handel's more early operas, yet it may be ranked amongst his most pleasing theatrical productions" (II, 775). With the same deliberation, moment by moment, piece by piece, Burney moves through a century of operas.

To a modern reader this endless procession will inevitably appear mechanical and tedious. Burney seems to regard an opera as so many musical beads on a string. Seldom if ever does he talk of dramatic form, or the relationship of scenes to each other, or the suitability of the musical style to the action. He acknowledges the usefulness of variety and contrast for keeping an audience awake, but his sense of structure hardly takes in more. As the acquaintance and future biographer (1796) of Metastasio,[114] who was supposed to have effected a final union of music and drama, Burney knows that opera should wed its airs to appropriate sentiments and good sense. Yet in practice, while he may praise the pathos of words and music alike, or debate the suitability of a given language for expressing a given thought in music,[115] he seems almost incapable of judging a work as a whole. We learn a

[113] On the critical methods of eighteenth-century writers on music, see R. M. Myers, *Handel's Messiah: A Touchstone of Taste* (New York, 1948).

[114] *Memoirs of the Life and Writings of the Abate Metastasio* (London, 1796). When asked to choose who he would have preferred to be if not himself, Burney named Metastasio (*Thraliana*, I, 377); he also knew and admired Gluck, another great exponent of the union of words and music.

[115] A Rousseauesque "Essay on the Euphony or Sweetness of Languages and their Fitness for Music" prefaces the fourth book of the *History* (II, 497-505).

great deal about Handel's skill in composing arias, but virtually nothing about his ability to make operas.

The theoretical justification for this critical partiality is supplied by Burney in his "Essay on Musical Criticism."

> It is not unusual for disputants, in all the arts, to reason without principles; but this, I believe, happens more frequently in musical debates than any other. By principles, I mean the having a clear and precise idea of the constituent parts of a good composition, and of the principal excellencies of perfect execution. And it seems, as if the merit of musical productions, both as to composition and performance, might be estimated according to De Piles' steel-yard, or test of merit among painters. If a complete musical composition of different movements were analysied, it would perhaps be found to consist of some of the following ingredients: melody, harmony, modulation, invention, grandeur, fire, pathos, taste, grace, and expression. . . . In this manner, a composition, by a kind of chemical process, may be decompounded as well as any other production of art or nature. (II, 8)

Such a recipe for criticism perfectly embodies "the persistent inorganic view of art in the eighteenth century."[116] Since 1800 critics have not been able to speak about music so disjunctively. We know that there is no method of decompounding the living productions of art or nature that does not involve killing them; and we know that in art the sum of the parts does not equal the whole. Even Jonathan Richardson,[117] following De Piles, needed a special category, grace and greatness, to circumvent or overmaster the mere ritualistic naming of parts. The metaphor which identifies the process of musical composition with the growth of living organisms and living feelings is so deeply ingrained in most of us that we can scarcely think of it as a metaphor. To violate the integrity of a work of art, in our criticism as in the novels of

[116] Monk, *The Sublime: A Study in Critical Theories in XVIII Century England* (Ann Arbor, Mich., 1960), p. 186. Cf. chapter seven, section seven above.

[117] According to Malone, Burney had frequently conversed with Jonathan Richardson (Burney arrived in London in 1744, a year before the death of the elder Richardson), and was subjected by him to a ceaseless stream of anecdotes. "Maloniana," in Sir James Prior's *Life of Edmond Malone* (London, 1860), p. 403.

Henry James, attests a sin equivalent to violating the integrity of a human being, and therefore the ultimate moral and critical transgression.

Burney's failure to criticize music in organic terms is especially fascinating because he was so close to the composers who were developing the new organic forms, and was so quick to appreciate them. Even as he wrote the *History of Music*, C. P. E. Bach and Haydn and Mozart were participating in the most famous of all changes in musical structure, the enrichment of sonata form and the symphony. Perhaps the cardinal tenet of this development is that each musical form, no matter how diverse its elements, must possess an underlying unity. According to a commentator on C. P. E. Bach, his keyboard music demonstrates "the simple fact that relationship is only possible on the basis of a comprehensive unity expressed in relationship, and that unity is a universal at once upholding and vanquishing the antagonism of subject and object."[118] Even if we are hesitant to accept the metaphysical adjuncts to sonata form (such as the popular argument that it adumbrates Hegelian dialectic in a thesis, antithesis, and synthesis of musical ideas), we are likely to find something profoundly offensive about the thought of playing *part* of a classical symphony. The movements of a symphony by Mozart or Beethoven or Schubert or Bruckner are organized, we know, in a meaningful sequence, interrelated by thematic material and by emotional or psychological coherence, and fully realized and intelligible only when the last note has sounded and we grasp the whole.

Burney, it seems, did not know so much, nor did he look for "that mysterious unity which is the compelling force behind the greatest music."[119] When the *History of Music* defends the new and difficult kinds of symphony and quartet being written by the admirable Haydn, it does not emphasize their coherence. "There is a general chearfulness and good humour in Haydn's allegros, which exhilerate every hearer. But his adagios are often so sublime in ideas and the harmony in which they are clad, that though played by inarticulate instruments, they have a more pathetic effect on my feelings, than the finest opera air united with

[118] Philip Barford, *The Keyboard Music of C. P. E. Bach* (London, 1965), p. 82.
[119] From a review of Rudolph Reti's *The Thematic Process in Music* (London, 1961) in *TLS*, LX (1961), 460.

the most exquisite poetry. He has likewise movements that are sportive, *folatres,* and even grotesque, for the sake of variety; but they are only the *entre-mets,* or rather *intermezzi,* between the serious work of his other movements" (II, 960). The analysis is performed piece by piece. Similarly, though Burney marvels at the ability by which the instrumental *Seven Last Words* maintains variety through seven slow movements, he does not speak of the formal concomitants, the unity or momentum, of such a succession. When he reports that critics have objected to Haydn's mixture of serious and comic, he fails to argue (on a Johnsonian parallel) that the mixture produces a more generally pleasing effect, or a harmonious whole; he merely comments that such critics have learned better.[120] If Burney understood that his age was engaged in a historic shift towards organic forms of musical organization, he was able to keep remarkably silent about it.

The very compartmentalization of criticism in the *History of Music* marks, however, a corresponding strength. As M. H. Abrams points out, the organic metaphor originates problems of its own. "To substitute the concept of growth for the operation of mechanism in the psychology of invention, seems merely to exchange one kind of determinism for another; while to replace the mental artisan-planner by the concept of organic self-generation makes it difficult, analogically, to justify the participation of consciousness in the creative process."[121] In contrast, Burney's mechanical distinctions render him sensitive to the composer's conscious shaping of materials for a specific end. He has no trouble in dealing with Handel's accommodation of his works to the desires of a particular audience, or to the limitations of a particular singer. He understands very well the rhetoric of music by which small causes produce distinct effects.[122] And however inorganic his principles, he delights in the new music and the new forms.

Burney's criticism, in fact, tends to be perceptive just where a more ambitious criticism might be weak. The ability to distinguish and to separate artistic virtues of different kinds, especially those kinds with no pretensions to grandeur or unity, may easily de-

120 *History,* II, 959. Burney's informant on criticism of Haydn was C. D. Ebeling.
121 M. H. Abrams, *The Mirror and the Lamp* (New York, 1953), p. 173.
122 On the restriction of contemporary theory to small forms, see L. G. Ratner, "Eighteenth-Century Theories of Musical Period Structure, *Musical Quarterly,* XLII (1956), 439-54.

teriorate when every work of art is obliged to embody a complete and self-contained way of life. Modern critics are often better equipped to deal with Wagner than with Handel, with the unity of a Bach suite than with its diversity. Yet those works of art whose excellence resides in the part rather than the whole, works as disparate as the Mozart Divertimento and the Marx brothers' film, stand to benefit from piecemeal criticism. If the *History of Music* is too mechanical in its vocabulary and perspective to predict the musical forms of the future, it copes neatly and decisively with the music it knows.

Moreover, the structure of the *History of Music*, for all its lack of unity and proportion, does not impose a false pattern on the sequence of events. At first, to be sure, Burney had intended to organize his work along rational and analytical lines.[123] He constructed the opening "Dissertation on the Music of the Ancients" in ten sections which discuss discrete subjects (notation, genera, modes, etc.) in artificial isolation. In later chapters, he considered the music of each European nation separately, and also divorced instrumental music from vocal. Yet while Burney goes to some trouble to preserve the appearance of a rational order, he follows no consistent plan. Many chapters whose titles seem to indicate a clear and precise intention ("Of the Invention of Counterpoint, and State of Music, from the Time of Guido, to the Formation of the Time-table") prove on inspection to be assemblages of notes brought haphazardly together, without a controlling argument or sometimes even an intelligible sequence. Burney will gladly interrupt his line of thought for a poem, an anecdote, or an opinion. The *History of Music* displays an alertness, a capacity for diversion, that is not commensurable with a rigid ordering scheme.

The center of Burney's *History*, as well as the test of its method, is its biographies of eminent composers. With the example of the *Lives of the Poets* before him, Burney exerts all his abilities to enshrine musicians in a similar hall of fame. "Palestrina, the Homer of the most *Ancient Music* that has been preserved, merits all the reverence and attention which it is in a musical historian's

123 *History*, I, 20. Proposals for printing the *History* in two quarto volumes were originally announced in the Italian *Tour* (1773). At that point Burney hoped to finish his work by the following year, rather than the sixteen years that he eventually required.

power to bestow" (II, 163). The hand of Johnson lies upon these biographies.[124] Burney borrows the program of many of the *Lives*: a brief summary of the artist's reputation; a survey of his career; a critical inventory of his works; and finally an estimate of his genius and his contribution to his art. Moreover, as in Johnson, each major biography contains materials for an essay on some topic of general interest.

The practical implications of Burney's biographical method may be placed in sharp relief by comparing his Life of Palestrina with Hawkins'. Hawkins' *History of Music* follows as always the trail of the documents; much of it debates the vexed question of the name of Palestrina's master.[125] Burney will have none of this argument: "Indeed the fact is not of sufficient importance to merit a long discussion; I shall therefore leave it as I found it" (II, 154). Similarly, Burney refuses to compete with Hawkins in citing praise from the authorities. Both historians disavow the intention in almost the same words—"To enumerate the testimonies of authors in favour of Palestrina would be an endless task" (Hawkins);[126] "It would be endless to transcribe all the eulogiums that have been bestowed upon Palestrina" (Burney, II, 156)— but Hawkins enumerates as many testimonies as he can, and Burney merely complains that none but musical writers ever mention musicians.

The main difference between the two accounts, however, is procedural. Hawkins follows strict chronology. Though his adjudication of documents sometimes leads him to digress, and though he ends with a catalogue of Palestrina's works, he moves in a straight line from birth to death. Burney, on the other hand, divides his biography into three sections: life, works, and criticism. To Hawkins' facts he adds not only felicity of style, but a principle of order. However simple, that principle enjoys one great advantage: it can interest a common reader by persuading him that he has moved from chronology to interpretation, from information to understanding.

The same ability to interest a reader informs all Burney's work.

124 E. D. Mackerness, "Dr. Burney, Biographer," *Contemporary Review*, CLXXXIX (1956), 352-57, discusses the influence of Johnson on Burney's biographical contributions to Rees's *Cyclopaedia*.
125 Hawkins' *History of Music*, pp. 420-21.
126 *Ibid.*, p. 429.

Rather than stop at recording the many editions of Palestrina, he shrewdly points to their significance: "Nothing more interesting remains to be related of Palestrina, than that most of his admirable productions still subsist" (II, 161). Burney climaxes his Life by providing the reader with a metaphor that may help him to approach Palestrina sympathetically. "Preaching upon a text has been called a Gothic contrivance; and yet what admirable lessons of piety and virtue have been produced under the denomination of Sermons! . . . the hearer who receives no pleasure from ingenious contrivance and complicated harmony is but a superficial judge" (II, 161-2). He concludes by reassuring the reader of his importance: "It is hoped that no apology will be necessary for the length of this article, which 'the reader can make as short as he pleases' " (II, 162-3). The Life of Palestrina acquires its order through an artful selection of details that will please a whole modern audience.

As a mode of organization, Burney's attention to his readers suffers from a grave drawback: the course of the *History* is dictated by outside forces. In the part as in the whole, its apparent order is often illusory. Thus the Life of Palestrina follows a track laid down by Hawkins' Life, by previous criticism,[127] and by the expectations of its first readers. The account of Handel's operas, we have seen, was written to satisfy only one reader, the king. Burney lacks full authority over his work, and all his borrowings from Johnson only emphasize the difference between an order imposed by the mind and the expedients of a flexible entertainer.

Nevertheless, Burney's many compromises do arrange a *History* whose organization avoids extremes: both the relative dogma of John Brown's music history,[128] and the relative chaos of Hawkins'. He knows the arts and wiles of the diplomat. Neither the Ancients nor the Moderns are allowed to claim Palestrina as an example of their theories. "My wish is to resolve the discords of contention, to augment the pleasure of both parties, and extend the compass of their views; that, like the Music composed *a due cori*, the friends of harmony and melody may *agree*, though performing

[127] The guiding spirit behind Burney's opinions is Padre Martini; see especially Burney's notes, II, 162.

[128] On Brown's theory of history, see H. M. Flasdieck, *John Brown (1715-1766) und seine Dissertation on Poetry and Music* (Halle, 1924).

different parts, at a distance from each other" (II, 162). The *History* reconciles ancient and modern, expert and novice, scholar and connoisseur. It satisfies the needs of the moment; it makes an order not so much rational as reasonable. Faced with divergent paths, Burney finds a middle way.

8. BURNEY AND THE AUDIENCE OF THE FUTURE

The legacy of Burney's *History of Music* to the future, then, was not the rule of taste but innumerable small acts of taste. He had learned, as we have learned, that the chaos of music history could not be healed through the application of a rigorous and rational method. No formula could account for the various excellences of past music. However pleasant it would have been to believe that "In the rationalistic historiography of the eighteenth century, . . . the historical presentation of the development of an art needed simply to show its progress toward an inherent rational norm,"[129] he had come too far along the road of history to trust any longer in a rational aesthetic divorced from time. The experience of listening to music through a lifetime conferred an authority on criticism that Burney would not concede to any abstract principle. He is not, or not primarily, a rationalistic historian.

Where else, however, shall we look for the achievement of the *History of Music*? An answer that Burney must have approved is supplied by the house review, written by Twining, which appeared in the *Monthly Review* in 1789-1790. Burney not only instigated this evaluation, but corrected the proofs; and the garland of friendship is strewn across its pages. Not surprisingly, Twining finds a great deal to like, and his central theme of praise responds to Burney's own hope "to fill up, as well as I was able, a chasm in English literature" (I, 14): "To Dr. B, the praise is justly due, of having first begun to supply, in a masterly and able manner, a *vacuity* in our English literature."[130] Yet the final accolade is reserved for a quality that many historians might consider beneath them: "a certain *amenity*, which is the general character of Dr. B.'s manner of writing, and which may best be defined, as the diametrical opposite to every thing that we call *dull* and *dry*." Here once again,

[129] P. O. Naegele, *August Wilhelm Ambros: His Historical and Critical Thought* (unpublished Ph.D. dissertation, Princeton, 1954), chapter II, part 1, i.
[130] *The Monthly Review*, n.s. I (1790), 277.

reflected through the genuine friendship of Twining, we meet that charm and illusion of intimacy which made every reader desire to be Burney's friend. Once again, Burney takes his place as the most welcome guest at the intellectual dinner party of the eighteenth century.

Yet our approach to the *History of Music* had better not stop there. What Burney offers his readers goes beyond charm. He gives them the benefit of his experience, his taste, his research, and a vision of the processes and uncertainties which join in making a single sensibility and an entire society. He gives them, in other words, a community of interest whose center is himself. The illusion shared by many modern writers, that the late eighteenth century has a unified view of music and that Burney is the perfect representative of that view, is an illusion created by Burney. The *History of Music* persuaded its contemporaries, and has persuaded us, that for a brief time a single book contained all that one needed to know about music. Burney tried to be all things to all readers, and momentarily his ambition seemed to be fulfilled.

Although that success could only be temporary, we should not underestimate it. Without restricting himself to an abstract theory of music, without ignoring the complications of history, Burney had gathered a whole art into a scope that could be understood by a common reader. The *History of Music* arranges music within a single community. That sense of community, the product of Burney's charm of style as well as his scholarly labors, is a luxury that lovers of music had never known before, and will probably never know again.

Much had been left out of Burney's community. He found no room for Hawkins, and he dismissed many kinds of music as beneath attention. Aside from some comments on Scottish folk song, the *History of Music* discusses only what we should call classical music of the western world. Nor can Burney's limitations—of time, of interest, of critical insight—be wholly forgotten. The *History of Music* often skims over reputable musicians with a slapdash precipitance, as if its author must rush to keep another appointment with the king, or with the press. By letting alone the spots in the sun which are invisible to common eyes, Burney eliminates a great deal of the world of music from his range of vision.

Nevertheless, Burney's confident and genial relation to the audience he pleased created a lasting alternative to older methods of writing about music. He had balanced the dignity of the art against the enjoyment of modern devotees, and had retained equilibrium. The music histories of the next generation in England testify to the difficulty and importance of his accomplishment. Thomas Busby, who condensed the work of Hawkins and Burney to synthesize his own *General History of Music* (1819), found little to add but a review of the moderns.[131] George Hogarth's *Musical History, Biography, and Criticism* (1835) substituted a new moral earnestness that diminishes Burney's community into a society for self-improvement; he concludes his book by pointing out that music can furnish the working classes with a rewarding occupation, and by quoting Burney on the moral value of musical pastimes.[132] Works like these are smaller in size than Hawkins' or Burney's histories, and they capture no more than a fraction of Hawkins' scholarly zeal, or of Burney's wide audience.

Indeed, the eighteenth-century historians of music had wrought more conclusively than they expected. Hawkins thought that a new birth of science might cure the musical world of its lust for fads; Burney optimistically concluded his *History* by predicting, on the basis of the Handel Commemoration, "that a certain road to full perfection in every department seems to have been attained" (II, 1023). But a century would pass before their own work was bettered in England, and the lesson of that century was that no one man could any longer pretend to hold in his mind a sense of the entire art of music. The order of music that Hawkins and Burney together had fashioned—the order founded on documents, the order founded on taste—remained as convincing as any other. Later historians would insist upon viewing the development of music as an organic growth, not as a certain road to full perfection, but their choice of metaphor did not banish the eighteenth-century histories of music from their shelves.

Moreover, the accomplishment of those histories, and of Burney's *History* in particular, continued to exert its fascination over critics. A latter-day Burney like Sir Donald Tovey followed the

[131] *A General History of Music from the Earliest Times to the Present, Condensed from the Works of Hawkins and Burney*, 2 vols. (London, 1819), preface.
[132] *Musical History, Biography, and Criticism* (London, 1838), II, 275.

eighteenth century in trying to define a main stream of music,[133] and to train an audience that might appreciate it. The idea of music that captured the generations after Burney was an idea rooted in history: the vision of a whole art and a whole audience joined by enlightened scholarship. For all their uncertainties and confusions, Hawkins and Burney had replaced the chaos of previous writing about music with principles and tastes not yet exhausted by debate. The conversation about music that they began still goes on.

[133] See the title essay of *The Main Stream of Music and Other Essays* (New York, 1949), pp. 330-52.

Part Four

THE ORDERING OF
POETRY

Pope, Warburton, Spence, and the
Uses of Literary History

1

THE men who assumed the task of "regulating and correcting the public taste" in painting and music found a willing audience in eighteenth-century England. By and large the public knew that it was ignorant about those arts, and it welcomed the expertise of Reynolds and Burney to set matters right. Thanks to their efforts, painting and music had at last become conversable. But the critics and historians of poetry faced a more delicate task, and a more complicated audience. English poetry was not a matter of indifference to the English public; its historian was appointed the defender of national pride, and the custodian of the language. In one essential respect the audience for poetry differs from the audience for any other art: every literate man carries in his mind the outline of a history of poetry. Moreover, in eighteenth-century England poetry enjoyed a critical prestige and a tradition of critical discussion that no other art commanded. Critics of painting and music borrowed their definitions from "what the word likewise implies in writing," and reserved their highest praise for "the poetry of the art." The critic of poetry needed to borrow only from his predecessors, from the rich heritage that ran from Aristotle through Dryden to the present. He was embarrassed not by the poverty of received opinion but by its wealth.

Thus the eighteenth-century men of letters who set out to take a full view of English poetry spoke to an interested and demanding public. If the Dick Minims of literature drew sustenance from the stock of familiar ideas—"criticism is a goddess easy of access and forward of advance, who will meet the slow and encourage the timorous"[1]—they could not win much credit for such meager

[1] *Idler* 60, 9 June 1759, in *The Works of Samuel Johnson* (New Haven, 1963), II, 185.

labors. What the public demanded, and what it eventually received, was a history of English poetry, or a survey of English poets, that would provide a basis for criticism by reviewing the entire range of the art. Warton and Johnson responded to a national desire for an evaluation of what English poets had achieved.

Indeed, so widespread was this desire that the question of how the first history of English poetry came about is less puzzling than the question of why it was so long in coming. René Wellek has answered these questions very thoroughly—Warton wrote his *History* only when the way to literary history had been prepared for him by the rise of critical ideas and antiquarian knowledge[2]—and I have suggested that neither the system of perpetual commentary adopted by scholars like Oldys nor the philosophical arrangements adopted by critics like Harris could provide a form for literary history. Yet the ubiquitous desire for a more comprehensive view of English poetry also points to another set of questions: not only *how* literary history and biography were created, but for *whom*; not only the *nature* of literary studies, but their *purpose*. The public for the first history of English poetry was many publics, and the history it demanded served many needs.

One of those needs, of course, was patriotic. If Johnson's apothegm rings true, we shall have to acknowledge that eighteenth-century literary history was often the refuge of scoundrels.[3] A century after Eugenius had reassured Dryden's audience that "I am at all times ready to defend the honour of my country against the French, and to maintain, we are as well able to vanquish them with our pens, as our ancestors have been with their swords,"[4] English critics and poets lost no opportunity of reminding their readers that the progress of poetry had led to the shores of their native land. England expected—from Thomas Warton— a glorious national poetic pantheon.

She expected such a history not only for patriotic reasons, but

[2] As Wellek comments in his preface to the paperback edition of *The Rise of English Literary History* (New York, 1966), p. iv, "the main thesis—the confluence of antiquarianism and criticism in the formation of literary history and the crucial role of Thomas Warton—has not been challenged."

[3] *Boswell's Life of Johnson*, ed. G. B. Hill and L. F. Powell (Oxford, 1934), II, 348. Cf. Johnson's remarks on "literary patriotism" in *Rambler* 93, 5 February 1751, *Works* (Oxford, 1825), II, 440.

[4] *Essay of Dramatic Poesy* (1668), *Essays of John Dryden*, ed. W. P. Ker (Oxford, 1926), I, 56.

for reasons of politics. Again and again the poets of the mid-century, Thomson and Akenside and Collins and Gray and Mason and Smart, wrote variations on a mythopolitical theme of Milton: sweet Liberty, the nymph who had freed English pens to outstrip the cloistered conservative rule-bound verses of less favored nations.[5] Patriotism and liberal politics inspire the influential, early literary history of William Temple—"Liberty begets Stomach or Heart, and Stomach will not be Constrained. . . . For my own Part, who have Conversed much with Men of other Nations, and such as have been both in great Imployments and Esteem, I can say very impartially that I have not observed among any so much true Genius as among the *English*."[6] They also inspire the historical myth of "Rule, Britannia!"—"The Muses, still with freedom found,/ Shall to thy happy coast repair:/ Blest isle!"[7]—and Christopher Smart's preaching that the English bulldogs, cats, and poets are the best in Europe.[8] English literary history was shaped by the need for a definition of the superiority of the national character.

Those who resisted this need also resisted the antiquarian zeal that made literary history possible. Goldsmith, who preferred to think himself a citizen of the world, and who thought that the historian needed to be free above all from party and national prejudice,[9] wrote elegant essays on literary history, and was content to leave more detailed study to English partisans.[10] The antiquarians rallied around more loyal citizens: Thomas Percy, whose *Reliques* showed that the English poetic genius had been alive even in ancient times; Thomas Warton, whose projected *History*

[5] A *locus classicus* for the conjunction of patriotism, the Muses, Whiggery, and Milton is part IV of James Thomson's *Liberty* (1736).

[6] "Of Poetry" (1690), in *Critical Essays of the Seventeenth Century*, ed. J. E. Spingarn (Oxford, 1909), III, 104-5.

[7] James Thomson, *Poetical Works* (London, 1908), p. 423.

[8] *The Collected Poems of Christopher Smart*, ed. Norman Callan (London, 1949), I, 60, 313, *et passim*.

[9] See his review of Smollet's *History of England* (*Collected Works of Oliver Goldsmith*, ed. Arthur Friedman [Oxford, 1966], I, 44-47).

[10] "To acquire a character for learning among the English at present, it is necessary to know much more than is either important or useful"; *An Enquiry into the Present State of Polite Learning in Europe* (1759), *Works*, I, 306. In spite of Goldsmith's association of liberty and letters (see Wellek, *Rise of English Literary History*, pp. 54-59), Letter XX of *The Citizen of the World* (1760) concluded that the English republic of letters was in reality an anarchy of literature. The English reviewers attacked him in turn for his sacrifice of scholarship to taste.

bore the standard of national pride. The English public looked for historians who would find their enchanted ground on the soil of England herself.

The patriotic motive for literary history, however, was always too coarse in its explanations to be taken quite seriously by cultivated men of letters. The quarrel between ancients and moderns had resulted not in a victory for the moderns, but in a sophisticated awareness that poets could use different eras and modes, the past and the present, together. In spite of Dryden's advocacy of his own countrymen, his professional influence worked to bring English poetry into a larger European tradition.[11] Augustan poets won their title by establishing commerce with the poetry of Greece and Rome and France, not by planting native roots, and a literary history that appealed to them could not afford to be parochial.

Nor could literary studies have grown without the active interest and concern of poets. In terms of form it may be true, as Wellek says of verse-catalogues, that "no real contribution can be expected from a form that primarily served poetical purposes,"[12] but in practice it was exactly to serve poetical purposes that most English literary history was cultivated during the seventeenth and eighteenth centuries. Poets delved for sources, for a more pristine language, for a more authentic mode of imagination. It was largely from their needs and their researches that English literary studies were born. The professional gossip and conversation about their mutual art with which Ben Jonson regaled and disgusted William Drummond in 1619 evolved into the critical and historical dissertations of a later age. Every neoclassical poet is an informal literary historian. Perhaps Anthony à Wood was mistaken when he reported that William Browne (1590?-1645?) had once embarked on the first history of English poetry;[13] yet the scholar, antiquary, and poet who combined his talents in *Britannia's Pastorals* had already shown many of the qualities appropriate to the historian of poetry. The antiquarians (Oldys and Thomas

[11] The introduction to R. A. Brower's *Alexander Pope: The Poetry of Allusion* (Oxford, 1959) describes the tradition of Dryden as "An Allusion to Europe."

[12] *The Rise of English Literary History*, p. 134.

[13] For the circumstances behind this report, see A. H. Bullen's introduction to *The Poems of William Browne* (London, 1894), pp. xxxi-xxxii.

Warton among them)[14] who revived Browne's *Works* in the mid-eighteenth century knew him to be one of their own kind.

Like the literary history that serves the patriot, however, the literary history that serves the poet will often be distorted by special interests. Poets notoriously shape their criticism to fit their own poetry, and their analysis of the history of poetry often describes poems not of the past but the future. A history and criticism for poets is not likely to be identical with a history for men who are primarily critics or antiquarians; the poet's history needs to be generative, not rational and complete. Such conflicts of interest provide the fascinating motive power of John Dryden's literary criticism and history. As Johnson remarks, "Dryden was known to have written most of his critical dissertations only to recommend the work upon which he then happened to be employed";[15] and even Johnson's respect for the father of English criticism, "a man, whom every English generation must mention with reverence as a critick and a poet," does not keep him from noticing the capriciousness as well as the elegance of his master: "In this, and in all his other essays on the same subject, the criticism of Dryden is the criticism of a poet."[16]

The difference between the literary criticism of a poet and a critic is finely exemplified by the difference between Dryden's and Johnson's comments on poetic imitations. Both men were deeply involved with the practice as well as the theory of "the imitation," and Johnson knew and admired Dryden's views. Yet Dryden, unlike Johnson, constantly tailored his theory to the work at hand. During the last twenty years of his life, as he returned again and again to problems of translation, he fluctuated between his first decision—"To state it fairly; imitation of an author is the most advantageous way for a translator to show himself, but the greatest wrong which can be done to the memory and reputation of the dead"[17]—and the more liberal ideas about translation that introduce his own more liberal versions of the Satires and the Fables.[18] The sentiment that closes his original attack on imi-

[14] E. R. Wasserman, *Elizabethan Poetry in the Eighteenth Century* (Urbana, Ill., 1947), p. 227.

[15] *Rambler* 93, *Works* (Oxford, 1825), II, 440.

[16] *Lives of the Poets*, ed. G. B. Hill (Oxford, 1905), I, 410, 412.

[17] "Preface to Ovid's Epistles," *Essays of John Dryden*, I, 240.

[18] *Ibid.*, II, 111-114, 265-68.

tation speaks with Dryden's true voice: "if, after what I have urged, it be thought by better judges that the praise of a translation consists in adding new beauties to the piece, thereby to recompense the loss which it sustains by change of language, I shall be willing to be taught better, and to recant."[19] Dryden's first concern is not to summarize the history of English translation (though he provides such summaries), nor to arbitrate among theories of translation (though he does judge them), but to make and defend his poems.

The criticism of Samuel Johnson, on the other hand, takes a consistent stand against imitation. "The Macedonian conqueror, when he was once invited to hear a man that sung like a nightingale, replied, with contempt, 'that he had heard the nightingale herself'; and the same treatment must every man expect, whose praise is, that he imitates another."[20] Thirty years later, Johnson gave his definitive opinion of the form in his criticism of Pope's *Imitations of Horace*: "what is easy is seldom excellent: such imitations cannot give pleasure to common readers. The man of learning may be sometimes surprised and delighted by an unexpected parallel; but the comparison requires knowledge of the original, which will likewise often detect strained applications. Between Roman images and English manners there will be an irreconcileable dissimilitude, and the work will be generally uncouth and party-coloured; neither original nor translated, neither ancient nor modern."[21] Behind these judicious words two shades hover: the ghosts of *London* and *The Vanity of Human Wishes*. Johnson, in his role as critic, says nothing at all about his own great imitations. Although we may read into his criticism some covert references to his poetry—there is perhaps some *Irene* in his view of *Cato*, and some rue in his conclusion that the poetic imitator must expect little credit—we shall search in vain for the close interplay between theory and practice that furnishes the key to so much of Dryden. Johnson's literary criticism and literary history are seldom those of a poet. He sacrifices every local consideration to a general understanding of the principles of art.

Nevertheless, the literary studies of the poet, the critic, and

[19] *Ibid.*, I, 242-43.
[20] *Rambler* 86, 12 January 1751, *Works* (Oxford, 1825), II, 403.
[21] *Lives of the Poets*, III, 247.

the antiquarian do not occupy separate compartments. All of them rely upon traditions, precedents, scraps of history, an idea of poetry. When Johnson the critic, in *Rambler* 29, counsels poets not to "submit to the servility of imitation" of the ancients, he is submissive enough to introduce his advice with the usual motto from Horace; and Dryden's translation of the motto, which Johnson also prints, is so free as virtually to amount to imitation.[22] Like the poet, the critic *uses* poetry, and they share the same literary traditions. Moreover, they share a professional interest. Whatever the theory of literary history, it remains a fact that the histories of poetry, the serious criticism of poems, the literary biographies were culminated in the eighteenth century by men who had established reputations as poets. Literary history followed the purposes of men of letters. And the study of literature, in the generation before Johnson, converged upon the poet who was above all others the master of a profession: Alexander Pope.

2

Of Pope it may be said that he was not only a student of literature himself, but a cause of literary study in others. His own superbly self-conscious poetic culture attracted a whole secondary culture of pretenders and pedants and commentators and scholars. We know this society well;[23] along with witling poets, it makes up the subject matter of most of Pope's last verse. Yet Pope did not shut his door to literary historians. His friendly attentions helped to make the careers of many men of letters, among them the most tasteful critic of the next age, Joseph Spence, and its literary tyrant, William Warburton. Merely to keep the memory of Pope fresh, as in Spence's *Anecdotes* and Warburton's edition of the poems, new literary genres were devised, and the task of preserving every detail of a poet's life and work took on a new impetus. Nor did his influence fade. When Joseph Warton set out to change the mode of thought about English poetry, his vehicle was a two-volume *Essay on Pope*; and the defenders of tradition found champions for Pope in Percival Stockdale and Samuel Johnson. The first stages of English literary history and biography revolve around Pope and his circle.

[22] 26 June 1750, *Works* (Oxford, 1825), II, 142-43.
[23] W. L. MacDonald supplies an anecdotal history of *Pope and his Critics* (London, 1951).

Properly speaking, of course, Pope himself wrote very little literary history.[24] His own proper study was the use of literary allusion; or to give things their right name, poetry. Yet Pope's career directly influenced the critical reputation of many of the great names of the past: Homer, Horace, Shakespeare, Dryden. He began with imitations, translations, and paraphrases, and the precocious *Essay on Criticism* showed that the poet as well as the critic was advised to master history: "*You* then whose Judgment the right Course wou'd steer,/ Know well each ANCIENT'S proper *Character*,/ His *Fable, Subject, Scope* in ev'ry Page,/ *Religion, Country, Genius* of his *Age*."[25] So richly were his poems laden with historical awareness that he could not wait for the patina of time to make his *Dunciad* into a Variorum. Fragments of literary history perfuse his talk and his lines; and at times he seems bent upon nothing less than rewriting all the best poetry of the past to his own measure.

Outside of poetry the fruit of all this activity is rather disappointing: a few essays, the prefaces to Homer and Shakespeare, occasional epistolary remarks, some observations reported by Spence. The most tantalizing product of Pope's ventures in literary history, however, is the list of poets first printed by Ruffhead in 1769, with the comment that "Mr. POPE once had a purpose to pen a discourse on the rise and progress of English poetry, as it came from the Provincial [*sic*] poets, and had classed the English poets, according to their several schools and successions."[26] The sketch tantalizes partly because we do not know for certain what Pope wrote or intended. Warburton told Hurd that the "scrap of paper" was "in Mr. Pope's own hand; but seems to want a poetical decypherer to make any thing of it";[27] and Ruffhead's version evidently introduces some errors for the sake of clarity. Probably more accurate is the "exact transcript" made by Thomas Gray,[28] although that text of Pope's "scribbled paper" is riddled

[24] One slim volume contains almost all the *Literary Criticism of Alexander Pope*, ed. B. A. Goldgar (Lincoln, Neb., 1965).

[25] *Poems* (New Haven, 1961), I, 252.

[26] Owen Ruffhead, *The Life of Alexander Pope, Esq.* (London, 1769), p. 328. The list was found by Warburton, and later passed through the hands of Hurd, Mason, Gray, and Thomas Warton.

[27] 18 July 1752; *Letters from a Late Eminent Prelate to One of his Friends* (London, 1809), p. 122.

[28] Printed by T. J. Mathias in the *Works of Gray* (London, 1814), II, vi-vii.

with petty confusions of chronology and sequence. In any event, our main frustration must be that Pope never filled out his history of English poetry. Yet the scraps that remain enable us to draw some conclusions about what that history might have been.

First of all, it would most likely have been a history of good style. A modern reader will tend to be struck more by Pope's omissions than his inclusions. No playwrights are listed, for instance, except Lord Buckhurst (Thomas Sackville), evidently because "His tragedy of *Gorboduc* is written in a much purer style than Shakespeare's was in several of his first plays."[29] Since Pope's sketch is obviously not complete (he includes neither Dryden nor himself), we should not jump to conclusions about his views of what he has left out. Silence about Shakespeare, for example, does not necessarily reflect Pope's judgment that Shakespeare's style was "the style of a bad age,"[30] and the inclusion of Milton's Juvenilia rather than *Paradise Lost* does not necessarily confirm that "Milton's style in his *Paradise Lost* is not natural; 'tis an exotic style. . . . it does very ill for others who write on natural and pastoral subjects."[31] Nevertheless, the sketch as a whole heavily emphasizes style. It is a Short View of Poetry, strongly influenced (as its heading attests) by Thomas Rymer's *Short View of Tragedy* (1692), and probably designed to follow Rymer's genealogy of poetic language: "they who attempted verse in English, down till *Chaucers* time, made an heavy pudder, and are always miserably put to't for a word to clink. . . . *Chaucer* threw in Latin, French, Provincial, and other Languages, like new Stum to raise a Fermentation; In Queen *Elizabeth*'s time it grew fine, but came not to an Head and Spirit, did not shine and sparkle till Mr. *Waller* set it a running."[32]

The plan of Pope's sketch enforces considerations of style by

[29] A remark reported by Joseph Spence, *Observations, Anecdotes, and Characters of Books and Men*, ed. J. M. Osborn (Oxford, 1966), I, 180.

[30] *Ibid.*, I, 183. In the same year (1736), Pope told Spence " 'Tis easy to mark out the general course of our poetry. Chaucer, Spenser, Milton, and Dryden are the great landmarks for it," and Spence comments, " 'Tis plain that he was speaking of our miscellaneous writers, by his omitting Shakespeare and other considerable names in the dramatic way" (*Ibid.*, I, 178-79).

[31] *Ibid.*, I, 197.

[32] *The Critical Works of Thomas Rymer*, ed. C. A. Zimansky (New Haven, 1956), pp. 126-27. On the style of Rymer's recommendation of more refined speech, it grieves us much (we might reply again) who speaks so well shou'd ever speak in vain.

dividing English poetry into schools, each of which has presumably contributed, "like new Stum," to the refinement of the language. Ruffhead's version enumerates six basic schools, those of Provence, Chaucer, Petrarch, and Dante in Aera I, and Spenser and Donne (with some additions) in Aera II. The poems that are specifically named mark transitions from one school to another. Thus the School of Provence contains "Chaucer's Visions, Romaunt of the Rose," but the *Canterbury Tales* are not named; they doubtless are understood to head the School of Chaucer which follows. Similarly Aera II begins with "Spencer, Col. Clout," and reserves mention of *The Faerie Queene*. This curious reticence about major works testifies also to a virtue of Pope's plan: his schools describe the relations among different literary families and nations,[33] not merely a few fixed achievements. By concentrating upon moments of transition, Pope prepares the way for a sense of historical evolution.

At the same time, the division of English poetry into successive schools obviously forces history into a simplified and artificial framework. Thomas Warton chose his words with delicacy when, in 1763, he told Hurd his reaction: "Mr. Pope's paper is certainly a great Curiosity, and is indeed, for so short a Scheme, very ingenious and rational."[34] Years later, in the preface to his own *History of English Poetry*, he made his objections explicit: "Like other ingenious systems, it sacrificed much useful intelligence to the observance of arrangement."[35] Perhaps Pope himself had arrived at a similar discovery. If we look at Gray's transcript of the sketch rather than Ruffhead's, we shall see that the division into schools is far from absolute. Many names seem not to fit under any subhead. "Walter de Mapes" and Skelton, for instance, occupy a space not in but below the School of Chaucer; and whatever his weaknesses in chronology, there is no evidence that Pope (who at least knew Map to have lived "rather be-

[33] "One might discover schools of the poets as distinctly as the schools of the painters by much converse in them, and a thorough taste of their manner of writing"; Pope to Spence, *Anecdotes*, I, 218. As a painter and a good friend of Jonathan Richardson, Pope must of course have been familiar with such histories of painting as the sketch in Richardson's *Science of a Connoisseur* (1719); Richardson's *Works* (London, 1773), pp. 284-302.

[34] 25 Dec. 1763; *The Bodleian Quarterly Record*, VI (1931), 304.

[35] *The History of English Poetry* (London, 1774), I, preface, v.

fore Richard II")[36] would have committed the blunder of lump-
ing them all together. In Aera II, moreover, only a few names fit
clearly within the schools of Spenser and Donne. We may hazard
a likely reconstruction of what happened: Pope began by arrang-
ing English poets into schools, jotted down more names as he
thought of them, and eventually covered his scrap of paper with
a scribble including families and strays, arrangement and ag-
glomeration. His little sketch, in other words, had prefigured
in brief the future of English literary history.

What Pope did not anticipate, however, was the revived interest
in antiquities which would so quickly make his historical perspec-
tive obsolete. Thomas Gray's outline for the history of English
poetry he once projected with William Mason displays a far
deeper knowledge of poetry before Chaucer. Its introduction be-
gins with "the poetry of the *Galic* (or Celtic) nations, as far back
as it can be traced,"[37] and with the Goths; and Gray's Common-
place Book reveals how carefully he had studied Welsh and the
"Gothic" languages in preparation for this task. To some extent his
advantage over Pope was simply better references.[38] Instead of
basing his list of poets upon Rymer, he began with Pope's own
sketch and with the same bibliographical source that was to
serve both Hawkins and Burney: Thomas Tanner's *Bibliotheca
Britannica* (1748). But Gray's main advantage was his consuming
interest in the primitive, an interest patently collateral with his
search for a new voice in poetry. His studies resulted, of course,
not in a history but in poems: the three specimen Odes from Norse
and Welsh he printed, in lieu of the history,[39] in 1768, as well as

[36] Spence's *Anecdotes*, I, 181. In the same place, I, 187, Pope comments that
"Michael Drayton was one of the imitators of Spenser." Osborn notes the disparity
between this and Ruffhead's listing of Drayton among "The School of Donne"; a
disparity that may be resolved by observing that in Gray's transcript Drayton's
name merely occurs *below* Donne's, not in his school.

[37] The plan is contained in Gray's letter to Thomas Warton, 15 April 1770,
Correspondence of Thomas Gray, ed. P. Toynbee and L. Whibley (Oxford, 1935),
III, 1123-24.

[38] On Gray's researches see W. P. Jones, *Thomas Gray, Scholar* (Cambridge,
Mass., 1937), p. 85ff.

[39] According to the advertisement before the Odes, "The Author once had
thoughts (in concert with a Friend) of giving *the History of English Poetry*" and
wrote "the following three imitations" as specimens of ancient style. "He has long
since drop'd his design" in favor of "a Person well qualified," Thomas Warton.
Cf. Mason's Memoirs of Gray, prefixed to *The Poems of Mr. Gray* (London, 1775),
pp. 337-8.

"The Bard" and "The Progress of Poesy." Far more than Pope, Gray quarried the origins of English poetry to replenish the materials of a poetic language and spirit.

The difference between the two sketches goes beyond changes in poetic fashion and scholarship. Like the history of English poetry that Pope did not write, the history that Gray did not write would have been a poet's history, used to affirm a theory of poetic value, and to generate new poems. Yet it would also have been an antiquarian history, with no significant principle of omission. The articles on language and prosody in Gray's Commonplace Book[40] manifest an impressive ability to salvage cadences and expressions for present use, but also a liberal attitude toward the past. Gray, like Thomas Warton, loved accumulating old mysteries far more than solving them, and like Warton he seems to lose interest in history as it nears the present. The last part of his sketch, "*School of France*, introduced after the Restoration. Waller, Dryden, Addison, Prior, & Pope, w[ch] has continued down to our own times,"[41] is by far the most casual, and by omitting Gray and his own school seems to cast him adrift from time into a legendary past of the imagination. The material of Gray's literary history, the history in which poet and antiquarian combine, includes both myth and scholarship; its mode is elegy.

Pope had recognized different materials and different modes, and they too contributed to the development of literary history. The simplest way of characterizing his approach may be through the conjunction, not of the poet and antiquarian, but of the poet and critic. It is significant that the dominant influence on Pope's sketch should have been Rymer, who constantly asserts the authority of the critic over the poet, and the poet over the historian. His first published words of criticism immediately stake his claim: "The Artist would not take pains to polish a Diamond, if none besides himself were quick-sighted enough to discern the flaw; And Poets would grow negligent, if the Criticks had not a strict eye over their miscarriages."[42] No poet could help but chafe somewhat against this stern regimen, yet on the whole Pope accepted the authority of the critic, and accepted Rymer as "one

[40] Reprinted by T. J. Mathias, the *Works of Gray* (London, 1814), II.
[41] *Correspondence*, III, 1124.
[42] "Preface to Rapin," *The Critical Works of Thomas Rymer*, p. 1.

of the best critics we ever had."[43] The emphasis upon correct style in Pope's sketch concedes the subordination of literary studies in general to the directives of the critic. Nor would he describe a history that was not instructive.

Pope's willingness to yield to the critic's authority was never exhibited more strikingly than in his submission to his champion, friend, and executor, William Warburton. To the exasperation of many of his other friends, as well as a good deal of posterity, Pope persisted in deferring to Warburton's taste and judgment. Both men assumed that when critic and poet met in literary studies, the critic should take the lead. Thus Pope, even during his own lifetime, resigned the care of his poems over to Warburton's hands, in the hope that in posterity "the Commentator (as usual) will lend a Crutch to the weak Poet to help him to limp a little further than he could on his own Feet."[44] Warburton quite agreed that Pope needed his aid. His edition of *The Works of Shakespear* (1747) laughs to scorn the "silly Maxim, that *none but a Poet should presume to meddle with a Poet*," and praises Pope's edition not so much because "by the mere force of an uncommon Genius, without any particular Study or Profession of this Art, [he] discharged the great Parts of it so well as to make his Edition the best Foundation for all further Improvements," as because "altho' much more was to be done before *Shakespear* could be restored to himself, . . . yet, with great Modesty and Prudence, our illustrious Editor left this to the Critic by Profession."[45] As Thomas Edwards announced with mock solemnity, "Here then is the foundation of the *alliance between poet and critic*."[46] Pope had left Warburton in charge of his reputation, and also in control of literary history. The new authority on English poetry would be no poet, no timid soul restrained by modesty and prudence, but William Warburton, Bishop of Gloucester, a Critic by Profession.

[43] Spence's *Anecdotes*, I, 205. In his notes to *The Dunciad* (*The Works of Alexander Pope* [London, 1822], V, 173), Joseph Warton comments, with considerable disgust, "Rhymer, at that time, gave the Law to all writers, and was appealed to as a supreme judge of all works of Taste and Genius."

[44] *The Correspondence of Alexander Pope*, ed. George Sherburn (Oxford, 1956), IV, 362.

[45] *The Works of Shakespear* (London, 1747), I, viii-x.

[46] *A Supplement to Mr. Warburton's Edition of Shakespear. Being the Canons of Criticism, and Glossary* (London, 1748), p. 5.

The opinion that Warburton was the great man of letters between the Age of Pope and the Age of Johnson would seem preposterous, had it not been shared by Pope and Johnson themselves. We seldom mention him now except to call attention to his absurdity, and his most lasting contribution to literature seems to be the vanity that provoked such extraordinarily fine and frequent attacks: he "was so proud, that should he meet/ The Twelve Apostles in the street,/ He'd turn his nose up at them all,/ And shove his Saviour from the wall."[47] Again and again the reputation of Warburton has been deflated. Yet the great men of his time thought him to be one of them. Pope told Spence that "Mr. Warburton is the greatest general critic I ever knew," and "He added (as if he had rather assumed Warburton's way of talking than expressed himself in his own usual manner) that 'he was the most capable of seeing through all the possibilities of things.' "[48] When in conversation about Warburton Lord Monboddo said, "He is a great man," Johnson replied "Yes, he has great knowledge, great power of mind. Hardly any man brings greater variety of learning to bear upon his point."[49]

To some extent these remarks may be explained away as the luck of the controversialist; Warburton enjoyed the good fortune of having supported both Pope and Johnson in their literary quarrels. Pope was profoundly grateful for being defended against Crousaz' charge of infidelity, and Johnson, whose sense of gratitude was honed on the wheel of early poverty, never forgot that Warburton gave him "his good word when it was of use to me."[50] A single polite reference to "the learned Dr. Warburton" in Johnson's early "Miscellaneous Observations on the Tragedy of Macbeth" (1745) had been rewarded by a rare kindness, praise in Warburton's *Shakespear* for the "Observations," "written, as appears, by a Man of Parts and Genius."[51] Although Warburton

[47] From "The Duellist," *The Poetical Works of Charles Churchill*, ed. Douglas Grant (Oxford, 1956), p. 280; the scourging of Warburton occupies lines 667-810.
[48] Spence's *Anecdotes*, I, 217.
[49] *Boswell's Journal of a Tour to the Hebrides*, ed. F. A. Pottle and C. H. Bennett (New York, 1961), p. 56.
[50] *Johnsonian Miscellanies*, ed. G. B. Hill (Oxford, 1897), II, 7.
[51] *The Works of Shakespear*, I, xiii. Perhaps Warburton knew that Johnson had undertaken (1746) an English dictionary, whose absence is deplored in the same

never thereafter showed immoderate regard for Johnson, and though he did not always respect the memory of Pope, his original forays on their behalf were repaid many times over.

Yet the vast reputation and power of Warburton could not have arisen only from friendship. His enemies, indeed, were fully as influential as his friends, and far more numerous.[52] In order for his writings to have cast such a spell, they must have compelled readers to admire their qualities; qualities which, exactly because we find them so hard to appreciate, may point to the difference between what we expect from literary history and what was expected by the audience of the mid-eighteenth century.

To start with, was Bishop Warburton a literary historian at all? Certainly not in any formal sense. His "masterpiece," *The Divine Legation of Moses Demonstrated* (1738-1741), "a stupendous monument of mental labour; a grand instance of intellectual energy; a noble exemplar of genius seconded by learning, industry, and perseverance,"[53] is a work of theology, history, and philosophy whose multiple paradoxes touch on every kind of learning, barely including the literary. Nor did he ever write an extended piece of literary history. His contributions, such as the history of tragicomedy in a note to his *Shakespear*,[54] or the influential argument for the Eastern origins of romance in a preface to Jervas' *Don Quixote* (1742), appear in occasional places. Even his projected Life of Pope, in whose interest the modest Joseph Spence surrendered all his own claims and materials,[55] never came into being. Controversy, rather than literature, seems to have been Warburton's proper element.

Nevertheless, it was to Warburton that contemporary men of

preface (I, xxv); perhaps he approved of Johnson's strong recommendation, in the opening of the "Observations on Macbeth," of the new field of literary history: "In order to make a true estimate of the abilities and merit of a writer, it is always necessary to examine the genius of his age, and the opinions of his contemporaries"; *Works* (Oxford, 1825), V, 55.

[52] A valuable guide to Warburton's controversial career is A. W. Evans, *Warburton and the Warburtonians* (London, 1932).

[53] The advertisement to a nineteenth-century edition of *The Divine Legation of Moses Demonstrated* (London, 1837), I, iii.

[54] *The Works of Shakespear*, V, 265-66.

[55] See Austin Wright, *Joseph Spence: A Critical Biography* (Chicago, 1950), pp. 73-76. Ruffhead's *Life of Pope* (1769) was written under Warburton's supervision.

letters turned when they required a symbol of literary eminence; Warburton whom Samuel Richardson asked to write the preface for the fourth volume of the first edition of *Clarissa*,[56] Warburton whom Henry Fielding invoked at the gateway to London in *Tom Jones*: "And thou, O Learning! (for without thy assistance nothing pure, nothing correct, can genius produce) do thou guide my pen. . . . give me a while that key to all thy treasures, which to thy Warburton thou hast entrusted."[57] Without having written any major literary history, or literary biography, or literary criticism of unusual perception, Warburton somehow convinced authors of his authority. His learning might be erratic, his criticism capricious, but he had that in his countenance which literary men would fain call master.

What was his secret? Isaac D'Israeli, after searching for "the SECRET PRINCIPLE which conducted Warburton through all his works," concludes that it was INVENTION,[58] and argues that Warburton has portrayed himself in a portrait of Bayle; "who, with a soul superior to the sharpest attacks of fortune, and a heart practised to the best philosophy, had not yet enough of real greatness to overcome that last foible of superior minds, the temptation of honour, which the ACADEMIC EXERCISE OF WIT is conceived to bring to its professors."[59] This application is clever and accurate; but like many other nineteenth-century critics of Warburton, D'Israeli exaggerates the moral significance of a style of argument.[60] Warburton's love of paradox, his willingness to argue on any subject with a belligerence that combines "the powers of a giant with the temper of a ruffian,"[61] look back to a rhetorical tradition. Like Erasmus and Nashe and Salmasius, he is a virtuoso of *copia*, and one of the last English

[56] See A. D. McKillop, *Samuel Richardson: Printer and Novelist* (Chapel Hill, N.C., 1936), pp. 163-65. The two men later broke, Warburton to follow Fielding, Richardson to follow Thomas Edwards.

[57] Invocation to Book XIII, Fielding's *Works* (New York, 1903), V, 263.

[58] Isaac D'Israeli, *Quarrels of Authors* (London, 1859), p. 247.

[59] *The Divine Legation of Moses* (London, 1837), I, 134.

[60] The nineteenth-century attacks on Warburton were culminated by Sir Leslie Stephen in Chapter VII of *History of English Thought in the Eighteenth Century* (London, 1876). Reading Warburton in the context of their own times, men like Stephen thought of him as the type of the Enemy: a vehement and dictatorial yet withal credulous and irrational old believer.

[61] From a review of Warburton's *Works* by Thomas Whitaker in *The Quarterly Review*, VII (1812), 394.

critics before Macaulay who chooses for his mode rhetorical abundance rather than precision of statement. To condemn his criticism for its *copia* is to rob Samson of the copious locks that give him strength.

As a compiler of dictionaries and a student of the Renaissance, Samuel Johnson understood Warburton's strengths and antecedents very well. Much of that understanding is compressed in an elegiac remark to Strahan: "Warburton is perhaps the last man who has written with a mind full of reading and reflection."[62] But Johnson's most judicious estimate of Warburton's literary character occurs in the *Life of Pope*. "He was a man of vigorous faculties, a mind fervid and vehement, supplied by incessant and unlimited enquiry, with wonderful extent and variety of knowledge, which yet had not oppressed his imagination nor clouded his perspicacity. To every work he brought a memory full fraught, together with a fancy fertile of original combinations, and at once exerted the powers of the scholar, the reasoner, and the wit. But his knowledge was too multifarious to be always exact, and his pursuits were too eager to be always cautious."[63]

Considering the source, such praise counts for a great deal. Johnson had a right to pride himself on his own full-fraught memory, and few literary virtues impressed him so much as a great fund of knowledge. Thus he was exhibiting his claim to learning as well as his respect when, in conversation with George III, "he said he had not read much, compared with Dr. Warburton"; and the king's reply shows that he understood the point of the comparison: "he heard Dr. Warburton was a man of such general knowledge, that you could scarce talk with him on any subject on which he was not qualified to speak; and that his learning resembled Garrick's acting, in its universality."[64] King and subject alike regarded Warburton as the type of the man of learning, not only a critic but a walking repository of literature.

This accumulation of knowledge, the product of an omnivorous love of reading that consumed everything from ancient philosophy to light romances, accounts for most of Warburton's reputation. He shared with Johnson "a naturally melancholy habit" that "makes my reading wild and desultory: and I seek refuge

[62] *Boswell's Life of Johnson*, IV, 49. [63] *Lives of the Poets*, III, 165-66.
[64] *Boswell's Life of Johnson*, II, 36-37.

from the uneasiness of thought from any book let it be what it will, that can engage my attention."[65] To be sure, such knowledge was hardly regular. For a classical scholar like Mark Pattison, "to have read many books and remembered their contents, is 'learning' only in a very popular acceptation of the word. But in no other sense was Warburton entitled to be called a 'learned' man."[66] Nevertheless, the characteristic quality of Warburton's writings, whether his treatises, his editions, or his letters, can be described by no other word. However undisciplined his learning, it covers all his pages with recondite ostentation. "Hardly any man brings greater variety of learning to bear upon his point."

As a technique of literary analysis, Warburton's *copia* can result in an extraordinary farrago. At times he will barrage a line of poetry with irrelevant stores of information, or with gratuitous opinions of his own. Thus a line from Pope's "versification" of Donne's second satire brings on a page of notes reviewing Donne's career, and culminating with a long attack on *Pseudo Martyr*, which the author of the *Divine Legation* thinks "absurd and blasphemous trash." Similarly, it is Warburton's anti-Catholicism, not Pope's distaste for enthusiasts, that governs the interpretation of the phantoms in the Cave of Spleen, "Dreadful, as hermit's dreams in haunted shades,/ Or bright, as visions of expiring maids"—"The poet by this comparison would insinuate, that the temptation of the mortified recluses in the Church of Rome, and the extatic visions of their female saints were as much the effects of hypocondriac disorders . . . as any of the imaginary transformations he speaks of afterwards."[67] When Warburton wishes to make a point, the feelings of the poet will not stand in his way.

The forced alliance between poet and critic reaches its crowning moment in Warburton's commentary on the "Essay on Criticism." Here the critic erects his own system over the body of the poem. An ingenious scholar has recently argued, with a Warburtonian flair for paradox, that such notes adapt the methods of textual criticism to close reading very much like the New Criticism in its "holistic interpretation of imagery, semantic analysis,

[65] Letter to Doddridge, in Evans, *Warburton and the Warburtonians*, p. 17.

[66] *Essays* (Oxford, 1889), II, 168; Pattison's article on Warburton first appeared in the *National Review* in 1863. Though Warburton read many languages, he often grossly misconstrued passages in Greek and Latin.

[67] The *Works* of Pope (London, 1751), I, 248n.

and what I shall call the search for complexity."[68] But Warburton pays little attention to the integrity of the text. Since he regards "The sound must seem an Echo to the sense" as a "trivial precept," for instance, he chooses to emphasize instead the preceding line, " 'Tis not enough no harshness gives offence." From this he concludes that the couplet as a whole is designed to warn poets against dissonance, not to encourage their tricks of language.[69] If "The hoarse, rough verse" of a few lines later does not fit this theory, Warburton is willing to let it pass without comment. In the alliance between poet and critic, he knows, the critic always has the last word.

The most famous example of Warburton's way with a text, his own declared "canons of criticism," is his edition of Shakespeare. Even in the highly competitive field of nonsensical conjectures about Shakespeare's text, this edition has won a special place. Who but Warburton, for instance, would have emended "One of your great knowing/ Should learn, being *taught*, forbearance," to "One of your great knowing/ Should learn (being *tort*) forbearance"?[70] Only a critic who obeyed Edwards' sixth Canon of Criticism: "*As every author is to be corrected into all possible perfection, and of that perfection the profess'd critic is the sole judge; he may alter any word or phrase, which does not want amendment, or which* will do, *provided he can think of any thing, which he imagines* will do better."[71] Warburton loads the text with every learned variant suggested by his knowledge and imagination. Although he sets out to restore Shakespeare to himself, he ends by multiplying and stretching all the possibilities of interpretation.

The absurdities to which such criticism is prone should not blind us to its virtues: its independence, vigor, perception of unlikely resemblances, surprising humor. We recognize those virtues when they occur in the scholarly farragoes of Rabelais, Swift, and Sterne, and the last, at any rate, probably learned much from

[68] R. M. Ryley, "William Warburton as 'New Critic'," *Studies in Criticism and Aesthetics, 1660-1800* (Minneapolis, 1967), p. 250.

[69] *Works* of Pope, I, 178-9n.

[70] Warburton's explanation, along with a long satirical comment by Thomas Edwards, is quoted in *The Canons of Criticism* (note 46 above), pp. 33-34.

[71] *Ibid.*, pp. 22-23. The example above illustrates Canon VII, "*He may find out obsolete words, or coin new ones, and put them in the place of such, as he does not like, or does not understand*" (p. 26).

Warburton.[72] Moreover, the controversial method ensures against the perpetuation of error; Warburton's literary tyranny inhibited his enemies no more than himself from trying conjectures before the public. If his theories were usually wrong, nonetheless they stimulated inquiries that led to many discoveries in history and philology.

Yet Warburton's learned and haphazard commentary, his wild and desultory scholarship, offered no pattern for the literary studies of the future. Despite all his knowledge he left nothing regular, nothing permanent.[73] When Samuel Johnson contemplated the great Warburton and his little critics in the *Preface to Shakespeare* (1765), he was oppressed by reflections on the futility of authorship. "Thus the human mind is kept in motion without progress. Thus sometimes truth and errour, and sometimes contrarieties of errour, take each other's place by reciprocal invasion. The tide of seeming knowledge, which is poured over one generation, retires and leaves another naked and barren; the sudden meteors of intelligence, which for a while appear to shoot their beams into the region of obscurity, on a sudden withdraw their lustre, and leave mortals again to grope their way."[74] The generation of men of letters after Warburton had inherited no fixed principles; they were left to grope their way.

The literary critic and historian of the eighteenth century could take comfort, however, in the same advice with which William Walsh had once encouraged the young Pope:[75] though there had been great predecessors, as yet not one had been correct. If one contemplated Warburton's learning and his powers, to rival him seemed a task for Hercules; if one contemplated his accomplishment, it became obvious that even Dick Minim could help rectify literary history. Rather than recognize the past, Warburton had merely raided books for present advantage. The time had come for more useful literary studies: for criticism that would instruct the public rather than keep a strict eye on

[72] See Evans, *Warburton and the Warburtonians*, pp. 226-32.

[73] An anthology of Warburton's literary criticism would have to rely heavily upon his letters to Hurd, and upon selections from his notes to Shakespeare and Pope. The sumptuous seven-volume *Works* (London, 1788) prepared by Hurd emphasize theological writings. Another line of influence is surveyed by Clifton Cherpack, "Warburton and the *Encyclopédie*," *Comparative Literature*, VII (1955), 226-39.

[74] Johnson's *Works* (Oxford, 1825), V, 141.

[75] Spence's *Anecdotes*, I, 32.

the miscarriages of poets; for a history of English poetry aimed at a wider audience than the poet and the critic; for "canons of criticism" that would be inclusive, flexible, and accurate; for an alternative to Warburton.

4

Joseph Spence was born on April 28, 1699, five months later than Warburton, and thus like him precisely midway between Pope and Johnson. Nature designed him to be Warburton's spiritual antithesis. Though the two men shared interests and acquaintances and the intimacy of Pope, and though the surface of their relations always remained cordial,[76] their habits of mind differ as pastoral differs from heroic drama. Spence's delicate and amiable temperament, his "moral loveliness"[77] and lack of fustian, held controversy at a safe distance. Thus Johnson, in spite of his sympathy for more gigantic talents like Warburton's, knew the contrasting virtues of Spence; "a man whose learning was not very great, and whose mind was not very powerful. His criticism, however, was commonly just; what he thought, he thought rightly, and his remarks were recommended by his coolness and candour."[78] If no one was disposed to overestimate Spence's gifts, neither would anyone deny that he had used them well.

The qualities that Spence brought to a friendship—his amiability, his mild and accurate discernment—also represent his contribution to literary studies. His first talent was polite conversation, and conversation forms the basis of all his best work. *An Essay on Pope's Odyssey* (1726), *Polymetis: or, An Enquiry concerning the Agreement Between the Works of the Roman Poets, And the Remains of the Antient Artists* (1747), and *Crito: or, a Dialogue on Beauty* (1752) are all written in dialogue form,[79] and his posthumously published masterpiece, the *Anecdotes*, de-

[76] Considering Spence's close friendships with such antagonists of Warburton as Robert Lowth and Samuel Richardson, his refusal to be drawn into a quarrel must be regarded as a triumph of diplomacy.

[77] From a review of Spence's *Anecdotes* by Isaac D'Israeli, *The Quarterly Review*, XXIII (1820), 404.

[78] *Lives of the Poets*, III, 142-43.

[79] The Preface to *Polymetis* (p. iv) defends dialogue on the grounds that the author wishes "to take off some of the sullenness, and severity, that has generally been thrown over the studies of Criticism, and Antiquities," and that "By this means one avoids the frequent use of that most disagreeable of all monosyllables, I."

rives much of its charm from our sense that we have been allowed to take part in conversations with Pope. Even *A Full and Authentick Account of Stephen Duck, the Wiltshire Poet* (1731) is composed in the form of a familiar letter based on interviews with Duck. The modest literary art of Spence expresses the values of polite society, sometimes falling into "the familiar vulgarisms of common talk" or the *"pert* or *low,"*[80] but never bullying the auditor or asserting the self. He hesitates even to speak in his own person; he exceeds no bounds.

Despite his modesty, however, Spence contributed far more to literature than did the great Warburton. Like his friend Pope, he never fell below expectation. To scholars he bequeathed his anecdotes, to his contemporaries the example of a refined and careful taste. The work he had done could be trusted, and did not need redoing; it did not further private interests, nor compel its audience to admire mysteries and learning beyond understanding. "A very learned comment, is like a very learned man; it is rather troublesome, than useful to you. When you consult them, their answers are for the most part as dark, and as equivocal, as those of oracles."[81] Spence displays no such learning. He writes to be useful, after the manner of his own dialecticians, "in a retirement every way agreeable, and in a full enjoyment of those pleasures which attend on a particular friendship, in an open and improving conversation."[82]

Unfortunately, Spence's most original contribution to English literary history did not open a conversation. His manuscript essay, "QUELQUES REMARQUES HIST: sur les Poëtes Anglois," was first published and analyzed as recently as 1949; and its predecessor, his "Acct. of our English Poetry," has only just come to light.[83] We cannot be sure of the exact provenance of these

[80] See "Maloniana," in Sir James Prior's *Life of Edmond Malone* (London 1860), p. 430. Spence himself, translating one of Erasmus' Colloquies, had observed that in this form Erasmus was one of the *Flemish* School, a Painter *low* and *strong;* "Sir Harry Beaumont," *Moralities: or, Essays, Letters, Fables; and Translations* (London, 1753), p. 26.

[81] *Polymetis* (London, 1747), p. 286.

[82] *An Essay on Pope's Odyssey*, "Evening the First," reprinted in *Eighteenth-Century Critical Essays*, ed. Scott Elledge (Ithaca, N.Y., 1961), I, 387.

[83] See the two articles by James M. Osborn: "The First History of English Poetry," *Pope and his Contemporaries* (Oxford, 1949), pp. 230-50; "Joseph Spence's 'Collections Relating to The Lives of the Poets'," *Harvard Library Bulletin*, XVI (1968), 129-38.

pathfinding historical sketches. Evidently Spence wrote them to introduce a Poetical Dictionary he was compiling; and James Osborn concludes that the "Remarques Hist" probably date from 1732-3, and are connected with Spence's election four years earlier as professor of poetry at Oxford. Whether intended for students or for the author himself, however, these trial histories of English poetry draw a clear and confident line of succession. Just as the guidebooks written for foreign visitors often leave them better informed than the natives, Spence's "Remarques" afford a more instructive guide than anything to be published in English for years to come.

Indeed, part of the value of the little history in French is its lack of self-consciousness about an audience. Spence need not assuage national pride, nor codify good style, nor impress his reader, nor discover new sources of poetry. Free from the defenses of a critic, he passes judgment unpretentiously but firmly. Moreover, his period divisions maintain historical neutrality: the sketch proceeds century by century, not according to schools or influences or reigns. Had Spence expected to publish a "History of English Poetry" he would have felt compelled to develop theories and justifications, but manuscript remarks in bad French were obliged only to state the most plausible views in the clearest way.

As befits a document composed for use rather than for show, the "Remarques" contain few surprises, unless we are surprised that a third of them are devoted to authors before Chaucer. Most of the early comments reflect the influence of John Leland's *Commentarii de Scriptoribus Britannicis*,[84] and most of the later resemble the opinions compiled in Spence's *Anecdotes*. Occasionally a thought betrays a special interest of the author—"Il me semble que *Spenser* a etudié la maniere de Milord Buckhurste parce que l'Introduction de celui-ci, et le Poëme Epique de celui-là, sont apparemment du même gout en plusieurs endroits"[85]—or a special French emphasis—"Dans les ouvrages

[84] Though compiled in the 1540's, Leland's collection had been first published, in a convenient though inaccurate edition, by Anthony Hall (2 vols., Oxford, 1709).

[85] Osborn, "The First History of English Poetry," p. 245. Cf. Pope's remarks in Spence's *Anecdotes*, I, 180. Pope, who had been given a copy of *Gorboduc* by Thomas Warton, Sr., in 1717, later passed it on to Spence, who edited it in 1736.

d'Esprit *Pryor* étoit três naif & três charmant. Il est le De-la-Fontaine d'Angleterre."[86] What is remarkable, however, is not individual learning or insight so much as the ability to view English poetry as a whole. The ease with which such a view is rendered almost lures us to overlook its significance. In Spence's history, and in no other contemporary document, an intelligent man of letters surveys and appraises the full range of English poetry from its beginnings to Pope.

He sees, to be sure, through Augustan shutters: *naif* is not a word we should choose for Chaucer, nor *puerile* for Donne. He suffers from too much taste and from short-windedness. Yet unlike many of his predecessors, he does seem to believe in the existence of such a thing as English poetry, a continuous development with an intelligible history, a thin but unbroken line of achievements. The shallow stream of Spence's learning never becomes diverted into going too deep, or lingering too long at one place. If momentum and breadth are the tests of literary history, then the "Remarques" inaugurate a new era.

But the new era did not come for forty years. Spence felt no urgency about transmitting literary history to a greater public. As a man of taste, he assumed that the polite arts "are certainly not of the highest importance to mankind; and if they are not entertaining, can have but very little else to recommend them. Instead of this, I know not how it has happened, that Criticism has generally appeared like a meer scold, and Antiquity like an old pedant."[87] And the scold and pedant who might have been best qualified for literary history could not lower his dignity to the mere recording of relevant facts: "Antiquarianism is, indeed, to true letters, what specious funguses are to the oak; which never shoot out and flourish till all the vigour and virtue of that monarch of the grove be effete, and near exhausted."[88] Between them Spence and Warburton, the man of taste and the man of learning, did not constitute a plenary literary historian; the first had too poor an appetite, the second too poor a digestion.[89]

[86] "The First History of English Poetry," p. 250.

[87] *Polymetis*, preface, p. iv.

[88] Warburton to Hurd, March, 1765, *Letters . . . to One of his Friends*, p. 359. The specific reference is to Percy's *Reliques*.

[89] Bentley had remarked of the *Divine Legation of Moses* that "the author had

Moreover, neither of them had much use for a definitive survey of English poetry. None of the strongest motives for making a history—the need to affirm a national identity, the search for poetry itself—appealed to them very forcibly. Spence thought he already knew what good taste was, and Warburton thought he already knew everything. Such surety removes the basis for literary studies. The "Remarques" seem contented with their estimate of English poetry, and Warburton believed that his editions had established textual "canons of criticism." They hardly realized how much they had left undone.

As knowledge of English poetry grew, uncertainty grew with it. The Age of Johnson possessed no one so stylish as Pope, so learned as Warburton, so tasteful as Spence. Its audiences claimed more from literary history: comprehensiveness, clarity, accuracy, amusement, romance, authority. The man who wrote the first full history of English poetry would need to be a poet, a critic, an antiquarian, a man of taste; the explorer of an unknown land in which everyone had already staked rights of ownership. He would need, in short, to be as uncertain of himself as Thomas Warton.

a voracious appetite for knowledge, but he doubted whether he had a good digestion." J. H. Monk, *The Life of Richard Bentley* (London, 1830), p. 656.

351

The Compromises of Thomas Warton and
The History of English Poetry

1. THOMAS WARTON'S MONUMENT

EVERYONE agrees that Thomas Warton's *History of English Poetry* is a monument; but few readers have ever agreed what it is a monument of. The *History* changes to suit its changing audience. Thus fifty years ago, when Edmund Gosse delivered the Warton Lecture on English Poetry to the British Academy, he knew Thomas Warton to have been a man much like himself, a rebel against the orthodox older generation. "To have been the first to perceive the inadequacy and the falsity of a law which excluded all imagination, all enthusiasm, and all mystery, is to demand respectful attention from the historian of Romanticism, and this attention is due to Joseph and Thomas Warton."[1] One year later Clarissa Rinaker, an ardent biographer, envisioned a Thomas Warton who had broken the cold bonds of classicism and become "the founder of a new school of criticism."[2] In those days, evidently, scholars who looked at the *History of English Poetry* saw an early romantic rebellion. That view remains plausible and appealing, and still dominates popular surveys; to accept it would be pleasant. But times have changed, and one cannot accept it any more.

As soon as scholars tried to match the vision of the rebel with the gentle features of Thomas Warton, they began to think again. Reviewing Miss Rinaker's biography in 1917, Odell Shepard put objections that have never been answered. "Never, surely, was there a milder revolutionist, never a more tender iconoclast or a

[1] "Two Pioneers of Romanticism: Joseph and Thomas Warton," *Proceedings of the British Academy*, VII (1915), 163.
[2] *Thomas Warton, A Biographical and Critical Study* (Urbana, Ill., 1916), p. 58. Although distorted by partisan claims for its hero, Miss Rinaker's work remains the fullest collection of facts about Warton (1728-1790).

more rational antagonist of reason. The fact is that in matters critical Warton was a compromiser, a balancer of old and new. In other things he was positively reactionary. Revolt simply was not in him."[3] Suddenly the romantic glamor of the *History of English Poetry* fled. For fifty years we have not seen it as a monument of rebellion.

Moreover, the very period that Warton once seemed to represent, the "Pre-Romantic" period, has begun to vanish from our sight, like "the Dark Ages" and "Modernism." The patronizing teleology which implied that the poets of the mid-eighteenth century had no existence, only a pre-existence, is yielding to new formulations of an Age of Sensibility with traits all its own.[4] Scholars used to think of the *History of English Poetry* as a repudiation of the past and a harbinger of the future; now it seems to occupy a present. According to such an interpretation, the significance of Warton lies in his accommodation to a time of process and transition, combining without resolving the various claims of classic and romantic, reason and feeling, enlightenment and imagination. The *History* mediates between extremes, and refuses to choose between its divided allegiances. If such a work can be a historical monument at all, it can only stand for that historical mixture of values which Raymond D. Havens calls "the eighteenth century dilemma."[5]

A similar dilemma undermines the view held by the best modern scholars, the view that Warton built a monument of literary history. Fourteen years after Gosse, another Warton Lecturer, David Nichol Smith, judiciously swung the emphasis away from Romanticism: "the book is not the manifesto of a school, nor a document in a controversy. It is, as it justly calls itself, *The History of English Poetry*, an impartial history, and our first history —on which every subsequent history is in some part founded, and to which every student of our literature is in some way in-

[3] "Thomas Warton and the Historical Point of View in Criticism," *JEGP*, XVI (1917), 163.
[4] Important contributions to the new formulation include R. S. Crane, "On Writing the History of English Criticism, 1650-1800," *University of Toronto Quarterly*, XXII (1953), 376-91, and Northrop Frye, "Towards Defining an Age of Sensibility," *ELH*, XXIII (1956), 144-52.
[5] "Thomas Warton and the Eighteenth Century Dilemma," *SP*, XXV (1928), 36-50.

debted."[6] These words ring with authority, and so does René Wellek's well-earned conclusion that "Warton was the first historian of English literature in the full sense of the term."[7] Yet most of Warton's *History* is not literary history at all. As Wellek concedes, "It was, first of all, an accumulation of materials, a bibliography and anthology, and only secondarily a history."[8] Even if we do not pursue the question of whether what Warton wrote was "a history," we are confronted by a sprawling and diverse collection of unassimilated matter. Nor can this dilemma be resolved. When we select from the *History of English Poetry* only that part which satisfies our expectations about literary history, we make a book perhaps better than, but certainly different from, the book that Warton wrote.

We are also constructing a work that Warton himself, when he changed his mind about adopting a coherent, limited historical scheme, chose quite deliberately not to write. In sacrificing both the dedication to the facts and the search for philosophic history to which other historians had aspired,[9] Warton worked out an uncertain compromise. Like the histories of music, the history of poetry resisted artificial methods of construction; it demanded its own way. Warton's surrender to this resistance, rather than his mastery of it, accounts for the uneven course taken by his *History*. As the work appeared to him, it was not clad in our trappings of vestigial Romanticism and rudimentary Historicism, but in a "complication, variety, and extent of materials, which it ought to comprehend."[10] No predetermined plan could hope to control the long process of heterogeneous research and writing.

Indeed, in its form as well as in its historical position, the *History of English Poetry* is a thoroughly compromised book. Its first reviewers, though generally admiring, never failed to point out how many different roles Warton had attempted to harmonize. "This elegant writer, already well known to the learned world as a poet, a critic, and an antiquarian, opposite as those

[6] "Warton's History of English Poetry," *Proceedings of the British Academy*, XV (1929), 99.
[7] *The Rise of English Literary History* (Chapel Hill, 1941), p. 201.
[8] *Ibid.*, p. 174. [9] See chapters three and four above.
[10] *The History of English Poetry* (London, 1774-1781), I, preface, v. Page numerals in the text will refer to this, the first, edition.

characters seem to be, has here in some measure united them all."[11]
Reaction to such variety has always been a matter of taste; the
friends of Warton thought the "rich blending of qualities"[12] his
principal literary beauty, and Sir Walter Scott thought that the
History of English Poetry would always remain "an immense com-
mon-place book of *memoirs to serve for such an history*."[13] Dis-
agreements like these are inevitable, because Warton's *History*
avoids the definite choices that would allow readers to perceive
a fixed intention. Rejecting a commitment to any one audience,
Warton blurs any clear line of interpretation.

Our search for the nature of Thomas Warton's monument, then,
must begin not with its accomplishments but with its compro-
mises. Our own favorite hypotheses about English poetry or lit-
erary history will not unravel the *History of English Poetry*. Its
era is transitional, its method uncertain, its principle eclecticism;
it obeys contradictory impulses and irrational motivations. We
cannot hope to rationalize Warton's monument, we can only
hope to understand it. Between the moment when the *History*
was conceived and the moment when Warton's death left it un-
finished, it was shaped by unforeseen pressures and contingencies,
by the burden of "writing *The History of English Poetry*, which
has never yet been done at *large*, and in *form*."[14] It took on a
responsibility whose extent its author only gradually came to
realize. And even in its moment of conception, Warton's *History*
was compromised.

2. RICHARD HURD AND THE GENESIS OF THE *History*

The notion of writing a history of English poetry suddenly crystal-
lized for Warton in 1762, sparked by a footnote and a letter from
a friend. While revising his *Observations on the Faerie Queene
of Spenser* (1754) for a second edition, he was troubled by a sen-
tence in which he had asserted that English poetry before Spenser
"principally consisted in the allegoric species."[15] As Warton went

[11] *The Gentleman's Magazine*, XLIV (1774), 370.
[12] Rinaker, *Thomas Warton*, p. 118.
[13] Scott's *Miscellaneous Prose Works* (Edinburgh, 1849), XVII, 4; first published
in a review of Ellis's *Specimens of the Early English Poets* in the *Edinburgh
Review* for 1804.
[14] Warton to Percy, 15 June 1765, *The Percy Letters*, III, *Percy-Warton*, ed.
M. G. Robinson and Leah Dennis (Baton Rouge, La., 1951), p. 118.
[15] *Observations* (London, 1754), p. 227.

deeper into Spenser and his sources that generalization no longer
rang true; English poetry required a broader and richer frame
of reference. In 1762 the second edition of the *Observations* re-
placed the offending sentence with one far less single-minded:
"If we take a retrospect of english poetry from the age of Spenser,
we shall find that it principally consisted in visions and allegories."
To this Warton appended a fateful note: "This subject may,
probably, be one day considered more at large, in a regular
history."[16]

Later in the same year a letter from Warton's acquaintance
Richard Hurd picked up the suggestion and wrapped it in en-
couraging flattery. "I hope You will [persist] in the noble design
of giving a history, in form, of the English Poetry. It is true, a
work of this nature requires the Antiquarian, as well as Critic.
But You are both; & the imputation needs not alarm You. For
your Genius will always enable You, as it does the true Poet, *ex
fumo dare lucem*: whereas the mere Antiquarian has no means
of breaking thro' the cloud, which his own Dullness, rather than
his Subject, throws about him."[17] If coaxing was required, Hurd's
assurances were sufficient. Warton's reply repaid the flattery, and
transformed his hint into a promise. "Your Letter has roused me
to think in earnest of, what I hinted in my *Observations,* a formal
History of English Poetry. I have long been laying in materials
for this work; and, with regard to the influence of Chivalry and
Romance on modern poetry, I may now enlarge with some free-
dom and confidence on this head, as you have so nobly ven-
tured to speak out. . . . Whatever I shall undertake to this purpose,
I cannot but confess that I shall wander with double delight on
fairy ground, while you are my guide and my companion."[18] With
suitable announcements and great expectations, the *History of
English Poetry* was under way.

Yet even then, before a word had been written, the *History* had
encountered its first reasons for delay: the puzzles raised by the
function of allegory in English poetry, and the mixed blessing of
Hurd's influence. Neither problem would ever be solved. Warton's
substitution of "visions and allegories" for "the allegoric species"

16 *Observations* (London, 1762), II, 101.
17 14 Oct. 1762, *The Bodleian Quarterly Record,* VI (1931), 303.
18 *Ibid.,* 22 Oct. 1762, pp. 303-4.

was a premature attempt to rid himself of dependence on a form he did not trust.[19] The chapter of the *Observations* in which the footnote appears, "Of Spenser's Allegorical Character," anticipates the *History* by sketching the backgrounds of English poetry, in order to demonstrate "that allegorical poetry, through many gradations, at last received its ultimate consummation in the Fairy Queen."[20] But Warton's defense of Spenser's allegory is notoriously erratic. He begins his chapter by arguing "that the encounters of chivalry subsisted in our author's age; . . . Spenser, in this respect, copied real manners, no less than Homer";[21] he ends by quoting the Abbé du Bos' attack on allegory: "It is impossible for a piece, whose subject is an allegorical action, to interest us very much. . . . Our heart requires truth even in fiction itself."[22] All Warton's love of Spenser cannot prevent him from feeling uneasy about allegory.

Part of the reason for that unease is suggested by the passage directly preceding the retrospect of English poetry in the *Observations*. Here Warton accuses Spenser of mingling divine mystery with human allegory, thus tending "to debase the truth and dignity of heavenly things, by making Christian allegory subservient to the purposes of Romantic fiction."[23] This charge could not be taken lightly. Warton could apologize that Spenser had committed the fault "through a defect of judgment rather than a contempt of religion," but as a clergyman he must have realized that his own weakness for Romantic fiction encouraged similar defects of judgment. *The Rambler*, a work he admired, had been very hard upon pastoral writers who "filled their productions with mythological allusions, with incredible fictions, and with sentiments which neither passion nor reason could have dictated, since the change which religion has made in the whole system of the world."[24] Warton agreed with this view; being a man of many minds, he also disagreed with it.

[19] Wellek, *Rise of English Literary History*, p. 169, incorrectly states that Warton changed "the allegorical species" to "visions and antiquities." The mistake, however, is suggestive; Warton does tend to move away from "allegories" to "antiquities."
[20] *Observations* (1762), II, 112. [21] *Ibid.*, II, 88.
[22] *Ibid.*, II, 113. Here and elsewhere in the chapter, Warton takes his views of allegory from *Réflexions critique sur la poësie et sur la peinture* (Paris, 1719), I, sections 24 and 25, which had been translated by Thomas Nugent in 1748.
[23] *Observations* (1762), II, 98.
[24] *Rambler* 37, 24 July 1750, Johnson's *Works* (Oxford, 1825), II, 185.

The most famous attack upon "indecent" allegory is of course Johnson's harsh words on "Lycidas."[25] In Warton's edition of Milton's *Poems upon Several Occasions* (1785), he framed a defense that reveals both his minds about the allegorical species. "Our author has been censured for mixing religious disputes with pagan and pastoral ideas. But he had the authority of Mantuan and Spenser, now considered as models in this way of writing. Let me add, that our poetry was not yet purged from its Gothic combinations; nor had legitimate notions of discrimination and propriety so far prevailed, as sufficiently to influence the growing improvements of English composition. These irregularities and incongruities must not be tried by modern criticism."[26] Warton invokes historical justifications for "Lycidas" while implicitly conceding Johnson's argument, the irregularity and impropriety that modern critics legitimately condemn. Although he affirms his love for the poem, he will not claim that its allegory is respectable. "He who thus praises will confer no honour."

Much of the same double attitude towards allegory and towards early English poetry of the allegorical species informs the criticism of the "onlie begetter" of Warton's *History*, Richard Hurd.[27] The importance of the *Letters on Chivalry and Romance* can easily be overestimated, and of late critics have rightly chosen to emphasize how much of Hurd's writing is casual and conventional.[28] We have already noted how carelessly the *Letters* redeem "Gothic" poetry by admitting it to be barren of philosophical or historical truth but relishing its very "deceits."[29] As a critic Hurd is an amphibian. He accepts the prejudices against medieval wildness and credulity—he knew the medieval romances only through Sainte-Palaye and Chapelain[30]—and ingeniously re-

[25] *Lives of the Poets*, I, 165. The religious basis for Johnson's attack is emphasized by Warren Fleischauer, "Johnson, *Lycidas*, and the Norms of Criticism," *Johnsonian Studies*, ed. Magdi Wahba (Cairo, 1962), pp. 235-56.

[26] *Poems upon Several Occasions* (London, 1785), p. 35.

[27] Hurd's influence on Warton is heavily emphasized by Edwine Montague, "Bishop Hurd's Association with Thomas Warton," *Stanford Studies in Language and Literature* (1941), pp. 233-56.

[28] See for instance Hoyt Trowbridge's introduction to the Augustan Reprint Society's edition of Hurd's *Letters* (Los Angeles, 1963).

[29] Chapter six, section seven above.

[30] See V. M. Hamm, "A Seventeenth-Century French Source for Hurd's *Letters on Chivalry and Romance*," *PMLA*, LII (1937), 820-28. Arthur Johnston, *Enchanted Ground* (London, 1964), pp. 60-74, discusses Hurd's views of epic and romance.

verses the argument by preferring wild epics to more regular art. Facile conjectures like these seem to cost him very little thought. With the same ease he could defend the aesthetic priority of Horace or Spenser, truth or allegory, and accommodate his tastes to each new context.

Hurd's influence, however, rests not on his tastes so much as on his willingness to defend any taste on systematic principles. Without being consistent, he consistently pushes his apologetics to an extreme. The *Letters* exalt Renaissance literature by arguing that its most controversial feature, the adoption of "romantic fictions," surpasses classical form as a source of the sublime; a dissertation "On the Idea of Universal Poetry," starting from the premise that the end of the art is to please through figurative expression, deduces that poetry "prefers not only the agreeable, and the graceful, but, as occasion calls upon her, the vast, the incredible, I had almost said, the impossible, to the obvious truth and nature of things."[31] This habit of mind, dubbed by Hoyt Trowbridge "systematic relativism,"[32] impressed Hurd's contemporaries far more than his supposed originality or historical knowledge. According to Samuel Johnson, "Hurd, Sir, is one of a set of men who account for every thing systematically; for instance, it has been a fashion to wear scarlet breeches; these men would tell you, that according to causes and effects, no other wear could at that time have been chosen."[33] And Warton, in the same letter in which he engaged to write the *History*, paid appropriate tribute to Hurd's *Letters*: "I have the vanity to say, that I was always of your Opinion on this Subject. But it was reserved for You to *display the System*."[34]

Yet all Hurd's systems could not help a historian of English poetry to learn or interpret the facts on which his work must depend. By assuring Warton that his poetic genius would enable him to pierce through the clouds of the mere antiquarian, Hurd was tempting him to be ashamed of his own proclivities for research. The possession of a system *a priori* dulled the search for a

[31] Hurd's *Works* (London, 1811), II, 9. The dissertation was first published in 1766.

[32] "Bishop Hurd: A Reinterpretation," *PMLA*, LVIII (1943), 457.

[33] *Boswell's Life of Johnson*, ed. G. B. Hill and L. F. Powell (Oxford, 1934), IV, 189.

[34] *Bodleian Quarterly Record*, VI (1931), 303. The italics are Warton's.

better inductive understanding. Indeed, Warton's shift of emphasis in 1762 from "the allegoric species" to "visions and allegories" may already reflect an ominous tendency to impose modern systems on history. Whatever the inadequacy of "allegory" as a formula for describing early poetry, the historian who followed the development of the allegoric species was at least reading and comparing literary works in a literary form. In contrast, the historian who concerned himself with visions could forsake literature for excursions into psychology, or conjectures about the poet's romantic heart. One of Hurd's favorite quotations is Theseus' speech in *A Midsummer Night's Dream*—"The poet's eye, in a fine frenzy rolling"—and he does not always discriminate the poet from his cousins, the lunatic and the lover. "A legend, a tale, a tradition, a rumour, a superstition; in short, any thing is enough to be the basis of their air-form'd *visions*."[35] A history based on principles like these would often be content to invite the reader to dream along with Chaucer.

Another idea popularized by Hurd was still more dangerous: the notion that "Gothic" poets, even at their most outlandish, were describing the romantic life they saw around them. As the *Observations* put it, "In reading the works of an author who lived in a remote age, it is necessary, that we should look back upon the customs and manners which prevailed in his age."[36] From the standpoint of literary history, this notion represents progress towards a better understanding of the past. Warton and Hurd, however, associated their historical relativism with a doctrine passed on by William Warburton, "that the Romances of Knight errantry are pictures of life and manners."[37] Warburton's unusual enthusiasm for Warton's History-to-be—"in so noble a work as you are engaged in, every common labourer should be at the service of the master-builder, who works so generously for an ungratefull age"[38]—may be explained partly by his belief that Warton, like Hurd, was his disciple in treating medieval poems

[35] *Letters on Chivalry and Romance*, ed. E. J. Morley (London, 1911), p. 136. Warton knew, however, that visions could also be formed from classical literary precedents; see the *History of English Poetry*, II, 218-19.

[36] *Observations* (1754), p. 217. As R. S. Crane has pointed out (*University of Toronto Quarterly*, XXII), this principle of "circumstantial" criticism is a commonplace that goes back at least to Quintilian.

[37] Warburton to Warton, 5 Dec. 1770, *Percy Letters*, III, 170.

[38] *Ibid.*, p. 172.

as historical documents. "I believe I was the first, who gave the hint, that those extravagant compositions were a rude picture of life and manners."[39] As a picture of life, however, early English poetry needed to be studied only for the customs and relics it described. The effect on the historian is once more to view the poem as source material for some other kind of study. Insofar as poems deal with antiquities, they claim our interest in the strange and quaint, not in art. Few poets, of course, excepting Warton's own contemporaries, seem quaint to themselves. By founding his *History* upon customs and manners, Warton made way for digressions on any antique remnant that might intrigue his own private sense of the past.

The *History* was to suffer for want of a more precise definition of early poetry. Though Warton, having read many of the poems that Hurd speculated about without reading, never rivalled his friend as a systematic relativist, he was easily lured into visionary rhapsodies, and conjectures on medieval customs. Yet the fault belonged not so much to Hurd as to the precedents they both shared. Joseph Spence interested himself in the career of Joseph Warton, Warburton in that of Thomas,[40] and the disparity between the examples they offered to a historian of English poetry increased the difficulty of his task. Was Warton to satisfy the critic or the antiquarian, the man of taste or the man of learning, the poet or the philosopher? Such questions faced him practically and concretely, and he found no answers in books, nor in well-meaning demanding letters from friends.

The immediate focus of Warton's problems, once he had collected his materials, was the design in which his book was to be cast. In the absence of a precedent, he could choose a structure suitable to some "idea of a universal poetry," or else a more open form capable of accommodating any number of ideas. Like Spence, he could write a narrative history; like Warburton, he could compile a series of copious but unrelated notes loosely aimed at proving an ingenious theory (perhaps the theory that English poetry before Spenser consisted in visions and allegories). To some extent, he eventually picked a more congenial way, and

[39] *Ibid.*, 24 Nov. 1770, pp. 168-69.
[40] See John Wooll, *Biographical Memoirs of the late Rev*[d]. *Joseph Warton, D.D.* (London, 1806), and the Letters of Eminent Persons appended by Wooll.

chose both. But Warton never came free from the confusion of influences that had overtaken the *History* in the moment of its genesis. Instead, he fell back on the methods that he already knew, the new developments in literary history that had been nurtured in the 1750's by him and his brother Joseph.

3. THE *Observations on Spenser* AND THE *Essay on Pope*

When Joseph Warton collected his brother's poems for the posthumous edition of 1791, he prefaced them with an unnecessary announcement: "A Reader of taste will easily perceive, that the ingenious Author of the following Poems was of the SCHOOL of SPENSER and MILTON, rather than that of POPE."[41] The Wartons had been making this distinction frequently for over forty years. Their father himself had been a Spenserian and Miltonian; and when he died in 1745, Jane Warton, insisting that "He must not lie in his cold Grave, among/ Poor shrieking Ghosts, unprais'd, unwept, unsung," appealed to "Lycidas" for aid, and Joseph Warton made a "wish for tender *Spenser*'s moving Verse" to mourn him.[42] Moreover, as early as 1747 Joseph's satire "Ranelagh House" had used the Devil to advocate "that Mr. Pope took his place in the Elysian fields not among the Poets but the Philosophers, and that he was more fond of Socrates's company than Homer's."[43] But the full contrast of schools was confirmed by the complementary works with which the brothers established their reputations as critics of English poetry: Thomas' *Observations on Spenser* (1754; rev. 1762) and Joseph's *Essay on Pope* (I ,1756; II, 1782).

The *Observations* and the *Essay* have always been coupled together, and indeed they have much in common. Each tries to reassess the stature of a major English poet, and to consider his relevance to the poetry of the present day; each was assembled from a collection of notes and marginalia, and then developed into "systematic elaborate commentary" filled out with scholarly digressions. Furthermore, the brothers discussed each other's work,

41 *Poems on Various Subjects* (London, 1791), advertisement.
42 Thomas Warton the Elder, *Poems on Several Occasions* (London, 1748), pp. 223, 227.
43 Reprinted by Wooll, *Memoirs of Joseph Warton*, p. 178.

and provided materials and suggestions that tended to coordinate their points of view still more.[44] Yet in spite of their surface resemblance, the *Observations on Spenser* and the *Essay on Pope* do not represent the same kind of criticism. As precedents for a *History of English Poetry* they lead in different directions.

They differ first of all because of Thomas Warton's modest intentions. The *Observations on the Faerie Queene of Spenser* promulgate no theory, and they seldom stray far from marginalia. Most of their generalizations about Spenser's art are tucked into the first section, "Of the plan and conduct of the Fairy Queen," and even here Warton sounds more apologetic than speculative. "Though the *Faerie Queene* does not exhibit that oeconomy of plan, and exact arrangement of parts which Epic severity requires, yet we scarcely regret the loss of these, while their place is so amply supplied, by something which more powerfully attracts us, as it engages the affection of the heart, rather than the applause of the head."[45] That undefined something hardly constitutes a critical theory. Rather, Warton tries to suspend judgment, to find a plausible justification for Spenser which will not indict his peculiar accomplishment. He struggles to keep his critical options open.

The will to be flexible, to bend criticism to the special nature of Spenser's poem, pervades the *Observations*. By scanning the opening and closing pages of each section we can summarize Warton's ideas, but only at the cost of misrepresenting the long stretches between. Some chapters, for instance the ninth, "Mr. Upton's opinion, concerning several passages in Spenser, examined," are wholly miscellaneous; and others, like the tenth, "Of Spenser's allegorical character," adopt so many different perspectives that even Warton could not discover what he thought. In the last and by far the longest section, "Containing miscellaneous remarks," Warton abandons even the pretext that his work follows any pattern not lent it by assorted problems in the *Faerie Queene* itself. The scope and form of the *Observations* are determined by the variety of its responses to and information about a text.

By the time that he came to write his postscript, Warton had

[44] See the letters printed by Wooll, especially pp. 214-224.
[45] *Observations* (1754), pp. 12-13.

decided that his piecemeal and various approach was a positive merit. "Mechanical critics will perhaps be disgusted at the liberties I have taken in introducing so many anecdotes of ancient chivalry. But my subject required frequent proofs of this sort." Steadfastly pursuing his subject, he had been forced to enrich and modify the historical method itself. "It was my chief aim, to give a clear and comprehensive estimate of the characteristical merits and manner, of this admired, but neglected, poet. For this purpose I have considered the customs and genius of his age; I have searched his cotemporary writers, and examined the books on which the peculiarities of his style, taste, and composition, are confessedly founded."[46] Although Warton had not invented this method, he had carried it out with a thoroughness that impressed all sides. Horace Walpole praised his profundity, and Warburton thought him capable of rescuing antiquarianism from the wits.[47]

The most significant compliment, however, came from a critic who never mistook novelty for originality, Samuel Johnson. "I now pay you a very honest acknowledgement for the advancement of the literature of our native Country. You have shown to all who shall hereafter attempt the study of our ancient authours, the way to success, by directing them to the perusal of the books which those authours had read."[48] Johnson specifically associates the *Observations* with his own *Dictionary*, then nearing completion, in the attempt to supply a context rich enough to make early poets intelligible. Like the lexicographer, Warton had plunged into the "wide sea of words," and helped every man to become his own critic.

The achievement of the *Observations*, then, rests primarily on selfless devotion to the subject. Perhaps Warton's own unwritten poems are the hidden theme of his research, but they are not allowed to intrude. He takes no final stand on the lessons about poetic genius to be gained from Spenser; he journeys along the road to Xanadu, not the road to Parnassus. His finest theo-

[46] *Observations* (1762), II, 266; 263-64.

[47] Their letters are printed by Wooll, pp. 281-84. When Warton praised the *Anecdotes of Painting*, Walpole replied "how can you, Sir, approve such hasty, superficial writings as mine, you, who in the same pursuits are so much more correct, and have gone so much deeper?"

[48] 16 July 1754; *The Letters of Samuel Johnson*, ed. R. W. Chapman (Oxford, 1952), I, 56.

retical success was to have evolved a theory so flexible and indefinite that it offended no one. If Thomas Warton had begun with the intention of defending a school, his defense had gone so deep that it was recognized at once to have left all schools behind.

Joseph Warton, on the other hand, does not forget his schools. The title of *An Essay on the Genius and Writings of Pope* implies much of its method. As an "essay," rather than "observations," it will set out to prove or test the nature of its subject, not merely to supply information; as a test of "genius," it will consider not only the "abilities" of the poet, but his "kind." Warton is announcing his intention to *classify* Pope. Nor does he leave much doubt about the result, which is anticipated in the first paragraph of the first volume, in the dedication to Edward Young. "I revere the memory of POPE, I respect and honour his abilities; but I do not think him at the head of his profession. In other words, in that species of poetry wherein POPE excelled, he is superior to all mankind: and I only say, that this species of poetry is not the most excellent one of the art."[49] Poem by poem, through eight hundred pages, the *Essay* repeats the distinction heralded by Warton nine years before, and brands Pope a philosopher rather than a poet.

Thus the interest of the *Essay* can only depend on the search for principles according to which Pope is to be excluded from the first rank of his art. "We do not, it should seem, sufficiently attend to the difference there is betwixt a MAN OF WIT, a MAN OF SENSE, and a TRUE POET. Donne and Swift were undoubtedly men of wit, and men of sense: but what traces have they left of PURE POETRY?"[50] The examples here are conventional —a few years earlier, for instance, Cibber's *Lives of the Poets* (1753) had remarked that Donne's "Hymn to God the Father" "breathes a spirit of fervent piety, though no great force of poetry is discoverable in it"[51]—but the words TRUE and PURE seem to promise a definition of the essence of poetry.

Unfortunately, the most notable critical quality of the *Essay* is a weakness for tautology. When Warton divides the English poets into four degrees, the first consisting of Shakespeare, Spen-

[49] *Essay on Pope* (London, 1806), I, i-ii.
[50] *Ibid.*, I, ii.
[51] "Cibber's" *Lives* (London, 1753), I, 211.

ser, and Milton, the second of noble moralists, the third of men of
wit, the fourth of mere versifiers, and adds that "In which of
these classes POPE deserves to be placed, the following Work is
intended to determine,"[52] his answer is predestined. We embark
on a long journey through the works of the poet only to confirm
the first idea of the critic. Nor does the conclusion prove more
satisfying. "Thus have I endeavoured to give a critical account,
with freedom, but it is hoped with impartiality, of each of
POPE's works; by which review it will appear, that the *largest*
portion of them is of the *didactic, moral,* and *satyric* kind; and
consequently, not of the most *poetic* species *of poetry.*"[53] Given
the categories, a glance at the table of contents of Pope's poems
would have told us as much. Since Pope's genres have been con-
signed to inferiority from the first, genres criticism of his works
can only move through a monotonous circle to a foregone
conclusion.[54]

The natural reaction to this trial by definition is the annoyance
that spurred Johnson to his famous peroration in the *Life of
Pope.* "It is surely superfluous to answer the question that has
once been asked, Whether Pope was a poet? otherwise than by
asking in return, If Pope be not a poet, where is poetry to be
found? To circumscribe poetry by a definition will only shew the
narrowness of the definer, though a definition which shall ex-
clude Pope will not easily be made." Johnson's first thought had
been still more blunt: "To circumscribe poetry by a definition
is the pedantry of a narrow mind."[55] Games played with words
reveal far more about the player than about the realities he names,
and Joseph Warton's play with "true and pure" poetry reflects
upon him, not upon the poet whose title he seeks to remove.[56]

Indeed, Warton's literary career makes a rare study in cautious
self-interest. The publication history of the *Essay on Pope* is

[52] *Essay on Pope,* I, vii, viii. [53] *Ibid.,* II, 401-2.

[54] A long attack on Warton's "ingenious" definitions of poetic genius was mounted
by Ruffhead's *Life of Pope* (London, 1769), pp. 329-60. Cf. P. F. Leedy, "Genres
Criticism and the Significance of Warton's Essay on Pope," *JEGP,* XLV (1946),
140-46.

[55] *Lives of the Poets,* ed. G. B. *Hill* (Oxford, 1905), III, 251 and n.

[56] G. B. P. Schick, *Joseph Warton's Essay on the Genius and Writings of Pope:
An Introduction and Commentary* (unpublished Ph.D. dissertation, Chicago, 1953),
defends Warton from this line of argument by emphasizing his ability to balance
between opposing qualities and categories.

so complicated as to have been the subject of an entire (and by no means definitive) book,[57] but even a glance will descry a multitude of strategies and debts. The first volume, published anonymously in 1756, used Warburton's edition and friendly help from Spence; its revised second edition of 1762 changed the crucial list of poets to suit the suggestions of the *Monthly Review*.[58] Darker strategies, however, surround the second volume of the *Essay*. Nearly completed, and half printed, in 1762, it did not appear for twenty years. We have a choice of reasons: caution, ambition, procrastination;[59] or as Johnson told Boswell, "we should have no more of it, as the authour had not been able to persuade the world to think of Pope as he did."[60] Yet when the complete *Essay* came out in 1782, it had been timed to reply to the critics. Johnson's indirect attack on the narrowness of the definer was rebuffed by a bolder denial of Pope's poetic genius, and other rebuffs may be detected in praise for the profundity of the "Essay on Man," and especially in the closing words of Warton's book, which contend that Pope "has written nothing in a strain so truly sublime, as the *Bard* of *Gray*."[61] Similar retaliations also mark Warton's later edition of Pope's *Works* (1797). Again and again he returned to the subject, not to modify his own point of view, nor to put the poet in a clearer light, but to devise new strategies and arguments "to persuade the world to think of Pope as he did."[62]

Nevertheless, the *Essay on Pope* has an importance beyond its artificial definitions and personal ambitions. If we do not learn to our satisfaction why Pope is not a poet, we do learn something about where poetry is to be found. Johnson himself, reviewing

[57] W. D. MacClintock, *Joseph Warton's Essay on Pope: A History of the Five Editions* (Chapel Hill, 1933).

[58] See Hoyt Trowbridge, "Joseph Warton's Classification of English Poets," *MLN*, LI (1936), 515-18.

[59] These are the reasons suggested by the most recent study, Joan Pittock, "Joseph Warton and his Second Volume of the *Essay on Pope*," *RES*, n.s. XVIII (1967), 264-73.

[60] *Boswell's Life of Johnson*, II, 167.

[61] *Essay on Pope*, II, 405. See James Allison, "Joseph Warton's Reply to Dr. Johnson's *Lives*," *JEGP*, LI (1952), 186-91.

[62] See W. L. MacDonald, *Pope and His Critics* (London, 1951), pp. 299-330. The argument was carried into the next generation by Percival Stockdale, William Lisle Bowles, and Isaac D'Israeli. The part of the world persuaded by Warton is well represented by Bowles' *Letters to Lord Byron on a Question of Poetical Criticism* (London, 1822).

the *Essay* on its first appearance, had conceded as much: "He must be much acquainted with literary history, both of remote and late times, who does not find, in this essay, many things which he did not know before."[63] The definition of poetic classes pales into insignificance beside the excited discovery of poets themselves: Dante and Boileau, Garth and Fracastorius. By far the greatest part of the *Essay* consists of asides in which Warton spares none of his knowledge and feelings. "I cannot at present recollect any painters that were good poets; except Salvator Rosa, and Charles Vermander, of Mulbrac, in Flanders." "Were it not for the useful mythological knowledge they contain, the works of Ovid ought not to be so diligently read." "None of the Roman writers has displayed a greater force and vigour of imagination than TACITUS, who was, in truth, *a great poet*."[64] Warton crams every page full of enthusiasms. Perhaps he is "an enthusiast by rule," perhaps "his taste is amazement,"[65] but his love of poetry never seems to flag.

Thus the *Essay* moves outward from its ostensible subject and grows into an anatomy of poetry at large. No one author or one literature sets bounds for it. "Warton's way of finding analogies between ancient and modern writers, and, indeed, of drawing even upon medieval and 'Gothic' authors, is due to the habit of mind which is accustomed to consider literature, and all knowledge as one great whole."[66] In the *Essay* Pope is once again the cause of literary history in others; his attempt to draw all past poetry into his own work becomes a pretext for considering the past rather than Pope. The processes of literary history themselves constitute the subject of Warton's inquiry, and the materials he evaluates. In its own erratic way *An Essay on Pope* is the history of poetry that Joseph Warton never wrote.

It is not, however, a brother to the history that Thomas Warton did write. If the *Essay* encourages the view that all literature forms

63 Johnson's *Works* (Oxford, 1825), VI, 46.

64 *Essay on Pope*, I, 150; II, 25; II, 164.

65 *Boswell's Life of Johnson*, IV, 33; Johnson as reported by William Windham's *Diary*, quoted by G. B. Hill in his edition of the *Letters of Samuel Johnson* (New York, 1892), II, 441.

66 E. J. Morley, "Joseph Warton: A Comparison of his *Essay on the Genius and Writings of Pope* with his Edition of Pope's *Works*," *Essays and Studies*, IX (1924), 102.

one great whole, the *Observations* demonstrate the unique co-incidence of each artist with his own historical setting. If the *Essay* places Pope within a hierarchy that stretches from Homer to Gray, the *Observations* insist that it is absurd to judge Spenser according to the practice of poets outside his own tradition. The *Essay*, literally indebted to Spence and Harris for tastes and categories, defines historical principles; the *Observations*, borrowing materials from Warburton and Oldys, develop historical methods. The two works complement each other, but they do not meet in a single precedent for literary history.

The contrasting possibilities open to the first historian of English poetry caused him real uncertainty. Like his brother, Thomas Warton found it congenial to think of literature as a dialectical argument between classes, between Reason and Feeling, pure and adulterated poetry, the didactic and the sublime. Yet the habit of his own mind was not confrontation but reconciliation. Although Joseph advised readers of taste that his brother's poems embraced the school of Spenser and Milton against that of Pope, the most lasting and representative of those poems, "Verses on Sir Joshua Reynolds's Painted Window at New-College, Oxford" (1782), uses Pope's own couplets and style to celebrate "truth, by no peculiar taste confin'd,/ Whose universal pattern strikes mankind," and "to reconcile/ The willing Graces to the Gothic Pile." Constitutionally Thomas Warton had no desire to represent a school.

Moreover, he was not sure that, as a scholar, he could believe in schools of English poetry. Were poets like Spenser not beyond the reach of any formula? Even Joseph Warton, trying to estimate Pope in terms of genres and classes, had been forced to break the framework of his categories with constant digressions and interpolations. Apparently such classification could not provide a principle of structure for a history of poetry. A better principle was required, something to combine the sweep of the *Essay* with the penetration of the *Observations*. As Thomas Warton awoke to the full extent of his commitment as a historian, he began to realize how difficult it would be to work his way of reconciliation between thousands of particular facts and an idea of English poetry.

4. The First Volume of the *History*

On April 15, 1770, Thomas Gray, at the request of Hurd, belatedly sent Thomas Warton a letter containing his sketch of a history of English poetry. The reply was both prompt and gracious. Warton praised the admirable construction of the plan, paralleled it to his own, and gave his thanks. "Although I have not followed this Plan, yet it is of great service to me, and throws much light on many of my Periods, by giving connected views and Details."[67] There was only one indication, in fact, that Warton was flatly rejecting Gray's sketch: he wrote of his own design as if it had already been executed. Evidently he wished to suggest that, excellent as the Pope-Gray-Mason plan might be, it had come too late for its schools to be incorporated into his own work. Four years passed before the first volume of the *History* was published. If he had chosen, Warton might yet have adopted the lucid model of English poetry that the two great poets of the century had joined in formulating. He did not make that choice. The plan summarized the main line of eighteenth-century thought about the history of poetry, and it outlined the history which literary men had wanted; but the time when Warton might have used it was already past.

By 1774 Gray had been dead for three years, and Warton could state his objections more frankly.

> I am apprehensive my vanity will justly be thought [great], when it shall appear, that in giving the history of English poetry, I have rejected the ideas of men who are its most distinguished ornaments. To confess the real truth, upon examination and experiment, I soon discovered their mode of treating my subject, plausible as it is, and brilliant in theory, to be attended with difficulties and inconveniencies, and productive of embarrassment both to the reader and the writer. Like other systems, it sacrificed much useful intelligence to the observance of arrangement; and in place of that satisfaction which results from a clearness and a fulness of information, seemed only to substitute the merit of disposition, and the praise of contrivance. The constraint imposed by a

[67] 20 April 1770; *Correspondence of Thomas Gray*, ed. Toynbee and Whibley (Oxford, 1935), III, 1128.

mechanical attention to this distribution, appeared to me to destroy that free exertion of research with which such a history ought to be executed, and not easily reconcileable with that complication, variety, and extent of materials, which it ought to comprehend.[68]

Politely turning his back upon schools and systems, Warton opens his history to the full complicated play of illimitable information.

The experiments through which Warton arrived at this decision had consumed many years. In 1762 the task of writing the *History* had not seemed so formidable, but when Warton died in 1790 his great work had reached only the end of the sixteenth century. The reason for this delay has always interested students of Warton, and they have suggested plausible explanations: the vast quantity of materials to be mastered, and the change of method they necessitated.[69] We have also observed the symptoms of danger concealed in the *History* even at its moment of genesis. From an early period Warton was oppressed by a great weight of expectation that he was not sure he could satisfy. He produced a part of the *History* only after a decade of hesitations and false starts.

Some clues to the ground for Warton's hesitations are exposed by his correspondence with Thomas Percy. From the first Percy took the lead in their antiquarian exchanges. His opening letter was perfectly calculated not only to interest Warton[70] but to supply him with information about the Ballads and the romances that would eventually be put to use in the *History*. Warton responded in kind, and each man benefitted from the scholarship of the other. Yet their exchanges as a whole leave a distinct impression that of the two Percy was the active member, prodding and persevering and lavish with suggestions. Most of Warton's letters begin with apologies for delay, while the tactful Percy has almost too much energy: "Were I at the fountain head of literature, as you are, I should be tempted to transcribe some of the curiosities that lie mouldering in your libraries for publication.—

[68] *History of English Poetry* (London, 1774), preface, I, iv-v.

[69] Wellek, *Rise of English Literary History*, pp. 171ff.

[70] Shenstone, when shown the letter, wrote Percy that it "must engage him to serve you, to the utmost of his Power"; 5 July 1761, *The Letters of William Shenstone*, ed. Marjorie Williams (Oxford, 1939), p. 582.

I am persuaded this of James would be acceptable to the public, both to the Antiquarians and men of taste."[71] Confronted by such an appetite for antiquities, Warton sometimes takes on the aspect of a dilettante. He speaks too easily of "Anecdotes of antient Manners, so amusing to the Imagination," or of making "another Excursion into Fairy-Land."[72]

The contrast is misleading; Warton took his scholarship seriously. But even a serious scholar of the eighteenth century was likely to worry about fatiguing his audience, and likely to miscalculate the enterprise of reconciling the man of taste with the antiquarian. Percy himself affords a cardinal example. Having converted Shenstone from man of taste to antiquarian, he ran afoul of his own creation when Shenstone bitterly resented the liberties taken with the Ballads.[73] Moreover, the popularity Percy gained by "improving" his *Reliques* eventually came near costing him his otherwise well-earned scholarly reputation. No antiquarian could expect to please both Walpole and Ritson, yet most antiquarians felt obliged to try. Sensing both attitudes in his audience, sharing both himself, Warton experimented with methods that would not prove an "embarrassment both to the reader and the writer."

His first experiment seems to have been a plan resembling the sketches by Pope and Gray that he later rejected. The manuscript "Plan of the History of English Poetry" cannot be dated, but internally it comports better with Warton's hopes of 1762 than his publication of 1774. Here Warton presents a clear and simple line of poetic progress, in five easy stages, which may be further simplified as follows: 1) "The old British Bards not yet lost"; 2) after Pierce Plowman, Gower, and Chaucer, "Poetry received a considerable Improvement from Lydgate, who is the first English Poet we can read without hesitation"; 3) "The Allegoric & inventive Vein seem'd in a little time to be lost. . . . But that bad Taste did not reign long; for S. Hawes soon restor'd Invention, & improved our Versification to a surprising Degree"; 4) "the

[71] 28 Nov. 1762, *Percy Letters*, III, 69. The work in question is the *Lamentation of King James I.*

[72] Pp. 129, 130.

[73] See Leah Dennis, "Thomas Percy: Antiquarian *vs.* Man of Taste," *PMLA*, LVII (1942), 140-54; W. J. Bate, "Percy's Use of his Folio-Manuscript," *JEGP*, XLIII (1944), 337-48; A. B. Friedman, *The Ballad Revival* (Chicago, 1961), chapter VII.

first classical age of this country," in which Wyatt and Surrey "are the very first that give us the sketch or shadow of any polish'd Verse"; 5) "A fine Harvest of Poësy now shew'd itself in Q. Elizabeth's reign."[74] Few of Warton's opinions changed between the time of this plan and the *History*, but the clear line of progress soon became smudged. The assertive good taste summarized by the outline could not appeal to Warton's inner antiquarian. Too much material, too much poetry, too many visions had been left out. The plan probably had been intended to be exhausted in a single volume, but the eventual three volumes of the *History* barely reach the Elizabethan harvest.[75]

In some respects Warton might have written a better history of poetry had he continued with his first plan. With more limited ambitions the *History* might, of course, have been finished. It would certainly have focussed more directly on poetry. When Warton put aside his outline, he made room for a medley of assorted curious facts quite irrelevant to the development of poetic language and versification. There is no hint in the plan of such motley as section IV of the first volume of the *History*: *"Examination and specimens of the metrical romance of* Richard the First. *Greek fire. Military machines used in the crusades. Musical instruments of the Saracen armies. Ignorance of geography in the dark ages."*[76] Antiquities, not merely antique poetry, become the subject. Distending the method he had fashioned in the *Observations*, Warton often allows background information to take precedence over the literature in the foreground.

Indeed, the emphasis on antiquarian lore is far from incidental to the first volume of the *History*. At some point in preparing his work Warton seems consciously to have decided that a history of early poetry could not exclude the customs and artifacts that give body to the play of the imagination. He expected their strangeness to charm his readers as he himself was charmed. Like Charles Burney, he would seize upon any diversion. When Burney wrote Warton in 1771 to ask him for "any thing . . . relative

[74] The entire plan is printed by Rinaker, *Thomas Warton*, p. 83.

[75] Warton seems to have stopped work on his *History* by 1783. At his death, in 1790, he left 88 pages of a fourth volume in print. An additional fragment has been edited by R. M. Baine, *A History of English Poetry: An Unpublished Continuation* (Los Angeles, 1953), as no. 39 in the Augustan Reprint series.

[76] I, contents, ii.

to my subject" that Warton had come across in his reading, he added that "it is impossible to give a history of Music which will not necessarily include a history of Poetry."[77] By then Warton himself must have judged that a history of poetry should necessarily include a history of past civilizations.

Still another experiment, however, was necessary to reconcile the antiquarian with the man of taste. The first volume of the *History of English Poetry* begins with two long dissertations, one "On the Origin of Romantic Fiction into Europe," the other "On the Introduction of Learning into England." Neither had been provided for in the early plan. According to Warton they serve to consider "some material points of a general and preliminary nature, . . . to establish certain fundamental principles to which frequent appeals might occasionally be made, and to clear the way for various observations arising in the course of my future enquiries" (viii). This explanation, especially in its claim of "fundamental principles," seems inscrutable until we perceive that the dissertations taken together pose just that dialectic of romance and learning, illusion and reason, which Warton balanced throughout his career. Before he could write his *History* he was compelled to establish alternating poetic currents, the dilemma of heart and head that allowed him to function.

It is therefore entirely appropriate, though hardly intentional, that the first of the dissertations, on romantic fiction, should prove to be fanciful and inaccurate, while the second, on the introduction of learning, should be competent and sober. Warton had been led by Warburton and others into a mistaken belief in the Arabian origin of medieval romances.[78] Like many of his contemporaries, he associated the Orient with wonders, magic, a capricious and extravagant fancy that sometimes was identified with the very sources of imagination. He succumbed to its spell. Hence the first dissertation argues "that even the Gothic EDDA, or system of poetic mythology of the northern nations, is enriched with those higher strokes of oriental imagination, which the

[77] 12 Aug. 1771; printed by Wooll, *Biographical Memoirs*, p. 384.

[78] The most thorough attack upon Warton's errors remains Joseph Ritson's *Observations on the three first Volumes of the History of English Poetry* (London, 1782). Though Richard Price rebuked Ritson for lack of manners, his own edition of Warton's *History* (1824) adopts and improves upon many of his charges. Warton's and Ritson's views of medieval romance are discussed by Arthur Johnston, *Enchanted Ground* (London, 1964).

Arabians had communicated to the Europeans. Into this extravagant tissue of unmeaning allegory, false philosophy, and false theology, it was easy to incorporate their most wild and romantic conceptions" (I, sigg. h4v). The second dissertation, on the other hand, hardly engages in speculation at all. While Warton patronizes the learning of the middle ages—"Their circle of reading was contracted, their systems of philosophy jejune" (I, sigg. d 4)— he does not attempt to compensate for the dryness of the facts with fancies of his own.

The contrast between romance and learning does indeed "establish certain fundamental principles" for the *History* as a whole. They are stated with some fanfare at the end of the second dissertation, after Warton has discussed the replacement of the "twelfth-century renaissance" by schools of casuistry. "But perhaps inventive poetry lost nothing by this relapse. Had classical taste and judgment been now established, imagination would have suffered, and too early a check would have been given to the beautiful extravagancies of romantic fabling. In a word, truth and reason would have chased before their time those spectres of illusive fancy, so pleasing to the imagination, which delight to hover in the gloom of ignorance and superstition, and which form so considerable a part of the poetry of the succeeding centuries" (I, sigg. k 4). Warton never relaxes this dialectical opposition. The first volume of the *History* constantly returns to the mutual incompatibility of fancy and truth, a principle reaffirmed by its last sentence: "As knowledge and learning encrease, poetry begins to deal less in imagination: and these fantastic beings give way to real manners and living characters" (I, 468). According to the kind of poet being considered at a given moment, now one of these alternatives is emphasized, now the other. The two introductory dissertations are the poles between which the *History of English Poetry* fluctuates.[79] From the earliest times, Warton suggests, English poetry has been a battlefield for the illusive Eastern spectres of fancy and the cold Northern light of reason.[80]

[79] The schematic organization of the first volume of the *History* is obscured by the nineteenth-century editions of Price and of W. C. Hazlitt (1871), who gathers all three dissertations (with two additions) into a separate first volume.

[80] This dichotomy is the central subject of the first volume of Paul Van Tieghem's

The issue is confused, however, by Warton's own mechanical view of imagination. Since he tends to locate the spirit of poetry in the objects it represents, rather than in the coloring given objects by the mind of the poet, he verges on saying that past times themselves are poetic. If that is so, then the early poet requires fancy less than accuracy in painting his fanciful surroundings. Thus, in the world of *King Horn*, truth equals fancy: "the pictures of antient manners presented by these early writers, strongly interest the imagination: especially as having the same uncommon merit with the pictures of manners in Homer, that of being founded in truth and reality, and actually painted from the life" (I, 42). Here Warton's two experiments in history writing come together: ancient customs prove to be the force that unites fantasy and reality.[81] By appealing to the reader's own imagination to make poetry out of antiquarian lore, the *History* seeks to fabricate a truthful enchantment.

In practice this reconciliation works only fitfully. Ancient customs, however fascinating, are not poetry, and by pretending that they are Warton forfeits his chance of considering poetry as an art. Satisfied with "artless simplicity," he often forgets to look for principles of construction. He knows that "the poetry of William of Lorris was not the poetry of Boileau," but his own praise for Guillaume errs in the opposite direction by emphasizing his "wild excursions of imagination," and the world he portrays: never before "had descriptive poetry selected such a variety of circumstances, and disclosed such an exuberance of embellishment, in forming agreeable representations of nature" (I, 382). Such criticism finds the source of romance in the magical rose itself. Warton likens poetry to a supernatural nature. He asks his readers to suspend disbelief in an idea his own divorce of truth and fancy contradicts, the idea that once the whole world was made of poetry.

Thus the first volume of the *History* is built upon two experiments that almost cancel each other out: the inclusion of historical facts to appeal to a modern imagination, and the critical principle

Le Préromantisme (Paris, 1924). For a suggestive recent discussion, see G. H. Hartman, "False Themes and Gentle Minds," *PQ*, XLVII (1968), 55-68.

[81] The notion was not of course original with Warton. A familiar example of contemporary literary criticism centering on "manners" is Hugh Blair's *A Critical Dissertation on the Poems of Ossian, the Son of Fingal* (1763).

that imagination cannot withstand modern learning. Chaucer combines these strands. Warton attacks Pope's imitation of *The House of Fame* for having corrected its "extravagancies," its "romantic and anomalous" Gothic principles (I, 396), yet also praises Chaucer for rising above his "gross and ignorant" age to achieve good taste (I, 435, 457). For another historian this inconsistency might have been troublesome. For Warton, however, it was something inherent in the *History* because inherent in poetry itself. In arranging his work to contain both the paraphernalia of imagination and the threats offered to imagination, he was duplicating the processes of his own creative life. To understand the dialectic of the *History of English Poetry*, we must also understand the history of Warton's own poetry.

5. WARTON AS A POET

Perhaps no generation of English poets has ever been more aware of its own impermanence, more oppressed by the burden of the past, more self-conscious, more inhibited, than Warton and his friends. Gray and Collins, the brightest stars, are poets who begin in despondency rather than gladness; they were not sure that they had been born into a world where poetry could be written. "By the middle of the eighteenth century, after a hundred years of the English neoclassic adventure in the arts, we find an almost universal suspicion that something had somehow gone wrong."[82] In Gray's lament that "not to one in this benighted age/ Is that diviner inspiration giv'n,/ That burns in Shakespeare's or in Milton's page,/ The pomp and prodigality of Heav'n,"[83] in Collins' fine series of odes celebrating poetic heights he feels himself unable to reach, poetry solemnizes its own ordeal. Our own controversies about the period, our own difficulty in defining its nature, are merely the latest stage in a series of doubts the age itself formulated.

The state of poetry and of Thomas Warton must be considered together, because poetry was Thomas Warton's life. He grew up in a literary family, surrounded by a father, an elder brother, and a sister who published verse, and he naturally partook in the

[82] W. J. Bate, "The English Poet and the Burden of the Past, 1660-1820," *Aspects of the Eighteenth Century*, ed. E. R. Wasserman (Baltimore, 1965), p. 252.
[83] "Stanzas to Mr. Bentley," lines 17-20.

genius of the household. Indeed, at the age of ten (nine, according to the family story),[84] when he sent his sister "the first production of my little Muse," he could already lisp in numbers. "When bold Leander sought his distant Fair,/ (Nor could the sea a braver burthen bear),/ Thus to the swelling waves he spoke his woe,/ Drown me on my return,—but spare me, as I go." It is characteristic of Warton that his maiden inspiration should be borrowed from the Latin (of Martial); and the sentiment he appends also sounds characteristic. "I agree with you that Friendship, like Truth, should be without form or ornament; and that both appear best in their dishabille. Let Friendship, therefore, and Truth, Music and Poetry go hand in hand."[85]

The extremely artful praise of artlessness here is the stock-in-trade of child performers, and to criticize its preciosity would be taking candy from a baby, but the stance is one that Warton never quite outgrew. Even as Poet Laureate of England he would glorify enthusiasm with calculated rhymes, and count on a younger brother's charm to gain indulgence when "By social imagery beguil'd/ He moulds his harp to manners mild."[86] Early and late the easy sentiment and the strategies by which sentiment is made pleasing are endemic to Warton, and so is the refusal to choose between the claims of sentiment and truth. If the taste for a truth without form or ornament must be called Romantic, then Thomas Warton had discovered Romanticism in 1738, at ten years of age.

Yet Warton's "little young Muse" is of course anything but original. Like everyone else, he patched together his juvenilia from scraps at hand, and his father and brother were happy to supervise. The problem for a young poet who suffers so much encouragement is to retain even a vestige of originality, and Warton's verses display no such vestige. Throughout his career any exotic image can usually be traced to a specific source. Thus one of his best odes may catch our eye, for good or ill, when King Arthur is spirited "Far in the navel of the deep"; until we recall

[84] The official version of young Warton's letter, preserved by Joseph and Jane Warton and published by Richard Mant in *The Poetical Works of the late Thomas Warton* (Oxford, 1802), I, xi-xii, is dated 7 Nov. 1737. However, manuscript evidence discovered by Burns Martin, "Some Unpublished Wartoniana," *SP*, XXIX (1932), 53-67, indicates that the original date was 1738, and that the letter was later revised.
[85] Warton's *Poems* (ed. Mant), I, xi-xii. [86] *Ibid.*, II, 106.

that a similar phrase appears not only in *Comus* but in an ode by the Wartons' good friend William Collins.[87] Thomas Warton was not ashamed to be a debtor in his art. He and his brother supplied lines for each other's poems, and Spenser, Shakespeare, Milton, and later Gray supplied much of the diction. In inspiration and in detail Warton makes his verses out of literature.

Any poetry so doggedly literary is bound to reek of the hothouse. The humility that charms in a child cloys in an adult. "O ever to sweet Poesy, / Let me live true votary! / She shall lead me by the hand, / Queen of sweet smiles, and solace bland!"[88] One can understand why many critics of Warton's poems seem exasperated by them. Moreover, he seems purposely to emphasize his archaisms and tricks of syntax. It has been argued that the Wartons "romanticized" their verse as they revised it for successive publications,[89] and such an argument holds so long as we understand "romanticizing" to mean a more recherché language, not a change of heart. "The Pleasures of Melancholy," written by Thomas Warton at seventeen, acquired a more sensitive and detailed patina of morbidity when he revisited it ten years later, but he betrayed no embarrassment at his youthful attitudinizing. Rather, it was the language, the now unfashionable turns of phrase and image, that required correction. "Fabled banks" became "winding marge," "painted" landscapes became "daedal."[90] In his "Ode on the Approach of Summer" (1753), Warton had put together the "musky wing" from *Comus* and Drayton's "nectar-dropping showers" to give April a "muskie nectar-trickling wing"; in the rewritten "Pleasures," the gods "on nectar-streaming fruitage feast."[91] Warton's pride as a poet demanded that he make

[87] *Ibid.*, II, 60; *Comus*, line 520; Collins' "Ode to Liberty," line 90. Similar chains of derivation are traced in the poems of Warton's father by Leo Kirchbaum, "The Imitations of Thomas Warton the Elder," *PQ*, XXII (1943), 119-24.

[88] "Ode on the Approach of Summer," *Poems*, II, 36.

[89] Arthur Fenner, Jr., "The Wartons 'Romanticize' Their Verse," *SP*, LIII (1956), 501-8.

[90] Lines 256, 248. The first version of "The Pleasures of Melancholy" was published in 1747; the revised version, which is generally reprinted, dates from 1755. Warton's changing taste in poetry at this time can be studied in his selections for *The Union* ("Edinburgh," 1753), the first book to include Gray's "Elegy" and Collins' "Ode to Evening." For the circumstances of Warton's contribution, see D. N. Smith, "Thomas Warton's Miscellany: *The Union*," *RES*, XIX (1943), 263-75.

[91] Line 292. See the notes by Mant, *Poems*, I, 94; II, 4-5.

his words new by steeping them in the nectar-showering phrases of the past.

The classic retort to this poetic formula is Ben Jonson's charge that Spenser "writ no Language,"[92] and in *Rambler* 121 Samuel Johnson applied his namesake's criticism to the "Echoes" of Spenser: "life is, surely, given us for higher purposes than to gather what our ancestors have wisely thrown away, and to learn what is of no value, but because it has been forgotten."[93] Johnson's devastating "Hermit hoar, in solemn cell,/ Wearing out life's evening gray" parodies the inversions of Warton's line, "The morning hoar, and evening chill," and its final recommendation—"Come, my lad, and drink some beer"—reflects Johnson's opinion that Warton had gotten drunk on less wholesome stuff: old English poetry.[94] His other famous lines on Warton's poems are still more explicit. "Wheresoe'er I turn my view,/ All is strange, yet nothing new;/ Endless labour all along,/ Endless labour to be wrong;/ Phrase that time has flung away,/ Uncouth words in disarray:/ Trickt in antique ruff and bonnet,/ Ode and elegy and sonnet."[95] The neoclassical elegance of this critique, its perfectly balanced lucidity, itself rebukes the quest for novelty. Johnson had contrasted "strange" and "new" before, in his criticism of the "bugbear style" of *Letters concerning Mind*,[96] and here again he condemns a labor squandered on manner rather than matter. Beneath all the flourishes and archaisms, he implies, the schoolboy polishes his commonplaces, two and two still make four. Poets like Warton have sacrificed their genuine thoughts and feelings for words, words, words.

From the brunt of this criticism there is no satisfactory appeal; Warton's poems continue to sound as derivative as an echo. Yet at least three answers to Johnson deserve a hearing. The first is provoked by the last line of his epigram, a line that has gone slightly flat. "Ode and Elegy and Sonnet" no longer strike us as

[92] *Timber: or, Discoveries*, ed. G. B. Harrison (London, 1923), p. 70.

[93] 14 May 1751; Johnson's *Works* (Oxford, 1825), III, 80.

[94] Johnson's *Poems* (New Haven, 1964), pp. 294-95; cf. Warton's *Poems*, I, 177. When Boswell defended Warton's style as "owing to his being so much versant in old English poetry," Johnson replied "What is that to the purpose, Sir? If I say a man is drunk, and you tell me it is owing to his taking much drink, the matter is not mended" (*Boswell's Life of Johnson*, III, 158-59).

[95] Johnson's *Poems*, p. 288.

[96] See chapter four, section three above.

ludicrously out of date. Johnson regarded the sonnet as an antique and trifling form, and even Warton's sympathetic biographer, Richard Mant, agreed that "The Sonnet, a species of poetry, foreign to the genius of the English language, and singularly liable to stiffness, was not very suitable to the talents of a man, whose prevailing fault was a want of ease."[97] But Warton's espousal of the sonnet helped give it a new lease on life, and it proved to have resources beyond what anyone could have expected. Similarly, the use of Spenserian stanzas by Warton and his contemporaries may have risen from affectation, but eventually it redeemed Spenserians for serious poetry.[98] The moral, surely, is that old forms have as much future as poets can give them; like the poetry of earth, the poetry of poetry is never dead. Warton's experimentation with phrases that time had flung away bore fruit for later poets.

A second answer to Johnson would defend Warton's preoccupation with poetic idiom by citing two well-known texts: Gray's "the language of the age is never the language of poetry"[99] and Yeats' "Words alone are certain good."[100] A knowledge of the possibilities of English is the one kind of knowledge an English poet cannot do without. From Chaucer to Donne to Pound, poets have broken through by developing a new vocabulary; once the idiom has been achieved, content and feeling will ordinarily take care of themselves. Although Warton's reminiscent diction hardly heralded a breakthrough, a few times he hit upon a strain that English poetry would use again. The strange words he brooded upon became part of the stock of Hunt and Keats. If his language did not exert much influence on Wordsworth, except indirectly through Bowles, we have personal testimony that Warton was a major link in the chain of English poets that led to Southey.[101]

[97] Warton's *Poems*, I, cliv. Cf. R. D. Havens, *The Influence of Milton on English Poetry* (Cambridge, Mass., 1922), pp. 497-98ff.

[98] See E. R. Wasserman, *Elizabethan Poetry in the Eighteenth Century* (Urbana, Ill., 1947), chapter III.

[99] To West, 8 April 1742, *Correspondence of Thomas Gray*, I, 192.

[100] "The Song of the Happy Shepherd," line 10.

[101] See the preface to Southey's *Poetical Works* (London, 1838), and his article on Hayley in the *Quarterly Review*, XXXI (1824), 289. Hazlitt and Scott both admired Thomas Warton's poetry. "Joseph Warton's Reputation as a Poet" is thoroughly documented by Julia Hysham, *Studies in Romanticism*, I (1962), 220-229.

A final answer to Johnson, a consequence of the others, would repeat the familiar charge that he remained indifferent and insensitive to the problems faced by the poets of his time as they strove to escape from a poetic malaise. He exhorted them to be original, yet savagely castigated any deviation from the prosody he had learned in his youth.[102] Perhaps this outworn "classic versus romantic" debate can be focused more clearly by considering once again the function of imitation.[103] Ultimately, Johnson disliked most of the poems of Gray, Warton, and their school not because of prejudice, but because of a sound and abiding truth: "No man was ever yet great by imitation,"[104] and certainly not by the imitation of other poets. Against the current of his time, he directs poets towards the study of nature and the inexhaustibly various modes of life, and away from the mere repetition of the literary past. In the face of much timid and reminiscent verse, Johnson demands that poets learn a more generous recognition of the world around them.

This, everyone will agree, is good advice, both reasonable and manly. It ought to be right. Yet it does not account for the way that poets come into their majority. Almost all poets start as imitators; they do not become *great* by imitation, but they do become *poets* by imitation. One thinks of Pope and his pastorals, of Keats and his Spenser, of Yeats and his Shelley. In itself this fact is not very interesting, because the poet does not become interesting until he has effected a release from the phase of imitation. Yet even that release may be spurred by an imaginative use of imitation. In Johnson's own time, Chatterton somehow "freed" himself as a poet by attempting to forge a medieval style, and the lesson was not lost on such admirers as Scott and Coleridge.[105] If one of the roads to poetic maturity leads through a part of the natural world that has yet to be mapped, another leads through

[102] See M. H. Abrams, "Dr. Johnson's Spectacles," *New Light on Dr. Johnson,* ed. F. W. Hilles (New Haven, 1959), pp. 177-87.

[103] Warton's view of imitation approximates that of Hurd's two dissertations *On Poetical Imitation* (1751) and *On the Marks of Imitation* (1757); cf. Joseph Warton's comments in *Adventurer* 63 (12 June 1753), where he both attacks and defends Pope's imitations.

[104] Imlac's dissertation upon poetry, *Rasselas,* chapter X.

[105] See R. D. Havens, "Discontinuity in Literary Development: the Case of English Romanticism," *SP,* XLVII (1950), 102-111.

the olden world of poetry itself. For the best of reasons, his respect for reality, Johnson could not accept that road as an alternative.

Warton, however, made a different choice, and he was aware that there was no turning back. Indeed, the question of whether or not an authentic poetry can be created out of a withdrawal from life supplies the major thematic conflict of his poems, a conflict rendered unsatisfying and pathetic because he fails to achieve authenticity. Long before he wrote the *History* he had given the names Fancy and Truth to the poles of this conflict, and had learned to reconcile them with belated ease in the last stanza. But he also knew that his work was victimized by his choice. In adopting a purely literary mode, he had cast his lot with a poetry as Arcadian and moribund as the inscription on a grave.[106]

Of all the Graveyard poets, clothing their imaginations with the accoutrements of death, none more consistently than Warton identifies his own imaginative process with the dissolution upon which it broods. A poetry that culls words and images from the dead past is inherently morbid. Thus "The Suicide," Warton's most popular poem, specifically equates the anguish of its desperate poet-hero with his poetic inspiration. "To griefs congenial prone,/ More wounds than nature gave he knew,/ While misery's form his fancy drew/ In dark ideal hues, and horrors not its own." Far more than any lady love, Fancy is the femme fatale here, who has "fill'd his soft ingenuous mind/ With many a feeling too refin'd,/ And rous'd to livelier pangs his wakeful sense of woe."[107] The Suicide is literally poeticized to death. If only his heart had been less romantic, one suspects, he could have eased his pains by visiting Gothic chapels and writing a history of English poetry.

Another voice, however, also speaks in "The Suicide," the "cherub-voice" that brings all the poetry to a close. "Forbear, fond bard, thy partial praise;/ Nor thus for guilt in specious lays/ The wreath of glory twine:/ In vain with hues of gorgeous glow/ Gay Fancy gives her vest to flow,/ Unless Truth's matron-

106 A similar conjunction among inscriptive verse, the imagination, and images of death (turned toward nature rather than literature) is richly elaborated by G. H. Hartman, *Wordsworth's Poetry 1787-1814* (New Haven, 1964).

107 Warton's *Poems*, I, 151; 150.

hand the floating folds confine."[108] The warning applies not only to the bard and his poet-suicide but to the historian of poetry. R. D. Havens complains that the poem "owes its original inception and all its vitality to that very sympathy for the sinner which its apparent purpose is to condemn,"[109] but the word "vitality" belies him. The wooing of death and the poetry of death supply Warton with a drama, not a final resting place, and death without tension has no vitality. All three voices of "The Suicide" belong to Warton: the voice of the melancholy hero, the voice of the bard who imitates him at a safe remove in time, and the cherub-voice of truth that corrects them both.

The *History of English Poetry* is a dialogue among similar voices. Sometimes Warton uses quotation and historical explanation to describe early poetry in its own setting; sometimes he uses sympathy and fancy to assimilate the past to modern poetic sentiments; sometimes he uses modern standards of good taste to shake off all barbaric enchantments. Just as his best poems represent dramatic conflicts, his criticism can hardly operate without the clash and interaction of contradictory elements. Indeed, one reason why the *History* proved so difficult to start and to complete may be that both uncivilized antiquity and the tasteful present offered too few internal contradictions. Only in the period between, the period when Fancy did not stand for death and Truth did not stand for prose, could Warton's own poetic spirit hope to find salvation. Chaucer and Spenser and Milton had found the way to poetry without suicide; they survived. In literature, the very stuff of his malaise, Warton looked for a remedy.

6. WARTON AS A CRITIC

The preoccupations of Warton's poetry account for much in his *History*: its fascination with language, its search for precedents, its tendency to entertain and finally rebuke the charms of romantic illusion. In the *History* as in the poetry, language comes first. "My performance, in its present form, exhibits without transposition the gradual improvements of our poetry, at the same time that it uniformly represents the progression of our language"

[108] *Ibid.*, I, 153. In the last section of Gray's "Bard," in which the Bard invokes future poets who, like Spenser, will dress "Truth severe" in "fairy Fiction," Milton appears with "A Voice, as of the Cherub-Choir."

[109] Havens, *SP*, XXV, 46.

(I, v). Warton often views poems as philological documents which demonstrate a progressive reform in diction and versification.[110] When he introduces Chaucer by remarking that he "has been pronounced, by a critic of unquestionable taste and discernment, to be the first English versifier who wrote poetically" (I, 341), the critic to whom he refers is Johnson, the work the *Dictionary*; and the standard of "poetically" is modern correctness. The praise of Surrey obeys similar standards: "Surrey, for his justness of thought, correctness of style, and purity of expression, may justly be pronounced the first English classical poet" (III, 27). For Warton as for Harris, literary criticism and history are themselves subheadings of "philology," and the study of language takes precedence over the study of works of art.

Warton's emphasis on language colors many of his judgments. Lydgate, for instance, assumes enormous historical importance because "philology was his object" (II, 52); proficient in polite learning, he had mastered both language and literature, and had attained "all the subtylte of curious makyng in Englysshe to endyte" (II, 70). Moreover, he could be read. "On the whole I am of opinion, that Lydgate made considerable additions to those amplifications of our language, in which Chaucer, Gower, and Occleve led the way: and that he is the first of our writers whose style is cloathed with that perspicuity, in which the English phraseology appears at this day to an English reader" (II, 52). Unlike other kinds of historical development, the advance of perspicuity is easy to judge and easy to compare, and at times the *History* substitutes it for any other historical criterion.

Nevertheless, Warton himself lacks expert linguistic knowledge. While sufficiently adept to see through Chatterton's forgeries— "Of these old words combinations are frequently formed, which never yet existed in the unpolished state of the English language: and sometimes the antiquated diction is most inartificially misapplied, by an improper contexture with the present modes of speech" (II, 155)—he read old poetry less easily and less accurately than his correspondent Percy.[111] Ritson, of course, thought his philological blunders a scandal. In any case, Warton has little taste for systematic philology. When he writes that Langland's

[110] See Wellek, *Rise of English Literary History*, pp. 181-83.
[111] See the *Percy-Warton Letters*, especially pp. 12-19.

"imposed constraint of seeking identical initials, and the affectation of obsolete English, by demanding a constant and necessary departure from the natural and obvious forms of expression, while it circumscribed the powers of our author's genius, contributed also to render his manner extremely perplexed, and to disgust the reader with obscurities" (I, 266-7), we can guess which reader he has in mind. Indeed, Warton did not perform the one minimal linguistic duty that is expected from professional students of English: he never learned Anglo-Saxon.[112]

Thus Warton, like many of his contemporaries, unconsciously regards polite English of his own day as a linguistic norm even for the past. Langland is accused of "the affectation of obsolete English" simply because he does not measure up to that norm. As Burney judges old composers according to their progress towards harmonic "perfection," so Warton judges the language and versification of old poets according to their progress towards modern English. The combination of this anachronistic prejudice with Warton's own relish for poetic archaisms induces another display of his characteristic ambivalence. On the one hand, nothing offends his modern taste so much as the unimproved and impolite English of a poet like Skelton. "His festive levities are not only vulgar and indelicate, but frequently want truth and propriety. . . . It is supposed by Caxton, that he improved our language; but he sometimes affects obscurity, and sometimes adopts the most familiar phraseology of the common people" (II, 342). On the other hand, he very much appreciates the romantic "taste for ornamental and even exotic expression" (I, 109) with which Spenser had retarded the progress of English.[113] Warton applies Gray's dictum that "the language of the age is never the language of poetry" with a vengeance; from poets of the distant past he demands a language that looks to the future, and from poets after the Renaissance he prefers a language that looks to the past.

The result of this Janus-faced view of language is a permanent split in the *History* between appreciation and criticism, or between

[112] Warton's deficiencies are surveyed by A. M. Kinghorn, "Warton's History and Early English Poetry," *English Studies*, XLIV (1963), 197-204.

[113] The long fourth section of the *Observations on Spenser*, "Of Spenser's stanza, versification, and language," concludes that Spenser's archaic prosody helps to contrive romantic effects.

what Warton calls the judgments of fancy and of reason. Wearing the formal robes of a critic, he can be a severe linguistic purist, preferring the language of *Gorboduc* to that "tumid phraseology" introduced when "our poets found it in their interest to captivate the multitude by the false sublime, and by those exaggerated imageries and pedantic metaphors, which are the chief blemishes of the scenes of Shakespeare, and which are at this day mistaken for his capital beauties by too many readers" (III, 363). Wearing the softer garb of a lover, he revels in "the mystic web which had been wove by fairy hands," "the gorgeous veil of Gothic invention" (III, xcvii). By the end of the *History*, when the critic has largely won the battle, his cherub-voice seems to have persuaded the fond bard to forbear his partial praise for such trappings of language.

If "philology" in the narrow sense governs much of Warton's criticism, however, he also practices "philology" in its wider sense of polite learning or comparative literature. "Nothing more fully illustrates and ascertains the respective merits and genius of different poets, than a juxtaposition of their performances on similar subjects" (III, 236). The technique developed in the *Observations on Spenser,* and so highly praised by Johnson, of directing attention to the author's predecessors and contemporaries, was congenial to Warton as a poet and as a historian. His own poetry offers the pleasures of recognition; we are meant to decipher and enjoy its copious cross-references to Spenser and Milton. Richard Mant's handsome two-volume edition of Warton's *Poems* is luxuriously footnoted with borrowed lines and phrases, not because he considers the work a classic but because it contains an anthology of classics. Similarly, the *History of English Poetry* is historical primarily by virtue of its awareness of literary derivations.[114]

Thus Warton praises Stephen Hawes' *Temple of Glass* for its good taste in precedents. "We must acknowledge, that all the picturesque invention which appears in this composition, entirely belongs to Chaucer. Yet there was some merit in daring to depart from the dull taste of the times, and in chusing Chaucer for a model, after his sublime fancies had been so long forgotten. . . .

[114] See F. S. Miller, "The Historic Sense of Thomas Warton, Junior," *ELH*, V (1938), 71-92.

In the mean time, there is reason to believe, that Chaucer himself copied these imageries from the romance of GUIGEMAR. . . . Although, perhaps, Chaucer might not look further than the temples in Boccacio's THESEID for these ornaments" (II, 215). And Boccaccio too has his sources. In the absence of critical principles more strenuously defined, the hunt for precedents dominates the *History*. The study of verbal and descriptive parallelisms, which had arisen in classical scholarship and later been transferred to the plays of Shakespeare, made its first full approach to English poetry in Warton's volumes.

Along with the virtues of comparative source studies, Warton also exhibits their problems. Once the critic has discovered a source, he may tend to overestimate its importance; and Warton's criticism, like his poetry, often wanders off into the past when it might better clarify the text presently at issue. Hawes is given the merit of choosing Chaucer, and Warton asks the merit of choosing romance. The critical principle involved is stated by a note in Warton's edition of Milton's *Poems upon Several Occasions:* "The best poets imperceptibly adopt phrases and formularies from the writings of their contemporaries or immediate predecessours."[115] As Coleridge comments in his marginalia, "This, no doubt, is true; but the application to particular cases is exceedingly suspicious." If the "Yet once more" of "Lycidas" echoes Sidney's "Yet once againe," then "Why, in Heaven's name! might not 'once more' have as well occurred to Milton as to Sidney?"[116] Warton breaks the poem into a collection of literary reminiscences, and his criticism seldom employs any faculty beyond his well-stocked memory of phrases.

Coleridge's running argument with Warton's source studies is climaxed by a cry of dismay. "Perhaps no more convincing proof can be given that the power of poetry is from a *genius, i.e.,* not included in the faculties of the human mind common to all men, than these so frequent 'opinions,' that this and that passage was formed from, or borrowed, or stolen, etc., from this or that other passage, found in some other poet or poem, three or three hundred

[115] The gloss refers to the first line of "Lycidas," p. 2. The circularity of this reasoning is exhibited by Warton's comment in his preface: "Milton, at least in these poems, may be reckoned an old English poet; and therefore requires that illustration, without which no old English poet can be well illustrated" (p. xxi).

[116] *Coleridge's Miscellaneous Criticism*, ed. T. M. Raysor (London, 1936), p. 172.

years elder. . . . That Mr. Bowle or Bishop Newton, or Mr. Cory, etc., should be unable to imagine the origination of a fine thought, is no way strange; but that *Warton* should fall into the same dull cant!!"[117] Like most nineteenth-century critics, Coleridge expects from Warton a dedication to originality that Warton was not prepared to give.[118] Far from accusing Milton of having borrowed or stolen passages, Warton thinks that a fine taste in literary reminiscences constitutes a principal beauty of poetry. He shares the eighteenth-century view that all men possess a poetic faculty—certainly all the members of his family had possessed one—and in practice his criticism fails to judge poetry as an art characterized by its extraordinary unifying or "esemplastic" powers. Warton's *History* celebrates poetic taste and parts, not the wholes made by genius.

Indeed, Warton seldom discusses any poem as a whole. To a modern eye this indifference to unity comprises the original sin of his criticism. He looks for a good image or an amusing detail, for glimpses of a poetical manner and heart and spirit. His long digression on the *Divine Comedy*, for instance, admires many "fine strokes" while utterly misconstruing Dante's notions of form. "Why should we attempt to excuse any absurdity in the writings or manners of the middle ages? . . . But the grossest improprieties of this poem discover an originality of invention, and its absurdities often border on sublimity. We are surprised that a poet should write one hundred cantos on hell, paradise, and purgatory. But this prolixity is partly owing to the want of art and method: and is common to all early compositions, in which every thing is related circumstantially and without rejection, and not in those general terms which are used by modern writers" (III, 241). Warton's sense of comparative literature gives him some insight into Dante's use of Virgil and anticipations of Spenser, but when the time comes for a sense of poetic form and unity the *History* falls apart. The "reason" with which it conquers "illusion" is not sufficiently reasonable to grasp that even illusions may have their own principles of structure.

[117] *Ibid.*, p. 178.

[118] Young's *Conjectures on Original Composition, in a Letter to the Author of "Sir Charles Grandison"* (1759), whose attack on literary imitation disturbed his friends the Wartons, made far less impression on their criticism than on Coleridge's German mentors.

Warton's disregard for structure, however, reveals not only a critical weakness but his own principle of composition. The *History* turns away from "ingenious systems" and "the observance of arrangement," and embraces the rich disorder, the contradictions and digressions, that Warton and his friends associated with the free play of imagination. Perhaps he fails to see the unity of the *Divine Comedy* because he does not want to see it; Dante's ability to harmonize a sublime imagination with a regular method cannot be fitted to a romantic idea of early poetry.[119] The *History* shuns harmony for compromise, and Warton was used to thriving on compromises. Whether reading poetry or writing its history, he expects not to arrive at a destination but to escape, not to find unity but to enjoy caprice. Out of his resistance to disciplined structures he builds the structure of his *History*.

7. THE ORDER OF THE *History*

The plans of Pope and Gray were put aside. Warton introduces the *History of English Poetry* with a clear idea not of what his book is, but of what it is not. "I have chose to exhibit the history of our poetry in a chronological series: not distributing my matter into detached articles, of periodical divisions, or of general heads. Yet I have not always adhered so scrupulously to the regularity of annals, but that I have often deviated into incidental digressions; and have sometimes stopped in the course of my career . . ." (I, iii-iv). The statement of method seems much less eloquent than the refusal of constraints. Warton vows not to omit anything he deems interesting; and eventually, as we know, he managed to find room for all sorts of material, for a miscellany and a catalogue and an anthology and a storehouse of odd facts. Through all its three volumes the *History* triumphantly eschews a fixed standard of relevancy.

As a result of this evasiveness, different readers construe the point of view of the *History* in different ways. It is easy to exaggerate the clues that we extract from the ellipses of the text. Thus Warton's rejection of a plan based on national schools may look like advocacy of indigenous native traditions; his anti-Catholi-

[119] Cf. Joseph Warton's criticism of Dante (*Essay on Pope*, I, 182-83), which praises "his sublime and original poem, which is a kind of satirical epic." for abounding in images and sentiments.

cism and suspicion of medieval theology—"as their religion was corrupted by superstition, so their philosophy degenerated into sophistry" (I, 339)—may look like approval of the Enlightenment. A reading of the *History* stimulates a hunt for the author's unspecified preconceptions. One suspects that exactly this process accounts for the legend of Warton as romantic rebel. Fastidious demurrers, repeated through a thousand pages, gradually reverberate like an everlasting No. As a famous connoisseur of chaos has written, a great disorder is an order.[120]

Not all readers have been willing to cooperate with Warton in ordering his *History*. Horace Walpole had been among the most encouraging of allies, yet when the first volume of the *History* finally appeared he expressed second thoughts to William Mason. "Well, I have read Mr Warton's book; and shall I tell you what I think of it? I never saw so many entertaining particulars crowded together with so little entertainment and vivacity. The facts are overwhelmed by one another, as Johnstone's [*sic*] sense is by words; they are all equally strong. Mr Warton has amassed all the parts and learning of four centuries, and all the impression that remains is, that those four ages had no parts or learning at all. . . . In short, it may be the genealogy of versification with all its intermarriages and anecdotes of the family—but Gray's and your plan might still be executed."[121] Even an author of *Anecdotes* thought the *History* deficient in form. A still more damaging slur on Warton's sense of organization occurred in 1785, the year he became Poet Laureate, when the satirical *Probationary Odes for the Laureatship* joined him to Sir John Hawkins in its mock Preliminary Discourses.[122] No historian of the arts could ask worse in popular esteem than to be recommended by Hawkins.

Yet the *History of English Poetry* is not a chaos. It is a more highly organized work than Walpole's *Anecdotes of Painting* or Hawkins' *History of Music*, not because it improves their modes

[120] *The Collected Poems of Wallace Stevens* (New York, 1961), p. 215.

[121] 7 April 1774; *Correspondence* (New Haven, 1955), XXVIII, 143-44.

[122] The *Probationary Odes* opens with two parodies: a "Preliminary Discourse" in Hawkins' name, and "Thoughts on Ode Writing" in Warton's. The main satiric targets in each case are pedantry and diffuseness. One deft touch is that all the odes in the volume are parodies except one: the ode assigned to the new Laureate, which Warton had in fact written earlier that year.

but because it combines them. Walpole's entertaining superiority to his own antiquarianism and Hawkins' profound respect for manuscripts, Walpole's eye for fashion and Hawkins' refusal to acknowledge taste, all come together in Warton. Like Walpole he hardly believes in history, like Hawkins he hardly believes in criticism. But out of his refusal to settle on either mode he develops the contrary voices, the complex negotiations between extremes, that give the structure of the *History* its dramatic interest.

Like many plays in three acts, the *History* reaches a climax at the end of its second part. Most of the second volume chronicles a period in English poetry, the fifteenth century, for which Warton's enthusiasm is restrained. After summarizing the rise of modern letters during the reign of Henry the Eighth, however, he suddenly launches into a retrospect of all the marvels that the modern world has lost. Here, in the most famous moment of the *History*, Warton summons the idea of poetry systematized by Hurd to an eloquent and impassioned eulogy for Romance.

> The customs, institutions, traditions, and religion, of the middle ages, were favorable to poetry. Their pageaunts, processions, spectacles, and ceremonies, were friendly to imagery, to personification and allegory. Ignorance and superstition, so opposite to the real interests of human society, are the parents of imagination. . . . Literature, and a better sense of things, not only banished these barbarities, but superseded the mode of composition which was formed upon them. Romantic poetry gave way to the force of reason and inquiry; as its own inchanted palaces and gardens instantaneously vanished, when the christian champion displayed the shield of truth, and baffled the charm of the necromancer. . . . the lover of true poetry will ask, what have we gained by this revolution? It may be answered, much good sense, good taste, and good criticism. But, in the mean time, we have lost a set of manners, and a system of machinery, more suitable to the purposes of poetry, than those which have been adopted in their place. We have parted with extravagancies that are above propriety, with incredibilities that are more acceptable than truth, and with fictions that are more valuable than reality. (II, 462-3)

There is no other passage in the *History* quite like this; nothing so sustained, nothing so charged with feeling.

To account for that strength of feeling, we shall obviously have to look elsewhere than to Warton's regret over the passing of the fifteenth century. Indeed, from the standpoint of history his fare-well to romance is oddly placed. His own favorite "romantic" poets, Spenser and Milton, waited far in the future, a future where the lover of true poetry would find many wonders un-corrupted by good sense. The sense of loss in Warton's words has little to do with chronology or with particular poems. It can hardly refer even to English poetry, since only Chaucer, of the poets surveyed in the first two volumes, is a name that the *History* conjures with. Rather, what Warton is mourning is a fiction he finds more valuable than reality, a fiction he prizes more strongly because his own historical analysis cannot sustain it: the fiction that judgment and imagination, method and creation, rea-son and poetry are forever separated, both in the world and in the mind.[123] He grieves not for a historical moment, but for a visionary prehistory in which truth was veiled by illusion, and in which all men lived his kind of poetry. From a middle ages made all of fancy, he wakes with regret to a renaissance of reality. It is the dialectic itself that has enchanted him.

Whatever the psychological necessity of such dialectic, the *History* required it as a structural necessity. The second volume of the *History*, like its first, is shaped by polarities; Warton sustains his multitude of facts and lack of plan by exploiting the tension inherent in his own contradictions. In the third volume of the *History*, when he began to see a clear line of progress leading to a poetic harvest, the tensions slackened, and he retracted his con-frontation of poetry and truth. The "Dissertation on the *Gesta Romanorum*" at the head of that volume opens by suggesting a reconciliation between fiction and reality: "Tales are the learn-ing of a rude age" (III, i); and by the end of the volume Warton's whole dialectic had been brought to equilibrium: "we were now arrived at that period, propitious to the operations of original and true poetry, when the coyness of fancy was not always proof

[123] A similar absolute dichotomy is entertained by parts of William Duff's *Essay on Original Genius* (1767), though in other places Duff recommends a poetry in which imagination is tightly controlled by reason.

against the approaches of reason, when genius was rather directed than governed by judgement, and when taste and learning had so far only disciplined imagination, as to suffer its excesses to pass without censure or controul, for the sake of the beauties to which they were allied" (III, 501).[124] Had he progressed much beyond the 88 pages of the fourth volume that have been preserved, his scheme would have forced him to display the triumph of reason, and the *History* would have abandoned visions and allegories for the study of poems. Already in volume three, still more in the continuation, the power of fancy begins to fade, and poetry has begun to belong to the poets, the makers of actual satires and lyrics and sonnets;[125] it ceases to belong merely to the imaginative heart of the historian. Whether the structure of the *History* could have survived this crisis in its dialectic we cannot know. When Warton lost the sharp antagonism between truth and fancy, he seems also to have lost some of his interest in finishing the *History*.

The work he substituted, however, his edition of Milton, supplies some hints about what the *History* might have become. Warton concentrates not on *Paradise Lost* but on Milton's early poems, which revive for him not only the spirit of romance but the dialectic between realistic correctness and fictional inspiration. "It was late in the present century, before they attained their just measure of esteem and popularity. Wit and rhyme, sentiment and satire, polished numbers, sparkling couplets, and pointed periods, having so long kept undisturbed possession in our poetry, would not easily give way to fiction and fancy, to picturesque description, and romantic imagery."[126] Once more Warton constructs a historical distinction based upon a systematic incompatibility between a time and manner favorable to poetry and the good taste that makes poetry wither.

[124] Hurd's dialogue "On the Golden Age of Queen Elizabeth," *Moral and Political Dialogues* (1759), furnishes a clear precedent for viewing the Elizabethan age as a reconciliation of extremes.

[125] Thus the continuation discusses Hall's satires at considerable length because "the first legitimate author in our language of a species of poetry of the most important and popular utility, which our countrymen have so successfully cultivated, and from which Pope derives his chief celebrity, deserved to be distinguished with a particular degree of attention." *History of English Poetry*, ed. W. C. Hazlitt (London, 1871), IV, 368.

[126] Milton's *Poems* (London, 1785), p. iii.

It was left to Coleridge, in a tantalizing note to this passage, to challenge Warton's distinction itself. "It is hard to say which of the two kinds of metrical composition are here most unfaithfully characterised, that which Warton opposes to the Miltonic, or the Miltonic asserted to have been eclipsed by the former. But a marginal note does not give room enough to explain what I mean."[127] What Coleridge did mean, however, may be inferred from what he says in other places, most notably in chapter IV of the *Biographia Literaria,* where Milton is characterized as having an *imaginative* rather than a *fanciful* mind.[128] By praising the early Milton for his "fiction and fancy," Warton commits the kind of divorce between judgment and genius that Coleridge cannot abide. Rather, a great poet writes unified poems from a unified soul where reason and feeling suffer no breach. "I think nothing can be added to Milton's definition or rule of poetry— that it ought to be simple, sensuous, and impassioned; that is to say, single in conception, abounding in sensible images, and informing them all with the spirit of the mind."[129] Coleridge will not accept a rule of poetry, or a history of poetry, that takes rise from fanciful distinctions rather than the synthesis made by the imagination.

Warton's idea of poetry achieved no synthesis, and neither did his *History.* The scheme of the *History* seems to imply a reconciliation of fancy and reason in Spenser, Shakespeare, and Milton, but from his other writings we know that he saw even the greatest poets as impaled on his own dilemma. Their fictions might be more valuable than reality, yet they were not real. Moreover, Warton's relativism admitted no resting place between extremes; the road of excess he liked to travel led forever away from the palace of wisdom. The *History* contrives no permanent order for English poetry.

Nor did Warton find a coherent principle of history. Earlier historians of poetry like Pope and Spence and even Gray could believe in a progress of poetry that had led to their own times; later historians could believe that all great poets join in a single community of genius which acknowledges no progress or division.

[127] *Coleridge's Miscellaneous Criticism,* p. 171.
[128] *Biographia Literaria,* ed. J. Shawcross (Oxford, 1907), I, 62.
[129] Coleridge's *Table Talk* (London, 1836), p. 26; 8 May 1824.

Warton could believe both, or neither. At times he applies the idea of progress dogmatically, at times he dogmatically contradicts it. The *History* describes a steady advance in poetic composition and a catastrophic loss of manners suitable for poetry, and it celebrates the one or deplores the other in an oscillation that ebbs and flows with the momentary feelings of the historian. Warton's lack of ease supplies the *History* with nervous energy, but it arrives nowhere in particular. Like the electricity that bestows light upon darkness, his view of English poetry survives only so long as it keeps in motion. To make a structure from such fluctuating movements was not only Warton's problem but his art.

8. The View from Reynolds' Window

In 1781, the year when the third volume of the *History* was published, Sir Joshua Reynolds at last completed his design for the west window of New College Chapel, Oxford [Frontispiece], a project that had cost him four years of hard work and had ended in disappointment. The following May he received his reward, a poem "by far the best that ever my name was concernd in":[130] "Verses on Sir Joshua Reynolds's Painted Window at New-College, Oxford." The poem has always been considered Warton's masterpiece. Reynolds was transported—"It is a bijoux, it is a beautifull little thing"[131]—and with good reason, because the reputation of his design among his contemporaries probably owes more to Warton than to the window itself. A poor example of Reynolds' art had occasioned the best example of Warton's.

The "Verses on Reynolds's Window" combines many genres and many talents. First of all, it pays sophisticated homage to the tradition of literary pictorialism, and especially to two poems it invokes with verbal parallels: Dryden's epistle "To Sir *Godfrey Kneller*" (1694) and Pope's "Epistle to Mr. Jervas" (1716).[132] Like his greater predecessors, Warton honors the friendly rivalry of *ut pictura poesis* by recreating with words the painter's images. Fur-

[130] Reynolds to Warton, 13 May 1782; *Letters of Sir Joshua Reynolds*, ed. F. W. Hilles (Cambridge, 1929), p. 95. Other letters of Reynolds discuss the planning of the window (pp. 58-61).

[131] *Ibid.*, p. 94. Cf. Northcote's *Life of Sir Joshua Reynolds* (London, 1818), II, 105-109.

[132] See the comments by Mant in his introduction to Warton's *Poems*, I, cxlvi-cxlvii, and in his notes, I, 54-62.

thermore, his praise displays the fine tact of a connoisseur. Reynolds had miscalculated the effect of light and shade necessary on glass, so that his colors benefit little from the natural light of the window.[133] Noticing this, Warton responds as if "Those tints, that steal no glories from the day,/ Nor ask the sun to lend his streaming ray:/ The doubtful radiance of contending dies,/ That faintly mingle, yet distinctly rise;/ 'Twixt light and shade the transitory strife" were a special beauty. Rejecting the more spectacular old-fashioned stained glass—"Ye Colours, that th' unwary sight amaze,/ And only dazzle in the noontide blaze!"—Warton asserts that Reynolds' technique converts the window to the more stable colors of oil painting. "Lo, from the canvas Beauty shifts her throne,/ Lo, Picture's powers a new formation own!/ Behold, she prints upon the crystal plain,/ With her own energy, th' expressive stain!"[134]

Warton's subtle flattery of Reynolds' art bears also upon a second dimension of the poem, its embrace of Reynolds' aesthetic principles. The "Verses on Reynolds's Window," like Herbert's "The Collar," dramatizes the story of a conversion; in Warton's case an aesthetic conversion with religious overtones. The "lingering votary" of the opening section, who has loved to roam where Superstition "With hues romantic ting'd the gorgeous pane,/ To fill with holy light the wondrous fane,"[135] yields to a softer light, a light that comes not from the sudden blaze of the sun but from the literal object of worship. Reynolds' design for the central New College window is a Nativity scene imitated from Correggio's great *Notte*, in which all the light emanates from the body of the infant Christ. Just as Reynolds' window disdains the scattered brilliance of facets and refractions, the picture he represents is illuminated only by incarnation; the truth of Christian revelation requires no dazzle of superstition, only its own shining reality, to carry immediate conviction. It is this detail, "Heaven's golden emanation, gleaming mild/ O'er the mean cradle of the Virgin's child," that brings on the "pensive bard's" total conversion. "Sudden, the sombrous imagery is fled,/ Which late my vi-

[133] See Derek Hudson, *Sir Joshua Reynolds* (London, 1958), pp. 162-3.
[134] Lines 49-53; 87-88; 91-94.
[135] Lines 25-26. Warton spent many of his vacations touring England in search of Gothic structures. His long note on Gothic architecture in section XI of the *Observations on Spenser* contains several phrases used again in the "Verses."

sionary rapture fed:/ Thy powerful hand has broke the Gothic chain,/ And brought my bosom back to truth again;/ To truth, by no peculiar taste confin'd,/ Whose universal pattern strikes mankind."[136]

The tribute to Reynolds' truth is paid, of course, in Reynolds' coin. Each of Warton's statements of principle could be glossed many times over by the *Discourses*; by Discourse IV, for instance: "The works, whether of poets, painters, moralists, or historians, which are built upon general nature, live for ever; while those which depend for their existence on particular customs and habits, a partial view of nature, or the fluctuation of fashion, can only be coeval with that which first raised them from obscurity"; or by Discourse VII: "A man of real taste is always a man of judgment in other respects; and those inventions which either disdain or shrink from reason, are generally, I fear, more like the dreams of a distempered brain than the exalted enthusiasm of a sound and true genius. In the midst of the highest flights of fancy or imagination, reason ought to preside from first to last."[137] Warton cleverly associates the truths of general nature with the truths of a religion free from superstition and with the undecorated literalness of Reynolds' clear stainless windows. In adopting their "universal pattern," he forsakes the relativism he had shared with Hurd. He even tunes his verses to a more classical measure. The opening show of emotion, sprinkled with Ahs and Gothic attitudes, defers to a steadier satiric beat and an echo of Pope: "Ye Martyrdoms of unenlighten'd days,/ Ye Miracles, that now no wonder raise:/ Shapes, that with one broad glare the gazer strike,/ Kings, Bishops, Nuns, Apostles, all alike!"[138] With Reynolds before him, Warton vows to be blinded no more.

How seriously are we to take this conversion, and how fully can we apply it to the rest of Warton's work? Reynolds himself, thanking Warton, knows better than to be literal-minded about a work

[136] Lines 59-66; 59-60, on Heaven's emanation, first appeared in the second edition of the poem (1783). Warton's theme, the aesthetic and religious conversion effected by the truth of classical art, had been anticipated by Dr. John Brown's ode "The Cure of Saul" (1763). Reacting against the affective theory of music celebrated by Dryden in the illicit passions of "Alexander's Feast," Brown shows a hero soothed and cured by music; celestial harmony, the uncorrupted music known to the ancients, brings Saul back to truth.

[137] *Discourses on Art*, ed. R. R. Wark (San Marino, Cal., 1959), pp. 73, 142.

[138] Lines 83-86. Cf. *The Rape of the Lock*, IV, 120.

of art. "I owe you great obligations for the Sacrifice which you have made, or pretend to have made, to modern Art, I say pretend, for tho' it is allowed that you have like a true Poet feigned marvellously well, and have opposed the two different stiles with the skill of a Connoisseur, yet I may be allowed to entertain some doubts of the sincerity of your conversion, I have no great confidence in the recantation of such an old offender."[139] Reynolds amusingly turns the tables. The reference to Warton's poetic touchstone—"the truest poetry is the most feigning"[140]—slyly calls attention to the paradox involved in the "Verses": a true poet feigns even when he advocates Truth. Warton's own principles convict him of pretending in his very moment of recantation.

The love of feigning, and the virtuosity that espouses either side of an argument with equal pleasure, comprise a third element in the "Verses on Reynolds's Window." Warton has written a small drama that makes use of many voices: the "pensive bard's mistaken strain," the satirist, the dignified critic of art. Moreover, even these voices sound too self-conscious to persuade us of their sincerity. When the bard begs the artist not to "steal, by strokes of art with truth combin'd, / The fond illusions of my wayward mind!"[141] his recognition of his own illusions shows him merely to be playing at waywardness. The poem is stagy, full of effects. In this respect once more it follows Reynolds. In the section of the window to the left of the Nativity, Sir Joshua has painted himself as a shepherd coming to worship,[142] but he looks over his shoulder not at the holy infant but into the chapel; the artist gazes at his audience to direct them toward the effect he has made. Similarly, Warton looks at himself looking at Reynolds. We may well "entertain some doubts of the sincerity" of this art. The mixed mode of the "Verses" asks us to sympathize with the bard's fairy dream, to respect the poet's reasoning, and to admire the "insidious artist's" many fine strokes.

Like Warton's *History*, Warton's poem raises the question of whether so mixed a mode can achieve unity. Reynolds, on this

[139] Reynolds' *Letters*, p. 94. [140] *As You Like It*, III, iii, 20.

[141] Lines 5-6.

[142] The other shepherd is Thomas Jervais, who painted the design of Reynolds' oil painting onto glass. Reynolds also put himself into Warton's poem, when he persuaded the poet to substitute *"Reynolds"* for *"Artist"* in line 101.

score at any rate, had no doubts. "It is short, but it is a complete composition; it is a whole, the struggle is I think eminently beautifull."[143] The whole and the struggle, as no one appreciated so much as Reynolds, are identical in an art based on dialectic. Yet the issue of unity in Warton cannot be resolved so easily. If Reynolds possesses the power he calls Genius, "the power of expressing that which employs your pencil, whatever it may be, *as a whole*,"[144] he attained that power largely from the habit of aspiration that drove his pencil in an unending struggle towards a greater truth and a more nearly ideal nature. His wholes are formed, in other words, from intellectual labor as it is shaped by its quest for perfection. Warton, on the other hand, neither loves labor nor aspires to perfection. He seems to enjoy all his postures equally, and requires no higher pleasure than surrendering at one moment to Spenser, at another to Reynolds. Thus his "struggle," while sometimes "beautiful," envisages no final confrontation; and the *History of English Poetry* entertains contradictory ideas of poetry without striving to join them in a single idea. Thesis and antithesis in Warton bring forth no synthesis.

What Warton does pursue, however, is the appearance of reconciliation. With that last effect he puts an end to the struggle of the "Verses." "REYNOLDS, 'tis thine, from the broad window's height,/ To add new lustre to religious light:/ Not of its pomp to strip this ancient shrine,/ But bid that pomp with purer radiance shine:/ With arts unknown before, to reconcile/ The willing Graces to the Gothic pile."[145] To judge the force of that reconciliation in Warton's mind, we should have to solve the ambiguous riddle of "arts unknown before." Were those arts unknown before to *Reynolds* (because he had not previously designed a painting for glass)? Were they unknown to the Gothic artists who designed the other windows before the advent of neoclassical technique? Or were they arts unknown before the present moment, new arts of reconciliation that promise a future in which Fancy and Truth will join? The last seems the most probable intention, yet it is hardly satisfactory. Practically speaking,

[143] *Letters*, p. 94.
[144] *Discourses*, p. 192. Discourse XI was delivered December 10, 1782, seven months after the "Verses."
[145] Lines 101-106.

400

as Leslie and Taylor pointed out long ago,[146] graces like Reynolds' do not suit with the pomp of Gothic cathedrals, and only absurd wishful thinking could believe that modern art would improve ancient shrines. Moreover, Warton himself has just argued that the charms of Reynolds' truth "deception's magic quell,/ And bind coy Fancy in a stronger spell," and he has instructed the older stained-glass pictures to "No more the sacred window's round disgrace,/ But yield to Grecian groupes the shining space."[147] Having presented Fancy and Truth as irreconcilable antagonists, Warton stoops to the impossible, and reconciles them.

Indeed, Warton's "Verses," like Warton's *History,* solves the conflict of its opposing strains only by taking refuge in enthusiasm. Classic graces coexist with Gothic pile because they are "willing"; the amiable observer agrees to enjoy them both alternately, and to enjoy his role either as bard or critic. To be sure, such mixtures sometimes approach bad taste or a lack of principle. Coleridge, who thought "that in point of *Taste* in the Fine Arts, and in first principles of Criticism, . . . there can be little doubt that we have the advantage over our Forefathers," could hardly understand the Wartons' willingness to compromise. With enough imagination to see through the shallow taste of neoclassical critics, "the Wartons first adventured a timorous attack, the censure so neutralized by compliments and half-retractions, that it might remind one of a Wasp staggering out of a Honey Pot, with both wing and sting sheathed in the clammy sweetness."[148] Neither in his verse nor in his *History* could Thomas Warton keep from wavering. Equally fond of his conversion and his relapse, he provides something to please and to offend every party, and tactfully avoids noticing that in principle both sides remain as unreconciled as ever.

Thus the art of Warton's "Verses," and the art of Warton's *History,* is an art derived from tergiversation. His weakness for pastiche, his pleasure in apostasy, his rapid maneuvering between extremes, lead to no clear and distinct idea of poetry. Yet they did produce the first *History of English Poetry* in form and at

[146] *Life and Times of Sir Joshua Reynolds* (London, 1865), II, 372.

[147] Lines 69-70; 89-90.

[148] British Museum MS. Egerton 2800, ff.66, 54-55. Reprinted by Kathleen Coburn, *Inquiring Spirit* (London, 1951), pp. 159; 157.

large. Untrustworthy, sophisticated, and eclectic, Warton incorporated contradictory notions into a long work that men of different minds would rewrite and reuse for a century. A historian of firmer principles would probably not have accomplished so much. An antiquarian, a man of taste, a philosopher, a critic, a poet could each have made a partial history, but Warton made a history for them all; a history whose oscillations found room for all their misgivings. The plans of Pope and Gray and Warton himself are compromised and reconciled in the *History of English Poetry*.

A plan also exists for the history that Warton did *not* write: a philosophical history of poetry based on "principles of Preference at once more general and more just." According to Kathleen Coburn, Coleridge may have drafted his "Memoranda for a History of English Poetry, biographical, bibliographical, critical and philosophical, in distinct Essays" as early as 1796. Why he never went further with the project, we hardly need ask: his "outline" for the fifth and sixth essays tells its own story.

"5. Shakespere!!! ⎤ Almighty Father! if thou grant me Life, O
 6. Milton!!! ⎦ grant me Health and Perseverance!"[149]
Even a historian granted more health and perseverance than Coleridge, however, would have needed many lives to satisfy his ambitions. As Coleridge dwells upon the requisites of his history, it gradually expands into "the PRODUCTIVE LOGOS human and divine" he also intended to treat "at large and systematically."[150] A critical and philosophical history of poetry demands a complete epistemology.

The eighth essay of the Memoranda exemplifies this process.

8. Modern Poetry . . . with introductory (or annexes?) Characters of Cowper, Burns, Thomson, Collins, Akenside, and any real poet, *quod real* poet, and exclusively confined to their own Faults and Excellencies.—To conclude with a philosophical Analysis of *Poetry, nempe ens = bonum*, and the fountains of its pleasures in the Nature of Man: and of the pain and disgust with which it may affect men in a vitiated state of Thought and Feeling; tho' this will have been probably anticipated in

149 MS. Egerton 2800, f.53. *Inquiring Spirit*, pp. 152, 153.
150 *Biographia Literaria*, chapter VIII, I, 92.

the former Essay, Modern Poetry, i.e. Poetry = Not-poetry, *ut lucus a non lucendo,* and *mons a non movendo,* and its badness i.e. impermanence demonstrated, and the sources detected of the pain known to the wise and of the pleasure to the pleasures [*sic*] to the corrupted—illustrated by a History of bad Poetry in all ages of our Literature.[151]

Here at last a historian of poetry utterly refuses to compromise. Coleridge searches for the essence of bad poetry as well as good, for a history at once entelechy and potentiality, for a poetic that will define the nature of man and knowledge of the good. His prospectus soars into the empyrean. It could not, of course, be brought to earth. Warton planned a history of English poetry that gradually grew beyond his comprehension, but Coleridge began with a dream.

If Coleridge's dream of an ideal history of English poetry has never quite been lost, Warton's compromises and relativism have proven to be more central to the course of literary history. A convert to whatever principle of art he happens to be viewing, Warton makes way for the multiple perspectives of later scholars and critics. Like Reynolds, he persuades his audience to relish even his own self-conscious stratagems. The *History* spurred a heterogeneous conversation about English poetry in which most of us still join.

In one respect, however, the *History* avoided the most interesting literary conversation of all. Its reconciliations came too easily, and they did not go deep enough. The reader who looked to Warton for a sense of how the forces of the past were related to the present received hardly any answer. From the *History* one can learn about an antique poetry ruled by fancy, and can infer a more recent poetry corroded by reason, but one can hardly learn about the "arts unknown before," the combination of fancy and reason that might coalesce to make a new beginning. For the practicing poet, and for the ambitious critic, no poetry is more important than that of the immediate past, the school in which he matures, the model he must surpass. Yet Warton had not confronted eighteenth-century English poetry, nor had he drawn lessons for the future. The ideas of poetry described by the *History,*

[151] *Inquiring Spirit,* p. 153.

like Warton's own poetry, remained essentially moribund. For a conversation less compromised, for a confrontation with an immediate past that could not be safely retired to the fancy, eighteenth-century readers required a work complementary to Warton's *History*. They asked for the *Lives of the Poets*.

The Lives of the Poets

1. THE MULTIPLICITY OF JOHNSON'S *Lives*

WHEREVER the study of the ordering of the arts in eighteenth-century England may begin, in the end it leads to Samuel Johnson. It was Johnson who adapted the lessons of Renaissance criticism to present use, Johnson who dedicated Reynolds' *Discourses* and Burney's *History*, Johnson who taught the public to trust its common sense about the arts, Johnson who stood for the force of reason against which Walpole and the Wartons wove their spells. Without himself being interested in painting or music, Johnson qualified the minds of many critics to think justly;[1] and of poetry he was master. Sooner or later all conversations come round to him. Listening to eighteenth-century colloquy on the arts, sooner or later we listen to his voice.

Thus *The Lives of the Poets* speak to many modern readers with the full authority of the eighteenth century. Of all those contemporary works which strove to present the whole range of an art, the *Lives* alone (with the possible exception of Reynolds' *Discourses*) maintain a living tradition. Moreover, their interest remains so immediate that many critics would like to associate themselves with that tradition. Johnson is our intermediary to the good sense of his age, and almost everyone agrees that the *Lives* represent the permanent value, the *ponere totum*, of eighteenth-century criticism.

Indeed, so much agreement is a little unnerving. Critics who can never by any persuasion be brought to agree with each other yet manage alike to agree with Johnson. Mr. Eliot and Professor Leavis, New Critic and neo-Aristotelian, humanist and theologian, Apollonian and Dionysian, all contrive to adopt him as a spiritual father. "Woe unto me when all men praise me!" One wants to know what the agreement is about. Are the *Lives*

[1] See James Northcote's *Life of Sir Joshua Reynolds* (London, 1818), II, 282.

admired for themselves, or because there are so many ways in which they can be used?

Looking steadily at Johnson's work has never been easy. It is not only that two centuries of Johnsonian scholarship have taught us the difficulty of differentiating the facts of his life from the folk-image, Boswell's hero from Macaulay's eccentric, Young Sam from the Great Cham, and the living author from his legendary personality; it is not only that those who know the delights of reading Johnson have often seemed to be engaged in a perpetual rescue operation, saving him from the prejudices of his enemies and himself, and from their own possessive affection. We have learned to live with many kinds of Johnson. But we often find it hard to separate his problems from ours, his own strong voice from the voice of conscience. What Johnson offers most of his readers, that is to say, is not so much a body of work as a stock of wisdom.

Now, to regard *The Lives of the Poets* primarily as "wisdom literature"[2] is by no means a vulgar error. Most of Johnson's best critics and admirers have always turned to him for sage advice about life. On one level, this attitude can lead to plundering the *Lives* for suitable quotations, but on another it encourages the deepest, most searching personal involvement. Anyone who has read many of the studies of Johnson will recognize a peculiar note, a somber plea for wisdom that sounds like the plea of Rasselas himself. One hears it, for instance, in the best general introduction to Johnson's works: "Because he had seen much of life, his last and greatest work, *The Lives of the Most Eminent English Poets*, is more than a collection of facts: it is a book of wisdom and experience, a treatise on the conduct of life, a commentary on human destiny."[3] Or again, in the most celebrated modern assessment of his importance: "it does not minimize Johnson's criticism or indeed his writing on human experience itself to say that his ultimate greatness lies in the example they provide."[4] So be it. In using Johnson's work as a guide to conduct, these writers are following the central line of John-

[2] A recent statement of this view is M. J. C. Hodgart, *Samuel Johnson and his Times* (London, 1962), pp. 120-24.

[3] Walter Raleigh, *Six Essays on Johnson* (Oxford, 1910), p. 26.

[4] W. J. Bate, *The Achievement of Samuel Johnson* (New York, 1955), p. 233.

406

sonian studies, and one with explicit Johnsonian sanction. "The only end of writing is to enable the readers better to enjoy life, or better to endure it."[5]

Nevertheless, as wisdom-seekers we have also some obligations to our saints. If the accomplishment of the generation of scholars who matured at the turn of this century was to begin to free the Johnson canon from Boswell, from careless texts, and indirectly from the gifted impressionism of Macaulay, perhaps the accomplishment of our own generation has been to take Johnson seriously on his own terms. Before we use him for our purposes, we had better be sure we understand him. And our very interest in his wisdom may impede that understanding. Wisdom literature, especially when it consists of wise sayings, has nothing to do with time or place or circumstances or contexts; it does not depend on specific literary genres or on particular applications. By its nature, wisdom is impersonal and abiding, and adaptable to many purposes. It can occur in a phrase, a word, even (Johnson on Berkeley) a gesture. Thus to study Johnson's wisdom must be to study his eternal aspect, and to put aside his individual works. It may also be to forget everything that makes his works differ from those of any other wise man.

As a wise man, however, Johnson is not quite satisfactory. He has strong, sometimes quirky opinions and, more important, his writings seem actively to resist any final neat formulation. *Rasselas*, of course, is as wise as any work of imagination can be, but *Rasselas* leaves us appropriately with the inscrutable unconsolation of its inconclusive conclusion. Unlike Du Fresnoy or Pascal, Johnson does not set out to purge his works of everything but aphorisms, nor does he construct visible doctrines and systems. Characteristically (and not only in Boswell) his wisdom is responsive, provoked rather than volunteered. We owe our knowledge of Johnson's meditations on evil to Soame Jenyns, and we owe most of his political philosophy to the Whigs and the Americans. If we seek from him a philosophy of life or a philosophy of art, we must make it for ourselves from scraps and fragments.

Nor have scholars been reluctant to do so. Recently a series

[5] From the review of Jenyns' *Inquiry into . . . Evil*, Johnson's *Works* (Oxford, 1825), V, 66.

of books has put together Johnson's opinions to build a regular system of political science, morality, literary criticism, and religion.[6] By demonstrating the coherence of Johnson's thought, these books perform a valuable act of homage. Yet they pay a cost for their coherence: they deliberately reduce to order what Johnson himself chose not to order. Out of a fluid and unpredictable medium they distill wisdom, mere wisdom, and let the rest go. The result is a perennial Johnson whose consistency and wholeness far surpass his reputation of two decades ago, but whose very unity seems at odds with the troubled and various character we once thought we knew.

The Lives of the Poets present this disparity in sharp relief. They are pre-eminently *occasional* masterpieces, and "In an occasional performance no height of excellence can be expected from any mind,"[7] since control of the subject and of time are out of the hands of the author. Here if anywhere Johnson is responding to sources rather than going his own way. Yet at the same time the *Lives* remain his most generally admired work. One by one they are made up of expedients and partialities, but together they seem to constitute something like the essential Johnson.

Why this should be, and what indeed the *Lives* are, has baffled contemporary scholars. Going through the sources of the *Lives* can be a frustrating experience. We learn that even the *Life of Savage*, where Johnson's information should certainly have been first hand and plentiful, depends heavily on earlier published accounts; that the *Life of Addison*, and the much praised *Life of Pope*, add relatively little to previous criticism.[8] Searching for Johnson's originality we are likely to be driven to the form of the whole rather than to any given part, or to ask, with Joseph Wood Krutch, "Is it possible, then, that the novelty of Johnson is merely excellence; that he seems to be doing something new

[6] A partial list should include D. J. Greene, *The Politics of Samuel Johnson* (New Haven, 1960); Robert Voitle, *Samuel Johnson the Moralist* (Cambridge, Mass., 1961); Jean Hagstrum, *Samuel Johnson's Literary Criticism* (Minneapolis, 1952); M. J. Quinlan, *Samuel Johnson: A Layman's Religion* (Madison, 1964); P. K. Alkon, *Samuel Johnson and Moral Discipline* (Evanston, Ill., 1967).

[7] Johnson's *Lives of the English Poets*, ed. G. B. Hill (Oxford, 1905), I, 424; cf. III, 219. Page numerals in the text will refer to this edition.

[8] Benjamin Boyce, "Johnson's *Life of Savage* and its Literary Background," *SP*, LIII (1956), 576-98; "Samuel Johnson's Criticism of Pope in the *Life of Pope*," *RES*, n.s. V (1954), 37-46.

merely because he is doing something better than it had ever been done in English before?" and to give a qualified affirmative.[9] This view of the *Lives* has much in common with the view that they are primarily repositories of wisdom. It accounts for their freshness in terms of Johnson's powers of mind, in an indefinable justness of perception, and it resolves the problem of how the *Lives* are related to their predecessors by claiming that literary traditions and genres are irrelevant in the light of such majesty of conception.

Yet this line of thought, satisfying though it may be as a celebration of Johnson's greatness, does not tell us much about the nature of his achievement. Of course he is great and he is wise; he is, indeed, Johnson. But his greatness takes many different appearances. No study of the *Lives* can be convincing unless it confronts their *lack* of any obvious unity, their formal variety, their passages of hack-work, their ability to please readers whose definitions of greatness have nothing to do with each other.

One modern test of literary greatness, in fact, a test with which Johnson himself would not have agreed, suits *The Lives of the Poets* very well. That is the test of a work according to the number of genres or precedents it is able to fuse together. One reason that critics of opposite persuasions agree about the *Lives* may be that they are not reading the same work. The *Lives* are 1) literary criticism both practical and theoretical, perhaps the finest single collection of literary criticism in English; 2) biography, certainly the most important literary biographies before Boswell; 3) prefaces to a definitive anthology of English poetry (as Johnson himself conceived them); 4) literary and intellectual history, as well as documents in that history; 5) moral and psychological observations, with affinities both to the periodical essay and to the Theophrastan character.[10] In addition, I have suggested, they are generally related to biographical encyclopedias like the *Biographia Britannica*[11] and to the characteristic eighteenth-century English effort to master and order the whole of an art. If Johnson was not doing anything new, he was nevertheless combining an unprecedented amount of the old.

[9] *Samuel Johnson* (New York, 1944), p. 464.
[10] Critics have also linked the *Lives* to sermons on vanity, to Johnson's poems, and to eighteenth-century fiction.
[11] See chapter three, section six above.

Once we perceive the multiplicity of the *Lives*, perhaps we can begin to understand that no one approach will do them justice. The literary critic who searches for literary criticism will find it all too cursory; the seeker after wisdom will often come upon a dry spell. The masterpiece that each of us sees, with a moral strength or intense insight that bears upon our own problems, was not the work in hand that confronted Samuel Johnson. For him the problems were more complicated and more immediate: how to organize his material, how to instruct and impress the public, how to join so many precedents into a consistent whole. *Ponere totum.* Before we see what we can make of *The Lives of the Poets,* we had better see what the author thought he had made.

2. THE GENESIS OF THE *Lives*

To begin with, of course, they were not *The Lives of the Poets* at all but *Prefaces, biographical and critical, to the most eminent of the English Poets.* The story of this project has been often told.[12] On March 29, 1777, while at his prayers of Easter Eve, Johnson was visited by a committee of London booksellers who asked him to supply prefaces for an authoritative edition of the English poets. Their appeal was patriotic as well as commercial: a poor but copious Scottish edition of English poets was being circulated in England, and a joint publishing venture lent authority by Johnson's name would serve to reclaim the market and the copyright for native businessmen. Johnson was most agreeable. Not only did he seem "exceedingly pleased with the proposal," he named a fee far below what he was entitled to demand. Thus "the accidents of publishers' rivalry"[13] stimulated Johnson's masterpiece, written to order for the honor of his nation.

The story is familiar, but a little misleading. For one thing, we know that the nation had been interested in commissioning the *Lives* long before 1777. During Johnson's famous interview with King George III in February, 1767, "His Majesty expressed a desire to have the literary biography of this country ably executed, and proposed to Dr. Johnson to undertake it. Johnson sig-

12 A standard account is the letter from Edward Dilly printed in *Boswell's Life of Johnson,* ed. G. B. Hill and L. F. Powell (Oxford, 1934), III, 110-111.
13 R. D. Altick, *Lives and Letters* (New York, 1965), p. 47.

nified his readiness to comply with his Majesty's wishes."[14] If not *quite* ready, Johnson nevertheless was still entertaining the idea during his tour of the Hebrides in September 1773, when, "Talking of biography, he said he did not know any literary man's life in England well-written. It should tell us his studies, his manner of life, the means by which he attained to excellence, his opinion of his own works, and such particulars."[15] And by 1775 there is evidence that some of the *Lives* were in embryo.[16] Apparently the booksellers were not instigating Johnson's project so much as supplying him with a proper, semi-official occasion for it.

Indeed, their call upon him seems to have been largely ceremonial. Johnson had already heard of the venture; he did not have to interrupt his devotions for very long in order to accept. That he should have waited till Easter Eve to conclude his bargain suggests a solemn covenant. Easter was always his time of fixing himself against indolence, and determining upon new efforts. "I hope for more efficacy of resolution, and more diligence of endeavour,"[17] he prayed the day after the booksellers' visit. In writing the *Prefaces* Johnson was able to pay a long-standing debt, and to answer his personal need "to renew the great covenant with my Maker and my Judge"[18] by undertaking a great contract for the public weal.

He also derived another benefit from his contract. Since his days on Grub Street, Johnson had always taken pride in his ability to turn out copy to order. Especially when he wrote prefaces and dedications, "it was indifferent to him what was the subject of the work dedicated, provided it were innocent."[19] A year before he received the London booksellers, as we have seen, he composed the dedication for the first volume of Burney's *History of Music*, a work of which Mrs. Thrale reports he told the author "The Words are well arranged Sir . . . but I don't under-

[14] *Boswell's Life of Johnson*, II, 40.

[15] Boswell's *Journal of a Tour to the Hebrides*, ed. F. A. Pottle and C. H. Bennett (New York, 1961), p. 204.

[16] The evidence is presented by W. R. Keast in an article on Johnson and Thomas Maurice, to be published in a forthcoming collection of essays in memory of Donald Hyde. See also J. L. Battersby, "Johnson and Shiels: Biographies of Addison," *Studies in English Literature 1500-1900*, IX (1969), 521-37.

[17] 30 March 1777; *Diaries, Prayers, and Annals*, ed. E. L. McAdam, Jr., with Donald and Mary Hyde (New Haven, 1958), p. 264.

[18] *Ibid.* [19] *Boswell's Life of Johnson*, II, 2.

stand one of them."[20] His practice, even his habit, we know, was to write under compulsion of a deadline (the *Rambler*) or extreme financial need (*Rasselas*). Once having been commissioned to furnish the *Prefaces*, he could take refuge in his own professional subordination. The lack of ultimate responsibility, the involuntary compulsion to supply whatever might be necessary at another's demand, comforted Johnson by removing the power to be indolent from his control. Viewing his writings as a salable product rather than a manifestation of self, the hack earns his integrity merely by doing the job well. Boswell, whose own writings were motivated more by thirst for fame than by necessity, did not have a keen grasp of such psychology. "I was somewhat disappointed in finding that the edition of the English Poets, for which he was to write Prefaces and Lives, was not an undertaking directed by him: but that he was to furnish a Preface and Life to any poet the booksellers pleased. I asked him if he would do this to any dunce's works, if they should ask him. JOHNSON. 'Yes, Sir, and *say* he was a dunce.' "[21] Though we, like Boswell, may regret the great man's willingness to put his talents on hire, we should also remember that without that mixture of compulsion and professional pride there would have been no *Lives*.

Unfortunately for Johnson, however, the work he had contracted for was not the work he had been preparing over so many years. The booksellers wanted prefaces, "a *concise* account of the life of each authour,"[22] and Boswell was probably right in inferring that what they desired from Johnson was principally his name: "is not the charm of this publication chiefly owing to the *magnum nomen* in the front of it?"[23] These terms were welcomed by Johnson. From the first he represented himself "engaged to write little Lives, and little Prefaces, to a little edition of the English Poets," and as time passed he reminded his friends that "Little lives and little criticisms may serve."[24] Such a work might have been written entirely from memory. After all, the edition

[20] *Thraliana*, ed. K. C. Balderston (Oxford, 1942), p. 176.
[21] *Boswell's Life of Johnson*, III, 137.
[22] Dilly's letter, *ibid.*, III, 111. Italics mine.
[23] Boswell to Johnson, 24 April 1777, *ibid.*, III, 108.
[24] *The Letters of Samuel Johnson*, ed. R. W. Chapman (Oxford, 1952), II, 170, 231.

was not *his*; "to put *Johnson's Poets* on the back of books which Johnson neither recommended nor revised" would be "impudent" and "indecent."[25] No one could blame him for taking the task lightly, in the spirit in which it was offered. "As this undertaking was occasional and unforeseen I must be supposed to have engaged in it with less provision of materials than might have been accumulated by longer premeditation."[26] He had been asked for very little.

Yet the booksellers received more than they had bargained for. What Johnson supplied, against expectation and against his own desire, was not *Prefaces* to someone else's *Poets* but his own *Lives of the Poets*, a whole new set of volumes. What had happened to those little prefaces and little lives? Johnson's own explanation, in his author's advertisement of March 15, 1779, sounds rather puzzled.

"The Booksellers having determined to publish a Body of English Poetry I was persuaded to promise them a Preface to the Works of each Author; an undertaking, as it was then presented to my mind, not very tedious[27] or difficult.

"My purpose was only to have alloted to every Poet an Advertisement, like those which we find in the French Miscellanies, containing a few dates and a general character; but I have been led beyond my intention, I hope, by the honest desire of giving useful pleasure" (I, xxv-xxvi).

Like Burney and Warton, Johnson had found that the nature of his enterprise demanded an exertion far beyond what he had planned to give. The *Lives* would be written in spite of the publishers, in spite of himself. The reasons why are perhaps more obvious to us than to Johnson. In retrospect, we can see the *Lives* as the "inevitable" outgrowth of his strongest interests, joining his critical abilities with his lifelong analysis of human behavior, on a scale set a third of a century before by the *Life of Savage*. Johnson had already invented literary biography, and he owed the form and the public some masterpieces.

We can also see that Johnson himself knew what he was doing

[25] From a statement in Johnson's autograph, *Boswell's Life of Johnson*, IV, 35n. Cf. Johnson's note to Nichols, *Letters*, II, 360-61.

[26] The author's advertisement to the third edition of the *Lives of the Poets*, I, xxvii; and see the note from Malone.

[27] In the third edition this word was changed to "extensive."

far better than he liked to admit. The sacrifice he offered to his creative process was a pretense that his objectives were limited, his ambitions scanty. Against the relish with which he wrote the *Lives*, expansively and swiftly, he had to balance the anguish and reluctance with which he always associated literary labor. The proportions are very nicely adjusted in a letter to his publisher John Nichols in July, 1778.

"You have now all *Cowley*. I have been drawn to a great length, but Cowley or Waller never had any critical examination before. I am very far advanced in *Dryden*, who will be long too. The next great life I purpose to be *Milton's*.

"It will be kind if you will gather the Lives of *Denham, Butler,* and *Waller,* and bind them in half binding in a small volume, and let me have it to shew my friends, as soon as may be. I sincerely hope the press shall stand no more."[28]

On the one hand, Johnson communicates apologies for length and for delays, and a willingness to eschew the whole project; on the other, pride in having been the first to examine the origins of modern poetry, and eagerness to show his work to his friends. In fact, though Johnson pronounced himself unhappy and dilatory, "he was writing under pleasanter and less lonely circumstances than he had ever written before."[29] We know from Mrs. Thrale and Fanny Burney that, while Johnson was composing the *Lives*, choice parts were read aloud to the Thrales and their guests at the breakfast table.[30] England, as well as the Thrales, expected and deserved some useful pleasure. The *Lives* grew to meet those expectations.

As they grew, however, they changed. The difference in degree between Prefaces and Lives necessarily became a difference in kind. The 311 words which serve to introduce Pomfret may have been the sort of piece for which Johnson was engaged, but the 446 paragraphs devoted to Pope fill out a volume by themselves, a volume whose form is only distantly related to the preface. Whatever Johnson had planned, he had willy-nilly created a new size and shape of literary biography. Out of the tension between the booksellers' commission and the author's preparation

28 *Letters*, II, 254. 29 Krutch, *Samuel Johnson*, p. 457.
30 See Madame d'Arblay's *Memoirs of Doctor Burney* (London, 1832), II, 176-79.

for something greater, the *Lives* took on a form individual to them alone.

3. Precedents for the *Lives*

Johnson began his work needing a mode of procedure modest enough for a preface and expansive enough for a full life. What precedent could satisfy both needs? The search for an answer is described by Hawkins. "When Johnson had determined on this work, he was to seek for the best mode of executing it. On a hint from a literary lady of his acquaintance and mine, he adopted, for his outline, that form in which the countess D'Aunois has drawn up the memoirs of the French poets, in her 'Recueils des plus belles pieces des Poëtes François'; and the foundation of his work was, the lives of the dramatic poets by Langbaine, and the lives of the poets at large by Winstanley, and that more modern one than either, their lives by Giles Jacob, whose information, in many instances, was communicated by the persons themselves."[31] Since this account fits with Johnson's own mention of the advertisements in the French miscellanies, it must be taken as substantially accurate.

The model which Johnson adopted for his outline is very likely the work of Fontenelle,[32] but from the time of its appearance in 1692 it had been attributed to Marie Catherine comtesse d'Aulnoy (Dunnois, Mme. D—, La Mothe). Whatever its correctness, this attribution is significant. As a historian, Countess d'Aulnoy is not trustworthy her modern commentators agree in linking the manner of her memoirs of court to her *contes*, and the editor of her once popular *Relation du voyage d'Espagne* doubts that she has so much as been to Spain[33]—but as a teller of anecdotes she enjoyed the sort of fame which could sell old poets to the public. And the French public needed such encouragement. When the *Recueil* was presented in a new, six-volume edition in 1752, its old-fashioned poems received short shrift. "A la vérité, la précipitation avec laquelle elle fut faite, y apporta des fautes essentielles. Nombre de Vers oubliés, et même des Stances entières, des mots

[31] *The Life of Samuel Johnson, LL.D.* (London, 1787), pp. 532-33.
[32] See George Watson, *The Literary Critics* (London, 1962), p. 94.
[33] See the introduction by Raymond Foulché-Delbosc to his edition (Paris, 1926).

absolument étrangers au sens et qu'il étoit impossible de sup-
pléer, défiguroient la plus grande partie des pièces de ce
Recueil."[34] Just as the name of Johnson was to confer glamor
on a miscellaneous package of poems, the charm of an accom-
plished story-teller might sugar the pill of an anthology of poets
no longer in good taste.

Nevertheless, the *Recueil* is more than an attempt to be amus-
ing at the expense of what is passé. Its author strives both for his-
torical perspective: "De plus, ce qui paroîtra médiocre auourd'hui,
étoit peut-être bon en son temps"; and for a canon and a main
line of French poetry: "il est fait pour donner une histoire de
la Poësie Françoise, par les ouvrages même des Poëtes." Thus
poems are chosen "qui marquoient le mieux le caractere de
l'Auteur, ou du siècle,"[35] and the criticism in the lives consist-
ently, if briefly, associates the poet's biography with his times and
his works. Moreover, there is a familiar readiness to pass moral as
well as literary judgment. Of Chapelle, "La vie libre et volup-
tueuse qu'il menoit, et le peu de soin qu'il avoit de conserver ses
écrits, sont cause de la perte d'une partie de ceux qu'il avoit com-
posés: mais ce qui nous en reste fait assez connoître la beauté
et la délicatesse de son genie."[36] In spite of its patronizing tone,
the *Recueil* is a serious work which tries to gather values and
standards far greater than the sum of the poems it collects.

Yet the student of Johnson's *Lives* will have trouble finding a
precedent here. The lives of the French poets are disposed of in
a few pages each; little effort has been expended on biograph-
ical information; and very few poems are individually analyzed.
Even the general critical statement offered by each preface more
often than not consists of a single concluding quotation of some-
one's epigram or couplet. Searching for a connection, we are
likely to be thrown back onto the bare outline of the French
advertisements, and to decide that "these *notices*, and no other
biographical model before Johnson, use the characteristic struc-
ture of Johnson's own *Lives*."[37] That conclusion is exaggerated
but plausible. It emphasizes the division of each *Life* into three
parts—biography, character, and criticism—and equates the

[34] *Recueil des plus belles pièces des Poëtes françois, tant anciens que modernes,
avec l'histoire de leur vie* (Paris, 1752), I, avertissement.
[35] *Ibid.*, I, vii-viii. [36] *Ibid.*, VI, 40.
[37] Watson, *Literary Critics*, p. 94.

rather scattered general comments which succeed biographical facts in the *Recueil* with the relatively set character study at the center of a typical *Life*. Though the "formula" of the French advertisements is by no means clear-cut or invariable, its design may have suggested to Johnson the form he was to elaborate and make his own.

Moreover, the *Recueil* offers something we rarely find in Winstanley, Langbaine, and Jacob: a direct and personal confrontation with the literature it surveys. While superficial, it is not disconnected; while narrow in taste, it compares each author with the full range of French poetry. In this respect, its reliance upon coherent judgment rather than accumulations of fact, it resembles Johnson's *Lives* more than any English predecessor save one.

The Muses' Library (1737), a "series" or anthology of English poetry with introductory sketches, is a trivial book that is easy to like. Compiled by Mrs. Elizabeth Cooper with the "generous assistance" of Oldys, and printed by Osborne in the year that Johnson began his Grub Street apprenticeship, it radiates conviction and good humor. With genuine originality, *The Muses' Library* "was intended to exhibit a systematic view of the progress of our poetry,"[38] and therefore its criticism traces a main line of English poetry or, as Mrs. Cooper says, "a Sort of *Poetical Chronicle*: which begins with the first dawning of polite Literature in *England*, and is propos'd to be continu'd to the highest Perfection, it has hitherto attain'd; That, in Spite of Difficulties, and Discouragements, it may be hardly possible for us to recede into our first Barbarism; or again lose sight of the true Point of Excellence, which Poetry, beyond all other sciences, makes its peculiar Glory to aim at."[39] In opposition to the school of Phillips, Winstanley, and Jacob, "the Characters of the Authors are not taken on Content, or from Authority, but a serious Examination of their Works," and though Mrs. Cooper may have been overrun by the universalizing enthusiasm of Oldys when she predicted that "In a Word, it may serve as a perpetual Index to our

[38] Henry Headley, *Select Beauties of Ancient English Poetry, with Remarks* (London, 1810), preface, p. iii (first edition, 1787). See also René Wellek, *The Rise of English Literary History* (Chapel Hill, 1941), pp. 142-43.

[39] *The Muses' Library; Or, A Series of English Poetry* (London, 1741), p. ix.

Poetry, a Test of all foreign Innovations in our Language, a general Register of all the little, occasional Pieces, of our Holy-Day Writers (as Mr. *Dryden* prettily calls them) which might otherwise be lost; and a grateful Record of all the Patrons that, in *England*, have done Honour to the Muses,"[40] she was right to claim some significance for her use of the anthology as a critical instrument.[41]

More important, the form of the prefaces in *The Muses' Library* furnishes a useful bridge between the clumsy early "literary biography" of Oldys and the *Lives of the Poets*. Its pattern is simple. Where the poet has some reputation, the preface begins by attaching a short tag to summarize his achievement: Langland, "The Author of the Satire, intitled, *The Vision of Piers the Plowman*, and who may be truly call'd the first of the *English* Poets"; Chaucer, "The Morning-Star of the *English* Poetry!"; Skelton, "The Restorer of Invention in English Poetry!"; Sidney, "Not more remarkable for his illustrious Birth, than his fine Accomplishments: Being acknowledg'd by all, the gallantest Man, the politest Lover, and most perfect Gentleman of his Times."[42] The tag is followed by a paragraph or two of biographical information, chatty rather than learned—Sir John Davies, "being introduc'd to his Majesty, by Name, the King immediately inquir'd if he was *Nosce Teipsum*? (The Title of his first Poem!) and, being inform'd He was, most graciously embrac'd Him, and speedily made him his Sollicitor, and Attorney-General for Ireland"—which in turn is succeeded by a brief character sketch— "Sir *John* [Harington] appears to be a Gentleman of great Pleasantry, and Humour; his Fortune was easy, the Court his Element, and Wit not his Business but Diversion."[43] The last paragraph of the preface often serves to introduce the poems that follow, and is embellished by references to general opinion about the poet, and by remarkably frank and personal critical appreciations. Thus on Spenser: "For my own Part, when I read Him, I fancy myself conversing with the *Graces*, and am led away as irresistibly, as if inchanted by his own *Merlin*. ————

[40] *Ibid.*, p. xv.
[41] B. H. Bronson, "Thomas Chatterton," *The Age of Johnson*, ed. F. W. Hilles (New Haven, 1949), p. 245, argues that "*The Muses' Library*, by and large, in tone and temper, in metrics and subjects, is at the very heart of the Rowleian afflatus."
[42] *Muses' Library*, pp. 7; 23; 48; 55. [43] *Ibid.*, pp. 332; 297.

But to suspend as much as possible this Female Fondness: If the greatest Fertility and Elegance of Imagination are the distinguishing Characteristicks of a Poet, *Spencer* has the Advantage of all who have assum'd the Honour of that Name; and, had He never debauch'd his Taste with the Extravagances of *Ariosto,* He might have vied in Fame (if we may judge by Translations) with the most venerated of the Antients, and deterr'd the most ingenious Moderns from hoping to equal Him."[44]

There is plenty to object to in Mrs. Cooper. She obviously believes (like the author of the *Recueil*) that her own age has achieved a perfection in verse which makes even the best of past ages seem a little quaint; and she overexploits the charming feminine breathlessness that flirts through her pages. Yet for all its informality, the prefatory method she devised has an intrinsic appeal to our interest, an appeal her predecessors had lacked. Offering her own reactions rather than a survey of information, and associating each poet's life with his writings, she becomes like Burney a surrogate for the reader. Johnson, we have seen, developed his own kind of literary biography partly by suppressing an underlying system of antiquarian perpetual commentary, the Oldys in himself. Mrs. Cooper seems to have suppressed her Oldys direct. *The Muses' Library* never allows research to interfere with human and literary interest.

Both the *Recueil des plus belles pièces des Poëtes françois* and *The Muses' Library,* then, offer an abbreviated model for Johnson's *Prefaces to the English Poets,* even if their scale remains too small to suggest the full-grown *Lives.* From Johnson's point of view, however, (whether or not he read them) each lacks something that literary biography cannot do without: a cogent mode of transition from the opening biographical section to the concluding literary criticism. In a casual work of a few paragraphs the gap between life and work might go unnoticed, or be easily covered over by a charming phrase, but in Johnson's own more ambitious efforts it might come to seem a crucial flaw. Johnson himself was highly sensitive to such problems of structural coherence. At the end of a letter to Mrs. Thrale, sent off "while I am seeking for something to say about men of whom I know nothing but their verses, and sometimes very little of them," he paro-

[44] *Ibid.,* p. 255.

dies the style of such as write without clear interconnections. "Now you think yourself the first Writer in the world for a letter about nothing. Can you write such a letter as this? So miscellaneous, with such noble disdain of regularity, like Shakespeare's works, such graceful negligence of transition like the ancient enthusiasts. The pure voice of nature and of friendship. Now of whom shall I proceed to speak? Of whom but Mrs. Montague, having mentioned Shakespeare and Nature does not the name of Montague force itself upon me? Such were the transitions of the ancients, which now seem abrupt because the intermediate idea is lost to modern understandings."[45] In a serious work he would not suffer lack of transition gladly.

Ultimately, of course, Johnson faced one insuperable problem in demonstrating the connection between a poet's life and work: he did not trust such connections. Readers like Boswell, whose pleasure in literature was excited partly by the sentiment of becoming acquainted with the author, aroused his suspicions. A serious critic, Johnson thought, could not indulge the vulgar fallacy of confusing the personality revealed by the poet's life with the genius and powers manifested by his poems. For this reason the *Lives* achieve no perfect formal solution to the structural hiatus between life and work. But in the absence of anything better, the central section on the character of the poet came to assume major importance. Of all the modes of biography, the generalized character study is most flexible. It can be a summary of the facts of a life, or an interpretation of them, or a way of accounting for actions, or a way of diverting attention from actions to a more profound inner life. Furthermore, the character study of a poet offers unique opportunities for covert literary criticism; the "literary character" was the main mode of Dryden's criticism, as it was to be of Arnold's. Describing character, a biographer can mediate between the poet and his poetry with all the subtlety and resourcefulness at his command.

This opportunity had been seized by literary biographers before Johnson. Thus Mrs. Cooper introduces Sidney not with a biography but with an extended panegyric: "may his Fame be ever Dear to Memory! And no *English* Writer ever quote the *Roman Mecœnas* [sic], without first acknowledging his Superior in the im-

[45] 11 April 1780, *Letters*, II, 340-1.

mortal Sydney!" and then catches herself up: "I find my Zeal has lead me into a strange Mistake, I have wrote his Character instead of His Life, whereas his Life had included his Character. — — — — But 'tis in Study just as 'tis in Action, many People see their Faults, but are too fond of them to endeavour at a Cure."[46] Obviously the apology is disingenuous. Mrs. Cooper wrote Sidney's character rather than his life because she wanted to shower undiluted rapturous praise on the writer as well as the man, and no mere life could have included that. Here as elsewhere, character writing can enforce judgments not inherent either in the facts of biography or in the analysis of individual poems.

In his reliance upon the character, Johnson surpasses all predecessors.[47] Formally speaking, the originality of the *Lives* consists in a new weight placed upon this central section, which is both clearly distinct from the rest of the Life and flexibly employed for a variety of purposes. More and more as the *Lives* progressed, the character study became the method by which Johnson attempted to smooth over the awkward transition from life to work. Whether or not he succeeded is a matter of opinion. One critic finds the formula rather barren, and notes that in spite of the character-section "One striking aspect of the *Lives* is the total absence of bridge-passages (which might have been easy enough to invent) connecting the two major sections, the biographical and the critical." Another critic, who considers the three-part division of the *Lives* a practical counterpart to Johnson's critical theory, thinks that in the *Lives* "his characteristic linkage of biography and criticism is brought to perfection."[48] Before we choose between these alternatives, we had better note that the method of the *Lives* is by no means uniform. The center section of the *Life of Cowley*, the famous examen of the metaphysical poets, is not a character at all; the Lives of little poets (for instance Gilbert West) often have no center section, and only a smattering of criticism at the end. Johnson's use of the character evolved to meet specific problems of organization during the

[46] *Muses' Library*, pp. 204-5.

[47] On Johnson's relation to the tradition of "literary characters," see Hagstrum, *Samuel Johnson's Literary Criticism*, chapter III.

[48] Watson, p. 95; W. R. Keast, "The Theoretical Foundations of Johnson's Criticism," *Critics and Criticism*, ed. R. S. Crane (Chicago, 1952), p. 407.

course of making the *Lives*. No one formula could suit both Pope and Tickell.[49]

What Johnson adopted from the form of the French advertisement, in short, was *only* a mode of procedure. He had taken a useful, perhaps even a decisive, hint about the most convenient plan for organizing his work-in-progress, but he had still to construct each Life soundly from the materials at hand. He also needed to adjust the proportions of biography to criticism; because once the size of the preface had been magnified beyond all precedent, he could not be sure that its structure would remain coherent. One by one the *Lives* had to find place for whatever Johnson knew or could learn about the English poets. But for this sort of labor there were quite different precedents.

4. "CIBBER" AND JOHNSON

The Lives of the Poets of Great Britain and Ireland to the Time of Dean Swift (1753), a five-volume work bearing the name of (Theophilus) Cibber, has always been something of an embarrassment to students of Johnson's *Lives*. Most Johnsonians would be much happier without it. For while Cibber's *Lives* undoubtedly are forerunners of Johnson's, they seem to be the sort of forerunner which discredits all that follows. Themselves the product of hack-work and plagiarism and publishing opportunism, they point to whatever in Johnson is merely time-serving and second-hand. The source material they contain makes them necessary objects of study, but the rewards of study are skimpy. And the confusion inherent in the way they were made and in their critical principles has a way of breeding confusion around it.

The tone of condescension that pursues Cibber's *Lives* is sounded by Johnson at the beginning of his own "Life of Hammond": "Of Mr. HAMMOND, though he be well remembered as a man esteemed and caressed by the elegant and great, I was at first able to obtain no other memorials than such as are supplied by a book called Cibber's *Lives of the Poets*" (II, 312). Johnson cites this source only to explain that its author has been misled by false accounts. Hawkins, still more scornful, calls it "a book of no authority other than what it derives from Winstanley,

[49] The criticism of Tickell's poems is scattered through the Life, and it ends with a description of his character.

Langbaine, and Jacob, and in other respects of little worth."[50]
This censure can hardly be confuted. Cibber's *Lives* does borrow
its facts wholesale from other collections, especially from Winstanley, and even its opinions have had the bloom rubbed off them.
Here, for instance, are the critical estimates of Wyatt that appear
respectively in *The Muses' Library* and in Cibber:

In his Poetical Capacity, he does not appear to have much Imagination; neither are his Verses so musical or well polish'd as Lord *Surrey*'s. Those of Gallantry, in particular, seem to me too artificial for a Lover, and too negligent for a Poet; for which Reason I have quoted but very few of them.	In his poetical capacity, he does not appear to have much imagination, neither are his verses so musical and well polished as lord Surry's. Those of gallantry in particular seem to be too artificial and laboured for a lover, without that artless simplicity which is the genuine mark of feeling; and too stiff, and negligent of harmony for a poet.[51]

The forerunner of Johnson is a work put together with scissors
and paste, and seldom does it show signs of a fresh response or
a controlling intelligence.

For this lack of individuality there is, as is well known, the best
of reasons: the authorship of "Cibber's" *Lives* belongs to various
hands. Exactly who may be responsible for what, is beyond discovery, but the basic situation seems clear: the greater part of the
work was first composed by Robert Shiels, at the time a friend of
Johnson and an amanuensis for the *Dictionary*, and was later revised by Colley Cibber's son Theophilus. Although Johnson, who
owned but did not preserve Shiels' manuscript, asserted that his
late friend was the sole compiler of the work, the testimony of
Griffiths (the publisher) and others renders that unlikely.[52] At
any rate, we have just seen that much of Cibber's *Lives* cannot
be called the original composition of Shiels or anyone else. The
Lives are "collected and digested" not by fresh research or writing,

[50] Sir John Hawkins, *The Life of Samuel Johnson, LL.D.* (London, 1787), p. 204.
[51] Left column, *The Muses' Library*, pp. 69-70; right column, Cibber's *Lives* (London, 1753), I, 54.
[52] See the discussions by Johnson, *Lives*, II, 312; *Boswell's Life of Johnson*, III, 29-30 and n.; and D. N. Smith in Raleigh, *Six Essays on Johnson*, pp. 120-25n.

not even by the fitting together of bits and pieces so typical of scholarship, but simply by transcribing assorted comments on assorted poets.

In the light of eighteenth-century publishing practice it would be senseless to denounce the confusions and plagiarisms of "Cibber." Johnson may not have been happy to see a lengthy extract from his still popular *Life of Savage* reprinted at no profit to himself, but he was not above some "borrowing" of his own, even in that same *Life of Savage*.[53] He could also be casual about acknowledging sources. After calling attention to Shiels' errors in the "Life of Hammond," for instance, he corrects him without telling us whence he derives his own better information.[54] We have less reason to wonder about the unoriginality of Cibber's *Lives* than about the comparative independence of Johnson's.

The circumstances of composition of Cibber's *Lives* are interesting, however, if only because of the possibility of Johnson's own involvement. Griffiths hints that "many of the best pieces of biography in that collection were not written by Shiells, but by superior hands,"[55] and Johnson's known contribution of *Savage* and *Roscommon* may lead us to suspect that he gave still more.[56] Did Shiels ask Johnson for his opinions, perhaps even for some critical writings? The question becomes acute when we consider "Cibber's" elaborate comparison of Dryden and Pope, from which "Johnson took ideas and phrases."[57] Here the later *Lives* directly confront the earlier.

"CIBBER"	JOHNSON
The grand characteristic of a poet is his invention, the surest distinction of a great genius.[58]	genius, that power which constitutes a poet; that quality without which judgment is cold and knowledge is inert; that energy which collects, combines, amplifies, and animates....

[53] See Boyce, *SP*, LIII.

[54] He later refers, however, to Dr. Maty, editor of Chesterfield's *Miscellaneous Works* (1777), who seems to be his source.

[55] From a letter printed by Raleigh, p. 122n.

[56] The whole issue is elucidated by W. R. Keast, "Johnson and 'Cibber's' *Lives of the Poets*, 1753," *Restoration and Eighteenth-Century Literature*, ed. Carroll Camden (Chicago, 1963), pp. 89-101.

[57] See Boyce, *RES*, ns. V, 42.

[58] Cf. Johnson on Milton, *Lives*, I, 194: "The highest praise of genius is original invention."

There are not in Pope's works such poignant discoveries of wit, or such a general knowledge of the humours and characters of men, as in the Prologues and Epilogues of Dryden.

[Dryden's] mind has a larger range, and he collects his images and illustrations from a more extensive circumference of science. Dryden knew more of man in his general nature, and Pope in his local manners.

Perhaps it may be true that Pope's works are read with more appetite, as there is a greater evenness and correctness in them; but in perusing the works of Dryden the mind will take a wider range, and be more fraught with poetical ideas: We admire Dryden as the greater genius, and Pope as the most pleasing versifier.

If the flights of Dryden therefore are higher, Pope continues longer on the wing. If of Dryden's fire the blaze is brighter, of Pope's the heat is more regular and constant. Dryden often surpasses expectation, and Pope never falls below it. Dryden is read with frequent astonishment, and Pope with perpetual delight.[59]

"Cibber's" comparison resembles Johnson's closely enough to suggest that Johnson either inspired it, perhaps through conversation, or consulted it, perhaps only in memory. We should note also that the passage is somewhat out of place in Cibber's *Lives*. Set off by itself at the end of "The Life of Pope," in a position usually reserved for a quotation from a leading authority, it is deliberately introduced as a set-piece: "It will not perhaps be unpleasing to our readers, if we pursue this comparison, and endeavour to discover to whom the superiority is justly to be attributed, and to which of them poetry owes the highest obligations."[60] This last phrase, duplicated in a similar set-piece in "The Life of Waller," represents one of the few occasions in Cibber when poetry itself, rather than the career of a particular poet, seems to be at issue. The question we are always conscious of in Johnson's criticism—the silent or specific reference of the human achievement revealed in poetry to human abilities in general—is voiced almost nowhere in Cibber's *Lives* except here.

[59] Left column, Cibber's *Lives*, V, 249-52; right column, Johnson's *Lives*, III, 222-223.
[60] Cibber's *Lives*, V, 248.

As soon as the two comparisons of Dryden and Pope are put side by side, of course, Johnson's superiority will be manifest. Cibber's selection of the strengths of each poet is sensible and distinct, but Johnson's elegant string of aphorisms is one of the great set-pieces of English criticism. Two arguments might be made for Cibber: 1) Johnson's superiority consists "merely" of style, a showy rhetorical virtuosity, not in any essential improvement of thought; 2) "If he had not read *Aminta*, he had not excelled it" (I, 296), that is, Johnson has the overwhelming advantage of knowing the earlier Life. To some extent these arguments are obviously correct. Yet they are also nugatory. Without Johnson's magnificence of style, without his ability to incorporate the best criticism of the past into his own, he would be much less impressive, to be sure, but he would also be much less Johnson. Only a critic who preferred plainness to elegance, and originality to justice, would fault Johnson for his characteristic strengths.

Indeed, Johnson's force and precision are all that bring his originality into question. Certainly originality is not at issue in Cibber's *Lives*. Cibber's or Shiels' "rewriting" of Mrs. Cooper's judgment of Wyatt is amusing, not disturbing, because we expect so little. But Johnson's use of other comparisons of Dryden and Pope (even perhaps of his own) distracts us, because he has taught us to expect better. Insofar as he surpasses his predecessors, he forces his readers to ask for an excellence and freshness they had never before sought from literary biography. The knowledge that he had created this new expectation was what caused Johnson's making of the *Lives of the Poets* to be at once so painful and so pleasurable for him.

Nevertheless, our expectations should not be unrealistic. A comparison of Johnson's *Lives* with Cibber's holds two lessons. The first is that, for all their differences, they share the same materials. Johnson commanded more and better sources of information than any of his predecessors—nor should we underestimate the stock and quality of knowledge compassed by his amazing memory—but he had to write his *Lives* as others had, a fact or a judgment at a time, leafing through and combining his pieces of fact. The ghost if not the spirit of perpetual commentary still haunts Johnson. The structural model he had adopted for his prefaces could not supply much help in making the in-

numerable small scholarly decisions which go into the full-grown *Lives*. In this respect he was retracing his steps over the same grounds where he had led poor Shiels.

The second lesson to be gained from Cibber's *Lives*, however, is its essential difference from Johnson's in critical approach. The earlier compilation provides masses of information but hardly any attitudes or principles to lend them significance; it fails in the leap of sympathy which Johnson thought the basis of all good biography: "All joy or sorrow for the happiness or calamities of others is produced by an act of the imagination, that realizes the event, however fictitious, or approximates it, however remote, by placing us, for a time, in the condition of him whose fortune we contemplate."[61] But beyond that failure, Cibber shirks judgment of the worth of a poem or the nature of English poets and poetry. Johnson is never chary of judgment. His modest determination to call a dunce a dunce has no precedent in English literary biography.

The concluding Lives of each work exemplify their differences. Cibber ends with a tribute paid to a Mrs. Chandler by her brother, who testifies that "She had a real genius for poetry."[62] Johnson, who wrote Lord Lyttelton's brother that "My desire is to avoid offence, and to be totally out of danger,"[63] nevertheless could not resist judging "poor Lyttelton"[64] by the same standards he applied to every other petitioner for fame as an English poet: "The Verses cant of shepherds and flocks, and crooks dressed with flowers. . . . Lord Lyttelton's poems are the works of a man of literature and judgement, devoting part of his time to versification. They have nothing to be despised, and little to be admired" (III, 446; 456). The small insistent voice of truth makes all the trouble, and all the difference.

Indeed, in one respect the contrast between Cibber's diffidence and Johnson's weight of judgment proved almost too great. Johnson was a competitive man and writer, and Cibber (still less his little aide Shiels) offered him no competition. Using many of the same materials as his predecessors, Johnson aimed at something new, the first respectable literary biographies in English, and

[61] *Rambler* 60, Johnson's *Works* (Oxford, 1825), II, 285.
[62] Cibber's *Lives*, V, 354.　　　　[63] 27 July 1780; *Letters*, II, 383.
[64] *Lives*, III, 452. On the resentment caused by this phrase, see Raleigh, *Six Essays on Johnson*, p. 141.

he could not help but be impatient when his gathering of facts led him to resemble the forerunners he despised. If the judgments of *The Lives of the Poets* sometimes seem contentious and harsh, one reason may be Johnson's unwillingness to brook comparison with littler men. His thirst for excellence could not be quenched by the likes of Cibber's *Lives*. Moment by moment, work by work, he would bring judgment and standards where none had been known before. From the conflict between this high resolve and the disorganized smattering of facts which threatened to erode it, *The Lives of the Poets* took their animus. Committed to an excellence he could not yet define, Johnson embarked upon a series of experiments towards a better literary biography.

5. THE *Life of Cowley*

The occasion had been set; the literary world waited; and Johnson rose to the occasion. The *Life of Cowley,* the first of the *Lives of the Poets,* proved to be his own favorite, "on account of the dissertation which it contains on the *Metaphysical Poets,*"[65] according to Boswell, or more narrowly because of its nice "investigation and discrimination of the characteristics of wit,"[66] according to Hawkins. At any rate, the peculiar brilliance of Johnson's *Cowley* is not in dispute. In recent years some sympathetic critics have found it necessary to clarify and defend the basic good sense of Johnson's discussion of the Metaphysicals,[67] but no one has needed to defend its own wit. Making good his promise to improve English literary biography, Johnson evidently took great care. We may well apply his comment on Dryden's early *Essay of Dramatic Poesy,* "laboured with that diligence which he might allow himself somewhat to remit when his name gave sanction to his positions, and his awe of the public was abated, partly by custom and partly by success" (I, 412). The analysis of wit accepts and masters the challenge to excel.

When we try to step back from those few passages that everyone knows, however, and to see the *Life of Cowley* as a whole, it becomes difficult to reconcile Johnson's theory of biography

[65] *Boswell's Life of Johnson,* IV, 38. [66] Hawkins' *Life of Johnson,* p. 537.

[67] See especially W. R. Keast, "Johnson's Criticism of the Metaphysical Poets," *ELH,* XVII (1950), 59-70; David Perkins, "Johnson on Wit and Metaphysical Poetry," *ELH,* XX (1953), 200-17; W. J. Bate, *The Achievement of Samuel Johnson,* pp. 212-16.

with his practice. Much of the best-known part of the Life does not concern Cowley at all. Johnson both promises and refuses to pack his biography with personal details. It is worth noting again that the first of the *Lives of the Poets* begins in the style of perpetual commentary, by referring not to Cowley but to Thomas Sprat, his respected biographer; and the opening clearly implies that Johnson intends to controvert Sprat's principles of biography in order to substitute his own. "The Life of Cowley, notwithstanding the penury of English biography, has been written by Dr. Sprat, an author whose pregnancy of imagination and elegance of language have deservedly set him high in the ranks of literature; but his zeal of friendship, or ambition of eloquence, has produced a funeral oration rather than a history: he has given the character, not the life of Cowley; for he writes with so little detail that scarcely any thing is distinctly known, but all is shewn confused and enlarged through the mist of panegyrick" (I, 1).[68] Surely Johnson is preparing to exhibit Cowley's private life as *Rambler* 60 recommends, in a judicious and faithful narrative.[69]

In fact he is not. The *Life of Cowley* corrects some of Sprat's indistinctness—"His father was a grocer, whose condition Dr. Sprat conceals under the general appellation of a citizen" (I, 1)— and it is stocked with wise reflections on the conduct of life— "The man whose miscarriage in a just cause has put him in the power of his enemy may, without any violation of his integrity, regain his liberty, or preserve his life, by a promise of neutrality: for the stipulation gives the enemy nothing which he had not before; the neutrality of a captive may be always secured by his imprisonment or death" (I, 10-11; *pace* St. Thomas More)—but it contributes little fresh information. By the end of some twenty pages Johnson is ready to admit that his biography is no great improvement. Dr. Sprat "was obliged to pass over many transactions in general expressions, and to leave curiosity often unsatisfied. What he did not tell cannot, however, now be known. I must therefore recommend the perusal of his work, to which my narration can be considered only as a slender supplement" (I, 18). This admission must have been necessitated, of course, by truth:

[68] Johnson here explicitly contradicts Sprat's own claim that he did not intend to write panegyric. See Sprat's "Life of Cowley," reprinted by Hurd with *Select Works of Mr. A. Cowley* (London, 1772), I, 30.

[69] Johnson's *Works*, II, 286.

Johnson really possessed no new sources. But a reader who hoped for relief from "the penury of English biography" might well feel unsatisfied.

Such disappointment, however, would be irrelevant to the main design of the *Life of Cowley*. In criticizing Sprat, Johnson calls attention not so much to his insufficiency of knowledge as to the importance of the spirit of criticism itself. From first to last the *Life of Cowley* derives its special character from Johnson's strong persistent exercise of judgment, his determination to leave no source, no poem, no moral predicament, no philosophical distinction unexamined. The critical dedication to truth borders on ruthlessness. Of Cowley's love poems, we are told "the basis of all excellence is truth: he that professes love ought to feel its power," and our knowledge that Cowley was *not* a lover "cannot but abate in some measure the reader's esteem for the work and the author. . . . No man needs to be so burthened with life as to squander it in voluntary dreams of fictitious occurrences" (I, 6, 7).[70] In all three sections of the *Life of Cowley*, the biography, the dissertation on the Metaphysical poets, the examination of Cowley's poems, a perpetual critical commentary dominates every other kind of organization.

Scrutinizing Cowley in this spirit, Johnson's perpetual criticism serves to treat him as if he were a contemporary. No mist of panegyric, and certainly no haze of historicism, is permitted to screen Cowley or his poems from the hard light of the best modern view. There is no trace of apology or of condescension. In this respect the nearest object of Johnson's commentary is not Cowley or Sprat but Bishop Hurd, whose *Select Works of Mr. A. Cowley* (1772) had already reached three editions. Johnson was originally very irritated at Hurd for having published a "mutilated edition" of selections intended to streamline Cowley for public consumption,[71] and though his anger later abated he never approved Hurd's self-appointed mission as a facile historical apologist. The *Life of Cowley* takes dead aim at the systematic relativists, the "set of men who account for every thing systematically."[72] Johnson insists upon his right to criticize

[70] Cf. Johnson's comment on Prior's love poems, *Lives*, II, 202.
[71] *Boswell's Life of Johnson*, III, 29, 227.
[72] *Ibid.*, IV, 189. See chapter twelve, section two above.

whatever he sees on its own merits, without excisions and without excuses. Rather than use historical arguments to avoid judgment of the past, he condemns any poem or action that serves no age but its own.

A conflict of a similar sort underlies the famous investigation of wit. To debate Cowley's virtues and faults in terms of wit was hardly a critical innovation; Addison, for instance, had spoken of little else: "Great Cowley then (a mighty genius) wrote,/ O'errun with wit, and lavish of his thought;/ His turns too closely on the readers press,/ He more had pleased us, had he pleased us less/ Thy fault is only wit in its excess,/ But wit like thine, in any shape will please," a sentiment quoted in lieu of criticism by Cibber's *Lives*.[73] Hurd is willing to forgive Cowley his wit, since "he generally followed the taste of his time, which was the worst imaginable," and besides "There is something in him, which pleases above his wit, and in spite of it."[74] Beneath such forgiveness one can discern a gentle but inflexible dogmatism which voices the fashionable prejudice against seventeenth-century poetry that some critics have attributed to Johnson himself. "One of the most glaring faults in the poetry of Mr. Cowley's age was the debasing of great sentiments and images by low allusions and vulgar expressions. What the reader looked for, was *wit*; and he looked no farther: as if that rule of common sense had been a discovery of yesterday—'*Expression* is the dress of thought, and still/ Appears more decent, as more *suitable*.' "[75]

Set in this context, Johnson's deepening conception of wit, and through wit of Cowley, clearly uses the terms of previous criticism in order to transform them. The *Life of Cowley* places the poet against his age not to excuse but to define him, and the opening words of the central section already deny the justice of merely historical defences. "COWLEY, like other poets who have written with narrow views and, instead of tracing intellectual pleasure to its natural sources in the mind of man, paid their court to temporary prejudices, has been at one time too much praised and too much neglected at another" (I, 18). Johnson will trace the ultimate sources of intellectual pleasure, not the tem-

[73] Cibber's *Lives*, II, 54.
[74] Hurd's *Cowley*, I, vi; cf. Pope on Cowley, *Imitations of Horace*, II, i, 75-78.
[75] Hurd's *Cowley*, I, 194n. The quotation, of course, is from Pope's *Essay on Criticism*, lines 318-19.

porary prejudices that explain or extenuate one line or another. Thus he compares Cowley's wit, not as previous critics had done to the wit of his contemporaries or theirs, but to the nature of wit itself. And in his hands the mere act of defining wit becomes a means of critical discovery.

The relation of Johnson's remarks on the Metaphysicals to critical tradition, moreover, is forthright and self-conscious. In successive paragraphs he invokes Aristotle, Dryden, and Pope; and the three successive definitions of wit may be seen as a review of the history of literary criticism in reverse, from the superficial modern view held by Hurd on the authority of Pope ("Pope's account of wit is undoubtedly erroneous; he depresses it below its natural dignity, and reduces it from strength of thought to happiness of language"; I, 19) to the better view held by Dryden and often echoed by Johnson himself (wit as a happy combination of the just and the new)[76] to the classical and philosophical idea of *discordia concors*.[77] By the end of this short but breathtaking survey we may well concede Johnson his own right to join the tradition.

Indeed, Johnson claims that right. It is not disrespectful to the *Life of Cowley* to emphasize its quality as a performance. Johnson intends to give Cowley and his school a critical examination they never had before by confronting earlier attempts at criticism and demonstrating their inadequacy. His superior moral sense, his ability to conduct a rigorous and philosophical debate, assert their authority. The language expands in an attempt to be more and more precise and commodious, to include the varieties of previous criticism while placing them all in a new order. "If [the metaphysical poets'] greatness seldom elevates their acuteness often surprises; if the imagination is not always gratified, at least the powers of reflection and comparison are employed; and in the mass of materials, which ingenious absurdity has thrown together, genuine wit and useful knowledge may be sometimes found, buried perhaps in grossness of expression, but useful to those who know their value, and such as, when they are ex-

[76] On Johnson's revision of Dryden see Hagstrum, *Samuel Johnson's Literary Criticism*, chapter VIII.

[77] The phrase comes from Manilius. Johnson had already anticipated this deepening sense of wit in *Rambler* 194; *Works*, III, 403.

panded to perspicuity and polished to elegance, may give lustre to works which have more propriety though less copiousness of sentiment" (I, 22). Here in a single sentence Johnson tries to balance and surpass opposing critical tendencies: Addison's pleasure at wit and Hurd's offense at grossness of expression, contemporary propriety and the inventiveness of the past. The sentence strains at the seams with an overweight of justice. But Johnson has included so much that his own comprehensive understanding is manifest. The *Life of Cowley* assumes the right to judge the proper aims of biography, the terms of criticism, the history of poetry; and its own performance makes its title good.

Yet the kind of excellence the *Life of Cowley* demonstrates was not a kind to be repeated through the whole *Lives of the Poets*. Johnson's experiment with perpetual criticism, an experiment reflected also in the unusually detailed critical commentary of the third section, succeeds partly because of its subject. Cowley, unlike most other English poets, lacked not a biographer but a critic, and his position at the end of a school enabled Johnson to summarize a considerable era of English poetry in preparation for his study of the moderns. Furthermore, the context of earlier criticism, full of half-truths and philosophical imprecision, afforded Johnson a mission as well as an opportunity. Cowley's final place in English poetry had yet to be settled, and his reputation had been exposed to odd fluctuations and selections; in an age which liked to rank and classify its poets, the standing of the Metaphysicals required clarification. In that sort of adjudication Johnson had no peer. Merely by following the tendency of his predecessors and correcting their misapprehensions he could perform a valuable service.[78]

The ordering principle of the *Life of Cowley*, then, was readymade. Literary history and literary criticism would have to furnish its main interest; the center section would not attempt to tie Cowley's life to his writings, but to determine the nature and value of the mode of poetry he cultivated. Johnson tells us relatively little about Cowley's "studies, his manner of life, the means by which he attained to excellence, his opinion of

[78] Contemporaries emphasized the *novelty* of Johnson's discussion. Boswell was following the line of the *Critical* and *Monthly Review*s when he wrote that Johnson had discovered "a new planet in the poetical hemisphere" (*Boswell's Life of Johnson*, IV, 38).

his own works, and such particulars."[79] Describing how Cowley became a poet, he significantly transposes the story with one told him by Reynolds.[80] What is important is the moral: not Cowley's genius but Genius—"The true Genius is a mind of large general powers, accidentally determined to some particular direction" (I, 2). At this point of the *Lives* we are to be instructed in poetry as a function of mind, not as a vocation or an aspect of character. "Truth indeed is always truth, and reason is always reason; they have an intrinsick and unalterable value, and constitute that intellectual gold which defies destruction" (I, 59). The whole of the *Life of Cowley* is informed by the search for intrinsic and unalterable value, and that is why it never relaxes its spirit of criticism.

By subordinating the poet to his poems, and his poems to poetry, however, Johnson had adopted an approach that could succeed only so long as the poet himself mattered less than his reputation and example. A poet like Milton, no member of a school, not uncertain in his reputation, neither demanding nor requiring any defense, could not be treated as an adjunct to critical discussion. Of this great original Johnson was not master. He would have to find some other way to write his life.

6. The *Life of Milton*

Johnson's *Life of Milton* has always been the most controversial of the *Lives,* and many readers have thought it a work profoundly at odds with itself. The praise that Johnson lavishes on *Paradise Lost* tastes sour to those who resent what he has said about Milton's politics or "Lycidas," and the judicious air of critical balance seems to be belied by an undertone of personal animosity. That the *Life of Milton* should be so well written only makes it more irritating. "Let Dr. Johnson however enjoy his reputation of fine writing, and the praises of his admirers even to adulation, but let him and them remember and remark, that no sublimity of style, no accuracy of expression, can ennoble the meanness, or atone for the virulent malignity of his political resentment against Milton."[81] Even those commentators who believe

[79] Boswell's *Journal of a Tour to the Hebrides,* p. 204.
[80] See *Lives,* I, 2, and Hill's notes 4 and 6.
[81] Francis Blackburne, *Remarks on Johnson's Life of Milton* (London, 1780), p. 131.

434

that Johnson's attacks on Milton's politics and early poems have the best of excuses—that is, that they are essentially right—tend to agree that the *Life of Milton* shows an animus beyond the requirements of strict justice or truth.[82]

Was Johnson prejudiced against Milton? Hawkins thought so,[83] and so did most contemporaries. Yet the mixed feelings of Johnson towards Milton go far deeper than prejudice. Although the critic resents the poet's transgressions very strongly, he does not omit giving him his meed of praise, and he understands the "multiplicity of attainments and extent of comprehension that entitle this great author to our veneration" (I, 147). Indeed, in some respects perhaps Johnson understands Milton too well. Boswell discerned that "In drawing Dryden's character, Johnson has given, though I suppose unintentionally, some touches of his own,"[84] and it would not be farfetched to say the same of Johnson's Milton. The proud and bookish poet, too much given to indulge himself in solitary fancies, enormously learned and curious but with "the usual concomitant of great abilities, a lofty and steady confidence in himself, perhaps not without some contempt of others" (I, 94), at times bears an alarming resemblance to his unfriendly critic. Yet such a resemblance could not have been very comforting to Johnson. The pride and love of dominating he shared with Milton were not his own favorite qualities, and he would reprimand them more severely to reprimand himself.

Moreover, from Johnson's point of view the life of Milton must have seemed singularly uninstructive. The greatness of Milton was of a luster to make an Englishman "claim some kind of superiority to every other nation of the earth,"[85] but the example of Milton was hardly to be emulated. Johnson's comment on Milton's use of blank verse perfectly catches this mixed moral. "I cannot prevail on myself to wish that Milton had been a rhymer, for I cannot wish his work to be other than it is; yet like

82 See Boswell, *Life of Johnson*, IV, 40-42; Warren Fleischauer, "Johnson, *Lycidas*, and the Norms of Criticism," *Johnsonian Studies*, ed. Magdi Wahba (Cairo, 1962), 235-56.

83 Hawkins' *Life of Johnson*, pp. 274-76. Cf. *Boswell's Life of Johnson*, I, 228-31.

84 *Boswell's Life of Johnson*, IV, 45.

85 From the postscript furnished by Johnson to Lauder's *Essay on . . . Paradise Lost* (1750), quoted in *Boswell's Life of Johnson*, I, 230.

other heroes he is to be admired rather than imitated" (I, 194). Compelled to recognize Milton's heroism, Johnson had no wish to recommend it to others; unhappy is the land that breeds such heroes, at least when they take an interest in politics. Even *Paradise Lost* is a poor model in many respects, since its strengths emanate from knowledge of books rather than human nature, and since the sublimity which is its proper element comes from a unique regard for first and last things, and therefore can never be repeated by another poet. Johnson has a handsome answer to these cavils: "Such are the faults of that wonderful performance *Paradise Lost*; which he who can put in balance with its beauties must be considered not as nice but as dull, as less to be censured for want of candour than pitied for want of sensibility" (I, 188). Yet the moralist in him regrets the lack of instruction to be derived from Milton's life. Johnson's word for *Paradise Lost* is *wonderful*,[86] and while standing struck by wonder we are not in a state to learn.

Thus the spirit of criticism that had worked so well with Cowley took on a different tone, a new asperity, when applied to Milton. Johnson's persistent efforts to harvest fruits of wisdom from stony ground often sound like mere aspersion, or what Cowper called "industrious cruelty."[87] Part of this effect must have been intentional. Johnson told Malone "we have had too many honeysuckle lives of Milton, and that his should be in another strain,"[88] and he must have been concerned lest the veneration owed Milton's poems should excuse the behavior of a regicide. The *Life of Milton* keeps any excess veneration well in check. Judgment, hard, rigorous judgment, is to be passed on each of Milton's questionable actions and pernicious principles.

For Milton's biographer, however, this vigilance brought with it some dubious side-effects. In the first place, of course, scolding so great a poet was bound to seem ungracious if not dastardly. Such is the notorious comment on Milton's blindness: "no sooner is he safe than he finds himself in danger, 'fallen on evil days

[86] He calls it a "wonderful poem" both in the preface to Lauder's *Essay on Paradise Lost* (1750) and in the *Preface to Shakespeare* (1765). See also P. K. Alkon, "Johnson's Conception of Admiration," *PQ*, XLVIII (1969), 59-81.

[87] To Unwin, 31 Oct. 1779, in Cowper's *Works*, ed. Robert Southey (London, 1836), III, 313.

[88] See Hill's note, *Lives*, I, 84.

and evil tongues, and with darkness and with danger compass'd round.' This darkness, had his eyes been better employed, had undoubtedly deserved compassion; but to add the mention of danger was ungrateful and unjust. He was fallen indeed on 'evil days'; the time was come in which regicides could no longer boast their wickedness. But of 'evil tongues' for Milton to complain required impudence at least equal to his other powers—Milton, whose warmest advocates must allow that he never spared any asperity of reproach or brutality of insolence" (I, 140). Whatever the justice of this charge, it could not win Johnson any friends. He who bestows so little sympathy must expect little in return, or as Cowper wrote, "Oh! I could thresh his old jacket, till I made his pension jingle in his pocket."[89]

In the second place, Johnson's determination to venerate Milton no more than his due seems to have extended from the man to his work. The *Life of Milton* has nothing to do with honeysuckle literary criticism. The cult of adulation for Milton's early poems, passed down from Thomas Warton the Elder to his sons, undoubtedly provoked Johnson's severity with "Lycidas" and the sonnets—"Those who admire the beauties of this great poet sometimes force their own judgement into false approbation of his little pieces" (I, 163)—and the fact that the poet had complained of evil tongues in *Paradise Lost*, not in a letter, did not protect him from censure. The poet could not be immune from the faults of the man. It is significant that foes of the *Life of Milton* were once indignant at its biographical sections, but now find them much less offensive than Johnson's literary criticism.[90] Can it be that Johnson's biographical and critical estimates of Milton are really all of a piece?

Boswell would certainly have been surprised at the question. To him the greatest puzzle of the *Life of Milton* was how such a poet and such a man could ever have coexisted. "I have, indeed, often wondered how Milton, 'an acrimonious and surly Republican,'—a man 'who in his domestick relations was so severe and arbitrary,' and whose head was filled with the hardest and most dismal tenets of Calvinism, should have been such a poet. . . .

[89] Cowper's *Works*, III, 315.

[90] See especially J. C. Collins, "Dr. Johnson's 'Lives of the Poets,' " *Quarterly Review*, CCVIII (1908), 72-97.

It is a proof that in the human mind the departments of judgement and imagination, perception and temper, may sometimes be divided by strong partitions; and that the light and shade in the same character may be kept so distinct as never to be blended."[91] Most of us, who are far more likely than Boswell to insist upon finding an identity of man and poet, and far less likely to believe that they can be distinctly partitioned in the human mind, will probably feel that Johnson's refusal to try to join the two sides of Milton leaves a gap in the Life. Whether or not we agree that "the two principal sections of biography and criticism are in full collision,"[92] we expect to learn what the egotistic rebel shares with the great poet, and Johnson never explicitly satisfies that expectation.

Never *explicitly*. Yet the question cannot be settled so easily. For our very discomfort is aroused, not by the separation of the biography from the criticism, but by the unacknowledged commerce between them. Even in *Rambler* 14, where Johnson proclaims the distance between a writer and his works, he acknowledges that Milton may be an exception. "Among the many inconsistencies which folly produces, or infirmity suffers, in the human mind, there has often been observed a manifest and striking contrariety between the life of an author and his writings; and Milton, in a letter to a learned stranger, by whom he had been visited, with great reason congratulates himself upon the consciousness of being found equal to his own character, and having preserved, in a private and familiar interview, that reputation which his works had procured him."[93] Like the learned stranger, Johnson reads the life of the poet to learn the truth of his reputation. He does not equate Milton's political independence with his poetic originality—the one is villainy, the other heroism—but his descriptions of the two are internally consistent, and from the *Life of Milton* as a whole we receive an impression of Milton that is indivisible.

Consider, for instance, Johnson on the attack. "Milton's republicanism was, I am afraid, founded in an envious hatred of greatness, and a sullen desire of independence; in petulance impatient of controul, and pride disdainful of superiority" (I, 157). Despite

<hr/>

91 *Boswell's Life of Johnson*, IV, 42. 92 Watson, *The Literary Critics*, p. 97.
93 Johnson's *Works*, II, 66-67.

their hostility, these scornful words correspond with Johnson's glowing peroration to the maker of *Paradise Lost*.

> He was naturally a thinker for himself, confident of his own abilities and disdainful of help or hindrance; he did not refuse admission to the thoughts or images of his predecessors, but he did not seek them. From his contemporaries he neither courted nor received support; there is in his writings nothing by which the pride of other authors might be gratified or favour gained, no exchange of praise nor solicitation of support. His great works were performed under discountenance and in blindness, but difficulties vanished at his touch; he was born for whatever is arduous; and his work is not the greatest of heroick poems, only because it is not the first. (I, 194)

The context of Milton's disdainful self-reliance has changed from one passage to the next, but the quality of self-reliance has not changed. Unlike Boswell, Johnson refuses to accept partitions in Milton's mind.[94] The *Life of Milton* implies a truth most lovers of poetry would prefer not to admit: that the very independence, impatience, and ardor for fame which make a man impossible to live with or like may help make a poet great. That Johnson describes and exemplifies this truth without stating it only renders it more uncomfortable.

Read this way, the *Life of Milton* appears to be essentially unified, in that it successively describes, reprobates, and comes to terms with a particular kind of genius. Indeed, its first readers must have felt suspense, as they wondered whether such vehement opposition could cease even in the presence of *Paradise Lost*. It did cease, of course, and Johnson paid luminous critical tribute to Milton's literary character. Yet we are never allowed to forget the republican in the hero. Johnson frequently reminds us of the bookish naïveté that is the dark side of Milton's originality. "No man forgets his original trade: the rights of nations and of kings sink into questions of grammar, if grammarians discuss them" (I, 113). Similarly, *Samson* follows ancient tragedies because of "long prejudice and the bigotry of learning"; Milton "had read much and knew what books could teach; but had min-

[94] Cf. Coleridge's argument against Thomas Warton's unsynthesized criticism of Milton, chapter twelve, section six above.

gled little in the world, and was deficient in the knowledge which experience must confer" (I, 189). Remembering the first part of the *Life*, we cannot help but feel the complications, the wry second and third thoughts, in Johnson's appraisal of Milton's genius. "The appearances of nature and the occurrences of life did not satiate his appetite of greatness. . . . reality was a scene too narrow for his mind" (I, 177-78). In context this is praise, but praise nervous with tensions based on a solid respect for the reality that Milton spurned. Johnson accommodates his criticism to Milton's genius without yielding his own firm judgment of the requirements of human life. That tension pervades and structures the *Life of Milton*.

If the parts of the *Life of Milton* are interdependent, however, they make at best an imperfect whole. Johnson himself was uneasy about the connections he perceived between the man and the poet. The central section, lacking either the literary criticism of *Cowley* or the intellectual and literary character of the later *Lives*, remains diffident, and the relations of Milton's way of life to his poems are sketched so tactfully as almost to elude observation. Perhaps that diffidence explains why Matthew Arnold, when he introduced an edition of six of the *Lives* in 1878, found so little positive to say about their criticism. For Arnold, criticism sought first of all to discover the "real man," and he valued Johnson for his insight into men more than for his judgment of poetry. "From Johnson's biographies the student will get a sense of what the real men were, and with this sense fresh in his mind he will find the occasion propitious for acquiring also . . . a sense of the power of their works."[95] It is in Johnson's biographical sections that Arnold finds his greatest critical strength.

Obviously Johnson, unlike Arnold and Macaulay, does not care to read the poet's work primarily as an aspect of his mind and life. The "real Milton" makes no appearance in the *Lives*. Johnson describes a more various reality. "He did not expect a poet to hold a mirror up to the events of his own life or to the variegations of his own taste, nor did he examine poetry in order to reconstruct the poet's biography or to psychoanalyze his personality."[96] The *Life of Milton* presents a consistent picture of

[95] *The Six Chief Lives from Johnson's "Lives of the Poets"* (London, 1881), p. xiii.
[96] Hagstrum, *Samuel Johnson's Literary Criticism*, p. 46.

its hero, but its criticism does not join the contexts of life and art. If Johnson noticed that the "haughtiness and obstinacy" (I, 173) of Milton's Satan have something in common with qualities in the poet, he managed to suppress it.

In theory, Johnson's tight rein on biographical criticism is entirely proper. His interest in evaluating the nature and degree of human genius by separating it from the adventitious circumstances that surround any poetic achievement is masterfully illustrated by his analysis of Milton's sublimity, the quality that Milton had offered the world beyond any other poet. Avoiding too explicit a parallel between man and poet, he avoids the excesses that were to vitiate Arnold's criticism of Byron and Shelley;[97] Johnson's aversion to Milton's public career does not lead him to disown the poems. Moreover, the subtle connection between the hero and the poet in the *Life of Milton* leads our attention to those constituents of mind that have enabled Milton to write as he does, not to any mere notions of personality. We return to and we conclude with the poems, not with gossip or, worse yet, with use of the poems as clues to their author's heart.

Yet in practice the method of the *Life of Milton* remains somewhat unconvincing. Here if anywhere we have a right to complain that there is "no sense that biography should have a certain structural logic, a symmetry as satisfying as the canons of neoclassical esthetics demanded of buildings and gardens and music."[98] The triumph of *Paradise Lost*, splendidly celebrated though it is by Johnson, is undercut a little by our sense of the problematical nature of Milton's genius, and the moral lessons of the life sometimes sound (what is rare in Johnson) more strident than just. Some critics have even thought Johnson's praise to be grudging or dutiful. Surely that opinion is wrong—we may recall, for instance, Mrs. Thrale's anecdote in which "Mr. Johnson pronounced a long eulogium upon Milton with so much ardour, eloquence, and ingenuity, that the Abbé rose from his seat and embraced him"[99]—but that it should be possible to entertain the idea indicates that the *Life of Milton* has lost some of its purpose. Whether Johnson's mixed feelings towards Milton are re-

[97] *Essays in Criticism*, Second Series (1888).
[98] Altick, *Lives and Letters*, pp. 56-57.
[99] *Johnsonian Miscellanies*, ed. G. B. Hill (Oxford, 1897), I, 216; cf. II, 165.

sponsible, or the unyielding nature of Milton's own art and genius, or Johnson's inability to find an appropriate substitute for the analysis of a poetic mode that had served him so well at the center of the *Life of Cowley*, the *Life of Milton* does not achieve a fully satisfying form. The magnificence of Johnson's critical judgment, a magnificence that even in the *Milton* sweeps everything before it, awaited a setting to show it to better advantage.

7. THE *Life of Dryden*

The *Life of Dryden* provides that setting. Perhaps of all the *Lives of the Poets* none furnishes a better test of Johnson's ability to write literary biography, because for once the subject was not only congenial but voluntary. We know from Boswell that Johnson's "partial fondness for the memory of Dryden" (III, 223) was accompanied by a special feeling of sympathy, and we know also that Johnson had brooded over this biography a long time before: "When I was a young fellow I wanted to write the 'Life of Dryden.' "[100] Even the opening words of the *Dryden* bespeak Johnson's appetite for his task. Instead of apologizing as at the start of *Milton*—"The Life of Milton has been already written in so many forms and with such minute enquiry that I might perhaps more properly have contented myself with the addition of a few notes to Mr. Fenton's elegant Abridgement, but that a new narrative was thought necessary to the uniformity of this edition" (I, 84)—he regrets not having done more: "Of the great poet whose life I am about to delineate, the curiosity which his reputation must excite will require a display more ample than can now be given" (I, 331). Johnson's poetic taste had been weaned on Dryden, whom the *Dictionary* cited more often than any other poet but Shakespeare,[101] and in writing this life he combined the natural pleasure of talking about Dryden with the incentive of doing him justice.

This combination of pleasures lends the *Life of Dryden* special attractions. On the whole Johnson's contemporaries preferred it to any of the other *Lives*,[102] and since then its critical reception has always been, if not uniformly enthusiastic, at least friendly.

[100] *Boswell's Life of Johnson*, III, 71.
[101] See J. W. Good, *Studies in the Milton Tradition* (Urbana, Ill., 1915), p. 198n.
[102] See Hawkins' *Life of Johnson*, p. 537.

Even the nineteenth-century critics who suspected Johnson's heart as well as Dryden's were ready to admit that "Johnson had a mind precisely formed to relish the excellences of Dryden."[103] For once we are not forced to inspect Johnson's views of the poet, and other critics' views of Johnson, for signs of prejudice.

Johnson certainly had the *opportunity*, then, to write a *Life of Dryden* that would provide English literary biography with the model of excellence he knew it required. The only question is whether he succeeded. And our answer is likely to be equivocal, depending on whether we measure Johnson against his predecessors or his successors.[104] On the one hand, Johnson's *Dryden* sustains interest far better than earlier lives of this, or perhaps any, poet. It resonates with the worldliness and sympathy that Johnson asked from biography and that we expect to find only in a work of art. On the other hand, "Johnson's treatment of the facts and fictions of Dryden's life is too general."[105] Looking for the detailed personal information we are accustomed to find in modern biographies, we may recall that, immediately after Johnson had complained that "he did not know any literary man's life in England well-written, . . . He said he had sent Derrick to Dryden's relations, and he believed Derrick had got all he should have got, but it was nothing."[106] Worse yet, not only did Johnson lack materials, he lacked a modern respect for them. It is the *Life of Dryden* which supplies the notorious sentence, "To adjust the minute events of literary history is tedious and troublesome; it requires indeed no great force of understanding, but often depends upon enquiries which there is no opportunity of making, or is to be fetched from books and pamphlets not always at hand" (I, 368), with which so many scholars have consoled themselves, not always in a proper context. Johnson forgoes the search for Dryden's private life, and is content to review the known facts of his public career.

Indeed, only by reading the *Life of Dryden* as a survey and analysis of the poet's career shall we make any sense of it at all.

103 Hallam, quoted by Hill, *Lives*, I, 331n.
104 See Altick, *Lives and Letters*, chapters I and II; John Butt, *Biography in the Hands of Walton, Johnson, and Boswell* (Los Angeles, 1966); Robert Folkenflik, *Samuel Johnson as Biographer* (unpublished Ph.D. dissertation, Cornell, 1968).
105 J. M. Osborn, *John Dryden: Some Biographical Facts and Problems* (New York, 1940), p. 37.
106 Boswell's *Hebrides*, p. 204.

Johnson's moral reflections on the difficulty of an author's life in general, and Dryden's in particular, are precisely the means by which the parts of his biography are brought into a whole. If we take no interest in such general observations the *Life of Dryden* will break into fragments.

For instance, the most frequently censured pages in the Life are those that deal (not always accurately) with the controversy between Settle and Dryden. Why should Johnson have preserved such trivia at the expense of something more psychologically relevant? "Dabbling in a puddle is never pleasing; and a puddle Dryden himself styles it."[107] One plausible explanation would point simply to the momentum Johnson acquired by obtaining and going through the tracts. Yet a stronger answer is provided by the moral Johnson himself draws: "Such was the criticism to which the genius of Dryden could be reduced, between rage and terrour. . . . But let it be remembered, that minds are not levelled in their powers but when they are first levelled in their desires. Dryden and Settle had both placed their happiness in the claps of multitudes" (I, 346). In all its parts the *Life of Dryden* addresses those problems of authorship that arise from the mere necessity of catering to an audience not deserving of such attention. Johnson's eye keeps steady watch not so much upon Dryden as upon Dryden's transactions and relations with his public.[108]

It is this professional interest which accounts for Johnson's selection of matters for comment: the rehash of the case Dryden vs. Settle; the many instances when Dryden "writing merely for money was contented to get it by the nearest way" (I, 372); the withering references to Dryden's adulatory dedications: "When once he has undertaken the task of praise he no longer retains shame in himself, nor supposes it in his patron. As many odoriferous bodies are observed to diffuse perfumes from year to year without sensible diminution of bulk or weight, he appears never to have impoverished his mint of flattery by his expences, however lavish" (I, 399). What is more, Johnson goes so far as to excuse Dryden's lapses from morality on similar professional

[107] *Gentleman's Magazine*, XLIX (1779), 363.

[108] A context for this account of the perils of authorship may be provided by *Rambler* 21 (*Works*, II, 104-8).

grounds. "His works afford too many examples of dissolute licentiousness and abject adulation; but they were, probably, like his merriment, artificial and constrained—the effects of study and meditation, and his trade rather than his pleasure" (I, 398). Even Johnson's equitable and tender review of Dryden's religious conversion—"enquiries into the heart are not for man; we must now leave him to his Judge" (I, 378)—seems ultimately directed towards the public nature of the poet's commitment, or what is called "his new profession." Dryden published *The Hind and the Panther*, we are told, "Actuated therefore by zeal for Rome, or hope of fame" (I, 380).

Thus Johnson makes a virtue of his restriction to facts on the public record, the external circumstances of Dryden's career rather than the secrets of his heart. Nor is judgment waived. Just as the *Life of Milton* may be considered a definitive study of the genius too independent and self-willed to be emulated, however admired, the *Life of Dryden* consistently pictures a genius vitiated by its willingness to please, to compromise with popular demand rather than insist on the best of which it is capable. Johnson firmly fixes this kind of genius with stroke after stroke. "There are minds which easily sink into submission, that look on grandeur with undistinguishing reverence, and discover no defect where there is elevation of rank and affluence of riches" (I, 400). "He is therefore by no means constant to himself" (I, 414). The wonder, as in the *Life of Savage*, is that so much clear-eyed condemnation can coexist with a regard for the poet. Here Johnson's impersonality of judgment allows him to analyze a mischievous quality of mind without disowning the possessor of that mind.

Moreover, Johnson's analysis mediates between general and particular with fine subtlety. Consider, for example, his treatment of Dryden's fluent criticism: "he poured out his knowledge with little labour; for of labour, notwithstanding the multiplicity of his productions, there is sufficient reason to suspect that he was not a lover. To write *con amore*, with fondness for the employment, with perpetual touches and retouches, with unwillingness to take leave of his own idea, and an unwearied pursuit of unattainable perfection, was, I think, no part of his char-

acter" (I, 413).[109] In principle, this passage must be taken to ad-
minister a rebuke to Dryden's carelessness. Yet its tone and dic-
tion hint at something else. The trace of "foolishness" in the
eighteenth-century "fondness," the self-indulgence of lingering
over one's *"own"* idea, the futility of seeking "unattainable" per-
fection, suggest that by shunning labor Dryden was also avoiding
affectation. Johnson, himself no great lover of perpetual revi-
sions and polishings, knows that the general principle that au-
thors should be perfectionists must be qualified by the virtues of
Dryden's own freer stream of thought. "The touchstone, if critical
judgment is to be close to its object, must always be human real-
ity itself and not a set of presuppositions."[110] If Dryden is to be
judged according to the ethics of authorship, so must the nature
of authorship be tested according to the example of Dryden.

This delicate sense of how even the lapses of a poet may have
a part in his unique contribution to poetry gives the *Life of
Dryden* its complicated balance. Johnson does not exculpate
traits like Milton's asperity or Dryden's malleability, but neither
does he forget that the felicities of poetry are produced by a com-
bination and exertion of mental powers any one of which, in isola-
tion or in the hands of lesser men, might deserve censure. Dry-
den's poetic accomplishment, like Cowley's, Milton's, and Pope's
in their several kinds, cannot be dismissed by listing his faults
(Johnson himself, piqued once by Garrick's showy enthusiasm for
Dryden, made up such a list on the spot).[111] Rather, a talent for
poetry depends upon an interplay of personal and cultural traits
which the biographer must learn to keep in proportion.

The *Life of Dryden*, then, as well as its supplement in the com-
parison with Pope, makes a continuous effort to judge the poet's
reasons for behaving as he did, as a man and a poet; not because
Johnson is absorbed by the Boswellian passion for accumulation
of details which constitute a "personality," but because be-
havior in one sphere of life supplies a key to the many sorts of
behavior that join in the creation of a work of art. The central
section of the *Dryden* (paragraphs 159-92), which hovers about

[109] Cf. I, 465; III, 218-221. Johnson omits a passage from the first edition in
which he had accused Dryden of writing his critical dissertations to increase the
book and the price (see Hill's note 3).

[110] Arieh Sachs, *Passionate Intelligence* (Baltimore, 1967), p. 88.

[111] *Johnsonian Miscellanies*, I, 185.

the relationship between Dryden's character and his works, seems far more integral than the corresponding section of the *Milton,* and at times Johnson speaks through the poet to the whole republic of letters: "He has been described as magisterially presiding over the younger writers, and assuming the distribution of poetical fame; but he who excels has a right to teach, and he whose judgement is incontestable may, without usurpation, examine and decide" (I, 396). The success of Dryden's poems justifies his character in the way it needs most to be justified. Even the less creditable events of his life, such as the controversy with Settle, must be forgotten once Dryden has transformed them into poetry: "Among answers to criticks no poetical attacks or altercations are to be included: they are, like other poems, effusions of genius, produced as much to obtain praise as to obviate censure. These Dryden practised, and in these he excelled" (I, 401). Out of the minute events of literary history and the balancing strengths and defects of character has come a poetry which is at once their product and all that makes them significant.

Johnson's emphasis on the poetic career of Dryden results in another formal concomitant. Properly speaking the *Life of Dryden* divides not into three sections but four. The fourth (paragraphs 321-56) is "a general survey of Dryden's labours" which goes far beyond the usual method of concluding a Life with a paragraph or two of summary and evaluation. As the second section adds a description of character to the events of the poet's life, the fourth supplements a review of the poet's works with an estimate of his specifically *poetic* character (as well as his versification). Here literary biography blends with literary history. Dryden's character, English poetry, and the profession of the poet are weighed and judged. "He did not keep present to his mind an idea of pure perfection; nor compare his works, such as they were, with what they might be made. He knew to whom he should be opposed. He had more musick than Waller, more vigour than Denham, and more nature than Cowley; and from his contemporaries he was in no danger. Standing therefore in the highest place[112] he had no care to rise by contending with

[112] Joseph Warton objected that Johnson was ignoring Milton. Either Johnson did not consider Dryden and Milton contemporaries, or here, as elsewhere, he thinks of Milton as incomparable.

himself; but while there was no name above his own was willing to enjoy fame on the easiest terms" (I, 464-5).

In criticism like this Johnson is going beyond, not only his predecessors in literary biography, but our own categories. He approaches a new genre in which the character of the poet, the nature of poetry in his time, the requirements of a literary career, and literary criticism both practical and theoretical all combine. If we have difficulty in evaluating this genre, which only a portmanteau word like *gesamtkritikwerk* could begin to describe, that is probably because we have little or nothing with which to compare it. A comparatively few modern literary biographies, and notably W. J. Bate's *John Keats* (a work generously influenced by Johnson's *Lives*),[113] have shown a similar interest in defining the vocation of the poet and the use to which we can put his example, but none moves so easily between the way that the poet competes with his contemporaries and the way that his poems compete with all poetry. Johnson's interests in human nature, not merely in personality, and in the general as well as the particular possibilities of poetry, all find place in the *Life of Dryden*.

That is not to say that the *Life of Dryden* is formally a masterpiece. Its structure remains experimental, given a peculiar shape because Johnson split off and expanded his usual final comment on the poet's relation to poetry and poets in general. Johnson was not to repeat this experiment. No other English poet required such a review, because no other had enjoyed so interesting a poetic career or so crucial a position in the development of English poetry. The *Life of Dryden* is adjusted to the special character of its subject. Nor does it satisfy our legitimate desire for a more private acquaintance with the poet, or for accuracy of detail. Yet its view of Dryden defines his contribution more generously and authoritatively than any other we have. Johnson was no longer ostentatious or uncomfortable. He had mastered the art of writing the life of a poet.

8. The *Life of Pope*

The paradigm of Johnson's mastery, the work that by common consent is no longer experimenting with but applying his methods

[113] See *John Keats* (Cambridge, Mass., 1963), p. 2 and *passim*.

of literary biography, is the *Life of Pope*. Here the three-part structure is clearly articulated, the style never loses its ease and grace, and general appreciation is perfectly balanced by technical analysis. What is more, Johnson's warm admiration for Pope's accomplishments—"Sir, a thousand years may elapse before there shall appear another man with a power of versification equal to that of Pope"[114]—removes the Life from any faintest tinct of negative prejudice. Even in this century no less an authority than George Sherburn continued to prefer Johnson's to any other biography of Pope.[115]

If the *Life of Pope* stands as a paradigm of Johnson's method, however, it also raises disturbing questions about that method. No other Life has been so thoroughly studied, and on the whole the result of that study has been to make us aware that what Johnson had mastered was largely a way of following the path of least resistance. Johnson's *Pope*, like the other *Lives of the Poets*, was written at great speed according to the main lines of previous biography and criticism. Pitting it against its sources, especially against Warton's *Essay on Pope*, can be disillusioning. It has certainly disillusioned Benjamin Boyce: "I have come to the conclusion that Johnson's remarks on Pope were not uniformly superior to those of previous critics and that he was, to an extent that probably few readers appreciate, regularly dependent upon those critics for direction in his commentary."[116] And F. W. Hilles, in a careful study of the making of the *Life of Pope*, demonstrates that "Johnson gave relatively little thought to the writing of the biographical section" and that "It is almost certain that he did not bother to reread Pope's poetry. Instead he apparently leafed through a few of the more available commentaries and contented himself with remarks provoked by these commentaries."[117] Remembering the notorious story of Johnson's reluctance to hear Lord Marchmont's information about Pope—"If it rained knowledge I'd hold out my hand; but I would not give myself the trouble to go in quest of it"[118]—we may well regard the *Life*

[114] *Boswell's Life of Johnson*, IV, 46.
[115] *The Early Career of Alexander Pope* (Oxford, 1934), pp. 13-15.
[116] Boyce on Pope, *RES*, n.s. V, 37.
[117] "The Making of *The Life of Pope*," *New Light on Dr. Johnson* (New Haven, 1959), pp. 267, 268.
[118] *Boswell's Life of Johnson*, III, 344.

of Pope as a work Johnson wrote merely by stretching out his hand.

Such an easy reliance on sources may or may not be disquieting. All criticism of value participates, of course, in a conversation that has been carried on since Aristotle, and originality in a critic, as in a host, often consists largely in an ability to keep the conversation moving. Thus, if "Johnson did not initiate so much as he attempted to adjudicate; he was often writing a critique of the critics,"[119] he was only doing in writing what he did so successfully in argument: allowing himself to be provoked into a response that transformed the whole discussion.

Nevertheless, Johnson's carelessness and indebtedness to others must severely qualify our estimate of his achievement. If Johnson's *Life of Pope* relies on previous critics for its direction and its turns of phrase, if the very logic, imagery, and cadence of the comparison of Dryden and Pope are based on Pope's own comparison of Homer and Virgil,[120] can we speak significantly of Johnson as an innovator in literary biography? Is his method anything more than patchwork and reminiscence?

The answer to these questions will depend on what we understand by "method." There are at least three plausible ways of describing the method of the *Life of Pope*. The first way, the structural, would point to Johnson's three part construction of his biography, and especially to the artful means by which sections one and three have been joined by the analysis of Pope's intellectual character in section two. The second way, the perspective of Boyce and Hilles, would view the Life as a perpetual commentary, constructed piece by piece according to the promptings of earlier writers. The third way, the thematic, would emphasize that the various observations of the *Life of Pope* are grouped around a common tendency or moral, which might be termed a lesson in *"poetical prudence"* (III, 219).

Each of these three descriptions of method seems true to the experience of reading the *Life of Pope*. Depending on what we are looking for, we shall find one or the other more or less persuasive.

[119] Boyce, *RES*, n.s. V, 46.

[120] *Ibid.*, p. 42, refers to a paper by Margaret Gregg on the resemblance of the two passages. Pope himself, however, is imitating Dryden. In Johnson's defense, we should cite his remarks in *Rambler* 143 on the difference between plagiarism and imitation (*Works*, III, 178-83); cf. *Adventurer* 95.

Thus the reader who searches for structural unity will notice the brilliance and finish of the second section (paragraphs 255-311), perhaps the most sustained passage in any of the *Lives,* and will single out those parts that relate Pope's life to his art: "Of his intellectual character the constituent and fundamental principle was Good Sense, a prompt and intuitive perception of consonance and propriety. He saw immediately, of his own conceptions, what was to be chosen, and what to be rejected; and, in the works of others, what was to be shunned, and what was to be copied" (III, 216-7). The reader who has been alerted to the perpetual commentary of the *Life of Pope* will point instead to the antecedents of this judgment in Warburton, Ruffhead, Cibber, and Warton, and will proceed to show how much of Johnson's best criticism is adaptation and reaction: Johnson "cannot forbear to observe that the comparison of a student's progress in the sciences with the journey of a traveller in the Alps is perhaps the best that English poetry can shew" (III, 229) because Joseph Warton could not forbear to find the same simile defective.[121] The reader who values the precepts and the steady wisdom of the *Life of Pope* more than their order will be able to draw support for his position from Johnson's own authority: "Of all homogeneous truths at least, of all truths respecting the same general end, in whatever series they may be produced, a concatenation by intermediate ideas may be formed, such as, when it is once shewn, shall appear natural; but if this order be reversed, another mode of connection equally specious may be found or made. . . . As the end of method is perspicuity, that series is sufficiently regular that avoids obscurity; and where there is no obscurity it will not be difficult to discover method" (III, 99).[122] The method we discover in the *Life of Pope* will reflect our own preoccupations.

Insofar as Johnson's *Pope* can sustain this variety of approaches, it benefits from a dialectical adroitness like that of Reynolds' *Discourses.* If Johnson, like Reynolds, borrows many of his ideas from other commentators, he puts them into a new, inclusive context which lends them a new significance. At the least this multiplication of methods should teach us not to be too concerned

[121] *Essay on Pope* (third edition, London, 1772), I, 142-43.

[122] The subject here is significantly the *Essay on Criticism*; the comment applies to all poems consisting (like Johnson's own criticism) of precepts.

with any one method; no single key will unlock the *Lives of the Poets*. Yet our experience of reading the *Life of Pope* should also warn us that Johnson's various ways of organizing his materials are not always in perfect equilibrium. Perpetual commentary sometimes intrudes upon structure by tempting Johnson into a digression whose main object is only to answer the critics; the desire to inculcate a moral sometimes leads Johnson to pontificate broadly on the basis of a very few facts, as in his long-winded and stately but trivial mockery of Pope's grotto: "It may be frequently remarked of the studious and speculative that they are proud of trifles, and that their amusements seem frivolous and childish" (III, 135). The *Life of Pope* is pulled in different directions by its effort to adjudicate even those disputes to which it brings no new information, and to stretch its wisdom thin until it can cover both the man and the poet.

Perhaps such an emphasis on problems of method may falsify our sense of the genuine unity of Johnson's *Pope*. After all, "one feels that on the whole Johnson understood Pope both man and artist better than any one can ever understand him now that he has been dead [more than] two centuries,"[123] and where Johnson excels all other biographers is not in method but in his profound analysis of behavior, an analysis which unites the virtues of the novelist and the moralist. If we borrow Johnson's own suspicion of "natural order," we may choose to locate the accomplishment of the *Life of Pope* in its "depth of criticism" or its "essential humanity." Or, taking a leaf from the anthologist who has counted the *Life of Savage* among *Great Short Novels*, we may simply enlist the *Pope* among works of art. Yet to insist on the integrity of the *Life of Pope* as a work of art also involves a falsification. Too much of it concerns local quarrels, and depends on references or on sequences of thought that are not specified, for it to possess the self-contained harmony of art. The reader of the *Life of Pope* must complete it by looking beyond it.

One place we must look, of course, is the other *Lives*, and especially the *Life of Dryden*. What might be termed the climax of the *Life of Pope*, and in a sense of all the *Lives of the Poets*, occurs in the parallel of Dryden and Pope. Here, at the end of the

[123] Sherburn, *The Early Career of Alexander Pope*, p. 15.

section on Pope's intellectual character, we learn the moral affirmed by his career. "Pope was not content to satisfy; he desired to excel, and therefore always endeavoured to do his best: he did not court the candour, but dared the judgement of his reader, and, expecting no indulgence from others, he shewed none to himself" (III, 221). This lesson gains a great deal from our earlier view of Dryden. We know how difficult the vocation of a poet must be, and we know also how much readiness to forgive Dryden lies behind the judgment that Pope "left nothing to be forgiven" (III, 221). Thus Pope's diligence completes the image of professional excellence we are entitled to expect from a great poet.[124] Together with Dryden's genius, the special virtues of Pope fit into a composite idea of what poetry can be, when the poet is true to himself as well as pleasing to others.

An even broader appeal to the idea of poetry is made by Johnson later when he summarizes his critical view of Pope's poems. "After all this it is surely superfluous to answer the question that has once been asked, Whether Pope was a poet? otherwise than by asking in return, If Pope be not a poet, where is poetry to be found? . . . Let us look round upon the present time, and back upon the past; let us enquire to whom the voice of mankind has decreed the wreath of poetry; let their productions be examined and their claims stated, and the pretensions of Pope will be no more disputed" (III, 251). We have already had occasion to remark that this celebrated peroration requires Joseph Warton's *Essay on Pope* to complete its meaning;[125] the question to which Johnson addresses himself was very much a living issue in 1780, and to appreciate his fervor we must know something of the work that has provoked it. We must also note, however, that Johnson's own answer, his mighty rhetorical question, has reference to much greater issues than might be comprehended either by Warton or by the *Life of Pope* itself. The more we linger, and Johnson lingers, over "where is poetry to be found?", the more we perceive that the question implies an answer, and that the answer is nothing less than the *Lives of the Poets*, as well as all similar efforts to distinguish true poetry from false. The reply to Warton avoids

124 Both Dryden and Pope had similarly portrayed the professional care of Virgil as a complement to the natural genius of Homer.

125 Chapter twelve, section three above.

being hollow only because it is backed by the full weight of Johnson's critical accomplishment. "Let us look round upon the present time, and back upon the past."

As soon as the context of the *Life of Pope* has been enlarged to this extent, however, we must abandon any hope of using the Life as a self-contained paradigm of Johnson's method. Indeed, the search for that method can lead only to the realization that no one Life stands for Johnson's *Lives*, and that finally the *Lives of the Poets* constitute a whole greater than any part. For all its art and wisdom, the *Life of Pope* is unified only because we can interpret its partialities and imbalances against the background of all of Johnson's work. Johnson had found ways of writing individual literary biographies with more or less success, but in the course of his various experiments he had made something far more lasting, a union of many kinds, a multiple but single work, the *Lives of the Poets*.

9. The Unity of Johnson's *Lives*

Like all collections written by one man of settled principles, the *Lives of the Poets* acquires a cumulative force. By the time that Johnson dismisses Lyttelton's "Progress of Love" on the grounds that "it is sufficient blame to say that it is pastoral" (III, 456), we know enough about Johnson and pastoral to infer a vast unspoken disdain. By the time that Johnson concludes his truce with Gray's "Elegy," we have become so accustomed to his application of rigorous standards that we understand what great honor he confers by thus disarming his criticism: "In the character of his *Elegy* I rejoice to concur with the common reader; for by the common sense of readers uncorrupted with literary prejudices, after all the refinements of subtilty and the dogmatism of learning, must be finally decided all claim to poetical honours. . . . Had Gray written often thus it had been vain to blame, and useless to praise him" (III, 441-2). In these words Johnson is pronouncing an epitaph not only upon Gray, but upon literary criticism itself. The ambitions of the *Lives of the Poets*, having been fulfilled so far as is possible to human hopes, are resigned before the greater claims of poetry and the common sense of readers. And the full power of that resignation is derived from its

reference, not to Gray alone, but to the whole of Johnson's biographical and critical endeavor.

If the *Lives of the Poets* constitutes a whole, however, that whole is difficult to define. Once again we do well to remember that Johnson himself was trying to reconcile many different purposes and many literary forms, that specialist readers can find enough about their specialties to convince each of them that he holds the crucial and decisive key to understanding, and that in works of such size and complexity the very notion of unity may be chimerical. Yet the quest for the one in the many, the general in the particular, is so central to Johnson's thought and work that no student of Johnson can afford to forsake it. Tentatively and humbly the reader of the *Lives of the Poets* must seek the principles that bind the whole together.

Our humility will serve us well, for surely the limitation on human capabilities, and the unlikelihood of human happiness, furnish main themes of Johnson's *Lives*. If the *Lives* are approached as essays in morality, on the grounds that "A genre like literary biography is no less moral (that is to say, dependent on the universal truths it makes us perceive in the particular instance) than the invented situations in *Rasselas*,"[126] then the moral they yield may well be the one we know from *Rasselas*, that life offers expectations in lieu of enjoyments and that on earth human wishes are vain.[127] Like the rest of mankind, poets do not live in security. Consider William Collins, after a fortunate inheritance: "But man is not born for happiness. Collins, who, while he 'studied to live,' felt no evil but poverty, no sooner 'lived to study' than his life was assailed by more dreadful calamities, disease and insanity" (III, 337). A disturbing number of the most memorable passages in the *Lives*, for instance the simple and pathetic account of Swift in his decline (III, 45-49), demonstrate how little consolation can be won by eminence in literature.

Indeed, Johnson seems eager to enforce this truth. Pope's feigned contentment with his Olympian reputation draws some

[126] Sachs, *Passionate Intelligence*, p. 82.

[127] On this theme see Paul Fussell, *The Rhetorical World of Augustan Humanism* (Oxford, 1965), p. 52.

stinging remarks: "He pretends insensibility to censure and crit-
icism, though it was observed by all who knew him that every
pamphlet disturbed his quiet, and that his extreme irritability
laid him open to perpetual vexation; but he wished to despise
his criticks, and therefore hoped that he did despise them" (III,
209). Convinced that no man's life would appear happy if we
could scrutinize it closely enough, Johnson often assumes misery
where he cannot prove it. In retrospect even a life on the surface
contented, like that of John Philips, teaches its melancholy les-
son about the ravages of time: "He died honoured and lamented,
before any part of his reputation had withered, and before his
patron St. John had disgraced him" (I, 316).

While lessons like these demonstrate how much the *Lives of
the Poets* shares with Johnson's other works of moral instruc-
tion, however, they do not distinguish the special character of
Johnson's moral vision in the *Lives*. Literary biography asks not
only whether men can be happy, but whether a literary voca-
tion can be successful. The emphasis upon poetry as a career,
an emphasis so prominent in the *Lives* of Dryden and Pope,
runs also through the other *Lives*. As befits the double nature of
literary biography, this question admits of a divided interest,
focusing sometimes on the progress of the poet in the eyes of the
world, sometimes on the degree of personal satisfaction he has
been able to feel at his progress. Johnson's answers are also com-
plicated. Since some poets have enjoyed a least as much fame as
they deserved, and since Johnson respects the verdicts of the
public, he cannot deny that literary success is possible. Moreover,
a few authors (Milton, for instance) undeniably have felt a
merited satisfaction at their own accomplishment. Insofar as men
are capable of happiness, then, poetry can make them happy. The
Lives of the Poets records the professional histories of men who
have tried to do something worthy of a man's attention, and thus
implies that a literary vocation may do much to fill the vacuity
of human life.[128]

If a literary vocation were to mean no more than this, it might
come to seem rather trivial. The *Lives* often toys with the notion

[128] In *Adventurer* 138, 2 March 1754, Johnson had pointed out that writers en-
joy at least one special gleam of felicity, in that authorship and hope necessarily
go together; *Works* (New Haven, 1963), II, 493-94.

that poetry may be, as Burney said of music, merely an innocent amusement. Johnson very nearly approaches this position in his comments on Somervile.

> It is with regret that I find myself not better enabled to exhibit memorials of a writer, who at least must be allowed to have set a good example to men of his own class by devoting part of his time to elegant knowledge, and who has shewn, by the subjects which his poetry has adorned, that it is practicable to be at once a skilful sportsman and a man of letters.
> Somervile has tried many modes of poetry; and though perhaps he has not in any reached such excellence as to raise much envy, it may commonly be said at least that *he writes very well for a gentleman.* (II, 318)

Such praise condescends not only to Somervile, but to poetry; a critic who can so amiably relax his standards is not taking his art seriously.

Yet most of the *Lives* exhibits a sense of poetic calling that is the very opposite of gentlemanly relaxation. Johnson has little tolerance for the gifted amateur, especially when his amateurishness, like that of Rochester, reflects a way of life. "In all his works there is sprightliness and vigour, and every where may be found tokens of a mind which study might have carried to excellence. What more can be expected from a life spent in ostentatious contempt of regularity, and ended before the abilities of many other men began to be displayed?" (I, 226) Unmistakably Johnson is blending his distaste for Rochester's character with his disdain for a poet who fails to respect his own talents. Though dilettantes may consider poetry a means of whiling away time or showing off wit, the critic understands that poetry has its own prerogatives: it demands study, knowledge, wisdom, dedication. "To be a poet," as Imlac says, "is indeed very difficult." The *Lives of the Poets* confronts and illustrates that difficulty.

Thus a poetic vocation, as we observe it throughout Johnson's *Lives,* can lend grace to a life otherwise of small fortune, like that of Savage, and sometimes confer even a limited kind of secular redemption. Without sharing all Imlac's raptures, Johnson shares some of his reverence for poetry. "Wherever I went, I found that Poetry was considered as the highest learning, and regarded with

a veneration somewhat approaching to that which men would pay to the Angelick Nature."[129] His own high sense of literary vocation persists through a long career, from his early words in the *Gentleman's Magazine* (1739)—"The Character of an Author must be allowed to imply in itself something amiable and great"[130] —through the moving conclusion of the "Preface to the *Dictionary*" (1755)—"The chief glory of every people arises from its authors: whether I shall add any thing by my own writings to the reputation of English literature, must be left to time"[131]— to the prayers for more diligence and resolution that accompany the *Lives* step by step. Though no single poet can altogether satisfy Johnson's high standards, every poet worthy of the name commands his high respect.

The seriousness of this attention to a poetic vocation gives the *Lives of the Poets* much of its purpose. In weighing the fruits of a poetic career against the potentialities of the poet, Johnson combines two of his deepest convictions: the literary belief that poetry, more than any other human activity, draws upon all the powers of men; and the religious belief that men are judged ultimately according to how well they have employed their God-given talents.[132] These two beliefs meet and become one in the greater *Lives*. While Johnson could define poetry only in the same way as Dante defined the Holy Spirit, through the metaphor of light,[133] his search for the spirit of poetry as realized in aspiring imperfect men constitutes the special quality of wisdom in his final literary biographies.

A failure to appreciate the constancy of this search accounts for the resentment that many of Johnson's contemporaries felt toward the *Lives*. Again and again the critics charged that Johnson's opinions were grudging, ruthless, and negative.[134] Doubt-

[129] *Rasselas*, ed. R. W. Chapman (Oxford, 1937), p. 47; the opening of chapter X.

[130] *Gentleman's Magazine*, IX (1739), 3.

[131] Johnson's *Works*, V, 49.

[132] On the variety of powers required by epic poetry in particular, see the *Life of Milton*, I, 170-1; for an application of the parable of the talents, see Johnson's poem "On the Death of Dr. Robert Levet."

[133] "BOSWELL. 'Then, Sir, what is poetry?' JOHNSON. 'Why, Sir, it is much easier to say what it is not. We all *know* what light is; but it is not easy to *tell* what it is.' " *Boswell's Life of Johnson*, III, 38.

[134] See H. L. McGuffie, *Samuel Johnson and the Hostile Press* (unpublished Ph.D. dissertation, Columbia, 1961); I. N. Walker, *Johnson's Criticism Criticized: The Contemporary View of Johnson's Later Reputation* (unpublished Ph.D. dissertation, Texas, 1965).

less so persistent a reaction contains a grain of truth. Yet it also reflects an insensitivity to Johnson's major loyalty, the loyalty to poetry that asks poets to strive always for the best of which they are capable. When Hawkins writes of the "defect in his imaginative faculty" that results in "the frigid commendation which Johnson bestows on Thomson,"[135] he overlooks the strength and precision of feeling at the heart of that commendation: Thomson "looks round on Nature and on Life with the eye which Nature bestows only on a poet, the eye that distinguishes in every thing presented to its view whatever there is on which imagination can delight to be detained, and with a mind that at once comprehends the vast, and attends to the minute" (III, 298-99). Only a critic who is not fundamentally serious about poetry will think it slight praise to say of a man that he has the eye of a poet. If Johnson is niggardly with praise, that is because he speaks for the claims of poetry. The laconic conclusion to the "Life of Young" confers a word of honor that goes far beyond easy raptures and enthusiasm: "with all his defects, he was a man of genius and a poet" (III, 399).

In such criticism there is nothing tentative, there is no compromise. Unlike Warton, Johnson refuses to qualify his own best judgment. He reviews the many claimants to literary honor with clear and unblinking eyes, and from them selects the few entitled to the name of poet. Thus the *Lives of the Poets* complements the *History of English Poetry* not only in its list of authors, but in the conclusiveness of its decrees. Johnson seldom broods upon poetry. Of Gray's Bard, as of Pope's unfortunate lady and Warton's romantic alter ego, it is enough to say that "suicide is always to be had without expence of thought" (III, 440). A few words—an aphorism, a rhetorical question, an appeal to time or the public—settle every controversy; the voice of wisdom permits no reply. Too authoritative to invite argument, the *Lives* goes beyond conversation about poets, and authenticates a regular right line of poetry.

From Johnson's point of view, this predication of authority must have seemed justified not only by his own powers but by his historical position. English criticism, he thought, had reached

[135] Hawkins' *Life of Johnson*, p. 535.

a stage at which it could do justice to English poetry; taste had evolved into science. Defending Addison's criticism against the attacks of Warburton and Hurd,[136] he depicts a sustained critical progress to modern times. "Addison is now despised by some who perhaps would never have seen his defects, but by the lights which he afforded them. That he always wrote as he would think it necessary to write now cannot be affirmed; his instructions were such as the character of his readers made proper. That general knowledge which now circulates in common talk was in his time rarely to be found. . . . His attempt succeeded; enquiry was awakened, and comprehension expanded. An emulation of intellectual elegance was excited, and from his time to our own life has been gradually exalted, and conversation purified and enlarged" (II, 146). The *Lives of the Poets* draws upon a fund of taste accumulated through a century in order to codify and purify it. The task of Addison, training readers to appreciate great poetry, had been completed: "by the blandishments of gentleness and facility he has made Milton an universal favourite, with whom readers of every class think it necessary to be pleased" (II, 147). The task of Johnson, compelling readers to put aside blandishments and affectations of taste, and "to determine upon principles the merit of composition" (I, 410), requires a new severity and strength of mind.

Thus the *Lives of the Poets* consciously assumes the burden of summing up a century of English poetry, as well as the human talents and careers that lie behind the poetry. Johnson contracts all the wisdom of his age into his canon of poets. Joining received opinion about the conduct of life to a scrupulous examination of the art that represents life at its highest point of achievement, he measures human experience both in its daily rounds and its final ends. The *Lives* is a book of conduct; it is less interested in the psyche of the poet than in how well he has performed, less interested in individual poems than in the models of excellence they provide. As biography, as criticism, it aims at being exemplary. Even Johnson's aberrations stem, more often than not, from a sense of responsibility that takes more comfort in the laborious piety of a Watts than in the singular brilliance of a Swift. A custodian of poetic virtue, like a judge, cannot afford to

[136] See Hill's notes, *Lives*, II, 125, 145.

be forgiving. Had the *Life of Savage* been written in 1779, rather than 1744, one suspects that Savage's "original air," his "genius truly poetical," would have fared no better with Johnson than did the greater genius of his friends poor Collins and poor Smart.[137] Johnson suffers no appeal. He speaks as if he were the verdict of history; and for the most part history has agreed with him.

The power of that claim upon history, the confidence with which Johnson speaks for his age, are final indications of the unity of the *Lives*. One by one they tell of personal misfortunes, failed hopes, flawed works, human weakness, but together they embody the critical advances by which "life has been gradually exalted." For all its intractability, the *Lives of the Poets* represents and defends the center of a society. Its power of example has never been rivalled. As Arnold was to say, not without envy of a literary criticism based on criticism of life, of a culture without anarchy, "we have not Johnson's interest and Johnson's force; we are not the power in letters for our century which he was for his."[138] Nor has anyone since Johnson exerted that power. In spite of its fascinating detail, Boswell's *Life of Johnson* fails to relate the man to the literary past and his literary vocation. More in keeping with the *Lives* would have been the work once contemplated by Samuel Parr: "I once intended to write *Johnson's Life*; and I had read through three shelves of books to prepare myself for it. It would have contained a view of the literature of Europe."[139] But that Life, "not the droppings of his lips, but the history of his mind," could only have been written by Johnson himself. The literary biographies that followed in his train sought out the inner nature of their heroes, and were willing to neglect their exemplary contributions to the conduct of literature and life.

137 The adjectives are of course Johnson's. We may recall that in Johnson's famous aphorism, "there is no settling the point of precedency between a louse and a flea," the poetic "flea" in question was Smart (*Boswell's Life of Johnson*, IV, 192-93). A reply in kind might take account of Smart's own praise for the clandestine vigor of the flea; *Jubilate Agno*, ed. W. H. Bond (London, 1954), Fragment A, no. 36.

138 Arnold, *Six Chief Lives*, p. xiv.

139 William Field, *Memoirs of the Life, Writings, and Opinions of the Rev. Samuel Parr* (London, 1828), I, 164. "If I had written it," Parr continued, "it would have been the third most learned work that has ever yet appeared."

Thus the *Lives of the Poets* writes an end to the search for a new authority on English poetry. Johnson had set the standards for which earlier critics had asked, and against which future critics would be measured. A century later Arnold could still recommend the *Lives* as a *point de repère;* half a century after that, T. S. Eliot could still return to Johnson as a model of poetic order.[140] And even today we cannot keep Johnson out of conversations about the poets he discussed. Our debates about the metaphysical poets, about Milton, about Dryden, about Pope, begin with his book. If no one mind, like that of Johnson, can now pretend to encompass all poetry, nevertheless the unity in variety of Johnson's *Lives* still provides a type of the various unity toward which literary critics and literary scholars aspire. He continues to remind us to look for the whole.

140 Arnold, *Six Chief Lives*, p. xii; Eliot, "Johnson as Critic and Poet," *On Poetry and Poets* (New York, 1961), pp. 184-222.

Epilogue

CANONS, of course, are made to be broken, and no art is ever ordered for long. Even as the critic sets his hand to the last note of his composition, painting, music, and poetry are changing around him. No writer as sensible as Reynolds, Burney, or Johnson, living amid the revolutions of the late eighteenth century, could believe that he had spoken the last word about works of art. "Surely to think differently at different times of poetical merit may be easily allowed. . . . Who is there that has not found reason for changing his mind about questions of greater importance?"[1] The authority of Johnson's *Lives*, like that of Reynolds' *Discourses* and Burney's *History*, endured as a point of departure, not a final resting-place. Yet for many years to come English historians and critics of the arts were forced to ratify or to challenge the new standards of taste. The works that had ordered the arts set the terms of discourse for the conversations of the next generation.

The tribute to them was paid in many ways—most obviously, in a torrent of reviews and compilations and editions. In the 1850's a student of English painting still could turn to no better work than one of the revised editions of Walpole's *Anecdotes;* a student of music could do no better than consult the reissue of Hawkins' *History* or perhaps the *History of Music* that Thomas Busby had put together by combining Burney and Hawkins; a student of English poetry would certainly possess a corrected and expanded version of Warton's *History* and a well-thumbed copy of Johnson's *Lives* (probably with some sharp retorts written in the margin). Not everyone agreed with the opinions of the eighteenth-century historians, but their books kept their public.

A less direct tribute was paid by the many works that set out to rearrange the new order. Again and again, in the late eighteenth century, such works bristle with hostility and confutations,

[1] Samuel Johnson, *Lives of the English Poets*, ed. G. B. Hill (Oxford, 1905), III, 167.

yet end by accepting the whole. Thus John Scott's *Critical Essays on some of the Poems of several English Poets* (1785), a running quarrel with some verdicts of Johnson's *Lives*, ultimately seems to circumstantiate their authority; much of it could have been printed as footnotes to the *Lives*. Insisting upon Goldsmith's right to the name of Poet, for instance, Scott begins by pointing out that Johnson has omitted him: "The Temple of Fame, lately erected under the title of The Works of the English Poets, affords a striking instance of caprice in the matter of admission to literary honours."[2] But Johnson would have been the first, of course, to claim Goldsmith for future editions of English poets. Such congenial attacks give no offence. When shown the manuscript after Scott's death in 1783, Johnson observed "that authors would differ in opinion, and that good performances could not be too much criticized," and offered to write an introduction.[3]

Even works far more hostile in intent are often undermined by a similar vein of grudging flattery. Robert Potter must have designed the title of *The Art of Criticism; as exemplified in Dr. Johnson's Lives of the most eminent English Poets* (1789) to carry a tinge of irony. He surely intended to ridicule Johnson personally: "O Johnson! thy vulgar notions, and thy palliatives, pardon me, are to me disgusting."[4] Nevertheless, the contrast between Potter's quibbles and Johnson's acknowledged greatness can only serve to remind a reader of the size of the man who is mocked: "the coarseness of his constitution, his vigorous mind being perhaps vitiated or degraded by the grossness of his body, vibrated not to the delicate touches of a Shenstone and a Hammond."[5] In such passages the irony goes flat, the malice turns on its author, and *The Art of Criticism* becomes one more ornament to Johnson's Temple of Fame. Most criticism of the arts during the last two decades of the eighteenth century was subject to similar hazards. Barry and Fuseli came round at last to Reynolds,

[2] John Scott (1730-1783), *Critical Essays on . . . English Poets* (London, 1785), p. 247.

[3] *Ibid.*, p. vi. According to Hoole, who collected the *Essays*, only Johnson's own death prevented him from supplying an account of Scott.

[4] *The Art of Criticism* (London, 1789), p. 155. Potter, a well-known translator of Greek classics, is reported to have taken offense at some of Johnson's disparaging remarks on his work.

[5] *Ibid.*, p. 191.

and their fellow critics could not escape the new order of the arts even when they repudiated it.

Indeed, nothing shows the power of an author more clearly than the obsessions he inspires. Blake on Reynolds, Ritson on Warton, Stockdale on Johnson pay the tribute of their intemperate and incorrigible animus. The case of Percival Stockdale (1736-1811) is especially revealing. A perpetually failed poet and literary hanger-on sinking in "a life of vanity, vexation, and oblivion,"[6] he seems almost infatuated with the reputation and secure literary position of "JOHNSON, tuneful, animated, strong,/ Our living glory both in prose and song."[7] Stockdale might have modelled his career on the airy hopes and poetic pride of Richard Savage—the *Life of Savage* was his favorite among Johnson's works—and his own *ignis fatuus* was recognition by Johnson as a peer. Yet after the *Lives of the Poets* he turned savagely against his master. Professional jealousy accounts for much of this change of heart: according to the unfortunate Stockdale, the booksellers had at first entrusted their great edition of English poets to *him*. When his "implacable, and powerful enemies, in the literary trade" had succeeded in transferring the commission to Johnson, they added insult to injury by proposing to Stockdale that he make the index. Informed of "their engagement to *me*, before they had made an offer of the work to *him*," Johnson, "on *this* occasion, made me no reply; he was perfectly silent."[8] But Stockdale was never silent. He determined to do himself justice, and to break the tyrannies of prejudice and fashion that "have raised this biographer to the rank of a poetical law-giver, in a free and enlightened country."[9]

The vehicle for this revolution, Stockdale's answer to the *Lives*, is a work in two volumes, now rare: *Lectures on the truly eminent English Poets* (1807).[10] Beginning with their title (an

[6] Thomas Campbell, *An Essay on English Poetry* (London, 1848), p. 267.

[7] Percival Stockdale, *The Poet. A Poem* (London, 1773), p. 29. Johnson is here favorably contrasted with "slashing WARBURTONS and piddling HURDES."

[8] *The Memoirs of the Life, and Writings of Percival Stockdale* (London, 1809), II, 193-201.

[9] *Lectures on the truly eminent English Poets* (London, 1807), I, 164.

[10] The *Lectures* were begun in 1795. Stockdale was prevented from completing them by illness, but eventually brought his work to an end with lectures on Chatterton and Gray. Symptomatically, though Stockdale designed them to be read aloud, he never found an audience.

attack on Johnson's collection of "eminent" English poets), the
Lectures deliver one of the longest tirades in English criticism.
No weapon is spared against "our modern Stagyrite":[11] memories
of old quarrels, philosophical rhapsodies, personal abuse, appeals
to sentiment, misquotation, and even a conversation with Dryden
(*sic!*) about Johnson's despotism.[12] Indeed, Stockdale is capable
of every response to the *Lives* but one; he cannot let them alone.
The old wounds still smart. Johnson's failure to mention Stock-
dale's book on Pope in the *Life of Pope* cannot be forgiven, and
Johnson's meanness of spirit—he "treated men greater than him-
self, with an unwarrantable superciliousness, and contempt"[13]—is
forever contrasted with Stockdale's own loftiness—"Even wounded
self-love has not been able to warp me."[14] The *Lectures* pursue
the ghost of their oracle and adversary through two sprawling
volumes, written over twelve years, and fail to exorcise him.
Twenty-six years after the *Lives*, nine years after the *Lyrical Bal-
lads*, Johnson could still be addressed as if his word about Eng-
lish poetry were law.

Obsessions, however, obey peculiar laws of their own. The
obsessed man asks not for justice but justification, and often he
comprehends his ostensible subject far less than his own struggle
to be free. "I must Create a System or be enslav'd by another
Man's."[15] In spite of their perpetual commentary on the *Lives*,
most of the *Lectures* do not follow Johnson's law. Stockdale's
interpretation of Johnson, like Blake's of Reynolds, depends
upon a radical dissent from his principles of art, a dissent so thor-
ough that it colors every critical opinion and every historical de-
tail. Stockdale does not try to understand the *Lives*; he tries to
abolish them.

The core of disagreement is the nature of poetry itself. Like
Johnson, Stockdale believes in the glory of the poet's calling, and
he highly approves Johnson's doctrine that a great poet confers
glory on all his nation. Unlike Johnson, however, he refuses
to consider poetry a human activity to be judged by ordinary
human standards. Rather, Stockdale insists, the poet is essen-

[11] *Lectures*, I, 122. The reference is ironic; Stockdale has little regard for Aris-
totle.

[12] *Ibid.*, I, 270-77. Cf. I, 177; II, 558-59.

[13] *Ibid.*, I, 134.　　　　　　　　　　　　[14] *Ibid.*, II, 537.

[15] Blake's *Jerusalem*, Plate 10, line 20.

tially different from other men, and his career cannot be properly valued by men of prose. The repetition of this theme sustains Stockdale's best received poem, *The Poet*, for a thousand lines: "Hard is the task the poet's life to scan,/ So different from the common mode of man." The bard lives in a world of his own making, indifferent alike to fortune and reality; he "snatches powers beyond a mortal's fate,/ And when he scorns to picture, can create."[16] In the spiritual world of the poet, rules of conduct and prudence do not apply. Moreover, since poetry consists of spirit, an immortal, self-created essence, it cannot be learned or qualified: "all the other sciences are attained, but . . . Poetry is inspired."[17] Johnson's emphasis upon performance, and upon the proper *use* of talent, is utterly foreign to Stockdale. Six of the twenty *Lectures on the truly eminent English Poets* are devoted to Chatterton—not because he wrote great poems, but because he evinced marvellous gifts. For Johnson, a poetic gift tenders responsibilities; for Stockdale, it confers privileges. And Stockdale could not forgive Johnson his attempt to judge poets by the laws of human experience and poems by the laws of common sense.

The debate between the two views—between noumenal and phenomenal interpretations of poetry—has continued into our own century, and it has not been resolved. Precisely because so many later authors on the arts were to incline toward Stockdale's position, however, the historical consequences of his theory of poetry require examination. First of all, a concern with poetic inspiration rather than poetic performance drastically changes the task of a biographer. If genius is all-important in the arts, and if the artist cannot be appraised by ordinary human standards, then above all else the biographer ought to search out and celebrate genius. He will not trace the development of the poet, since genius, being inspired, is not developed but brought to light; he will not study literary precedents, since each revelation of genius is intrinsic and unique. Instead he will search the outer appearance of the poet's life for its inner meaning, and read a literary career symbolically as the quest of genius for its truest expression.

16 *The Poet*, pp. 1, 47.

17 Stockdale, *An Inquiry into the Nature, and Genuine Laws of Poetry; including a particular Defence of the Writings, and Genius of Mr. Pope* (London, 1778), pp. 166-67.

Principles of biography like these led, in the age after Johnson, to the constant romantic preoccupation with the life of Chatterton. Few critics chose to dwell on Chatterton's poems. It was the latent powers, of which the poems were merely visible signs and portents, that fascinated them, and that drew from Stockdale a sympathetic awe unmatched anywhere else in the *Lectures*. Self-created and self-destroyed, the genius of Chatterton seemed to demand a biographer who would accept the life itself as an emblem of the poet. Dying so young, he had made himself into a legend. Hazlitt's notorious reaction, in his *Lectures on the English Poets* (1818), follows the belief in the poet's autonomy to its logical conclusion. "I cannot find in Chatterton's works any thing so extraordinary as the age at which they were written. . . . Nor do I believe he would have written better, had he lived. He knew this himself, or he would have lived. Great geniuses, like great kings, have too much to think of to kill themselves. . . . He had done his best; and, like another Empedocles, threw himself into Ætna, to ensure immortality."[18] Ingenious as it is, this judgment lacks humanity; but then poets, on the same theory, are not altogether human. Rejecting Johnson's interest in rules of conduct, biographers began to popularize the notion that every artist is exceptional, that genius is a law unto itself.

Moreover, they began to identify with their subjects. Johnson, like most eighteenth-century critics, had believed in the reality of a standard of taste, based on principles of art and psychology, and upon the shared experience of mankind. The *Lives of the Poets* implicitly promises every reader that with patience and study he can expect to become a competent objective judge of poetry. Stockdale's *Lectures* offer no such promise. In place of critical standards, they espouse a criticism based wholly on sympathy, on a full-hearted surrender to the mastery of the poet. The clearest statement of this creed occurs in Stockdale's assault on the concluding passage of *Observations on the Faerie Queene*. Warton's mild comment that the critic requires discernment more than enthusiasm draws a passionate reply. "Whatever deserves the name of poetry is addressed to the sentiments; to the imagina-

[18] *Lectures on the English Poets* (London, 1818), pp. 243-44. As Hazlitt explained in the following lecture, "What I meant was less to call in question Chatterton's genius, than to object to the common mode of estimating its magnitude by its prematureness."

tion; as well as to the judgement: therefore all just criticism on poetry must appeal *from* the imagination *to* the imagination." Reason may have its place, "But I must beg your leave to *insist,* that, in the province of which we are treating, the imagination, and taste of the critick, must mingle their rays with the glory that beams from the page of the poet."[19] Such criticism rejects analysis of the poem in favor of submission to the poetic spirit. In practice, Stockdale seldom discriminates good poems or good lines from bad. He asks the critic, like the poet, only to be sympathetic, enthusiastic, and sincere, to look into his heart and read. On more than one occasion he invidiously contrasts Aristotle with Longinus, and "Aristotelian" logicians like Johnson or Joseph Warton with the "Longinian" warmth of James Harris.[20] A man of feeling, Stockdale writes for "liberal, and sentimental minds."

During the early years of the nineteenth century better critics than Stockdale would join in his attack on eighteenth-century "objectivity." Hazlitt's criticism, for instance, disdains all opinions not founded on an imaginative leap of sympathy, his own "capital excellence, the 'unbought grace' of poetry, the power of moving and infusing the warmth of the author's mind into that of the reader."[21] The new romantic critics captured the reading public by impressing it with their own participatory enthusiasm, a subjective energy unbound by rules. Yet even such critics felt the need for some test of artistic merit that would go beyond the passions of a moment. If poetry is inspired, if the sensitive reader need only vibrate to that inspiration at second hand, nevertheless some poems seem more inspired than others. The necessity of making comparisons among works of art raised immense difficulties for a criticism based on the premise that every work of genius is unique.

Many of these difficulties are adumbrated by Stockdale's *Inquiry into the Nature, and Genuine Laws of Poetry* (1778), a defense of Pope against Joseph Warton's *Essay.* Paradoxically, Stockdale uses his own criterion of inspired feeling to vindicate

[19] Stockdale, *Lectures,* I, 37.

[20] See *The Poet,* p. 44; *Inquiry,* p. 159; *Lectures,* I, 122. As such references make clear, Stockdale is by no means "original"; as much as Johnson's, his attitudes are rooted in ideas current in eighteenth-century criticism. Rousseau, Young, and Akenside are among the strongest influences upon his work.

[21] Hazlitt's *Lectures,* p. 180. The context is the excellence of Thomson's "Seasons."

a poet whom many others learned to condemn by the same criterion. But the pivot of the argument is his scorn for Warton's habit of arranging poetry into classes and categories. Such arrangements, according to Stockdale, violate the nature of poetry; they exalt the critic over the poet, and intrude the calculations of reason into the realm of spirit. Yet how can the stature of Pope be estimated except by comparing him with other poets? The *Inquiry*, in fact, employs the same methods of proof that it condemns in Warton. More than thirty pages are devoted to an attack on Gray, and Stockdale justifies himself with a critical principle as inorganic and categorical as De Piles' steel-yard: "by endeavouring to assign to each of those productions it's respective rank in the poetick scale, we improve in a just, and distinguishing taste; in the accuracy of poetical criticism; and we, consequently, gain a more perspicuous, and comprehensive knowledge of the constituents of Poetry."[22] Without accepting Johnson's standards, Stockdale aspires to a Johnsonian certainty about degrees of poetic excellence. The attempt to gain such certainty by sheer will, to found a canon of poets on the unsteady movements of the heart,[23] accounts for his long obsession with the *Lives of the Poets*.

In the next age the possibility of comparing works of art, and thus establishing canons of art, came to seem more and more remote. Critics who relied entirely on their response to genius could hardly regard criticism as a science. As nineteenth-century historians of art acquired sources of knowledge, they lost confidence in their ability to classify what they had learned. Many readers were willing to accept Thomas Campbell's notices of British poets in *Specimens of British Poetry* (1819) as a canon-making *Lives of the Poets* for the new day; but Campbell himself had no such pretensions. Contemplating Thomas Warton's rejection of the historical schemes of Pope and Gray, he drew a moral for his own work. "Poetry is of too spiritual a nature to admit of its authors being exactly grouped by a Linnaean system of classification. Striking resemblances and distinctions will, no

[22] *Inquiry*, p. 123. See John Hardy, "Stockdale's Defence of Pope," *RES*, n.s. XVIII (1967), 49-54.

[23] Justifying his career at the end of the *Lectures*, Stockdale insists that his efforts "are impelled, and animated, by the irresistible, and therefore, not presumptuous hope, that I write for ages" (II, 619-20).

doubt, be found among poets; but the shades of variety and gradation are so infinite, that to bring every composer within a given line of resemblance would require a new language in the philosophy of taste."[24] Coleridge tried to invent that language; but his example, most of his contemporaries thought, was not encouraging. A theory of art that sought to unite studies of individual artists in a metaphysical whole might be tampering with the roots of genius itself. Like Johnson's labor to reconcile the general and the particular in a scientific view of poetry, Coleridge's struggle for philosophic unity served to warn men of letters that in matters of taste and matters of genius even the best minds could not create an order that would endure.

Indeed, the disciples of the men who ordered the arts, no less than their enemies, changed their lessons beyond recognition. Northcote's passionate defense of Reynolds as an intuitive genius compromised Reynolds' principles of art far more thoroughly than the attacks of Blake or Hazlitt.[25] When Burney, in the preface to his biography of Metastasio (1796), declared his own debt to Johnson, his very next words premeditated a decisive infidelity. "Dr. Johnson, in his admirable Lives of our Poets, though his opinions concerning the merit of some of them are disputed, and have never satisfied my own mind, has manifested such powers of intellect, and profound critical knowledge, as will probably settle the national opinion on many subjects of literature upon an immoveable foundation. Indeed his biographical sketches are more confined to discriminative criticism on the works of our poets, than their manners and private life; but of Metastasio, whose writings are well known to breathe the most noble sentiments, and purest morality, we wished to know how his private life corresponded with his public principles."[26] Like Boswell, Burney founded his literary biography on private letters and on a sense of personality. No "immoveable foundation" of opinion could rest on such a basis. When Johnson's emphasis on conduct and art was sacrificed to an interest in

[24] *An Essay on English Poetry; with Notices of the British Poets* (London, 1848), p. 370. This volume was extracted by Peter Cunningham from Campbell's much admired notes to *Specimens of British Poetry*, an anthology in seven volumes.

[25] See chapter seven, sections one and three above.

[26] *Memoirs of the Life and Writings of the Abate Metastasio* (London, 1796), I, vi.

singularity and genius, Johnson's authority would not long survive.

No art is ordered for long. Authors like Hawkins, Reynolds, and Johnson deplored the convulsions and the vulgarity of modern times; each of them wished, in his own way, to provide a steady center of taste in a changing world. They had codified tradition, and directed the public to appreciate the best works and the best principles of art. But traditions of art seldom outlive the men who codify them. Indeed, to formulate a tradition is probably to accelerate its decline. When once the history of painting, of music, or of poetry has been set down, it becomes subject to revision and correction; common property, it stands for the limits that every proud artist feels called upon to exceed. Attempting to fix standards of taste, eighteenth-century studies of the arts may have provoked the revolution they opposed. The heritage of Byrd and Handel, of the Carracci and Du Fresnoy, of Dryden and Pope, represented, for many artists of the next generation, the *ancien régime* whose overthrow was the price of freedom. Canons are made to be broken.

Yet the ordering of the arts achieved, however temporarily, by the writers of the eighteenth century continued to exert its influence long after its rules and judgments had faded. Above all, it had revived a dream: the dream of a unified culture in which all works of art could be securely ranked and placed within one great idea of art. Arnold's and Eliot's admiration for Johnson's magisterial literary values, Roger Fry's dedication to Reynolds' search for an ideal of painting, Donald Tovey's resolution to describe a main stream of music, and the freshly defined images of tradition in the works of Ruskin, Berenson, Leavis, and Frye, all reflect the perseverance of that dream. Reinforced by particular details, the scholarly ideal of Junius had been restored for future generations. Nor are many historians of the arts even now willing to relinquish the hope that their own work makes part of an order, that each discovery of fact, each revival of a reputation, may help to purify and reconstitute the canons of art. For good or ill, eighteenth-century critics and historians persuaded many of their successors that an art could be gathered into an intelligible whole. The traditions of painting, music, and poetry had been given their first full expression; a long conversation had begun.

Bibliographical Sketch

THIS sketch is intended to provide basic bibliographical information for readers who would like to pursue some of the questions raised by this book. As an introductory guide, it aims to be synoptic, selective, and short. It may also serve to reveal some of my biases and trains of thought, and to record some of my debts.

I have not attempted here to survey individual authors; the notes to each chapter in the text review the appropriate scholarship. Nor have I tried to be definitive or complete. Fuller lists of eighteenth-century works on the arts may be found in J. W. Draper, *Eighteenth Century English Aesthetics: A Bibliography* (Heidelberg, 1931), J. E. Tobin, *Eighteenth Century English Literature and its Cultural Background: A Bibliography* (New York, 1939)—both of them useful though incomplete—and *The Cambridge Bibliography of English Literature*, II, especially J. M. Osborn's excellent section, "Literary Historians and Antiquaries." A bibliography of modern studies of English literature, 1660-1800, including sections on cultural backgrounds, has been published annually since 1926 by *PQ*, and those up to 1960 are available in four volumes with indices (Princeton, 1950-62).

My sketch is divided into four parts, the first of which reviews works that deal with more than one art, or with the history of ideas; the second reviews works on painting; the third, works on music; the fourth, works on poetry. Each part considers primary and secondary sources in turn. Where no location is specified for primary sources, the place of publication is London.

I. Backgrounds and Relations of the Arts

1

The student of eighteenth-century ideas about the arts can profitably begin, as contemporary authors began, by reading classics in a British context; Thomas Twining's translation of *Aristotle's Treatise on Poetry* (1789), with fine notes and two dissertations on poetical and musical imitation, and Richard Hurd's commentary and dissertations on Horace's *Ars Poetica* (1757) are especially recommended. This is not the place for a survey of eighteenth-century aesthetics, but Part II of Dugald Stewart's *Philosophical Essays* (Edinburgh, 1810) offers a

lucid review and synthesis of theories of beauty, the sublime, and taste.

Prior to the eighteenth century, much history and criticism of the arts appears miscellaneously in symposium literature like the *Deipnosophists* of Athenaeus of Naucratis (*ca.* 200 A.D.), or in treatises on rhetoric like Quintilian's *Institutio Oratoria* (*ca.* 95 A.D.); Francis Meres, *Palladis Tamia. Wits Treasury* (1598), and Thomas Wilson, *The Arte of Rhetorique* (1553), provide important English examples of these forms. Courtesy books, especially Henry Peacham's discriminating *The Compleat Gentleman* (1622) and Richard Blome's compendious *The Gentleman's Recreation* (1686), often survey the arts. Later, the quarrel between ancients and moderns provoked many discussions of the arts; in England the most notable include—on the side of the ancients—Sir William Temple, *An Essay upon the Ancient and Modern Learning* (1690), and—on the side of the moderns—William Wotton, *Reflections upon Ancient and Modern Learning* (1694).

During the eighteenth century, historical and critical observations were more often incorporated into works that drew parallels among the arts. The most impressive of this kind, the Abbé Jean Baptiste Du Bos, *Réflexions critiques sur la pöesie et sur la peinture* (Paris, 1719), was translated by Thomas Nugent, *Critical Reflections on Poetry, Painting and Music* (1748); the Abbé Charles Batteux, *Les Beaux Arts réduit à un même principe* (Paris, 1746), was also well known in England, especially through *The Polite Arts, or, a Dissertation on Poetry, Painting, Musick, Architecture, and Eloquence* (1749). Hildebrand Jacob, *Of the Sister Arts; An Essay* (1734), and Daniel Webb, *Observations on the Correspondence between Poetry and Music* (1769), both offer clear, wide-ranging, unoriginal surveys of the arts. Dr. John Brown, *A Dissertation on the Rise, Union, and Power, the Progressions, Separations, and Corruptions, of Poetry and Music* (1763), attempts more ambitiously to demonstrate the essential unity of the arts from their origins to the present. Such parallels were effectively challenged by G. E. Lessing's famous *Laokoon oder über die Grenzen der Malerei und Poesie* (Berlin, 1766), though significant correspondences continued to be drawn, notably by J. G. Sulzer in his influential dictionary of aesthetics, *Allgemeine Theorie der schönen Künste*, 2 vols. (Leipzig, 1771-74). The most pretentious combination of aesthetics with a scholarly history of the arts, Thomas Robertson, *An Inquiry into the Fine Arts* (1784), expired after only one volume (on music) had been completed.

Historians also turned to the arts. Giambattista Vico's great *La Scienza nuova* (Naples, 1725) and J. G. Herder's *Ideen zur Philosophie*

der Geschichte der Menschheit, 4 vols. (Riga and Leipzig, 1784-91), tr. T. Churchill (1800), both emphasize the central role of the arts in human history. David Hume interspersed his monumental *History of England* (Edinburgh and London, 1754-62) with rather slight sections on culture, and included a brilliant short analysis "Of the Rise and Progress of the Arts and Sciences" in his *Essays and Treatises on Several Subjects* (1777). A far more thorough history of the arts is contained in *The History of Great Britain* by Robert Henry, 6 vols. (Edinburgh, 1771-93).

Biographical dictionaries and encyclopedias supply other sources of information. The form was popularized by Louis Moréri, *Le Grand Dictionnaire Historique* (Lyons, 1674), tr. Jeremy Collier, *The Great Historical, Geographical, Genealogical and Poetical Dictionary* (1701), and improved by Pierre Bayle, *Dictionnaire historique et critique* (Rotterdam, 1697). Thomas Birch directed an English supplement to Bayle, *A General Dictionary, Historical and Critical* (1734-41), and his principles were adopted by the *Biographia Britannica,* ed. William Oldys and Joseph Towers (1747-66); 2nd ed., to F, ed. Andrew Kippis (1778-93). Few eighteenth-century reference works were more often consulted than Thomas Tanner's *Bibliotheca Britannico-Hibernica* (1748), an account of all British authors before the seventeenth century. Ephraim Chambers' *Cyclopaedia, or Universal Dictionary of Arts and Sciences,* 2 vols. (1728), and Diderot's great *Encyclopédie* (Paris, 1751-72) also contain significant, though scattered, entries on the arts. Concise and informed summaries of many of the theoretical questions discussed by this book appear in *The Cyclopaedia; or, Universal Dictionary of Arts, Sciences, and Literature* (1802-19), ed. Abraham Rees, whose articles on music were composed by Charles Burney. It should not go without saying that Burney and many other authorities on the arts contributed to *The Monthly Review,* indexed by B. C. Nangle, 2 vols. (Oxford, 1934-55), as well as to *The Critical Review* and *The Gentleman's Magazine.*

2

Many of the best modern studies of eighteenth-century philosophy, history, and criticism of art have concentrated on the shift in attitudes from neoclassicism to romanticism. The most stimulating and profound of these works is M. H. Abrams, *The Mirror and the Lamp: Romantic Theory and the Critical Tradition* (New York, 1953), which touches upon theories of music and painting as well as poetry. Wladyslaw Folkierski's pioneering study, *Entre le classicisme et le romantisme: étude sur l'esthétique et les esthéticiens du XVIII^e siècle*

(Cracow and Paris, 1925) remains provocative though thin; W. J. Bate, *From Classic to Romantic: Premises of Taste in Eighteenth Century England* (Cambridge, Mass., 1946), serves as a useful introduction to general ideas. The teleological assumptions of books that view eighteenth-century authors as forerunners of romanticism have been repeatedly criticized in recent years; by Northrop Frye, for instance, in "Towards Defining an Age of Sensibility," reprinted in *Fables of Identity* (New York, 1963), and by many of the contributors to *From Sensibility to Romanticism*, ed. F. W. Hilles and Harold Bloom (New York, 1965).

Among more specialized studies of aesthetics, S. H. Monk, *The Sublime: A Study of Critical Theories in XVIII-Century England* (New York, 1935), elegantly traces the history of one idea; W. J. Hipple, Jr., *The Beautiful, The Sublime, & The Picturesque in Eighteenth-Century British Aesthetic Theory* (Carbondale, Ill., 1957), analyzes individual texts and systems with assiduity. Though Christopher Hussey's *The Picturesque: Studies in a Point of View* (London, 1927) now needs revision, and R. G. Saisselin's *Taste in Eighteenth Century France* (Syracuse, 1965) relies too much on taste alone, each offers a clear and lively introduction to an important subject. P. O. Kristeller, "The Modern System of the Arts," reprinted in *Renaissance Thought II: Papers on Humanism and the Arts* (New York, 1965), assembles a rich store of information about the development of the concept "Art." For a general history of aesthetics, the work of Benedetto Croce, especially the second part of *Aesthetic*, tr. Douglas Ainslie (London, 1922), remains indispensable, though colored by Croce's belief that his own work had finally resolved the dilemmas of eighteenth-century theory; M. C. Beardsley, *Aesthetics from Classical Greece to the Present: A Short History* (New York, 1966), supplies an informed, unpretentious survey.

An adequate scholarly study of eighteenth-century historiography has yet to be written, though a spate of recent specialized studies has laid the groundwork. J. B. Black, *The Art of History: A Study of Four Great Historians in the Eighteenth Century*—Robertson, Hume, Voltaire, and Gibbon— (New York, 1926), and R. G. Collingwood, *The Idea of History* (London, 1946), both furnish suggestive essays that now show their age. Arnaldo Momigliano's "Ancient History and the Antiquarian," reprinted in his *Studies in Historiography* (New York, 1966), is a seminal article, and Hugh Trevor-Roper, "The Historical philosophy of the Enlightenment," *Studies on Voltaire and the Eighteenth Century*, xxvii (1963), 1667-87, is provocative. Peter Gay, *The Enlightenment: An Interpretation*—especially vol. i, *The Rise of*

Modern Paganism (New York, 1967), with a fine bibliographical essay—insists upon the importance of history to the philosophes; and J. W. Johnson, *The Formation of Neo-Classical Thought* (Princeton, 1967), emphasizes the role of historical scholarship in forming eighteenth-century attitudes. On history as well as aesthetics, Ernst Cassirer, *The Philosophy of the Enlightenment*, tr. F.C.A. Koelln and J. P. Pettegrove (Princeton, 1951), displays a depth of thought that compensates for a certain determined abstractness. A standard work on biography, pedestrian but informative, is D. A. Stauffer, *The Art of Biography in Eighteenth Century England* (Princeton, 1941).

Interrelations among the arts in the eighteenth century have been the subject of several fine studies, though we still await a synthesis. Thomas Munro, *The Arts and Their Interrelations* (New York, 1949), provides an intelligent basis in theory. The effect of painting on poetry is skillfully traced by J. H. Hagstrum, *The Sister Arts: The Tradition of Literary Pictorialism and English Poetry from Dryden to Gray* (Chicago, 1958); and problems of practical criticism raised by the analogy are explored with perception by Ralph Cohen, *The Art of Discrimination: Thomson's* The Seasons *and the Language of Criticism* (London, 1964). On the analogy with music, Brewster Rogerson, *Ut Musica Poesis: The Parallel of Music and Poetry in Eighteenth Century Criticism* (unpublished Ph.D. dissertation, Princeton, 1945), deserves to be better known. John Hollander, *The Untuning of the Sky: Ideas of Music in English Poetry, 1500-1700* (Princeton, 1961), has brilliant analyses of poems; and the articles by H. M. Schueller, cited in III, 2, below, might also be cited here.

For cultural history of the eighteenth century, *Johnson's England: An Account of the Life & Manners of his Age*, ed. A. S. Turberville (Oxford, 1933), is a mine of information. B. S. Allen, *Tides in English Taste (1619-1800): A Background for the Study of Literature* (Cambridge, Mass., 1937), supplies a useful narrative of changes in fashion; and E. F. Carritt has compiled *A Calendar of English Taste from 1600 to 1800* (London, 1949), a charming "museum of specimens." A. R. Humphreys' *The Augustan World: Society, Thought, and Letters in Eighteenth-Century England* (London, 1954) is a deft and knowledgeable survey. For intellectual history, Sir Leslie Stephen's classic *History of English Thought in the Eighteenth Century* (London, 1876), which reproaches the Enlightenment for not being enlightened enough, retains much of its value; it has been supplemented but not surpassed by Basil Willey, *The Eighteenth Century Background: Studies on the Idea of Nature in the Thought of the Period* (London, 1940), and by Paul Hazard's racy, cosmopolitan testament, *European Thought in the*

Eighteenth Century: From Montesquieu to Lessing, tr. J. L. May (Cleveland and New York, 1963).

II. PAINTING

1

Serious English discussion of painting begins with the translation of G. P. Lomazzo's *Trattato dell' arte de la pittura* (Milan, 1584) by Richard Haydocke, *A Tracte Containing the Artes of Curious Painting, Carvinge, & Buildinge* (1598). Popular treatises of the seventeenth century include Peacham's *Graphice* (1612), Sir William Sanderson's *Graphice* (1658), and William Salmon's *Polygraphice* (1672). Sir Henry Wotton, *Elements of Architecture* (1624), epitomizes Italian doctrines of art, with emphasis on Neoplatonism; and C. A. Du Fresnoy, *De arte graphica* (Paris, 1668), elegantly converts them to French taste (for a list of versions in English, see Chapter Two above). Essential studies of ancient art begin with Franciscus Junius the Younger, *De pictura veterum* (1637), translated by him as *The Painting of the Ancients* (1638), and continue with Roland Fréart de Chambray, *An Idea of the Perfection of Painting*, tr. John Evelyn (1668), George Turnbull, *A Treatise on Ancient Painting* (1740), and J. J. Winckelmann, *Reflections on the Painting and Sculpture of the Greeks*, tr. Henry Fuseli (1765); Winckelmann's great *Geschichte der Kunst des Alterthums* (Dresden, 1764) seems not to have been published in English until 1850. Among biographical collections, William Aglionby accompanied his *Choice Observations upon the Art of Painting* (1685) with selections from Vasari's famous *Le vite de' piu' eccellenti pittori* (Florence, 1550); Richard Graham drew on many standard sources, including G. P. Bellori and André Félibien, for "A Short Account of the Most Eminent Painters both Ancient and Modern" which he contributed to Dryden's version of Du Fresnoy, *De Arte Graphica. The Art of Painting* (1695); Bainbrigg Buckeridge added "An Essay towards an English-School," biographical sketches of British painters, to an English translation of Roger de Piles' influential *The Art of Painting, and the Lives of the Painters* (1706).

Jonathan Richardson initiated eighteenth-century conversation on painting with *The Theory of Painting* (1715), *Essay on the Art of Criticism* and *The Science of a Connoisseur* (1719), all reprinted in his *Works* (1773), and *An Account of Some of the Statues, Bas-reliefs, Drawings and Pictures in Italy* (1722). Conventional accounts of the theory of painting are given by Gerard de Lairesse, *The Art of Painting*, tr. J. F. Fritsch (1738), Daniel Webb, *An Inquiry into the Beauties*

of Painting (1760), Count Francesco Algarotti, *An Essay on Painting* (1764), and William Hayley's popular verse epistles, *An Essay on Painting* (1771). William Hogarth's *Analysis of Beauty* (1753) is a radical and reductive attempt at "fixing the fluctuating ideas of taste."

Sir Joshua Reynold's fifteen discourses delivered at the Royal Academy were printed individually from 1769 to 1791; *Seven Discourses* (1778) were translated into Italian, German, and (with an eighth) French. The complete discourses were first collected in the great edition of Reynolds' *Works,* ed. Edmond Malone (1797), which also includes his letters to the *Idler* (1759-61), "A Journey to Flanders and Holland," and his commentary on Du Fresnoy (1783). Among Reynolds' later associates at the Royal Academy, James Barry (1783), John Opie (1809), and Henry Fuseli (1820) also published their lectures. Reynolds' teachings were carried into the next generation by his student James Northcote, especially in *The Life of Sir Joshua Reynolds* (1818); William Hazlitt's pungent *Conversations with Northcote* (1830) preserve a lively debate between two ages of art.

Though George Vertue's notebooks were not published until this century, in the *Volumes of the Walpole Society*—xviii, xx, xxii, xxiv, xxvi, xxix, xxx (Oxford, 1929-52)—they supply the factual basis of Horace Walpole's *Anecdotes of Painting in England,* 4 vols. (1762-80). Thomas Martyn, *The English Connoisseur* (1766), supplements Walpole with an account of the paintings owned by English nobility; and Edward Edwards, *Anecdotes of Painters . . . in England* (1808), amends and adds to Walpole's information. Matthew Pilkington, *The Gentleman's and Connoisseur's Dictionary of Painters* (1770), is based on French sources; but the editions of 1798 and 1805, the latter revised by Henry Fuseli, contain significant additions by him and James Barry. R. A. Bromley, *A Philosophical and Critical History of the Fine Arts* (1793-95), offers an ambitious though undistinguished survey of the arts in all times and countries. In the following generation Allan Cunningham wrote a useful compendium, *The Lives of the most Eminent British Painters, Sculptors, and Architects* (1829-33).

2

On the earlier period, Henry and Margaret Ogden, "A Bibliography of Seventeenth-Century Writings on the Pictorial Arts in English," *Art Bulletin,* xxix (1947), 196-201, is invaluable; and Luigi Salerno, "Seventeenth-Century English Literature on Painting," *JWCI,* xiv (1951), 234-58, informative. R. W. Lee, *Ut Pictura Poesis: The Humanistic Theory of Painting* (New York, 1967), first published in the *Art Bulletin* (1940), surveys classical theory with elegance and learning.

The theory of art in eighteenth-century England still awaits the definitive treatment that many fine books and articles have prepared. Albert Dresdner, *Die Entstehung der Kunstkritik in Zusammenhang der Geschichte des europäischen Kunstlebens* (Munich, 1915), an intelligent account of early art criticism, has little to say about the English. The historical facts of authorship were gathered long ago by G. L. Greenway, *Some Predecessors of Sir Joshua Reynolds in the Criticism of the Fine Arts* (unpublished Ph.D. dissertation, Yale, 1930). Edgar Wind, "Humanitätsidee und heroisiertes Porträt in der englischen Kultur des 18. Jahrhunderts," *Vorträge der Bibliothek Warburg* (1930-31), 156-229, brilliantly describes the influence of theory on practice. More recently, art in the later part of the century has been discussed by several books, of which David Irwin, *English Neoclassical Art* (London, 1966), is notable for prodigal illustrations, and Robert Rosenblum, *Transformations in Late Eighteenth Century Art* (Princeton, 1967), for original and penetrating analyses. I have glanced at works on aesthetics above, 1, 2.

Much of the best scholarship concerning English painting has centered on Reynolds. C. R. Leslie and Tom Taylor, *The Life and Times of Sir Joshua Reynolds* (London, 1865), supply great stores of materials, and E. K. Waterhouse has gathered the paintings in his *Reynolds* (London, 1941), as well as in his standard study of *Painting in Britain: 1530-1790* (London, 1953). I have found F. W. Hilles, *The Literary Career of Sir Joshua Reynolds* (Cambridge, 1936), an indispensable source of information. Reynolds also plays a leading role in *The Farington Diary*, ed. James Greig, 8 vols. (London, 1922-28), a contemporary painter's notes on the world of art; in W. T. Whitley's lively collection of anecdotes, *Artists and their Friends in England 1700-1799* (London, 1928); and in Nikolaus Pevsner's stimulating "essay in the geography of art," *The Englishness of English Art* (London, 1956).

Horace Walpole's *Anecdotes of Painting in England* were extensively revised in nineteenth-century editions, first by James Dallaway (1826-28), then by R. N. Wornum (1849). The best biography is R. W. Ketton-Cremer, *Horace Walpole* (London, 1940). I must also mention, with gratitude, the magnificent *Yale Edition of Horace Walpole's Correspondence*, under the direction of W. S. Lewis, and *Volumes of the Walpole Society*. Useful specialized studies of the organizations that promoted eighteenth-century art include Sir Lionel Cust and Sir Sidney Colvin, *History of the Society of Dilettanti* (London, 1898), Nikolaus Pevsner, *Academies of Art, Past and Present* (Cambridge, 1940), and Joan Evans, *A History of the Society of Antiquaries* (Oxford, 1956).

III. Music

1

Few early books on music remained an influence on eighteenth-century English writers, though Thomas Morley, *A Plaine and Easie Introduction to Practicall Musicke* (1597), was always mentioned with respect, and such great collections of speculative lore as Marin Mersenne, *Harmonie Universelle* (Paris, 1636), and Athanasius Kircher, *Musurgia Universalis* (Rome, 1650), were valued for their information. Seventeenth-century English treatises on music seldom rise above the trivial: Isaac Vossius, *De Poematum viribus cantu et viribus Rhythmi* (Oxford, 1673), a defense of the ancients, is cranky and disputatious; and Thomas Mace, *Musick's Monument* (Cambridge, 1676), a "remembrancer" of practical music, is cranky and amusing.

In the eighteenth century, the first significant British study of music is by Alexander Malcolm, a clear, erudite, and compendious *Treatise of Musick, Speculative, Practical, and Historical* (Edinburgh, 1721). Roger North's lively and sensible *Memoirs of Musick* (1728), used by Burney in manuscript, were not published until 1846, by E. F. Rimbault. Standard information about music, including a catalogue of authors, is retailed by Sebastian de Brossard, *Dictionnaire de musique* (Paris, 1703), enlarged (with the help of Dr. Pepusch) by James Grassineau, *A Musical Dictionary* (1740). Full-fledged English criticism is inaugurated by Charles Avison, *An Essay on Musical Expression* (1752), whose second edition (1753) also contains a reply to William Hayes' interesting *Remarks on Mr. Avison's Essay on Musical Expression* (1753).

Among continental works on music that influenced English taste, one should mention at least J. P. Rameau's important rationalization of theory, *Traité de l'harmonie* (Paris, 1722), J. J. Rousseau's provocative *Lettre sur la musique française* (Paris, 1753) and *Dictionnaire de musique* (Paris, 1767), and C.P.E. Bach's formulation of practical musicianship, *Versuch über die wahre Art, das Clavier zu spielen* (Berlin, 1753). Many continental collections of historical facts lie behind Hawkins and Burney. J. G. Walther, *Musikalisches Lexicon, oder Musikalische Bibliothec* (Leipzig, 1732), and the miscellaneous writings of Johann Mattheson and F. W. Marpurg contribute much information. Formal histories were also attempted, among which W. C. Printz, *Historische Beschreibung der edlen Sing- und Klingkunst* (Dresden, 1690), is important for its time; Padre G. B. Martini, *Storia della musica* (Bologna, 1757-81), is immensely learned, though only three volumes of its projected five were ever completed; and Martin

Gerbert, *De Cantu et Musica sacra* (St. Blasien, 1774), is an erudite sifting of documents.

In addition to *A General History of the Science and Practice of Music*, 5 vols. (1776), Sir John Hawkins' contributions to music studies consist of some notes in his edition of *The Complete Angler* (1760), a brief *Account of the Academy of Ancient Music* (1770), and "Memoirs of Dr. William Boyce," in Boyce's *Cathedral Music*, 2nd ed. (1788). Charles Burney's reputation as an author was established by *The Present State of Music in France and Italy* and *The Present State of Music in Germany, the Netherlands, and the United Provinces* (1771-73); *A General History of Music, from the Earliest Ages to the Present Period* was published in four volumes (I, 1776; II, 1782; III and IV, 1789). Beside Burney's other major work, *Memoirs of the Life and Writings of the Abate Metastasio* (1796), his occasional pieces on music include a translation of Rousseau's operetta, *The Cunning-Man* (1766); an *Account of An Infant Musician* (1779), about the prodigy William Crotch; *An Account of the Musical Performances In Commemoration of Handel* (1785); and the articles noted in 1, 1, above. *The Memoirs of Doctor Burney, arranged from his own Manuscripts* by his daughter, Madame d'Arblay, 3 vols. (1832), subordinate Burney's autobiography to Fanny's own story.

The most important competitor against Hawkins and Burney in their own time was J. N. Forkel, whose *Allgemeine Geschichte der Musik*, 2 vols. (Leipzig, 1788-1801), formulates new principles of historiography; it ends, however, with the sixteenth century. In England no competitor appeared for a long while. Richard Eastcott, *Sketches of the Origin, Progress and Effects of Music* (Bath, 1793), is in a light, chatty vein; and both Thomas Busby, *A General History of Music from the Earliest Times to the Present* (1819), and George Hogarth, *Musical History, Biography, and Criticism* (1835), derive most of their information from the earlier histories.

2

In recent years the poverty of scholarship on English music and music writing of the eighteenth century has begun to be remedied; we now possess, for instance, an excellent *History of British Music* (London, 1967) by P. M. Young, with intelligent chapters on eighteenth-century musical practice. K. H. Darenberg, *Studien zur englischen Musikaesthetik des 18. Jahrhunderts* (Hamburg, 1960), furnishes a useful introduction to theories of music. On the history of musical ideas, I have found most helpful the series of articles, still uncollected, by Herbert M. Schueller: "Literature and Music as Sister Arts: An Aspect of

Aesthetic Theory in 18th Century Britain," *PQ*, XXVI (1947), 193-205; "'Imitation' and 'Expression' in British Music Criticism in the 18th Century," *Musical Quarterly*, XXXIV (1948), 544-66; "The Pleasures of Music: Speculation in British Music Criticism, 1750-1800," *JAAC*, VIII (1950), 155-71; "The Use and Decorum of Music as Described in British Literature, 1700 to 1780," *JHI*, XIII (1952), 73-93; "Correspondences between Music and the Sister Arts, According to 18th Century Aesthetic Theory," *JAAC*, XI (1953), 334-59; and "The Quarrel of the Ancients and the Moderns," *Music & Letters*, XLI (1960), 313-30. As a general survey of the music known to eighteenth-century historians, M. F. Bukofzer, *Music in the Baroque Era from Monteverdi to Bach* (New York, 1947), retains much of its authority. P. H. Lang, *George Frederic Handel* (New York, 1966), is a rich study of the composer whose music did most to shape the convictions of contemporary audiences and critics.

The rise of music historiography has been touched on by only a few scholars. W. D. Allen, *Philosophies of Music History: A Study of General Histories 1600-1900* (New York, 1962), a reprint of a work first published in 1939, provides a capable broad perspective on historical shifts. The decisive influence of eighteenth-century historians on the future is emphasized, perhaps too dogmatically, by Elisabeth Hegar, *Die Anfänge der neueren Musikgeschichtsschreibung um 1770 bei Gerbert, Burney und Hawkins* (Strassburg, 1932).

Any student of the eighteenth-century historians of music must remember Percy A. Scholes with gratitude for his contributions to *Grove's Dictionary of Music and Musicians*, his edition of *Dr. Burney's Musical Tours in Europe*, 2 vols. (London, 1959), and above all his biographies, *The Great Dr. Burney: His Life—His Travels—His Works—His Family—and His Friends*, 2 vols. (London, 1948), and *The Life and Activities of Sir John Hawkins, Musician, Magistrate and Friend of Johnson* (Oxford, 1953). Scholes' charming and scattered life of Burney has been supplanted, however, by Roger Lonsdale's impeccable work of literary scholarship, *Dr. Charles Burney: A Literary Biography* (Oxford, 1965), whose appearance induced me to revise many of the facts and judgments in Chapter Ten above. Roger North's manuscripts have been edited by Hilda Andrews, *The Musicall Grammarian* (London, 1925), and John Wilson, *Roger North on Music* (London, 1959). Fortunately both Hawkins' and Burney's histories of music have come back into print, the former (New York, 1963) in a republication of the edition by J. Alfred Novello (1853), the latter (New York, 1957) in a republication of Frank Mercer's edition (1935); each edition is compressed into two volumes, with sparse and not very scholarly notes.

IV. POETRY

1

The progress of English literary history during the eighteenth century may be epitomized by three brief outlines of the history of English poetry, each intended to guide a historical project that never came about, and each sketched by a great poet: Pope, Gray, and Coleridge. Pope's plan (*ca.* 1735?) was first printed by Owen Ruffhead, *The Life of Alexander Pope, Esq.* (1769), p. 328; the transcription by Thomas Gray, *Works*, ed. T. J. Mathias (1814), II, vi-vii, may be more exact. Gray's own plan (*ca.* 1755) appears in his *Correspondence*, ed. P. Toynbee and L. Whibley (Oxford, 1935), III, 1123-24. Coleridge's memoranda (*ca.* 1796) have been printed by Kathleen Coburn, *Inquiring Spirit* (London, 1951), pp. 152-53. To these we may compare the sketch (*ca.* 1733) by Joseph Spence printed by J. M. Osborn, "The First History of English Poetry," *Pope and his Contemporaries*, ed. J. L. Clifford and L. A. Landa (Oxford, 1949), pp. 240-50, and Thomas Warton's own plan (*ca.* 1770) for his *History*, printed by Clarissa Rinaker, *Thomas Warton, A Biographical and Critical Study* (Urbana, Ill., 1916), p. 83. Other useful epitomes of poetic history are formulated by such poems as Michael Drayton's "Epistle to Henry Reynolds, Esquire, *of Poets and Poesie*" (1627), John Dryden's "To the Earl of *Roscomon*, on his Excellent *Essay* on *Translated Verse*" (1684), Joseph Addison's "An Account of the Greatest English Poets" (1694), and Gray's "The Progress of Poesy" (1757); nor should we forget how many of the poems of Alexander Pope and William Collins review the history of poetry.

Behind these brief summaries of literary history lie several converging lines of more ambitious scholarship and criticism. Much of the basic information was gathered by biographical catalogues such as John Leland, *Commentarii de Scriptoribus Britannicis* (*ca.* 1545), ed. Anthony Hall, 2 vols. (Oxford, 1709); Edward Phillips, *Theatrum Poetarum* (1675); William Winstanley, *The Lives of the most Famous English Poets, or the Honour of Parnassus* (1687); Gerard Langbaine, *An Account of the English Dramatick Poets* (Oxford, 1691); Giles Jacob, *The Poetical Register: or the Lives and Characters of all the English Poets*, 2 vols. (1719-20); and eventually Theophilus Cibber and Robert Shiels, *The Lives of the Poets of Great Britain and Ireland to the Time of Dean Swift*, 5 vols. (1753). Antiquarian research on particular figures or periods filled in many gaps in knowledge; among the landmarks are George Hickes, *Linguarum Veterum Septentrionalium Thesaurus Grammatico-Criticus et Archeologicus*, 2 vols.

(Oxford, 1703-05), which placed Anglo-Saxon in its historical setting; Thomas Warton, *Observations on the Faerie Queene of Spenser* (1754); Thomas Percy, *Reliques of Ancient English Poetry,* 3 vols. (1765); Thomas Tyrwhitt's edition of *The Canterbury Tales of Chaucer* (1775-78); and the many editions of Shakespeare culminated by Edmond Malone (1790).

Meanwhile, critical arguments about poetry drew upon increasingly sophisticated historical information. The surveys of poetry incorporated by authors like George Puttenham, *The Arte of English Poesie* (1589), Sir Philip Sidney, *An Apologie for Poetrie* (1595), and Samuel Daniel, *The Defence of Ryme* (1609), were far surpassed in scope by the historical dialectics of John Dryden, *An Essay of Dramatic Poesy* (1668), Thomas Rymer, *A Short View of Tragedy* (1692), John Dennis, *The Grounds of Criticism in Poetry* (1704)—intended as the preliminary to a complete critical study of English poets—and Richard Hurd, *Letters on Chivalry and Romance* (1762). By the late eighteenth century, most literary critics had made themselves perforce into historians; Joseph Warton's *Essay on the Genius and Writings of Pope,* 2 vols. (1756-82), estimates Pope's stature by measuring him against the full range of the history of poetry.

The immense continental effort in literary research can only be touched on here. Seminal works include Nicolás Antonio, *Bibliotheca Hispana,* published in two parts, *vetus* and *nova* (Rome, 1672-96), and later edited by Francisco Pérez Bayer and others, 4 vols. (Madrid, 1783-88); Giovanni Mario Crescimbeni, *L'Istoria della volgar poesia* (Rome, 1698); Giovanni Maria Mazzuchelli, *Gli scrittori d'Italia,* 6 vols. (Brescia, 1753-63)—completed only through the letter B—; Girolamo Tiraboschi, *Storia della letteratura italiana,* 13 vols. (Modena, 1772-82); Claude Pierre Goujet, *Bibliothèque françoise, ou histoire de la littérature françoise,* 18 vols. (Paris, 1740-56); Antoine Sabatier de Castres, *Les trois siècles de la littérature; ou tableau de l'èsprit de nos écrivains,* 3 vols. (Paris, 1772); and Erduin Julius Koch, *Grundriss einer Geschichte der Sprache und Literatur der Deutschen,* 2 vols. (Berlin, 1795-98).

Aside from poems, Thomas Warton's literary activities consist of his editions of poetic miscellanies, especially *The Union* (1753); the *Observations on Spenser* (2nd ed., 2 vols., 1762) mentioned above; lives of Ralph Bathurst (1761) and Sir Thomas Pope (1772); an edition of Theocritus, 2 vols. (Oxford, 1770); *The History of English Poetry,* 3 vols. with 88 pp. of a fourth (1774-81); an edition of Milton's *Poems upon Several Occasions* (1785); and miscellaneous essays. Samuel Johnson's *Prefaces, biographical and critical, to the most eminent*

of the English Poets, 10 vols. (1779-81), had already been issued as *The Lives of the most eminent English Poets*, in 4 vols., by 1781; his other significant literary studies include essays in *The Rambler* (1750-52), *The Adventurer* (1753-54), and *The Idler* (1758-60), the preface and notes to his edition of *The Plays of William Shakespeare* (1765), and many incidental prefaces, reviews, and private communications.

A new era of literary scholarship began immediately after the publication of Warton's *History*, with the attack by Joseph Ritson, *Observations on the three first Volumes of the History of English Poetry* (1782). Later Warton's *History* was edited, with radical revisions, by Richard Price, 4 vols. (1824), and W. C. Hazlitt, 4 vols. (1871). Percival Stockdale tried to supplant Johnson with *Lectures on the truly eminent English Poets*, 2 vols. (1807); more successful were William Hazlitt, *Lectures on the English Poets* (1818), and Thomas Campbell's prefaces and notes to *Specimens of the British Poets*, 7 vols. (1819). A useful retrospect of British poetry through nineteenth-century eyes may be found in William Wordsworth's "Essay, Supplementary to the Preface," *Poems* (1815).

2

The indispensable work on early studies of poetry, René Wellek, *The Rise of English Literary History* (Chapel Hill, N.C., 1941; reprinted, with a few additions, New York, 1966), traces the development of ideas and scholarship through Thomas Warton; it should be supplemented by Wellek's monumental *History of Modern Criticism: 1750-1950*, whose first volume (New Haven, 1955) deals with the later eighteenth century in Europe. J.W.H. Atkins, *English Literary Criticism: 17th and 18th Centuries* (London, 1951), provides a standard but mediocre account of critical ideas, brilliantly reviewed by R. S. Crane, "On Writing the History of Criticism in England, 1650-1800," reprinted in *The Idea of the Humanities* (Chicago, 1967), II, 157-75; Crane's invaluable "English Neoclassical Criticism: An Outline Sketch," reprinted in *Critics and Criticism* (Chicago, 1952), has not been surpassed as an introduction to the field. Scott Elledge has edited a useful anthology of *Eighteenth-Century Critical Essays*, 2 vols. (Ithaca, N.Y., 1961). The appropriate chapters of George Sherburn's contribution to *A Literary History of England*, ed. A. C. Baugh (New York, 1948), now reprinted separately as *The Restoration and Eighteenth Century (1660-1789)*, with bibliographical additions by D. F. Bond (New York, 1967), pack much information and good sense into a few pages.

Raw materials on eighteenth-century literary historians were gathered by the indefatigable John Nichols, *Literary Anecdotes of the*

Eighteenth Century, 9 vols. (London, 1812-15), and *Illustrations of the Literary History of the Eighteenth Century,* 8 vols. (London, 1817-58). For the earlier period, a rich contemporary source is Joseph Spence, *Observations, Anecdotes, and Characters of Books and Men,* ed. J. M. Osborn, 2 vols. (Oxford, 1966). The many volumes of Isaac D'Israeli, especially *Curiosities of Literature,* 6 vols. (London, 1834), filter multitudinous facts of literary history through an active but wayward mind.

There are fine modern editions of the critical writings of John Dryden, ed. W. P. Ker, 2 vols. (Oxford, 1900), or George Watson, 2 vols. (London, 1962); Thomas Rymer, ed. C. A. Zimansky (New Haven, 1956); and John Dennis, ed. E. N. Hooker, 2 vols. (Baltimore, 1939-43). Oliver Goldsmith's occasional writings on literature are included in his *Collected Works,* ed. Arthur Friedman, 5 vols. (Oxford, 1966). We could use better editions of the criticism of Joseph Addison and Edward Young. None of the recent spate of reprints of Thomas Warton's *Observations on Spenser* and *History of English Poetry* has adequate scholarly notes, though René Wellek has supplied a preface to the *History* (New York, 1969); R. M. Baine edited a few additional pages, *A History of English Poetry: An Unpublished Continuation,* Augustan Reprint Society, No. 39 (Los Angeles, 1953). While awaiting the Yale edition of Samuel Johnson's *Lives of the Poets,* we are still fortunate to possess the edition by G. B. Hill, 3 vols. (Oxford, 1905), the last fruit of Hill's great career as editor of Johnson.

Only a few special studies of Warton and Johnson can be mentioned here. The annual Warton Lectures of the British Academy have often been devoted to their eponym; David Nichol Smith, "Warton's History of English Poetry," *Proceedings of the British Academy,* xv (1929), furnishes an excellent introduction to the problems faced by eighteenth-century literary historians. R. D. Havens, "Thomas Warton and the Eighteenth Century Dilemma," *SP,* xxv (1928), 36-50, is an intelligent survey of Warton's poetic ideas. On Johnson as a literary scholar and critic, Walter Raleigh, *Six Essays on Johnson* (Oxford, 1910), has yet to be replaced, though it shows signs of age; J. E. Brown has compiled a useful dictionary of *The Critical Opinions of Samuel Johnson* (Princeton, 1926); Joseph Wood Krutch, *Samuel Johnson* (New York, 1944), takes its subject seriously as a writer and thinker; Jean Hagstrum ably reviews the main topics of *Samuel Johnson's Literary Criticism* (Minneapolis, 1952); and W. R. Keast elegantly abstracts "The Theoretical Foundations of Johnson's Criticism," *Critics and Criticism,* ed. R. S. Crane (Chicago, 1952).

Index